THE PERSISTENCE
OF MEMORY

THE PERSISTENCE OF MEMORY

A BIOGRAPHY OF

Meredith Etherington-Smith

DA CAPO PRESS • NEW YORK

Library of Congress Cataloging in Publication Data

Etherington-Smith, Meredith.
 The persistence of memory: a biography of Dalí / Meredith Etherington-Smith.—1st Da Capo Press ed.
 p. cm.
 Originally published: New York: Random House, c1992.
 ISBN 0-306-80662-2 (alk. paper)
 1. Dalí, Salvador, 1904– . 2. Artists—Spain—Biography. I.
Title.
N7113.D3E84 1995
759.6—dc20
[B] 95-214
 CIP

First Da Capo Press edition 1995

This Da Capo Press paperback edition of *The Persistence of Memory* is an
unabridged republication of the edition published in New York in 1993.
It is reprinted by arrangement with Random House, Inc.

Copyright © 1992 by Meredith Etherington-Smith

Published by Da Capo Press, Inc.
A Subsidiary of Plenum Publishing Corporation
233 Spring Street, New York, N.Y. 10013

Manufactured in the United States of America

To my husband, Jeremy Pilcher

When a man makes celebrity necessary to his happiness, he has put it in the power of the weakest and most timorous malignity, if not to take away his satisfaction, at least to withhold it.

Dr. Johnson

Some young sardines are making their first outing under the supervision of their parents. A submarine passes by. The little fishes, alarmed, question their father:

"Papa, what's that?"

"That, my children, is our revenge which is passing: a great tin made of sheet-iron in which men, covered in oil, are held inside, pressed against each other."

Salvador Dalí, *My Friends, the Beasts*

PREFACE

GESTES ET SILENCES DE SALVADOR DALÍ

B iographies dedicated to the life and work of Salvador Dalí should
without exception be called *Secret Life I, Secret Life II,* or perhaps
Hidden Faces I, Hidden Faces II, had Dalí in person not got there
first by using these titles forty years before his end.

The aim of a biography worthy of the name consists in the advanc-
ing of various pieces on the chessboard of history. Many biographies
merely reproduce facts that were badly documented to begin with, and
whose source has never been seriously checked, if at all.

Often, nowadays, the author may be a hurried pilgrim, harrassed by
the dates of his publisher's contract. Many modern biographies' mis-
takes achieve their badness from the rag-bag of vague information ill-
digested by newshounds in various media. A "good" mistake must be
granted its own life and its originator thanked. Such "good" mistakes
are both stimulating and necessary: This is a recognized fact. We may
recall the example of the layout of Laon Cathedral, which was held up
as a remarkable exception by specialists in medieval architecture. Up
until the time, that is, that one of them who had had the curiosity to
check it on the spot stated that the plan was in no way different from
that of other edifices. This mistake, which had been repeated over
three centuries, seemingly had a beneficial result in encouraging his-
torians to other research.

I remember the birth of a similar confusion occurring with Dalí
at the beginning of the 1970s. He was then working on his book
Ten Recipes for Immortality, whose publication a friend and I were
underwriting. One fine day I saw Dalí appear triumphantly, bran-
dishing an old engraving of Trajan's Column and exclaiming: "It's
the first strip cartoon in bas-relief." This Roman monument is, of

course, famous for its outside sculptures standing out in a spiral down the body of the column. An interior stair allows access to the top. The print dug out by Dalí showed the building partly "flayed": The sculptures unrolled from left to right, and the revealed spiral staircase rose from right to left. Hence Dalí's excitement: "It's amazing; the Romans already had a premonition of the genetic code. It's the DNA double spiral!" When the details were checked, it appeared to be a mistake on the draftsman's part. But Dalí stayed true to the application of his paranoiac-critical method and would not let it go. "The discovery of such a picture with its Jesuitical mistake now seems like pure chance," he said. "But do not worry, you know better than anyone how rarely such irrational things like that happen to Dalí without one day showing their true meaning. So we must wait and put the picture in our book."

In the prologue to the same book, the artist raises the corner of the veil on his strategy of confusion.

The way to write a book which may increase the number of its buyers every day and achieve even greater success: one assembles for communication practical recipes which will interest the human being's curiosity for information, for example "How to demoralise for life a cretinous art critic" or perhaps "Ten recipes for immortality." Each recipe must contain a satisfying truth: what Leibnitz called "The sufficient reason." When the whole thing becomes too clear, dazzlingly so, you have to obscure the ideas and thus pay homage to Heraclitus the Obscure and to Tantalus when your readers get tired of everything which is too clear or too obscure. Then you must adopt the technique of "fumatora" chiaroscuro, peculiar to Eugène Carrière, in order to keep up the temptation to know more but allowing the reader to find some parcels of the truth which are of interest to him.

Secretiveness, silences, and confusion were used by Dalí and Gala as a defensive rampart with a few scraps of truth—fairly scanty in some cases—deliberately broadcast at first, scattered as a reflex action later, and alternating with an apparent profusion of subsidiary details thrown to the winds.

Some examples: of silence, to start with. In the autumn of 1975, following the stand he took on the executions ordered by Franco, Dalí hurriedly left Spain for Geneva and America. He then swore to one

and all that this was the first time he had gone in an airplane. No one questioned this statement. I think I was one of the few to show any further curiosity. Was it his first flight, or rather his first Atlantic flight? In fact, the second part of my question was near the mark. Dalí told me how, at the beginning of August 1940, Gala was in Lisbon waiting for him to return from Spain before leaving for the States. He was then in Madrid to obtain his visa, and rejoined Gala in the company of his friend Eugenio Montes, who had the use of an airplane through the courtesy of the Spanish government.

Then, take confusion: Still in the 1970s, a Paris publisher wanted to acquire the rights to *Hidden Faces,* the novel published in New York in 1944. Dalí signed the contract and then forwarded to the stupefied publisher—who knew Dalí wrote in French—a copy of the American edition, while affirming that the work had been written in English to begin with by his friend the translator Haakon Chevalier on the basis of certain verbal notes and instructions that Dalí delivered every day of their three months' stay on the Marqués de Cuevas's estate. In August 1982, after Gala's death, Dalí commissioned me to repatriate the contents of a storage room in New York. How great was my surprise to discover in a suitcase the manuscript of *Visages Cachés*—eight hundred pages written in Dalí's own hand in French.

Finally, the quality of live testimony: Dalí and Gala's highly developed feeling for complete independence—cultivated in tandem by the two of them—coupled with their massive irony left biographers little solid evidence to winnow from that collected by so-called friends, stuffed with dollars and swollen with self-conceit and bitterness. These limits make the modern biographer's task a difficult one and by that token a more respectable one. A path must be hacked out through the Dalinian rain forest. This pioneer work, Meredith Etherington-Smith's biography, represents one of the finest examples to be found today. She has the ability to use Dalí's works as frescoes aligned so as to guide us along the corridor of Dalí's and Gala's lives. Only time will be able to fill in the final uncertainties—when, that is, computers will tell us in detail of Salvador Dalí's exact movements at midday one September Sunday at Port Lligat.

Robert Descharnes
Paris 1992

ACKNOWLEDGMENTS

One of the great advantages of writing a biography of a subject whose life, in the sense of time, has overlapped one's own is that he introduces you, as it were, to his circle. In the case of Salvador Dalí, his many friends, acquaintances, and those he chose to work with have generously given me not only information but also their friendship and their encouragement in the often very difficult task of unraveling the ball of string that led me through Dalí's labyrinthine life.

Particular thanks go to Robert Descharnes, president of Demart Pro Arte and guardian of Salvador Dalí's artistic and intellectual legacy, whose support and encouragement have meant a great deal, and whose preface to this book is very generous. Mr. and Mrs. A. Reynolds Morse, founders of the Salvador Dalí Museum, St. Petersburg, Florida, were prodigal of their time and their memories. The curator of the Dalí Museum, Joan Kropf, led me through its unique collection of Daliniana. Antoní Pitxot, vice president and artistic director of the Fondación Gala Salvador Dalí, gave me invaluable insight into Dalí's early years. The trustees of the Edward James Foundation not only allowed me access to their extraordinary archive, but graciously permitted this access before the archive had been officially opened for study. To their chairman, Robert Farmer, to the principal of West Dean College, Peter Sarginson, and in particular to their archivist, Sharon Kusunoki, I owe a great deal. My thanks also to the BBC Archives, the Centre Georges Pompidou, Christie's, the staff of the London Library and in particular the librarian, Douglas Matthews, who prepared the index, the Museum of Modern Art, New York, the Harry Ransome Humanities Research Center, the University of Texas at Austin, the Southern Illinois University at Carbondale, Illinois, the Tate Gallery, and the Wadsworth Atheneum and its curator, Eugene R. Gaddis, all of whom provided pieces of the jigsaw.

A great many other individuals made a contribution to this book, in Britain, in Spain, and in America. These contributions varied from

the provision of a single, important introduction to the patient response to a great many questions. While I have made every effort to include every institution and individual who has helped me on my voyage through Dalí's life, I may have unintentionally overlooked some. I hope that they will forgive me. My thanks go to:

Jane, Lady Abdy, Michael Alexander, Mrs. Herbert Bayer (formerly Joella Levy), Peter Brown, Mick Brunton of Time Inc., Herbert Cerwin, Fleur Cowles, Ann Creed, Señora Montserrat Dalí y Bas—Dalí's cousin, John J. Danilovich, Mrs. Jane Dart, Guy Dunham, Señor Durán of the Hotel Durán in Figueres, Diana Edkins—the archivist at *Vogue,* Daniel Farson, the late Prince Jean-Louis Faucigny-Lucinge, Jean-Paul Grivory, the Hon. Mrs. Jonathan Guinness, Trevor Hadley, Andrew Harvey, Gijs Van Hensbergen, the Hon. Julian Hope, Madame Nanita Kalachnikoff, Jocelyn Kargère, the Comtesse Jennie de Kergourlay, Mary Killen, George Koenig, Karl Lagerfeld, Elena Lagorio, Eleanor Lambert, Edward J. Landrigan, Suzanne van Langenberg of the National Magazine Company Archive, Carlos Lozano, Dr. Karen Frank von Maur, Dr. F. B. Mercer, Christopher Moorsom, Lawrence Mynott, Julia Parr, Daniel Pearl, Michel Peissel, the late Major Anthony Porson, Emilio Puignau, the Baron Alexis de Rédé, Professor Carlos Rojas, Rafael Santos Toroella, John Saumarez Smith, Joán Senent-Josa, Señor F. Serrano Suñer—director of the Spanish Institute, Lady Smiley, Michael Ward Stout, Madame Denise Tual, Hugo Vickers, Mike Wallace, Ian Watson, and Robert Whittaker.

To Dale Miller, my research assistant, no acknowledgment could be too great. I am also indebted to Marilyn McCully and to Benjamin Dreyer. I would like to thank my agents, Gillon Aitken and Andrew Wylie, for their encouragement and support. I would also like to acknowledge the immense care, attention, and erudition given to the American edition by Sharon DeLano at Random House, and I would like to thank Ian Jackman for his patience.

But, above all, I would like to thank my husband, Jeremy Pilcher, my keenest critic. He not only translated numerous books and an enormous volume of correspondence for me, but also supported me at every juncture in the years of travel and research I undertook during the preparation of this biography.

Note: It has been necessary to make decisions about when to use Catalan and when to use Spanish spellings and forms. On the whole, I

have chosen Spanish, though names of people are in Catalan when appropriate.

Meredith Etherington-Smith
London 1993

CONTENTS

PART FIVE

This Approaching Metamorphosis 1980–1989

LIST OF ILLUSTRATIONS

COLOR ILLUSTRATIONS

PROLOGUE

The world into which he was born, the curious world of Catalonia, in northeastern Spain, occupied the background of Dalí's paintings, filling his vision, coloring his subconscious mind. The Catalans are a separate tribe from other Spaniards and differ from them psychologically. Catalonia is one of the least "Arab" parts of Spain, owing more to the French Languedoc for both temperament and tradition. Catalans are said to be energetic, creative, and interested in making money; they have been merchants and traders since the thirteenth century, and there is a large and prosperous middle class.

Catalonia has for much of its history been dominated by Barcelona, the second largest city in Spain—politically alive, historically a hotbed of nationalism and modernism. "It is a truism that all cities are shaped by politics," Robert Hughes remarks in his study of the place. "But it is true nevertheless—and true, to a spectacular and insistent degree, of Barcelona."[1] If one goes a little farther up the coast, however, passing through Girona, the provincial capital, to Figueres, which is only fifteen miles from the French border, one finds a world in which people were for a long time able to go about their business untroubled by savage labor disputes, freethinkers, or outbreaks of the anarchism endemic to Barcelona in the early years of the century, when Dalí was a boy.

Figueres is the largest town in the easternmost part of Catalonia, known as the Empordà; it is situated on the northern rim of the plain of that name, a corner of the Mediterranean littoral with a long history. The plain takes its name from Empúries, a port of the ancient Greeks that subsequently became a sophisticated seaside resort for the grander Romans who settled in the area. The road that bypasses Figueres is built on the ancient highway of the Via Heraclea, the route taken by

Hannibal and successive waves of traders, conquerors, and, in the Spanish Civil War, half a million refugees heading out of Spain for France.

From the highway, Figueres looks much like any other provincial Spanish agricultural or commercial center. It is a dusty agglomeration of narrow streets rising up a small incline to a little nineteenth-century castle. As in almost every other Spanish town, its center is the *rambla,* a wide paved avenue. On second glance, however, the traveler's eye is caught by something that sets Figueres apart. In the dense center, where the buildings are closest together, a huge bubble floats above the roofs. It is in fact a geodesic dome, the roof of the stage of the Teatro Museo Gala-Dalí. Immediately below it, under an unmarked slab of stone, lie Dalí's remains.

Roofless and deserted after the Civil War, this little provincial theater was restored by Dalí and is a curious monument to his life and work. The theater is his self-created Escorial, the ultimate statement of the Surrealist "found object"; at the same time, it is the last and most permanent Surrealist joke of the many Dalí played on the inhabitants of his hometown during his lifetime. It is truly Dalinian, in that while appearing to have been conceived in a mischievous moment by the painter to irritate the bourgeois Figuerans, the theater museum now attracts over half a million visitors a year, and is thus the town's major source of income.

It was here, when the theater was still a music hall, that Dalí had his first exhibition of paintings, when he was fifteen. "All my early remembrance and erotic events happened exactly in this place, and this is the most legitimate place for my museum to exist," Dalí explained in a television interview toward the end of his life.[2] Across the little plaza to the south of the theater is the church of Sant Pere, in which Dalí was baptized, and three streets away lies the house in which he was born.

The Empordà region is different geologically from any other part of Spain. To the north, the Pyrenees bar the way to France. To the south are the Albera hills, on the other side of which lies the Mediterranean and, on its narrow shore, the fishing village of Cadaqués. Between is the Empordàn plain, "the most concrete and the most objective piece of landscape that exists in the world."[3] The plain is flat and fertile, one step up the evolutionary ladder from a salt marsh. It is furred with reeds and ruled into grids by roads so straight they quickly disappear

into infinity. It is as if the whole flat expanse were a squared-up blank canvas, ready for the painter's brush. So flat is the plain that its perspective appears to be foreshortened, and this effect is exaggerated when the Tramontana wind blows from the north, at which times, in the sharpness of the air, the fields and hills seem trapped in a crystal sphere. Looking south from Figueres toward the sea, as Dalí did all his life, the eye is brought up short on clear days by the Albera hills, which spring from the plain so abruptly that they might have been cut out from the sky by a giant pair of scissors.

The plain, its surrounding hills, the curious round mill towers that punctuate the flatness, the narrow white roads—all look familiar, and they are. We have seen this curious universe, only twenty miles square, in countless paintings by Dalí. Sometimes he paints it in an autobiographical mood, the background to his memories of the stiff, black-suited businessmen from his childhood who walk, as if in a dream, down its long roads and who are dwarfed by its distances. This secret corner of Catalonia was Dalí's world. Most of his conscious and subconscious psychodramas were played out against it, whether in his paintings, in his writings, or in his life. It was also a prison from which he constantly sought to escape, only to be drawn back time and again to what he regarded on the one hand as a stifling backwater, and, on the other, as the only place he could find harmony and calm. Anywhere else was, he said, "camping out."[4] He always had to return, for only here could he paint. Only the Empordà held the key to his memories and to his inner reality.

Recurrent antipathy to what Dalí often referred to as his prison could be very violent. Writing in the magazine *Le Surréalisme au Service de la Révolution* at the height of his first rupture with his family, he said of the Empordà and its inhabitants:

> I think that it is absolutely impossible for any place on earth . . . to produce something as abominable as what is commonly called . . . Catalan intellectuals. They are an enormous filth; they used to wear mustaches full of veritable and authentic shit. . . . Sometimes these intellectuals affect polite and mutual homages . . . they dance "conudo"* dances, such as the Sardana, for instance, which alone would

* A Dalinianism, meaning, roughly, *disgusting.*

be sufficient to cover with shame and opprobrium an entire country, even given the fact that it is impossible, as it happens in the Catalan region, to add one more shame to those that the landscape, the towns, the climate, etc., confer on that ignoble country.[5]

No painter has possessed a particular place as thoroughly as Dalí, nor found such a place so inescapable. However famous he later became, however much he became the personification of the tensions, the fears, and the preoccupations of the age in which he lived, Dalí was always a true son of the Empordà. There is only one picture, he said, "which you continue all your life on different canvases, like frames on the real film of the imagination."[6]

PART ONE

THE EARLIEST SCENT OF SPRING
1904–1928

The Alpine distance and the Alpine tears
stir a keen whispering, which the live root hears;
and from the scent of winter springs a thing
which has the earliest, tenderest scent of Spring.
"The Metamorphosis of Narcissus," Salvador Dalí
(translated by Edward James)

1

THE PERSISTENCE OF MEMORY
1904–1921

S alvador Dalí was born twice. His father (also called Salvador Dalí) was twenty-nine when the first son, Salvador Dalí, was born at eleven in the morning on October 21, 1901, in Figueres. This first Salvador Dalí died on August 1, 1903, at the age of twenty-one months. The second Salvador Dalí was born nine months and ten days after the death of his brother. The death of the first baby was attributed at the time to catarrh with gastroenteritic infection. There have been, however, various other theories advanced over the years, one of which is that the child died of meningitis, which may or may not have been the result of his father's hitting him in one of his frequent rages. Another theory is that the child died as a result of a weakness passed on by his father because of venereal disease. There is no proof of this, but Dalí's father was, as were so many men at the time, terrified of the consequences of sexual adventure. Many years later Dalí recalled that "on top of the piano in my house, my father left a medical book in which there were photographs enabling one to appreciate the terrible consequence of venereal disease. He wished to terrify me. My father maintained that this book should be kept in every home to instruct boys."[1]

Whatever the cause of the death of the first Salvador Dalí, the parents never recovered from the tragedy. They talked of the dead Salvador constantly. Giving their new son the same name as his dead brother not only ran counter to a local superstition about its being bad luck to do so, but also ensured that Dalí would carry a lifelong burden of guilt that he had "stolen" his elder brother's very existence.

Dalí told the writer André Parinaud that, as a small boy, it made his teeth chatter whenever he went to his parents' room, where there was a photograph of the first Salvador over the bed—"a lovely child all decked out in lace"[2]—his forerunner, his double:

> I later had to develop all the resources of my imagination to treat the theme of my mortuary putrefaction by projecting images of my flesh as a rotting worm and finally exorcising it so I could get to sleep.[3]

Dalí believed that his problems and, indeed, his triumphs stemmed from this prenatal tragedy.

> All the eccentricities which I commit, all the incoherent displays are the tragic fixity of my life. I wish to prove to myself that I am not the dead brother, but the living one. As in the myth of Castor and Pollux, in killing my brother I have gained immortality for myself.[4]

When Dalí's father looked at him, he was

> seeing my double as much as myself. I was in his eyes but half of my person, one being too much. . . . For a long time I had in my side a bleeding wound that my impassive, insensitive father, unaware of my suffering, kept continually reopening with his impossible love for a dead boy.[5]

Dalí's mother often referred to her dead firstborn as a "genius" and took the infant Dalí to see his brother's grave, which, for the little child, seeing his own name on the headstone, was deeply disturbing. His brother's toys and games were everywhere, and Dalí's extreme egocentricity must have certainly stemmed from these constant reminders of the "other" Salvador. He was fighting early on to prove that he existed.

The second Salvador Dalí was born at 8:45 A.M. on May 11, 1904, in his family's apartment on the first floor of 20, calle Narcis Monturiol, a small apartment building just off the *rambla* in the center of Figueres.

The family belonged to the *crosta,* or upper crust, of the town, which, at the time, consisted of some 13,000 inhabitants. His father, Don Salvador Dalí y Cusí, was one of five local notaries and thus an influential figure in the district. While notaries could not plead in court, in spite of having a law degree, they were considered to be legal experts, qualified to act as signatories in trust, inheritance, and estate business. Dalí's father was known as "the money doctor."

The Dalí family is reasonably well documented. A certain F. Rahola y Sastre, who studied the relevant archives in Cadaqués and those of the Crown of Aragón (to which the province had belonged in medieval times), traced the Dalí family back to Guillem Dalí, who was taken on in 1450 as an oarsman in the galley *Santa Maria y Santa Celdoni,* commanded by Galcera Dusay and commissioned to convey ambassadors to the King of Naples. Guillem Dalí was paid nineteen sueldos for four months on embarkation. In 1625, Jaume Dalí received charity from the convent of Sant Domènech, and at the same time there was a rector in Llança called Dalí. At the beginning of the eighteenth century there was also a night watchman in Cadaqués called Dalí.

In 1871, the baptismal register in the church at Cadaqués records the birth of a daughter, Amicela Francisca Ana, to Dalí's grandfather Galo Dalí and Teresa Cusí, a widow who also had a daughter, Catalina, by her first marriage. The records show that at the time of this baptism the parents had not been married by the Church. In 1874, one month after the birth of their second son, Dalí's uncle Rafael, they were married in church but soon sought a separation.[6]

At the beginning of the 1890s, Dalí's grandparents seemed to have become reconciled, and the family moved from the isolated yet prosperous village of Cadaqués to Barcelona. According to Dalí's cousin Montserrat Dalí y Bas, Dalí's grandfather believed that his two sons would stand a better chance in the capital and that they were more likely to be given appointments in the civil service if they went to the university in Barcelona. Dalí's grandfather became a stockbroker, but in the financial crash that occurred at the time of the Spanish-American War he lost all his money and jumped from the third-floor balcony of his house to his death. His widow managed to save enough from this debacle to enable both her sons to complete their education. Dalí's father, the elder of the two boys, passed his notary examinations, and

Rafael, the younger brother, became a successful doctor and art lover who would later introduce his nephew to his intellectual colleagues in Barcelona.

When they were in their mid-twenties, both Dalí's father and his uncle married girls from Barcelona. Dalí's mother, Felipa Domènech, had a brother, Anselmo, a well-known bookseller and bibliophile who owned a bookshop in the *rambla* in Barcelona. Anselmo, though he did not see his nephew very frequently, was quite close to him, and when Dalí was in his teens apparently corresponded with him on the wide variety of ideas that had begun to interest the young painter. He may also have recommended the purchase of certain books to Dalí's father, who was always interested in furthering his son's education.

But by far the greater influence on the course of Dalí's life, indirectly at first, was Ramón Pitxot. Pitxot belonged to a large, cultivated, and wealthy Catalan family living on the calle de Montcada in Barcelona, on the same street that now houses the Museo Picasso; at the turn of the century, the family had a salon. They also owned estates outside Figueres and a villa in Cadaqués. Ramón Pitxot and his brothers and sisters built a simple summer house, which was designed by Miguel Utrillo in about 1899 and which sat on the dramatic rocks of Punt dels Sortel, a promontory on the west side of the Bay of Cadaqués.[7] Here the Pitxot family spent summers with friends from all over Europe. They gave wonderful parties, once going out to Cap de Creus, the rocky headland beyond Cadaqués, and playing classical music to create a dialogue with the waves.

Ramón Pitxot had made a name for himself as a painter in Paris by the turn of the century and exhibited in the Salon d'Automne; his colored etchings were enthusiastically praised by Apollinaire in his *Chroniques d'Art* in 1910. He had settled in a house in Montmartre called La Maison Rose around 1905, but always spent his summers in Cadaqués.

Ramón Pitxot was a central figure in the Barcelona-Paris group of painters who met, when in Barcelona, at a café–cum–beer garden called Els Quatre Gats. This group included Picasso and Derain, both of whom went to Cadaqués in 1910, not only to paint the strange, beautiful, and wild village, but to spend the long weeks of summer with the enchanting and eccentric Pitxot clan. Indeed, so close did the friendship become between Ramón Pitxot and Picasso that Pitxot

spent a great deal of time in Paris with Picasso in his studio at the Bateau-Lavoir.

Ramón's brother Ricard was a cellist with a penchant for giving recitals to flocks of turkeys—an early Surrealist without realizing it. Another brother, Lluís, was a violinist. The brothers performed concerts for King Alfonso XIII at which their sister Maria Pitxot de Gay, nicknamed "Nini"—a contralto of considerable, if theatrical, talent—took on various Wagnerian roles. Pepito, another brother, decorated the cool house (seemingly influenced by the ideas of Charles Rennie Mackintosh) on the peninsula at Cadaqués and had a unique talent for gardening. Mercedes Pitxot, the younger sister in this exceptional tribe, married the Catalan poet Eduardo Marquina, who became a particular friend of Dalí's father and whom Dalí himself believed had "brought to the picturesque realism of this Catalonian family the Castilian note of austerity and of delicacy which was necessary for the climate of civilization of the Pitxot family to achieve its exact point of maturity."[8]

According to his nephew, Antoní Pitxot, it was Ramón who persuaded Dalí's father to return to the Empordà and become a notary in Figueres under the patronage of the Pitxot family. Dalí's father thus started his practice with the business of the Pitxot estates. As well as the house in Cadaqués, the family owned land around Figueres centering on a large manor called El Molí de la Torre, the administration of which would be guaranteed to keep a notary extremely busy.

The Pitxots were the first to recognize Dalí's early talent and to persuade his father to encourage his son in his art. Had it not been for their patronage, who knows whether Dalí would ever have developed his enormous natural gifts, or indeed known that there was any sort of life beyond the narrow confines of the measured days of a provincial Catalan town. The Pitxot family opened Dalí's eyes to the larger worlds of art, music, and literature in Europe.

Dalí's father brought with him to Figueres his wife, Felipa, her mother, Ana Ferrer, and his wife's younger sister, Catalina, always known by the family as "Tieta," or "Aunt," who opened a millinery shop just off the *rambla*. Rafael elected to stay in Barcelona and practice medicine there. He had prospered sufficiently to buy a small estate at Cambrils

in the hills north of the city, where the Dalí family would gather for Christmas and New Year's.

Dalí's father achieved great success in Figueres. He was, however, a controversial figure. He had become a "Barcelona freethinker" and agnostic during his time at college, and was given to quoting Voltaire to the locals. A volatile man, his frequent outbursts of temper became an accepted, later legendary, part of the texture of life in Figueres. In appearance he was something like Mussolini. He had deep-set, pene-trating eyes, a thickset body, and, in the early drawings done of him by his son, an air of brooding if somewhat thwarted power, not to say latent ferocity, in his monumental bulk and the fixity of his gaze. The Catalan writer Josep Pla knew Dalí's father for many years. "He was a great character," Pla recalled:

> In the garden at Es Llaner [the Dalí summer house in Cadaqués] he told me with great hopefulness and with many gestures . . . "My friend, this broccoli, these lettuces, don't they support the unquestionable existence of a first cause, of an omnipotent, eternal and universal God? If it is not clear to you, either you've got something in your eye, or you're lacking in grace."

Pla concluded that Dalí's father was "a difficult man to shake but full of curiosity and with a way about him that his son has perhaps inher-ited. His son has also let fall certain contradictions always in the name of the ultimate and decisive philosophy. That is the way of the Dalís. . . ."[9]

In spite of his frequent public outbursts and contrary behavior, Dalí's father was popular. Every day he strolled down the *rambla* dressed in his shiny black suit and stiff white collar to take his *copita* of sherry and join in arguments about politics or other topics of the day with the local dignitaries who were the habitués of the Café l'Exprès or the Figueres Sporting Club. Josep Pla describes Figueres as a town of "confusing and inextricable anarchy."[10]

In 1907, three years after Dalí's birth, a sister, Ana Maria, was born. The family was now complete.

It was a household dominated by women: the old grandmother

sitting in her rocking chair; Dalí's overprotective mother; his unmarried aunt; his nurse, Llúcia; his little sister; the maids in the kitchen. At the center of this world was Dalí, the pampered prince around whom this firmament of females revolved.

His father was remote. Dalí's earliest memory of his father was of him rocking in his chair in the evening listening to Gounod's "Ave Maria" emerging from the huge horn of a phonograph. "Standing in front of him, against the background of the music, I can see his leonine jaw coming and going above my head, full of its terrifying energy."[11]

The family lived in a large first-floor apartment in calle Narcis Monturiol. A short street in the middle of Figueres, running from the open space of the *rambla* for two blocks before it reaches a small plaza, it is known locally as "the street of the geniuses," in which lived Monturiol, the man who invented a primitive forerunner of the submarine, as well as the poet Carles Fages de Climent and Josep "Pep" Ventura, a musician. The house is solid, much the same as many others built in the late nineteenth century. It has large double doors with smaller guichets cut into them, and the apartments are large and airy, with overhanging glassed-in balconies, or *galerías,* somewhat reminiscent of the Moorish-influenced architecture of Andalusia.

When the Dalí family lived there in the early years of the century, the house backed onto a large and beautiful garden owned by a local grandee, the Marquesa de la Torre. Dalí and his sister were allowed to play in this garden while their mother sewed in a pergola covered in vines. Occasionally the children visited the Matas family, Argentinians with adolescent daughters who lived two floors above them. The Dalís seemed rarely to entertain visitors. Dalí's father's social life was led in the cafés of the town, in the Hotel Durán, and on the *rambla.* The women of the family were expected to be happy in their own company.

Dalí's tantrums and his childish ailments (which he later called "anginas") dominated the claustrophobic life of the apartment. From a very early age he would fall into paroxysms of rage that could be soothed by his nervous mother only with promises that he could dress up as a king in a fancy-dress outfit all children wore for *"Els Reis"* (the Feast of the Magi). The costume had been sent by his uncle from Barcelona.

Dalí's mother was forgiving of even his worst behavior. Physically he resembled her, having the same hauntingly delicate features dominated by huge, rather sad eyes. He worshiped her saintly moral values and counted on her goodness. Since she loved him so much, and since she could not possibly be wrong, he concluded that his wickedness must, in fact, be something quite marvelous. Many years later, Dalí told his biographer Fleur Cowles that at his mother's deathbed he "swore vengeance, his teeth clenched with weeping."[12]

But vengeance for what? There is a clue, a hint, in *Hidden Faces*, the novel Dalí wrote many years later. Veronica, the American heroine of this curious work (who is really Dalí), describes her relationship with her mother:

> *We sleep together whenever she feels like weeping. This happens about twice a week. . . . She comes running into my bed and makes me put something on; otherwise she would feel shame; then I have to snuggle up to her from behind, hold her tight, rest my cheek against the back of her neck to warm it. That makes her sleep. Then immediately I slip out of my pyjamas and get rid of them; and if she wakes up in the middle of the night she screams with fright as if my body were a demon's.*[13]

This description has the texture of experience. There were deeply disturbing undercurrents in the household when Dalí was growing up. In later life Dalí would, from time to time, refer to a "secret" that only he and his father shared. It would take him some years to understand what the cause of this disturbance was. When he did comprehend it, it would affect him most profoundly.

It is telling that Dalí rarely painted his mother; there is one drawing he did of her, when he was about ten, as part of a family group in a boat, and a further drawing, done when he was in his late twenties, entitled *The Butterfly Chase*, in which she might be one of two naked women, their legs spread, leaning over a large butterfly net with a long handle while a bearded man in the background embraces them both, watched by three children.

If Dalí's mother was his idol, his father became his enemy, his rival for his mother's affections, the cause of her unhappiness. From a very early age he began to challenge his father in battles of will. The child's self-induced coughing fits terrified the father and made him tremble

until he had to leave the table. Dalí deliberately wet his bed until he was eight, and a lifelong scatological obsession developed when he was little and used to deposit feces all over the house. Later Dalí discovered that bad behavior and inattentiveness at school upset his father even more. Education, leading to a "respectable" job, was of paramount importance to Dalí's father, who was the son of a bankrupt suicide and whose widowed mother had made great sacrifices to enable him to finish his own education.

This guerrilla war with his father went on all Dalí's life. Many of his more excessive displays of temperament were aimed at the man who he felt tyrannized and dominated him. Dalí's father, on the other hand, felt that his eccentric and wayward son needed guidance, direction, and discipline, none of which Dalí was able or willing to accept. Eventually, the warfare would erupt into the open, but as Josep Pla points out, this is "normal" in the Empordà: "[It is] a country of lawsuits between fathers and sons and sons with fathers. Dalí's row with his father was typical."[14]

Yet life in the Dalí family did have its quieter moments when, for a time, hostilities between father and son ceased. Music was a great bond. Dalí's father was very musical, a legacy, perhaps, of his Barcelona childhood and the great Clavé choirs of that city.* He was enthusiastic about Sardanas, folk dances so old the music for them had almost disappeared. His neighbor and friend "Pep" Ventura had collected and rearranged the Sardana music, and on hot summer evenings the children were allowed to stay up to listen to these piping jigs, medieval in their simple counterpoint, being played by bands in the *rambla*.

At bedtime the nurse, Llúcia, read them stories. Dalí loved Llúcia and described her as looking like a pope. She was very tall, unlike Dalí's grandmother, who was tiny and to Dalí resembled a spool of white thread. When he was ill at about the age of fourteen, he painted a portrait of Llúcia sitting on the beach, which was later transformed, as were so many of these early paintings and drawings, into a Surrealist work entitled *The Weaning of Furniture-Nutrition,* depicting not Llúcia but Lidia Nogueres, a fisherwoman from Port Lligat, mending

* Choral societies founded in the mid-nineteenth century to involve the working class in music.

her nets. At the same time, Dalí also painted a touching and penetrating portrait of Ana Ferrer, his ancient grandmother, sewing in a quietly glowing interior that has a Dutch quality in its silence and depth.

His talent had manifested itself very early, at about the age of four, when he formed the habit of drawing on the tablecloth and on the edge of the cot in which he was confined. The drawings were baby drawings and would have excited no comment but for the fact that Dalí applied himself to them with a concentration held at the time to be remarkable in one so young.

When Dalí was five, his family moved from the familiar apartment in the calle Narcis Monturiol to a much larger one on the corner of the plaza Palmier and the calle de Camano, a few yards away from their original home. The move was prompted by the building over of the Marquesa de la Torre's garden and the removal of the Matas family to Barcelona, which broke up the intimate circle in the building. The new apartment was much lighter and had a gallery looking out over the square to the Bay of Roses and the mountains of Sant Pere de Rades across Dalí's beloved plain of Empordà. "The whole panorama, as far as the Bay of Roses, seemed to obey me and to depend upon my glance," he remembered.[15]

At the age of six, he decided that he wanted to be a cook. His favorite room in the new apartment was the kitchen, from which he was banned, and to which he naturally went as often as possible to steal whatever he could find to eat. He remained interested in good food and was very fussy about it for the rest of his life.

When he was seven he decided that he wanted to be Napoleon. This ambition had arisen during visits to the Matas family with Tieta, his aunt. In the Matas dining room he had noticed that the tin keg containing the sweet maté tea the family, being Argentinian, was in the habit of drinking had a portrait of Napoleon on one side. Dalí became possessed by this image. The "attitude of Olympian pride, the white and edible strip of his smooth belly, the feverish pink flesh of those imperial cheeks, the indecent, melodic and categorical black of the spectral outline of his hat, corresponded exactly to the ideal model I had chosen for myself, the king."[16]

Dalí's father had to drag him kicking and screaming to his first school, protesting against both the interruption of his female-dominated routine and the imposition of his father's will on his own child-

ish yet precociously defined desires. True to his declared stance as a freethinker and agnostic (both of which attitudes he would abandon in later years in favor of Catholicism and republican politics), his father placed the little boy in the local communal school for poor children rather than in a religious foundation for the children of the bourgeoisie run by Christians from the order of Marist monks, which would have been more suitable for the son of a notary. The school Dalí's father chose was run by one of those grotesques, so usual in the Empordà, who, besides being a very bad teacher, was possessed of other, possibly more sinister attributes.

S. D. Esteban Trayter (which name Dalí later observed was something like the name for an omelet, "*truita*," in Catalan) had a white beard divided into two plaits that hung well below his knees. He was never seen without a top hat, and when he was not asleep in class, which was virtually all the time, he took snuff and sneezed it all over his beard. This man, Dalí later observed,

> could allow himself all sorts of things; he lived under a legendary halo of intelligence that rendered him invulnerable. Sometimes on Sunday he left on excursions and returned with his bag filled with sculptured saints which he stole from Sunday churches. Once he discovered a Romanesque capital lodged in a belfry which pleased him especially. He arranged to break in at night and tear it from the wall, but so deep did he dig that part of the belfry crashed and two great bells fell on the roof of a neighboring house, making an enormous hole and a din that is easy to imagine. The awakened village had just time to understand what was happening when Señor Trayter fled—reached, it is true, by a few inhospitable stones. Though the incident upset the people of Figueres, it became part of Señor Trayter's glory, because it made him a kind of martyr art lover.[17]

Trayter had a private room, behind the classroom, which was a repository for curious objects that had caught his attention. Dalí later wrote that it must have been like the room where Faust worked. Señor Trayter sat Dalí on his knee and "clumsily caressed the fine lustrous skin of my chin between an index and thumb which had a dull skin of the odor, the color, the temperature, and the imperfections of a wrinkled potato warmed by the sun and already a bit rotten."[18]

Whether Trayter's attentions to Dalí went beyond mere chin strok-
ing must be a matter of conjecture, but given that Dalí had in later life
a horror of being touched, it is reasonable to suppose that his visits to
Señor Trayter's back room might have contributed to his aversion to
normal contact.

Trayter showed Dalí odd things, including a rosary so big he had to
carry it on his back, and a mummified frog hanging on a string that
Trayter called his "dancing girl" as the frog jerked and quivered. In this
sanctum were other, even more peculiar, objects that were probably
medical paraphernalia and whose unknown use tormented the young
Dalí with the "scabrous ambiguity of their explicit shapes."[19] But it was
a large square box, a sort of optical theater, that really impressed Dalí,
but that he was never quite able to reconstruct. Perhaps it was a
stereopticon. It showed a series of views of Russia among which was
an image of a little Russian girl covered in white furs sitting in the
bottom of a sleigh surrounded by wolves. Later, Dalí was convinced
this image was of his wife, Gala.

These menacing machines and implements, the images in the optical
theater, would, like the photographs in the book about venereal dis-
ease and so much else in Dalí's childhood, including his own childish
looks, make their appearance in his later paintings.

Far from being the product of a "waking dream," Dalí's Surrealism
was autobiographical. In his early and middle-period Surrealist work,
one can see the infant Dalí dressed in his sailor suit gazing at his
father; the landscape is recognizable, indeed portrayed with astonish-
ing fidelity, as Reynolds Morse, the greatest collector of Dalí's work,
points out in a privately published monograph that identifies many
locations in the Empordà and matches them to specific paintings.[20]
Fountain of Milk Spreading Itself Uselessly on Three Shoes (1945), for
instance, is a view of the Bay of Roses from the road to Cadaqués. *The
Weaning of Furniture-Nutrition* (1934), the composite portrait of Llúcia
and Lidia the fisherwoman, is obviously set in the little bay of Port
Lligat.

But most revealing of all is the origin of the amorphous shape that
appears first in *The Great Masturbator* (1932) and in many subsequent
paintings. When Dalí was about six or seven, a whale was washed up

on the shore of Port de la Selva, the fishing port in the bay north of Cadaqués, and he was taken to see it. In the town hall at Cadaqués there is a photograph of this beached whale; one need look no further for the origins of this curious and dominating image in Dalí's iconography. Indeed, Dalí's autobiographies, *The Secret Life of Salvador Dalí* and *Diary of a Genius,* are far less revealing of the secrets of his life than are many of his Surrealist paintings.

Trayter's importunate eccentricities were not the only problem facing Dalí at his first school. His classmates came from much poorer families and attended school in cast-off clothes and mismatched espadrilles (if they wore shoes at all). Dalí was clad by his mother in immaculate navy-blue sailor suits, shod with silver-buttoned shoes, and allowed to carry a small cane with a silver dog's-head handle. Although he implied in his autobiographies that his classmates treated him like a superior being from another planet, he was in reality badly bullied by the other children, who threw snails at him.[21]

He did have one friend from a poorer family, Joan Butxaques. "Butxaques" literally means "pockets," and young Joan, coincidentally, wore a suit with many little pockets sewn onto it. At one time, Dalí told André Parinaud, he might have "even fallen in love with Butxaques and his little rear end, so clearly marked out by his tight-fitting trousers, had he been willing not to behave like a violent, brutal boy who was already sex-conscious."[22] From this nascent love affair developed Dalí's obsession with pockets and with drawers in furniture.

Tormented and bewildered, Dalí escaped (as he would so often during his life) into daydreams. He began to invent what he would later call his "false memories." They are an aspect of Dalí's self-mythologizing. He was, in fact, always entirely aware of the difference between fantasy and reality. He admitted in his autobiographies that he could fantasize at will, could consciously switch from reality to fantasy. He learned how to use fantasy.

Haunted by the death of his older brother, the other Salvador, Dalí constructed a fantastical alter ego for himself, a spectral "brother." This process began very early, and his fantasy life was aggravated by constant battles with his father. Joined for all time in the personality of Dalí's father were sex, guilt, and a wish to dominate. Add to this the

equally powerful personality of Dalí and the fact that his father could be violent in the pursuit of what he believed to be right, and the pattern that engendered Dalí's extraordinary character begins to become apparent. Though Dalí was not, in the modern sense, a child at risk, he was certainly a morbidly sensitive child who struggled to assert himself.

Josep Pla tells an illuminating story about the very young Dalí:

> *One day Dalí Senior said to me, "I'd gone to Barcelona with Salvador. When we got to Empalme station where they were cooking perfectly decent tortillas, I told Salvador to go and buy two and gave him the necessary money. After a moment he returned and handed me two long rolls split lengthways. There was nothing in them. 'And the tortillas, where are they?' 'I got rid of them,' he said with the utmost naturalness. 'And why did you get rid of them?' 'Because I didn't like the yellow,' he replied with rock-solid conviction. I have a son," the notary added, "who pays not the slightest heed to reality; he doesn't know what a five-centimo piece is, nor a peseta, nor a duro, nor any bank note. He has no idea, you realize; he's a hopeless case. How will all this end? I've no idea. It's a question that gives me the shivers."*[23]

After a year at Trayter's school, Dalí had learned nothing. He could neither read nor write, so his father abandoned his freethinking principles and sent his son to the Colegio Hermanos de las Escuelas Cristianas in Figueres, which Dalí attended from 1912 until July 1915. But this was no more successful; Dalí's behavior pattern had become fixed. Dalí sat in classroom 1 in his new school, looking out of the window more often than he attended to his teachers. From his desk he could see two large cypresses, and as he gazed at them day after day, he became absorbed in the change of light on the two trees. He noticed, for instance, that at a certain moment just before sunset the pointed tip of the cypress on the right would appear as if illuminated with dark red, as though it had been dipped in wine, while the cypress on the left, already completely in shadow, appeared deep black. To Dalí's eye they burned in the sky like two dark flames. When darkness fell in the winter, the lights were turned on in the classroom and the trees became invisible. Dalí then turned his head toward the corridor, where he could spy a copy of Millet's *Angelus*.

His teacher moved him so that he could not see out of the window. Stubbornly, Dalí re-created the cypress trees in his mind. Later he re-created them in his paintings because it was "torture not being allowed to see that beloved plain of Empordà, whose unique geology with its utter vigor was later to fashion the entire aesthetic of the philosophy of the Dalinian landscape."[24]

He had started to make friends, among whom was Jaume Miravitlles, the son of a respected Figueres family that owned a shop in the *rambla*. "I gave him private lessons in mathematics, and if I ever worked a miracle in my life," Miravitlles said later, "it was when I prevented him from failing his algebra examination."[25] Dalí was so inattentive a pupil during his first year with the Christian brothers that his report card noted that he was dominated by a kind of mental laziness so deeply rooted that it made it almost impossible for him to achieve any progress in his studies. A modern pedagogue might have considered him differently—as a highly gifted child in need of constant mental and visual stimulation, without which he would not develop.

Dalí was kept back in the lowest class for a second year, pretending not to know even the things that, in spite of his daydreaming, he had taken in. His handwriting was nonchalant, with thousands of blots and characters of bewildering irregularity. But he did this on purpose. He could in fact already write perfectly well. Writing badly was another skirmish in the war with his father. All his life, Dalí would continue to use writing as a weapon and as a means of concealment. Deliberately, he would write incomprehensibly to those he felt to be authoritarian. He would use writing as camouflage or, on occasion, as persuasion. Over the years, he developed several different hands. One was perfect copperplate with infinitely delicate curlicues like the whorls on a shell. Another was a febrile zigzag in which the letters were violently compressed horizontally, shooting into precipitous verticals. A third was minuscule and somewhat infantile.

What role did Dalí's mother play on this battlefield of personalities? She is a shadowy figure, sewing in a quiet room at dusk, comforting Dalí after some particularly heinous escapade, encouraging him to be ill. His mother was an accomplice, because his "anginas" would keep him by her side. Understandably vigilant of her surviving son, she treated him as if he hovered on the brink of death.

* * *

What his mother and father were slow to realize was that this self-important, spoiled child was becoming—without histrionics, but with the natural inevitability of the genuinely gifted—a painter. At about the time he first went to school, he bullied his parents into letting him have a little playroom:

> For some time my mother had been asking me, "Sweetheart, what do you wish? Sweetheart, what do you want?" I knew what I wanted. I wanted one of the two laundry rooms located on the roof of our house . . . and one day I got it. . . . The walls were covered with pictures that I painted on the covers of hatboxes of very pliable wood which I stole from my aunt Catalina's millinery shop.[26]

Here Dalí kept his collection of *Art Gowans*. This was a series of illustrated monographs on the great artists that his father had given him as a present. On hot days, Dalí would sit in the laundry tub, fill it with cool water, and prop the issue of *Art Gowans* he was studying on a plank put across the tub. He came to know by heart the paintings he studied for hour after hour. "The nudes attracted me above all else, and Ingres' 'Golden Age' appeared to me the most beautiful picture in the world. . . ." He was lazy at school; but when his mind was engaged, he was dedicated. His father's gift of *Art Gowans* must have been in recognition of this passionate interest.[27]

In the laundry room, at the age of ten, Dalí painted his first real picture. Called *Paisaje,* it was painted on a board with the first oil paints Dalí owned. (These had possibly been given him to play with by Siegfried Burman, a refugee German scene painter who had drifted from Barcelona to Cadaqués during World War I.) This little impressionistic landscape (perhaps influenced by what he had seen of Ramón Pitxot's work) not only has perspective but a depth and confidence astonishing in the untutored work of a ten-year-old.

Every summer of his childhood, Dalí's life changed from the round of restrictive classroom and dreamy laundry room, and became wild, free, and natural at Es Llaner, the house his family had built on the

seashore in Cadaqués near Els Sortel peninsula to be close to the Pitxot clan.

In the early days of the century, Cadaqués was a day's cart ride from Figueres. An isolated but prosperous fishing village, it was linked to the rest of Spain by a rough and precipitous road over the mountains. Today, the road is clogged with cars and tour buses in the summer, but Cadaqués itself has managed to retain a hint of its separateness and self-regarding preoccupations. Old fishermen still say, "The sea is our road," and there are still many boats in the natural harbor. The most adventurous fishermen went to Cuba in the early 1900s and worked in the cane fields for a time to make their fortunes. They then returned to Cadaqués and built curiously designed houses reminiscent of Swiss chalets in an Art Nouveau style; the locals call these houses *"Las Indianas."* The adventurous fishermen of Cadaqués also sailed to Genoa with their catch, coming back with elaborate wrought-iron beds that are still to be found in many Cadaqués houses.

The village is wild and isolated. The mountains behind are tiered with terraces that contained vines until phylloxera destroyed them. Now the terraces are empty; bands of flinty soil are punctuated by the occasional olive tree. The village clings to a shallow foreshore at the foot of the mountains and climbs up a steep hill to a large and very beautiful seventeenth-century church. The narrow, exceedingly steep streets are paved with black flint setts and overhung with white-painted fishermen's houses splashed with magenta bougainvillea; most of these houses are now owned by summer visitors.

Cadaqués was (and is still) very different from the cozy bourgeois world of Figueres. It is surrounded by the rocks and the sea, a place of a violent climatic change. The location is said to encourage eccentricity bordering on outright madness. People speak of a lunatic streak due partly to inbreeding over many generations and partly to the Tramontana, the offshore wind, which blows for about nine months a year. In the past, when the Tramontana blew, day after day, month after month, suicides were frequent. There are still trees behind the church on which the inhabitants hanged themselves.[28]

In Dalí's youth, he was allowed to roam the village on his own and fraternize with robust characters such as Josep Barrera, a smuggler who lent Dalí a hut that he used as a studio, and Noi de Tona, a mixture of tramp, political joker, and rogue who pulled teeth for a

living. But Lidia Nogueres was the most interesting figure of those early summers. Dalí developed a curious and important relationship with her, compounded half of terror and half of admiration for her bond with nature, with the land, sea, and myths of Cadaqués.

Lidia was the widow of a fisherman, Nando Nogueres, who had died young at sea, and she was generally acknowledged to be a witch, or the descendant of witches. She had two sons who lived with her; both were slow-witted and completely dominated by their mother. Lidia got by, by taking in paying guests in her house in Cadaqués, where, during the summer, encouraged by the example of Picasso and Derain, artists and writers were increasingly in the habit of staying. One such writer was the Catalan poet and critic Eugeni d'Ors, who, under his nom de plume, "Xenius," was the art critic for *Veu Catalunya,* the Catalan daily newspaper. D'Ors invented the term *"Noucentisme"* for the Mediterranean movement of painting that flourished in the first two decades of this century, and was generally acknowledged to be in the vanguard of Catalan writing and thought. Lidia had a mind predisposed to poetry and had been struck with wonder by the young Catalan intellectuals. To Dalí, she represented the darker side of magic, the presence of numinous forces, the Underworld wherein dwelt the ever-present Pollux, the first Salvador, awaiting his chance in the sunlight to consign Castor to oblivion.

Es Llaner, the house on the shore where the Dalí children spent the long magical summers of their youth, is still there. But the garden with its rows of vegetables growing in the black shade of the olive trees, painted by Dalí when he was eleven, is gone, as is the huge screen of geraniums that was all that separated the house from the shore. In its place there is now a road between the house and the beach where once the sea used to wash up to the garden at high tide.

Here the two Dalí children were allowed to play barefoot on the seashore and later to wander through the village at will. The fisherman who looked after the family boat in the summer would take them on trips around the eastern headland, past the tiny little bay of Port Lligat, past innumerable other bays with olive groves coming down to the edge of the water, past cliffs and caves to Cap de Creus. As Dalí watched the black rocks move slowly past the boat, he could see them changing into curious humanoid and anthropoid shapes that became, according to the vantage point, eagles, lions, human heads, the face of

a woman, a hunched-up old man. For all these figures the fishermen had names that were part of the local lore. These "double" images would later become a recurrent and highly important motif in Dalí's paintings.

The long summer months were, for Dalí, balanced between two poles. On the one hand, there was the "natural" earthiness of Lidia and other local characters living in the tiny world of Cadaqués. On the other was the informed sophistication of the Pitxots. From these earliest years the shape of Dalí's life was determined; a series of violent oscillations between the two extremes.

When Dalí was about twelve and had been painting in his laundry-studio for two years, he fell ill again. He said later that he had outgrown his strength. Whatever the cause, and it seemed to have a hysterical rather than a physical origin, the malady was serious. When Dalí was well enough to be moved, Bruses, the family doctor, recommended that he spend some time in the country to recuperate. Pepito Pitxot, the lawyer of the family, offered to have him to stay at the Molí de la Torre, just outside Figueres on the way to Roses. The Molí de la Torre was an old manor house set within a shady garden, which in turn was surrounded by the huge wheat fields of the Empordà and by olive groves. Here Dalí, influenced by Ramón Pitxot's impressionistic and pointillistic paintings, many of which hung in the dining room, started to use his imagination as well as his eyes.

Ramón Pitxot's paintings "made the deepest impression on my life," Dalí wrote later, "because they represented my first contact with an anti-academic and revolutionary aesthetic theory."[29] He admitted that he could not then see all he should have in those "thick and formless daubs of paint which seemed to splash the canvas as if by chance in the most capricious and nonchalant fashion,"[30] but he had begun to realize that this musically colored medley could become, as he put it, organized and transformed into pure reality. So attentive was he to these pictures, hung against the whitewashed wall, that he often spilled his milky breakfast coffee down his shirt. What might have infuriated his father passed unnoticed by the Pitxots, who were content to let him do as he might; thus he spent his days in a large whitewashed granary where corn dried on the floor. In these

somewhat unlikely surroundings Dalí started his long odyssey as a painter.

Leaning against one of the walls was an abandoned door, riddled with wormholes, which Dalí used as a canvas. He painted a picture of cherries, using three colors: vermilion for the light side of the cherry, carmine for the dark, and white for the highlights. He decided to apply the paint directly from the tube, and held the vermilion and carmine in his left hand, the white in his right. When Ramón Pitxot pointed out that he had omitted painting the stems of the cherries, Dalí arrived at a perfect Dalinian solution: He ate some of the fruit and glued the stems onto the door to "finish" the painting. Impressed by this result and the dedication with which it had been achieved, Pitxot told Dalí he would speak to his father about extra drawing lessons, whereupon Dalí apparently replied that he did not need a drawing teacher because he was an impressionist painter. Ramón Pitxot was obviously highly amused by this, but insisted. According to Dalí's later elaborate encrustations of the mythic carapace he deliberately built around the true facts of his childhood, this recuperative visit to the Molí de la Torre was one of the most decisive events of his life; for it was here he began consciously to look at his surroundings and to paint them. It was also, although he does not mention it, the first time he had been separated from his family, and thus a crucial step toward independence and self-knowledge. His earliest self-portrait, *The Sick Child,* dates from this period; he portrays himself as a delicate, almost consumptive, fragile being. The lachrymose appeal of sick children to nineteenth-century sensibilities was reflected in the "Salon" art of the time, and Dalí must have seen several pictures on this subject by academic painters such as Millet in the art books his father gave him.

On Dalí's return to Figueres, he was enrolled for evening classes with Professor Joan Núñez of the Municipal School of Drawing, and also studied with him at home. Núñez was an excellent artist who had won the Prix de Rome in engraving, and he inspired respect and devotion in Dalí. Among his possessions was an original Rembrandt etching that he allowed Dalí to study. Núñez was a more cautious character, artistically, than Dalí, and told him he should "never go beyond the limits" —advice that of course was never taken. However, to Núñez must go

the credit of establishing the foundation of Dalí's art by encouraging his draftsmanship. Whatever psychological, political, religious, or scientific motives Dalí would later ascribe to his painting, whatever he did, whatever he wished to achieve, all was built on a solid rock of drawing of such accomplishment and delicacy that he must be credited with being one of the finest draftsmen of the twentieth century. Although Dalí denied that drawing had any importance during his teens, he had, by the time he went to art school in Madrid, become passionate in his belief in Ingres's insistence that "drawing is the probity of art." The original talent on which Núñez built was prodigious, as can be seen from the pages of Dalí's schoolbooks, on which he drew sensitive portraits. There is, for instance, a drawing of a man in evening clothes (probably one of the Pitxot brothers) executed in Dalí's physiology book when he was about fourteen, which for economy of line and quality of observation is already the work of an able draftsman and shrewd observer.

In almost any Spanish bourgeois family of the time, a telegram was an event of great moment, usually announcing a birth or a death. One night the doorbell rang while the Dalís were at dinner and a telegram was delivered; the family steeled itself for bad news. The death announced was that of Carolineta, Dalí's first cousin from Barcelona. Aged about seventeen, she had died from consumption. She had been a frail and poetic figure, and Dalí later told Edward James that he remembered her in flowing, rather Blake-like drapery—"post–Jane Eyre and pseudo-Brontë."[31]

Naturally, the telegram was handed to Dalí's father. The family had been chatting before it arrived, and some conversation continued; the clatter of spoons and forks had not wholly died down until the brown envelope was torn open and the stentorian voice of the head of the family announced what most of them had already guessed. "Then from the old lady who was my grandmother came a cry of such strength that the whole room was struck by it, and following that there arose a general groan which filled the room with the family sobbing, like a vase filling with water."[32] Thus the spectral, lachrymose figure of Carolineta joined the whale, the tower, the nurse, and the black-suited bourgeois in Dalí's iconography.

* * *

From the time he was eleven until the age of fifteen, Dalí attended the Marist school in Figueres, where his eccentricities became even more pronounced and provided sport for his classmates. One of the most prominent was a fear of grasshoppers, which never left him. His classmates tortured him with the insects, and he threw fits of such violent hysteria that the teachers forbade grasshoppers ever to be mentioned. Drawings of them were also banned, as they disturbed Dalí equally. Still inattentive, except in his drawing classes, he managed to pass his exams because if he had not his father would have carried out his threat not to allow him to spend the summer in Cadaqués. Dalí's summers of freedom were of vast importance to him. "Its [Cadaqués's] beauty is a magic of imponderables," he told André Parinaud.

> *Where else does one find so desolate a feeling, such abandoned pathways, such indigent roads, so sparse a vegetation, but also where an imagination living with more luxury in the excellence of the line of the hills, the design of the bay, the shape of the rocks, the fine and shaded gradation of the espaliers leading down to the sea? Solitude, grace, sterility, elegy—the contrasts come together as in the nature of man, and we live in a perpetual set of miracles. O excellence of those things from which my eyes will never cease to take nourishment.*[33]

It was at Cadaqués that adolescence announced itself, with the "birth of body hairs."[34] He had noticed his first pubic hair one summer morning while swimming naked with other children in the Bay of Roses. Puberty seems to have enhanced his rebellious streak. He grew his hair long, inspired by Raphael's self-portrait, and began to steal his mother's cosmetics, powdering his face with rice powder, crayoning around his eyes, and biting his lips to make them red. The reactions of his family can only be imagined, for Dalí does not tell us. He also started to masturbate very regularly, in love with this new image of himself. "I espied my first pubic hairs and found expression for my narcissistic desires among the rocks at Cap de Creus. I ecstatically sowed my seed as I masturbated along the coves, creating a sort of erotic Mass between that earth and my body."[35]

Still short on ideas, he wrote of himself at this time that he was

long of hair and side-whiskers. To contrast with my thin, swarthy face I wore a huge ascot tie. My jacket was complemented by plus fours and gaiters that came up to my knees. A meerschaum pipe, the bowl of which was an Arab grinning broadly, and a tiepin made of a Greek coin were my usual vestimentary accessories.[36]

His parents seem to have become fatalistic about the fact that their only son would always be different. Remarkably, when one considers their circumstances, the time in which they lived, and their position in Figueres society, they put very few outward restraints on even the most bizarre adolescent fantasies. Perhaps they were exhausted by the unending struggle with this curious child, who was both timid and violently aggressive.

Dalí enjoyed being the subject of controversy: "Is he mad? Is he not mad? Is he half-mad?" He began to believe that anything abnormal or phenomenal that occurred was automatically attributed to him: "As I became more 'alone' and more 'unique' I became by that very fact each day more 'visible'—I began to exhibit my solitude, to take pride in it as though it were my mistress, whom I was cynically parading loaded with all the aggressive jewels of my continual homage."[37]

Not all Dalí's thoughts were centered on his image; he had begun to exhibit that devouring intellectual curiosity and quickness of mind that prompted Picasso to describe Dalí's brain as an outboard motor. In his painting he moved away from the techniques of impressionism to those of cubism, the existence of which he had discovered through reading the magazine *L'Esprit Nouveau.* He also began to read the huge encyclopedia his father had given him, and a great many books he found in the public library that were most definitely not on the Marist brothers' curriculum. He read Nietzsche's *Thus Spoke Zarathustra* and Voltaire's *Philosophical Dictionary,* and studied Kant, whose categorical imperatives seemed beyond his comprehension and threw him into reflection. Similarly, the ideas of Spinoza and Descartes sowed seeds that provided Dalí with the basis of his later philosophical methodology.

When he was fifteen, just after World War I ended, Dalí was expelled from the Marist school for disruptive behavior. He had, however, passed his exams and could therefore attend the senior educational establishment in the town to gain his *batxillerat.* This was

the Instituto General y Técnico in Figueres. Surprisingly, when he graduated in 1921 he had earned brilliant marks. Perhaps the freer, more "adult" atmosphere of the institute enabled him to learn without feeling the necessity to rebel.

His parents christened Dalí's later teens "the Stone Period." He continued the experiments started in the Pitxots' granary. From cherry stems he had moved on to stones, which he stuck to his canvases and then painted in intense colors. One of these "stone" paintings, a large canvas of a sunset with scarlet clouds, hung for a while in the family dining room. While Dalí's mother sat sewing after dinner in the dusk and his father listened to Gounod, something would rattle softly on the floor. Dalí's mother would stop and listen, and his father would reassure her by saying, "It's nothing, it's just another stone that has dropped from our child's sky."[38]

Some painters can write, others are dumb, Dalí once said, citing Joan Miró as a "dumb" painter. Dalí himself belonged to the first category, and at about sixteen he began to put his thoughts down. In *"Tardes de Estiu"* ("Summer Afternoons") he was inspired by his earliest excursions into painting at the Molí de la Torre:

> Then he started to paint. He had a marvelous idea for a canvas; in the foreground the courtyard of a house, a whitewashed house which, in the sun, revealed great subtleties and a great profusion of colors; in the middle of the courtyard, a luxuriant cherry tree loaded with fruit was growing which enlivened the fine colorations even more; in the distance, the whole plain with its orchards and fields reverberated with the light and the warmth. . . . And way off in the distance at the horizon . . . the intense blue line of the sea.[39]

To Dalí, writing and painting were both equally part of his creative life. There is, in his paintings, a literary quality, even in the most Surrealist work he did in the 1930s, while his writing is full of complex and original visual imagery. In one instance, and one alone, the painting and the writing become the same; the painting is *The Metamorphosis of Narcissus*, and Dalí wrote a long poem of the same title that, while it

does not "explain" the painting, augments and amplifies its effect, acting as a coda to the canvas—or is it the other way around?

In January 1919, Dalí had his first public show of paintings as part of the exhibition given by the Concert Society of Figueres, in the foyer of the municipal theater. On January 11, the newspaper *Ampordà Federal* published a review of the exhibition, in which the reviewer, who signed himself "Puvis," had the following to say:

> . . . *let us speak about Mr. Salvador Dalí Domènech. The man who has within him what the paintings he has exhibited in the salon of the Concert Society reveal to us already has great artistic talent. . . . We have no right to speak of the young Dalí, since such a young person is already a man. . . . We do not have the right to say that he is promising, but that he produces. . . . Mr. Salvador Dalí Domènech will be a great painter.*[40]

Dalí had been given a small studio near the family apartment, and he began a series of studies of the Gypsies with whom he had become friendly. These paintings are reminiscent of the "genre" paintings not only of Pitxot but also of Joaquín Sorolla and depict the Gypsies in a very realistic manner. The Gypsies were delighted to pose for Dalí, whom they called "Señor Patillo" ("Mr. Whiskers") in acknowledgment of his extravagant sideburns.

With two friends from school, Dalí produced a magazine called *Studium* that lasted from January until June. Dalí wrote articles on the great masters of painting: Goya, El Greco, Dürer, Leonardo da Vinci, Michelangelo, and Velázquez. In the last issue, Dalí published his first poem, *"Cuan els Sorolls S'Adormen"* ("When the Noises Sleep"), a poem of seventeen lines describing the onset of twilight:

Cuan els sorolls s'adormen

Els reflectas d'un llac . . .	The reflections of a lake
Un cloquer romanic . . .	A Romanesque bell tower
La quietut de la tarda	The peace of the afternoon
morenta. . . . El misteri	moribund. . . . The mystery
de la nit propera . . . tot	of the night that approaches . . . all
es dorm i difumina . . . i	fall asleep and become blurred . . . and
es allavors que baix la pálide	it is then that in the pale

claror d'une estrella,	*limpidity of a star,*
bora el portal d'una casa	*near the porch of an old*
antiguar es sen enraonar	*house, one hears low talking*
baix i tot seguit els sorolls	*and soon the sounds*
s'adormen i el fresc	*fall asleep and the fresh*
aureix de la nit gronxant	*breeze of evening lulling*
les acacias del jardí	*the acacias in the garden*
fa caura d'amun dels	*causes a rain of white flowers*
anamurats; una pluja	*to fall on the lovers.*[41]
de flors blancas.	

Dalí was also involved in the production of a humorous newspaper called *El Senyor Pancraci,* printed on brown wrapping paper. The first issue came out in August 1919 and contained Dalí's idealized portrait of the mythical Pancraci dressed in clothes of the 1830s: a stovepipe hat, a high-collared coat, and what looks like a neckcloth. In his lapel Pancraci has some sort of decoration; the deep, dramatic shadows suggest the influence of Goya.

Dalí had been keeping a diary for some years (he did this intermittently all his life and used it as a basis for various writings—the novel *Hidden Faces,* the autobiographies), but only one volume has ever been published in its original version, and it is called *Book Number 6 of My Impressions and Private Memoirs by Salvador Dalí January 1920.* It opens on January 7 and the last entry is dated "January 32" [*sic*]; in it Dalí paints a picture of his late teens very different from what he would later depict, when he had embroidered a more elaborate version.

The diary concerns itself with daily events—Dalí goes to the railway station with his friends to look at girls passing by. It also concerns itself with politics—Dalí believes that a series of armed attacks has been planned and executed not by the trade unions, as is given out, but by "certain bourgeois organizations with the help of the government and of the 'respectable' citizens."[42] He includes a letter to his uncle, Anselmo Domènech, in which he discusses his development as an artist:

> Every day I realize more and more how difficult art is . . . but also every day I rejoice and like it. I keep on admiring the great French impressionists, Manet, Degas, Renoir. I wish they would become the most strong guiding forces in my life.

I have almost completely changed my technique. Now my shades are much lighter than before; I have completely abandoned the strong blues and reds, which before made a contrast (an unharmonic one) with the lightness and vividness of the others. . . .

I still pay no attention to the drawing; I do completely without it. I devote all my efforts to the color and the feelings. . . . I just couldn't care less if one leg is longer or shorter than the other; it is the color and the shades which give life and harmony.[43]

He tells of soccer matches, of going to see a French biplane that had landed outside Figueres, of roaming the streets at night, of a picnic with his family on the seashore, during which he and his friends read poetry to one another and eat *garota*, the sea-urchin soup. Girls appear —"Estela," the two "Countesses," "Rouget"—and Dalí is obviously interested in them. He tells of the death of Professor Sans, his algebra teacher: ". . . during lunch when I was commenting on the unhappy end of our good Professor of Mathematics and although I was sincerely affected, I felt an irresistible urge to laugh. I do not know why. Perhaps it was due to the strong impression he had made on me." The diary ends: ". . . with Subias we talked about art till dinner time."[44]

When the diary was translated and privately published by Reynolds Morse in the early 1960s, Dalí said it was a "disaster, a calamity," and he asked that the entire edition be destroyed because it competed with his two autobiographies. The real reason was that the picture the teenage Dalí depicted in it was far more conventional than the version given in the later books. In the diary he appears as a bright, sociable member of the institute, a boy with friends, who played soccer and went to the plaster-cast room at the art school in search of girls. This is far removed from the tortured image he took care later to put about:

Most human beings seemed like wretched wood lice to me, crawling about in terror, unable to live their lives with courage enough to assert themselves. I deliberately decided to emphasize all aspects of my personality and exaggerate all the contradictions that set me that much more apart from common mortals. Especially, to have no dealings with the dwarfs, the runts that were all around me, to change no whit of my personality, but on the contrary to impose my view of things, my behavior, the whole of my individuality on everyone else. I have never deviated from this line of conduct.[45]

Yet beneath the uncompromisingly self-confident exterior that Dalí gradually developed, there lived another. If most humans were wood lice, Dalí was a hermit crab. He wore his consciously created personality like a skeleton on the outside, as armor to deflect the potentially threatening inquisitions of the curious; as a shield, too, against the intrusion of emotions with which he knew he would be unable to deal, or situations he would be unable to control. All his life he admired crustacea for their external armor. Like the meat of crabs, lobsters, or his favorite sea urchins, his was tender flesh indeed, and few could get past the armor he had so carefully constructed.

One of those who knew that her child was timid, passionate, and anxious was Dalí's mother. But on February 6, 1921, she died of cancer in Barcelona. She was forty-seven and had been ill for six months. Dalí was seventeen and still very dependent on her care and understanding, and on her presence as a bulwark against his father. She was the one person who had never failed him, in whose universe he occupied the central position, whom he adored with perhaps the truest passion of his life. Now she had left him alone and defenseless.

Dalí could not speak of his mother and their relationship until he was well into his thirties, and even then he did so with the greatest difficulty. Her death destroyed the precarious balance between her calm acceptance of his eccentricities and his father's almost brutal methods of pushing Dalí into a mold of his own devising. From this point until his eventual rupture with his family at the end of the decade, Dalí would try to distance himself from the claustrophobic atmosphere of the family home.

Dalí's father and his aunt Catalina (his mother's younger sister) had probably been having an illicit affair for some years before Dalí's mother died. Certain paintings Dalí did when young, notably one entitled *Voyeur,* contain hints that he may have seen his father and his aunt in compromising situations. *Voyeur* is a curious and compelling painting. A shadowy, elongated figure is slumped on a balcony, at his side a table on which is a cup. Beyond, on the other side of the street, there are lighted windows. In one, there is a glimpse of a woman taking her stockings off. In another, a man embraces the woman; the man is dressed in a black suit, the woman in a white nightgown or chemise. In a third window, the woman, now attired in a camisole,

puts up her hair in front of a mirror. It is completely unlike any other painting Dalí did at the time in its almost graphic, comic-book sequence of events, painted in bright primary colors, counterpointed by the strong diagonal of the slumped figure in the foreground painted in a blue wash.

In another little drawing of his father made at about the same time, the solid figure of the notary is depicted in his black suit, his watch chain spread over his chest. At right angles to this drawing is another depiction of Dalí's father with the shadowy figure of a naked woman sketched in. In one of his autobiographies Dalí makes oblique reference to the affair, when he recounts his break with his family and says that there was something that would always be "between my father and myself."

Dalí's sister, Ana Maria, now thirteen, was old enough to replace, in part at least, his mother in Dalí's private pantheon of tutelary deities. She became his idealized woman, and the brother and sister grew very close indeed over the next few years; perhaps too close, for Dalí drops the strongest hints of some sort of exploratory if not fully incestuous relationship that probably lasted until he went to Madrid in 1925. Such a relationship would explain the continued violence of Ana Maria's antipathy toward Gala, which lasted until Gala's death.

Dalí painted his sister frequently; indeed, until 1929 she was his only female model, as Gala would become later. He portrays her leaning out of a window, looking out to sea. She sews with her back to us, turned toward the hill and the church in Cadaqués. Tellingly, he also painted her holding the baby Salvador.

In 1925, Dalí portrayed Ana Maria and their father in a masterly and academic drawing of great power and resonance. It is now in the possession of his cousin Montserrat Dalí y Bas. Dalí's father sits at a table, his broad body planted solidly on his chair. His gaze is piercing, with a disturbing hint that he is finding what he sees—his son drawing him—wanting. Behind him, standing, is Ana Maria. Her gaze, too, is turned toward the viewer, but hers is a gentler glance that seems to hold some element of apprehension at the back of the eyes. There is, with both figures, an impression of uneasiness, as if they were almost frightened at giving themselves away to Dalí.

* * *

With the death of his mother, Dalí's childhood ended and he found it easy to take the first tentative step out of the small world of Figueres and Cadaqués. He first managed to slip as far as Madrid, which proved to be a lengthy halt on the long and final escape from what he had come to believe was the prison of his family, his memories, his secrets, and the stifling but essential landscape of his infant world. In fact, he would never escape. He took with him into the world of his adulthood his extraordinary timidity, scarcely visible beneath the external personality he had now constructed with such ruthless care. He also took with him his childhood and its fully delineated landscape with figures; it would haunt him always.

In one of the many self-portraits Dalí painted during this period, he looks toward us, away from his past and the Bay of Cadaqués, away from the cypress trees, and toward his future. Inspired by Raphael's self-portrait, Dalí gives himself the face of the poet and the dreamer: strongly marked eyebrows, huge wistful eyes, a sensual mouth that is painted red, as are the grapes that frame his head. A second self-portrait from the same time gives a much darker view of the young painter; his meerschaum pipe in his mouth, a soft felt hat on his head, this is a more realistic treatment, reminiscent of his painting of the mythical Señor Pancraci, and of Goya. Moreover, one can see here that his face has achieved its final form; it has a haunting sadness, and a sense of loss plays over his features.

2

SELF-PORTRAIT SPLITTING INTO THREE
1921–1926

In May 1921, Dalí left Catalonia for the first time. Chaperoned by his father and sister, he went to Madrid to take the entrance exams for the Escuela Especial de Pintura, Escultura y Grabado de Bellas Artes de San Fernando. It would have been more convenient for him to attend the Llotja in Barcelona, the high reputation of which was in great measure due to Picasso's having studied there. It would have been easier, too, for Dalí's father to have exercised some control over his son's life in Barcelona, where many relatives could keep an eye on this most impractical of beings. But there was one insuperable drawback to the Llotja; it did not offer qualifications for the teaching of art, and this would mean that at the conclusion of his studies Dalí would not be able to earn his living as anything but a painter.

In a preface to a logbook on his son's career he started to keep in about 1925, Dalí's father wrote that he proposed a compromise to the effect that Dalí should attend the school in Madrid, take all the courses that would be necessary for him to obtain the official title of professor of art, and that once he had completed his studies he should take the competitive examination in order to be able to earn his living as a teacher in an official art school. "In this way I would have the assurance that he would never lack the means of subsistence," his father wrote, "while at the same time the door that would enable him to exercise his artist's gifts would not be closed to him."[1]

Dalí told Antoní Pitxot years later that his father was determined he would get some official qualification because he had seen with horror

the fate of Ramón Pitxot, Antoní's uncle, who had spent all his money living a bohemian life in Paris and was by the early 1920s reduced to buying and selling books for a living. But Dalí's father was, apparently, capable of avoiding the truth; had he been less anxious about Dalí's future, he might have paused to consider the absolute impossibility of his son's ever being capable of, or willing to, control a classroom of art students, or even to prepare lessons.

To Dalí himself this compromise meant escape from Figueres: from the constant references to his incubus, his dead brother, and the memories of his unhappy mother. But to get into the Escuela de Bellas Artes, he first had to pass an examination, which consisted of making a drawing from the antique, in this case a cast of the *Bacchus* by Jacopo Sansovino. The drawing had to be completed in six days according to strict rules stating that the finished work should have the exact measurements of *papier Ingres,* the paper used for the examination.

Whether Dalí did not perfectly understand this stipulation or, more likely, was overcome by nerves, something went wrong. According to Dalí, on the third day of the test his father, who had formed the habit of waiting for his son at the school, was told by the porter that it looked as if Dalí would not pass the examination because his drawing was so small that the surrounding space could not be considered as merely a margin. Dalí's father took fright, seeing his son's opportunity to lead a respectable, worthwhile life as an art teacher slipping away. That night, during a visit to the theater, he asked Dalí whether he felt he had the courage to start the drawing again, with three days left to complete it. As usual, Dalí "derived a certain pleasure from tormenting him on this subject."[2]

The next day Dalí erased what he had done and started again with new measurements. But he was now so nervous that he miscalculated again and by the end of the day rubbed out this second drawing as well. The next day, his father having spent a sleepless night, Dalí once again attacked the *Bacchus.* This time he made it too large. The feet of the figure extended beyond the edge of the paper. Again, Dalí erased it completely.

That evening, according to his autobiography, Dalí upbraided his father for his interference. Had the first drawing really been too small? Had his father been too hasty in condemning it? The strand of white

hair that his father habitually twisted around his finger in moments of anxiety stood out like a horn.

Dalí was calm on the last day of the examination. His terror at the thought of having to return a failure to Figueres had reached fever pitch the night before. He set to work and, according to his later account, finished a perfect drawing in one hour. He spent the remaining hour admiring it, but became terrified when it occurred to him that it was even smaller than the original version.

To Dalí, the successful result of this examination came both as a great relief that he would not have to return to Figueres and go to the agricultural school there, and as an affirmation that even though his drawing broke the rules it was good enough to be accepted. He was admitted to the school with this mention:

> *In spite of the fact that it does not have the dimensions prescribed by the regulations, the drawing is so perfect that it is considered approved by the examining committee.*[3]

This story is typical of Dalí's conscious re-creation of his youth. His autobiography is a deliberate attempt at mythmaking and of Dalí's fixed intention to turn the fairly ordinary events of his life into the stuff of high drama. What is more likely is that Dalí did but one drawing, and took six days over it rather than one hour. His account has overtones of one of the classical myths he had read as a child, possibly the Labors of Hercules, and is a deliberate elaboration of a simple truth. Most of Dalí's accounts of his early life are based on truths; he simply took the truth as a starting point for flights of fancy, or re-created it to suit his purpose.

Dalí's father set about making sure that his son led a reasonably supervised and protected existence in Madrid when not in class. There was to be no wasteful and irresponsible bohemia. To this end, he enrolled Dalí in the Residencia de Estudiantes and, in so doing, unwittingly altered and enriched his son's entire life.

The Residencia de Estudiantes was an interesting and high-minded educational experiment typical of the period. Instituted by royal decree on May 6, 1910, it was the offspring of the Institución Libre de

Enseñanza (the Free Teaching Institution). It housed 130 students who lived in small dormitories or individual rooms, and paid between 185 and 245 pesetas a month, which included all services. Situated on the outskirts of Madrid, it lay at the end of the No. 8 tram route, next to the Palace of Industry and the Fine Arts, now the National History Museum.

The Residencia had been founded by Alberto Jiménez Fraud, an academic who had spent a brief but formative period at Oxford in the early years of the century. Its aims were an extension of those of the Institución Libre de Enseñanza. The idea was that only by the creation of a select group of men and women concerned with the advancement of Spain could the country rise again from defeat and despair. According to the writer Luis Carandell, the "Resi" (as it was popularly known) was the most "liberal, civilized, and refined institution that had ever existed in Spain."[4]

Natalia Cossío, Jiménez Fraud's wife, was very much involved with this educational experiment:

> My husband was commissioned to found the Residencia in 1910, when he was twenty-six, and he tried to model it on English colleges and their tutorial systems, especially in art and medicine. It would still exist but for the Civil War.[5]

Jiménez Fraud himself often spoke of the Residencia's activities as being a refuge for Western cultural values. Already the time was coming, he believed, of "immense bureaucracies in which individual dignity counted for nothing."[6]

These ideas were echoed in a lecture given at the Residencia by Hilaire Belloc in 1923 entitled "Life and Thought in English Universities at the Present Time." Belloc told his audience that the aristocratic character of England was reflected in its universities, and that students went up to Oxford or Cambridge less with the intention of building character or acquiring knowledge than with the object of getting to know young men who would be the future rulers and administrators of the nation.[7]

Spain had desperate need of a meritocracy that would supersede the old regional, social, and religious divisions that had been barriers to her development as a modern nation. The Residencia's raison d'être

was to create a new governing class of well-rounded, cultured men who would look outward to Europe rather than inward to their own region and family connections. What it did in fact create was a fertile seedbed for three of the most startling geniuses of twentieth-century Spain: the Andalusian poet Federico García Lorca[8]; the film director Luis Buñuel; and the painter Salvador Dalí. All three of them spent their time at the Residencia developing in directions very different from those envisaged by its earnest founder, Don Alberto.

The Residencia, set in a grove of poplars, was approached over a bridge spanning a little canal and consisted of a series of white-painted buildings designed by the architect Antonio Flórez in the neo-Mudéjar style, inspired by Moorish builders working for the Christians in Andalusia after 1492. These buildings were hung with ivy and grouped around a central patio. The interiors were plain and functional, with tiled floors on which stood pine furniture. Touches of color were provided by reproductions of paintings, glazed tiles, and pottery from Talavera.

Similarities with the Oxford of Jiménez Fraud's youth did not end with the cultivation of ivy; he regularly asked selected students to meals, a habit not common among pedagogues in Spain at the time:

> We used to have eight in for lunch or dinner. Federico [García Lorca] came a lot, played the piano, and lectured on popular music. Dalí came with Federico and didn't talk! He was then very simple and natural. One day I found him sitting in an armchair absorbed in looking at my drawing room—a room so different from the surroundings he had then painted.[9]

Presumably Señor Jiménez Fraud had seen only the paintings of the Gypsies and Sardana dancers, and had assumed, from these lively evocations of Figueran low life, that Dalí came from a humbler background than in fact was the case.

Medical students, drawn to the laboratories in the Residencia, and industrial engineering students, by the proximity of the Residencia to their school in a wing of the nearby Natural History Museum, were in the majority at the Residencia. The remainder had come to be educated in the humanities and in the arts as well as in their chosen disciplines. They came from all over Spain: from Andalusia, Aragon,

Asturias, from Cádiz, Galicia, and, of course, Castile. Most were the sons of the emerging Spanish haute bourgeoisie, the only parents able to afford the high boarding fees, thus giving rise to justifiable accusations of elitism.

The students met at cultural events; there were conferences, concerts, literary lectures, or simply conversaziones, for the Residencia entertained intellectuals from all over Europe eager to contribute to this impressive experiment. Marie Curie came on behalf of the Instituto de Cooperación Intelectual; this body had been founded by the French and was eventually superseded by UNESCO. The students listened to H. G. Wells on the emancipation of women, Keynes on economic theory, and Einstein on the theory of relativity, though this last lecture was not an unqualified success, since Einstein spoke in German and José Ortega y Gasset had to translate. Freud's revolutionary new theories on dreams were fully discussed, which is how Dalí first heard of the limitless plains of the subconscious. Poets stayed at the Residencia and mingled with students, among them Paul Claudel and two who were later to become intimately connected with Dalí, Louis Aragon and Paul Eluard.

A somewhat "hearty" atmosphere prevailed at the Residencia, in spite of the rich intellectual fare on offer. Football, tennis, and hockey were popular—Buñuel, a big, tough, aggressive Aragonese, ran every day (which was not common in Spain at that time), and was proud of his pugilistic and gymnastic ability, yet he was also part of what Dalí later called a snobbish literary group of aesthetic dandies, the Madrid equivalent of the postwar Oxford generation of Bright Young Things. This group included García Lorca, Pepín Bello,[10] Pedro Garfías, and Eugenio Montes.[11] At the time Dalí arrived at the Residencia, they were junior members of the avant-garde "Ultraist" group, who admired the Dadaists, Jean Cocteau, and the futurist Marinetti.[12] Dalí owed his acceptance into this rarefied educational institution to Eduardo Marquina, who was entrusted by Dalí's father with his son's allowance.

Dalí's first appearance in the dining hall of the Residencia in September 1921 caused a stir. Flanked by his father and his sister, both dressed in mourning for his mother, Dalí presented a consciously extravagant vision:

The boy stood out. . . . His long side-whiskers and hair came down to his collar. He wore a hunting jacket with baggy breeches buttoned up to the knee. His legs were covered by puttees, known as "mulataires" as worn by Catalan muleteers. . . . To achieve a startling and comic effect Dalí left gaps between the strips, exposing his hairy calves. The hundreds of Residencia students from all parts of Spain were already making sotto voce *comments about the new arrival.*[13]

Dalí had already learned how extraordinary clothes could act as a kind of armor, diverting attention from the timid boy beneath; now he took eccentricity to extremes. The majority of students favored drab English tailoring and club ties. Dalí must have presented a rather pathetic, certainly provincial, sight, with Siegfried Burman's waterproof cape as a final pièce de résistance. But to judge by photographs of him at the time, these ridiculous clothes could not disguise his thin, haunting, dark good looks.

Dalí's father and sister returned to Figueres and to another death in the family. Dalí's grandmother Ana, now ninety, was fading. She had never really recovered from the death of her daughter and the shock of a flood earlier that year. She had stopped sewing in silence and now talked for hours about her distant youth. She remembered how her father had built the first house at 36, calle Pelayo and had made tortoiseshell combs. She remembered how she had gone on the first train from Barcelona to Mataró and had been able to drink a glass of water without spilling any. She recited Góngora[14] for hours or prayed with the nurse, Llúcia, in front of a statue of Christ. In extreme old age, her fine, pale face looked remarkably like that of her grandson, whom, even in her more lucid moments, she seemed to have forgotten. However, Ana Maria later recounted that on the night their grandmother died:

She got up in bed and, looking at the doctor's friendly face, said "My grandson is in Madrid. My grandson will be a great painter, the best Catalan painter." She went to sleep and died without any change in her face, unsurprised by death.[15]

This story has all the flavor of a pleasant family legend with little basis in fact and indeed was part of Ana Maria Dalí's effort, many years later,

to "normalize" the years of youth she felt her brother had turned into a perverted myth in *The Secret Life*.

Meanwhile, in Madrid, Dalí was left to his own devices for the first time. Since most rooms at the Residencia were for two people, another student, Marcel Santaló, from Girona, was asked whether he would mind sharing with a fellow Catalan, probably to make him feel more at home. The arrangement lasted for a week. "I think I remember that living together was impossible in view of the different lives we led," Santaló recalled later. "He got up very late and I had to do so very early and already he gave evidence of his 'eccentricities.' "[16] The other students must soon have recognized Dalí's talent, however, for during his first week at the Residencia he painted the posters for the annual athletic festival. Santaló also said that Dalí subscribed to *L'Humanité* (which he had begun to do in Figueres two years before) but that he never saw him read it.

But read it he did, as he also read *L'Esprit Nouveau,* published in Paris between 1920 and 1925, and *I Valori Plastici* (1918–1921), both of which informed him of the work of Picasso, Georges Braque, Juan Gris, Carlo Carrà, and Alberto Severini, and of movements within the European avant-garde generally; it was at this time that Dalí began to paint his first cubist pictures. They were virtually monochrome, in complete contrast to the vibrant colors of his Gypsy series. Dalí restricted his palette to white, black, sienna, and olive green. The structures and forms within a painting began to interest him far more than mere figurative painting, though later his cubism would become less abstract and begin to show some more typically Dalinian tendencies, such as sharply receding perspectives. But in his first days at the Escuela de Bellas Artes and in the work he did in his room at the Residencia, his cubist paintings were severely abstract.

The school itself disappointed Dalí. In spite of "general initial enthusiasm . . . I immediately understood that those old professors covered with honors and decorations could teach me nothing."[17] The majority of his fellow students had not been exposed (as Dalí had, by Ramón Pitxot and through his own reading) to artistic movements in the rest of Europe, particularly in Paris, though some of these movements had been influenced by Spanish painters: Picasso, Miró, and Juan Gris.

Surprisingly, Dalí despised most of his professors not because they

were too academic, but because they were not academic enough. As a pupil of Núñez's and having thus come under the influence of Ingres and been made to understand Ingres's insistence on the importance of form conveyed by line, Dalí respected—and always would—the necessity of a solid grounding of drawing.

Only one professor, the drawing master José Moreno Carbonero, one of Picasso's mentors, taught drawing in the old manner, correcting the students' work with white gloves on, so as not to dirty his hands. He had, according to Dalí, only to make two or three rapid strokes with a piece of charcoal to make a drawing miraculously right, but most students rubbed out his corrections when he left.

Dalí went to the school expecting to find "limits, rigor, science. I was offered liberty, laziness, approximations!"[18] He discovered that the professors had never heard of cubism, but were influenced by the painting of light by such artists in Spain as Joaquín Sorolla. Dalí would ask technical questions, such as how to mix oil correctly, or what method to follow to obtain a given effect. "My friend," his professor would reply, "everyone must find his own manner; there are no laws in painting. Interpret—interpret everything and paint exactly what you see, and above all put your soul into it; it's temperament, temperament that counts."[19] Temperament Dalí had in abundance; he was thirsty to learn technique, believing that "constraint was the very mold of form."[20] He wished to be a student of academic technique during the day. At night and in his free time, he worked on his own. Inspired by the examples of painters in Paris about whom he read in his art magazines, he was becoming a painter who was, slowly but ever more surely, inventing his own world.

To begin with, he concealed his contempt for the course and wrote to his family in Figueres very enthusiastically, not wishing to prompt a supervisory letter or even visit from his father. The truth was that he was leading a very introverted and solitary life, but he gave his family the impression that he had thrown himself into every activity and every lesson.

On Monday the lesson on engraving finally began. . . . The "swing" concert will be a real event; I have a sketch for the curtain which will be very beautiful. It represents a Negro's paradise. . . . The boarders' exhibition is not worth a visit—very dreary things and of little interest. I

am more optimistic than ever and have rarely felt better and paint better all the time. Last summer's work now seems to me very bad. Nevertheless the people here are delighted and I realize that objectively the things have some value and some are good.[21]

Whether "the people here" had even seen what Dalí was painting in his room is doubtful. His fellow students considered him to be reactionary, an enemy of progress and of the avant-garde. Impressionism was the thing; they were allowed to paint as they pleased, to eliminate black from their palettes, calling it "dirt" and substituting it with purple: Shadows, they were taught, were iridescent, therefore they needed no black. But Dalí had been painting in this way at the age of twelve, under the influence of Ramón Pitxot. He despised his fellow students and forecast that they would mark time with their "dirty, ill-digested rainbows for years and years."[22] He was not wrong.

Dalí was a reasonably well behaved pupil during his first term, though he was tempted from time to time to demonstrate to the teachers what real "personality" and "artistic temperament" could be when they were unleashed by an original mind. He was never absent from class, he was always respectful, and he worked extremely hard. His professors were disappointed; here was no true "born artist"; he worked too hard at it. They believed he was serious, clever, successful in what he set out to do. "But he is as cold as ice, his work lacks emotion, he has no personality, he is too cerebral. An intellectual, perhaps, but art must come from the heart," they said.[23]

In *The Secret Life,* Dalí was at great pains to emphasize his good behavior during these first months in Madrid, setting the scene so that the explosion, when it came, would be more shocking, more mythic. In reality, his normal anarchistic high spirits were not in abeyance. He had become very friendly with a fellow Catalan art student, Josep Rigol Fornaguera. Rigol came from Tarrasa and was seven years older than Dalí, which had prompted Dalí's father to ask him to keep an eye on his son when they met during the entrance examinations. Rigol had worked as a painter and decorator to pay for his studies in the art school, but his underlying seriousness of purpose did not prevent him from becoming Dalí's accomplice in his pranks, and his protector when they went wrong.

They were known collectively as *"Los Catalanes"* at the art school,

which had anarchist implications for the sons of Castile, Andalusia, and Aragon, most of whom disapproved of the intent and the strength of Catalan separatism. They became the inventors and instigators of adventures and practical jokes, and soon gained well-deserved reputations as public nuisances. "One of the things which we most enjoyed was holding up the traffic," Rigol recalled later. "On coming out of school we'd get a group together on the pavement and Dalí or I would say, 'Look, look, it's coming from there!'—and would point to a roof or the sky. Then everyone would mill around us until the trams stopped, because of the jams we caused. When the police arrived to break it up, we'd run off."[24] It didn't take Rigol very long to realize why Dalí's father had asked him to keep an eye on his son. Dalí's impracticalities soon became known to his fellow students, who took advantage of him. When he ran out of paper, they would go out and buy some more for him, and if it had cost a real, they would charge him two or three, as he still had no idea of the value of money.

One day he appeared very annoyed and said to me, "Imagine how stupid the people are here. I went into a shop to buy paper and pencils and they told me they didn't have any." The fact was he had gone to a fishmonger. He would do this all the time, for he seemed to think that any shop would have everything a customer needed, as if the shop were like a modern supermarket. Thus it was that I was always ready to help him overcome the everyday problems of life. I also became his bodyguard, for when it came to it, he was incapable of punching anyone, even in self-defense. This did not prevent him from stirring things up, such as when we organized an attempt on King Alfonso's life.

One day we were told the king was going to pay a visit to the college, and Dalí, who then had very anti-monarchist sentiments, said to me in all seriousness, "Let's put a bomb under him." As I was used to his ways I answered, "Good, we'll plant it. But how are we to make it?" "Well, it's very simple," he explained. "You get an empty milk can, fill it with powder, put a wick in, and there it is." "And where do we get the powder?" I insisted. "That's easy," he replied. "I'll buy a few cartridges from a gunsmith because we're going to make a protest bomb, not one to kill."

The king had to go up the grand staircase, and there were some stone urns by the banister, in one of which we placed the bomb. At the opportune moment, we lit the wick, but it didn't work.

> *No one ever knew anything of this failed "atentat"; it was a big secret between Dalí and me. If they had discovered the bomb, they would immediately have accused us Catalans, as we were the ones who organized the "insurrections" in the college hall. Dalí would end up coming to blows with a monarchist group who had deplored his conduct in making fun of the king. Dalí was always a coward when it came to fighting because, among other things, he always knew when he was likely to lose. . . . His was a non-violent character.[25]*

Dalí amused himself one day in his life class by firing clay missiles at the male model. When the man discovered who was playing the fool, he got down from the dais and said to Dalí aggressively, "Listen, do you know you're a son of a bitch?" To which Dalí, unperturbed, replied, "Well, yes, I already know that." The man was so surprised he went back to his dais and took up his pose once again.

The two cubist works he painted in his room during these first weeks in Madrid did not survive, since he prepared the ground of both canvases with paint mixed with glue; the resulting paste was so thick that it cracked, and both paintings eventually fell to pieces. But before this happened, they (and Dalí) were discovered by the most interesting and exclusive group of students in the Residencia.

It happened in this way: The students in the Residencia were divided into several groups and subgroups. There were the "hearties," among whom Buñuel, when first at the Residencia, had been something of a star, and there was a small group of students in the artistic-literary avant-garde—a nonconformist group of strident revolutionaries from which, as Dalí percipiently put it, "the catastrophic miasmas of the postwar period were already emanating."[26]

The group had become influenced by trends in avant-garde thought more or less related to the Dadaists, now headquartered in Paris. This was hardly surprising, since the Dadaists were attracting a great deal of attention in Spain through the medium of *Littérature,* a Dada magazine founded by André Breton,[27] Louis Aragon, and the poet Philippe Soupault.[28] In an early issue, published in January 1920, Breton had defined Dadaism thus:

> *Cubism was a school of painting, Futurism a political movement: Dada is a state of mind. . . . Dada devotes itself to nothing, neither to love nor*

to work. . . . Dada, only recognizing instinct, condemns explanations a priori. According to Dada we can keep no control over ourselves. We must cease to think about these dogmas: morality and taste.[29]

Such jolly anarchy, arising out of the horrors of World War I, a war none of the students in the Residencia had directly experienced, was perfectly in tune with the high spirits and inquisitive intellects of the more literary and artistic students, and the group that coalesced was a large one. It was led by Federico García Lorca, Luis Buñuel, and the goofy medical student Pepín Bello, who never passed an examination in his entire stay at the Residencia. The poets Eugenio Montes and Rafael Alberti[30] also belonged, as did Pedro Garfías and others. All these students knew Dalí by sight; his flowing locks and puttees had prompted them to nickname him "the Musician" or "the Czechoslovak artist" or "the Pole."[31] His rather dirty locks and flowing cravats had marked him out not as a bohemian eccentric, but as a rather common-place hairy romantic. Their dandyish predilection was for British-style tweed golfing jackets and smartly trimmed hair.

At the time Dalí began to notice the group, they were all "possessed by a complex of dandyism combined with cynicism, which they displayed with accomplished worldliness."[32] In photographs these future governors of a restored Spain appear dressed in the height of suave 1920s tailoring, which makes them look a great deal older than their years and less radical than they actually were, and which emphasizes their "clubbable" quality.

A portrait of Dalí in his first months in the Residencia was limned by his fellow student Rafael Alberti, who was one of the first to seek out this odd newcomer:

Dalí seemed to me in those days timid and taciturn. I was told he worked all day sometimes, not eating or arriving in the refectory too late for the meal. When I went into his room, a simple cell like that of Federico [García Lorca], I could hardly get in because I didn't know where to put my feet: The floor was covered with drawings. Dalí had a formidable vocation, and at that time, in spite of his youth, he was an astonishing draftsman. He drew as he wished, from nature or from his imagination. His line was classical and pure. His perfect stroke, which recalled the Picasso of the Hellenistic period, was no less admirable; outlines jumbled

with rough marks, blots and splashes of ink, lightly heightened with watercolor, already heralded the great Surrealist Dalí of the first Paris years.

With a serious air characteristically Catalan, but hiding a rare humor, which not a feature of his face betrayed, Dalí never failed to explain what was happening in each picture, revealing thus his incontestable literary talent.

"That, there, is a beast gomitting" [Dalí's strong Catalan accent transformed vomiting into gomitting]. It was a dog vomiting, which looked rather like a bundle of tow. "That, there, is two policemen making love with their mustaches and all the rest." Indeed you could see two tufts of hair topped with tricorns entangled on something that could be a bed. "That, there, is a putrefacto [the name Lorca, Dalí, and their group gave to conformist philistines or, indeed, to anyone they disapproved of] sitting at a table in a café" (the drawing was a fine vertical line with a little mustache above, cut by a horizontal which indicated a table). "And here again, the beast still gomitting."[33]

In describing the contents of his drawings, Dalí was using the irony he had developed among his schoolmates and in the cafés of the *rambla* in Figueres as a defense against the bourgeoisie who wanted to know what each drawing was "about."

One day, about three months after Dalí had come to the Residencia, the chambermaid had left his door open, and Pepín Bello, happening to pass, saw two completed cubist paintings. He could not wait to tell the rest, who crowded into Dalí's room to see what the "Czechoslovak artist" was doing. Dalí was in such awe of them that he thought he would faint, but not so much in awe that he abandoned his naturally cynical attitude:

They came all in a group . . . and with the snobbishness which they already wore clutched to their hearts, greatly amplifying their admiration, their surprise knew no limits. That I should be a Cubist painter was the last thing they would have thought of! . . . I still kept a speculative distance. I wondered what benefit I could derive from them, whether they really had anything to offer me.[34]

In Figueres, Dalí had never really been part of any group, of any collection of friends of the same age who, meeting regularly in a cho-

sen café, formed a *peña* (roughly translated, "a club"). He was too preoccupied with his painting and his interior world. His childhood and adolescence had been spent very close to his family or with much older friends and patrons, such as the Pitxot brothers, or the anarchist Martí Villanova. He had never had many friends of his own age; here, suddenly, was a whole group of them. The almost monastic life he had been leading gave way to companionship with peers who not only thought his eccentricities were perfectly in order but to a certain extent understood and admired his painting and the original tenor of his thought. To begin with, this companionship had another distinct advantage—it made no emotional demands on Dalí. The group immediately became very protective of him, obviously regarding him as something of an idiot savant, and Buñuel especially was not averse to picking fights with those café wits whose comments on Dalí's appearance verged on the insulting.

Dandyism soon began to appeal to Dalí, and it was not long before he decided to conform to the dress code of his new friends. He had his hair cut very short by the preferred barber in the Ritz. He bought an expensive tweed suit with which he wore a sky-blue silk shirt with sapphire cuff links. He spent hours slicking down his hair, which he had first soaked in very sticky brilliantine, then set in a special hairnet he had bought, and, finally, varnished with real picture lacquer. Until his hippie period in the 1960s, Dalí would always dress in the manner of a 1920s dandy, inspired rather more by Rudolph Valentino or John Gilbert than by the English affectations of his new friends. Dandyism became an integral part of the personality he was beginning to develop.

Membership in this group widened Dalí's horizons in many different ways, since his new coterie by no means confined itself to intellectual activities. Being no different from other young men of the postwar generation, these youths spent a great deal of their fathers' money sitting drinking in bars and cafés or, when they could afford it, in the Ritz or Palace hotels. They taught Dalí how to binge. "I spent about three days at it," he wrote. "Two days for the barber, one morning for the tailor, one afternoon for money [presumably he had to visit Eduardo Marquina and ask him for an advance], fifteen minutes to get drunk, and until six o'clock the next morning to go on the 'bender.' "[35]

The group spent hours at the Residencia listening to American jazz records and drinking homemade rum. They put on plays such as Zorrilla's *Don Juan Tenorio* or simply played the fool; one game Buñuel invented was called *las mojaduras de primavera,* or "the watering rites of spring," which consisted of pouring a bucket of water over the head of the first person to come along. They indulged in *chulería,* a blend of aggression, virile insolence, and self-assurance. Buñuel wrote:

> There was a dancer at the Palacio del Hielo whom I called La Rubia. I adored her elegance and style, and used to go to the dance hall just to watch her move. One day Dalí and Pepín Bello were so fed up by my constant eulogizing that they decided to come along and see for themselves. When we got there, La Rubia was dancing with a sober, mustachioed, bespectacled gentleman I immediately dubbed "the Doctor." Dalí was disappointed. Why had I dragged him out? "It's only because she has a horrendous partner," I retorted. Having had a good bit to drink, I got to my feet and marched over to their table. "My friends and I have come to see this girl dance," I announced. "You make her look ridiculous. Do me a favour and go and dance with somebody else."[36]

Expecting the Doctor to hit him, Buñuel started back to his table, but nothing happened. Buñuel's victim sat there openmouthed, then rose to his feet and rushed away—Buñuel was horrified and thoroughly embarrassed by what he had done.

Fun and games apart, the main attraction for Dalí was the group's acknowledged leader, Federico García Lorca, who had come to the Residencia in 1919, two years after Buñuel. Buñuel described him as "brilliant and charming with a visible desire for sartorial elegance—his ties were always in impeccable taste. With his dark, shining eyes, he had a magnetism that few could resist."[37] Lorca, who had come to Madrid to study philosophy but soon switched to literature, lost no time in getting to know everybody and making sure they knew him. "His room in the Residencia was soon one of the most important places to meet in Madrid."[38]

Buñuel was studying agricultural engineering and was established as the leading hearty in the Residencia, but he lost no time in falling under Lorca's poetic spell:

In spite of the contrast between the rough Aragonese and the refined Andalusian, or perhaps because of it, it was not long before we were inseparable. At night we would go to a field behind the Residencia [the plain receded to the horizon], sit in the grass, and he would read me his poems. He read slowly and beautifully and through him I was transported little by little into a new world which he revealed to me, day by day.[39]

Eventually, under Lorca's influence, Buñuel abandoned his agricultural engineering studies, and in 1926 graduated in philosophy and letters.

Not all the students liked Lorca; some, sensing his proclivities, kept their distance. Among them was a certain Martín Domínguez Berrueta, a Basque, probably jealous of Lorca's influence in the Residencia, who spread the rumor that Lorca was a homosexual. Buñuel could not believe it and resolved to confront Lorca: "We were sitting in the refectory side by side. . . . After the soup I said to Federico in a low voice, 'Let's go out. I have to tell you something very serious.' "[40] They went to a nearby tavern, where Buñuel told Lorca he was going to fight Domínguez Berrueta. Naturally, Lorca wanted to know why. Buñuel hesitated and then asked point-blank whether he was a queer. Lorca, deeply hurt, rose, told Buñuel their friendship was over, and left; but by the evening they were reconciled. Buñuel commented that Lorca disliked overt homosexual behavior and abhorred even humorous references to it.

Lorca was twenty-three when Dalí first met him in the Residencia.

The poetic phenomenon in its entirety and "in the raw" presented itself before me suddenly in flesh and bone, confused, blood red, viscous and sublime, quivering with a thousand fires of darkness and of subterranean biology, like all matter endowed with the originality of its own form.[41]

Dalí resisted Lorca's magnetism by saying nothing that was indefinable, nothing of which, as he put it, a "contour" or a "law" could not be established, nothing that one could not "eat" (this was then and always one of his favorite expressions, denoting an understanding of an idea or a concept so complete that one could make it one's own by literally digesting it). When Dalí felt "the incendiary and communica-

tive fire of the poetry of the great Federico rise in wild, disheveled flames, I tried to beat them down with the olive branch of my premature anti-Faustian old age."[42]

In the beginning, Dalí's resistance to Lorca was not because he feared his sexuality—he was far too innocent emotionally and sexually to have understood the precise nature of Lorca's interests—but was compounded of a certain steely determination to be independent rather than subordinate to another: He had had enough of that in his relationship with his father. But Dalí was also envious of Lorca's domination of the group during their frequent excursions to such fashionable bars as Rector's or tearooms such as the Crystal Palace.

In a letter to his friend the influential art critic from Sitges (a center of Catalan art) Sebastià Gasch, written five years later, Dalí analyzed his relationship with Lorca as being characterized by the violent antagonism of Lorca's eminently religious and erotic spirit and Dalí's antireligious and sensual spirit:

> I remember the interminable arguments. . . . At that time in the Residencia everybody was reading Dostoevsky; the Russians were in vogue. Proust was still unexplored territory. Lorca was indignant at my indifference toward these authors. To me, whenever he made reference to the interior world, he would leave me absolutely indifferent, or rather, it struck me as something extraordinarily disagreeable.[43]

At the age of eighteen Dalí was still thin, gawky, pallid, and adolescent in appearance. In spite of his lacquered hair and his smart new suit, he was very young for his years and so timid he would still blush when spoken to. He used his painting and his ironic sense of humor, expressed in his distinctive low, hoarse voice, as a shield to protect him from intimacy. The group in turn treated him as a combination of small boy and mad mascot. Bello, Lorca, and Buñuel used to eat at a table in the refectory on the platform near the president's table, where Don Alberto sat with the guests of the day. But there was no way of getting the pathologically shy Dalí up there. He was also extremely disorganized. Every practical aspect of his life at the time involved incomprehensible "chits": Examination papers were "chits"; tram and theater tickets were "chits"; as were bills.

But Dalí used his shyness and impracticality as, years later, he

would use his mustache, as a diversion behind which he could develop his persona and his painting, and do exactly as he wanted. There came a time toward the end of his first year in the Residencia when, seeking to be independent, he began to avoid Lorca and the group. It was, according to Dalí, the culminating moment of Lorca's irresistible personal influence within the group, and the only moment in Dalí's life when he thought he "glimpsed the torture that jealousy can be."[44] Sometimes, as the friends were walking along the paseo de la Castellana on their way to the Café Pombo where they held their usual literary meetings, and where Dalí knew Lorca would "shine like a mad and fiery diamond," Dalí would begin to run and would vanish for three days. But he would always come back.

The years between 1922 and 1925 were the high point of the relationship among Lorca, Buñuel, Dalí, and the fourth inner member, Pepín Bello. Bello was one of those genial characters who, without being a painter or a poet himself, was nevertheless artistic and encouraged others. For Dalí, he replaced the benevolent interest of Ramón Pitxot. Bello was perhaps closest to Lorca; for a time he shared Lorca's room at the Residencia. By the end of Dalí's first year at the Residencia, Lorca, Buñuel, and Dalí constituted a group within the group, with Pepín Bello as an associate member. As the dynamics of such a closely knit group would dictate, the members invented symbols and words that acted as passwords to the inner circle. Some of these passwords and symbols would become the scenario of one of the first Surrealist films, *Un Chien Andalou;* many of them would form the basis upon which Dalí developed his own complex and highly personal visual iconography. To the recurring images of the grasshoppers and the rotting whale, glimpsed on the beach at Port de la Selva, were added other images of death and decay, including *putrefactos* such as the *asno podrido,* or rotting donkey.

Bello had a great influence on Buñuel and Dalí. He was a pleasant fellow by all accounts, but according to Rafael Alberti, who remained a peripheral character at the Residencia:

He was witty, sharp, and someone to whom extraordinary things happened. All the business of donkeys and pianos, most of that came from him. . . . Bello was full of imagination—and the putrefacto came from Pepín. It was then that Dalí drew the putrefactos, but the person who

had talked most about all this was Bello, who passed his time in the streets without doing anything, which he called ruismo.[45]

The games became elaborate. In 1921, Buñuel had discovered Toledo when he went there for a few days with the philologist Antonio Solalinde, and on subsequent visits with Dalí and Lorca as part of the extracurricular program available at the Residencia. In 1923, he set about organizing the "Noble Order of Toledo," having become fascinated by the city and its history of waves of invaders: Roman, Visigothic, Moorish, Jewish, and Christian.

Among the cofounders of the Order were Lorca, his brother Francisco (known as Paquito), Dalí, Pedro Garfías, the Basque painter José Uzelay, the librarian Ernestina González, and Pepín Bello. Buñuel was appointed Grand Master of the Order, and the others became Knights (*caballeros*) or Squires. Less central members were "Guests of the Guests of the Squires." Dalí was a Knight, but Buñuel later demoted him for an unspecified reason. The admission requirements were simple: You had to love Toledo, to get drunk, and to wander through its narrow, shadowy streets to see what adventure you might stumble on. One night Buñuel ended up in a house occupied entirely by the blind. There was no light in the house, but on the walls hung a group of pictures of cemeteries. The pictures were made entirely of hair, down to the tombs and the cypresses.

The order provided its members with a splendid opportunity for dressing up. Buñuel often appeared as a priest, and Dalí's costumes were always extremely bizarre, attracting a great deal of attention in the streets of the town. Far from disbanding the order when he went to Paris in 1925, Buñuel drew in French writers and filmmakers, among them the poet René Crevel, Pierre Unik, and Georges Sadoul. The order lasted until the outbreak of the Civil War, which put paid to its harmless pranks.

In a little-known manuscript, Dalí gives a revealing glimpse of the intellectual atmosphere of the group in about 1923:

In Room 3 of the Residencia de Estudiantes a secret meeting of an avant-garde group: Buñuel: "Wonderful evening! Weather which was yearning for rain. You cannot imagine what joy it causes me, despite the literature." Lorca: "My friend, I feel for you with all sincerity. Yesterday you

were stirred before the lilies on the canal and later under the light of the moon; if we'd stayed there you would have ended up by saying foolish things. If I remember rightly, you recited, though in a low voice, those lines of Verlaine which begin 'La lune . . . boit.' "

Guillermo de Torre (suddenly entering the room): " 'Universal hatred for the moon!' says Marinetti. What's the point of your having been born under the wings of aeroplanes? And you dare call yourselves avant garde; don't you know that the internal-combustion engine sounds better than hendecasyllables? I'm leaving, leaving straightaway because I fear contact with you will convert me into some antediluvian being and above all because my sensibility does not allow me to stay silent. I need the constant reflection of colors, multiform images; your ridiculous sentimentality is understandable because you spend days on end digressing and immobile in this room. Avant-garde meetings must have a dynamic quality—they are only logical if combined with speed."[46]

The avant-garde movements that so engaged and fascinated the group did not interest Dalí's fellow art students. In spite of this, and in spite of the pleasures of getting drunk and playing pranks with the group, Dalí was never diverted from the real business of his life, that of painting. His time in Madrid was crucial to his development as a painter, informed by the afternoons he spent as a truant from school, studying on his own in the basement of the Prado. Dalí haunted this basement, where were stored such paintings as were not to the taste of the time. Principal among these were the allegorical paintings by Hieronymus Bosch, known in Spanish as *"El Bosco,"* most of which had been acquired by Philip II of Spain, and which he had kept in his private rooms in the Escorial, presumably to remind him of the vanity of his earthly existence. Close study of Bosch influenced Dalí and gradually turned him away from cubist influences toward the unknown, the subconscious, dreams, and soft objects, painted in a rigorously controlled manner reminiscent of the Dutch masters. Premonitions of the typical Dalinian obsession with decay, symbolized by soft objects in the amorphous, pink, squidlike forms that writhe in eternal torment, can be seen in many of Bosch's paintings in the Prado. Such forms were already familiar to Dalí from his childhood: the detailed medical illustrations of venereally diseased flesh in the book his father left on the piano in the calle Monturiol; the curious objects such as the mummified frog collected by his teacher Señor Trayter; the

rotting whale on the beach. Dalí would later use Bosch's luminous technique in constructing his own Surrealist world.

But at the beginning of 1923, his second year in Madrid, Surrealism was still in the future. Dalí's cubism began to give way to "purism," the movement founded in 1918 by Amédée Ozenfant and Charles Jeanneret (Le Corbusier), which was based on the principle of the marriage of the object and pure geometric form. However, Dalí was never a successful purist; he could not help but imbue the objects he tried to analyze with his own quirky vision rather than with the abstraction of pure geometry. Reality kept creeping in, though Dalí made an intense study of the work of Picasso and Juan Gris, who dominated the pages of L'Esprit Nouveau at the time. In fact, Dalí was experimenting with several styles concurrently, always searching for his own identity as a painter by studying the work of other masters, both past and present.

At this time Dalí claimed to believe that painting must be carried out without any aesthetic doctrine, that it must never be subject to anything, but follow the impulse of the most unbridled feelings. You must paint romantically, he asserted, without considering whether what you paint is reasonable:

> Painting is a sensual art. What is essential for a painter is lack of doctrine and method; a painter cannot trace out a road to follow without violating his sensibility and burying his spirit in the route artificially created, for it is impossible to have a clear, prophetic vision of our own nature.[47]

But there would come a time when Dalí would set himself up as a prophet of his own soul.

In February 1922, Dalí became known as a painter to an important new audience, the Barcelona avant-garde. Under the auspices of the Catalan Student Association, he exhibited eight pictures in a group exhibition at the Galeries Dalmau. This group show was a significant stepping-stone in Dalí's career, since Josep Dalmau was the most important dealer in modern art in Catalonia at the time. In 1912 he had organized the Exposició d'Art Cubista in Barcelona, one of the first

cubist exhibitions to take place outside Paris. Dalí, who was only eight then, could not have seen it, but Ramón Pitxot certainly must have shown his young protégé the catalog at some point.[48]

During World War I, Spain's neutrality attracted to Barcelona a great many foreign artists who exhibited in the Galeries Dalmau and whose shows were publicized in Francis Picabia's magazine *291*, the first four numbers of which were published in Barcelona. Dalmau continued to try to create a market for contemporary art in Barcelona after the war, and in 1920 mounted an important exhibition of the French avant-garde, which included cubist works by Braque and Fernand Léger, fauvist paintings by Henri Matisse, pointillistic works by Henri Edmond Cross, and the work of two Catalans, Joaquim Sunyer and Joan Miró. In 1922, Dalmau organized an exhibition of works by Picabia that was presented by André Breton, who had come to Barcelona to give a paper entitled *"Caractères de l'Evolution Moderne et Ce Qui en Participe,"* outlining the search for an alternative to Dadaism. It would take Breton another two years to appropriate Apollinaire's term *"Surréalisme,"* to break with the Dada movement, and to become the leader of the Surrealist group.

Dalí did not attend these exhibitions, but they were nonetheless important to his future as a painter, since they helped to create in Barcelona a knowledgeable climate for the European vanguard in art, which Dalí certainly could not find in Madrid. His participation in this group show would lead to his being taken up by Dalmau, just as Miró had been four years previously, and given his first one-man show in the gallery.

By the beginning of his second academic year in Madrid, Dalí's relationship with most of his professors had soured to the point where he led an open rebellion against them. There was to be an examination to fill the vacant post of teacher of painting at the academy, and several well-known painters competed for it. Each participant executed two paintings, one on a subject of his own choice and one on a prescribed theme. By now known as the leader of the avant-garde faction, Dalí went with his fellow students to look at the exhibition and felt very strongly that all the paintings were mediocre, with the exception of those by Daniel Vázquez Díaz, whose works appeared to him to have at least some relationship with postimpressionism, if not with cubism. But rumors floating around the school held that influence and intrigue

were at work, and that the post was to be given to someone whom the students did not feel deserved it.

Dalí later wrote a letter to Rigol recounting the sequence of events after the academicians had reconvened on the platform and announced the success of another candidate:

> *There are shouts, insults to the tribunal, vivas, cries of "Death to," yelling, confusion, and everything else. Tormo and Cecilio [two of the professors] are cheered, and the others take refuge in the Natural History School and call the police, who don't take long to arrive. I don't take part in the row as I am a friend of Vázquez and I'm with him all the time, angrily commenting on the injustice, and had it not been for that, I'd have been one of those who shouted most.*
>
> *The trams stop in the calle Alcalá, and the public, who are numerous, as it is eight o'clock, take part in the demonstration and whistle at the police, who want in vain to remove them from the academy grounds; a cavalry charge is announced, and finally people disperse. All the students go to the newspaper offices to protest. . . . On the following day the dailies write up the event, together with a protest by the students—big panic in the college, no one is pleased about it, everyone's afraid, the faculty is reassembled, and a disciplinary council is to be held. As they can accuse no one in particular of the demonstration, as everyone took part—above all, people from outside the college—they call for those of us who they know feel and behave like us.*
>
> *I go into the council chamber, and Blay [one of the Professors] tells me that it is being said that I am one of the principals in the demonstration; I deny it, as in fact I didn't do any more than I've told you, and I tell him I wish to submit to any evidence he has. As he has none, he cannot give me any.*[49]

After being cross-examined and asked to name others who had taken part in the riot, which he refused to do, Dalí was dismissed. The verdict of the council was harsh: By that night, several students, including Dalí, were suspended for a year.

The suspended students visited the director at the Ministry of Public Education the next day, where they left a petition claiming they had been expelled simply for the sin of having an opinion. Buñuel roped in his friend Dr. Barnadas, gym instructor to King Alfonso XIII, who attempted to intercede with the monarch; but the suspensions were

not rescinded and it was uncertain whether Dalí would be allowed to return to the art school at all.

Dalí's father was furious—so furious that rather than confront his son he sent Tieta to Madrid to report back to him what had happened. She wrote that others, without specifying whom, had great admiration for Dalí's painting. Perhaps she meant the group, whom she probably met in the Residencia during her visit. Tieta's letter was optimistic about the possibility of Dalí returning for the following academic year and eventually qualifying as a teacher. When they went to the Escorial, Dalí had lain on his back before an El Greco (probably *Saint Francis Receiving the Stigmata;* this was undoubtedly some joke connected with the Noble Order of Toledo, in whose pantheon El Greco figured). In spite of this account of Dalí's bizarre behavior, his father calmed down.

Back in Figueres, Dalí wrote to Josep Rigol Fornaguera that his family had realized the monstrousness of the affair and were resigned about it.

Official punishment of a much more serious nature was to be Dalí's lot during his year in Figueres. It was the time of Miguel Primo de Rivera's "benevolent" dictatorship. There had been an abortive uprising by Catalan separatists, which led to unrest. In May 1924, Dalí's father acted as a returning officer in a local election at Boadella, a town not far from Figueres, and was prevented from carrying out his official task by the Guardia Civil, who threatened to shoot him, arrested him, and told him to look at their list of the people who they believed were likely to disturb the public order. The first name on the list was that of his son. Dalí was only twenty. His father saw through the ruse, which was to frighten the father by getting hold of the son.

Accused of being the super-separatist of the area, Dalí was, together with his anarchist friend Martí Villanova, arrested on May 14 ard remained in jail until June 12, first in Figueres but then, local feeling running very high, in Girona. Long afterward, Dalí told Luis Romero, one of his biographers, that he had requested to see the prison governor, as was his right, and when asked why, he told his jailers that the governor's sword and decorations would provide him with a welcome distraction. He seems to have wanted to create the impression that he

did not take his imprisonment as seriously as did his father, who lodged an official complaint against the detention. A special judge was appointed to look into the affair. Accusations flew to and fro, notably from Rodríguez Chamorro, the civil governor and former chief of police, who accused the notary of "the bad order arising from his lack of attendance at Café Sport Figuerense."[50]

The impasse was resolved when the dictatorship declared an amnesty for electoral crimes. Dalí was released just in time to go to Cadaqués for the summer. His imprisonment must have been more frightening and made more of an impression on him than he would admit at the time, for years later he still remembered how he had arrived in Figueres from Girona at dinnertime, and that he ate eggplant, and that when he went to the cinema after dinner the news of his freedom ran through the town and he was given an ovation as he walked down the *rambla* in the dusk.

That summer in Cadaqués, Dalí had a studio in carrer Riba Pichot, one of the narrow streets leading steeply down from the church in the center of the village. But he also worked *en plein air*. There is a photograph of him painting *Port Alguer* on the quay of the little harbor in the middle of the village. This was the period in which he painted both big constructivist and cubist canvases, and numerous portraits of his sister, Ana Maria, the domestic calm and intimacy of which were the fruit of his earlier study of and admiration for Vermeer, and his later studies in the Prado. In a cubist manner, Dalí portrayed his sister sewing, looking out at Cadaqués in the same attitude as he had portrayed his grandmother ten years previously. This was the summer, too, when he painted *Banyistes dels Llaner,* a picture with echoes both of pointillism and cubism, of twenty-four attitudes of the same girl. His family, not always in awe of his talent, christened his sunbathing women "logs."

It was the summer that Dalí called himself "the man of the rocks" as he jumped barefooted from one to another in an ecstasy of freedom and well-being. He had been set free, his family had stood by him, his father had encouraged him to go on as a painter, and it seemed more and more possible that he could go back to Madrid for the next academic year. It was a happy summer of small concerns and continuing

achievements. While Dalí painted, his father was preoccupied with building a garden to contain cypresses and urns. Dalí started engraving; Núñez, his erstwhile professor, came from Figueres to give him lessons; and his father gave him a printing press. Dalí also made the illustrations for *Les Bruixes de Llers* (*The Witches of Llers*), a book of poems by Fages de Climent that was published at the end of 1924.

That autumn, Dalí went back to Madrid and the Residencia, even though he was not yet allowed to reenroll at the art school; he would have to wait another year for that. He trailed clouds of romance as a political prisoner, and the group welcomed him as a hero. Dalí's father drastically cut down his allowance because of his overspending in the previous year, but Dalí, typically, came up with a solution: he simply signed for everything and sent the bills directly to his father.

The members of the group were almost always broke. There were visits to the municipal pawnshop (known in Spain as "the Mount of Piety"), but sometimes matters were desperate, and they had to stay in the Residencia rather than go out and meet their friends in the Madrid cafés. But there was always a way through, as Lorca later recounted:

> *One day, Dalí and I were totally broke. Like so many other days. We made a "desert" in our room at the Residencia with a cabin and a marvelous angel (a camera tripod, angel head, and wings made from starched collars). We opened the windows and asked for help from the passersby, lost as we were in the desert. We went two days without shaving, without leaving the room. Half Madrid filed through our cabin.*[51]

That winter, the group became more extravagant, even more "dandified," and fell even deeper under the influence of the personality of Lorca. They spent a great deal of time in one *peña* or another, meeting in cafés from three to five in the afternoon, or after nine at night, to discuss in an informal way matters of mutual literary concern. The most interesting of these "clubs" was the literary circle organized by the writer Ramón Gómez de la Serna in the cellar of the Café Pombo every Saturday night. Gómez de la Serna is now known mainly for his *greguerías* (literally meaning "noise," "uproar," "confusion"), the name given by Gómez de la Serna himself to his prose style, which consisted

of brief whimsical interpretations of various aspects of everyday life. At this point in his career, Gómez de la Serna had just abandoned the legal profession to devote his life to writing, and his opinion on literary matters was very much respected. Many years later he wrote an extremely interesting essay on Dalí as a painter from a literary point of view.

The inner group continued to invent and play private games that became more and more complicated and allusive. One game was called *anaglifos* and consisted of choosing three nouns. The first of these had to be repeated twice, the second had to be *gallina* (hen), and the last had to shock by its unexpectedness. Thus:

El buho	*The eagle owl*
el buho	*the eagle owl*
la gallina	*the hen*
y el Pancreator	*and the Pancreator*

The game became a brief craze, eventually put paid to by Lorca, who invented a final, baroque version:

Guillermo de Torre	*Guillermo de Torre*
Guillermo de Torre	*Guillermo de Torre*
la gallina	*the hen*
y por ahí debe andar algún en-	*and through there a swarm must*
jambre	*go*

But more important by far than *anaglifos* was the use of the word "*putrefacto*" by the group. Literally meaning "putrid," it was applied to whatever or whoever was considered bourgeois, out of date, or, as Lorca put it, "rancid." Possibly it derived from an expression from Baudelaire's *The Phosphorescence of Putrescence*. Dalí did drawings of *putrefactos*, Lorca wrote about them, and the group constantly referred to the term, Buñuel eventually using the imagery in *Un Chien Andalou*.

Death in its corporeal sense was an obsession with Lorca, Dalí, and Buñuel, and lay behind the clause in Buñuel's will that he should be cremated. Dalí himself later maintained that in order to avoid putrefaction he would have himself frozen so that he could be returned to life later. But it was Lorca, the leader in this as in so many things, whose

obsession with enacting his own death became an important part of the group's private mythology.

Sometimes at the end of an evening, instead of returning to his room, Lorca would stretch out on a sofa, claiming the attention of the whole group. Little by little, death, or its appearance, would seize him. The group would fold his hands and maintain a vigil. Death seemed to advance from the depths of his body and begin its destructive task. The group would play the game to the end, putting Lorca in a "coffin," carrying him down the stairs as carefully as professional undertakers. Dalí and others were frightened, but Lorca insisted that the funeral procession proceed along the pavement. The "corpse" was shaken about because of the potholes, and these jolts would finally break down the gravity of Lorca's face. With this theatrical show, the poet managed to convey to his friends, every time they went through the enactment, which was frequently, the distress he suffered over his fear of death.

Since he was not allowed to continue his studies at the Escuela de Bellas Artes until the 1925–1926 academic year, Dalí enrolled in the Free Academy run by Julio Moises and spent his time there drawing nudes in pencil on *papier Ingres*. His companions included Francisco Bores and José Moreno Villa.[52] In the Residencia he painted his friends, among them Buñuel, showing an acute psychological insight into the determination and intelligence of his subject, and a sinister portrait of Lorca in the Café Oriente in which the poet looks as if he has decomposed. From this time, too, dates the painting *Sifón y Botellita de Ron, en una Mesa de Café,* which Dalí gave to Lorca and in which Surrealist touches may be observed. Dalí later said of this picture that he did not depart from the clearly abstract and geometric relationships —as had Severini, for example—without being motivated by "plastic exterior feeling."

Dalí also spent a great deal of his time reading. He was particularly interested in Freud's *The Interpretation of Dreams*, which was the subject of frequent discussion among the group in the Residencia. There were, too, further visits to the crypt of the Prado to look once more at the Bosch paintings, whose imagery, when taken in conjunction with Freud's theories and his own childhood memories, would begin to mesh together in Dalí's mind as a basis for his paranoiac-critical method.

* * *

Sometime in the autumn of 1924, after Dalí had left for Madrid, his father married Tieta. Whether or not they had been having an affair before the death of Dalí's mother will remain unproven, but it is highly likely. Why did they marry? After all, Dalí's mother had been dead for three years, during which time Tieta had continued to live in the notary's home and to keep house for him. According to Montserrat Dalí y Bas, it was "because the people in Figueres said they ought to marry, that it was not proper for her, an unmarried woman, to be living in his house."[53] Dalí never mentions this marriage in *The Secret Life,* nor in any other autobiographical writings, and always refers to his stepmother as his aunt. Ana Maria seems to have become the idealized "mother figure" Dalí needed in his universe at this time, and in the 1924 series of portraits she appears as a pregnant figure looking older than her seventeen years; indeed, he made a drawing of her cradling a doll figure that might well be construed as the infant Dalí. There was, as we have seen, something sexual in his regard for his sister, as there had been in his relationship with his mother; this is particularly evident in *Girl Standing at the Window,* painted in 1925, which is extremely sensual in its handling of line and color.

Imperceptibly, the relationship between Lorca and Dalí was deepening. It changed from Lorca's being the leader to a more equal footing, perhaps best described by the term "sentimental friendship." On Lorca's side, the seducer had become seduced; and Dalí, that most timid of sexual beings, was apparently beginning to feel the pull of an attraction to Lorca other than the merely cerebral. So close had they become by Holy Week 1925 that Dalí asked Lorca to join his family for the holidays. They went by train from Madrid to Figueres and thence by taxi over the mountains to Cadaqués, where they were met by Ana Maria and Tieta, who had gone to open up the house at Es Llaner.

Dalí was always at his best in Cadaqués; the tensions and inconsistencies of his personality seemed to coexist more evenly in this beloved landscape. Now Lorca was able to see him in a new light, in surroundings of great beauty and, to the native Granadine, strangeness. Lorca felt that he was in a magical land, writing *"Olivos de Cadaqués, ¡que maravilla! Cuerpo barroco y alma gris . . ."*[54] Dalí became the

personification of this magical world of rocks and sea. Lorca fell in love with him.

Casting spells was Lorca's speciality, and it was not long before the whole Dalí family fell victim to his personal magnetism. Lorca, they said, was like a swan: heavy and graceless when out of the water, but as soon as he was "on the lake" he shed beauty on all that surrounded him. According to Ana Maria, he was ill-favored and clumsy when not reciting his poetry, reading his plays, or singing his favorite *cante jondo,* the traditional Gypsy songs of Andalusia.

Dalí showed Lorca his private world of mineral magic; there were boat trips to see Dalí's favorite rocks, particularly Cap de Creus. There were swimming parties (marred by Lorca's terror of drowning). There were picnics in hidden coves and there were expeditions to see the ruins of the Greek and Roman trading port in the luminous Bay of Roses, where the poet, finding a mosaic of Iphigenia, wrote a poem on the subject. The hot days stretched out, one after another, in glittering perfection, but nothing was as perfect as the young, exuberant, energetic Dalí.

Lorca shone, too, particularly in the evenings, when he entertained the family after dinner with poetry recitals, songs, anecdotes, and magic tricks. Another friend of Dalí, the guitarist Regino Sainz de la Maza, often joined them and gave concerts on the terrace. The *"Tremulo Studi"* of Francisco Tárrega was a favorite, and the rocky beach in front of the house filled up with people who had come to listen. It must have reminded Dalí of earlier evenings spent with the Pitxot family.

Dalí's childhood friends came to see Lorca, and Dalí took him to meet Lidia Nogueres, who immediately fascinated the poet. Later, Lorca would place her portrait on his piano. Eugeni d'Ors had written that Lidia had the madness of Quixote, but Lorca told Ana Maria that "Don Quixote's madness is a dry madness. . . . Hers is wet."[55] One evening Lorca read his play *Mariana Pineda* to the Dalís and some of their friends, all sitting quietly in the golden light of the oil lamps. They were fascinated by him, none more so than Ana Maria. She was now seventeen, dark and nubile—a dangerous age at which to meet a magnetic poet in his late twenties. While Dalí painted every morning in his studio, Ana Maria had Lorca to herself and would accompany

him on outings in the boat to the hidden beaches tucked into the cliffs to find shells and fossils for Dalí. One morning, as the boat waited to take them to Tudela, a beach beyond Cap de Creus, Lorca appeared bearing a coral branch that he told Ana Maria was blood from veins that had solidified. "I can still see him coming in with the branch lit by the morning light and putting it into the hand of the Virgin. . . . It was between spring and summer, and awoke old memories as we walked hand in hand back to the village."[56] The coral branch is still in the hand of the Virgin, at Es Llaner, seventy years later.

Ana Maria was beginning to fall in love for the first time. She must have felt that Lorca was falling in love with her, too. For the rest of her life she would never admit the truth, that it was her brother with whom the poet was in love and whom he was now pursuing in earnest. Photographs of Dalí show him posing seductively in a tiny swimsuit on the rocks or sitting across the table from Lorca, who is gazing at him. One, taken in his studio in Cadaqués, shows why Lorca was so attracted to him. His face is formed in the now familiar sharp planes. He is thin, deeply tanned, with huge, penetrating eyes, and is ambivalently dressed in a tight shift of vaguely Egyptian aspect. His pose is languid and seductive. The photograph reveals something else, what the Spaniards call *la mirada fuerte,* defined as a shamanistic ability through intense observation to possess something or someone—in this case Lorca.

Dalí began obsessively to paint Lorca, and for the next three years the poet replaced Ana Maria as Dalí's chief model. But Lorca did not attempt a sexual relationship as yet. Did Dalí suspect his friend's growing attraction to him? Did he provoke it deliberately? Probably not. But as vague as Dalí was about anything except painting, innocent of even the most primary of adolescent heterosexual urges, he might unconsciously have sought to gain the upper hand in his relationship with Lorca, seeking to dominate his friend, the acknowledged leader of the group at the Residencia, by making the poet fall in love with him.

His first portrait of Lorca showed him in his corpselike moments. Dalí made preliminary sketches, and Ana Maria took a photograph of Lorca lying down simulating death. The picture was completed a year later and was called *Natura Morta (Invitació al Son) (Still Life [Invitation to Sleep]).*

On one occasion Dalí took Lorca to Girona to see the Easter cere-
monies, and on another, determined to introduce his friend to people
he knew and admired in Barcelona, Dalí invited several acquaintances
to spend the day in Cadaqués. This was important to Lorca, since it
was his first contact with some of the participants in the city's lively
and avant-garde intellectual and artistic life.

After the Holy Week holiday, the Dalí family went back to Figueres,
Lorca accompanying them, and he was asked to read *Mariana Pineda*
to the members of the Figueres Arts Club. This took place in Dalí's
father's law chambers, and Lorca also gave a poetry recital at a lunch
organized by the club. To round off this most successful of visits, Dalí's
father arranged for an open-air performance of his favorite Sardanas,
which thrilled Lorca, who had never before heard this primitive music.

Before Lorca left Cadaqués, he had had the opportunity to judge for
himself the somewhat eccentric atmosphere of the town. One day,
when the family was at lunch, the maid announced that some gentle-
men had arrived to see the notary. Irritated at the interruption, Dalí's
father told her to tell them to see him in office hours. The maid came
in again to tell him that they wouldn't go away, for it was about
something very important. The notary could bear these interruptions
no longer and said, "Let's see who these gentlemen are." The answer
given by the servant astonished Lorca. "Señor, it's Ulysses, bringing
Greeks with him." Then Don Salvador, observing the effect this had on
his guest, said, "Let the Greeks enter!" It was in fact Ulises Ballesta,
then the mayor of Cadaqués, accompanied by the Koutos family,
Greek divers who had recently arrived in Cadaqués, where their de-
scendants still live.

From Figueres, Dalí and Lorca went to Barcelona and stayed with
Dalí's maternal uncle, Anselmo Domènech, the bookseller, in the
rambla de Catalunya. Lorca was immensely stimulated by the free
and questioning atmosphere, and conveyed his enthusiasm to the
Granadine historian Melchor Fernández Almagro:

> *Barcelona . . . is really something else, isn't it? The Mediterranean wit,
> adventure, the great dream of perfect love. There are palm trees, people
> from every land, surprising public announcements, Gothic towers, and a
> rich urban tide egged on by typewriters. How I enjoyed myself in that
> atmosphere surrounded by all that passion.*[57]

But it was Cadaqués that was to remain the perfect memory of his visit to Catalonia, inseparably linked with beauty, harmony, symmetry—and Dalí. He could not resist writing a nostalgic letter to Ana Maria:

> I think of Cadaqués. It seems to me an eternal and real landscape—but perfect. The horizon is raised up like a great aqueduct. The silver fish jump to catch the moon and you wash your plaits in the water. Then I remember sitting in an armchair; I remember eating crespell [doughnuts] and drinking red wine. You are laughing and your brother sounds like a golden drone.[58]

Shortly after returning to Madrid in April 1925, Lorca began work on one of his greatest poems, "Oda a Salvador Dalí," in which he captures the magic days and nights spent in Cadaqués as a metaphor for his growing feeling of friendship and more for Dalí. The ode took Lorca a year to write and was published in April 1926 in Revista de Occidente, edited by José Ortega y Gasset. Written in Alexandrines, the poem deals not only with the poet's friendship with the painter but with their shared love of harmony, symmetry, objectivity, and clarity, exemplified, in Lorca's eyes, by Dalí's rigorously unsentimental painting. Lorca's biographer Ian Gibson comments that the poet appreciated that Dalí's work was a flight from both outmoded realism and "Impressionist mist."[59] The poem is also a love song from Lorca to Dalí, in which he links Cadaqués with the emotions he feels about the painter and his work:

> Cadaqués, en el fiel del agua y la colina,
> eleva escalinatas y oculta caracolas.
> Las flautas de madera pacifican el aire.
> Un viejo dios silvestre da frutos a los niños.
>
> Sus pescadores duermen, sin ensueño, en la arena.
> En alta mar les sirve de brújula una rosa.
> El horizonte virgen de pañuelos heridos
> junta los grandes vidrios del pez y de la luna.

> Cadaqués, balanced between the water and the hill,
> raises steps and hides seashells.

The wooden flutes still the air.
An old sylvan god gives fruit to the children.

Her fishermen sleep, without dreams, on the sand.
On the high sea, the rose serves as their compass.
The horizon, free of wounded handkerchiefs,
merges the large crystals of fish and the moon.

In the poem, Dalí becomes the spirit of the harsh mountainous landscape and the caves, the sparse white houses, the sparkling light, the pure mineral magic of the rocks and the sea, the curves of the mountains, and the silvery olive terraces.

¡Oh Salvador Dalí, de voz aceitunada!
No elogio tu imperfecto pincel adolescente
ni tu color que ronda la color de tu tiempo,
pero alabo tus ansias de eterno limitado.

O Salvador Dalí, with an olive-smooth voice,
I'll not extol your imperfect adolescent brush
nor your color that flatters the color of your time;
I'll rather sing of your anxieties of external confinement.

(. . .)

¡Oh Salvador Dalí, de voz aceitunada!
Digo lo que me dicen tu persona y tus cuadros
No alabo tu imperfecto pincel adolescente,
pero canto la firma dirección de tus flechas

Canto tu bello esfuerzo de luces catalanes,
tu amor a lo que tiene explicación posible.
Canto tu corazón astronómico y tierno,
de baraja francesa y sin ninguna herida.

O Salvador Dalí, with an olive-smooth voice,
I'll speak of what your person and pictures speak to me.
No praise for your imperfect adolescent brush,
but rather sing of the perfect path of your arrows.

I'll sing your beautiful effects with Catalan lights,
and your love for all that is explicable.
I'll sing your tender, astronomic heart,
your card-game heart, a heart without wounds.

Lorca and Dalí were destined not to see each other again until the following year, for Dalí stayed in Figueres and Cadaqués working "like a madman," as he put it, for his first one-man show, which Josep Dalmau was to give him in November 1925. Letters went between Lorca and Dalí discussing painting and the progress of Lorca's poem; and there were other letters from Lorca, asking Dalí to join him in Granada, to which Dalí replied that he could not come, he could not leave the pictures he had started, but that Lorca should come to him instead. Lorca still had to learn that Dalí's painting would always come first.

Dalmau, it will be remembered, had first seen Dalí's paintings in the group show of 1922 and had been following his progress with interest ever since. The one-man show ran from November 14 to 27, 1925, and, with the exception of one early landscape, *Paisaje Cadaqués,* painted between 1917 and 1920, all the rest of the works had been painted in 1924 and 1925. There were seventeen paintings and five drawings in all, including a powerful portrait of Dalí's father and one of Dalí's friend from Figueres, Ramoneta Montsalvatje.

In the catalog, Dalí printed a comment from the art historian Elie Faure that summed up Dalí's attitude toward his painting at the time:

A great painter only has the right to take up tradition again after he has gone through the revolution, which is only the search for his own reality.

For good measure, Dalí also included three of Ingres's *pensées* about painting, which were in direct contradiction to the postimpressionism he so despised, including his favorite maxim: "Drawing is the probity of art." Dalí was turning away from cubism and purism toward a more classical form, echoing developments in Paris. For it was now that Picasso, Giorgio de Chirico, and even Matisse were, if only briefly, returning to the idea of classical form, looking back to the golden

mythological age of the Mediterranean littoral for inspiration. In *Venus and a Sailor,* painted that summer in memory of the Catalan poet Salvat-Papasseit, who had recently died, the heavy classical body of Dalí's Venus is embraced by a wraithlike cubist sailor; the two worlds of modernism and mythology meet and are synthesized, if only spectrally.

Dalí's first one-man show was a success, and the Catalan critics were enthusiastic. In the December issue of *La Gaseta de les Arts,* the anonymous critic wrote that

> *a sensitive and keen spirit is aware of all the conce ns of the time and throws himself impetuously into all speculations and, we may say, with real grandeur. . . . For a twenty-one year old, what this man does is surprising, and we are sure that he will find himself finally after his gleanings, and this is what interests us most about the exhibition.*[60]

No less successful was Dalí's participation in the first exhibition held by the Society of Iberian Artists in Madrid at the end of 1925. All the other artists were much older than Dalí, but his pictures attracted favorable critical attention, from Eugeni d'Ors among others.

Dalí went back to Madrid and the Residencia that autumn and once again entered the Escuela de Bellas Artes. But the group was no more. Buñuel had left and was working in Paris as an assistant in a film studio. Lorca, short of money, was living at home in Granada where he was trying, unsuccessfully, to get *Mariana Pineda* produced and to see Dalí again.

But this was not to be until the poet and painter met again in Madrid in May, after the publication of the *"Oda a Salvador Dalí."* Dalí had delayed coming back to Madrid after the Easter holidays because his father, presumably delighted with his son's success with Dalmau, had offered him a trip to Paris. Josep Dalmau had written letters of introduction for him to the poet Max Jacob and to André Breton, and his stepmother and sister were to accompany him on his journey. To Dalí, this brief visit was in the nature of a preliminary reconnaissance:

I knew that the road to success led through Paris. But in 1925 Paris was far from Figueres, far away, mysterious and big. I landed there one morning with my sister and my aunt to judge its distance and size, as a boxer does during a round of studying his opponent.[61]

The reassuringly familiar figure of Buñuel was waiting at the terminus when Dalí arrived, and this augured well. Dalí lost no time in visiting Versailles, which he thought less impressive than the Escorial, and, through an introduction he obtained from Manuel Angeles Ortiz, a cubist painter from Granada, he met Picasso. When he arrived at Picasso's studio on the rue de la Boétie, he later recalled, he was as deeply moved and as full of respect as if he were having an audience with the Pope. "I have come to see you," Dalí told Picasso, "before visiting the Louvre." "Quite right," Picasso answered.[62] Dalí had brought a small back-view portrait of Ana Maria, called *The Girl of Figueres,* to show Picasso, who looked at it in silence for some time. He then, still in silence, conducted Dalí on a guided tour of his paintings. At the end, they exchanged glances that to Dalí meant, "You get the idea?" "I get it!"[63]

In spite of his reunion with Lorca in Madrid after the Easter holiday, Dalí began to plan a permanent life in Paris, at the heart of the avant-garde, away from his family, away from Spain and what he began to see as its retrogressive thinking. His studies at the art school now seemed to him irrelevant, and the prospect of life as a drawing teacher in some provincial Spanish town an ambition so small as to be negligible when set against the possibility of being free to paint. Dalmau had offered him a second exhibition in December 1926, arising out of the success of his first, and he was painting furiously. The classroom was already a thing of the past.

It is not surprising, therefore, that in his academy examination that summer he produced a typically Dalinian solution to the problem of his future; he engineered a final expulsion from the school. When he was asked by the jury examining the theory of fine art to choose a subject, he replied: "No. Given that none of the professors at the Escuela de Bellas Artes has the competence to judge me, I withdraw."[64]

Later, he explained his motive as the desire to be finished with the

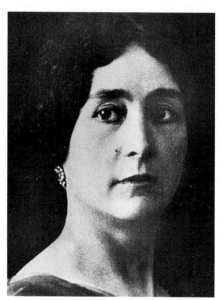

Salvador Dalí's mother, Felipa, c.1900.

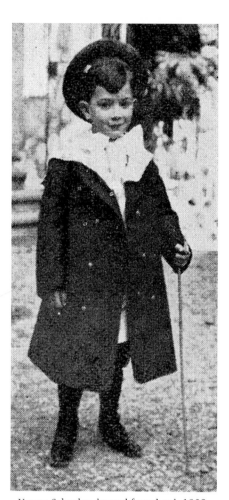

Young Salvador dressed for school, 1908.

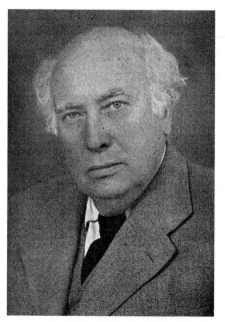

His father, Don Salvador Dalí.

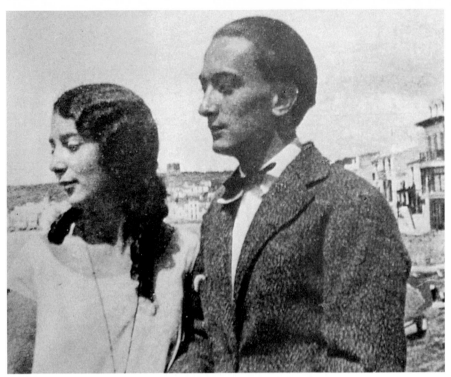

Dalí and his sister, Ana María, 1924.

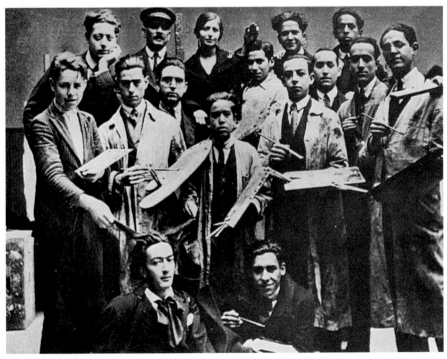

Dalí (*bottom left*) in a class photograph taken in 1925 at the Escuela de Bellas Artes, Madrid.

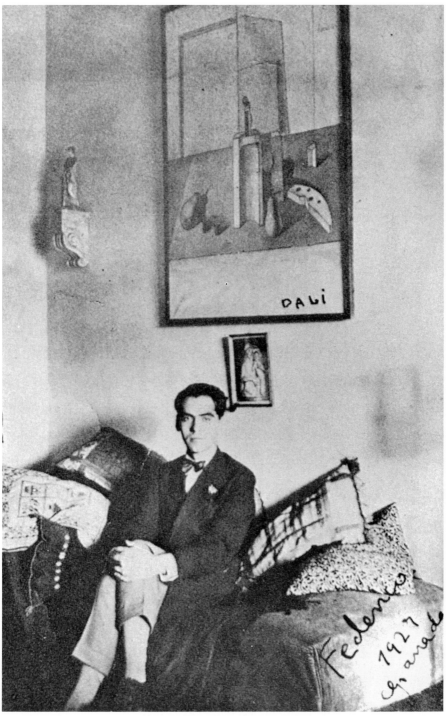

Federico García Lorca in his room at the Residencia de Estudiantes, Madrid, in 1921.
Lorca and Luis Buñuel were part of Dalí's circle at the Residencia.

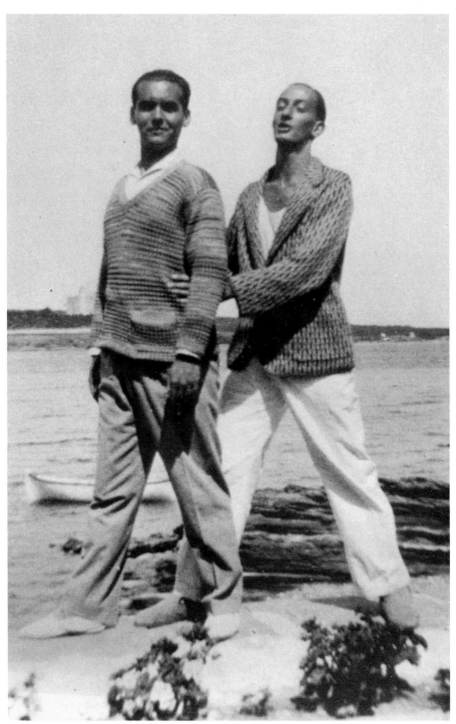

Lorca (*left*) and Dalí at Cadaqués, the summer home of the Dalí family, in 1925.

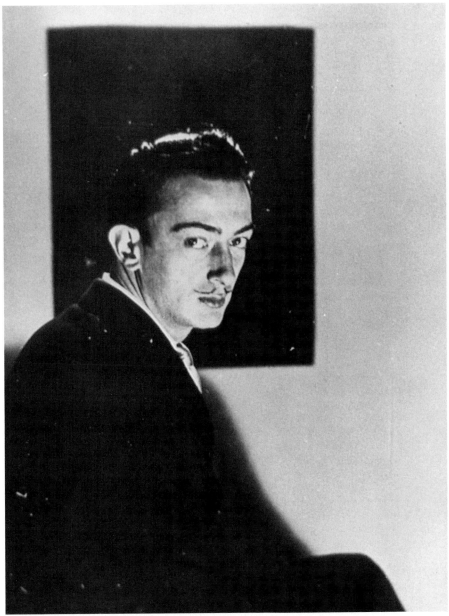

Dalí posed for Man Ray in 1933. A version of this portrait appeared on the cover of *Time*.

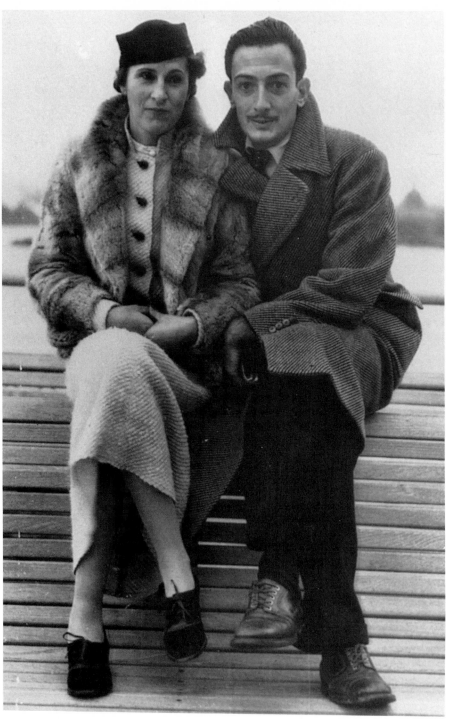

Dalí and Gala aboard the *Champlain* on their arrival at New York in November 1934.

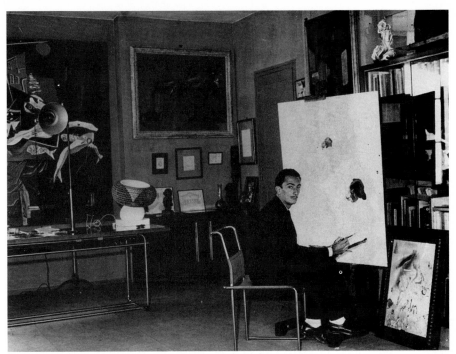

Dalí in his first Paris studio, c.1930.

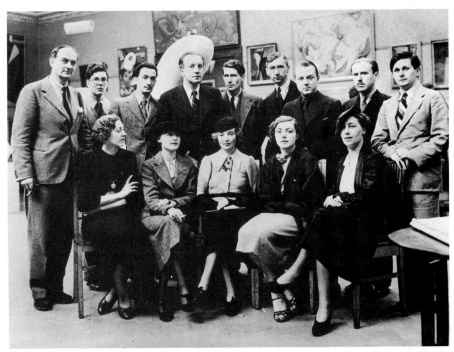

Participants in the first Surrealist exhibition in London in 1936. Back row (*left to right*):
Rupert Lee, Ruthven Todd, Dalí, Paul Éluard, Roland Penrose, Herbert Read, E.L.T. Mesens,
George Reavey, Hugh Sykes-Davies. Front row (*left to right*): Diana Lee, Nusch Éluard,
Eileen Agar, Sheila Legge, and a friend.

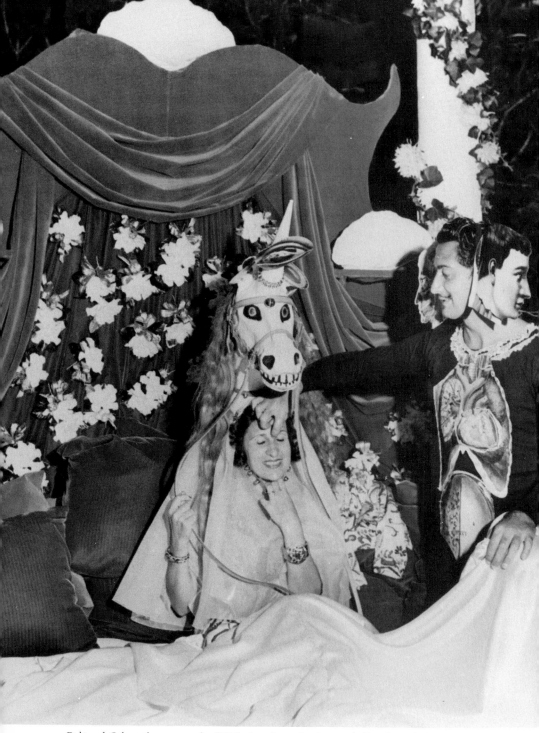

Dalí and Gala at the spectacular "Night in a Surrealist Forest" ball at the Del Monte Lodge, Pebble Beach, California, September 1941.

"orgiastic" life of Madrid, once and for all, and to return to his home and paint.

> *I wanted to be forced to escape all that and come back to Figueres to work for a year, after which I would try and convince my father that my studies should be continued in Paris. Once there, with the work that I would bring, I would definitely seize power!*[65]

On June 14 he was expelled. There was an official announcement in *La Gaceta,* a leading Madrid daily, an order signed by Alfonso XIII, on October 20, 1926.

As may be surmised, his return to Figueres was not a happy one. His father's hopes of establishing his difficult son in a career that would ensure his independence and shelter him from dreaded bohemian influences had been shattered. Dalí cites the evidence of his father's distress in the double pencil portrait he drew of his father and Ana Maria, believing that in the expression on his father's face could be seen "the mark of the pathetic bitterness which my expulsion from the academy had produced on him."[66] However, this is a typical Dalinian revision of the truth; the fact is Dalí had drawn the portrait a year earlier, when his future seemed assured.

He was now twenty-two, acknowledged as a painter with promise and working toward his second one-man show; but he was still trapped in Figueres in the web of his family. His way forward as a painter was clear; he was working very hard on new paintings, in which he was trying to draw positive conclusions from his cubist experience by linking its lesson of geometric order to traditional principles. His years at the art school had given him a solid, formal base for his work, but most of his teachers had never succeeded in communicating with him at a fundamental, creative level. It had been left to the group in the Residencia to introduce him to a life of intellectual inquiry and of mondain fun.

The pattern was set; the eternal adolescent had grown up as much as he ever could or would. Now he needed to escape to Paris and stay there, out of the reach of his father and the perpetual battle for supremacy in which they were engaged. Escape looked difficult, but not impossible. It was just a matter of time.

3

HONEY IS SWEETER THAN BLOOD
1926–1928

T he time Dalí spent in Figueres and Cadaqués after his expulsion from the academy and before he went to Paris has been termed "the Lorca years." It might just as easily be called "the lost years." Dalí's life had shrunk back to the familiar provincial round and the claustrophobia of existence within his family.

Dalí himself always implied that he had gone almost directly to Paris after his expulsion, but in fact he spent three years in artistic and social limbo, painting on his own, away from the influences of fellow painters and away from the temptations of the Residencia and Madrid. This breathing space, this isolation, was extremely important in his development; had he gone immediately to Paris, as he was longing to do, his painting might have become very much more influenced by the *bande catalane* working there, led by Picasso. As it was, this period became his transition into Surrealism. His work at this time also contains abstruse allusions to his relationship with Lorca, which was now passing into a new phase in which Dalí, almost in spite of himself, was being drawn into the poet's net.

Buñuel, now in Paris, had always counterbalanced Lorca's influence on Dalí. His straightforward, rather arrogant manner contrasted sharply with that of the poet, and he was, in a sense, a "healthier" influence. But his removal to Paris left the field clear for Lorca to try to become much closer to Dalí, who was isolated from the other friends he had made at the Residencia. His father was adamant that Dalí would not "pounce on Paris," and there was no money forthcoming for the

wayward (and now unemployable) son to be led into temptation. The fate of Ramón Pitxot, who had died the year before, virtually penniless as a result of the "immoral" life he had led in bohemian Paris, was always at the back of Dalí's father's mind. So, Dalí was thrown back on his own considerable intellectual and creative resources.

His hopes were raised that summer of 1926 when Joan Miró came to Cadaqués, accompanied by Pierre Loeb, then his Paris art dealer, and asked to see Dalí's paintings. The interest of two such successful men made a favorable impression on Dalí's father. While Ana Maria was talking to Loeb during this visit, Miró took Dalí to one side and warned him that Paris and the Parisians were not as easy as they seemed. Then, a month later, Dalí received a letter from Loeb that, far from enclosing the longed-for contract, asked him to keep in touch while he developed his undeniable gifts; at the moment his work was "too confused and lacked personality."[1] Loeb was right; Dalí was still experimenting with cubism, with realism, with classicism, and with the beginnings of his personal syntax. He had not yet found his direction. Loeb's verdict must have been enormously disappointing to Dalí, but his spirits lifted when Miró wrote to urge Dalí's father to send his son to Paris and to assert that Dalí's future would be brilliant.

In October 1926, at the first Autumn Salon in Barcelona, Dalí exhibited two paintings that showed the direction in which his thoughts were turning. One, *Noia Cosint* (*Girl Sewing*), was another portrait of Ana Maria, hitherto his favorite model, in his "classical" style, which, imperceptibly, he was moving away from. The other, *Naturaleza Muerta al Claro de Luna* (*Still Life by Moonlight*), depicts the severed and joined heads of Dalí and Lorca lying on a moonlit table in the Dalí sitting room at Es Llaner, beside a guitar, the artist's palette, some fish, and a fishing net. Another painting of the same date, *Naturaleza Muerta al Claro de Luna Malva* (*Still Life by Mauve Moonlight*), which was not exhibited in the salon, develops this theme in an even more complex composition.

Dalí's second exhibition at the Galeries Dalmau took place from December to January 1927 and included, apart from the neo-realist works of the previous year, cubist and neo-cubist works such as *Neo-*

Cubist Academy. A more classical and mystical painting was the first version of *Cesta de Pan* (*Basket of Bread*), a theme to which Dalí would return time and again. Here, his exposure to Zurbarán at the Prado may be seen as an influence. The exhibition was a success; the Pittsburgh Museum of Modern Art acquired *Cesta de Pan,* and his other paintings were sold to Catalan buyers. The sale of one of his paintings to America impressed his father, but Don Salvador was still adamant that he would not finance his son's escape to Paris.

Critical reaction to this exhibition was, though on the whole positive, more varied than it had been for Dalí's first exhibition. He was no longer a novelty or a prodigy and had to prove himself as a mature painter. The show did, however, attract the attention of Sebastià Gasch. Early in 1927, Gasch wrote a long article about Dalí's work in the influential *L'Amic de les Arts,* in which he perceptively pointed out that there was less evidence in these new paintings of Dalí's hyperintelligence, and that his sensibilities had "been given greater play."[2] In another review, in *Ciutat,* Gasch commented that in these new works it was possible to see a new facet of the crystal polyhedron in Dalí's art. "This new aspect in Dalí's most recent work might be said to represent what Christian Zervos, the intelligent director of the *Cahiers d'Art,* recently named 'the anxiety of today.' "[3]

Gasch wrote:

> *Dalí, like all the vigilant spirits of this generation, has felt the need to advance his work through the aesthetic gymnastics of cubism and through the austere discipline of pure painting. But as with so many artists of our time, this coarse discipline took him too far. Happily, he has immediately perceived the necessity of softening the dogmatic conceptions of his earlier work by the means of diverse concessions arising out of his poetic instinct, which no artist should ignore.[4]*

Another influential visitor to the exhibition was the Catalan poet and pastry maker J. V. Foix, who subsequently described a meeting with Dalí in a manner that owed more to poetry than to the accepted tenets of art criticism:

> *At the entrance to the exhibition room Dalí was stroking a huge, manycolored bird, which perched on his left shoulder.*

"Surrealism?"

"No. No."

"Cubism?"

"No, not that: painting, painting, if you don't mind."

And he showed me the windows of the wonderful palace he had built at Dalmau's. I felt very acutely that I was present at the exact moment of the birth of a painter. The vivisection hall showed, stripped to the bone, unlimited physiological landscapes; splendid groves of bleeding trees cast their shade over the brief lakes where the fish strive from morning to night to escape their shadows. And in the depths of the pupils of the painter, the harlequin, and the tailor's dummy, black stars fled across a silver sky.[5]

Like Gasch, Foix belonged to the group of avant-garde writers in Barcelona who collaborated on *L'Amic de les Arts,* which was published in Sitges, haunt of the turn-of-the-century "luminist" movement of landscape painters. This journal was very important to Dalí, since he believed that he could use it both as a platform to "revolutionize the artistic ambience of Barcelona"[6] and as a vehicle to keep his name in the public eye. He secretly regarded the journal as petty and provincial, but, always the realist, he said:

Its sole interest for me naturally was that of a preliminary experiment before Paris, an experiment that would be useful in giving me an exact sense of the degree of effectiveness of what I already at that time called my "tricks." These tricks were various . . . terroristic and paralyzing devices for imposing the ferociously authentic essence of my irrepressible ideas by which I lived, and thanks to which my tricks not only became dazzlingly effective, but emerged from the category of the episode and became incorporated into that of history. I have always had the gift of manipulating and of dominating with ease the slightest reaction of people who surround me.[7]

His interview, if so it could be called, was Dalí's first and very successful foray into the fine art of manipulative publicity. Throughout 1927 and 1928 he published at least one article in every monthly issue of *L'Amic de les Arts* and sometimes more. He also began to contribute to *La Gaceta Literaria* in Madrid, under the aegis of Ernest Giménez Ca-

ballero, an old Residencia friend, who was now the voice of the Spanish (as opposed to Catalan) avant-garde.

Dalí's involvement with *L'Amic de les Arts* drew him into Sebastià Gasch's circle, and the two became close enough to initiate an intermittent correspondence that lasted until 1931. Dalí's first letter to Gasch, written sometime toward the end of 1926 but, like so many of his letters, undated, is important from a biographical perspective, since it gives us a summary of Dalí's state of mind at the time.

He first admits to his new friend his complete absence of any religious faith, even from his earliest years, and confesses that this never caused him the least metaphysical worry. He discusses his relationship with Lorca, which, when it began, was characterized by "the violent antagonism of his highly religious spirit (erotic) and my anti-religiousness (sensual)."[8] Interminable discussions on religion went on until three or five in the morning at the Residencia, Dalí reported.[9]

He was passionate about geometry but spurned everything to do with human emotions, his preference leaving room only for purely intellectual concerns. Hence during the period from 1921 to 1922 he painted abstract pictures, giving a conceptual explanation of the most immediate objects and having often minimal plastic intentions. These preoccupations gained in importance, becoming in 1923 his single main preoccupation. Did this mean, Dalí asks rhetorically, that he had lived without intense feelings, without frissons and passion? Nothing, he reassures Gasch, could be more mistaken, for it was "precisely the absolute absence of religious instinct and the inner world that led me, even as a small child, toward a passion for the exterior world."[10]

Dalí then tells Gasch of the time he spent in the Prado, where he met Marjan Paskiewicks, a Russian who was, Dalí believed, very well informed about modern painting and who painted according to geometric rules à la Alberto Severini.[11]

This total reaction to my recent free-for-all [i.e., his expulsion] produced in me the most exacting and heartless control of my sensibility and earned my reaction to the furthest extremes (and with great passion). I embarked on a program of persistence, austerity, in which I copied the neo-classical plaster statues in the lead mine [the academy]. Truths,

*primary answers, physical virtues, simple certainties both clear and defi-
nite—asepsis. I met Lorca and our friendship, based on complete antago-
nism, began.*[12]

Dalí continues:

*If the physical aspect of futurism had attracted me, the symbolism of a
Gauguin meant nothing to me, nor did expressionism, despite its power of
influence, nor did any painting that turned on the inner world, nor
subjective speculations. Nothing was further from my thinking than ev-
erything mystic—nothing. I may tell you, Gasch my friend, that the inner
aspect of things is a superficial reality; the deepest is still an epidermis.*
Things have no significance outside their strict objectivity *and it is in
this that their miraculous poetry dwells. For Maritain [the French philos-
opher] an ear can become poetic through what it can awaken or make
significant in our spirit; for me an ear is poetry precisely because the
miracle of it consists in not signifying anything beyond its anatomical
morphology and physical construction, etc.*[13]

At this stage of his artistic development, Dalí was preoccupied by the
external world alone.

Meanwhile, Lorca was still in Granada, trying to earn enough money
through his writing to join Dalí. He was spending a great deal of time
preparing to launch a literary review that was to appear as the supple-
ment of a local newspaper, *El Defensor de Granada;* this supplement
was to be called *El Gallo del Defensor* (*The Cockerel of El Defensor*),
which was later modified to the simpler *Gallo.*

Dalí had become fascinated with the symbolism of the martyred
Saint Sebastian (so often a homosexual icon), who also happened to be
the patron saint of Cadaqués. In his continuing lively and sentimental
correspondence with Lorca, Dalí invited the poet to consider his new
type of Saint Sebastian, which consisted of the "pure transmutation of
Arrow into Sole. . . . What makes Saint Sebastian agonize so deli-
ciously is the principle of elegance. In him there is an anti-elegant
sense. . . ."[14]

Lorca asked Dalí to send him a drawing of a cockerel that could be
used for the cover of his new literary review, which Dalí did in Febru-

ary 1927, together with a letter that included a typically oleaginous greeting card. It depicted a winged and clothed mermaid offering a large bowl of fruit. Beneath the drawing was printed a sentimental poem, "To My Adored One," in which Dalí had changed the line *"un amor extenso y sin fin"* ("love wide and without end") by underlining "wide" and putting an asterisk against the word "without" with a note reading "instead of without, read with, signed Saint Sebastian."[15]

What did Dalí mean by this alteration? That his relationship with Lorca was making him, as always, unsure of himself, uneasy? That the relationship diminished him in some way? That although he was, for now, in love with Lorca, the idea of love without end, love beyond death, could not be borne, as he had never been able to bear the death of his mother—just as he could not contemplate his own putrefaction?

In the same letter, Dalí told Lorca that he had just started his military service. The idea of the dandyish Dalí dressed in neat military gear, drilling as a raw recruit on the parade ground, beggars imagination. But reality, as Dalí admitted to André Parinaud in *The Unspeakable Confessions,* was different. He did nine months' "deluxe" service (generally referred to as "per diem"). Under this system, conscripts, no doubt because of parental influence, were not subject to any duty roster, could eat out, wear a tailor-made uniform, and sleep at home. A few jealous noncommissioned soldiers assigned unpleasant duties to their more privileged fellow soldiers, however, and to Dalí fell latrine duty. But in general his military service simply gave him time to think about his future and to make plans that were, imperceptibly, beginning to exclude Lorca.

Lorca had other ideas. At the end of March 1927, he went to Madrid to discuss *Mariana Pineda* with the actress-manager Margarita Xirgú, who had undertaken to give the play its premiere in Barcelona that summer. Lorca promised that Dalí would design the sets. The scenery was to be simple and largely black-and-white, like an old engraving, and without, as Lorca was careful to reassure Dalí, "a single folkloric note."

Dalí needed this reassurance, for the two friends were beginning to diverge in their thinking. In one letter, written in April or May 1927, Dalí started by praising Lorca's "delightful songs," referring to the poems based on folk and Gypsy songs, which eventually became *Romancero Gitano.* Then, adept at flattery with a sting in its tail, he told

Lorca that he liked one particular song "more perhaps than the purest line of the *Thousand and One Nights* or of a popular song, but I like it in the same kind of way."[16]

He went on to say that they were both living in the age of the machine: "Until the invention of machines there had never been perfect things, and man had never seen anything so beautiful or poetic as a nickel-plated engine."[17] This phrase smacks of Marinetti's *Futurist Manifesto,* and it is fair to assume that Dalí may well have read it as part of his continuing interest in the Italian futurist movement both in painting and writing. He told Lorca that when he read Petrarch he saw large bosoms covered in flowery lace, but that when he looked at paintings by Miró, Léger, and Picasso, he knew that there existed machines and new discoveries in natural history.

He then got to the kernel of the argument that would eventually destroy their friendship: He told Lorca his songs were "Granada without trams and even without planes; an ancient Granada with its natural elements, distant from today, which are constant and of the people. Constant, you'll tell me, but that which is constant and eternal, as your people will say, takes on its own flavor in each age, which is the flavor that we who live with the new types of the same constants prefer."[18] Dalí, in effect, accused his friend of old-fashioned sentimentality and subjectivity. He advised Lorca not to turn his back on the twentieth century, and the problems therein, in favor of wishy-washy folkloric nostalgia. Dalí proclaimed:

> *I am superficial and I love the external, for when all's said and done, the external is the objectivity. What I like most in poetry is the objective, and only in the objective do I find any vibration of the ethereal. [At the end of the letter, perhaps realizing he has gone too far, Dalí retreats.] Yes sir, I'm talking rubbish and writing to you out of control, and I really need to do it meticulously and calmly. But talking has made this clear: You in any case will catch my meaning because you can grasp my ideas—even the most confused and silly ones that may occur to me.*
>
> *P.S. A further explanation: The age of the troubadours was that of song sung to the mandolin. Nowadays it's the song sung to jazz, and it's to be heard through the best of instruments, the phonograph. There is a song for our time. One can compose such a song under the name "popular song" with all the irony lent by our age, but purely as a feature of the widest meaning of "popular."[19]*

Lorca, however, was undeterred in his passion for Dalí and went ahead with his plans for their collaboration on his play, which would, once again, bring him into the closest possible contact with the man he loved. Lorca arrived in Barcelona at the end of April or beginning of May 1927 to attend rehearsals. *Mariana Pineda* was only a limited success, but he had been promised by Margarita Xirgú that there would be further performances in Madrid later on in the year, and Dalí had been complimented on his sets, which were felt to look very "Andalusian." The longed-for meetings were few, for Dalí had to spend most of his time in the barracks.

Stimulated by the nearness of Lorca, Dalí began two extremely important "Lorcan" paintings that were turning points for him. *La Miel Es Más Dulce que la Sangre* (*Honey Is Sweeter than Blood*) was originally called *El Bosc d'Aparatus* or *El Bosc d'Aparells* (*The Forest of Gadgets*), a title suggested to Dalí by Lorca. The eventual title came from a remark by Lidia Nogueres, who said that a bloodstain was easy to remove. She added, "Blood is sweeter than honey," explaining, "I am blood, and honey is all the other women," telling Dalí that her sons "at this moment are against blood and are running after honey," which lends credence to the persistent rumors of her incestuous relationship with her sons. The other "Lorcan" painting Dalí worked on in May 1927 was originally entitled *Cenicitas* (*Little Cinders*) but was eventually (and revealingly) called *Els Esforcos Esterils* (*Sterile Efforts*).

Many things unspoken, perhaps even unrealized, by Dalí may be discerned in *Honey Is Sweeter than Blood*. Lorca's head casts the shadow of Dalí's and is half buried in the sand. Beside it is a decapitated female dummy and a *putrefacto,* a rotting, fly-infested donkey. Nearby lies another severed head—probably Dalí's—separated from the poet's by a severed arm and a rotting corpse that might or might not represent Buñuel. Objects that look like skewers—or arrows—are sown in ranks down the beach. In the background a curved plain is lividly illuminated.

Honey Is Sweeter than Blood is always described by art historians as a pre-Surrealist picture; it might equally well be described as a post-Residencia work, for many of its images refer back to the games and jokes of the group at the "Resi." It also gives us clues about the state of

the friendship between Lorca and Dalí at the time it was painted: Dalí's growing uneasiness at the physical side of the relationship; his belief that in some way he and Lorca were twin souls (a belief to which the poet subscribed as well), a reworking, as it were, of Dalí's Castor and Pollux obsession. This important painting marks Dalí's new preoccupation with the subject he painted, rather than with the physical act of painting itself. Until Gala began to upbraid him for his technique in the early 1930s, Dalí was so preoccupied with the "literary" content of his painting that the act of painting itself was a secondary activity.

Honey Is Sweeter than Blood was shown at the Autumn Salon in Barcelona in 1927 and was bought by the Duchess of Lerma. It was reproduced in the magazine *Ciutat* in October 1927 to illustrate an article by Dalí entitled *"Film-Arte, Fil Antiartístico"* ("Film-Art, Anti-Artistic Thread"). It was considered by Dalí to be the key painting in the series that also included *Cenicitas* and *Apparell i Ma* (*Apparatus and Hand*), in which can be seen the branches of coral found by Lorca on the beach at Cadaqués and placed by him in the hand of the statue of the Virgin.

In *Cenicitas* there is a lyrical female nude, typically seen from behind. Lorca's fallen head lies by the sea; a skeletal donkey flies into the air beside spectral breasts. An amorphous, blimpish, fleshy torso floats on the horizon, obviously influenced by Miró in the flat way it is painted, but also by Dalí's early sight of the beached whale at Port de la Selva. Dalí was assembling for the first time fetishes, memories, and materializations of subconscious desires. He would use and reuse many of these images. For Dalí, no experience was ever forgotten, nor was it wasted. He just reshaped his perceptions and observations in the crucible of his subconscious, sometimes to be immediately adopted into his iconography, at other times to emerge only years, even decades, later.

Lorca, probably even more aware of the hidden meanings of these paintings, christened the series, which he admired a great deal, "Forest of Apparatuses." "This ardent work," as Dalí described them, alternated with intense meditation, for which he had plenty of time. "I put together, for my own account, the jigsaw puzzle of my genius and conceived the early beginnings of my paranoiac-critical method, which these works attest."[20] Dalí was henceforth "in the saddle," as he put it, but increasingly solitary, isolated, and inward-looking. He had uncon-

trollable fits of laughter. "I was suffocating beneath the pressure of my own genius," he later wrote. His deepening physical and mental attachment to Lorca was also exerting a malign influence on him.

To André Parinaud, forty years later, Dalí said that during this period he was convinced that a mysterious machinery was at work, forming the circumstances of his destiny, and that when the time came, everything would be ready for his triumph.

Cut off from his intellectual equals, Dalí spent his days in the barracks or with his reproachful family, who still could not forgive him for ruining what they thought would be a splendid career. He must have been miserable indeed. But, living without any real hope of escape from Figueres, he was nothing if not courageous in the pursuit of what he felt to be his destiny. Virtually without any external stimuli, Dalí formed the basis of his philosophy as a painter, and as a man.

In the July 31, 1927, issue of *L'Amic de les Arts*, Dalí published *"Sant Sebastià,"* an essay that he dedicated to Lorca and in which are hidden references to their friendship. The essay is divided into several subsections, the first of which is titled "Irony." Nature likes to hide herself, Dalí says, which was for Alberto Severini an expression of modesty. To Dalí, this is an ethical matter, since modesty is born out of the relationship between nature and man. In discussing what engenders irony, Dalí quotes from his own experience: "Enriquet, the Cadaqués fisherman, told me these same things in his own language one day when, looking at a painting of mine that represented the sea, he said, 'You've caught it exactly. But it's better in the painting, because there you can count the waves.'"

Dalí describes the figure of Saint Sebastian:

> . . . *the more I observed his face, the odder it appeared. Nonetheless, I had the impression that I had known him all my life, and the aseptic light of the morning revealed the smallest details with such clarity and purity that it was impossible for me to be disturbed. . . . All the arrows bore an indication of their temperature and a little inscription engraved on steel that read: Invitation to the Coagulation of the Blood. On certain parts of the body, the veins appeared on the surface with their deep, patinated storm blue and effected curves of a painful voluptuousness on the pink coral of the skin.*[21]

Compare this description with *Cenicitas* and it will be seen that the same elements occur in both painting and prose, and that both are, in a sense, portraits of Lorca.

Next comes a section Dalí entitled "Trade Winds and Anti–Trade Winds": "On the sand covered with shells and mica, precise instruments belonging to an unknown physics projected their explicative shadows and offered their crystals and aluminums to the disinfected light." This not only refers to the beach scene Dalí painted in *Honey Is Sweeter than Blood,* but might also be connected to his early memories of Señor Trayter's strange collection of medical instruments.

In the section entitled "The Sea Breeze," Dalí evokes the smell of the sea as a device to release memory and what he terms "a whole series of intellectual delectations." There follows "Heliometer for the Deaf and Dumb," the first of many devices Dalí invented as part of his personal mythology. This notional calibrator measured the saint's death throes and was, Dalí writes, composed of a small dial of graduated plaster in the middle of which a red blood clot, pressed between two crystals, acted as a sensitive barometer for each new wound or penetration by an arrow.

In "Invitations to Astronomy," Dalí invokes contemporary words and populist images in a manner strongly reminiscent of both Marinetti and the *Futurist Manifesto,* and of the text for *Parade,* of which, it having had its first performance in 1917, he would have been aware. Dalí used these contemporary images to build a prose collage that is, in effect, a hymn to modernism:

On the deck of a white packet boat, a girl with no breasts was teaching the south-wind-imbued sailors to dance the "Black Bottom." Aboard other liners, the "Charleston" and "Blues" dancers saw Venus each morning in the bottom of their gin cocktails at the time for their pre-aperitifs. . . . I see the girls playing polo in the nickel headlamp of the Isotta-Fraschini. . . . At Portland autodrome, the blue Bugatti race, seen from the aeroplane, acquires the dreamlike movement of hydroids that descend spiraling to the bottom of the aquarium with their parachutes open.

The rhythm of Josephine Baker in slow motion coincides with the purest and slowest growth of a flower produced by the cinematographic accelerator.

Cinematographic breeze again. White gloves and black notes of "Tom Mix," pure as the last amorous embraces of fish; crystals and stars of Marcoussis.

Adolphe Menjou, in an anti-transcendental atmosphere, provides us with a new dimension of the dinner jacket and of ingenuity (now only acceptable with cynicism).

Buster Keaton, here's true Pure Poetry, Paul Valéry!—post-machine-age avenues, Florida, Le Corbusier, Los Angeles. The pulchritude and eurhythmics of the standardized implement, aseptic, anti-artistic variety shows, concrete, humble, lively, joyous, comforting clarities to oppose a sublime, deliquescent, bitter, putrescent art.

Laboratory, clinic.
The white clinic falls silent around the pure chromolithography of a lung. Within the crystals of the glass case the chloroformed scalpel sleeps like a Sleeping Beauty in the wood of nickels and Ripolin enamel, where embraces are impossible. The American magazines offer to our eyes Girls, Girls, Girls, and under the sun of Antibes, Man Ray obtains the clear portrait of a magnolia, more efficacious for our flesh than the tactile creations of the futurists.

Shoes in a glass case in the Grand Hotel.
Tailors; models. Models quiescent in the electric splendor of the shop windows, with their neutral mechanical sensualities and disturbing articulations. Live models, sweetly stupid, who walk with the alternative and senseless rhythm of hips and shoulders and carry in their arteries the new, reinvented physiologies of their costumes.

The models; mouths, Saint Sebastian's wounds.

In the final section of *"Sant Sebastià,"* entitled "Putrefaction," Dalí says he sees "the whole world of the putrescent philistines; the lachrymose and transcendental artists, far removed from all clarity . . . the family that buys objets d'art to put on top of the piano."[22]

Here, in this prose and in his paintings, is contained the basis of the universe Dalí was creating for himself. That art should reflect the spirit of the age, that it should be objective rather than sentimental, sums up

Dalí's attitude. At the same time his use of popular imagery echoes much of what was beginning to happen in poetry at the time; one is tempted to think of T. S. Eliot in this connection, particularly of *The Waste Land,* in which Eliot employs the same device of modern images and ideas against a classical landscape. Dalí may have drawn technical and aesthetic inspiration from the painters of the past, but what he wanted to paint was the present and the future. A mustache reminded him of Velázquez's self-portrait. It also reminded him of Adolphe Menjou and Charlie Chaplin.

There is a strong implied criticism of Lorca's "folkloric sentimentality" in *"Sant Sebastià."* On a photograph of Lorca, taken in the plaza Urquinaona in Barcelona in 1927 at the time *Mariana Pineda* was being performed, Dalí imposed a representation of Saint Sebastian. Lorca stands on the "broken plinth." His haloed head is lying on the ground. Dalí also drew a sad face over Lorca's lower parts, presumably a comment on Lorca's continued but unsuccessful sexual advances.

After his play closed in Barcelona, Lorca spent two months on holiday in Cadaqués with the Dalí family. He brought with him a friend, the guitarist Regino Sainz de la Maza.

In the morning everyone worked. Sainz de la Maza practiced, Dalí painted, and Lorca wrote. In the forenoon there were expeditions on the boat *Son,* crewed by the fisherman Beti to Cap de Creus, and often picnics in the little bays beyond the cape (Dalí's favorite was Tudela), after which there was a siesta in one or another shadowy cave. At night, after dinner, the threesome walked about the little town, talking, mainly about politics, or went to L'Excelsior, a smart nightclub, where Dalí apparently danced the Charleston like a professional.

It was an idyllic time, and none found it more so than Dalí's sister, Ana Maria, who accompanied them on expeditions. She was now twenty and was strongly attracted to Lorca. That Lorca might be homosexual would never have occurred to this well-brought-up daughter of the bourgeoisie; nor would it have to her father. Ana Maria took many photographs of her brother and his friend: clowning around on the beach, rock climbing, diving from rocks, sunbathing. In some of these photographs, Dalí still looks androgynous, posing, for instance, like a 1920s vamp on the rocks at Cap de Creus; but it can also be

seen in other photographs that he was beginning to thicken physically and to look more masculine, tougher.

At the end of July, Lorca left Cadaqués and passed through Barcelona on his way home to Granada. While staying in the Hotel Condal in the carrer de la Boqueria in Barcelona, he wrote Dalí a long letter, of which only a fragment survives. He again reiterated the impression made upon him by the unique surroundings of Cadaqués and told Dalí how much he admired *Honey Is Sweeter than Blood.* "Now I realize how much I am losing by leaving you," he wrote. "It's delicious for me to recall the slippery curves of my shoulders when for the first time I felt in them the circulation of my blood in four spongy tubes that trembled with the movements of a wounded swimmer." At the end of this highly charged letter, he apologized for his "appalling" behavior toward Dalí, without going into details.

But it has been postulated by Rafael Santos Toroella and subsequently by Ian Gibson that this apology concerns an attempt by Lorca to sodomize Dalí. This might have happened on the little beach at Port Lligat (or in a more secluded cove), for in *Calavera Atmosférica Sodomizando a un Piano de Cola* (*Atmospheric Skull Sodomizing a Grand Piano,* 1934) the background to this curious metaphor for a sexual encounter shows the *barraca,* or little fisherman's hut, owned by Lidia Nogueres and subsequently bought by Dalí to become the kernel of his extraordinary house.

Dalí later wrote:

> He was a homosexual, as everyone knows, and madly in love with me. He tried to screw me twice. . . . I was extremely annoyed, because I wasn't homosexual, and I wasn't interested in giving in. Besides, it hurts. So nothing came of it. But I felt awfully flattered vis-à-vis the prestige. Deep down, I felt that he was a great poet and that I did owe him a tiny bit of the Divine Dalí's asshole.[23]

Probably Dalí, who was terrified of any physical contact of a sexual nature, submitted to Lorca's advances but could not go through with it. From this point, the days of their close relationship were numbered.

* * *

During the summer, both Lorca and Dalí had written to Buñuel, who was still in Paris, although he had been in Madrid briefly in May to lecture on avant-garde cinema at the Residencia. This had been a great success; *le tout* Madrid had turned out, and the lecture had prompted Ortega y Gasset to confess to Buñuel that, were he younger, he would have loved to try his hand at movies too. "True to form," Buñuel wrote in his autobiography, "when I realized how aristocratic my audience was, I suggested to Pepín Bello that we announce a menstruation contest and award prizes after the lecture, but like so many other Surrealist acts, this one never happened."[24]

Buñuel did not approve of what he perceived to be Lorca's seduction of Dalí. From Brittany, where he was on holiday in July, Buñuel wrote to Pepín Bello saying he had received a "revolting letter from Federico and his acolyte Dalí."[25] At the beginning of September, when he had returned to Paris, he went into detail:

> *Federico sticks in my craw incredibly. I thought that the boyfriend [Dalí] was putrescent, but now I see that the other is even worse. It's his awful aestheticism that has distanced him from us. His extreme narcissism was already enough to make a pure friendship with him impossible. It's his outlook. The trouble is that his work may suffer as a result.*
>
> *Dalí is deeply influenced by him. He believes himself to be a genius, thanks to the love Federico professes for him. He's written to me saying: "Federico is better than ever. He's the great man, his drawings have genius. I'm producing amazing work, etc." And then, of course, his [Dalí's] successes in Barcelona are so easily achieved. How I'd love to see him arrive here and renew himself far from the dire influence of García! Because Dalí is a real male and very talented.*[26]

Sometime at the end of that summer, Buñuel, Lorca, and Dalí met in Madrid. According to Buñuel, Dalí insisted that Buñuel hear Lorca reading his play *The Love of Don Perlimplín for Belisa in His Garden:*

> *Federico was reticent about reading it; he thought—not without cause—that my tastes were too provincial for the subtleties of drama. But Dalí insisted, and finally the three of us met in the cellar bar at the Hotel Nacional, where wooden partitions separated the room into compartments, as in certain Eastern European restaurants.*
>
> *Lorca was a superb reader, but something in the story about the old*

man and the young girl who find themselves together in a canopied bed at the end of Act One struck me as hopelessly contrived. As if that weren't enough, an elf then emerges from the prompter's box and addresses the audience.

"Well, eminent spectators," he says. "Here are Don Perlimplín and Belisa—"

"That's enough, Federico," I interrupted, banging on the table. "It's a piece of shit."

Lorca blanched, closed the manuscript, and looked at Dalí.

"Buñuel's right," Dalí said in his deep voice. "Es una mierda."[27]

Later, Buñuel told Max Aub what happened next:

Federico got up, angrily collected his papers, and left. We followed him, talking loudly so he'd know we were there—we arrived at a church that stood at the entrance of the Gran Vía. He went in and knelt down with open arms. Even the dumbest would have known we were coming. Dalí and I went off and went on drinking. On the following morning I asked Salvador, who shared a room with Federico, "How are you?"

"Everything is sorted out. He tried to make love to me but couldn't."[28]

When asked to confirm this incident years later, Dalí said he could remember nothing of it.

To Rafael Santos Toroella, Dalí torn between Lorca and Buñuel is an allegory. The trio represents the contradictions of Spain. The dark angel and the angel of light struggle to get control of the soul of an innocent. And, says Santos Toroella, the fable does not have an edifying moral. Buñuel was jealous of Lorca's and Dalí's success in Spain. In Paris, he was not doing as well. No one was paying any attention to his writing, and he was no nearer being able to direct his own films. In the letter quoted above, he observed sourly that Dalí was now *vieux jeu* in Parisian terms, due to Lorca's influence on his work.

From the autumn of 1927, Buñuel did everything he could to separate Dalí and Lorca, and in this he eventually succeeded. What he did not realize was that Dalí was beginning to distance himself from Lorca of his own volition—not because of Lorca's sexual advances, but because he had begun to realize that Lorca was not "modern," and modern was what Dalí wanted to be. He wanted to separate himself from Spain, to go to Paris and to paint in the thick of the avant-garde there,

rather than to stay in Spain and to dwindle into a genre painter. Buñuel was to be his link.

On November 6, 1927, Buñuel was appointed coordinator of the film pages of the *Cahiers d'Art* and *La Gaceta Literaria.* He published pieces like *"Cuando la Carne Sucumbe"* ("When the Flesh Succumbs") in *Cahiers* and *"La Dama de las Camelias"* in *La Gaceta.* In the issue dated December 15, Buñuel published Dalí's essay *"Film-Arte, Fil Antiartístico,"* which had appeared in *Ciutat* early in the year. Dalí was thus made aware that Buñuel now represented a valuable new channel through which Dalí could be published in Spanish and French, rather than in Catalan, and in magazines that would undoubtedly be read in Paris by the avant-garde, particularly the Surrealists.

Antoní Pitxot recalled that "Dalí told me once that he deliberately cultivated Buñuel at the time because he was more modern, moved in the avant-garde, and lived in Paris, and that in the end he chose his career by ending his relationship with Lorca and throwing in his lot with Buñuel, for this reason."[29] It was the hearty, homophobic Buñuel who would play the most important part in enabling Dalí to become a success in Paris rather than the literary, homosexual Lorca.

In 1927 Dalí decided that he wanted to join the Surrealists. The art historian Dawn Ades maintains that the process of change had started with the influence, possible to perceive in Dalí's paintings of the 1924–1925 period, of the *metafísicas,* especially Giorgio de Chirico and Giorgio Morandi.[30] His pre-Surrealist paintings, particularly *Honey Is Sweeter than Blood,* were a short step away. And he was obviously influenced by what he had seen of the work of the artist Yves Tanguy, a founding member of the Surrealist group.

Lorca still hoped Dalí would come to Granada when he had finished his military service, but Lorca had come too close both physically and mentally. He was demanding what Dalí could not give, what he should not give, if he were to keep his "Holy Objectivity" intact; if he were to keep his personality from imploding; if, in other words, he were to remain sane.

In March 1928 Dalí fired off a salvo against the Catalan intellectual establishment in the form of the *"Manifest Groc"* ("Yellow Manifesto"), one page written on yellow paper, written and laid out in a manner

obviously derived from Marinetti's *Futurist Manifesto*. The main contributors were Sebastià Gasch, Lluís Montanyà, and Dalí. Lorca had worked with Dalí the summer before on a draft but had not contributed to the final diatribe.

The *"Manifest"* rejected all imitations of earlier art and insisted—as Dalí had insisted in his letter to Lorca a year earlier—that the machine was the symbol of the new age. The three authors listed the painters and writers who they felt represented the age of the airplane, jazz, and the cinema. Among them were Picasso, Juan Gris, Amédée Ozenfant, de Chirico, Joan Miró, Jacques Lipchitz, Constantin Brancusi, Hans Arp, Le Corbusier, Pierre Reverdy, Tristan Tzara, Paul Eluard, Louis Aragon, Robert Desnos, Jacques Maritain, Maurice Raynal, André Breton, Jean Cocteau, and Lorca. When Lorca published the *"Manifest"* translated into Spanish in *Gallo,* he crossed his name off the list.

The *"Manifest"* provoked raucous partisanship on both sides. The totalitarian side of Dalí's character had begun to emerge. He had no time for those who did not agree with his principles, and took the war into the enemy camp by writing insulting letters to many of the friends he had made in the Residencia, calling them pigs. He happily compared himself to a clever bull avoiding the cowboys and generally had a great deal of fun stirring up and scandalizing almost every Catalan intellectual worthy of the name. Dalí was beginning to burn his bridges with the zeal of an arsonist.

He followed up the *"Manifest"* with a lecture given in the Ateneu in Sitges during which he proposed the abolition of regionalism, local color, folklore, and Sardanas, and the destruction of the Barri Gòtic, the old part of Barcelona. He also adjured artists to take up sport, bathe daily, and change their underclothes. Buñuel's "healthy" influence can be detected here, as can the signs of a new offensive against his father, now joined in Dalí's mind by Lorca as a legitimate object of his ridicule.

Dalí and Buñuel then wrote a joint letter to their former friend the poet Juan Ramón Jiménez, whom they had met during their years at the Residencia and whom they had both liked, even if they had not agreed with his views. Jiménez was the spiritual father of the Andalusian poets, the "Generation of '27." Buñuel, Dalí, Bello, and other friends in the Residencia had applied the name *perros Andaluces* (An-

dalusian dogs) to this group of poets who were, they felt, insensible to revolutionary poetry with a social content.

"We had resolved to send a poison pen letter to one of the great celebrities of Spain," Dalí later told his biographer Alain Bosquet.

> *Our goal was pure subversion. . . . Both of us were strongly influenced by Nietzsche. . . . We could have done what Breton advocated, that is to say, go down to the street and start shooting into a crowd. But instead of exposing ourselves we said: "Who is the most prestigious man that we could insult?" We hit upon two names: Manuel de Falla, the composer, and Juan Ramón Jiménez, the poet. We drew straws and Jiménez won. As a matter of fact we had just left him in a state of soupiness and he had said to us: "I've found the group of the future. Dalí is a genius, Buñuel is insane, violent, passionate, and he's producing the most extraordinary things. Federico García Lorca is a wonderful poet." So we composed a frenzied and nasty letter of incomparable violence and addressed it to Juan Ramón Jiménez.[31]*

It read:

> *Our Distinguished Friend:*
> *We believe it is our duty to inform you—disinterestedly—that your work is deeply repugnant to us because of its immorality, its hysteria, its arbitrary quality.*
> *Especially:* MERDE! *for your* Platero y yo,* *for your facile and ill-intentioned* Platero y yo, *the least donkeyish and the most odious donkey that we have ever encountered.[32]*

Buñuel was worried about posting the letter but they finally sent it off; it caused Jiménez great pain. The next day, according to Dalí, Jiménez was prostrate. He said, "I just don't understand. I'll never comprehend how people, who are so ardent and admiring and sensitive in my presence, can send me such arrant nonsense. I don't understand such a demented outburst of filth against me."[33] Dalí told Bosquet that in the Spain of those days, "an inexplicable event was in order, and we succeeded in creating one."[34]

In April 1928, *Revista de Occidente* published the *Romancero Gitano*,

* Jiménez's most famous prose work, a story about a donkey set in the poet's Andalusian hometown, Moguer.

which was to bring Lorca immediate fame. It was almost universally praised, but there were two dissidents in the chorus of acclaim: Dalí and Buñuel. Dalí brooded about the book for most of the summer, and it was not until September 1928 that he wrote Lorca the following letter:

> I've read your book calmly and I cannot refrain from making a few comments. Of course I can agree in no respect with the opinion of the big putrefactos pigs who have commented on it . . . but I think that my opinions, which grow more definite about poetry every day, may interest you.
>
> . . . your present poetry falls between the traditional and in it I notice the fattest poetical substance that has ever existed: but! it is completely bound up with the norms of ancient poetry and incapable of moving us and satisfying our present desires. Your poetry is tied hand and foot to old poetry. Perhaps you may consider certain images daring, or may find an increased dose of irrationality to your effects, but I can tell you your poetry is limited to illustration of the most stereotyped and conformist areas.
>
> . . . Little Federico, in your books, which I brought to read in the mineral places, I have seen you, little beast that you are, like a little erotic beast with the sex and the little eyes of your body and your hair and your fear of death and your wish that, if you were dying, the gentlemen would come and tell you; your mysterious spirit made up of little idiotic puzzles with a strict correspondence to your horoscope. Your thumb in strict correspondence to your prick . . .
>
> . . . I love you for what your book reveals of you, which is quite the opposite to the reality which the putrefactos have forged. . . . I love and admire you as the sole which appears in your book. . . . Farewell, I believe in your inspiration, in your sweat and your astronomic fate. . . . Now I know something of sculpture and real clarity—now, far from any Aesthetic.
>
> [Dalí could not resist adding a postscript.] Surrealism is one of the means of escape. It's that escape which is the important thing. I'm going to keep myself and my style at the edge of Surrealism, but this is something that is alive. You can see that I don't speak of it as I did. I had the pleasure of thinking very clearly last summer. How cunning, eh?[35]

For Lorca this letter was the final blow, and he would neither meet, nor speak to, Dalí for seven years.

"I have always been opposed to the folklore aspect of his poetry," Dalí told Bosquet.

> *He was much too fond of the gypsies, their songs, their green eyes, their flesh that looked as if it were molded with olives and jasmine: all the crap that poets have always loved. He had an annoying tendency to consider a gypsy more poetic than a civil war, whereas I . . .*[36]

Dalí was painting harder than ever in Figueres during the latter part of 1928 and had begun to work on a series of collages with gravel and sand stuck to them; many of these were overtly erotic. In some of them, cork created suggestive protuberances, and two of these, *Dedo Gordo, Playa, Luna y Pájaro Podrido* (*Fat Finger, Beach, Moon, and Rotten Bird*) and *Diálogo en la Playa* (*Dialogue on the Beach*), were refused by the Sala Parés in Barcelona, where the annual Autumn Salon was held.

The first of these two paintings was a cartoon with oils and a collage of thick sand; on one side fingers in a stiffly contrived position stuck out. One of them looked like a little phallus. There were other meanings that could be

> *simultaneously attributed to the other folded fingers, namely testicles, and the masturbatory effect of the hand, and to sharpen the fantasy, the gap between [the fingers] might symbolize rather than represent the female sex. On the opposite side of the picture, rounded but defined shapes suggested an unattainable female. . . . The picture and its rejection set off a lively feud in which critics and aficionados took sides. It didn't go beyond a storm in the local effervescent teacup, but it attracted the attention by which its provocative intention succeeded.*[37]

That summer, Buñuel, whose job as filmmaker Jean Epstein's assistant on *The Fall of the House of Usher* had come to an end, and who had also resigned from *Cahiers d'Art* over a disagreement about a rave review he had written about American films, was asked by Dalí to Cadaqués, where no doubt they plotted other subversive activities. Lorca had by this time found consolation in Emilio Aladrén, a young sculptor.

Buñuel's induction into the Surrealist group had not been a sudden decision; he had been introduced to most of the members at their

regular café, the Cyrano, on the place Blanche, a haunt of prostitutes and their pimps, and had attended many of their meetings. By January 1929, by general consent, he had become a full member, and as he was the only one interested in and knowledgeable about film, he decided to use the aesthetics of Surrealism for the screen. But what kind of film should he make? First, he needed a script.

In a letter to Pepín Bello written that January, Buñuel told his friend that he was going to spend a couple of weeks with Dalí in Figueres to collaborate on some filmic ideas. By February 10, Buñuel wrote again to Bello, telling him that he and Dalí were more united than ever:

> We have worked together to make a stupendous scenario, quite without precedent in the history of the cinema. . . . We were going to call it El Marista de la Ballesta [The Marist of the Crossbow] but for the moment it is provisionally entitled Dangereux de Se Pencher en Dedans [Dangerous to Lean In].*
>
> We had to look for the plot line. Dalí said to me, "I dreamed last night of ants swarming around in my hands," and I said, "Good Lord, and I dreamed that I had sliced somebody or other's eye. There's the film, let's go and make it."[38]

They wrote the script in six days.

> We wrote with minds open to the first ideas that came into them and at the same time systematically rejecting everything that arose from our culture and education. They had to be images that would surprise us and that we would both accept without discussion. Nothing else. For example: The woman seizes a racket to defend herself from the man who is about to attack her. And then he looks around too for something to counterattack with and (now I'm speaking to Dalí) "What does he see?" "A flying toad." "No good." "A bottle of brandy." "No good." "Well, he sees two ropes." "Good, but what's on the end of the ropes?" "The chap pulls on them and falls because he's dragging something very heavy." "Well, it's good he falls down." "Attached to them are two dried gourds." "What else?" "Two Marist brothers." "That's it! Two Marists. And then?" "A cannon." "No good, let's have a luxury armchair." "No, a grand piano." "Very good, and on top of the grand piano a donkey—no, two rotting

* A joke on the notice in French trains, "Dangereux de se pencher au dehors" ("Dangerous to lean out").

donkeys." "Wonderful." Well, maybe we just drew our irrational repre-
sentations with no explication. . . ."[39]

Many years later Buñuel told the Mexican review *Nuevo Cine:*

> *On some things we worked very closely together. In fact, Dalí and I were*
> *extremely close during that period. . . . I lived for a time in Figueres*
> *while I was preparing the plot. . . . Dalí's contribution to the film con-*
> *sists only of the scene of the priests who are dragged in on ropes, although*
> *it was a joint decision to exclude all narrative sense, all logical associa-*
> *tion.*[40]

The film was eventually called *Un Chien Andalou.*

By April 1929, Dalí had persuaded his father to give him enough
money to go to Paris on a brief visit, to assist in making the film. He
was also determined to meet the Surrealist group, and to join it.

The Surrealists eschewed the Ritz and other smart haunts of *le tout*
Paris in favor of the Café Cyrano, while more serious meetings were
conducted in André Breton's studio around the corner at 42, rue Fon-
taine. By the time Dalí came to Paris, the Surrealists had been "taken
up" by Parisian socialites keen to be in touch with contemporary art
movements.

Surrealism, commented Roger Vailland, was not a literary school. "It
was above all a common ground and meeting place for young, petit-
bourgeois intellectuals particularly aware of the futility of every activity
expected of them by their background and their era."[41] By 1929, Sur-
realism had become highly organized and very controversial. The
word *"surréalisme"* had been coined by Apollinaire in his 1917 play,
Les Mamelles de Tirésias, and had, by 1924, been appropriated by
Breton and the group he had gathered around him.

The movement had grown out of the high jinks of the World War I
Dadaists, led by Marcel Duchamp and Francis Picabia in New York;
André Breton and the writer Jacques Vache, who met while working in
a mental hospital in Nantes; and Tristan Tzara, Richard Huelsenbeck,
and Hans Arp in Zurich, where the Cabaret Voltaire became the first
Dada headquarters, a center for Dada performances by artists as well

as writers. Essentially, Dadaism was centered on performances and "happenings" rather than works of art, but when the Dadaists reached Paris in 1919, they were immediately promoted by such established writers as Paul Valéry and André Gide.

Although Surrealism was not a literary movement as such, publishing was always an integral part of its activities. With the publication of the review *Littérature,* founded by Louis Aragon, André Breton, and Philippe Soupault in late 1919, the aims of Dadaism were promoted to a wider audience that became appreciative of its jocular, not to say anarchistic, views. The Dadaists made their headquarters in the Bar Certà, tucked away at 11, passage de l'Opéra, just off the boulevard des Italiens. This was a very rowdy meeting place; quarrels broke out constantly and so did organized happenings, such as the theft by Paul Eluard of a waiter's wallet, which gave rise to much controversy about contemporary morals. Yet the Dadaists had also found a larger audience; *Le Coeur au Gaz,* by Tristan Tzara, proved popular with the theatergoing public.

By 1921 there were signs that Dada was coming to an end. Tzara had been quarreling with Breton by insisting on maintaining his frivolous attitude, and the rich and flamboyant Picabia was also at odds with Breton, preferring to race around Paris in one of his fast cars rather than to attend serious meetings. In the history of the Paris avant-garde, the years 1922 to 1924 are often referred to as *l'époque floue,* the "indistinct period" of transition between the merry anarchy of Dada and the organized effort of Surrealism, led by Breton.

Tzara's Dada magazine, *Le Coeur à Barbe,* was eccentric in the extreme. The April 1922 cover displayed razors, hot-air balloons, and steamships cohabiting with mussels, snakes, and camels. Breton, meanwhile, had embarked on a new series of *Littérature* in which he definitively moved away from what he perceived as the idiocy of Dada and toward nonliterary Surrealism. He described the aims of his group as "designating a certain psychic automatism that corresponds rather closely to the state of dreaming."[42]

In July 1923, a violent altercation broke out at the gala Dada arts soirée at the Théâtre Michel on the rue des Mathurins. Man Ray had constructed a film (called *Le Retour à la Raison*) that ran for two minutes. As it ended, and Tzara's play began, Breton raced on stage, boxed the poet René Crevel's ears, and broke Pierre de Massot's arm with his

walking stick. The poets Louis Aragon and Benjamin Péret soon joined in, as did Paul Eluard when he realized his poems had been included in the program without his permission. Eluard fell into the footlights just as the police arrived to break up this poetical riot.

By 1924, the smoke had cleared. The Surrealists had formed a coherent group, split from the Dada movement, published their first manifesto, and established a Surrealist Research Bureau. Breton rapidly took control of the movement and before long had earned the title of "Pope" of Surrealism; his two lieutenants at the time were Louis Aragon and Paul Eluard. Breton's didactic, high-minded dominance of the group concealed its essentially jocular and playful mood.

Breton was a curious man. Born in 1896, the son of a gendarme in the Orne, he attended local schools and then the Chaptal College in Paris, where the education was scientific and modern. It was while he was at college that he began to be interested in the arts, and he wrote his first poems for the college magazine. The Musée Gustave Moreau was not far from the college, and here Breton became fascinated by the exhibits of primitive art. With the money he had been given for passing his *baccalauréat,* he bought his first primitive sculpture. In 1913 he began to study medicine, but was spending a great deal of his time making constructions (one of which appeared in No. 18 of Apollinaire's review, *Soirées de Paris,* dedicated to Picasso). In 1915 he was called up as an orderly and was sent to a hospital at Nantes. During this brutal interruption of his education, he was reading Mallarmé, Wilde, Rimbaud, James, and Laforgue. He was also conducting a regular correspondence with Paul Valéry, whom he had met in Paris before the war, and with Apollinaire, to whom he sent his poem "December."

One of the patients at the hospital in Nantes was the writer Jacques Vache, who influenced Breton's thinking even though they met only four or five times before Vache died. At the end of 1916, Breton was sent to a mental hospital run by a Dr. Raoul Leroy, a former assistant of Jean-Martin Charcot, one of the precursors of the psychiatric movement. During his leaves, Breton would journey to Paris to meet poets, painters, and writers.

At the end of the war, Breton came to Paris and joined up with the Dadaists, becoming particularly close to the monocled Romanian Tristan Tzara. A man who liked to control, Breton could be very dictato-

rial, a fact that would contribute not only to the establishment of the Surrealist movement, but eventually to its dissolution. For instance, Breton enrolled various poets and artists in the movement by simply putting them on his list without asking them. He once even tried to enroll Matisse; Man Ray "thought it delicious," he told Gertrude Stein, "to hear of Matisse speak of drawing hands that look like hands and not like cigar butts."

But Breton was a man with a mission; he had serious goals in mind for the Surrealists. They must change society, he insisted, not make jokes about it. In about 1925, Breton and others offered themselves to the Communist party as a group. Breton was furious when they were told they must enter as individuals. James Thrall Soby, then curator of the Museum of Modern Art, recalled that "they were assigned to cells, and Breton was given a cell in the cellar and three weeks to think about communism. [But he] couldn't stand anonymity."[43] Breton finally led a smaller group out of the political arena and assumed an even tighter control over them. "About him," observed the critic Georges Ribemont-Dessaignes, "there lurked the odour of the secret society."[44] "He was always pronouncing new causes against everybody and everything," commented Prince Jean-Louis Faucigny-Lucinge, "because he probably did not approve of their way of life in general. He was very tiresome, very intelligent, very brilliant, but he was the kind of man who is always forbidding things."[45]

The first issue of La Révolution Surréaliste appeared in December 1924, marking the establishment of the Surrealists as the dominant group in the Parisian avant-garde, dedicated to the overthrow of authority and to the subconscious. The list of members had been drawn up by Breton, and included Aragon, Benjamin Péret, Crevel, Buñuel, Soupault, the poet René Char, and Robert Desnos.

But by 1929 it had become obvious, even to Breton, that the Surrealists needed a new impetus, a fresh injection of ideas; in other words, a new hero who could point the way forward, out of the factionalizing that had begun to split the group into quarreling minorities. In Salvador Dalí they found the perfect candidate, but they little realized that he would turn the movement upside down and inside out for his own benefit.

* * *

In 1929, Paris was a Modernist free-for-all. It gyrated to jazz, and had become cosmopolitan, being full of young Americans living like princes on the favorable dollar exchange rate; South Americans, Italians, Spaniards, and Germans spent huge fortunes at the couturiers, at the jewelers, and on staying in hotels. Paris was full of writers and painters who had come there because it was the center of all that was avant-garde and because the avant-garde were as near as the next table in a café.

Dalí took the train from Perpignan, alone and independent for the first time. His father had given him some money and paid his fare, and Buñuel had promised him some more money when he arrived in Paris. He was to live in a small hotel in Montmartre, recommended by Buñuel, and work on *Un Chien Andalou*. It was the first time since the Residencia days that he had managed to escape from his family, so his first move on his arrival was hardly surprising. He asked a taxi driver to take him to a brothel.

The taxi driver took him to the Chabanais, a brothel that had been established in the Second Empire and still contained the thick red plush curtains, elaborate mirrors, and deep Turkish carpets of that epoch. But Dalí only looked at the girls through spy holes provided for that purpose. He may have been far away from his father but Don Salvador's influence still held strong; Dalí could not bring himself to touch the women. However, he left "with enough to last me for the rest of my life in the way of accessories to furnish, in less than a minute, no matter what erotic reverie, even the most exacting."[46]

Once established in his small hotel he went to see Joan Miró in his studio on the rue Tourlaque. Miró took him out to dinner with a girl named Marguerite, who proved rather a disappointment to Dalí; he had misunderstood and believed he was going to meet Magritte, a painter whom he admired greatly. According to Dalí, the meal was silent, but when Miró got up to leave, having paid the bill, he gave Dalí a piece of advice: "You must get yourself a dinner jacket, we will have to go out in society."[47]

Dalí immediately bought a dinner jacket, and a few days later, Miró took him to dinner at the Duchesse de Dato's. The Duchesse was the widow of a conservative minister recently assassinated in the rue de Madrid. Dalí observed that Miró, "imprisoned in a swelling shirt, stiff as armor, continued not to talk."[48] After dinner, they went on to the

Bateau-Ivre, where Miró told his young friend that he should not talk too much.

The next night, the ever-kind Miró took Dalí to dinner with his dealer, Pierre Loeb, whom Dalí had already met in Cadaqués. Dalí met Pavel Tchelitchev, the Russian artist, that night. Tchelitchev left with Dalí, and when he told him he would have to get out at the Métro station before Dalí's own stop, Dalí burst into tears. From then on Dalí took taxis and, with complete disregard for money, ordered them to wait for him.

Reading between the lines in his autobiography, it is perfectly apparent that Dalí was miserable during his visit to Paris. Far from welcoming him, Paris ignored him, and without the carapace of his family, he began to fall apart. As he had done when he was under pressure as a child, he became ill. But now he had no mother to tell him he would get better soon. He spent a week alone in his hotel bedroom, "utterly dejected, accustomed as I was to being always cared for with the most exaggerated ritual."[49]

Frightened by women, yet attracted, he wandered the streets in search of girls he could pick up, but they ignored him, so he masturbated alone in his hotel room. He often went to the Jardins de Luxembourg, sat down on a bench, and wept. Invitations were few for this little Spaniard who looked like a provincial gigolo with his "Menjou" mustache and his natty clothing. But one evening Camille Goëmans, a Belgian art dealer who had seen Dalí's work and had halfheartedly promised him a contract, took him to the Bal Tabarin, where he pointed out a man coming into the club in the company of a woman dressed in black spangles. The man was Paul Eluard; the woman was not Eluard's wife, Gala, then in Switzerland for her health, but Alix Apfel, a mistress of Eluard's known to Surrealist Paris as "La Pomme."

Goëmans introduced Dalí to Eluard and they spent the rest of the evening in conversation. Perhaps Dalí talked longingly of his beloved Cadaqués and its "mineral" quality; he must certainly have painted a persuasive picture, for by the end of the evening Eluard had promised to visit him in Cadaqués that summer.

And what of Buñuel? While Dalí and Miró spent silent evenings together, Buñuel was preparing to make *Un Chien Andalou*. He had borrowed $2,500 from his mother, half of which he had spent in his "usual nightclubs." The other half paid for the hire of the Billancourt

Studios, and the two professional actors, Pierre Batcheff and Simone Mareuil, and for the wages of Albert Dubergen, the cameraman.

To Dalí, involvement in the film took precedence over the social career Miró was planning for his young protégé. "I prefer to begin with rotten donkeys," Dalí told Miró. "This is the most urgent, the other things will come by themselves."[50] He was not mistaken.

The shooting of the film took fifteen days in April, using a crew of six, and it is still a matter of debate as to how much Dalí actually contributed. The atmosphere on the film was tense and emotional; Pierre Batcheff was a drug addict who smelled constantly of ether and who committed suicide on the last day of shooting. Dalí was heading for a nervous breakdown, and Buñuel himself was so affected by the scene where the girl's eye appears to be slashed by a razor that he was ill for days afterward.

Dalí appears in the film as one of the Marist brothers, together with his schoolfriend Jaume Miravitlles, who happened to be in Paris at the time and was roped in to play the second Marist brother being dragged across the floor. Dalí was also involved in the shooting of the scene of rotten donkeys and grand pianos; he "made up" the putrefaction of the donkeys (they were stuffed) with great pots of sticky glue that he poured all over them. He removed the donkeys' glass eyes and enlarged the sockets by hacking them out with scissors, and cut their mouths open to make their teeth show to better advantage.

From the first shot of the knife slicing the girl's eye, the film induces in the spectator a sense of shock that never lessens. This one image at the very beginning of his career gave Buñuel immediate notoriety. But the film is more than one horrifying image; right up to the last shot of the hero and heroine buried up to their necks in sand, dressed in rags and blinded, being eaten alive by the sun and by swarms of ants, *Un Chien Andalou* disturbs.

Many years later, Buñuel explained his intention thus:

> *Historically, the film represents a violent reaction against what in those days was called "avant-garde," which was aimed exclusively at artistic sensibility and the audience's reason. . . . In* Un Chien Andalou *the film maker for the first time takes up a position on a poetic-moral plane. . . . His object is to provoke instinctive reactions of revulsion and attraction in the spectator. Nothing in the film symbolizes anything.*[51]

It is apparent, however, that the games that were played at the Residencia—the dressing-up as priests in Toledo, the word games, the *putrefactos* and *anaglifos*—are central to the language of the film and to its meaning, and that *Un Chien Andalou* is the logical artistic conclusion to which these conceits could be employed. Also, in addition to being the title of a book of Buñuel's poems, "Andalusian dog" had been the term of opprobrium employed by Buñuel, Dalí, and Pepín Bello in describing philistines, those addicted to folklore and sentimentality. Indeed, Lorca, when he heard what the film was called, suspected that it was an attack on him personally.

Dalí himself believed the film ruined ten years of pseudo-intellectual postwar avant-gardism in a single evening. For his part, André Breton, always on the qui vive for people or events he could take over, acknowledged *Un Chien Andalou* as the first Surrealist film the minute he saw it. The film was not shown in public until October 1929. But it is reasonable to suppose that Breton might have attended a private premiere at the Théâtre des Ursulines in June, which was also attended by, among others, Picasso, Le Corbusier, and the Vicomte and Vicomtesse de Noailles.

At the premiere, Buñuel was so apprehensive about the possibility of a violent reaction that he arrived with stones in his pocket, with which he fiddled while addressing the audience. He then stood nervously behind the scenes playing Argentinian tangos on a gramophone. He need not have worried: The audience loved it.

None was more excited than the Vicomtesse de Noailles, who had a salon in the place des Etats-Unis. Marie-Laure de Noailles was an exceptionally cultivated woman; a direct descendant of both Petrarch and the Marquis de Sade, she kept the manuscript copy of *Les 120 Journées de Sodome* in a leather case shaped like a phallus.

The Noailles lost no time in seeing the film again. Jean Hugo (the husband of the Surrealist painter Valentine Hugo, who was then Breton's girlfriend) recorded that after a dinner in their Paris house on July 10, 1929, at which the guests included Cocteau, Madame de Chevigné, the composer Francis Poulenc, the Hugos, and Comte Etienne de Beaumont,[52] *Un Chien Andalou* was shown to applause.

But fame was not yet to come to Dalí. He stayed in Paris until the end of May, trying to bring Goëmans to the point of signing a contract. He did, however, sell a picture to Robert Desnos, whom he had met in

La Coupole one night, and who asked him back to his apartment. Dalí had formed the habit of walking around Paris with a painting under his arm as a sample. Desnos bought *The First Day of Spring* because it struck him as being like nothing being done in Paris.

A month before the private premiere of the film, Dalí gave up and packed to go home. "The few times I had gone out into society had remained isolated episodes, completely useless. My timidity had prevented me from 'shining' in these circles, so that each occasion had left me with a disagreeable feeling of dissatisfaction."[53] He would take his revenge on Paris society and its rejection of him in due course. Meanwhile, he took the train from the Gare d'Orsay back to Spain. But he had not abandoned his ambition to conquer Paris; Camille Goëmans had finally offered him a one-man show in November and *Un Chien Andalou* had a date booked for a public showing in October. So Dalí planned to spend the summer in Cadaqués, painting new works for what he hoped would be his second and final return to Paris.

Dalí must have realized that he had to make a decisive emotional and financial break with his father. Childhood must be left behind and real life embarked upon in earnest. But he could not do it on his own, and he could not not rely on old friends such as Buñuel to look after him. Resuming his relationship with Lorca was out of the question. Whom could he depend on to organize the practicalities of his life? His sister now belonged to that intricate past from which he was trying to escape, and besides, his father would never let her go to Paris chaperoned by her brother. Nor would he finance such an arrangement.

This problem seemed insoluble. As a result, Dalí began to exhibit signs of a severe breakdown during that last summer with his family in Cadaqués.

►
►
►
►
►

PART TWO

YOUTH'S ANATOMY, DIVINE AND CLEAR 1929–1939

When youth's anatomy, divine and clear
leans toward the water's listening ear
and darkly in the glass of the lake, sees
his body lucent among sombre trees . . .

When his white torso folded to the fore
stiffens and fixes in the trickling core,
bent in the silver curve of his decline
hypnotically warped as frozen wine . . .

"The Metamorphosis of Narcissus," Salvador Dalí

4

ACCOMMODATIONS OF DESIRES
1929–1930

Dalí painted, as he had always done, in solitude. He started as soon as the light came up and worked until lunchtime, afterward going out on the boat to his beloved Cap de Creus. These were habits that had become second nature. But now, at the end of the day, when he walked around the village as he had always done, he showed outward signs of his deep inner conflict and uncertainty. He became prone to fits of hysterical laughter when he caught sight of friends he had known as a child.

Later he maintained that these fits were self-induced by imagining the inhabitants of Cadaqués with tiny owls on their heads, but it is more likely that they were involuntary, bred of his impotent desire to break out, to be free. The hysterical tension this induced, as he confronted his father's protective tyranny day after day, made him almost mad. Years afterward, he wrote that from the moment of his arrival in Cadaqués that summer he was "assailed by his childhood," a childhood he wished to escape but could not. The years in Madrid, the time with Lorca, the assault on the Catalan intelligentsia, the months in Paris, receded into the background.

His father was dismissive of Dalí's behavior, particularly since Don Salvador had just negotiated a contract with Camille Goëmans on behalf of his son under the terms of which Dalí was to receive the sum of 3,000 francs for all the paintings he could finish during the summer. They would be shown in Paris in November. Goëmans would

have a percentage on the sale of each painting and would keep, besides, three canvases of his choosing.

Dalí's father was perhaps tentatively looking forward to a future in which he would assume a new role in the cafés of the *rambla,* that of the father of a famous painter. The manic laughter was dismissed, Dalí recalled later: " 'What's going on? That child laughing again!' my father would say, amused and preoccupied as he watered a skeletal rosebush."[1]

These manic attacks led Dalí deeper into a maze of his own choosing from which he drew the essence of his oneiric painting. In *Le Jeu Lugubre,* executed that summer, the grasshopper, the lion, the pebbles, the lips shaped like a vulva, the snail, the weights and measures, all are part of his iconography and are assembled by him in a receding landscape; but in the foreground there is a scatological element, a new and disturbing departure—the figure of a man with soiled pants standing on a huge staircase. Dalí worked over this tiny piece of canvas again and again, neurotically painting and repainting the feces. The statue of the man at the rear of the painting has one huge hand held out, with the other covering his face; the emphasis on these hands is a clear reference to masturbation, an activity Dalí pursued with relentless energy when he was not painting.

Dalí painted this picture and the others he did that summer by waiting for subconscious images to surface, and then immediately putting them on the canvas. Sometimes he said, he would wait for hours before a new image would suggest itself to him from the deepest recesses of his childhood memories. His understanding of Freud's *The Interpretation of Dreams* coupled with his morbid mental state centering on his almost frenzied autoeroticism, and the remembrance of childhood totems and terrors, combined to create an iconography analogous to psychoanalysis. In this way he was fulfilling the Surrealist ideal of automatism. But Dalí took this one stage further, into waking dreams, which he could transmit to canvas, but at enormous risk to his sanity.

What Dalí was going through was so far outside the experience of his family, so removed from their lives, that they could not understand him. Instead they feared him, in the way primitive societies fear those who speak in tongues. Dalí spoke with his painting, and the messages were becoming clear even to those who did not wish to see. His

condition, his family felt, was not of their making. His transmogrifica-
tion from a charming, dandified young painter into a haunted creature
demanded that a scapegoat be found outside the family. Duly, a scape-
goat—or a savior—appeared: Gala Eluard.

Gala will always, by her own choice, and with Dalí's connivance, be a
mystery. She gave Dalí permission to tell her story in his autobiogra-
phy but in the end he decided to keep her secrets, which were, in the
profoundest sense, his too. He was given later to saying that she was
the secret within his secret, and this is as accurate a description of
their morbid dependence on each other as is possible to achieve. She
herself became, as the years went by, sibylline, enigmatic, a fearful
witchlike creature who moved silently around the loquacious Dalí in a
penumbra of menace and secrecy. When she talked about herself, or
her past, her stories changed. She appeared to be in a constant state of
reinvention.

Gala was born in Kazan, on the Volga, sometime in the early 1890s
(she was about ten years older than Dalí), and her legal name was
Helena Deluvina Diakonoff. She was the second of four children; there
were a younger sister, Lida, and two brothers, Nikola and Vadim.

According to her biographer, Tim McGirk, Gala's legal father had
disappeared while prospecting for gold in Siberia, and since her
mother could not remarry under the law of the Russian Orthodox
church, she lived with a wealthy lawyer in Kazan. Of the four children,
only Gala got on with her stepfather. It is known that he was Jewish
and probably a convert to the Russian Orthodox church. Robert
Descharnes, who knew Gala well, established in conversations with
Gala's sister, Frau Lida Jaroljmex, that the first husband died before
Gala's mother had had any children, and that the second husband was
in fact the father of her children; but this, as with so much about Gala,
cannot be confirmed.

What is known is that Gala much disliked the name Diakonoff
because it was a very common Jewish name in Moscow; she was often
given to implying that she was really a Russian aristocrat. She told
many fantastic stories over the years about her antecedents. At one
point, for instance, she told Edward James that her real father was a
Kirgizi Gypsy from Siberia who lived with her brothers and their

horses in a big tent east of the Ural Mountains. His profession was to prospect for gold from surface deposits in rivers, and "she and her seven brothers would go for months without finding any gold, but then they would make a strike; for instance they might come upon a big nugget of raw gold in the deep snow."[2] On such occasions, she told James, the horses, too, would drink *"champanski"* with them.

The true story was more mundane. Brought up in provincial Kazan, Gala could not, being a girl, go to college. However, she did take a university course in literature while attending a finishing school in St. Petersburg, so she must have been academically clever. Early photographs show a strong, determined face with particularly luminous deep-set dark eyes, high cheekbones, a delicate nose, and a small, secretive mouth. These photographs also show determination and a hint of defiance in the eyes.

Gala's later attitude toward her stepfather was ambivalent. She said once that she had been sexually abused by him; on another occasion she told a friend that one of her brothers had abused her; but neither story can be denied or confirmed, for Gala was an accomplished mythomaniac. However, some sort of incident such as this might explain her later excessive sexual behavior.

Gala was a sickly child. There are also strong hints that she may have suffered from an unspecified mental illness when she was in her teens. In 1912, when she was about seventeen, tuberculosis was diagnosed and she was sent alone to Switzerland to take a cure. Here, in the sanatorium at Clavadel, she met a French boy, a year younger than herself, called Paul-Eugène Grindel, who had changed his name to Eluard, his mother's maiden name. He wanted to be a poet, and he was in rebellion against his father, a wealthy builder in Paris, who had every intention that his literary son would join him in the family business.

The two adolescents lived in an extraordinary atmosphere in the sanatorium. Both were separated by disease from the influence of their relatives, from their friends, and from the ordinary life of family and school. At their most impressionable age, they were living in a huge clinic full of dying people. The sanatorium was hung with chandeliers; it had plant-filled sunrooms, luxurious dining rooms, even a ballroom. The pretense was that it was a grand hotel rather than a hospital. The

inhabitants, when they were well enough, flirted, played cards, smoked, gossiped, and had love affairs, much as they might have done had they been taking a long sea voyage instead of sliding toward death. Outside was the pure beauty and the sparkling air of the Alps.

It is hardly surprising that Eluard and Gala fell in love. He was handsome and something of a dandified aesthete, dressed in smart clothes from Paris. They read the poetry of Walt Whitman together, and Eluard wrote his own poetry while Gala played the first act in her role as literary and artistic muse. The two adolescents ate together, took long walks when they felt well, and went as Pierrot and Pierrette to a fancy-dress ball for the patients. They also watched their fellow inmates die slowly but inexorably. There can never have been a more perfect hothouse in which adolescent passion could flourish—and flourish unchecked, for there appeared to be no supervision of their days, other than the necessary medical rituals. They were left to their own devices.

It is tempting to conclude that never again would Gala experience such pure and exalted emotion; in her later years, when she became unhappy or sad, or just bored, she would often return to Switzerland in a pathetic attempt to recapture with young ski instructors the pure erotic passion of those early days of love.

By 1914, when she was nineteen, Gala's health had improved so much that she was sent home to her family in Russia—a journey fraught with difficulty, since World War I was just about to break out. Before they parted, she and Eluard became unofficially engaged, and Eluard promised her (even then conscious of money) that he would work for his father's building firm until he could earn enough to keep them by writing.

When Gala arrived home, she found that her brother Vadim had been called up from the university and sent to an officers' training school. Meanwhile, Eluard had returned to Paris and had been drafted into the French army, but because of his poor health had become a medical orderly on the Somme. Back in Kazan, Gala rejected the suitors her mother kept producing for her and spent her time planning how she might be able to travel to France and Eluard. She pined for him and at one point even went on a hunger strike. They wrote to each other constantly, but even though France and Russia were allies

and kept open a circuitous postal route, these letters took weeks to arrive if they arrived at all.

Finally, when she was twenty-one, in the summer of 1916, Gala's determination overcame the minor obstacle of a world war, and her parents gave in, allowing her to travel to Paris on her own to marry Eluard. History does not relate how she got there, but she probably traveled from a Russian port on the Baltic Sea.

Was Eluard's attraction for Gala romantic? Or was what he offered her an escape from a dull routine in the Russian provinces? Whatever the reason, she exhibited a steely determination to get her own way, as she did throughout her life.

She had neither friends nor connections in Paris, and so her future mother-in-law, the supremely bourgeois Madame Grindel, had, grudgingly, to take her in and house her in the family flat in the rue Ordener, near the Sacré Coeur. One can imagine her feelings: a husband and a son away at the war, and a stony-faced Russian girl who spoke broken French on her doorstep. Gala had hardly any money, and she had brought only her smartest clothes. Presumably, she had counted on being given money by Eluard when she reached Paris.

Hoping to earn her living as a translator, she soon realized that her poor French disqualified her. Another of her plans—to become a fashion designer—was quashed by Madame Grindel, who was a good seamstress herself and who pointed out that Gala was completely inexperienced. Relations between the two women, initially lukewarm, soon worsened. Small domestic pinpricks included the older woman's habit of marking the pots of jam in case Gala was stealing food.

During Gala's first month in Paris, Eluard returned on leave and the two became lovers. Eluard was a virgin, and was astonished and rather taken aback at his fiancée's sexual exuberance and inventiveness. Back at the front, in the midst of the appalling tally of wounded, he began to brood about Gala's willingness to engage in, even initiate, certain sexual practices. He suspected that she had been introduced to sex by another man. Finally, he wrote to ask her whether she had been a virgin. Her reply, that never after their meeting had she been with someone the way she was with Eluard, cannot have been reassuring. In another, later letter, she told Eluard, "Despise me and insult me, but not my love. . . . If I do everything with you—even 'strange things' —I'm certain that because I love you all is pure, beautiful and right."[3]

Madame Grindel, although well-off, was self-made, as was her husband, and she took pride in her housekeeping. Gala told Eluard: "I'll never have the appearance of a housewife, I'll be a proper coquette (bright, perfumed and with manicured hands). I'll read a lot, a lot. I'll work in design or translation. I'll do everything but have the air of a woman who doesn't exert herself."[4]

In December 1916, even though he was still adamantly opposed to the war and had written several antiwar poems, Eluard requested a transfer to the infantry to fight. He feared being thought guilty of cowardice and wanted to lead a life that was "harder and less servile." Gala was horrified and tried to dissuade him, but failed. In February 1917 he obtained four days' leave, and Gala married him in a white wedding dress chosen by her mother-in-law. In their letters to each other, Eluard and Gala had never discussed the possibility of children; their plans seemed to stop short at Eluard making a success as a poet, and Gala being his muse and his glamorous wife. But by August 1917 she was pregnant. The pregnancy was probably an accident, and was the first and only time Gala felt out of control of her destiny, which might explain her callousness toward her only child, her daughter, Cécile.

It must have been a very difficult time for Gala; in common with many of the French middle class, her parents-in-law had lost a great deal of money investing in Russian bonds; without justification, they blamed her. News from Russia, now in the throes of revolution, was appalling; Gala's family had been reduced to living in one room of the family flat in Kazan, and her brother Vadim had come home from the front only to die of hunger and exhaustion in a corner of what had once been their drawing room.

When Eluard was demobilized in 1919, the young couple moved out of the family apartment into one of their own, in the suburban rue Saint-Brice, paid for by Eluard's father, who also provided his son with a job building a suburban housing development. Eluard worked all day and wrote his poetry at night. He soon came into contact with the Dadaists by submitting poems that were accepted for *Littérature,* whereupon Breton took him up and enrolled him in the movement. Eluard had a very good eye for painting and acted as *Littérature's*

unofficial arts editor. Thanks to his father, he was earning enough money to buy works by Picasso and Miró. In 1920, he first saw the work of Max Ernst in a gallery called Au Sans Pareil, and was so taken by what Breton once described as "Ernst's haunted brain" that he made a special visit to the German painter's studio in Cologne to try and persuade him to move to Paris. He took with him Gala, who immediately set about conquering Ernst.

Lou Straus-Ernst, Ernst's wife at the time, described Gala as "that Russian female . . . that slithering, glittering creature with dark, falling hair, vaguely oriental and luminant black eyes, and small delicate bones, who reminded me of a panther. This almost silent, avaricious woman, having failed to entice her husband into an affair with me in order to get Max, finally decided to keep both men, with Eluard's loving consent."[5]

The Eluards made many visits to the Ernsts between 1920 and 1922, and the affair between Gala and Ernst continued with Eluard's complicity and active participation. Eluard liked group sex, preferring a triangle that included another man, and so did Gala. This was not to be the last time he and Gala "hunted" as a pair in pursuit of a painter they both admired. Gala's clairvoyant's eyes and surly sexuality attracted more than one Surrealist to their ménage.

In the summer of 1922, the Ernsts and the Eluards spent a holiday with other Dadaists in the Tyrol, and soon Ernst was openly joining Gala and Eluard in their room, down the corridor from the one he was meant to share with his wife, or romping with Gala unashamedly in the lake, watched over by a benevolent Eluard. This was rather too much, even for the Dadaists. Tristan Tzara thought the fault was entirely Gala's, and he told another guest, "Of course we don't give a damn about what they do, or who sleeps with whom. But why must that Gala make it such a Dostoevsky drama? It's boring, insufferable and unheard of!" Later Tzara told Pierre Argillet, the art dealer, that he believed Eluard liked group sex and was keen for his friends to make love to Gala while he watched or joined in.[6]

In 1922, Max Ernst decided to move to Paris but was denied an entry visa, so Eluard smuggled him in on his own passport. Ernst was immediately employed by the editors of *Littérature* to draw covers, but as an illegal immigrant he could not support himself. So Eluard invited him to live with Gala, Cécile, and himself in a remote villa that he had

bought at Eaubonne, on the edge of the forest of Montmorency. Ernst came to lodge with them there in a cozy ménage à trois and painted all the walls with frescoes. The inside of the house was, according to Cécile,

fantastic and strange. All the rooms were filled with Surrealist paintings, even my room, my parents' bedroom, the salon, everywhere. Some of these paintings made me feel frightened. In the dining room, for example, there was a naked woman with her entrails showing in very vivid colours. I was eight at the time, and those images made me very, very afraid.[7]

During the week, Eluard worked in his father's office, but on weekends held open house for the Surrealists. Gala would drift among them, dressed in long silk robes, fixing men with her piercing gaze and telling their fortune with tarot cards, while André Breton, dressed entirely in green, smoked his green pipe.

Gala's self-confessed clairvoyance and her liberal attitude toward sex ensured that she was one of the few women taken seriously by the Surrealists, and the Gala-Eluard-Ernst threesome was not above going on fishing expeditions for talent that could be incorporated into the Surrealist group. Sometime in 1923, they went to Rome to meet Giorgio de Chirico, who soon gathered that Gala was available and did not refuse her, though later he explained to Pierre Argillet that he was not keen on the idea of four people in bed. After a while, the Surrealist trio began to annoy de Chirico, and he eventually threw them out. He had contemplated keeping Gala, but when he found out she could not or would not do any housework, he threw her out too. While this sexual adventuring was going on, poor Cécile was forgotten, banished to the care of her grandmother, Madame Grindel. This would be Cécile's lot for the rest of her life. Her father was distant, if loving. Her mother ignored her.

By 1924 the curious triangle with Ernst was beginning to have an effect on Eluard. On March 24 he sent a telegram to his father telling him he was leaving Gala, and that the best thing would be to pretend he had had a hemorrhage and was in a Swiss sanatorium. Withdrawing 17,000 francs from his father's business account, Eluard set off on a journey around the world. Gala found out about her husband's disappearance when his father arrived clutching the telegram. Far from

being contrite, Gala went with Ernst to Germany. Eventually Eluard begged her to join him. Monsieur Grindel, frightened that he would lose his son forever, paid for Gala and Ernst to travel to Saigon, where the three met up.

This was virtually the end of the affair. Throughout his life, Ernst fell violently in love with women, only to get bored and drift off, and he may by this stage have been relieved to get rid of the sibylline intensity of Gala. When he eventually returned to France, he found that he was no longer welcome in the Eluard home. But Gala took Ernst's defection badly, and it is clear that she did not make a clean break with him, even though he had found a new lover. They wrote to each other and saw each other from time to time.

Back in her suburban house, without her lover, Gala began to assume the mantle of Surrealist groupie. André Thirion remembers her in 1927 as elegantly dressed and haughty at Surrealist gatherings organized by Breton.

> Gala knew what she wanted, the pleasures of the heart and the senses, money and the companionship of genius. She wasn't interested in politics or philosophy. She judged people by their efficiency in the real world and eliminated those who were mediocre, yet she could inspire the passions and exalt the creative forces of men as diverse as Ernst, Eluard and Dalí.[8]

She was something of an outcast—neither an artist nor a housewife. Her few friends, chief among whom was René Crevel, the homosexual poet, were outcasts too.

By 1929, her affair with Ernst having finally come to an end with his marriage to his second wife, Gala must have felt she desperately needed another artist. A new genius must be found, and one capable of earning enough money to keep her in the luxury she craved. For Gala was, above all, greedy. She knew that Eluard, though a wonderful poet, would never earn the amounts she felt were her due. And she was incapable of creating anything herself. Someone else would have to do it for her.

* * *

The trip that Eluard, Gala, and Cécile made to Cadaqués in July 1929 was tiring, and they arrived at the only hotel, the Miramar, dusty, hot, and exhausted. Gala was in a vile temper at the prospect of this "cheap" holiday suggested by her husband. She would probably have rather been in the Alps at Arosa, rekindling the erotic passions of her adolescence, than in a Catalan fishing village.

They set out to look for Dalí, whom they discovered on the beach opposite Es Llaner with René and Georgette Magritte, and Camille Goëmans, who had brought with him a girlfriend called Yvonne. There, too, was Ana Maria, obviously uncomfortable with this new group of her brother's friends. When she set eyes on Gala, she was immediately apprehensive.

"It was in that very summer," Ana Maria wrote forty years later, "that Salvador was affected by the change that alienated him from his friends, from us, and even from himself. The stream of his life, so well channeled, was deflected under the influence of those complex beings who could understand nothing of the classic landscape of Cadaqués."

She continued:

Those strange characters failed to notice the bounty of tenderness. . . . Their longing to destroy the basis of morality and decency in human beings was so fanatic that their spleen knew no bounds whenever for an instant they caught a glance of a decent and pure world opposed to their own.

It seemed impossible that my brother should be taken captive by them, but so it was. And with the passion that always characterized his impulses and ideas, he stuck to it, as if the solutions to all his worries were to be found there. But not only was this not to be, but in addition he lost his peace of mind and the well-being that hitherto his works had reflected. The pictures he then painted were horribly hallucinatory. He designed real nightmares on his canvases, and the disturbing figures were like torture, seemingly trying to explain the inexplicable—things that, as in dreams, seem to have some meaning when seen but then leave only the memory of hallucination. . . .

My brother always had a forceful character and found those friends of his very intelligent. Perhaps they were, but one less passionate than he could have seen how perverse and destructive their intelligence was; and even when they took my brother with them to Paris they could do nothing about our Cadaqués, which was unchanged in its quiet serenity, full of

beauty in the rhythm produced by sun and moon slipping smoothly from darkness into light. But the time was approaching for a further tragedy.[9]

Ana Maria must have felt threatened and excluded by the group's anarchic conversation, even by the gossip about people whom she had never met—and probably never would meet. The subterranean tensions (of which she had been unaware during the Lorca summers) now surfaced.

Dalí and Eluard got on very well. Dalí started to paint a masterly portrait of the poet. Then, at the beginning of September, Eluard left for Paris with the Magrittes. He was to move into a new and luxurious flat that he had bought in the rue Becquerel in Montmartre in order to tempt Gala to spend more time with him. Gala, Cécile, Camille Goëmans, and Yvonne stayed behind.

Buñuel arrived. He was bent on collaborating with Dalí on the scenario for his new film, *L'Age d'or;* his presence added to an already tense situation. Things were very different from the previous summer, when Dalí and Buñuel had worked amicably together. Lorca's influence over Dalí had ceased and thus posed no threat to Buñuel, but now Buñuel found that Dalí seemed to be turning his attention toward Gala, and this Buñuel did not like at all. "All he could talk about was Gala: he echoed every word she uttered," he wrote in *My Last Sigh.* Gala for her part criticized everything Buñuel said after his unfortunate remark that what repelled him more than anything else in the female anatomy was when a woman had a large space between her thighs; he admitted embarrassment when, swimming the next day, he realized that Gala had just that attribute.

Once again, Buñuel was fighting to be the most influential friend in Dalí's life. Matters came to a head one day when the group was on a picnic. Buñuel said that the view reminded him of a painting by a second-rate Spanish painter.

"How can you bear to say such stupid things!" Gala shouted at me. "And in the presence of such gorgeous rocks!"

By the time the picnic was over, we had all had a great deal to drink. I've forgotten what the argument was about, but Gala was attacking me with her usual ferocity when I suddenly leapt to my feet, threw her to the ground and began choking her. Little Cécile was terrified and ran to hide

in the rocks. . . . Dalí fell to his knees and begged me to stop. I was in a blind rage, but I knew I wasn't going to kill her. Strange as it may seem, all I wanted was to see the tip of her tongue between her teeth. Finally, I let go.[10]

Buñuel left Cadaqués immediately after this incident without having secured Dalí's cooperation for his screenplay.

Dalí's own account of how he fell irrevocably in thrall, if not in love, has assumed the status of a legend, encouraged by his highly colored account (written fifteen years later) of what must have been a very curious summer.

To begin with, he was in a hysterical state before Gala arrived in Cadaqués; this had been induced by his subconscious realization that he would have to break away permanently from the dominating influence of his father and the smothering love of his sister if he was ever to become a three-dimensional personality, living in the tough, real world he had caught a glimpse of in Paris. But could he survive on his own?

The answer was: Probably not. What he needed was another benevolent bully who, like his father, would take care of practical matters, leaving him to paint and to become what he most desired—famous. Although he had a homosexual bent, he could not bear to be touched, nor could he entertain the idea of any sort of sexual intercourse. Lorca had become too possessive, and Dalí had shied away from a love that demanded physical payment.

The "Surrealist muse" was not much impressed by Dalí. She thought he had a "professional Argentine tango slickness."[11] This first impression was hardly surprising: When Dalí was in his studio painting, he was virtually naked because of the heat, but when he went out in the evening, he slipped back into the dandyism of his Madrid student days, pomading his hair, wearing white trousers, heavy silk shirts with low necks and very full sleeves, and finishing off his outfit with a necklace of imitation pearls and a lamé ribbon tied to one of his wrists. Dalí admits in his autobiography that this gave him a very feminine appearance; it would hardly have endeared him to Gala, whose taste lay more toward postadolescent men.

In order to make his presence felt, Dalí had begun to exhibit eccentricities in his dress, trying to achieve an effect somewhere between a romantic, poverty-stricken painter and what he imagined was the exoticism of an Arab. He slit his silk shirt here and there, and, dissatisfied with his swimming trunks, turned them inside out. Further refinements were called for; he shaved his armpits, but finding they lacked the requisite "bluish" tone he felt they demanded he shaved them closer, until they bled.

Next, he became preoccupied with finding exactly the right sort of scent, finally determining on a mixture of fish glue and cow dung, which he boiled up into a paste. Having anointed himself with this nauseous mixture, he stuck a bright orange geranium behind his ear. And then, seeing Gala sitting on the beach in front of the house, he lost his nerve and cleaned himself up, finding the whole effect lamentable. However, he kept on his pearl necklace and the geranium behind his ear.

Gala was less than entranced by the continued fits of manic laughter. But, as Dalí realized, imperceptibly she had begun to take him seriously. She considered him a genius, "half-mad but capable of great moral courage. And she wanted something—something which would be the fulfilment of her own myth. And this thing that she wanted was something that she was beginning to think perhaps only I could give her!"[12]

Dalí's friends became increasingly worried about the coprophiliac content of *Le Jeu Lugubre* and were uneasy about what this reflected of Dalí's own obsessions. One day Gala was deputized to take him aside. A time was arranged for the two of them to go for an early-evening walk among the rocks, where they would be able to talk without the hovering presence of the Surrealists or Dalí's very possessive sister and father.

It took Gala a little time to come to the point, but eventually she told Dalí that if he intended to use his pictures as a means of proselytism and propaganda, even in the service of what he might consider an inspired idea, "We believe you run the risk of weakening your work considerably, and reducing it to a mere psychopathological document."[13] Gala had put her finger on Dalí's fundamental problem with his art in that troubled year. It was developing into a brilliant pictorial record of a troubled personality. To take his work any further down

the road of recording madness would, she felt (probably rightly), ruin his future as a painter before it had begun.

She had found a cause worthy of her. To cure Dalí, to make him whole, to unleash the full force of his genius, which was threatened by permanent incarceration in a madhouse of his own making, would justify her own life. And indeed so it proved, but the task of curing Dalí and then extricating him from his family so that he would shine under her influence was not to be an easy one.

Dalí's laughing fits became more and more spastic and painful as the nature of the choice confronting him became more obvious. He began to hate Gala, just as he had hated Lorca. She had "come to destroy and annihilate my solitude and I began to overwhelm her with absolutely unjust reproaches: she prevented me from working, she insinuated herself surreptitiously into my brain, she 'depersonalized' me."[14] He was convinced she was going to do him harm, but he also knew he was approaching the greatest trial of his life, that of love both given and returned.

He would leave Gala after one of their solitary walks saying to himself, " 'It's awful!' Gala was beginning to make repeated references to 'something' which would have to happen 'inevitably' between us, something 'very important,' decisive in our 'relationship.' " But Dalí, confronting for the first time head-on the problem of his sexuality, was "fighting this central problem of my life, this bull of my desire who, I knew, would at a given moment be there immobile and menacing a few centimeters from my own immobility, confronting me with the sole and only choice: either to kill him or be killed by him."[15]

Gala was no Lorca. She was tough, more determined even than his father to possess Dalí. But why Dalí? Michael Stout, Dalí's lawyer for many years, believes that, initially, it was simply because Dalí came from a rich family and Gala was passionate about money. After all, she was now in her mid-thirties, and the life of a Surrealist muse was bound to offer less and less as the years went by. The painter might offer her a comfortably luxurious life.

And what of Eluard? Back in Paris, unsuspecting, he wrote to Gala in early September to tell her he was busy ordering some "lovely furniture. . . . We'll have a very good bed . . . a splendid American

hospital mattress."[16] Letter followed letter. Eluard sent Gala 1,000 pe-
setas so that she could stay in Cadaqués until the end of the month.
He also bought a "very beautiful" Dalí canvas from the dealer Charles
Ratton. In one letter he tells her he misses her, he loves only her, and
in a postscript asks her to bring back some Dalí paintings to Paris,
including his portrait and *Le Jeu Lugubre*.

Meanwhile, leaving Cécile alone in the hotel, Dalí and Gala contin-
ued their courtship. Dalí admitted in his autobiography that they must
have been a curious sight, both behaving in a highly irrational manner.
Gala was often sick with nerves, playing this game as she was for very
high stakes. Dalí often threw himself on the ground to kiss her feet.
They managed, in the middle of a very inquisitive village, to meet
alone at Eugeni d'Ors's house, where Gala asked Dalí to "kiss me till I
burst."

He began *The Accommodations of Desires*. In this painting, the lions'
heads represent desire and the frightening effect it had on Dalí. But the
painting contains many other indications of the state of his subcon-
scious at this crucial time in his life. In the far background is a square
building that could be the Molí de la Torre, toward which a child
walks. Nearer, another small figure holds his hand up toward the
tower: this is obviously Dalí's father—it is, in fact, a very good like-
ness. Far in the background is the sea. In the foreground are a series of
egg shapes out of which come a human head, a lion's head, and a
lion's muzzle. Ants cluster on another egg shape, and on yet another
are snails and a vulvalike opening surrounded by hair. In the middle
ground of the picture, a man with a beard clasps to him a young boy
who is hiding his face. Hands, coming out of the ground, point to
them in a beseeching manner.

The picture is tiny. Dalí's chaotic state of mind when painting it is
apparent. Later pictures painted by Dalí employing the paranoiac-
critical method would be more overtly psychological; this one has the
hallmark of real oneiric painting.

Dalí's courtship of Gala—or, rather, Gala's courtship of Dalí—con-
tinued among the rocks and olives and vines of Cadaqués throughout
the month of September. Its high spot was the moment when Dalí
finally got up enough courage to ask her what she wanted of him. She
replied: "Kill me." And, according to Dalí, who had thought of killing
her by pushing her off the cathedral bell tower in Toledo, this "secret"

desire they shared cured him of his madness. But he was apparently still a virgin; there is no hint that they consummated their unlikely union, if they ever did, until later. What promises they made to each other will never be known either. Perhaps Dalí was too dazed and Gala too bemused to make plans. The mineral magic of Cadaqués enfolded and enchanted them. It was enough.

At the end of September 1929, Gala, who had not managed to bring Dalí to the point of leaving with her, ran out of money and returned to Paris with Cécile, with the prospect of moving into the expensive new flat in the rue Becquerel prepared for her lovingly by Eluard. She was seen off at Figueres station by Dalí. With her she took the completed *Le Jeu Lugubre* to be delivered to Goëmans, and a suitcase full of notes and jottings by Dalí on the subject of his paranoiac-critical method. She also took with her Dalí's promise to meet her again in Paris at the end of October, when the premiere of *Un Chien Andalou* would take place.

Dalí's first exhibition at the Goëmans gallery was due to open on November 20, but there were still paintings to complete for it, so Dalí stayed in Figueres that autumn. Once more, and for the last time, he was enclosed by the iron grip of his family and his childhood. His old work habits reasserted themselves, and he finished the portrait of Paul Eluard begun in Cadaqués that summer. He also finished another important painting, *The Great Masturbator*, which had been inspired by a nineteenth-century photograph of a woman smelling an arum lily. Released from his mental delirium by Gala or by his own assertions against domestic tyranny, he was now at the true beginning of his life as an adult and as a painter. Gala had begun to turn the wayward child of the Dalí family into as much of a man as he would ever be capable of being.

But Dalí was not yet quite ready to exchange one sort of captivity for another, or to reckon his childhood world well lost for love. He returned from seeing Gala off to Paris exclaiming: "Alone at last!" For if, as he wrote in his autobiography, "the vertiginous twists and turns of the murderous impulses of my childhood had in fact disappeared from my imagination forever, my desires and my need for solitude would be long and stubborn to heal. . . . I wanted to know that

she was alive and real, but also I had to remain alone from time to time."[17]

He didn't communicate with Gala at all during the month of October. Perhaps he was too busy completing the paintings for his first major show in Paris to think about her, wondering, as he sat at dinner with his family in the familiar surroundings, or exchanged ironical jokes in the cafés of the *rambla,* whether this time, in Paris, he would become famous. Perhaps he needed her physical presence to confirm the reality of what had happened between them that summer.

Gala and Cécile arrived back in Paris to find that the new flat was not ready. Cécile was packed off to her grandmother's in Montlignon, and Gala and Eluard moved into the Hôtel Terrasse, where Buñuel was also living. When Gala learned this, she became very agitated and described to her husband Buñuel's attempt to strangle her on the beach at Cadaqués. Eluard also panicked and went out and bought a pearl-handled revolver.

Gala did not make it clear to Eluard how far things had gone in Cadaqués. Perhaps she thought she could re-create the triangular affair she had had with her husband and Ernst. More likely she was unsure whether Dalí would ever be able to come to Paris, so inept was he at organizing the simplest travel arrangements. With two months to go to the opening of Dalí's exhibition, Goëmans had only two paintings in his possession. But slipping easily back into her role as Surrealist muse, Gala attempted to interest André Breton in her Spanish genius. She worked hard to give Dalí's notes and jottings what he described later as a "syntactic" form, and these would appear in 1935 under the title *"La Femme Visible."*

In 1929, the Surrealist group was still divided by the political schisms of the previous three years. Breton's methods had always been to expel and enroll members with equal facility, but he had just suffered a mass defection and needed to find a new direction in which to take the movement. Twelve members of the group, led by Louis Aragon, had finally decided that the French Communist party offered many more opportunities to subvert and change the current social system than did a small group of artists led by Breton. They were, in fact, pushed into defecting by Breton himself.

When Gala began to explain Dalí's paranoiac-critical theories to Breton, he paid them a great deal of attention, seeing a way out of the impasse into which he had led his movement by, as André Thirion once wrote, "creating a high temperature of revelation by stage-managing tests and clashes for better or worse."[18]

In October, *Un Chien Andalou* had its public premiere at Studio 28 in Montmartre. Cyril Connolly, who was there, wrote:

> *This contemptuous private world of jealousy and lust, of passion and aridity, whose beautiful occupants patter about like stoats in search of blood, produced an indescribable effect, a tremendous feeling of excitement and liberation. The Id had spoken and—through the obsolete medium of the silent film—the spectators had been treated to their first glimpse of the fires of despair and frenzy which were smouldering beneath the complacent post-war world.*
>
> *The picture was received with shouts and boos, and, when a pale young man tried to make a speech, hats and sticks were flung at the screen. In one corner a woman was chanting 'Salopes, salopes, salopes!' . . . With the impression of having witnessed some infinitely ancient horror, Saturn swallowing his sons, we made our way out. . . .[19]*

Dalí missed this public premiere, probably because he was working hard in Figueres for his exhibition and also because he was relishing a brief respite from his new occupancy of emotional high ground.

Dalí was in the habit of corresponding with his friends; his letters to Lorca, to the poet J. V. Foix, and to many others bear this out. Why did he not write to Gala, the woman with whom by the end of the summer he believed he was in love? His exaggerated sense of separateness might have had something to do with it; so might the fact that he was still terrified of the relationship and probably needed time to calm down and think.

Did Gala write to him? No records exist, but it is unlikely. Dalí certainly planned to see her in Paris, as her possession of the case filled with his scraps of notes would indicate. They had probably made a plan of campaign; she had been sent on ahead as his messenger. Dalí believed in letting others spread his reputation, always referring to Buñuel, for instance, as the "messenger of my fame."

* * *

Dalí went to Paris, financed this time by Goëmans's advance for the two paintings the dealer already had in his possession. Dalí timed his arrival for a few days before his exhibition opened on November 20, and his first act was to try to buy Gala some roses. As usual, he got into a muddle. He pointed to a large mass of roses and asked how much they were. "Three francs" was the reply. Thinking that three francs was the price of the whole bouquet rather than a single stem, Dalí ordered ten bunches and, when given the bill, naturally could not pay. He spent 250 francs, all he had on him in cash.

But far from going straight to Gala with the flowers, he idled the rest of the morning in cafés. At noon he had two Pernods and then took the roses and one or two of his paintings on to Goëmans's gallery. There he met Paul Eluard, who, always happy in the role of pander to his wife, told him that Gala was irritated because he had not called on her immediately. This would imply that Dalí had either written to her to say precisely which day he was due to arrive in Paris or, more likely, that he had written to Goëmans, who had then told her.

He was asked to dinner that night with others in the Surrealist group, including Breton, in the flat in the rue Becquerel. Although initially Gala was rather frosty, everyone at the dinner had a great deal to drink, and Dalí, who had scarcely drunk any alcohol since he had left Madrid four years before, found that his timidity disappeared:

> It was a revelation to discover that besides painting what I was painting, I was not an utter cretin. I also knew how to talk, and Gala with her devoted and pressing fanaticism furthermore undertook to convince the Surrealist group that besides talking I was capable of "writing" and of writing documents whose philosophic scope went beyond all the group's previsions.[20]

The Surrealists were tempted to take Dalí more seriously after the fourth number of *Documents,* which appeared in Paris just before his arrival. Georges Bataille, who had founded the review in an attempt to get out from Breton's shadow, was one of the first to understand what Dalí was trying to do. He interpreted his imagery in a way different from Breton. In his essay on *Le Jeu Lugubre* Bataille wrote: "Against half

measure, evasions, delirious betraying, the greatest poetic impotence, only a black anger and even an undeniable bestiality can be opposed."[21]

In his preface to Dalí's exhibition at the Goëmans gallery, Breton had written that here "for the first time the windows of the mind had opened wide." Dalí was very wary of the Surrealists, believing that they subconsciously knew that he had come to destroy their revolutionary work, just as he had tried to destroy the Catalan intellectuals with the *"Manifest Groc."* He was opposed to a revolution he felt had been engendered by postwar dilettante anxiety:

> . . . *even while I hurled myself with greater violence than any of them into demential and subversive speculations just to see what the heart of revolutions in the making carried in its belly, with the half-conscious Machiavellism in my scepticism I was already preparing the structural bases of the next historic level—that of eternal tradition.*[22]

Even as he was admitted to the group by André Breton, he was plotting its downfall by what he later described as occult, opportunistic, and paradoxical means. He had waged such campaigns before and fancied that he had become an adept. He later wrote that he took definite stock of his stronghold, of his inadequacies, and of the weaknesses and resources of his friends. He determined that "if you decide to wage a war for the total triumph of your individuality, you must begin by inexorably destroying those who have the greatest affinity with you." To Dalí, alliances depersonalized everything. He hated the collective. Separateness was the fundamental tenet of his life.

Where did Gala fit into Dalí's lonely universe? Was theirs an alliance of convenience? Was it money on his side and nursing care on hers? In a sense, yes. But it was more than that; Gala possessed him in the truest spiritual sense. In the end they were indivisible, two psyches perfectly complementing each other. Gala needed a genius, and she believed she had found one. Dalí's painting was her meat and drink, her bread and butter, her passport into the arts and into society. She would do everything necessary to make sure that he could paint, and this meant running his life and catering to his sexual needs. Gala took care of money, dealt with clients, kept house, and cooked for Dalí until they could afford servants. She kept him sane.

Gala was one of the few women (the others being Meret Oppen-
heim, Valentine Hugo, and, later, Leonora Carrington) who played a
decisive role in the Surrealist world. But Gala's role was passive; she
simply encouraged painters, and it became a Surrealist saying that
when a painter had achieved something out of the ordinary "he must
have been in love with Gala." She waged her campaign to enslave Dalí
using tactics she had learned with Ernst, with de Chirico, and with
other Surrealist painters; but now these tactics were honed and re-
fined. It did not take long. She seems at first to have been unsure of
her success, and might have believed she could form part of a triangle
with Eluard and Dalí. But Dalí was no Max Ernst. He needed attention
twenty-four hours a day. And sexual jealousy could not be used as a
weapon against him; he was an autoerotic.

Two days before the opening of his one-man show, Gala persuaded
Dalí to act decisively. He cast in his lot with hers forever. She per-
suaded him to elope to Barcelona and Sitges for a "honeymoon" spent
walking on deserted winter beaches in the bright sunlight. Why did
Dalí not stay for the opening of the most important show of his life?
Luis Romero suggests that he might have had an attack of nervous
timidity and that Gala might instinctively have felt it best if her new
possession were removed from a situation that could loosen his precar-
ious hold on sanity. And she might have felt that she wanted him to
herself. Time and solitude were needed to complete the process of
enslavement.

The process of becoming one, becoming Dalí-and-Gala, a relation-
ship that would last for fifty-three years, took a month at Sitges, dur-
ing which time Dalí wrote that they were both so much occupied by
their two bodies that they hardly for a single moment thought about
Dalí's exhibition. At the end of this time the enslavement was com-
plete; Dalí referred to his exhibition as "our" exhibition.

But as the month wore on, Dalí began to feel guilty about his family.
He had not written to them to explain what he had done, and they
thought he was still in Paris. So he decided to go back to Figueres to
see them and then on to Cadaqués to pursue his new ideas on paint-
ing. Gala left him at the Figueres station and went back to Paris.

The meeting with his father, stepmother, and sister at dinner in the

family apartment in Figueres went as badly as could be expected. Dalí's father said he was brokenhearted about the way his son was treating his family and asked him about money. Dalí had signed a two-year contract with Goëmans, and he says in his autobiography that he infuriated his father by not being able to remember what the terms were. This is untrue, for Dalí's father had been deeply involved in the negotiations for the contract when Goëmans had visited Cadaqués the previous summer. What does ring true is that Don Salvador wanted to know how much money Dalí had left from the advance Goëmans had given him. By dint of rummaging in his pockets, Dalí managed to find 3,000 francs in torn and crumpled bank notes.

The row simmered and rumbled—about money and about Gala. Gala was married, ten years older than Dalí, possibly a whore, and, by repute, a drug addict. Things were egged on by Ana Maria, who was, and would remain for the rest of her life, adamantly jealous of Gala. Buñuel arrived at this critical point. He observed the end of the row, which he described later:

> *At first, all I could hear were angry shouts, then suddenly the door flew open and, purple with rage, Dalí's father threw his son out, calling him every name in the book. Dalí screamed back while his father pointed at him and swore that he hoped never to see that pig in his house again.*[23]

Buñuel had come determined to get Dalí to cooperate with him on the scenario and script of *L'Age d'or,* the making of which had been financed by the Vicomte de Noailles, who had advanced the huge sum of 1 million francs to Buñuel. It was a fortunate arrival. Had Buñuel learned of Gala's return to Paris without Dalí? Did he see a chance of winning Dalí back from Gala's sphere of influence? He arrived with good news: Dalí's show had been an enormous success, and every picture had been sold at prices that ranged between 6,000 and 12,000 francs. Even more important in hindsight was the news that the Vicomte de Noailles had bought *Le Jeu Lugubre,* which was now hanging among the Dürers and Cranachs in his town house on the place des Etats-Unis.

Dalí and Buñuel left Figueres and headed for Cadaqués and Es Llaner to work on the film. But more quarrels ensued. Dalí told Buñuel he wanted "a lot of archbishops with their embroidered tiaras bathing

amid the rocky cataclysms of Cap de Creus,"[24] and so they were. But Dalí felt that Buñuel was turning the film into anticlerical polemic; he wanted comedy and "authentic sacrilege," not anticlericalism.

> I had some thirty gags: a cart going through the middle of a party in the drawing room; the forester who kills his son on an impulse, the defenestrated bishop, etc. Dalí brought in other gags, like the man with the rock on his head. But we discovered we both disliked each other's ideas. "That's very bad," he'd say to me, and I'd say, "That's worst of all," referring to something of his. There was no agreement. Besides, the first film and this were different. In Un Chien Andalou there was no line, but in L'Age d'or there was—a line very similar to that of La Fantôme de la Liberté [Buñuel's 1974 film], which consists in moving from one thing to another by means of some detail.[25]

Buñuel left for the Abbaye Saint Bernard, the Noailles' château near Hyères, after two weeks of disagreement. Dalí stayed on alone. He was stranded between his father and Gala. In his autobiography he tells of feeling an anguished paralysis, and it is by no means clear which he would have chosen. But a final fury caused his father to push him out of the family.

Dalí's father had read in an article written by Eugeni d'Ors that at the bottom of one of his son's chromolithographs exhibited in Paris he had inscribed: "Sometimes I spit on the portrait of my mother." Dalí's father now wrote to him in Cadaqués telling him that because of this appalling slur on the memory of his mother he would be disinheriting him and banishing him from his family, and that he would die, as had always been forecast, poor and alone.

There was something between Dalí and his father, a secret Dalí did not wish to reveal. It may have had something to do with an affair Dalí's father and his stepmother began while Dalí's mother was still alive; it may have been even more unsavory in that the affair involved both children, too. Whatever the secret that led Dalí to insult his father by insulting his dead mother, it had the desired effect of engineering their final break.

In January 1930, Dalí's father wrote to Lorca, ostensibly to send the poet a newspaper review of his play The Shoemaker's Prodigious Wife, but in reality to obtain sympathy from Lorca.

I do not know whether you were aware that I had to throw my son out of the house. That was very painful for all of us but for reasons of dignity it was necessary to take such a desperate resolve. In one of the pictures of his exhibition in Paris he was vile enough to write these insolent words: "I spit on my mother." Supposing that he might have been drunk when he wrote it, I asked him for an explanation, which he refused to give, and he insulted all of us once again. You can well imagine the sorrow that such piggish behavior is giving us.[26]

Dalí was enormously upset. His first reaction was to shave off all his hair and bury it on the beach. "Having done this I climbed up on a small hill from which one overlooks the whole village of Cadaqués and there, sitting under the olive trees, I spent two long hours contemplating that panorama of my childhood, of my adolescence and of my present." Had he known, he should have added "of my future." But he did not know. All that remained for him was to turn his back on Cadaqués and on his past, and head for Paris and an uncertain life with Gala.

In mid-January, two weeks after his final quarrel with his father, Dalí finally summoned up enough courage to leave. Typically, he took a taxi to the frontier with the last of Goëmans's money. From Perpignan, he took the train to Paris to be reunited with Gala, who was still living in Eluard's flat on the rue Becquerel while he was living in one or another small hotel nearby.

On the way up the hill from Cadaqués, Dalí got out of the taxi to have one last look at his past, then he turned to look ahead. He later told André Parinaud that, as he stood motionless, his eyes set on the road before him, he knew his "back was leaning against the land of my childhood that stuck to my skin as the bark to the tree."[27]

5

THE SPECTER OF SEX APPEAL
1930–1933

The "Russian woman" would now assume the role she was to play for the next five decades, what Dalí once called a "porter."

> *I regarded most of the people I met solely and exclusively as creatures I could use as porters in my voyages of ambition. Almost all these porters sooner or later became exhausted. Unable to endure the long marches that I forced on them at top speed and under all climatic conditions, they died on the way. I took others. To attach them to my service, I promised to get them to where I myself was going to that end-station of glory which climbers desperately want to reach. . . .*[1]

On the forced march of Dalí's life, Gala was not only the chief porter but also mistress of the caravan, as well as an extension of Dalí's very self. Her furious energy and determination stood her in good stead.

Dalí became restless in the rue Becquerel apartment, which was still a center for the Surrealists, who had formed the habit of dropping in to see Eluard and Gala. He needed the solitude of a studio in which he could reassume his by now ingrained habit of work and semiconscious contemplation. He wanted, in other words, to leave Paris, but he could do that only if Gala accompanied him.

Gala must have persuaded him to stay, for a time at least, in order to consolidate his position within the Surrealist group and to meet important new patrons who had bought paintings at the first Goëmans show, but who did not yet know Dalí. Chief among these new patrons to be cultivated were Marie-Laure and Charles de Noailles, who had

purchased *Le Jeu Lugubre* at the show in November and whose opinion counted for much in the more avant-garde part of the Parisian *"gratin."*

Life in high society was still difficult for Dalí, however much he wanted to become part of it, because, as he admitted, he had not yet become a "talker." He was still very timid indeed, despite the reassurance of Gala's single-minded support. The rift with his father and his past must have dazed him; life must have seemed dreamlike and unreal now that he was at last free (or so he thought) of his past. At the beginning of this new life, Dalí uttered only words of strict necessity (which he had probably rehearsed beforehand) such as the slogans he fed sparingly to the Surrealists: "Raymond Roussel[2] as against Rimbaud; the art nouveau object as against the African object; still-life deception as against plastic art; imitation as against interpretation."[3]

The Noailles were the key, and Dalí lost no time in engineering an invitation to their *hôtel particulier* in the place des Etats-Unis. This was the apogee of the modernist orbit of *le tout* Paris:

> *Everywhere silken tapestries and statues situated in long perspectives. Space is filled by steps rising from landings and further steps from other levels. And then, drawing the eye as if by some magic object, is a great picture: in a blue void both luminous and dark, two birds, light as air, invisible and almost hieratic. It's Max Ernst's* Monument aux oiseaux, *which Marie-Laure bought as soon as it was completed, in 1927. Its charm is added to by the white stone staircase reflected in a large Louis XIV mirror. Canvases and frames abound as in every other corner of the house.*[4]

Le Jeu Lugubre was hanging between a Watteau and a Cranach in the Noailles' house, and this reassured Dalí. He also made the discovery during dinner that the aristocracy was

> *infinitely more vulnerable to my system of ideas than the artists and especially the intellectuals. . . . The second thing I discovered were the climbers. . . . I decided that I would thenceforth have to make use of these two kinds of discoveries—of society people to keep me and of the climbers to open a way of prestige for me with the blundering calumnies of their jealousy. I have never feared gossip. I let it build up. All climbers work and sweat at it and I always end by finding a way to turn it to my advantage.*[5]

While he was waiting for his slogans to take effect like a virus among the Surrealists and for members of society to flock to him, Dalí left Paris at the end of February, flush with the money Goëmans gave him after his exhibition, and headed for the Côte d'Azur, to the Hôtel du Château at Carry-le-Rouet, to spend time working in solitude. Taking two rooms, one of which was used as a studio, Dalí and Gala spent two months, during which he wrote that he knew and consummated love with the same speculative fanaticism he put into his work. But did he consummate his relationship with Gala? It is highly unlikely, despite his later affirmation. It is more probable that he got his pleasure from masturbating with his "other self" watching, or perhaps she devised ways to satisfy him that did not actually involve physical contact.

But whatever happened sexually between Gala and Dalí in those two darkened rooms, from which they scarcely stirred, the enforced solitude had the effect of binding them together indissolubly. Gala became Dalí's "secret." Perhaps he told her of the other sinister secrets in his life and in doing so exorcised them, and bound himself even closer to her in their complicity. During these two months alone together, Dalí spent hours gazing at Gala, and began to familiarize himself with the strange landscape of a female body just as he had gazed at the landscape of his childhood:

> *I fixed in my memory the value of every grain of her skin so as to apprehend the shadings of their consistency and color; so as to find the right attentive caress. . . . I spent hours looking at her breasts, their curve, the design of the nipples, the shadings of pink to their tips, the detail of the bluish veinlets running beneath their gossamer transparency; her back ravished me with the delicacy of the joints, the strength of the rump muscles, beauty and beast conjoined. Her neck had pure grace in the slimness; her hair, her intimate hair, her odors, intoxicated me.*[6]

And what of Gala? She had not abandoned Eluard, to whom she wrote several erotic letters during this two-month "honeymoon." In these letters, judging by Eluard's replies (the only side of the correspondence still in existence), she must have encouraged him to believe that there was still room for him in her life. She maintained this contact probably for two reasons: Eluard had a little money and he was also an important member of the Surrealist group, one of Breton's two "lieutenants";

and, second, she may have entertained the notion of reestablishing a ménage à trois once they had returned to Paris.

But Eluard was not as easy either to put off or to cajole as Gala perhaps had reckoned. In a letter of May 5, 1930, for instance, he questions her motives. "The larger part of my letter spoke of our common situation. You answer it only with absolutely vague and conventional pronouncements: 'Rest absolutely assured,' 'Yours absolutely,' etc. . . ."[7] Gala obviously gave as her reason for staying in the south of France that she was ill.

At Carry-le-Rouet, Gala began her lifelong habit of telling Dalí's fortune for him each evening, as she had previously told the fortunes of the Surrealists at Eaubonne. He believed in Gala's skill with tarot cards and that she was a sorceress. She did seem to have some talent in that direction, for she apparently forecast, very accurately, the Munich Agreement of 1938 and, subsequently, the fall of France.

At the end of two months Dalí received a letter from the Vicomte de Noailles telling him that the Goëmans gallery was on the verge of bankruptcy. He offered to help Dalí financially. Dalí and Gala were running short of funds, and they decided that Gala should go to Paris to salvage what money she could from Goëmans and that Dalí would go to Hyères and offer to do an important picture for the Vicomte de Noailles, for which the price would be 29,000 francs in advance. With this, and the money they hoped Gala would collect, together with whatever other money she might receive from Eluard, they would, they decided, go back to Cadaqués and build a small house.

Although he had worked hard during their two months at Carry-le-Rouet, Dalí recognized the need to be in the familiar terrain that induced his waking dreams. "I like only the landscape of Cadaqués and I would not even look at any other."[8] Both plans worked. Gala came back from Paris with some money from Goëmans, and Dalí returned from the Noailles' with a check for the full amount for the picture that would become *The Old Age of William Tell*.

However, Dalí, being superstitious, read future trouble into the seeming ease with which they had solved their immediate financial problems.

There began the period of my life which I consider the most romantic, the hardest, the most intense, the most breathless and also the one that

"surprised" me most; for favorable hazards have always seemed to me to be my due—and suddenly it looked as though my good luck were going to end, to spoil. . . . Now began the battle that I was to wage against life, and which until then I had always thought I would be able to elude. . . . I was going to return to Cadaqués, where instead of being the son of Dalí the notary, I would be the disgraced son, disowned by his family and living with a Russian woman to whom I was not married.[9]

News of this disgrace, and of his defection to Paris, did not seem to have perturbed Dalí's intellectual coterie in Barcelona, who were to have an opportunity in March to hear him give an important lecture at the Ateneu. In this speech Dalí told his audience that they, like the Surrealists, should not only "ruin definitively the ideas of family, country, and religion"[10] but that what should also concern them "is everything that may contribute to the ruin and to the discomfiture of the world of the intellect and the senses, which, in the process of connection with reality, may be condensed into a violently paranoiac will to systematize confusion, that taboo confusion of occidental thought that has finally been idiotically reduced to the nullity of speculation, to idleness, or to stupidity."[11]

Dalí went on to define what he termed "emotional family relationships" in which he cites self-denial: "a wife loving her husband takes care of him throughout two years of a cruel illness; she cares for him day and night with a self-denial that exceeds all bounds of tenderness and sacrifice. As a reward for so much love, the husband is cured; subsequently the wife falls ill with a severe neurosis."[12] Dalí believed that people would logically think that this was as a consequence of nervous fatigue but maintained that it was far from that.

For happy people there is no such thing as nervous fatigue. Psychoanalysis and the painstaking interpretation of the patient's dreams confirms for us the very intense subconscious desire (though unknown to the patient herself) to get rid of her husband. It is for this reason that his recovery produced a neurosis (in her). The death wish came back to her. Extreme self-denial is used as a defense against unconscious desire.[13]

Dalí thus publicly blamed his father for his mother's death from cancer; the contents of the speech, which were bound to be reported,

would certainly reach the notary. Later in the speech he told the audience that he had recently painted a picture that represented the Sacred Heart, entitled *Amalgam* or *I've Spat on My Mother*.

> *Eugeni d'Ors (whom I consider to be an utter cunt) saw in this remark a more private insult, a mere cynical showing-off. Useless to say that this interpretation is wrong and removes all the really subversive meaning from such an inscription. On the contrary, it is really a question of a moral conflict of a similar order to that presented by a dream in which we assassinate a person we love—this dream is a common one.*[14]

Concluding his speech, Dalí informed his audience that the Surrealist revolution was above all a revolution of the moral order, and that in addressing the new Catalan generation he wished to inform it that a moral crisis had been provoked and that those who persisted in the amorality of decent reasoned ideas would find their faces covered in his spittle. His lecture was enthusiastically received.

No such welcome awaited Dalí and Gala in Cadaqués. Dalí's father had done his work; no one would house them. The only hotel, the Miramar, refused them rooms on the pretext that they were rebuilding. They had to live in a tiny boardinghouse owned by a former family maid, who did all she could to make them comfortable.

Their only other ally was Dalí's old friend Lidia Nogueres. Lidia and her two sons owned a *barraca*, a one-room fisherman's shack built of rough flints, which she sold to Dalí. This *barraca* was next door in the bay of Port Lligat, which could be reached only by boat, or by walking across the intervening headland. At night this walk across the rough, bare terrain was made even more eerie by the fact that at the top of the hill the little path passed by the local cemetery, a ghostly garden full of sepulchers and small family mausoleums.

The shack had been used by Lidia's two sons to keep their fishing tackle in, and for shelter from storms. It was only four meters square, with no sanitation at all, and the roof was falling in. But to Dalí it was perfection, for it looked out over the arid rocks sloping steeply up from the shingled shore and the little bay where he wanted to paint more than anywhere in the world.

There was in those days in Port Lligat a small population of fishermen who paid no attention to Dalí's father's diatribes against his son

and the "Russian whore"; these men quickly became friendly with Dalí and Gala, reasoning: "He doesn't need his father's money. He's free to do what he likes with his youth."[15]

Dalí and Gala's neighbor was a defrocked priest with two wives; he eked out a precarious living by making briar pipes. The screams of the two women competed with the howling of the night wind in this desolate spot. It was a place for misfits and outcasts, remote, mysterious. With the money from the Noailles, Dalí and Gala were happy drawing up plans for their house with a local carpenter. The one room was to serve as dining room, bedroom, studio, and entrance hall. Up a few steps, doors led to a shower and a lavatory; a kitchen was set off a tiny hallway.

They eventually brought the modernist nickel-and-glass furniture so carefully assembled by Eluard to please Gala from the apartment in the rue Becquerel and painted the walls with several coats of enamel. Fifty years later, the original four-meter-square room had become the hallway of a house Dalí had formed by the simple expedient of buying, one by one, the little *barracas* behind the original one that climbed up one side of the village street. The house had by then become so complicated as to resemble a labyrinth.

The builder Emilio Puignau, who became a close friend of Dalí's and mayor of Cadaqués, built a great deal of the house over the years. "Dalí would send drawings of how he wanted a chimney breast or a new room built when he was in New York, and when he returned I had done it," he remembers. "Sometimes it wasn't quite what he had drawn, but he never seemed to mind."[16]

While the carpenter was getting on with his work, Dalí and Gala went to Barcelona to cash the check from the Noailles, their remaining money having been exhausted on the building work. In the bank, Dalí presented the check but then refused to give it to the clerk until he had been given the money. Gala, embarrassed at the naïveté of her lover, accused him, not for the last time, of being a Catalan peasant. They left the money in a safe at the Hotel de Barcelona, out of temptation's way, for it was destined for the house in Port Lligat. At this point Gala, always in a battle against ill health, was stricken with a bad case of pleurisy.

Paying no attention to Gala's illness, Dalí accepted the invitation of the poet José María Hinojosa, a friend from his Madrid days, to visit

him in Torremolinos, where Hinojosa had offered to pay for their stay while the *barraca* was being altered. He offered to buy a picture into the bargain. His house was set in a field of blood-red carnations on a cliff looking out to sea. Torremolinos was then primitive. The fishermen, according to Dalí, thought nothing of excreting in front of their friends on the beach, indeed seemed to take pleasure in being viewed doing so. Gala's habit of walking around topless fitted into this richly natural frieze (though it was greatly to upset people in Port Lligat in subsequent years). The future poet and critic José Luis Cano, then seventeen, visited Torremolinos, and commented that Gala was much less approachable than Dalí and less communicative. He added that "her gaze impressed me. Her pupils flashed intensely, and the soft light of the evening seemed to form a sort of halo around her appearance."[17]

The house in Torremolinos where they stayed had two whitewashed rooms, one of which they lived in. Dalí painted in the other one while Gala sorted through his jottings and put them into some order, so that in the evening he could write his essay *"La Femme Visible."* It was an idyllic existence punctuated only by argumentative visits from various Surrealist friends.

One day they received a batch of mail that upset their idyll. The Goëmans gallery, which owed them a month's money in arrears under the terms of the contract Dalí had signed the year before, had finally gone into liquidation, and, if this weren't enough, Buñuel wrote to say that he was going ahead by himself with the production of *L'Age d'Or.* Nor was that all; the carpenter working on the house at Port Lligat was asking for the rest of his money, together with further expenses, and at the same moment Hinojosa went off without leaving his address, airily saying he would be back in twenty days.

The money they had brought with them was virtually gone; they could live for another three days without additional funds, so they cabled various friends in Paris asking for advances on the paintings Dalí was working on. None answered, and matters became desperate. Dalí went through all his pockets for change. A Surrealist friend from Málaga, a Communist sympathizer (thus not as popular as he might have been with Dalí), called and was immediately dispatched to send a telegram to the bank in Barcelona holding the money from the Noailles.

Two days passed. The heat was intense and the atmosphere menacing; in the house next door, an insane young man had just half killed his mother with a pair of tongs. Gala took a pragmatic view. She insisted that their lack of ready cash was annoying rather than tragic, and that all they had to do was go to Málaga, settle in a hotel, and wait for the money. Dalí admitted he would not listen to this voice of reason, for he wanted to "play out the drama of my anger once and for all. . . . I would not admit the affront, the injustice, the monstrousness of the fact that I, Salvador Dalí, should have to interrupt the writing of 'The Visible Woman' because I, Salvador Dalí, found myself without money."[18] The role of spoiled and protected child was to prove very hard to slough off.

Dalí stormed out of the house, having manufactured a row with Gala, who was busy packing, as she was to do so often for Dalí, and went down to the beach. It was evening, and the Gypsies who lived in grottoes hollowed out from the cliffs were cooking and the women were suckling their babies. This proved to be a powerful aphrodisiac to Dalí, who went off to a deserted cove and masturbated. Overcome with remorse, he hit himself in the mouth so hard he lost a tooth.

To Dalí, always influenced by portents, this was an omen, a favorable omen for the new house, his new life. The tooth, he told Gala when he returned, would be hung by a string in the center of their new home in Port Lligat.

The check from Barcelona was soon reposing in a bank in Málaga, and Dalí and Gala decided to return to Paris so that Dalí could earn money by selling his new paintings. Among these was *The Great Masturbator,* the meaning of which he explained as "the expression of my heterosexual anxiety." The nineteenth-century lady holding a white lily whose photograph inspired the work is visible in the painting. A grasshopper, ants, and a fishhook are embedded in a skull that is both Dalí's head and the memory of the stranded whale from his childhood. *The Average Bureaucrat* was also painted that summer; the figure of the bureaucrat appears in many of Dalí's paintings, but here the large head is virtually empty save for some seashells from the beach at Cadaqués. The painting is a rejection both of his father and of all Don Salvador stood for, which Dalí and the Surrealists were determined to destroy. But the two small figures to the left of the bureaucrat's head indicate that Dalí still felt nostalgia for his childhood.

Back in Paris, Dalí saw Pierre Colle, an art dealer with his own gallery on the rue de Cambacérès, and arranged for a one-man show in June 1931. Dalí had by now become a fully paid-up member of the Surrealist movement, and he immediately began to contribute to literary and art magazines, as he had done in Catalonia in 1928. He helped to found *Le Surréalisme au Service de la Révolution* with Breton, largely at Eluard's instigation, and he not only designed the frontispiece of the second Surrealist manifesto but contributed several articles to it, one of which denigrated Catalonia. Another, *"La Rêverie,"* shocked the more prudish Surrealists, dealing as it did with his sexual relationship with "Dulita," a theme he would pursue in an unpublished novel, *La Vie Surréaliste,* and in the opening chapters of his autobiography. He also participated in various Surrealist collective shows and appeared in a group photograph. Symbolically, perhaps, Dalí is right in the center between André Breton and Max Ernst.

In late June, having concluded a new contract with Pierre Colle, Dalí and Gala could now return to Port Lligat to immerse themselves in work and each other. They were certainly there by July, as the long-suffering Eluard wrote to them in Cadaqués at that time telling them that he had sold the rest of his "stock" (i.e., the pictures that had remained unsold after the Goëmans show and that Eluard had rescued from the receivers) and that as a consequence he now owed Dalí 1,000 francs.

Eluard had been left, so to speak, holding the baby by Gala, who took no interest at all in her by now twelve-year-old daughter, Cécile, who lived with Madame Grindel and rarely saw her mother. (Prince Jean-Louis Faucigny-Lucinge, a friend with whom Dalí and Gala later went on holiday, did not even know Gala had a daughter.[19]) By now Eluard was obviously reconciled to Gala's new relationship and was living with Nusch, a homeless prostitute on whom he had taken pity when he found her starving on the street. She would never take the place of Gala, but eventually Eluard would marry her. Plans were made for Nusch, Eluard, and the Surrealist poet René Char to come to Cadaqués that August for a holiday, as Eluard had done the year before, and the party embarked from Marseilles for Barcelona and Cadaqués at the end of the month. Before they arrived, and all that summer, Gala wrote to Eluard regularly and affectionately, describing the paintings Dalí was working on. She also asked him for more and

more money, for by now the Noailles' money had gone and Dalí was not due to show at the Galerie Pierre Colle until the following year.

Lack of money had no apparent effect on Dalí, who painted some extraordinary pictures that summer. Now firmly ensconced in the landscape he loved, he seemed to worry not at all that he was banned from seeing his family and family friends, nor that his father was lurking, impotently, on the other side of the headland in Cadaqués. But his paintings at this time tell a different tale. He began to explore the story of William Tell, which for Dalí was the story of a threatening father figure whose aim, conscious or subconscious, was the castration of his son. In *The Old Age of William Tell,* which Robert Descharnes dates to 1931, but which was begun in the summer of 1930, the father is pursuing the Dalí-Gala couple, who appear three times in the picture, first clutched in an embrace, then, at the right, in an attitude strongly reminiscent of Adam and Eve and their expulsion from Paradise, and, finally, in the far distance, apparently in the process of metamorphosizing into the rocks of Port Lligat. Dalí's father is portrayed as a bearded hermaphrodite, and the woman next to him appears to be masturbating him, but her hand is hidden behind a semitransparent sheet on which the shadow of a lion, symbol of fear and anguish in the Dalinian bestiary, is reflected. If Dalí's paintings are autobiographical rather than strictly Surrealist in content, then *The Old Age of William Tell* is a very good example of the way he used painting to exorcise what would otherwise have been the completely insoluble problem of his relationship with his father.

The paintings Dalí did that summer were exceptional. In a sense they are the high-water mark of his early Surrealist period. In painting them he produced enduring images that have woven their way into the collective subconscious of the twentieth century, particularly the soft watches in *The Persistence of Memory,* which represents Dalí's exploration of hard versus soft in the physical world, and of the nature of time itself. In this picture the amorphous form of the Great Masturbator appears again, but time seems to have conquered him, as he lies prone on the beach. Dalí created his somnambulistic effects through a combination of shadows, jewellike clarity of color, and miniaturism.

Dalí's fear of female sexuality is apparent in *The Bleeding Roses,* a painting of a nude with bloody roses emerging from her womb. Un-

usually for Dalí, her breasts are emphasized, even exaggerated. She is standing on the by now familiar Tower of Desire, and the shadow of a man emerges from the right-hand side of the picture. This painting proved to be prescient, for two years after Dalí painted it Gala had to have a hysterectomy.

He continued to paint *The Invisible Man* during 1930, which would be shown at the Colle gallery in 1931; *Vertigo* was also painted at this time. It was sometimes called *The Tower of Desire* and evokes certain memories of Dalí's early sexual adventures in the mill tower at the Pitxots' estate, which was his first studio. Of this painting, Dalí remarked that the critics began to be more interested in his art, but only the Surrealists and society people seemed to be really touched to the quick. This comment may have been prompted by the eventual purchase of this painting, after a time, by Prince Jean-Louis Faucigny-Lucinge.

Dalí and Gala returned to Paris sometime toward the end of October to spend the winter consolidating and enlarging Dalí's influence on the Surrealists and on high society. Things were very difficult financially, for they had to survive six months until Dalí's next show. Dalí described Gala as being truly heroic during this time but admitted that their practical life grew increasingly difficult. "It was as if people were reacting to the horrible disease of my intellectual prestige which was demolishing and destroying them, by communicating to me that disease of which they alone possessed the germs—the continual gnawing of 'financial worries.' "[20] But Dalí preferred this disease to the one he was busy giving them, because he knew it was curable.

They now lived in a tiny studio on the rue Gauguet near the Parc de Montsouris and the railway yards, for Eluard had sold the flat in the rue Becquerel, being short of money after the Crash of 1929. It was here that their new friends in high society began to visit them to see what Dalí was painting and to hear him discuss his ideas, chief among which was antimodernism. Dalí and Gala cultivated high society with what the photographer Brassaï called "an avid, frenzied snobbery."[21]

They met Coco Chanel and Elsa Schiaparelli and Misia Sert, and were invited to dine at the White Russian Prince Mdivani's and at the Maharaja of Kapurthala's; they went to the house of Princesse Marie-Blanche de Polignac, the daughter of the couturiere Jeanne Lanvin;

they knew the supreme thrower of fancy-dress balls, Comte Etienne de Beaumont, and the South American Maecenases, the Chilean guano magnate Arturo López-Wilshaw and the Argentine Señor Anchorena. They had, almost, arrived.

Prince Jean-Louis Faucigny-Lucinge was one of the first architects of the Dalís' life in high society. He was walking down a narrow street on the Left Bank in 1930. "In the shop window there was a little painting that I loved. I didn't know who had painted it but I went in and bought it." It was by Dalí.

> *Then I met Dalí and Gala and we ended up seeing a lot of them. I had great admiration for what he did and I wanted him to be known. You know, when you like someone, you want him to be known. I always remember bringing two art lovers, one was Prince Paul of Yugoslavia and the other Baron Robert de Rothschild, to see a little bit of his work, and they were absolutely horrified.*
>
> *They lived very modestly in a little street that gave on to stairs and the stairs gave on to the boulevard du Parc Montsouris. It was a small house, a little studio and a little room. It was kept nicely because Gala was very orderly.*[22]

Bettina Bergery, wife of Gaston Bergery, the Radical-Socialist deputy, whom Dalí once described as a "praying mantis married to a Stendhal,"[23] remembered that Gala would give visitors meals made of mysterious little things. At that time it was unusual to eat raw mushrooms in salad.

> *You would have a wonderful dinner and then she would proudly tell you how little it cost her. She was always thinking about two centimes and where she could buy the cheapest bread. I can still see the little scrunchy way she would wrinkle up her eyes when she was thinking about money. . . .*
>
> *They always fitted in with everybody quite easily; Dalí had charming manners, you know, he was very well brought up, and Gala knew how to manage also. I think that Dalí would perhaps have been more sauvage if it hadn't been for Gala because she understood the price of meeting people, and the importance of meeting people, and of course she encouraged it. She's the one who made the connections, kept up with people and all that.*[24]

Prince Jean-Louis Faucigny-Lucinge observed that in those days Paris was very different, that society and artists mixed socially much more than they do now.

> *We often went out together, the Dalís, my wife, and myself. The conversation was about painting, plays, cinema; the cinema played a great part in all our lives at the time. We used to go to fairs at Neuilly or to Luna Parc and dine out together. They were charming. He was young and gay and full of interest and curiosity. He hadn't yet developed the fake madness. That came later, when he built up his personality. I always thought that he played at being mad, but that at the same time he was also a little bit mad inherently. It was always difficult for him to make the distinction between reality and fiction.*
>
> *. . . And then Gala was very attractive, intelligent, and gay. She didn't show herself to be the bitch that really was her true character. She was full of charm at the time, and we didn't see that she would develop into the hard-boiled woman she became. We saw later how hard she had been with Eluard, her former husband, who adored her to the end, and how she completely neglected her only child. . . . Gala and Dalí used to visit us often in the summer; we went to Corsica, for instance. And there were my two daughters, my two elder daughters, who came with us, and never once did Gala talk about her own daughter.*
>
> *She was as hard as nails. She disciplined Dalí, kept him in order; and he always adored her. At the time he worked very hard. They really had no money at all, and it was when I believe he did his best work. He was much simpler at that time. His extravagant side developed much later, and I think it was really America that did it because, quite cleverly, he felt he had to develop an extraordinary personality there, which he did.*
>
> *He had the most agreeable and intelligent conversation, and it was very original. He was well-informed, but politics and events of the day did not interest him. His mind was always on metaphysical subjects and that kind of thing. There is no doubt that he was a genius. He had conceptions of the greatest originality. I realize that genius is a big word, but I thought at once he was a very great painter, as soon as I saw that first picture I bought.*[25]

L'Age d'or, which had finally received the approval of the censors, was shown from November 28 to December 3, 1930, at Studio 28 without anything untoward occurring. But on Wednesday, December 3, the *"commissaires"* of the Patriots' League and representatives of the

Anti-Jewish League interrupted the show by throwing violet ink at the screen and screaming at the moment in the film when the monstrance is placed in a stream. Slogans such as "We shall see if there are still Christians in France!" and "Death to Jews!" were shouted.[26] Smoke bombs and stink bombs were thrown, and the spectators were bludgeoned.

Then, going into the foyer, which had been set up as an exhibition hall, the demonstrators destroyed paintings by Dalí, Ernst, Man Ray, Miró, and Tanguy, tore up books and magazines, and cut the telephone wires. Nevertheless, the spectators stayed until the end of the film and, as they left the wrecked cinema, dictated and signed a protest against the demonstrators. The damage was estimated at 80,000 francs.

Right-wing newspapers latched on to the incident as a reason for demanding the withdrawal of the film. The Patriots' League sent a communication protesting against the immorality of this "Bolshevist show," which attacked religion, the state, and the family. They demanded the intervention of the police, stating that the damage had been done by the crowd. The police prefect of Paris, a Monsieur de Launay, called a meeting of the Municipal Council. The Ministry of Public Education was dragged in, too, and on the evening of December 6, Monsieur Mauclaire, the manager of Studio 28, was ordered to delete from *L'Age d'or* "two sequences with bishops," which were duly taken out of the film. But this was not the end of the story; Mauclaire was summoned to show the whole film to the Board of Appeals of the Bureau of Censorship on Thursday the eleventh.

Meanwhile, Launay wrote an open letter to the chief of police denouncing the film and coupling it with the magazine *Le Surréalisme au Service de la Révolution* and the works of its collaborators, whom he collectively termed "scum." Commenting on this letter, the newspaper *Le Figaro* invited the chief of police to stamp out Surrealism altogether.

On the eleventh, the film was banned. All existing copies were confiscated, except one that was missed at Studio 28 and one other that was at Mauclaire's house. So great was this scandal that the Vicomte de Noailles was asked to resign from the Jockey Club, partly because he had backed the film and partly because the film included a scene of a garden party at the Noailles'. For this a musicale had been arranged, a little quartet playing compositions by some of the more

fashionable young composers—Georges Auric, Darius Milhaud—and Paris society had been invited:

> *They were filmed for the cinema, applauding politely, in all their summer finery, a pretty little divertissement by Poulenc. But when the film was projected they were no longer applauding the quartet. Their lorgnettes and politeness were focused on a brutal scene of erotic violence and ecstasy. . . .*[27]

A warning note was sounded in *L'Humanité* by Robert Caby, who, writing on December 13, pointed out that "an exposition of Surrealist paintings that decorated the walls of Studio 28 were vandalized. . . . Consequently one might ask oneself if the censors and the police will be long in attacking plastic works of art that were, in the past, so inoffensive in their golden frames, and that are now judged too revolutionary and perilous. . . . Just when will the time come that a showing in public of the works of Dalí will be banned?"[28]

Two days later, on December 15, Dalí published *"La Femme Visible,"* which dealt with *The Great Masturbator:*

> *The Great Masturbator, his immense nose reclining upon the onyx floor . . . in order to render the desirable horror of this flesh—triumphant, rotting, stiff, belated, well-groomed, soft, exquisite, downcast, marconised, beaten, lapidated, devoured, ornamented, punished—invisible or at least unperceived by the human face that resembled that of my mother.*[29]

"La Femme Visible" has sections on "The Putrescent Donkey," "The Sanitary Goat," and "Love," and includes a theoretical excursus introducing the paranoiac-critical method that Dalí defined as a "spontaneous method of irrational knowledge based upon the interpretative critical association of delirious phenomena."[30]

"La Femme Visible," far from breaking new ground as far as Dalí was concerned, represented the culmination of the theories he had begun to develop with Lorca, Buñuel, and Pepín Bello at the Residencia, and which he had refined during the five years since he left. As Dalí became more central to the Surrealist group, so this treatise became one of its rallying points and established him as a thinker as well as a

painter. Breton now accepted the paranoiac-critical method as an innovative and valid Surrealist ploy.

Dalí's paintings, too, at this time, while being nominally influenced by the work of Ernst and Tanguy, show how his syntax and iconography had developed in a markedly individual way. The technique of the paintings, on the other hand, had not developed; Dalí was still preoccupied with re-creating the texture of Dutch masters like Hieronymus Bosch, which he had admired since his days in Madrid, and with achieving an almost photographic verisimilitude to his waking dreams.

Dalí had become famous, or infamous, partly because of the *L'Age d'or* scandal. But a number of potential patrons had been frightened off, including the Vicomte de Noailles, who wrote to him at the end of the year to the effect that, for the time being, he felt it politic not to buy new paintings. Perhaps this was because the Vicomte's mother had had to make special intercessions with the Vatican to stop her son's being excommunicated from the Catholic church as a result of the *L'Age d'or* scandal.

It was a time of paradox: of great deprivation, on the one hand, and increasing fame, on the other. Dalí decided that if people were too frightened to buy his paintings, he would turn his agile brain to inventions that Gala could then sell. He invented artificial fingernails with tiny mirrors in which one could see oneself; furniture in Bakelite that could be molded to fit the contours of the buyer; cleverly combined makeup that would eliminate shadows; shoes that could be provided with springs to augment the pleasure of walking; dresses that would have insets and anatomical paddings calculatingly and strategically disposed in such a way as to create a type of feminine beauty corresponding to a man's erotic imagination.

Dalí was half a century ahead of his time with these inventions. One has only to think of training shoes with sprung soles, or the work of the fashion designer Jean-Paul Gaultier. Ahead of his time, too, were certain experiments with found objects, which were the precursors of pop art. His painting *Fireworks* is a prime example: Dalí depicted the fireworks in a highly colored, diagrammatic style reminiscent of a turn-of-the-century catalog. He experimented with fin de siècle painted busts, which he repainted and crowned with found objects and loaves of bread.

Every day, after their meager lunch cooked by Gala, which often

consisted of vegetables for which she had foraged in the local market, she would set out to try and sell these inventions, taking buses all over Paris to do so. So persistent was she that the dealers christened her *"La Gale"*—*gale* meaning both a shrew and scabies, an irritating skin disease. She grew very bitter about these abortive attempts to sell Dalí's ideas and once told an American collector that she had come to hate the Jews "because they would always try to feel me up before they'd buy a painting. Just because I was the artist's woman, they thought I'd do anything to sell his work."[31]

Every evening she came home pale, tired, and unsuccessful; and Dalí admitted in his autobiography that they would often sit and weep before going out to the friendly darkness of a neighborhood movie theater. But Dalí made the point that, even though they were hungry and poor, "never did the dirty ears of Bohemianism enter our home. . . . Never have either Gala or I yielded a single inch to the defeats of the prosaic that financial difficulties drag in their wake. . . . Thanks to the strategist that Gala became on these occasions, external difficulties made us on the contrary harden our two souls even more."[32]

If they had a little money, they ate soberly at home; they hardly went out, for they both felt that their strength lay in the fact that they always lived a healthy life without smoking, without taking drugs, without sleeping around; it was as if they were in strict training for their future. Together they continued to live as much alone as Dalí himself had lived during his childhood and adolescence. It was, he wrote, necessary to leave an area of free space around one to be able to run away from time to time.

For Dalí and Gala this free space was Cadaqués.

The first months of 1931 were spent in Port Lligat. They left Paris from the Gare d'Orsay in late January "loaded as bees"[33] with ten suitcases stuffed with books, photographs of morphology, insects, architecture, texts, and Dalí's endless notes. They took with them a whole collection of butterflies and leaf insects mounted under crystal, together with gasoline lamps and heaters, for there was no electricity in Port Lligat. Dalí's painting supplies by themselves made a whole pile of baggage, among which was a huge revolving easel.

It was bitterly cold in Port Lligat, and the four-meter-square *barraca*

heated with gasoline stoves did little to keep out the Tramontana. The walls were damp with condensation and they tried to dry them by turning gasoline lamps on. At the end of the second day, they were visited by Lidia Nogueres, who sat on a little chromium stool at the foot of the large double divan on which Dalí and Gala lay. She had come to make their supper and brought a live chicken, which she killed with a pair of scissors. She then proceeded to pluck it, and feathers floated around the room. Next she eviscerated it, laying its entrails on a crystal dish next to a rare copy of facsimiles by Giovanni Bellini. When Dalí protested, she told him, as she had done before, that bloodstains were easily removed.

The villagers of Cadaqués were still very hostile. Dalí and Gala spoke only to the Port Lligat fishermen, to Lidia, and to another local eccentric, Ramón de Hermosa, who made a life out of doing nothing, being given to saying: "There are years when you don't feel like doing anything." At night, the fishermen and the mad maid that Lidia had found for them left for Cadaqués. Port Lligat was then deserted, save for Dalí and Gala, and their neighbor the defrocked priest. It was in these solitary hours between nine in the evening and five or six in the morning that, free from interruption, Dalí continued to write, while Gala tried to classify his notes and put them in order, whereupon he would promptly scramble around in them to find something and so upset her careful collation or make her unpack one of the many suitcases in search of something he might need for his work.

For the spoiled, pampered son of the notary it was a bitter, hard life, and his paintings reflected this, becoming smaller, with an air of desperate sadness. The colors are colder and weaker, and a certain fundamental spiritual tiredness appears to have taken over from mental agility, jeux d'esprit, and hallucinations. It was a life that was "hard, without metaphor or wine, a life with the light of eternity. The lucubrations of Paris, the lights of the city and of the jewels of the rue de la Paix, could not resist this other light—total, centuries-old, poor, serene and fearless as the concise brow of Minerva."[34]

He told Gala that it was mostly with her blood that he painted his pictures, and his habit of signing her name with his (dating from early 1931) reflects his growing dependence on her encouragement and unerring eye. Gala was as involved and excited by a new work as if she

had painted it herself, as indeed in a sense she had, so minutely detailed were her criticisms and help.

In the forenoon, after a frugal lunch of fresh fish or his favorite sea urchins, Dalí would take long walks up the hill in the direction of Cadaqués, past the graveyard. He could see his father's house in the distance and it seemed to him to be like "a piece of sugar—a piece of sugar soaked in gall." As a special treat, when he had finished a painting, he and Gala would go off with the fishermen for a feast of fried sardines and chops on Cap de Creus.

In June 1931 they went back to Paris for his show at Pierre Colle's gallery. Here, Dalí exhibited *Sleeping Woman Horse Invisible Lion,* which he described as the fruit of his contemplations of the rocks of Cap de Creus while being rowed past them by the fishermen. This was bought by the Vicomte de Noailles, together with *The Dream;* the *L'Age d'or* scandal had obviously died down. *The Profanation of the Eucharistic Host* was bought by Jean Cocteau, and André Breton bought *William Tell.* A little later, the Prince Faucigny-Lucinge bought *The Tower of Desire.* The exhibition was a financial and critical success, for the critics in Paris, who had tended to dismiss Dalí as a Surrealist poseur, were now more seriously interested in the paintings than in the personality of the man who had painted them.

Julien Levy, a young art dealer in New York, first met Pierre Colle in Paris just before the Dalí exhibition, when Colle was arranging for Dalí's paintings to be shipped from Spain. Levy knew of Dalí's paintings and was interested in cooperating in a Dalí exhibition in his New York gallery but was worried about the reaction of the distinctly philistine American Customs Bureau to some of his imagery. They had, after all, impounded Brancusi's *Bird* some fifteen years previously. Colle was at pains to reassure Levy that, of the three paintings *"sans ordure,"* one was still available. It was *The Persistence of Memory,* and Levy bought it for $250. The other two works *"sans ordure"* that had been bought by Americans were *The Feeling of Becoming,* purchased by Mrs. Murray Crane, and *Au Bord de la Mer,* bought by A. Conger Goodyear, then president of the Museum of Modern Art board of trustees.

In his book, *Memoirs of an Art Gallery,* Levy tells of his first meeting with Salvador Dalí in the summer of 1931. The two men must have

looked like positive and negative. Levy wore a white duck suit and a Panama hat. Dalí turned up dressed in a black pin-striped suit, a black shirt, a crimson tie, and what Levy subsequently thought may well have been orange shoes. Levy was impressed by Dalí but found

> *him disquieting. . . . He has never ceased to be so [to me], not because of his ambiguity, but rather by his single-minded intensity and frankness. He fixed his piercing black eyes on me, he crowded against me, his restless hands alternately picking at my sleeve or suit lapel, or fluttering emphatically as he described his very newest, his most revolutionary of all Dalinian theories. . . . He bombarded me with staccato mispronunciations of the French language that would seem untranslatable and incomprehensible, except that their intensity propelled them directly from his conception to my reception—as if the words were not conveyors but merely an accompaniment of background noise.* "Les comedons authendiques, les brais comedons scubdur superiorre d'anderrior, brotte combisiffmong." *Every possible consonant became a percussive b and all rs were violently rolled. Thus the bbbarrage. In French, it translates to* "Comédons authentiques,* vraie sculpture supérieure d'intérieure, frottent convulsivement" *[Authentic snot, real and superior sculpture from the interior, rubbed convulsively].*[35]

But so impressed was Levy with Dalí's work, if not with his French, that he decided to put on an exhibition in New York of the works unsold at the Colle gallery.

At around this time, Dalí met Alfred Barr, director of the Museum of Modern Art, at the Noailles'. Dalí later told André Parinaud that Barr was "a nervous young man of cadaverous paleness, but fantastic plastic culture, a veritable radar of modern art, interested in every type of innovation and disposing of a budget larger than that of all the museums of France combined."[36] Here was a patron worthy of Dalí's ambition, and it would seem that Alfred Barr recognized in Dalí the alchemy that would convert an eccentric Catalan Surrealist into an American celebrity. He told Dalí that he should come to America, where he would be a lightning success.

Although three of Dalí's paintings had been shown in 1928 at the Carnegie International Exhibition in Pittsburgh, these predated his

* *Comédon* is in fact French slang for "blackhead."

Surrealist days, so when A. Everett (Chick) Austin, the young and experimental director of the Wadsworth Atheneum in Hartford, Connecticut, decided to introduce the work of the Surrealists to the worthy citizens of Hartford and its purlieus (prompted by his friend Julien Levy), it was the first time that Dalí's Surrealist works had been seen in America.

Chick Austin introduced the exhibition as follows:

> *These pictures which you are going to see . . . are chic. They are entertaining. They are for the moment. We do not have to take them too seriously to enjoy them. Many of them are humorous. . . . Some of them are sinister and terrifying: but so are the tabloids. It is much more satisfying aesthetically to be amused, to be frightened, even, than to be bored by a pompous and empty art which has become enfeebled through the constant reiteration of outmoded formulae.*[37]

In addition to *The Persistence of Memory,* the paintings shown in the exhibition that opened in November 1931 were *Fantaisies Diurnes, Le Lever du Jour, L'Homme Poisson, La Solitude,* and *Paysage avec Chaussure,* all of which had prices attached, even though they were being exhibited in a museum. Austin bought *La Solitude* for $300, leaving Levy to sell *The Persistence of Memory* from the group Surrealist show he put on in December 1931 to a Museum of Modern Art trustee, Mrs. Stanley B. Resor of New York.

The Persistence of Memory, of all Dalí's paintings, can truly be said to be a twentieth-century icon. Dalí had been interested in the concepts of "soft" and "hard" for some considerable time in his paintings, but the genesis of the "soft watch" is of particular interest. Dalí had stayed at home one night with a headache when Gala and other friends went out to the movies after dinner. Musing in the quiet flat, his glance took in the remains of a Camembert and he thought of the philosophy of the "super soft"—the hermit crab in his protective shell—and thus of his own psychological makeup, the outer hard shell that had become a necessary fortress protecting the inner hermit crab Dalí from the world.

Going into his studio to look at a painting then in progress, Dalí realized that the landscape near Port Lligat represented a potential setting for some surprising image. Suddenly he "saw" two soft watches

and painted them. When Gala came back from the movies, he asked her whether, in three years, she would have forgotten the image that had suddenly appeared, and she told him, quite rightly, that no one could forget it once they had seen it. *The Persistence of Memory* exercises a fascination on all who see it. It has been made fun of, used commercially, and become as much part of the furniture of the collective subconscious of the twentieth century as, say, Man Ray's *Le Violon d'Ingres*.

Before the Colle and New York shows started to improve their fortunes, Dalí and Gala were living in considerable poverty, though they made it a *pundonor* (point of honor) never to let their material difficulties be known. "Dying of hunger is nothing, provided everyone else thinks you are dying of indigestion,"[38] Dalí said in later, more prosperous years. They continued to mount sorties into Parisian high society through the Prince Faucigny-Lucinge, his wife, Baba, and the Noailles. The two of them were often invited to dinner, but rather as if they were a cabaret act, a fact that Dalí was not slow to exploit. His pronouncements on paranoiac-critical painting were new enough to titillate the jaded appetites of such *salonnières* as the Princesse de Polignac.

He became more loquacious and outspoken, his timidity decreasing at the same time as his respect for Paris society, as it started to court him, increased. It was not long before many grandes dames adopted certain forms of Dalispeak. "My dear, I have a phenomenal desire to cretinize you. . . . For two days I haven't been able to localize my libido. . . . How was Stravinsky's concert? It was beautiful, it was gluey! It was *ignominious!*"[39] Things began to be defined in Paris society as being "edible"; Dalí termed his language "crudely Catalonian" and believed that it was, in effect, "extremely suited, as it spread by contagion, to filling in the gaps between bits of real society gossip."

In 1931, Dalí and Gala were introduced to Caresse Crosby by René Crevel. Mrs. Crosby was an expatriate American, the recent widow of the sun-worshiping Harry Crosby, the nephew of J. P. Morgan, the banker. She was intelligent and cultivated, and had money enough to fund a small private press that published Ezra Pound, D. H. Lawrence, and James Joyce under the Black Sun colophon. Mrs. Crosby was keen to keep abreast of new trends in Paris life and determined to have a

smart Surrealist lunch. The party took place at her apartment in the rue de Lille. The Aurics—Georges, the composer, and Nora, his wife— were at the lunch, as were the Edouard Bourdets (he the author of the notorious lesbian-themed drama *La Prisonnière*) and René Crevel. In his autobiography, Dalí remembered the luncheon as being entirely white: They ate cream of celery soup, breast of chicken with rice, little boiled onions, blancmange with cream, and, to finish, marshmallows with white mint. Dalí also wrote that Mrs. Crosby wore white shoes and white stockings. (Later she said that she had not and that she did not believe the rest.) The occasion was a success, and the Dalís were asked to spend the weekend at the Moulin du Soleil, a house with a great deal of history.

Harry and Caresse Crosby had bought it some years previously from Armand de la Rochefoucauld, the Duc de Doudeauville, on whose estate it was situated. The Moulin had been abandoned for years but had once been lived in by Jean-Jacques Rousseau and by Count Ca- gliostro the magician, mesmerist, and alchemist. Surrounded by trees, it was on the edge of a forest containing deer and wild boar. Nearby was the mysterious Mer du Sable, a huge sea of sand that had risen from the forest floor five centuries before. The Moulin itself consisted of the towered millhouse and a courtyard on the other side of which was a ruined stable. The Crosbys had a swimming pool built and fed it from the millrace. On the ground floor was a huge cobbled banquet hall with a fieldstone fireplace. The former hayloft was broken into ten bedrooms, each of a different color; they were small and simply fur- nished. Above, beneath the eaves, was an attic room where guests could relax and listen to the latest gramophone records from America.

Dalí and Gala became frequent visitors to the Moulin, and he de- scribed a representative weekend there in the early 1930s:

> We ate in the stable filled with tiger skins and stuffed parrots. There was a sensational library on the second floor and also an enormous quantity of champagne cooling, with sprigs of mint, in all the corners; many friends came, a mixture of Surrealists and society people who sensed from afar that it was in this Moulin du Soleil that "things were happening."[40]

On that first weekend of many, Julien Levy had brought with him a movie camera and, naturally, spent his time making a very Surrealist

home movie. Caresse Crosby remembered "one shot when Max [Ernst] appeared to hurtle from the parapet of the sun tower, and then his shirt and trousers, empty of the body, went swirling through the air to lie limp upon the cobblestones below. The shirt was kicked aside into the pool while the trousers walked disconsolately away into the forest. Presently Max's arm, back in the shirt, beckoned to us from a watery grave."[41]

Dalí took part in this and may even have tried to direct it, judging from an aside in his autobiography to the effect that he was "present, by chance, at the shooting of a lamentable comic film in which, without advising me, they were utilizing most of my rejected ideas. It was idiotic, badly done and completely pointless—a disaster."[42]

Although Dalí's finances had begun to improve, another worry recurred: Gala was not well. She had recovered from pleurisy the year before, but her breathing became labored again and the specter of tuberculosis haunted her. In August she and Dalí went with René Crevel, who was in fact suffering from tuberculosis, to Vernet-les-Bains for the fresh air. They stayed in the Hôtel Portugal, where they were joined by Eluard for a few days. On the twentieth he went back to Paris, and the other three went on to Port Lligat, where they stayed for September and October.

The three got on extremely well. Their triangular relationship echoed, in a sense, other triangles from earlier years, and it is possible that the homosexual Crevel had become attracted to Dalí, but nothing seems to have come of it. They played games, experimenting with photography, using the shadows cast upon a sheet to create the same solarized shadow effects that Dalí (inspired by Man Ray) had used in his painting *The Old Age of William Tell*. They sunbathed, and started to make a garden at the back of the *barraca*, putting up a row of Romanesque columns they must have found somewhere locally.

Crevel was working hard on his book *Dalí ou l'Antiobscurantisme*. This brief text was published in November 1931 and explained not only the two "subversive" films, and the multiple images in *Sleeping Woman Horse Invisible Lion*, but also discussed the paranoiac-critical method and, among other things, the significance of William Tell, which Crevel compared to the Oedipus complex discovered by Freud.

As September wore on, the damp *barraca* took its toll and Gala became worse. By the end of October, even Dalí had become worried, and he took her to Barcelona for X rays. While Gala was having her tests, Dalí reacquainted himself with what was happening in Barcelona and with his Catalan friends. Dalí and Gala went back to Paris at the end of November no wiser about what was wrong. They had virtually run out of money again, but it was obvious that Gala needed to consult a specialist, so, borrowing from Eluard, who was now very hard up himself, Gala underwent further tests by a Dr. Jacquemaire. A diagnosis was reached that a fibrous tumor was growing inside Gala's lung and had to be removed. The operation was successful and cured her of her chest problems, but it also revealed another tumor, in her uterus, and she had to undergo a hysterectomy which was still so painful to her that, forty years later in describing the operation to a friend, she cried, saying the doctors had "emptied" her.

Did this operation contribute to Gala's rampant libido? It is clear that she valued sex, its quantity and its frequency, as a measure of her success as a human being. Her self-image, apart from her dual existence with Dalí, was entirely bound up in her sex life. After all, it was the only part of her life she did not share with Dalí; it was the only part of her life to which she had exclusive ownership. But later, her nymphomania, for so her exhibitionism and troilism became, arose out of her constant need to prove that her identity was separate from the Gala-Dalí construct she had built so carefully and with such self-sacrifice.

To help her recuperate from the operation, Dalí took Gala back to Port Lligat at the end of January 1932. Eluard wanted to join them but could not get a laissez-passer to Spain because of his self-declared communism. He had therefore to write Gala long letters from Port Grimaud, where he had gone with Nusch. These letters, written every five days or so while Gala was in Port Lligat, mainly contain anxious inquiries after her health, but from time to time Eluard reminds Gala of their continuing sex life, unhindered by his relationship with Nusch and her relationship with Dalí. On February 6, for instance, he writes, "I saw a naked Arab dancer in a film who looked like you. What longing it gave me for you. I love, I adore your eyes, your mouth, your breasts, your arse, your legs, your sex, their colour."[43]

Meanwhile, in Paris, the rupture between Aragon and his fellow

Communist sympathizers, and Breton and the Surrealists, widened, and Dalí was writing to Breton on March 2: "In Barcelona, Soviet films have aroused the enthusiasm of the most bourgeois public, the most Catholic artists and curators; they say that it amounts to a confession of all that is healthy."[44]

In March, Dalí and Gala were visited by Breton and Valentine Hugo. Valentine had also had a brief affair with Eluard and had subsequently become very friendly with Gala (she was probably Gala's only woman friend). The foursome was photographed at Port Lligat and on Dalí's favorite rocks at Cap de Creus.

Dalí and Gala stayed at Port Lligat until the beginning of May 1932. In March, Eluard wrote to Gala that the break with "Ara[gon], Buñ[uel], [Pierre] Unik, [Georges] Sadoul and [Maxime] Alexandre" had actually taken place. Eluard thought that "Surrealism would be a good deal stronger than before. Remaining: Breton, Ernst, Crevel, Char, Tanguy, Tzara, Thirion, Péret and I. Giacometti is not too sure."[45]

Why did he leave out Dalí's name? Dalí was an integral member of the group and certainly was not about to join the Communist secessionists. Perhaps he forgot. Several days later, in a subsequent letter, Eluard asked Gala to make sure Dalí wrote to Crevel to insist on the force to be given to the pamphlet against Aragon, and ten days later he told Gala of his own pamphlet, *"Certificat,"* against Aragon and mentions that he has also, as Dalí did, answered "the inquiry into desire."[46]

Eluard had also been persuaded by Gala to write the preface for Dalí's forthcoming exhibition. His poem "Salvador Dalí" appeared in the exhibition catalog. "It will be a great spring for Surrealist activity," wrote Dalí to his friend J. V. Foix, then in Barcelona.

Among other projects, a very full exhibition of Surrealist objects. . . .
We are studying how to perfect a method of making up totally unforeseen
objects; hallucinations due to pure chance. I have even to tell you of the
imminent appearance of automatic sculpture.[47]

At the same time, Dalí was writing to Cassanyes, another friend in Barcelona, that he was going to Paris and taking six pictures, a multitude of objects, a book on painting, "and also a sort of novel."[48] The two books he referred to were *La Peinture Surréaliste à Travers les Ages*

and the unpublished novel *La Vie Surréaliste*. By the end of April, Dalí, Gala, Eluard, and Nusch were all back in Paris, and Dalí and Gala were putting the finishing touches to his new show.

Dalí's second exhibition at the Galerie Pierre Colle opened on May 25 and was a great success. Foix, who had reviewed Dalí's first one-man show at the Galeries Dalmau and had later been involved with Dalí when he was contributing to *L'Amic de les Arts,* mentioned the Colle show in *La Publicitat* under the title "An Important Dalí Exhibition in Paris," listing the works shown. For the next four years Dalí kept his friend in touch with Surrealist events in Paris. It is possible that he was using him as a messenger to the other Catalan intellectuals he had recently savaged in *Le Surréalisme au Service de la Révolution.*

On July 12, 1932, Dalí published *Babaouo,* brought out by René Laporte under his Cahiers Libres imprint. This was a scenario for a Surrealist film written because Dalí felt that, contrary to current opinion, the cinema was infinitely poorer and even more limited in terms of the expression of the functional reality of thought processes than were writing, painting, sculpture, or architecture. The scenario might also have been a riposte to Buñuel's by now well-known assertion that Dalí had little if anything to do with *L'Age d'or* and may have been an effort to reestablish his reputation as a Surrealist cinéaste.

Dalí's preface contained some sweeping statements. The only thing worse than films, he maintained, is music, in which the spiritual value, as everyone knows, is virtually nil. He went on, at considerable length, to cite examples to illustrate his thesis, applauding the Marx Brothers and the infinitely prosaic look of Charlie Chaplin at the end of *City Lights.* And then comes his scenario, which takes place in "it does not matter which European country" during a civil war. The playing of the *"Renacimiento"* tango is heard as a leitmotif throughout the film. The scenario contains no dialogue but gives specific instructions; at one point Babaouo hears hysterical laughter and the sound of objects being thrown around in the hotel room he is about to enter, and Dalí suggests that a recording of laughter, cataloged as "Pathé X 6285," could be used for the scene. The film was never made.

By the second half of July, Dalí and Gala were back in Port Lligat, where they remained until October, apart from a brief visit by Dalí to Barcelona, where he met Foix at the Café Royal. He wrote to Breton to tell him he had been to *Le Chemin de la Vie,* which was "the most

boring film" he had ever seen, but which the young Catholics had enjoyed because of their "exemplary morality."[49]

Dalí was working twelve hours a day, he told Foix in a letter he wrote at the end of November, in which he mentioned the English review *This Quarter*, owned and published by Edward Titus (using his wife, Helena Rubinstein's, money). *This Quarter* had just published a Surrealist edition to which Dalí had contributed an article he called "The Object as Revealed in Surrealist Experiment." Dalí directed Foix's attention to the theory contained within this article of the "phenomenon of the 'cannibalism of objects,' cannibalisms of minerals being lava and other geological extremes, states of fusion, edible composition of mineral and inedible."[50]

The phrase "cannibalism of objects" recurs again and again in letters and other writings of Dalí's during 1932, and may have represented a new source of inspiration for him. Certainly he began to turn more toward the creation of Surrealist objects rather than simply painting.

Back in Paris in November 1932, Dalí and Gala reestablished themselves at their studio in the rue Gauguet. Eluard and Gala divorced so that Eluard could marry Nusch.

Brassaï took a picture of Gala and Dalí in their studio in the winter of 1932. Dalí stands with his back to the wall, his arm around Gala's shoulder. She catches his hand in hers. Beside them is an as yet unadorned fin de siècle bust. On the other side of the doorway hangs *The Great Masturbator* above a writhing Art Nouveau vase whose handles twist and turn to become a predatory lily. This stands on a wind-up gramophone, which in turn stands on a modernist chrome side table. Glimpsed through the doorway is another room with strange shapes pinned on the wall.

The couple seem to emerge hydralike from one body, as Dalí's trousers and Gala's skirt occupy the same shadow. They also look very far away from the camera, but this is a psychological rather than merely a physical distance. Notable is the penetration of Gala's eyes and the fact that, of the two of them, she is the more upright; Dalí seems not only to be leaning on but also to have become welded to her.

Brassaï had been introduced to them by Picasso. Later, when Dalí

decided to relaunch Art Nouveau as a counterblast to the prevailing fascination with Negro art and African primitivism, Brassaï collaborated with him. Brassaï's photographs of "houses with contorted façades, columns of 'fevered flesh carved from spun-sugar, the work of a confectioner' . . . as well as Hector Guimard's Métro entrances with their exotic decorations,"[51] were eventually published in the arts magazine *Minotaure,* together with Dalí's text "The Terrible and Comestible Beauty of Art Nouveau," another instance of his new inspiration derived from the "cannibalism of objects" and fueled by his anti-modern-art stance. Many years after this article had appeared, Louis Aragon wrote that "it must not be forgotten that the fuss about modern art began at the end of the twenties, and that in this respect— and to Dalí must be given his due—he was John the Baptist."[52]

That winter of 1932, Dalí had a three-day exhibition at the Galerie Pierre Colle to raise money, even though he had very little new work to show. There were eleven paintings in this small exhibition, presumably painted in the five months since Dalí's June show in the gallery. There is no record of how the paintings sold, but Dalí and Gala were so hard up at the beginning of 1933 that Gala decided that they would throw themselves on the often mercurial mercy of their potential customers, those avant-garde members of high society they now called their friends.

It is not known who thought up the concept of the Zodiac group, but the Prince Faucigny-Lucinge remembers that Gala came to see him. "She said, 'We have a very hard life and I don't want Dalí to commercialize himself,' which was not at all the case in years to come, but at that time they were pure. So she said, 'Could you find twelve people who would each ensure a month of the year for our living?' "[53]

The Prince found the twelve without difficulty. They were the Vicomte de Noailles, the architect Emilio Terry, the expatriate American writer and diarist Julien Green, Julien Green's daughter, Caresse Crosby, the Comtesse de Pecci-Blunt, the Marquesa de Cuevas de Vera, the illustrator André Durst, René Laporte, the Prince himself, Felix Rolo, and Hubert de Saint-Jean. "Each of us," recalled the Prince, "had a right to two etchings or one picture done in the particular month we drew in a lottery. And then, at the end of the year, we all met for dinner, a picnic dinner, at the Dalís' studio, where there was a little auction, and at that auction someone won a picture."[54]

Julien Green's month was February, and on the twenty-sixth he went to Dalí's to get his picture.

> *I am given the choice between a large painting with an admirable land-scape of rocks as a background, but with the foreground taken up by a sort of naked and whiskered Russian general, his head sorrowfully bent to show the shells and pearls that pepper his skull, and a small picture in wonderful shades of gray and lilac, plus two drawings. I choose the small painting. Dalí talks to me about Crevel, who is ill but "estoical." He enlarges greatly on the beauty of his own painting, carefully explains the meaning of my picture, which he calls the "Geological Transformation" and which represents a horse turning into rock in the midst of a desert. He is going to Spain and speaks with terror of the customs formalities and the thousand petty annoyances of a trip by ferrocarril, for he is a little like a child who is scared by life.[55]*

Green became very friendly with Dalí and often used to visit him in his studio where he worked

> *from six in the morning to the Angelus at night. He enabled me to discover his world with its singular geography, its fauna and its anamor-phic characters. To penetrate this* terra incognita *one needed a key which resembled the key of* les songes *and which was generally not to be found. Dalí in a gay way spoke of unconsidered things which on reflection were very sensible, the work of a mind of superior tone.[56]*

Other new commissions began to flow Dalí's way, the first of which was to illustrate that seminal Surrealist text, *Les Chants de Maldoror* by Lautréamont, with forty acid engravings. The commission came from the visionary Swiss publisher Albert Skira, who had already published two previous deluxe illustrated books, the *Metamorphoses* by Ovid, which had been illustrated by Picasso, and some poems by Mallarmé, illustrated by Matisse. Dalí had been recommended to Skira by Picasso, who was generally very supportive of his young compatriot during those first difficult years in Paris. Both painters worked together on engravings in Lacourière (a studio that still exists in Montmartre). Skira sold the even numbers of the first hundred copies of *Les Chants,* keeping the odd numbers for later sales. The engravings are exquisitely delicate, demonstrating the startling power and sure-

ness of Dalí's draftsmanship and his sense of spatial composition within a very confined area. They also contain a virtual dictionary of his iconography at the time: the amorphous objects, the soft objects, the grasshoppers, and the lions.

Skira also involved Dalí in the new magazine he was putting together, *Minotaure,* an avant-garde art review in a large format edited by the critic Tériade. The first issue, which came out in May 1933 with a cover by Picasso, was eclectic, and linked to various art circles, but was by no means as experimental as had been the various small Surrealist magazines.

Minotaure became a very important magazine to the Surrealists, for *Le Surréalisme au Service de la Révolution* ceased publication with a double number in May 1933, leaving the movement without any coherent vehicle for putting its views across to the public. André Breton began writing for *Minotaure* from the first issue. Gradually, over the next three years, the Surrealists became the dominant factor, and *Minotaure* gave them the perfect medium for projecting their activities to a much larger international public and for putting forward the idea that Surrealism had a growing influence in all fields of intellectual activity, not just in painting and writing. Eventually and inevitably the Surrealists took over. They got rid of Tériade and formed an editorial board, led by Breton, supported by Eluard, Duchamp, Maurice Heine, and Pierre Mabille, which ran the magazine for the remainder of its life; the last issue, No. 12/13, was published in May 1939.

Dalí was an enthusiastic proselytizer for the new magazine and wrote to Foix asking him to encourage his friends to take out subscriptions. "*Minotaure* . . . will be a really sensational review by virtue of its literary content and really extraordinary documents. I believe that its dissemination in Catalonia could be interesting—and not comparable with the usual shit of *Cahiers d'Art* and other reviews long since mummified."[57] Dalí was involved one way or another with *Minotaure* in all its issues. His contributions varied from covers to articles on Art Nouveau to features on Gaudi, with photographs by Brassaï in Paris and by Man Ray in Barcelona.

Not everything was going Dalí's way, however, in these early months of 1933. Dissenting voices could be heard, among them that of "Joan Sacs," the Catalan critic Feliu Elias's literary pseudonym (he used "Apa" for his drawings). In an article, *"El Cas de Salvador Dalí,"*

published in the weekly *Mirador* in March, Sacs attacked the author of
"La Femme Visible." Dalí had sent him a deluxe copy, signed and
inscribed. Such thoughtfulness did not prevent Sacs from writing that
he considered Dalí to be "suffering from the same and analogous inco-
herences and contradictions of other Surrealists, with reminiscences of
badly assimilated reading, a good dose of pedantry, and the naughti-
ness of a student."[58]

It is worth citing Dalí's response in full, since it demonstrates the
breadth and depth of his thought at this time as it related to the
development of his work:

> *Distinguished Friend: I'm very happy with your advice; I'm well aware of
> what you recommend. More precisely I'm making a scrupulous study of
> Greek drawings in my next book,* La Peinture Surréaliste à Travers les
> Ages. *I suppose you are aware of the psychoanalytic interpretation of
> these drawings, which reveals an indubitable relationship with certain
> pathological conditions that seem to upset you so much.*
>
> *After reading your friendly* Mirador *article, I feel obliged to recom-
> mend to you the study and consideration of the recent scientific contribu-
> tions to the problem of madness—especially the thesis of Dr. Jacques
> Lacan,* De la Psychose Paranoïaque dans Ses Rapports avec la Per-
> sonnalité *(Le François, Paris), and in general all the recently strictly
> phenomenological German studies and analyses (against the construc-
> tionalist theories). There is also Prinzhorn's book, which I am forced to
> think you know nothing of. We are aspiring to a way of thought identical
> to that of madmen, except that we are not mad.*
>
> *I much regret that your only idea of this problem was derived from the
> wretched* "L'Art chez les Fous" *by Marcel Reja, and I'm pleased that this
> object may be made up as a result of our contact. I don't doubt that a
> true knowledge of the productive cognitive value of mental and psycholog-
> ical states will make you see Surrealist activity under another light. In the
> French psychoanalytical review and in Italy there are studies and analy-
> ses of Surrealist work that are rigorously scientific.*[59]

Unrepentant, Sacs made later attacks on Dalí's art. On Dalí's exhibition
that June at the Colle gallery, he said that Dalí was "lost, lost, lost. Lost
in a Sahara the size of a telephone kiosk."[60]

* * *

From June 7 to 18, Pierre Colle showed an important Surrealist group exhibition of works by Arp, Breton, Eluard, Duchamp, Magritte, Valentine Hugo, Picasso, Giacometti, Tanguy, Man Ray, Tzara, Crevel, René Char, Ernst, Georges Hugnet, Miró, and others. Writers were included, for they had become involved in the creation of Surrealist objects and manuscripts. The list of objects included "sausages, phobias, intrauterine memories, automatic objects, objects to smell, disagreeable objects." Dalí showed two pictures, *Invisible Harp* and *Meditation on the Harp,* and an object, *Retrospective Bust of a Woman,* a polychrome figure of which several copies were made.

This group show was a major statement by the Surrealists, and served to emphasize their precarious unity after the political arguments and schisms of the early 1930s.

It was immediately followed by Dalí's third one-man show at the Colle gallery. Dalí showed some very important pictures, including *Meditation on the Harp, Gala and the "Angelus" of Millet,* and *Atavistic Dusk,* and portraits of two of the members of the Zodiac group, the Vicomtesse de Noailles and Emilio Terry.

Georges Hilaire, writing of this exhibition in *Beaux Arts* of June 30 under the title *"Chez les Surréalistes,"* commented:

> Dalí's painting is reactionary, it is self-explanatory. Picasso explains nothing, he just feels. De Chirico is a logician of the enigma (find the wolf, find the shepherd) in which he adjusts ex abrupto (des laisses-pour-compte choisis d'érudition). Salvador Dalí is the enemy of the abstract, enemy of the pictorial crossword. . . . In terms of imaginative painting he prefers the detailed and edible anecdote, the "objective hazards" of dreams, the "action objects."[61]

Hilaire concluded that Dalí's painting was the greatest work in the reincarnation of still life.

In a notable essay on contemporary Spanish painting, published in the July 1933 number of *La Renaissance,* the critic Jean Cassou, having discussed Picasso and the Catalan school, described Dalí's place in "this era of the Spanish aesthetic" as having kept his taste.

> But he employs it to confess the clearest chimeras. As a painter, he has had the extravagant courage to become an apologist of Meissonier, the

maniac of photographic detail, and that of Böcklin, master of the bad-taste allegory. His manner holds in effect with this double tradition, but affirmed and reasserted with a cynicism that re-creates a new manner. As to the themes that constitute the spiritual essence of this art, one knows all the pathetic problems that they pose, and how, in being translated directly from dreams and from the imagination, they are pure psychoanalytic matter.

August, September, and October were spent in Port Lligat. Dalí wrote to Foix that the beaches were full of nudists and that at Cap de Creus, although dreadfully disfigured by erosion, he could still make out the famous *Angelus* couple sculpted in "colossal dimensions" at the entrance of Francasos. Marcel Duchamp had that summer taken a temporary house in Cadaqués that he shared with Mary Reynolds and the sculptress Mary Callery, and Dalí and Gala spent two weeks in September with Duchamp and his friends in Barcelona, which formed the basis of a lifelong admiration on the part of Dalí for Duchamp. In Cadaqués, Man Ray photographed Dalí dressed in a sheet as a ghost and also took photographs of some of Dalí's "found objects" that were in his olive garden at the time (Man Ray had come to Barcelona to take photographs to illustrate Dalí's article in *Minotaure*). Eluard, meanwhile, who had stayed in Paris to collect the material for *Minotaure*, which he was virtually editing, wrote constantly to Cadaqués to ask for articles and paintings from Dalí.

During his time in Barcelona in September, while working with Man Ray, Dalí made arrangements to participate in a group exhibition in the basement of the Llibrería Catalunya, at 3, Ronda de San Pedro. The basement had been rented by Josep Dalmau after his gallery had gone bankrupt, and was known as Galería d'Art Catalónia. The exhibition opened on December 8 and received the support of artists and intellectuals of the avant-garde. This was some compensation for the views of the general public, who were either uninterested or treated the works with typical Catalan irony.

Dalí exhibited two oils, three drawings, twenty-seven of the forty engravings he had finished for the *Maldoror* series, and six photographs by Man Ray of well-known works such as *The Great Masturbator*. One of the oils, *The Birth of Liquid Desires*, now owned by the

Reynolds Morse Foundation, is a very strong statement—possibly Dalí's strongest statement yet—against the sexual act.

Dalí's first one-man show in New York at the Julien Levy Gallery had opened at the end of November to general acclaim. Writing in *The New Yorker,* Lewis Mumford said, "These pictures by Dalí are as inexplicable as a dream. . . . Dalí does not permit the dream to dissolve; his pictures are, as it were, from nightmares. It would be intolerable to look at them if one could not also smile, and if one did not suspect that the madman who painted them is grinning at us, too—a little impudently, like a precocious schoolboy who has mastered a new obscenity."[62]

Art News gave Dalí two separate reviews. Writing on December 2, the critic "L.E." commented, "For sheer handling of paint Dalí has points, but the subconscious that guided his brush must have been very different from the one that inspired Hieronymus Bosch."[63] Dalí showed *Nostalgic Cannibal* and *The Temptation of Saint Anthony* and, curiously, a picture called *The Enigma of William Tell,* which was also, apparently, shown at the Dalmau gallery at the same time; there seem to have been two pictures with the same title.

By December 17, Gala and Dalí were back in Paris in the rue Gauguet, whence he wrote to Foix jubilantly of the success of his show. But, as always, just when his work and his relationships with his patrons and public seemed to be going well, as it was here at the end of 1933, he would become restless and stir up some new mischief to annoy, to publicize his work, or just because his mind needed a new channel for its energy.

Dalí was nearly thirty. His painting and his writing had matured, but he was still very juvenile in behavior. He could still not go anywhere without Gala to look after money (which he would never understand), to pack his belongings, to organize every detail of his life. Having been in thrall to his father, he was now in thrall to Gala, who was strict with him. He had substituted one masochistic relationship for another. But he was free of all demands except those of his work; he was now approaching the height of his powers as a painter, and as a thinker.

6

METAMORPHOSIS OF NARCISSUS
1934–1935

D alí's relations with the Surrealists were becoming strained because
of his interest in Hitler. Breton had been horrified to receive a
letter from Dalí in July 1933 in which he wrote that he felt Hitler
had to be judged "from the Surrealist point of view. . . . Take my
advice, pay a great deal of attention to the Hitlerian phenomenon." He
was sure that the Surrealists were the only ones capable of "saying
pretty things on the subject."[1]

Hitler and Lenin, Dalí told André Parinaud many years later,
"turned me on."

> *I often dreamed of Hitler as a woman. His flesh, which I had imagined
> whiter than white, ravished me. I painted a Hitlerian wet nurse knitting
> sitting in a puddle of water. I was forced to take the swastika off her
> armband. There was no reason for me to stop telling one and all that to
> me Hitler embodied the perfect image of the great masochist who would
> unleash a world war solely for the pleasure of losing and burying himself
> beneath the rubble of an empire: the gratuitous action par excellence
> that should indeed have warranted the admiration of the Surrealists.*[2]

Hitler took a less rosy view of the Surrealists:

> *If they really paint in this manner because they see things that way, then
> these unhappy persons should be dealt with in the department of the
> Ministry of the Interior where sterilisation of the insane is dealt with, to
> prevent them from passing on their unfortunate inheritance. If they really*

do not see things like that and still persist in painting in this manner, then
these artists should be dealt with by the criminal courts.[3]

Eluard and Crevel, Dalí's strongest supporters within the Surrealist
group, had managed to keep a lid on the row he was provoking, but at
the end of 1933 they both went to Nice for health reasons, leaving Dalí
on his own. In a letter to him dated January 23, 1934, Breton wrote:

You know with which ear I am always forced to listen to certain extreme
proposals of agitation to which you have subscribed and how, for some
years, the most marked of these has been a road accident that would
affect, in particular, those traveling third-class. If I remember right, you
were trying to justify this point of view by private sexual considerations
promoting tolerance of this way of looking at things as the expression of a
perversion that would pertain to you alone and that could not produce
any sort of contagion. I should have been annoyed with myself too for not
having taken humor into consideration in this attitude and in the taste for
shocking—at any cost—the least shockable of people, which also comes
naturally to you.

For history's sake it must be admitted that your statements on the
subject have not failed to have demoralizing and, I think I can say,
weakening effects on Surrealism.[4]

Demanding a written response, Breton left the door open for Dalí's
recantation, and the next day he received a long letter in which Dalí
said that he was not intentionally "a Hitlerian [which he spelled 'Itle-
lirient'*] but I refuse to interpret or explain Hitlerism in the manner in
which it is explained by the Communists."[5] On January 25, Dalí was
summoned by Breton to sign a statement in which he confirmed that
he was not "an enemy of the proletariat."[6]

The pan finally boiled over on February 2, the first day of the Salon
des Indépendants, when Breton, Benjamin Péret, Tanguy, Gui Rosey,
Marcel Jean, and Georges Hugnet saw *The Enigma of William Tell,*
which depicted Dalí's familiar crutched figure but with the face of
Lenin, the idol of those Surrealists who, while not Communists, cer-
tainly believed in the principles of Marxism and its main disciple.
Breton and the other Surrealists were so incensed that they tried to

* A subtle joke on Dalí's part. *Rient* means "laughing" in Catalan.

poke holes in the picture with walking sticks. To their frustration, it was hung too high for them to reach.

Typically, Breton then resorted to a bureaucratic strategy: A statement was issued, signed by Victor Brauner, Breton, Ernst, Hugnet, Meret Oppenheim, Péret, and Tanguy, which read:

> Dalí, having shown himself guilty on several occasions of counterrevolutionary acts leading to the glorification of Hitlerian Fascism, we the undersigned propose, in spite of his statement of January 25, 1934, to exclude him from Surrealism as a Fascist element and to oppose him by every means.[7]

Ranged on Dalí's side were Yoyotte, a young black Martinican intellectual who was fascinated by him, Arp, Char, Maurice Heine, Gilbert Lély, Etienne Léro, Marcel Jean, Robert Mesnil, Jules Monnerot, Henri Pastoureau, Man Ray, Gui Rosey, and Raymond Tchang. Those absent from Paris—Eluard, Crevel, Giacometti, and Tzara—were invited to write in their responses to the order. Eluard, Crevel, and Tzara expressed their regret at the attacks to which Dalí had been subjected, firmly telling Breton they did not feel it possible to continue Surrealist action without Dalí. Eluard also wrote to Gala:

> I can't fool myself about the almost insurmountable problems which Dalí's Hitlerite-paranoid attitude, if it persists, will engender. Dalí absolutely must find a different subject of delirium. . . . The praise of Hitler, even and especially in Dalí's scheme of things, is unacceptable and will engender the downfall of Surrealism and our break-up. . . . The essential thing is to continue to support common action, without which any individual action will soon become vain, even noxious, because it will grow bourgeois.[8]

Eluard's insistence on Dalí's remaining in the Surrealist group may have been prompted by the fact that Gala had married Dalí on January 30, in a simple civil ceremony in Paris. Under Spanish law she could not otherwise inherit his money if he died or went mad. Eluard still loved Gala, and loving Gala meant supporting Dalí, for were they not the same person?

Finally the whole group of Surrealists, with the exception of Eluard

and Crevel (still in Nice), met at Breton's studio at 42, rue Fontaine. Dalí had a sore throat and was running a fever. Though he ignored Gala's bouts of ill health, he was always extremely cautious where his own health was concerned. He dressed very warmly for his hearing, placed a thermometer under his tongue, and, just before he left his studio, remembered to put on his shoes.

When Dalí and Gala got to rue Fontaine, the Surrealists were waiting in a fog of smoke. Breton, dressed as usual in bottle green from head to foot, lost no time in reciting Dalí's misdemeanors, pacing back and forth in front of Dalí's *La Gradiva,* which he owned. Dalí, checking the thermometer, discovered that he had a temperature of 101.3, and he decided that to bring down the fever he would take off his shoes, camel overcoat, jacket, and sweater. Then he put the jacket and coat back on because, as he would tell André Parinaud, "in such cases it is also important not to cool off too quickly."[9]

Breton asked him what he had to say for himself, and Dalí replied that the accusations leveled against him "were based on political or moral criteria which did not signify in relation to my paranoiac-critical concepts."[10] Breton was not only being upstaged by Dalí, but spat on by him too, for he had spoken these brave words through his thermometer. By the time Dalí got up again, took off his coat and jacket and a second sweater, which he threw at Breton's feet, then put his coat and jacket back on again, the others in the room could not stop laughing.

Dalí stripped off his coat and jacket again to remove yet another sweater. He repeated this maneuver several times. Down to his sixth sweater, Dalí struck, telling the assemblage that to him

> the dream remained the great vocabulary of Surrealism, and delirium the most magnificent means of poetic expression. I had painted both Lenin and Hitler on the basis of dreams. Lenin's anamorphic buttock was not insulting, but the very proof of my fidelity to Surrealism. I was a total Surrealist that no censorship or logic would ever stop. No morality, no fear, no cataclysm, dictated their law to me. When you are a Surrealist, you have to be consistent about it. All taboos are forbidden, or else a list has to be made of those to be observed, and let Breton formally state that the kingdom of Surrealist poetry is nothing but a little domain used for the house arrest of those convicted felons placed under surveillance by the

vice squad or the Communist party. So, André Breton, if tonight I dream
I am screwing you, tomorrow morning I will paint all of our best fucking
positions in the greatest wealth of detail.[11]

All Breton could manage by way of a riposte was to hold his pipe
tightly between his teeth and say, "I advise you not to, my friend."[12]
Dalí had one more sweater to remove, which he did as Breton called
on him once again to forswear his ideas about Hitler. Dalí knelt on the
thick carpet and swore that he was no enemy of the proletariat, for
whom, as he admitted later, "I didn't give a fig, for I knew no one of
that name and merely granted my friendship to the most disinherited
men on earth, namely the Port Lligat fishermen."[13] As Dalí rightly
claimed, he had transformed Breton's bureaucratic hearing into a truly
Surrealist happening.

In an undated letter to Breton, Dalí denies that his Lenin canvas is
in any way derogatory, and assures Breton of his unconditional Surre-
alism. He had obviously thought better of his playful attitude toward
dictators. A clue to this lies in a letter to Foix of early August in which
he congratulates Foix on his defense of the poetry he made in some
"notes i simulacres." There was, wrote Dalí, "nothing more abject than
'applied' poetry for patriotic, Marxist Hitlerian propaganda, etc."[14]

In April, Dalí and Gala went back to Cadaqués for two months to
prepare for an exhibition in June at the Galerie Jacques Bonjean in
Paris. On their way to Port Lligat, they stopped in Barcelona, where
the launch of *Les Chants de Maldoror* with Dalí's illustrations took place
in the Galería d'Art Catalónia. The book was launched to great acclaim
in New York at the Julien Levy Gallery on April 3 and in the Quatre
Chemins bookshop in Paris in June.

On April 11, while he was in Barcelona, Dalí sent a postcard to
Lorca, who was passing through the city on his way to Argentina. This
was the first communication of any kind between the two in nearly
seven years, although, as Ian Gibson points out, they must have kept
in touch with each other's progress through their many mutual
friends. Lorca must certainly have been astonished to hear of Dalí's
obsession with Gala. In a conversation with Rafael Alberti quoted by
Gibson, Lorca said that he could not conceive how any woman would

be able sexually to satisfy his friend, who hated breasts and vulvas, was terrified of venereal disease, and had problems about impotence and a tremendous anal obsession.

Addressing him as "Dear Lorciatto," Dalí wrote to Lorca that he felt sure they would both find it amusing to meet again and that it would be a sin if Lorca did not come to Cadaqués, where Dalí would be spending the rest of the month. Telling Lorca that he had a big project for an opera based on "important" people such as Sacher-Masoch and Ludwig II of Bavaria, he suggests that they might work together. Besides, Dalí adds, coming at last to the point, Gala was very curious to meet him.

Did Lorca remember when the pure ones would decline?, Dalí asked—an elliptical reference to the "Resi" games, perhaps. All this, he said, was in accordance with Lorca's sexual obsession with "the spectral and superfine anachronism. Read my article which came out in numbers 3 & 4 of the *Minotaure*. There's also an article on the postcards of Eluard which you'll like, not just a theoretical *mise au point* of Breton's on the v.v. important communication: don't fail to answer soon."[15] Dalí signed himself "Your Budo [Buddha] S. D." (This had been a youthful joke between the two of them.)

Why did Dalí suddenly write to Lorca after so many years' silence? In any case, Lorca did not respond.

Dalí's paintings had, for the past two years, exhibited a mental tiredness, an acedia. Was he paying too high a price for Gala's all-enveloping care? Certainly their sexual relationship, always delicately balanced, had degenerated into voyeurism. Henri Pastoureau, a student on the fringe of the Surrealist circle, attended "sexual investigation sessions" conducted by Gala and Dalí. These took place on Wednesday evenings, and explored the participants' sexual behavior and fantasies. No other women were allowed to attend, and Gala, according to Pastoureau, "wouldn't hesitate to describe in the crudest details her wildest debaucheries, but she always added that surgery had stopped her from continuing with this."[16] Dalí was almost always quiet during these discussions, unless he had "some new and delirious fantasy, always of a scatological kind."[17] On other occasions, Gala would make love to men in front of Dalí, once with Eluard.

In a letter to Foix of September 1934, Dalí told his friend not to give too much importance to "my psychical depression, as it is a very

frequent occurrence among people of our type. Despite my privileged (as you suppose) position of painter, I've had moments of irrational anxiety without any conscious motive."[18]

Hints that his past relationship with Lorca, possibly colored by nostalgia, may have been at the forefront of his mind that summer are contained in two paintings, *Atmospheric Skull Sodomizing a Grand Piano* and *Atavistic Dusk*. A series of paintings based on the beach at Roses, particularly *Apparition of My Cousin Carolineta on the Beach at Roses,* suggest also that Dalí had once more begun to look to childhood memories for inspiration. This may have had something to do with the fact that, as he admitted in a letter to Foix, he had been psychoanalyzed. "An autopsychoanalysis can be excellent. When this has worked, you'll feel an extraordinary new taste for life."[19]

Dalí had subjected himself to the questions of Jacques Lacan, a young psychiatrist whose contact with the Surrealist group had led him to write *De la Psychose Paranoïaque dans Ses Rapports avec la Personnalité*. This appeared in late 1932, making its author famous and putting him on the "threshold of psychoanalysis."[20] Dalí had received a telephone call from Lacan, who wanted, at the suggestion of Breton, to meet Dalí to discuss his text *"L'Ane Pourri."* Dalí spent the morning prior to Lacan's visit in a state of extreme agitation and tried to plan the course of their conversation in advance. He was working at the time on his portrait of Marie-Laure de Noailles, so it must have been early in 1933. The portrait was painted on burnished copper, which glared in the light and made it difficult for Dalí to see his drawing properly. He had discovered that if he stuck a piece of white paper on the end of his nose it was easier to see what he was doing, since its reflection in the copper made his drawing perfectly visible.

Lacan arrived at rue Gauguet, and they immediately began a very technical discussion, discovering that their views were quite similar. Whether Lacan was sizing up Dalí with the idea of psychoanalyzing him is not certain. But Dalí noticed that the young psychiatrist peered at his face from time to time with a curious smile. This worried Dalí. "Was he intently studying the convulsive effects upon my facial morphology of the ideas that stirred my soul?"[21] It was only after Lacan left, as Dalí recounts in *The Secret Life,* that he discovered he had forgotten to remove the piece of white paper from his nose. It is tempting to speculate that Dalí had left it there deliberately to divert

his interlocutor's attention, in the way he was later to use his mustache.

In the first issue of *Minotaure,* Lacan published "The Problem of Style and the Psychiatric Conception of Paranoiac Forms of Experience," which was obviously influenced by Dalí. Whether Dalí used their exploratory conversations about the paranoiac-critical method as a form of psychoanalysis, or whether he went through a more formal analytical process, is one of the secrets he so closely guarded. But certainly, Dalí's contact with Lacan through the next few years made him more consciously aware of the value to his work of his past. The series of paintings on the Roses beach, and the piano paintings, indicate that he had gone back for inspiration to his childhood, adolescence, and early youth—a time before Gala changed his life forever. This leads one to suppose that his marriage may have become a prison for Dalí. He was dependent on Gala for everything except his work. She was both mother and wife to him, but she was also voraciously demanding. At this point in Dalí's life, his work was the most important link between the two of them. Later, Gala's voracity would tip the balance, and material rather than creative well-being would become more important. Perhaps, in being depressed, Dalí foresaw the fate from which he could not escape. Lacan, for his part, became convinced that paranoia was "the value of the creative imagination in psychosis, and to the relationship of psychosis to genius."[22]

In 1933, Dalí met Edward James at the Noailles' villa at Hyères. James was one of those rich English social dilettantes—others were Lord Berners and Peter Watson—who were passionately interested in the arts and who flourished in the interwar period. Had he been born two centuries earlier, James would have gone on a Grand Tour, had himself painted in swaggering satins by Batoni, and collected classical antiquities and hardstone furniture during his travels. Born in the first year of the twentieth century, he was painted in a pin-striped suit and bowler hat by Magritte, and sat on a shocking pink-lip sofa designed for him by Dalí.

Edward James had a genuine and courageous eye for the avant-garde, and enough money not just to collect (he abhorred being called

a collector) but to be a patron, commissioning ballets and putting painters under contract for future works. He thought of himself as a creative man—indeed, he published novels and poetry—and liked to believe that his creativity brought out the creativity in others, which was, in many instances, true. But like many rich men, James was afraid of being cheated. The history of his relationships with those he patron- ized is strewn with complaints about money, often about small amounts. It is telling that, when asked why he became friends with so many famous people, James replied, "One cannot buy the affection of a superior man, one has to have it in oneself, one has to have some- thing in common."[23]

James was a bisexual, and this complicated his relationships, nota- bly with his wife, the Austrian dancer Tilly Losch, for whom he founded Les Ballets 1933. Losch soon tired of her husband and was unfaithful to him, notably with the Russian Prince Serge Obolensky. James divorced her—scandalously and acrimoniously—in the early 1930s. At the time he met Dalí and Gala he had had a brief affair with Marie-Laure de Noailles and was flirting with the American actress Ruth Ford, sister of Pavel Tchelitchev's boyfriend, the poet Charles Henri Ford.

James owned a London house, at 35 Wimpole Street, as well as West Dean, the large estate he had inherited in West Sussex. It was to the London house that Dalí and Gala made a brief visit sometime in the summer of 1934, possibly at the end of June, after Dalí's exhibition in Paris, before they returned to Spain. Dalí and Gala probably went to London to make arrangements for an exhibition that autumn at Zwemmer's, a showing that prompted Herbert Read to write a well- argued piece in *The Listener* that November comparing Dalí to Bosch and concluding perceptively that the "proved permanence of Bosch's art should warn us against a too hasty dismissal of Dalí and the Super- realists in general."[24]

James's house was run in the grand manner, with a butler called Thomas Pope and the usual complement of servants. When Dalí and Gala paid their first visit, the house was furnished in an elaborate Regency Revival style popularized among the cognoscenti by Lord Gerald Wellesley (later the Duke of Wellington). The decoration had been carried out by Norris Wakefield, who later worked for James at Monkton, a small summer house on his estate designed for his mother

by Edwin Lutyens and turned into a Surrealist fantasy by James and Dalí.

Dalí and Gala were doubtless extremely pleased to have been "taken up" by Edward James. Rich, with a discerning eye, he was genuinely knowledgeable. And he was very attracted to Dalí. In fact, he was "rather in love with Dalí, who was wonderful to look at in those days,"[25] and was happy to pay for the privilege.

Later that summer, James and his new friends were in the same fashionable house party at the Catalan painter José María Sert's summer house at Palamós, about fifteen miles from Cadaqués. Known as the "Tiepolo of the Ritz," Sert had made enormous amounts of money painting huge baroque murals. These had become very modish, largely due to the promotional efforts of his former wife, Misia Godebska. Not everyone was enthusiastic about Sert's murals: Once, the painter Jean-Louis Forain was looking at the vast numbers of fat-cheeked, full-breasted, wide-hipped, big-bottomed angels in a mural Sert had painted for the apse of a chapel, and a companion asked, "But how will they ever be able to ship the thing? Will they roll it up, or fold it, or will it have to be cut up into pieces?" "No," Forain replied, "it can be deflated."[26]

By the time the Dalís met him, Sert had married Roussy Mdivani, one of the "marrying Mdivani" clan, originally from Georgia, and together they had created a very luxurious house in Palamós, generally considered to be the grandest seaside villa in Europe. It was a far cry from the joined-together *barracas* at Port Lligat. "Mas Juny was on a bluff overlooking the harbor and was furnished in a very luxurious style," says Denise Tual, who stayed there. "It looked nothing, but it was expensive. The house was white, with huge pieces of leather furniture and rush mats everywhere, and Roussy, who had wonderful taste, curtained all the windows in white muslin. Everyone adored her," says Madame Tual, "and she and her husband had their own little lodge right at the end of the cliff, looking out to sea. And they used to leave their guests to their own devices."[27]

Sert was the scion of a very rich Catalan textile dynasty, and when he wasn't painting huge secular murals full of blackamoors and elephants, he was continuing his life's work on religious murals in the Cathedral of Vich. In no sense did he offer Dalí any competition, being about as far from the Surrealists as possible, both in his painting and

in his political beliefs. Strangely ugly (Dalí once said his head reminded him of a potato), Sert was a man who ignored conventions in favor of outlandish behavior, which endeared him to the fashionable people, such as Coco Chanel, with whom he liked to surround himself. He may well have served as an example to Dalí of how much one could get away with—if one had enough money—and, certainly, holidays at Port Lligat later came to imitate those prewar summers at Mas Juny.

By early August, Dalí had left the heady social scene and was back in Port Lligat, working. René Crevel was a guest, and Dalí painted an ink-and-gouache portrait of him called *Man with Cigarette*. Dalí continued to cultivate his intellectual friends in Barcelona, but only when it suited him, writing to Foix rather dismissively, for instance, about a suggestion that he produce an article for the *Revista de Catalunya*, "I personally should have no difficulty, but you know of the [Surrealist] group's strictness about collaboration in any review which is not specifically Surrealist."[28]* Dalí went on to suggest that a separate Surrealist number would not contravene the rules of the group, thus leaving the initiative with Foix and not severing their friendly contact; this had become important to Dalí as a means by which he could keep in touch with Catalan avant-garde activity.

In October, Dalí showed the work he had done that summer with Josep Dalmau in Barcelona. Five paintings were shown, among which were *The Weaning of Furniture-Nutrition, Materialization of Autumn,* and *Hypnagogic Image of Gala*. While he was in Barcelona, he visited his paternal uncle, Rafael, to see whether he could effect a reconciliation with his father.

Rafael's daughter, Montserrat Dalí y Bas, described the incident to Meryl Secrest:

> *He really wanted a reconciliation, and he went around to all his father's friends, but his father was so wounded he wouldn't hear of it. Anyone who tried to make such a suggestion was shown the door.*

* The reasons for this refusal were more personal than Dalí admitted: Foix had not mentioned Dalí's name as the coauthor of *L'Age d'or* in a review earlier in the year, and Dalí had been incensed.

On October 4, a date I shall never forget, he came to our house and said, "I love Papa and I want him to understand that I am through with the Surrealists. I have broken with all that." He told my father, "You are the only one who can help me," and so the three of us went to Cadaqués to make his father understand that he must pardon him.

The moment Dalí appeared in the doorway his father said, "Out! Never!" So my father shoved him into his office and talked to him for a long time. When he came out, Dalí said, "Please, please forgive me," and his father did. It was a very moving moment.[29]

In spite of his assurances to his father that he had broken with the Surrealist group, Dalí intended to continue with his plan to give a lecture on October 5 at the Llibréria Catalunya, entitled "The Surrealist and Phenomenal Mystery of the Table of Night," but this never took place, for events in Catalonia came to a crisis that day, and it was no time to give a lecture on Surrealism.

The Unión General de Trabajadores, representing the workers, called a general strike all over the country on October 4. This arose from the struggle between the left and right in Spain, which had come to a head on October 1 when the Cortes (Spanish parliament) met and the government resigned. The right-wing CEDA party leader Gil Robles demanded a majority of the seats in the next cabinet for his followers. The parties of the left warned President Manuel Azaña y Diaz that if he ceded to this request and any member of the CEDA entered the government, they would regard it as a declaration of war. The writer Gerald Brenan has commented that all the disasters that followed for Spain may be traced to a single unhappy decision: The president instructed Alejandro Lerroux García to form a government that would include three minor members of the CEDA. The Socialists did not accept this compromise, and on the following day declared a general strike.

The revolution that followed broke out in three centers: Madrid, Barcelona, and Asturias, the mining district in northern Spain. In Barcelona, four factions struggled for power: the republican petite bourgeoisie led by Lluís Companys; a separatist group, the Estat Català, made up of young patriots led by Josep Dencàs and Miquel Badía; the Catalan Socialist party, a small group composed of working men closely linked with the cooperative movement; and the Rabassaires, the peasants' party.

The republicans represented Catalan nationalism, while Dencàs's party, the Estat Català, was violently opposed to the Anarcho-Syndicalists, with whom the republicans had linked up. The Estat Català had a small paramilitary organization, the Escamots, who wore green uniforms and represented Catalan nationalism at its most uncompromising and extreme; they were, in fact, the Catalan equivalent of Hitler's Brownshirts or Oswald Mosley's Blackshirts. The Estat Català had gained ascendancy largely through this paramilitary organization, and it now demanded that Catalonia should take the opportunity of the general strike to make a break with Madrid. Companys decided to cede to Dencàs's demands rather than destroy his party, and to lead the movement for independence himself.

Early on the morning of October 6, the Dalís were awakened by Josep Dalmau, with whom they had been staying, "appearing to have emerged from a nightmare, hair on end, beard unkempt, flushed in the face, his fly open like some wild animal who had just escaped a pack of husbands on his tail to castrate him. 'We're getting out,' he said, 'it's civil war.' "[30]

The evening before, Companys had proclaimed Catalan independence from the balcony of the Generalitat. But the support he had counted on from the Escamots never arrived, and soon after ten that evening several groups of soldiers left their barracks and surrounded the Generalitat. A few shells were fired, and before dawn next morning the building had been taken and Companys was a prisoner. The political fight was over, but the fighting in the streets of Barcelona and in the surrounding countryside raged between the various factions; there were machine guns at every window, and it was not wise to be seen in the streets wearing those badges of the bourgeoisie, a collar and tie.

It took Dalí and Gala two hours to get a safe-conduct and half a day to find a driver with a car willing to drive them to the border at Port Bou (Dalí had to meet the driver in a urinal just off the *rambla* in order not to arouse suspicion). As usual, they had an enormous amount of luggage in addition to the pictures and drawings from the exhibition. Halfway to Port Bou they had to make a dangerous halt at a small village to get gas; years later Dalí remembered the scene:

> *The men are carrying ridiculous but lethal weapons, while under a big tent people are dancing to the tune of the "Beautiful Blue Danube."*

*Carefree as you like, girls and boys, in each other's arms, waltz madly.
Some are playing ping-pong, while old men wait to be served from a
barrel of wine. I look out the car door at this idyllic picture of a small
Catalan village celebrating, and then I hear the voices of the four men
who, over pregnant silences, are exchanging remarks about Gala's lug-
gage, which seems provocative, offensive to them in its ostentation. They
feel inspired by an anarchist proletarian hatred. One of them, looking me
in the eye, suggests we ought to be shot, there and then, as an example. I
fall back on the car seat. I gasp for breath. My cock shrivels like a tiny
earthworm before the vicious mouth of a pike. I can hear our driver's
shouted swearwords ordering them to get out of our way.*[31]

Dalí and Gala arrived unharmed at the French border at Cerbère. The
driver was not so lucky; on the return trip he was killed by a random
burst of machine-gun fire. "I can still see how he had picked up a stray
ping-pong ball and returned it to the awkward player with great gen-
tleness. I still shudder at the idea of the idiotic death unleashed by the
wild men on all sides."[32]

Dalí would include his terror and anguish in his future pictures,
and the memory of their journey kept him away from Spain—apart
from one short visit—for many years.

Dalí and Gala went straight back to Paris. Here Dalí painted *Premoni-
tion of Civil War*, also known as *Soft Construction with Boiled Beans*. It is
a horrifying image: Dismembered bodies and their entrails litter the
plain of Empordà, and behind this pyramid of destruction can be
glimpsed the figure of the universal bourgeois, head bent as if in
prayer.

Dalí became obsessed with getting away from Europe. He decided
that it was time to take Julien Levy at his word and to conquer Amer-
ica, a country by which he and Gala had become more and more
intrigued as they sat at the Moulin du Soleil with Caresse Crosby,
weekend after weekend, playing Cole Porter's "Night and Day," Mrs.
Crosby's favorite song, and leafing through *The New Yorker* and *Time*
magazine. Dalí had been badly frightened in Spain, and the Surrealists
had by no means forgotten his admiration of Hitler. In *Le Figaro Littér-
aire* on November 20, 1934, in a piece entitled *"Petite Contribution à la*

Vie Secrète de Salvador Dalí" under the subheading *"Hitler et Salvador Dalí,"* Georges Hugnet raised the subject once again:

> *Dalí's imagination (and its terrible pace) acted in such a manner that the most fervent followers of communism, the zealots who held the most to their ideological platforms, forgave him his wanderings. . . . But then the situation changed. For some time already, Dalí had offered the symptoms of an excessively developed delirium and the proofs of a behavior that alarmed the revolutionary consciences of the Surrealists. . . . In his conversation, and even in certain articles, the name of Hitler, always mentioned in good terms and accompanied by favorable remarks, recurred too often and with too much succulence. He gargled with this abhorrent name . . . he embroidered on this theme with an amorous volubility. He dreamed of it, he lived it . . . he polished it.*

What had started as a "tease" to annoy the Surrealists had got out of hand. Perhaps Dalí and Gala felt that a strategic, if temporary, retreat was in order.

It was Caresse Crosby who persuaded Dalí and Gala that they should travel with her on the *Champlain* to America in November 1934. They had just enough money for two third-class tickets, but they needed an extra $500 for living expenses while they were in the United States, a sum so large in those days as to seem impossible to come by. They wished to preserve the secret of their dismal finances from their high-society friends, for it would never do to let them know how vulnerable the seemingly invulnerable Dalí really was. Finally, and almost at the last moment, Picasso generously gave them the money they needed, and all that was left was for Gala to make the always laborious arrangements for a voyage with a husband who could not even handle a taxi fare and who was rigid with fright at the prospect of traveling by sea to a country whose language he did not speak.

When Mrs. Crosby arrived on the boat-train platform, the Dalís were already aboard the train:

> *In a third-class compartment next to the engine he sat like a hunter in covert, peering out from behind the canvases that were stacked around, above, below and in front of him. To each picture he had attached a string. These strings were tied either to his clothing or his fingers. He was very pale and very nervous. "I am next to the engine," he said, "so that*

*I'll get there quicker." He refused to eat lunch on the way for fear
someone would pickpocket a soft watch or two.*[33]

Dalí's fears did not abate when he was on the *Champlain*. He in-
sisted that he and Gala wear cork life jackets during their infrequent
walks on deck. Mrs. Crosby was traveling first-class and asked the
Dalís to join her for dinner. They appeared looking eccentric to say the
least. Both wore long overcoats. Dalí sported several sweaters up to his
ears and mittens on his hands. Under her coat Gala wore a serviceable
pair of trousers and on her head a turban.

Mrs. Crosby and Gala stood on deck to see the New York skyline,
but Dalí would not leave their cabin, although he had been packed
and ready to disembark from the third day of the voyage. Mrs. Crosby
was always good copy to reporters accustomed in those days to meet
the liners from Europe. Her ensemble, on this occasion, of a very short
black velvet skirt, two black whippets on leads, and a great many
diamond bracelets prompted the usual requests for photographs. She
took the opportunity to introduce Dalí to the press. "If you want a
story, see Dalí," she told a reporter, giving him the number of the
Dalís' cabin. The bewildered journalist reappeared a few minutes later.
"Dalí has a story all right," he told Mrs. Crosby, "but I can't under-
stand a word of it." Mrs. Crosby offered to interpret, and led reporters
and cameramen to the cabin. There they found Dalí, attached by
pieces of string to his paintings. "These are gentlemen of the press,"
she told him in French, "and they can take or leave you."[34] Dalí imme-
diately began stripping the paper from the largest of his paintings
while Mrs. Crosby gave a brief lecture on Surrealism. They then asked
Dalí which was his favorite picture, and he answered, *"The Portrait of
My Wife,"* which was the portrait of Gala with lamb chops on her
shoulders. "I used to balance two broiled chops on my wife's shoul-
ders," Dalí later explained, "and then by observing the movement of
tiny shadows produced by the accident of the meat on the flesh of the
woman I love while the sun was setting, I was finally able to attain
images sufficiently lucid and appetizing for exhibition in New York."[35]
The reporters were enchanted with this eccentricity, and the picture
took the place in all the morning editions of what Mrs. Crosby de-
scribed as "cheesecake."

When Dalí and Gala arrived at Julien Levy's gallery, the majority of

the paintings for his exhibition had been hung, but Dalí had brought with him some "objects" that had to be installed. One was the aphrodisiac dinner jacket, with hundreds of small glasses containing crème de menthe straws and dead flies, and others were plaster casts that had been painted with typical Dalinian views and small people.

Joella Bayer, who was at the time Mrs. Julien Levy, remembered them well:

> These casts were the kind seen, in those days, in art-store windows in Paris. Mostly of parts of Michelangelo's David's head. I remember one of the lower part of the nose and chin. I have never seen these pieces again and never reproduced—I wonder where they went!
>
> To lighten the intensity under which Dalí was operating, I asked him if he enjoyed painting on plaster. He swiveled around to face me with wide eyes. "Have you got any?" Politely, I said I would look, not having the slightest idea if I had anything. I sat in the back of the office looking at the shelves and suddenly remembered the Man Ray head of me. I got on a ladder and dug it out to an overjoyed Dalí, who immediately took it with him to the Saint Moritz Hotel in a taxi. (I had to go downstairs and get him a taxi and pay the driver ahead, as Dalí was unable to do the simplest thing for himself.) He painted the head, designed the glass case and brought it back for the opening.[36]

Dalí also composed a small Surrealist manifesto euphonically to be read aloud at the opening of his show:

> Aye av ei horror uv joks
> Surrealism is not ei jok
> Surrealism is ei strangue poizun
> Surrealism is zi most vaiolent and daingeros
> toxin for dsi imaigineichon zad has so far
> bin invented in dsi domein ouve art
> Surrealism is irrezisteible and terifai-ingli
> conteichios
> Biuer! Ai bring ou Surrealism
> Aulredi meni pipoul in Nui York jave bin infectid
> bai zi laifquiving and marvelos sors of Surrealism.[37]

By January 20, 1935, Dalí was able to report to Foix that he had sold twelve pictures at very high prices and given five lectures with slides. One of these lectures, "Surrealist Paintings, Paranoiac Images," was given at the Museum of Modern Art on the occasion of its fifth anniversary. Dalí spoke in French, and Julien Levy translated for him. His lecture was received with incredulity and bafflement. Dalí showed slides of work by Picasso, in his Surrealist phase, and by Max Ernst and other followers of Freud. He confused his audience even further—if that were possible—by also showing slides of seventeenth-century engravings in which appeared images similar to those in the Surrealist paintings he had shown.

Dalí admitted that he did not understand the content of his pictures. "I am the first to be surprised and often terrified by the extravagant images that I see appear with fatality on my canvas. . . . The fact that I myself at the moment of painting my pictures know nothing of their meaning is not to say that the images in question are without sense. . . ." As the subconscious mind is absorbed with such elemental realities as love, death, time, and space, Dalí explained, so Surrealist art deals with "these fundamentals in terms of symbols which occur in the mind, both in dreams and during waking hours."[38] It was all very provocative, concluded the reviewer in *Arts and Decoration,* "especially when [Dalí] pointed out vultures in old masterpieces and the Oedipus complex in the Mona Lisa's smile."[39]

Mrs. Crosby had made sure that the Dalís met a great many New York socialites, some of whom the couple had already encountered during their forays into high-society Paris. One of them, worried that Dalí's coat was too thin for the New York winter, took him to Abercrombie and Fitch to buy an overcoat. When asked what sort of coat he wanted, Dalí replied, "One like a chocolate cake." Something was found in chocolate-brown fur (probably alpaca), and the painter was satisfied.[40]

His show had been a great success, and Dalí had the vast sum of $5,000 to take back to Europe with him. He insisted on changing the money into traveler's checks of small denominations. Julien Levy, who had gone with him to the Central Hanover Bank, explained that

> this would be a bulky business, but that was just what he wished. He said his bundle must have bulk to be really convincing.

Dalí began signing very slowly, carefully and elaborately. In fact he occasionally improvised little landscapes and battle scenes in combination with his signature.

"You will have to reproduce each of those signatures," a bank official tried to explain.

"I can do that too—Dalí surely can reproduce Dalí."

And he continued stubbornly with the elaborate and, one would suppose, unreproducible signing.[41]

On February 18, the day before Dalí and Gala left on the *Ile de France* to return to Europe, they gave a ball. Never before had they possessed enough money to entertain more than a few people with buffet dinners in their Paris studio, and they were not extravagant now. The guests, invited to come disguised as their most recurrent dream, not only had to pay an entrance fee to cover expenses but also to pay for their drinks and supper.

The Dream Ball (or Bal Oneirique) caused a full-blown international scandal. The shocks started at the door, where guests exchanged an invitation card for a link of sausage. Dalí and Mrs. Crosby had spent hours in a five-and-ten (a favorite hunting ground for Dalí in later years) searching for Surrealist props. The waiters, in dinner jackets, wore horn-rimmed spectacles and paste tiaras. The barmen each wore a white coat accessorized with a tie in either blond or auburn hair, knotted as a four-in-hand. The effect, according to Mrs. Crosby, was "absolutely disgusting." The doorman wore a wreath of pink roses instead of a cap and sat in a rocking chair on the pavement waiting for the guests. Impeding their entrance was a casually placed hundred-pound block of ice, tied up with red satin ribbon. An empty bathtub looked as if it were sliding down the stairs, and the carcass of a cow wore a white wedding veil as it sat at the far end of the room. Where once had been its stomach, a gramophone played the latest French tunes. All these Surrealist effects had been put together in the space of twenty-four hours. "I hate to think what would have materialized if we had had a little while longer,"[42] Mrs. Crosby wrote later.

Dalí himself was dressed as a corpse in tails with a bandage around his head. Set into his shirtfront was a square opening lit from within, illuminating a pair of tiny breasts, "very small, like those made in miniature for advertising women's underwear."[43] These were enclosed

in a brassiere made by the ever-resourceful Mrs. Crosby (who in fact has been credited as being the inventor of this particular garment). But it was Gala who caused the scandal. She wore a black headdress in the middle of which was a doll, or baby's corpse, according to the way one looked at it; in its forehead was a wound, which was filled with carefully painted ants. Its skull was being clutched by a lobster, and a pair of gloves acted as wings on either side. It must be said that this costume contained many of Dalí's favorite symbols. But it was perceived as referring to the recent kidnapping and murder of the Lindbergh baby, a crime that had horrified America.

The ball and Gala's costume caused such an uproar that even Dalí was forced to make excuses, having been read the riot act by Julien Levy. "In his best hermetico-psychoanalytic jargon he explained to the journalists that Gala's costume was a purely Freudian representation of the infamous X-complex."[44] Dalí denied that Gala's costume alluded to the Lindbergh baby, asserting that this was a complete invention of a newspaperman, who had "telegraphed the sensational news that the wife of the famous painter Salvador Dalí had appeared with a bloody representation of the Lindbergh baby on her head and had created a great scandal thereby."[45]

The attention paid to the costume ball by the international press was extraordinary. The story even reached Russia, where a Sunday paper published an account complete with photographs. In spite of Dalí's belief that this soirée "would have turned my little Surrealist pals green with envy as they sat around their marble-topped café tables in place Blanche, masturbating in the name of Lautréamont,"[46] the Surrealists filed a lawsuit against Dalí, accusing Gala of having created a scandal. Dalí later maintained that he was indifferent to the row: "The truth was that they were losing sleep because I was getting ahead. Especially the little group of Communists led astray by Aragon." He claimed that his version of events had been accepted at a meeting of the Surrealists. Buñuel had a different story: "Breton reported to me that during the meeting Dalí fell to his knees, clasped his hands, and, his eyes filled with tears, swore that the press had lied, that he'd never denied the fact that the disguise was well and truly the Lindbergh baby."[47]

The huge new public for Surrealism had scarcely heard of Breton. But they knew all about Dalí, and to them, he *was* Surrealism, what-

ever the leaders of the group might say. This situation would last, with sniping from both sides, for the next five years, until the larger conflict of World War II ended the internecine squabbles of a movement by that time on the wane. And yet, Dalí would never quite be able to lose the sobriquet "Surrealist." It became part of the increasingly heavy and badly packed baggage with which he journeyed through his life.

Dalí and Gala did not stay long in Paris. They went to Cadaqués, now more welcoming since Dalí's reconciliation with his father. The story is told that Gala hid behind the fishing boats on the shore when Dalí went to the family house, and came out only when Dalí's father invited her in. Ana Maria spat on the floor as Gala entered; she was nevertheless obliged by her father to receive both of them.

Once in Cadaqués, Dalí and Gala lost no time writing to their various friends and patrons, among whom was Caresse Crosby, now back in Paris. Dalí had *"traballé boucoup"* and they both remembered New York and Mrs. Crosby, *"que nous aimons boucoup."*[48] At the beginning of May they were making their plans for the summer, which included a visit to Italy—Dalí's first. Here they hoped to meet Edward James, whom they were trying to persuade to fund *Tristan Fou*, a ballet conceived by Dalí. Affectionate letters were written, putting their case:

> I'll send by parcel post the design of Body with Drawers, *which I've already started—also very important and urgent, dear Petitou, I'm waiting for your letter about your wishes to show* Tristan Fou *with all the luxury for the next season.*[49]

While in Cadaqués, Dalí painted *Face of Mae West Which May Be Used as an Apartment*, destined, in its way, to become just as much a twentieth-century icon as *The Persistence of Memory*. *Eco Nostálgico* was also painted in the two months Dalí spent in Cadaqués before going to stay with the Serts for Easter.

The enormous improvement in their finances had permitted the Dalís to move from their cramped studio in the rue Gauguet and take a much larger one in the rue de l'Université, on the Left Bank. They

were back in Paris in May decorating and furnishing this studio rather than attending a Surrealist exhibition that was held in Santa Cruz de Tenerife, in which Dalí exhibited some paintings. On June 10, Dalí's *"Psicología No Euclidiana de una Fotografía"* appeared in the seventh issue of *Minotaure*. That same month, his essay *"La Conquête de l'Irrationel,"* which dealt with his explorations into his subconscious and how he applied them to his work, was published in Paris and received much attention from the Surrealists. It seemed that Dalí had finally achieved the success for which he and Gala had fought so bitterly.

In the midst of these triumphs came sorrow. On June 19, René Crevel, their best friend, one of Dalí's main supporters in the Surrealist group and the architect of their success in first meeting influential members of high society, killed himself. A committed Marxist, Crevel had been desolated by the schism between the Communists and the Surrealists. "The antagonism between our group and the Communists has reached its ultimate point with the suicide of René Crevel," Dalí wrote in a letter to Foix dated June 20. "It was four months ago that Crevel had adopted a similar position to Aragon's and was collaborating in the organization of the Congreso Internacional de Defensa de la Cultura."[50] When this congress of the Association of Revolutionary Writers and Artists was held in Paris in 1934, Crevel had tried to play go-between. He had hoped that Breton would speak up for unity. But Breton slapped Ilya Ehrenburg, a member of the Soviet delegation to the congress, just before he was supposed to speak, and Breton was then denied the floor. This incident completed the break.

Crevel was deeply affected, but in his letter to Foix, Dalí said, "It would be absurd, and would amount to failure to recognize the 'phenomenon' of suicide, to attribute Crevel's death exclusively to that, but at any rate I believe the fact he killed himself on the eve of the congress means something and is terribly symptomatic of the intellectual and moral dramas through which we are living."[51] However, Dalí added in the margin of his letter, Crevel had become aware of a new illness. "This must have played a decisive role, for he'd constantly been in sanatoriums and couldn't bear the idea of getting ill again."[52]

David Gascoyne, the British poet, was spending a great deal of time with the Dalís when they heard the dreadful news:

One morning I came to work and found both of them greatly distressed and Dalí putting on an overcoat, about to leave having completely forgotten his usual worry about the length of the baguette of bread; his voice became raucous and his words incoherent through very mortification. Gala was saying: "Et surtout ne l'embrasse pas," and it gave me a bit of a start, implying as it did some kind of homosexual relationship between them. Apparently they knew Crevel was ill, but did not know it was a suicide attempt. She thought he had been stricken by something contagious and wanted to make sure Dalí didn't catch it.

We learned later that he was found in the bathroom with the gas tap for the hot water heater turned on full. He had pinned a little note to himself that said: "Disgusted, Disgusted." When Dalí came back and told us—Gala was a hard woman—but she had tears in her eyes and so did he.[53]

Dalí's later version was slightly different: He said he had phoned Crevel to let him know he did not endorse Breton's stand, and a voice answered that Crevel had just attempted suicide and was dying. Dalí arrived at the house at the same time as the firemen. Crevel was trying to fill his lungs with oxygen from a bottle:

His baby face was bloodless. He had put a cardboard label around his left wrist with his name printed on it all in capitals like an epitaph. In my memory he still lives today like some magnificent dream phoenix ever arising anew in the name of friendship, honour and the appellation of free man. A most terrible evidence of the fundamental incompatibility between politics and poetry.[54]

That evening, Dalí, Gala, and Gascoyne went to the Café de la Place Blanche, the alternative Surrealist meeting place to the Café Cyrano in the same square. Breton, as always, presided in a green tweed suit and a pipe. Eluard, who had virtually withdrawn from these Surrealist rendezvous, came that evening. He was very shocked, for he had heard that Crevel was going to be given a religious funeral. The Surrealists reacted to this news by discussing whether they should have a demonstration at the funeral and slash all the chairs, but nothing came of this.

A few days later, Dalí wrote to Emilio Terry, who had been a very close friend of Crevel's, saying, "You cannot in truth imagine how

much we are thinking of you. The dreadful death of R. C. has thrown us into such a state of panic and defeat that it will need courage to emerge from it. . . . Paris in moments like this is even more wretched."[55]

Fifty years later, Dalí was still talking about Crevel. He told Max Aub, for instance, that Crevel "on the day before his suicide was talking to [the writer] Jouhandeau of the Immaculate Conception—something which for him must have been like being sodomized. What a man! He was as good-looking as Jean Marais when he was young. A golden boy. A man with a *maravellos* body."[56] After the war, Dalí wrote the foreword to an edition of *Difficult Death*, one of René Crevel's books, in which he said of his friend:

> *No one ever "creveled," that is croaked, so many times in quick succession, nor was anyone ever subject to so many "rené-esque" renaissances as our own René Crevel. René spent his entire life in and out of hospitals. He was admitted half dead [crevé] only to be released reborn [rené] flourishing, shining, euphoric as a newborn babe. It never lasted. The self-destructive frenzy soon returned. He went back to suffering and smoking opium and tackling insoluble ideological, moral, aesthetic and emotional problems. . . . The whole time René was our guest at Port Lligat he lived like an anchorite in imitation of me. He got up in the morning before me, before the sun, and spent long days stark naked in the olive grove. . . . René loved me more than anybody else but he loved Gala more. . . . It was at Port Lligat that René wrote his books* Les Pieds dans le Plat, Le Clavecin de Diderot *and* Dalí et l'Antiobscurantisme.[57]

Dalí and Gala had returned to Cadaqués by the end of June for an uninterrupted summer of work, punctuated only by another visit to the Serts in August, where they joined a house party that consisted of Bettina Bergery, a frequent visitor, Contessa Madina di Visconti, and Baroness Maude von Thyssen with her lover Alex Mdivani, Roussy's brother. Alex was the most successful of the Mdivani brothers in that he had married two American heiresses—Louise Van Alen and Barbara Hutton—from both of whom he had received substantial settlements. The party was completed by Edward James, who had probably been responsible for the Serts' inviting the Dalís.

This ferociously fashionable house party had some strange under-

tones, for Dalí remarked to Edward James and to Gala, "Some disaster hangs suspended over this house, *il faut prendre garde! Il faut faire beaucoup d'attention et tenir le coup*" (when recounting this incident in a letter, James commented that *"tenir le coup,"* literally "stick it [out]," had always been one of Dalí's favorite expressions). Dalí and Gala became more and more nervous, and Gala wanted to return to Paris, so oppressive was the atmosphere. But there were still moments of fun and laughter, such as the conversation at dinner one night when Madina di Visconti tried to explain to Dalí how she was descended from Julius Caesar. She explained that her mother's family were Venetian and that several of her ancestors were doges. Edward James recorded the scene in one the many long, rambling fragments of what conceivably was intended as a memoir and in which he often referred to himself in the third person.

> *Noticing that Dalí still appeared skeptical, Madina then added, "You must understand that my mother was a Pappadopoli." This statement finally succeeded in hitting Dalí where he lived, which, in those days, was exclusively in the world of Surrealism.*
>
> *"Oh! Now I understand!" he exclaimed, breathing out an immense sigh and his eyes bulging in goiter-bright hyperthyroid enthusiasm. Then turning to me he whispered, "What exactly is a 'pappadopoli'?" "If you really want to know," Edward James answered, "a Pappadopoli is the name of an aristocratic Venetian family. What else do you suppose it could be?"*
>
> *"Oh!" exclaimed Dalí. "You must excuse me, Madina! I thought a pappadopoli was something like a duckbilled platypus."*[58]

After lunch the next day, Alex Mdivani took Maude von Thyssen in his Rolls-Royce to catch the Paris train. An hour later the news came: Alex Mdivani was dead, and Maude had been discovered by the roadside with most of the bones in her face smashed. "How strangely clear a thing is the moment that announces death," Dalí remarked to Edward James two days later.

James seemed more upset by the accident than was Dalí, whose strong strain of Spanish fatalism, plus his feeling that once more he had cheated mortality, produced a renewed fervor in his work. As James wrote to his close friend Diane Abdy, Dalí

chose as his cure a bout of violent work. . . . Perhaps to have witnessed such terrible scenes may even have added some curious strength and spice to what he has in the last month subsequently produced, but I cannot be sure of this, for I know that he had already several days before the tragedy begun painting marvels: and as he was already in such a bonne voie I think he hardly needed any outside stimulus. It was a horribly painful and exacting interruption for him in the middle of a most fertile moment of production; so I doubt whether his art really gained anything from it.[59]

In this same letter to Lady Abdy, James told her of his return to Spain to fetch the Dalís for their first trip to Italy. "I spen. a delightful ten days at Cadaqués with them and five more extremely entertaining days in Barcelona, where Salvador caused me to meet many of his friends, but in particular a very delightful and sympathetic one whom I am convinced from what he read to us (which lasted all one evening, though the hours went by like minutes) is a really great poet, perhaps *the only really great one whom I have ever met*—García Lorca."

The dating of this letter is of great interest, for Dalí always maintained that this meeting with Lorca took place two months before the Civil War in 1936, a year later. In *The Secret Life* he told the story that he and Edward James had tried to persuade the poet to go with them to Italy, but that Lorca had stayed in Spain to look after his father in Granada, then suffering from a heart complaint. And thus, Dalí maintained, Lorca's refusal to join the Dalís and James was the direct cause of his death. In fact, this meeting took place on September 28, 1935. Lorca had come to Barcelona because Margarita Xirgú had begun a month's season in the Teatro Barcelona on September 10 with Lorca's version of Lope de Vega's *La Dama Boba,* after which she acted in his own *Yerma.*

Learning from the newspapers that Lorca was in the city, Dalí lost no time in going to see him. Dalí, Gala, and Edward James had lunch with Lorca on the twenty-eighth in the Canari de la Garriga restaurant, opposite the Ritz, where in former days they had spent happy hours. James was dressed in embroidered Tyrolean shorts and a shirt with lace on it, causing Lorca to compare him to a "hummingbird dressed like a soldier from the time of Swift." Lorca and Gala got along extremely well; she was always very sympathetic to homosexuals, and may have

entertained the notion that Lorca would take the place in her life so abruptly vacated by René Crevel. The meeting was so successful that Lorca ignored a concert held in his honor that night in Barcelona. The audience finally had to be told that the poet had just met his friend after seven years and that they had in fact gone off together to the town of Tarragona, fifty miles away.

Lorca was, according to Ian Gibson, exhilarated to be with Dalí again and made no attempt to hide it. Gibson quotes Josep Palau i Fabre as having noticed that the poet talked incessantly about Dalí, saying that he was going to write something in collaboration with the painter and that they would design the sets together. Palau had interviewed Lorca for *L'Hora,* a weekly paper that was the organ of the POUM (Partido Obrero de Unificación Marxista), the small anti-Stalinist Communist party, and he spent a great deal of time with the poet while he was in Barcelona. "[Dalí and I] are twin spirits," Lorca told him. "Here's the proof: seven years without seeing each other and yet we agree on everything as if we'd never stopped talking since then. Salvador Dalí is a genius, a genius."[60]

Dalí and Lorca met every day, usually in a café next to the Teatro Barcelona frequented by the actors and actresses in Lorca's play, and re-created the atmosphere of the *peñas* of their youth in Madrid. A young actress in Margarita Xirgú's troupe, Amelia de la Torre, was astonished by Dalí's ties, which were made from newspapers, and by the total attention Lorca was giving his friend.[61]

One last letter survives from this extraordinary friendship, written by Dalí in March 1936, in which he asks Lorca to visit him in Port Lligat. But the poet did not come. They were never to meet again.

After five days in Barcelona, during which time Dalí and Gala were almost constantly in Lorca's company, Edward James and the Dalís set off by train to Turin. Dalí put his first visit to Italy to good use, increasing his knowledge of Italian painting and sculpture of the Renaissance, and pursuing his enthusiasm for the baroque. At the beginning of October, Dalí wrote to Foix from Rome, telling him that "Italy is more Surrealist than the Pope. Rome is in paroxysms of imperialism and *trompe l'oeil.* As we are traveling by car, we are able constantly to discover unsuspected things."[62]

In Rome, Edward James introduced Dalí to his friend Lord Berners. Gerald Berners had inherited a considerable fortune, as had James, but rather than spending it on patronage, he applied it to his own entertainment. When Dalí met him he was the First Secretary at the British embassy in Rome, and excited a great deal of interest by driving about the city in a Rolls-Royce specially adapted to hold a spinet on which Berners, a talented musician, would compose as the car glided through the streets from party to party. Naturally, Dalí and Gala lost no time in making friends with this Surrealist joker, and he in turn became very attached to them. Dalí always maintained that Berners's Surrealist book, *The Camel,* dealing with the sudden incursion of a camel into a quiet English vicarage, was one of his favorite works. Berners, however, could not resist making a joke of the Surrealists in his famous stanza:

> *On the pale yellow sands*
> *There's a pair of clasped hands*
> *And an eyeball entangled in*
> *String*
> *And a piece of raw meat*
> *And a bicycle seat*
> *And a thing that is almost a*
> *Thing.*

As they were driven through Lombardy by Miss Prufrock, one of James's long-suffering amanuenses, James and Dalí decided to collaborate on a book to be called *The Morphology of the Centuries.*

> *It was to describe the evolving river of visual patterns, which has bored a twisting bed for all chronological idiosyncrasies down the valley of the sequence of periods. . . . To be complete, the book would have to comprise all lands and races, as well as periods, down the chronological course; for this would be a history of the whole human race's subjective appetite for beauty.*[63]

As with so many collaborative exercises Dalí toyed with over the years, this one came to nothing. James was far too much of a dilettante to apply himself, and Dalí was never allowed by Gala to waste time on work other than his ever more lucrative painting.

Unlike so many of Dalí's friends from the old days, James was unencumbered by memories of Dalí before he met Gala and was favorably impressed by her influence over his friend. Writing to Edith Sitwell on October 22, after the Dalís had returned to Spain, he said:

> *He is a really remarkable young man and I have become very attached to them both. . . . In the last year Dalí has made such amazing strides forward and he has left behind him so many tiresome and unfortunate obsessions which used to hang like parasites upon his work and detract from the value of it: he is now the most normal and happy man imaginable, no longer overwrought with nerves. . . . What a wonderful thing it is for an artist to find exactly the right wife for him. This must happen once in a hundred times only. It has happened to Dalí, and I think it is going to make the entire difference to his career—in fact all the difference between his remaining an interesting phenomenon of a distorted decade in painting and his becoming one of the two or three leading figures of the coming age.*[64]

By the end of October the Dalís were back in Paris, writing to James to thank him for their stay at his house, and worrying that various boxes that presumably contained paintings and Dalí's usual assembly of found objects had not arrived. Dalí told James, "Gala and I love you, Edward, and are very good friends. . . . You have left a vacuum in my back like the cloak of night in question, in the giving of Italian food and your phenomenal tenderness."[65]

Thus an intimate correspondence was initiated. It was the Dalís' way of making sure their new Maecenas kept them constantly in mind when he was on his travels, which were frequent and fraught with changes of plan. James, for his part, liked not just to buy paintings, but to be involved in the creative process, and Dalí encouraged him. James was constantly collecting little *trouvailles* to inspire Dalí, as is apparent in a letter of December 14, 1935, with which he sends some paranoiac images:

> *The first paranoiac face was a dandy with a hair grip on his forehead like a whipper-snapper; he smokes a pipe sitting with his arms crossed and his legs crossed too: his time is that of Louis-Philippe. Perhaps he's a friend of young Baudelaire or perhaps he's the devil. He has a handkerchief (in the distressing form of a tongue) which hangs from his back*

pocket. . . . The second image is the bust of an elephant. . . . Turn the images over and you will find all sorts of other silhouettes. . . . Turn over the elephant in particular and you will see something very gripping.

Edward James was to play a part of great importance in Dalí's life. Through his encouragement and his later financial support, he would give Dalí an inestimable gift: the time to paint the pictures he wanted to paint rather than having to struggle to earn the money so avidly and incessantly demanded by Gala.

7

THE GREAT PARANOIAC
1936

On January 24, 1936, Dalí gave a lecture in Paris entitled *"Le Canibalisme Surréaliste,"* expounding his ideas of the comestibility of beauty. The event's high point was an old lady who, to illustrate Dalí's theory, made an entrance with an omelet on her head. This omelet was, according to Marie-Laure de Noailles, "fortunately dry and rather like a cataplasm. [The woman] poured milk on Dalí's foot. . . . I think the whole thing would have better been left undone."[1]

Why an omelet? Perhaps it was unconsciously connected in Dalí's mind with his old schoolmaster Señor Trayter, whose name sounded like omelet (*"truita"*) in Catalan. Dalí himself told Edward James that the lecture was "very hygienic and I feel as if I've had a marvelous bath. . . . I'm sure it would have amused you very much."[2]

Dalí and Gala went to Port Lligat in the middle of March and returned to the régime of painting all morning, a long lunch, a siesta, and evenings spent keeping up with the Surrealists, with old friends, and with new patrons by a constant stream of letters and postcards.

To Lorca, for instance, Dalí wrote on March 27:

I was very disappointed that you didn't come and find us in Paris; we would have had so much fun. We must still do some things together. Yerma is full of very obscure and Surrealist ideas. We've spent two months in Port Lligat to take a cure of analysis and objectivity and to eat all those fantastic things that no one knows and that are broad beans in a stew of prime quality, superfine and smooth, a pleasure just to look at,

and that are really the hysterics of Eleusis as far as flavoring is concerned. . . . We shall always be pleased to see you here at home.[3]

A lively correspondence ensued between Dalí and Edward James, in which Dalí tried to persuade his new friend to visit them in Port Lligat:

How much we have already lived. . . . A drawing and picture started, and in the evening before going to bed essential and substantial conversations. . . . It's absurd to find ourselves in the center of this poverty . . . of these large rocks, and this hard and aseptic sea.[4]

But James, typically, eluded them, possibly because he had found the house, which he had visited briefly the year before, too primitive for his taste. Also, James no doubt preferred the role of host and dispenser of good things to the Dalís. Dalí moved on briskly in his letter to financial matters. They wanted to acquire the house next door in order, he said, that James could stay with them, but the fisherman who used it wanted the large sum of 10,000 francs for it, which Dalí counted on raising half from the proceeds of a picture they were in the process of selling James and half from Lord Berners, who was also in the course of buying one.

Dalí tended to denigrate those many other friends of James's—artists, writers, and composers—who also felt they had a claim on his patronage. He reserved his major salvos for Yvonne, the Marquesa de Casa Fuerte, who, with James's financial support, had become one of the leading patronesses of modern music in Paris in the 1930s. This irritated Dalí and, especially, Gala, who was always suspicious of other women, particularly other women who might be helping themselves to money she felt was her due. Dalí didn't, according to James, mean it as a slight when he called the Marquesa a "44."

He just stated this dispassionately as a fact. I knew what he meant, for 44 is a blonde, open number. It is completely foursquare and golden and, if it had eyes, 44 would have scabia-blue [sic] or cornflower blue eyes. . . . The word which comes to mind about Yvonne is wholesome. That wasn't quite Dalí's cup of tea; for there is certainly nothing wholesome about Salvador Dalí or about Gala either for that matter. . . . Of course the Dalís wanted me to spend all my spare money on painting—preferably on his painting, so Gala resented any of it going to such an evanescent

thing as concerts. Paintings were, they felt, an investment, and indeed so they proved to be.[5]

James lost no time in sending Dalí the 10,000 francs which arrived in Cadaqués at the end of March, but by this time the Dalís had come up with the cheaper solution of building a bathroom, studio, and bedroom onto the original house, the first of many such additions carved out of the little adjoining *barracas* as the Dalís acquired them. The work was begun in April.

But James again proved elusive. He had to stay in Paris to undergo treatment for an unspecified intestinal problem that did not, however, preclude him from getting out and about, seeing friends and going to parties. The attractions of the simple life in Cadaqués obviously palled in comparison to the Paris season, which did not deter Dalí, who replied to James's delaying letter two days later: "Write and tell me especially about your projects, and how you are, when you're thinking of coming here. We frequently remember your so rare crackling optimism and your multiple and neo-futuristic image."[6]

James was, however, working in his friend's behalf in Paris, persuading Albert Skira to print *White Calm,* the painting he had recently bought from Dalí, in *Minotaure* and asking Dalí to write articles for the magazine, in which he had been persuaded to invest. In May, Dalí received a telegram from Breton and "Estyre" (Skira), asking him for an article on Pre-Raphaelitism, and he then wrote to James in Paris, asking him for photos of "rare and sensational Pre-Raphaelite pictures."[7]

In this same letter there is a reference to a document written by Dalí called "A Day in the Life of a Bearded Lady," in which, he told James, he had recounted in minute detail all that the woman did from the moment she got up until she went to bed "and also all the more or less hairy ideas that go through her head. . . . I'm happy you can read this document; I think that you should do a whole page because these beings become more real, and also she becomes more carefree and obsessive."[8]

The article on the Pre-Raphaelites appeared in *Minotaure* No. 8, with a cover by Dalí, and was entitled *"Le Surréalisme Spectral de l'Eternel Féminin Pre-Raphaelite."* The article on the bearded lady appeared in the next issue, under the title *"Première Loi Morphologique sur*

les Poils dans les Structures Molles" ("First Morphological Law on Hairs in Soft Structures"). Presumably the "bearded lady" description was some arcane joke between Dalí and James. Certainly the frequent telegrams that James sent Dalí to urge him to deliver the document prompted Dalí to write that "the native telephonist already has a dreamy and lost air that characterizes the state of everyone we approach more or less." Her abstraction is not to be wondered at, as she was bombarded with telegrams in typical Dalinian spelling such as "*Feme barbue arribera bien portaste bon jour—Dalí.*"[9]

Edward James now decided to subject 35 Wimpole Street to Dalinian notions of interior decoration, possibly with a view to enticing Dalí and Gala to come and stay with him again:

> *Now, do you still want to do something for me? Eight months ago, that is since the first day I saw this rock, I decided to make a room—the big room at Wimpole Street which I have still never decorated—to have the walls of this room done in big panels whose surface would be of something which looks like pitted rocks (a bit like gruyère) like you see on Cap Creole [sic]—see the piece you have given me and the piece you have in Paris which was photographed in an issue of* Minotaure. *But my London architects tell me that the weight would be too great; and if I put pieces of this rock on the walls, the house, being old and fragile, would crumble under the weight. So we're going to copy it, this rock, with plaster, a bit of cement and paint mixed with some particles of mica. They have already tried a sample of the panel. But having only the one little piece I had to show them to work on, they did not know how to show these marvellous holed formations on a large scale. So that they can understand the character of a large area of this rock better, they have asked for photographs of large pieces of it. . . . I am sure that it's worth trying; aren't you?*[10]

Thus began a short-lived but stimulating incursion into interior decorating for Dalí, who, over the next three years, would with James's encouragement create some extraordinary effects, such as the lip sofa, the cat's-cradle chair, and the champagne-glass standard lamps, which took Surrealism and the "found object" into the realms of domestic decorative fantasy. He also painted a triptych for James's drawing room. This is now lost, but preliminary sketches and a photograph of

it in place show it to be a variation on the "Cousin Carolineta" series, of a girl skipping on the beach at Roses.

In spite of the almost daily postcards and letters sent by Dalí exhorting James to let him know when he would come to Cadaqués, James yet again failed to arrive. "I'm filled with egomaniacal patience," Dalí wrote on May 10. On the eleventh, Gala weighed in, telling James that the diet his doctors recommended (trout, sole, milk, and bread) was easy to find, with the exception of sole—but surely, she insisted, "this fish could be replaced with another." Dalí added a footnote to this letter requesting that James lend *Paranoiac Face* for the collective Surrealist exhibition in London.

Ten days later, Dalí wrote a very long letter to James lamenting that the cover he had done for *Minotaure* No. 8 had got lost:

> *I'm not thinking of redoing the cover because that would be too upsetting (it's impossible to redo something that was very well done the first time, impossible to find new labyrinths, passion, etc.), but your telegrams have persuaded me. . . . Anyway, I think I've found a new idea as a substitute, a very rare photo of clouds, very rare from a morphological point of view (clouds have always been the sky's labyrinths, for it's through looking at them that one loses oneself in the sky) . . .*[11]

In this same letter Dalí also tells James that there has been another telegraphic drama over his participation in the International Surrealist Exhibition: "Colle and Company are trying to exhibit old relics of pictures that they have, which would be very bad for me and could do me considerable harm 1) because they're fragmentary pictures and 2) because I can't control the prices."[12] Telling James that he has authorized the showing of three pictures only, *The Dream* (1931), *Oiseaux* (started in 1929 and bought by Paul Eluard in that year), and *The Car of the Dead,* Dalí goes on to say, "Should they insist on or wish to exhibit other pictures of mine, I'll withdraw from the exhibition. In other words, I beg you not to lend a single picture to anyone until I've cabled or written to you to say that you may do so."[13]

The reason for Dalí's caution was that he was severing his connection with Pierre Colle's gallery in April, letting them handle pictures they had in stock but sending them nothing new. The gallery had not been successful and, moreover, had not paid Dalí what he was owed.

Ultimately, more than three works by Dalí appeared in the International Surrealist Exhibition in London, which was prefaced by an exhibition, entitled *"Exposition Surréaliste des Objets,"* at the Charles Ratton Gallery in Paris from May 20 to 29. This exhibition had been organized and edited by André Breton, who had also put together the catalog.

Among the objects Breton chose were Dalí's *Monument to Kant* and *Aphrodisiac Jacket,* a version of which had been shown in Dalí's show at the Julien Levy Gallery in 1934. Gala herself contributed a maquette for a Surrealist apartment, the central feature of which was a staircase leading to a blown-up photograph of a sculpture of Cupid and Psyche. Photographs of these objects, together with Dalí's essay *"Honneur à l'Objet,"* were published in a special edition of *Cahiers d'Art,* the main competition to *Minotaure.* The Paris exhibition was extremely successful, attracting a large number of visitors and considerable critical acclaim, and many of the objects were then sent to London for the International Surrealist Exhibition, which opened on June 12.

Dalí did not go to London until the twentieth. For on the nineteenth he held his own one-day vernissage from five to nine—not in a gallery but in a new house he and Gala had taken in Neuilly out beyond the Lion de Belfort at 101 *bis,* rue de la Tombe-Issoire. The house, decorated by Emilio Terry, was of white stucco, both inside and out. As with the house in Port Lligat, it was simple and fresh, with Spanish provincial pieces around the walls. Gala may have authorized this scheme to encourage Dalí to work away from Port Lligat but in similar surroundings.

Early de Chiricos, probably bought from Eluard, who was still suffering considerable financial reversals, were hung on the walls of the main salon, which was reflected in the depths of a concave mirror hung on one wall. Dalí's large studio on the top floor was devoted to his recent paintings, and this was where the vernissage was held. By the time Julien Levy arrived, accompanied by Léonor Fini, he found that every painting had been sold. Marie-Laure de Noailles told him that some *"sale anglais"* had bought them all.

Levy was taken aback, admitting that he had not "yet learned that [Dalí] was scrupulous in regard to agreements."[14] His own agreement to act as Dalí's U.S. agent was a verbal understanding. At the vernissage, Dalí ignored Levy's overtures, and Gala was remote and

uninterested until Léonor Fini said "Come on, let's get out" and made for the door, at which point Dalí and Gala abandoned their cat-and-mouse game and were ready to talk about Dalí's next show in New York, which, of course, had been their purpose throughout.

While this was going on, *le tout* Paris eddied around, exclaiming at the new work and at the decoration and furnishings of the new house. No other artists were there, except Picasso and Léonor Fini. Dalí, aided by Gala, was now forcefully in charge and saw no need to invite painters to his vernissage; they could be of no further help to him and they would not buy his pictures. He was no longer the "half-timid, half-malicious foreigner, but now expensive and elegant and quite formidable."[15]

To his new society friends, even the slightest pronouncement in his appallingly thick French was "amusing" or "fascinating." Photographs of him at this time show him well-tailored, something of a boulevardier. The ephebic and adolescent leanness has vanished; Dalí was now harder, more muscular and more masculine in appearance. Timidity had been replaced by a mature acceptance of the visible pattern and shape of his life, with Gala as his protectress. His work, whether painting or writing, was valued and acclaimed, both by his peers and by his patrons. Dalí was beginning have a precise idea of his worth—and, unfortunately, this showed.

Gala, too, had changed. No longer dressed in simple, inexpensive skirts or shorts and sweaters, which were once all she had been able to afford, she now emerged as an infinitely more soignée figure, dressed by Chanel and Schiaparelli in couture clothes that were often paid for by Edward James to keep her in a good temper. These designers' sharp, rather androgynous clothes suited Gala's lean, hard figure. The Dalís began to look what they were: an extremely fashionable and powerful couple able and ready to wield money and influence. Surrealist conferences at the Café Cyrano were now rare; the Dalís were far more likely to be found lunching at the Ritz.

Dalí and Gala arrived in London on the twentieth and went straight down to Cecil Beaton's house, Ashcombe, in Wiltshire, with Edward James to join a large house party; other guests included Lady Caroline Paget and Lord Berners. Dalí signed the visitors' book with a little

drawing of his recurrent amorphous being on the sands of Roses beach.

Dalí admired Lord Berners's Surrealist sense of humor and must have felt comfortable at Faringdon, Berners's country home, which he visited on his way back to London. So much so that, encouraged by his host, he gave an impromptu Surrealist performance by having Berners's grand piano placed in the pool on the lower terrace and substituting éclairs for the black keys; whereupon Berners, an excellent pianist and composer, proceeded to play the newly "Surrealised" instrument. It must have been a rather squashy concert. From these smart house parties, the Dalís moved into 35 Wimpole Street.

The International Surrealist Exhibition was the consequence of the intimate involvement of Roland Penrose and David Gascoyne with the movement and its members in Paris. Penrose, a great friend of Picasso's, had become a "country member" of the Surrealist group during the time he was in Paris painting. Blessed with considerable private means, he was also a good organizer, and it was through his efforts that the exhibition became a success. David Gascoyne was a young poet who had gone to Paris and joined the Surrealists. He had come to know Dalí and Gala well through their mutual friend René Crevel. There was more than a hint of proselytizing about the exhibition, as Roland Penrose recounted:

> Our urgent desire was to make clear to Londoners that there was a revelation awaiting. It could release them from the constipation of logic which conventional public-school mentality had brought upon them. Centred around Herbert Read . . . a small group came to life which included Humphrey Jennings, Henry Moore, Paul Nash, Hugh Sykes-Davies, Eileen Agar. . . . In their enthusiasm and their wish to become more familiar with the activities of the Surrealists in Paris, they interrupted their séances of automatic writing and cadavre-exquis drawings with a well-organized attempt to stage in London an international Surrealist exhibition.[16]

"The sudden attention took me by surprise," wrote Eileen Agar. "One day I was an artist exploring highly personal combinations of form and content, and the next I was calmly informed I was a Surrealist!"[17]

Roland Penrose was ideally suited to the role of organizer and, in many instances, mediator: He was a polymath, a famous collector, a writer, and an artist. It was he who wrote to owners of major Surrealist works requesting their loan; it was he who made sure they were insured—the premium amounted to the sum of £20 6s. 11d.

The exhibition was officially opened on June 11 by André Breton. It was a hot day in a very hot summer, and Burlington Gardens was crowded with the curious and the serious. The large rooms were filled with works by de Chirico, Dalí, Duchamp, Klee, Miró, Picabia, Picasso, Magritte, and Man Ray. Sculptures by Brancusi, Arp, Moore, Giacometti, and Calder were interspersed with examples of tribal art lent by museums and collectors. By the last day, over ten thousand visitors had seen the exhibition. Dalí could not resist writing a long letter to Foix on June 24 to boast:

> I imagine you've been following in the English press the "enormous effect" produced by the Surrealist exhibition. . . . We ourselves could not imagine the ideological coherence given off by the exhibition, nor the quantity and quality of what has been collected. Surrealism is catching on marvelously in London as it resuscitates the latent occult atavism of the English tradition of Blake, Lewis Carroll, Pre-Raphaelitism, etc.[18]

Sheila Legge, a young Surrealist artist, was photographed feeding the pigeons in Trafalgar Square, her head entirely covered in roses. But the events planned by Dalí drew the most attention. In July, he gave a lecture entitled "Paranoia, the Pre-Raphaelites, Harpo Marx, and Phantoms." The curiously assorted subject matter was fodder enough for controversy; Dalí chose to make his delivery even more of a Surrealist event by wearing a cumbersome diving suit and helmet, found for him by Lord Berners; the suit was intended, as Dalí put it, "to show that I was plunging down deeply into the human mind."[19]

The Daily Mail described the "fashionably dressed and slightly exotic young men of the 'Mayfair Modernist' school" drinking in the first genuinely Surrealist event London had seen. In his diving suit, which had a Mercedes radiator cap on top and plastic hands stuck to the torso, Dalí made one of the great entrances of his life. He was holding two white Russian wolfhounds on a leash in one hand, a billiard cue in the other, and he had a jeweled dagger in his belt.

But what he had not taken into account was that he would not be able to breathe in the helmet. He started his lecture, but soon began to fail. The audience was unaware that he was suffocating. Gala, alas, had slipped out for a cup of coffee (or possibly to see a film matinée). When it became apparent that something was terribly wrong, Edward James and Lord Berners rushed on stage and tried to hammer the bolts on the helmet to make them turn. Finally, when Dalí was nearly dead, a workman was found with that mundane and far from Surrealist tool, a wrench, which released him.

Meanwhile, at Reid and Lefevre, there ran a companion one-man show of Dalí's work in which twenty-nine pictures and eighteen drawings, lent by James, were shown. It was equally successful. In *Studio* No. 112 (September 1936), an anonymous reviewer said:

> *Of the newer figures specially associated with the [Surrealist] movement, by far the most accomplished is Salvador Dalí, who paints like a Pre-Raphaelite gone queer in the head. The qualities about Dalí's work which really pleased the crowds who flocked to his one-man show at Messrs Reid and Lefevre's galleries are those which it shares with that of eminently respectable figures like Holman Hunt.*[20]

After the exhibitions finished, Gala and Dalí seemed to be in no hurry to return to Cadaqués, and they relaxed with James in his house on Wimpole Street. Here they planned further decorative schemes and Surrealist jeux d'esprit. People had laughed at Dalí's early inventions, so energetically marketed around Paris by Gala at the beginning of the 1930s; now any idea Dalí had was taken up seriously and immediately by James. Among them was the possibly most famous object ever invented by Dalí: the lobster telephone.

In 1935, during his second visit to New York, Dalí had been commissioned by the magazine *American Weekly* to execute a series of drawings based on his impressions of New York. One of these drawings was given the title *New York Dream—Man Finds Lobster in Place of Phone*. Later, in 1938, Dalí contributed to the *Dictionnaire Abrégé du Surréalisme* a piece called *"Téléphone Aphrodisiaque,"* which started with the proposition that telephones would be replaced by lobsters. Later, in *The Secret Life*, he developed the theme:

I do not understand why, when I ask for a grilled lobster in a restaurant, I am never served a cooked telephone; I do not understand why champagne is always chilled and why on the other hand telephones, which are habitually so frightfully warm and disagreeably sticky to the touch, are not also put in silver buckets with crushed ice around them.

Telephone frappé, mint-colored telephone, aphrodisiac telephone, lobster-telephone, telephone sheathed in sable for the boudoirs of sirens with fingernails protected with ermine, Edgar Allan Poe telephones with a dead rat concealed within, Böcklin telephones installed inside a cypress tree (and with an allegory of death in inlaid silver on their backs), telephones on the leash which would walk about, screwed to the back of a living turtle . . . telephones . . . telephones . . . telephones . . .[21]

The lobster telephone now in the Tate Gallery is different from that illustrated in the Centre Pompidou catalog to the Paris retrospective of Dalí's work. The Tate's model was made by the Bell Company in Belgium with a handset made in London. Another, more old-fashioned type of telephone, its receiver surmounted by a lobster, can be seen in a photograph of the installation of the Paris International Surrealist Exhibition of 1938 (reproduced in *La Vie Publique de Salvador Dalí*). The lobster, made of plaster of paris, was designed to clip onto any standard receiver of the time, and Edward James was so enamored of this seminal Surrealist object that every telephone in his Wimpole Street house sprouted a lobster.

The other Surrealist object, the "Mae West's Lips" sofa, arose out of Dalí's 1934 *Mae West* painting and a related drawing, *The Birth of the Paranoiac Furniture* (1934–1935), bought by Edward James. The Surrealists were fascinated by lips; the cover of the second issue of *Le Surréalisme au Service de la Révolution* had featured the imprints of many Surrealists' lips, and Man Ray had explored the theme further using Lee Miller's lips in *The Observatory of Love*. Edward James decided to produce some of Dalí's Surrealist furniture as limited editions. He had the prototype made by the firm of Green and Abbott in Wigmore Street. An envelope on the back of which Dalí had drawn the dimensions of the sofa, and that now contains photographs of the sofa under construction, still survives. Two more sofas were made by Jean-Michel Frank in Paris for Elsa Schiaparelli, who did not like the finished result and never took delivery of them.

* * *

Dalí and Gala stayed with Edward James until July 24; it was fortunate that they had broken their by now established habit of spending the summer months in Cadaqués, for on July 18 the Spanish Civil War finally broke out.

Dalí heard of this while he was at dinner at the Savoy with Edward James and commented that it had nothing to do with him, since he was a Communist, but this was said for effect. In an undated letter, probably written about two years later, James berated Dalí for his attitude toward the war:

> When the Civil War broke out you and your wife were my guests in London and you daily cheered the news of Communist and Anarchist violence in Spain. All your old associates had been of the leftist intelligentsia. But they were sincere and did not change sides when they began to see that Franco would win. We all watched you do that. We who had loved you felt a secret shame at your behaviour; but you showed no vestige of shame—indeed felt none.[22]

Dalí's response to the Civil War remains unsavory. He had in fact been interested in politics when growing up in Figueres—far more interested than he later wanted his public to believe. The Spanish Civil War brought out the worst side of his character, the opportunism that was never very far from the surface. James continued in the same letter:

> I do remember your introducing me to Buñuel in Paris in the second or third week of the Civil War with the suggestion that I might contribute funds to buy aeroplanes to be flown from Czechoslovakia to Madrid for the defence of the Republican government, in return for which I might have certain pictures by El Greco to hold as security until the money raised to buy the aeroplanes had been refunded me. The pictures, you remember, were to be exhibited in London at Burlington House and the funds raised by entrance fees to the exhibition were to be paid to the Spanish Republican cause. It was for this purpose that you introduced me to Buñuel. I went so far as to approach Sir Kenneth Clark, then Director of the London National Gallery, and he quite seriously considered the proposition of exhibiting the El Grecos in London, but said he would have

*to consult with the director of the Louvre because the French had already
had a similar idea.*

*I remember too how you ridiculed Yvonne de Casa Fuerte in my
London house because, being herself very Catholic and conservative in
her opinions, she did not join with you in jubilating over the initial
violence and small successes of the Communists in Barcelona during the
first ten days of the Civil War. Your words were—I remember them
vividly: "Just because she is a Marquise, she feels she cannot agree with
us that General Franco is a scoundrel and a bandit."*

*When General Franco's eventual success became probable your
change of side began, at first by refusing to donate any pictures or draw-
ings toward funds which were being raised in Paris for the relief of
Spanish Republican refugees; and at the time that Picasso was painting
his "Guernica" for the Spanish Pavilion at the World's Fair, you hesitated
about contributing, then finally told me a few months later that a Repub-
lican Spaniard had come to ask you to contribute and you had refused
because you said you found him personally unattractive, saying that he
was a little "arriviste" (that favourite word of yours again) and added
that the representatives of both sides in the conflict were equally "oripil-
lant" to you.[23]*

In distancing himself from the Spanish Civil War, Dalí acted in charac-
ter; naturally timid, he disguised his terror of physical violence by
making bad jokes about the war. There was, as always with Dalí, also a
strong element of self-interest in his change of sides. Politically aware
from a very early age, he was, when he shifted his allegiance to Franco,
looking ahead to a possible time after the Civil War when he might go
back to Spain if he had been seen to support the winning side. This
self-absorption was always the least attractive side of Dalí's character,
but his attitude toward the Civil War should be set against his belief
that he could fulfill his destiny as an artist only by painting in Spain.
To Dalí, this overrode any consideration of right, or of loyalty.

As a son of the middle class, Dalí would have been at great risk had
he returned to the Empordà. In Catalonia, the workers, through their
party and trade-union organizations, initially became the real rulers of
the country. Workers' committees formed in July 1936 lasted until
October of that year, and during these months organized the militia to
carry on the war against the enemy forces of the republicans.

Terrorism came to the Empordà, and vigilantes destroyed or intimi-

dated what they believed to be the enemy in their midst. Factories and estates abandoned by their owners were sequestrated and run by the workers. When a workers' committee in a particular district was anarchist, a policy of collectivization was instituted, thought by its perpetrators to be the first step on the way to a more profound social revolution.

There were many victims in these first months of the Civil War, selected by so-called public-safety committees of the three working-class parties or by military intelligence committees. Executions were carried out by small groups who took the accused from their homes in the middle of the night in trucks. These final journeys were called, ironically, *paseos* (outings), and they became an opportunity to settle old scores and to weed out what was perceived by the left-wing workers in Catalonia as right-wing decadence.

Figueres, and more particularly Cadaqués, did not escape these vigilantes. A photograph from this time has made an occasional appearance pinned up in a shop window in Cadaqués, only to disappear again mysteriously after an hour or so: It shows about thirty men, blindfolded and with their hands tied behind their backs, assembled in a circle in the village plaza to be shot, watched by horrified villagers, some of whom are being forcibly restrained.

The economy of Cadaqués was soon destroyed. The owner of the canning factory was killed, as was every substantial man of business in the village. Houses were burned out. About thirty of Dalí's friends were killed, including three of the fishermen from Port Lligat who had supported him during the early months of his estrangement from his father. Many Catalonians fled to France in a great diaspora, and by the end of 1936, the countryside was depopulated. The peaceful and prosperous little world of Dalí's childhood lay in ruins, its inhabitants poverty-stricken and terrified to go out as bands of vigilantes roamed through the Empordà.

The Dalí family did not escape unscathed: Ana Maria was arrested by a military intelligence committee on the pretext that she had been making visits to a friend's boat anchored in the bay, which may or may not have contained a radio. Rumor had it she was communicating with the Falange. She was taken to Barcelona and imprisoned, possibly raped, certainly tortured, and then released. For a year afterward she was hysterical and unable to speak.

The Dalís' house in Cadaqués was shelled and one of the balconies was knocked off by a bomb. The house was partially ransacked by the workers who had built fires on the dining-room floor to cook their meals. Things were no better in Figueres; some anarchists defecated on the notary's desk which they took to be a symbol of property, but Dalí's father and his second wife were unharmed.

Dalí's house in Port Lligat was virtually destroyed; there was no trace of any of the contents, and everywhere, on the walls, Dalí later recalled, were "graffiti, which, in their challenge-game, recorded each passage of rival armed troops shouting their arrogant certainty of victory. I could follow the progression of the war as on a general-staff map. Anarchists pushed out by the Communists, return of the Trotskyists, the Separatists, the Republicans and finally the Francoites with their '¡Arriba España!' covering a whole panel."[24]

Lidia Nogueres alone seems to have sailed through the terrifying events of the Civil War, devising a solution for survival among the warring forces only she could have thought of. She lit a large bonfire on the beach at Port Lligat each evening and when, chilled and cold, the soldiers who for the moment held the area saw the flames, they came over and opened their packs and gave what food they had to Lidia to cook. She became their canteen keeper and their fence for loot. Next day an opposing group might drive these soldiers out, but then Lidia would rebuild her fire and resume her role as provider. As she told Dalí, "There is always a time when they have to eat."[25]

In Granada the political situation was exactly the reverse. The republicans were in the minority and the Falange was in power during the early days of the Civil War. But the number of executions was as high; in the first three months, the right summarily executed many republicans unfortunate enough to be trapped in the city.

On August 18, Federico García Lorca was arrested, then taken out in the middle of the night and shot. Dalí maintained that Lorca did not die as a symbol of one or another political ideology, but as the propitiatory victim of that "total and integral phenomenon that was the revolutionary confusion in which the Civil War unfolded. . . . People killed one another not even for ideas, but for 'personal reasons,' for reasons of personality; and like myself, Lorca had personality to spare and, with it, a better right than most Spaniards to be shot by Spaniards."[26] Another view is that he was shot for his homosexuality.

Dalí is said to have exclaimed *"Olé"* when he heard about Lorca's death, and indeed is quoted by André Parinaud as saying this, as if a particularly brave bull had died at the hands of the matador, but whether he actually said it at the time is doubtful. He did, however, subsequently refer to his "villainy" in making this comment at all. Afterward, Dalí would claim that if Lorca had only gone to Italy when he was asked, Dalí could have saved him; but this of course was a typical Dalinian mix-up over dates, witting or unwitting.

Dalí stayed in London with Edward James until the beginning of August. On July 31 he signed an agreement with James to sell a portrait of Gala for 25,000 francs, of which 20,000 was to be paid on signature, the remaining 5,000 on delivery. There was a curious clause allowing that Dalí could, if he wished, retain the portrait at his own risk until July 30, 1939, at which point he would be obliged to hand it over—or, if he had died in the meantime, his personal representatives would hand it over. This one-page contract would cause a great deal of trouble between Dalí and Edward James in the future.

Dalí and Gala paused briefly in Paris to gather what news they could from Spain, and then made their way to Italy, where Dalí was to prepare work to be exhibited in New York that winter. Many of his acquaintances thought that Dalí ought to have gone back to Spain to join in the struggle. He had a ready Dalinian reply to that. He was in Italy to study the Renaissance, he explained, for he had concluded that "all Europe would sink into war as a consequence of the communist and fascist revolutions and from the poverty and collapse of collectivist doctrines would arise a mediaeval period of reactualisation of individual, spiritual and religious values. Of these imminent Middle Ages I wanted to be the first, with a full understanding of the laws of life and death of aesthetics, to be able to utter the word 'renaissance.' "[27]

The research Dalí carried out on the work of painters of the Italian Renaissance during this, his second trip to Italy, would, fifteen years later, be the basis on which he forged his way to a new stage in his painting and his philosophy. In the meantime, he was still at heart a Surrealist, and during the two months he spent in Italy, shuttling between Edward James, at the Villa Cimbrone at Amalfi, and Lord Berners, at his palazzo in Rome, he painted *Impressions of Africa*, the famous double-image painting based on a postcard of tribesmen dancing.

He also studied assiduously, making many drawings from classical statues and collecting what he termed "very fine photographic nudes" bought in Taormina, probably male nudes taken by the pedophile Baron von Glaeden, which were readily for sale at the time and which enjoyed considerable réclame among many of Dalí's friends.

News of the dreadful events in Spain came almost daily, and Dalí became upset and disturbed enough for Gala to be concerned. As always, her solution to any problem was to head for the mountains, and they ended up at a hotel near Cortina at Tre Croci, near the Austrian frontier. Here Dalí calmed down, until Gala had to leave him for twelve days to do some business in Paris, probably in connection with making sure payments would get through to them. While she was away, Dalí sank into a lethargic state induced by indecision. Presumably it had been Gala's counsel that had stopped him from returning to Spain. Now, removed from the immediate effects of her presence, he had second thoughts. But these came to nothing; not for the first time in his life, Dalí was being selfish as well as realistic. He abandoned the idea of immolating himself on a martyr's pyre.

By October, Dalí and Gala were back in Paris, and Gala wrote to Edward James that Dalí was "preparing with fury" for a December exhibition at New York's Museum of Modern Art, a show entitled "Exhibition of Fantastic Art, Dada, and Surrealism," or "Art of the Marvelous and Fantastic." Dalí, Gala told James (untruthfully), was "essentially organizing the presentation in the museum," and she asked James whether he would lend *Paranoiac Face, The Car of the Dead,* and the "drawing of the woman of drawers."

At the foot of this letter Dalí drew two figures of women with drawers holding up their hands as if to implore James to do what he wanted. Dalí and Gala must have been desperate to get their hands on these pictures, since they wrote again to James the same day. James's secretary replied (on the Dalís' own letter, which he mailed back to them): "Mr. James has 25 of Dalí's pictures and it is not very easy for him to be sure that Thomas [Pope, the butler at the Wimpole Street house] will find the ones you want. Very sorry."

A few days later Dalí wrote:

I'm working like a very controlled storm but as I'm working around me mountains of intrigue and jealousy are forming which sometimes take on menacing proportions. . . . They want to exclude me from a huge exhibition of modern art but they've ended up by not being able to. They've counted on the lack of pictures they've seen at my house to make my section look feeble, that's why I'm taking pains on the contrary to surprise them with a resounding display, and I beg, beg, beg you if you will to get to me as quickly as possible through Thomas the following pictures:
1 Autumn Cannibalism
2 Child Looking at the Moon
3 Great Paranoiac Face
4 City of Drawers[28]

This appeal worked, and the pictures in question were duly dispatched to New York in time for the opening of the exhibition at the beginning of December.

Presumably the machinations to which Dalí referred in his letter were those of the inner circle of Surrealists, led by Breton, to which Dalí no longer belonged. That being the case, one can imagine the fury with which this group saw the December 14 issue of *Time* magazine, which ran as its cover Man Ray's black-and-white portrait of Dalí, taken some two years previously and originally intended to form part of a collection of similar portraits of leading Surrealists. *Time* went further: "Surrealism would never have attracted its present attention in the U.S. were it not for a handsome 32-year-old Catalan with a soft voice and a clipped cinemactor's moustache, Salvador Dalí." There followed a short biographical article on Dalí, informing *Time* readers that he "has a faculty for publicity which should turn any circus press agent green with envy."

This almost wholesale hijacking of the New York exhibition by Dalí did not improve his relationship with his Surrealist colleagues, and André Breton in particular became more vociferous in his anti-Dalí proclamations. This cover photograph and the magazine's singling out of Dalí marked the third and final stage in the deterioration of his relationship with the Surrealist group.

"With the amazing activities of Salvador Dalí, both in painting and in life," wrote John G. Frey in *Parnassus* in December 1936, "the Romantic movement, of which both Surrealism and Dada are a part,

reaches its extreme limit. It is hardly likely that Surrealist *painting* can be pushed beyond the point it has now reached. Painting has been abolished, the painter has been abolished, there is left only the semi-madman, the voluntary lunatic driving on in a desperate battle with reality."[29]

Dalí declared a truce in his "desperate battle" with reality that December by signing a contract with Edward James, in which he agreed to sell and James to buy "all paintings, drawings, and sculpture" completed by Dalí during the three years commencing on the first day of June 1936 and ending on the first day of June 1939. The contract also specified that Dalí was not allowed to sell, hire, let, or loan any of the works completed during the given period to any other person. The agreement excluded any drawings ordered by newspapers or magazines, but Dalí had to pay James 30 percent of the price he got for any such work.

In exchange, Dalí was to get £2,400, payable on the first day of each calendar month in installments of £200, and, during the said period, Dalí had to complete not less than twelve large pictures approximately 550 square inches in size, eighteen small pictures approximately 120 square inches in size, and sixty drawings of a minimum size of approximately 120 square inches. The contract also specified penalty clauses for nondelivery and minimum resale prices for the pictures.

Dalí was assured of a regular monthly income, and neither he nor Gala had to do business with dealers. Because of the war, they could no longer spend six months of the year cheaply in Port Lligat; they had to stay in Paris, which was expensive, or live in hotels in Italy, if they were not staying in friends' houses. The enormous assured sum of £200 a month enabled Dalí to concentrate on his painting and writing to the exclusion of almost any practical detail at all.

This release from financial care acted as a stimulant to Dalí, pushing him further away from the Surrealists and back to painting based on his own ego and, as always, on his own past. These three years in which he was being supported by Edward James saw the culmination of many of the themes Dalí had developed throughout the earlier years of the decade. Because of the Spanish Civil War, Dalí was separated from the scenes of his childhood that had always inspired him. It was almost as if by forcing himself to paint these familiar scenes he could exorcise his homesickness.

FREUD'S PERVERSE POLYMORPH
1937–1939

In the period preceding World War II, Edward James and Dalí became lovers. Gala, who was no stranger to triangular relationships, turned a blind eye; but, from time to time, possibly when she felt Dalí was escaping her clutches, she would explode.

James himself admitted this in a long, undated note, probably written after his relationship with Dalí had ended:

> . . . Gala more than guessed how close Dalí and I were to each other—and now [in about 1936] accepted it as workable, even after she did once create a scene of jealousy one night in an hotel in Modena, which erupted into a scandal—with Dalí coming to my room in tears and wearing only the top of his pyjamas. . . . He stood protesting outside the door how he could not stand her nagging about Lorca and now about me any longer.[1]

It was a pity, James indicated, "that I wasn't actually a king—and though munificent towards him couldn't give him a castle in Bavaria to transform into a Surrealist nightmare." Had this been possible, he admitted, "all Gala's jealous scenes would be alleviated and shelved once and for all. In the end a few expensive evening dresses from Schiaparelli and a few jewelled clips from Boivin, the smartest modern jeweller in Paris, plus a rare seventeenth-century gold-and-enamel snake bracelet, with a large emerald in the head, purchased when we were together in Venice from an antiquary in that city, did this trick all right . . . up to a point."[2]

When Dalí came home to their Montparnasse apartment "after

spending all night with me at the Ritz once, Gala threatened to leave him and go to Portugal—'je vais au Portugal' she kept on repeating. But I carried her Christmas present in a velvet-lined case in my pocket— and Dalí kept on jabbing me in the ribs and whispering with a hiss 'Donne-le-lui, maintenant, tout de suite.' After I had got the message and Gala opened the case and saw the stringed cabochon sapphires, rubies and emeralds in a gold setting, Portugal was immediately forgotten and she went delightedly to the kitchen to fix us scrambled eggs."[3]

James went on:

> His real interests were instinctively far more homosexual than heterosexual; Gala tried to believe that she had cured him of his homosexuality, but she knew in her heart that she had not really at all. She had, however, managed to keep it "sublimated" (if you can call it that) by channelling it into erotic drawings and some obscene pictures which are owned by private collectors who buy pornography. Pierre Colle . . . offered me one small brilliantly painted oil which was sheer pornography.
> . . . As for Dalí's sex life with his wife, far from being jealous of her sexual infidelities, he actually facilitated them; one day he confessed to me: "Je laisse Gala prendre des amants quand elle veut. Actuellement, je l'encourage et je l'aide, parce que cela m'excite."[4]

But the relationship between the Dalís and James was stormy; Edward James was a man who saw a slight where none existed, and, as was his habit, Dalí blew hot and cold. Gala, for her part, became increasingly greedy and little by little began to cheat James out of paintings, which she sold privately. The threesome was an arrangement doomed to eventual failure; that it lasted for three years was extraordinary.

There was a honeymoon period, when Dalí would constantly consult James about the progress of a particular painting, poem, or piece of writing, and this of course fulfilled James's view of himself as a patron at his most creative. In his mouvementé and muddled life he managed to be in the same city as Dalí and Gala more often than not, and had them to himself in Italy during their long holidays at the Villa Cimbrone. He was in New York with them at the turn of the year and wrote proudly to his friend the actress Brigitte Hardwick that nearly all Dalí's works had sold and that Surrealism had become a household word used even in the Middle West. The New Yorker magazine could

hardly think anymore of a joke that did not have something to do with Surrealism, he told her.

James must have thought that he had made a good investment in Dalí's future work when he looked at the results of the new one-man show at the Julien Levy Gallery, which had opened on New Year's Day 1937. Twenty-one oil paintings and numerous drawings in the show were sold, but a warning note was sounded by the anonymous critic of the *Art Digest* who, under the title "Dalí, Waster of a Great Painting Talent," referred to him as the "outstanding exponent of the coffee-before-bed facet of many-sided Surrealism" and pointed out the paradox that a Spaniard should "appropriate a Dutch realistic technique to paint tales of a Vienna doctor."

Sometime toward the end of January, Dalí and Gala went west, possibly in search of portrait commissions but also because they both wanted to meet film stars. They liked Hollywood, which they found more than ready to adopt Surrealism, and very much to their taste. Writing to James from the somewhat louche hotel the Garden of Allah, Dalí told him they had done absolutely everything:

> *Lots of desert, frozen Indians, excursions on horseback among the most artistic cactus in the world, fair super-platinum "beautiful symmetries," etc. I shall record all that on records which I shall have sung near you so that we can dance to them soon somewhere.*
>
> *ARPO is a delicious person and one of the finest, I'm doing a drawing of him with his ARPE which I think is* very lovely.[5]

In common with many of the European intelligentsia, Dalí had always admired the Marx Brothers' films and said they were truly Surrealist. He had been excited when he was introduced to Harpo Marx at a party in Paris the year before. For Christmas 1936, Dalí had sent Harpo as a present a Surrealist construct: a harp with barbed-wire strings. Harpo had responded with a photograph of himself with bandaged fingers, and a telegram in which he told Dalí he would be "happy to be smeared by you." The signs for a portrait commission were propitious. At this second meeting, Harpo, according to "Surrealism in Hollywood," an article written by Dalí that appeared in *Harper's Bazaar* five

months later, was naked, crowned with roses and surrounded by harps in his garden. Whatever the more prosaic truth of this meeting, Dalí did some drawings of Harpo, inspired, so he told *Harper's Bazaar*, by his vision of the comedian as an eighteenth-century figure, evoking Watteau's *L'Embarquement pour Cythère*.

So friendly did the two become that Dalí decided to write a scenario for Harpo to be called *Giraffes on Horseback Salad*. Unfortunately, for the cinema might have been richer for a film combining the extraordinary talents of Dalí and Harpo, this never materialized, in spite of an enthusiastic letter Dalí wrote to Harpo from the Sporthotel in Zürs on his return to Europe at the end of February:

> *I'm spending a week in the snow and I'm going to take this advantage to write the scenario in which you are the only protagonist, after I've got to know you. I'm absolutely decided that we will do something together because we really do both think the same sort of things and we like exactly the same "type of imagination"; I'm sure that a short film, with the sensational scenario made expressly for your genius, with extraordinary decorations and a very lyrical music, like Cole Porter's, would be something hallucinatory which in addition to amusing us could make a successful revolution in the cinema.[6]*

Dalí did produce one small scenario, *The Surrealist Woman*, together with some sketches for scenery, for the Marx Brothers, but this was never performed nor published.

For the benefit of the *Harper's Bazaar* reader, Dalí appended a "Spectral and Surrealist Analysis of the Hollywood Heavens":

> *Cecil de Mille is Surrealist in his sadism and fantasy.*
> *Harpo Marx is Surrealist in everything*
> *Adolphe Menjou's moustache is Surrealist.* [This last was a direct reference to the jeux d'esprit played at the Residencia. Now at last Dalí had had the opportunity to meet the owner of the much-admired moustache.][7]

He ended his list by telling the readers that Clark Gable was not Surrealist. Presumably Gable's mustache was not to his liking. Even so, Dalí immediately felt that Hollywood was full of possibility and "Surrealism takes to it like honey on explosive giraffes."[8]

* * *

On Dalí's return to Europe, there was more serious work afoot than meeting film stars. In Zürs that spring, he started on a major work whose theme had been gestating for years. *The Metamorphosis of Narcissus,* together with an accompanying poem, of the same title, that amplified and explained the painting.

This painting, originally owned by Edward James, now hangs in the Tate. It shows, apart from Dalí's preoccupation with the double image (the figure of Narcissus turns into a petrified hand holding an egg out of which bursts a narcissus), the influence on his iconography of the several visits he had already made to Italy in order to study Italian painters of the Renaissance. The attitudes of the dancing figures in the mid-background, for instance, carry undertones of Botticelli. While the landscape in the foreground is still recognizably that of Cap de Creus, the golden glow of the background is far more reminiscent of a painting of the Umbrian school. There are, as the poem points out, meanings in the painting beyond the initial double image of the reflective Narcissus and the hand holding the egg with the narcissus. Explaining this egg, Dalí reports a typical conversation between two Cadaqués fishermen (probably Lidia Nogueres's sons):

> *First fisherman: "What does that boy want to look at himself all day in the mirror for?"*
>
> *Second fisherman: "If you really want me to tell you: He has an onion in the head."*[9]

In the rich imagery of Catalan, an "onion in the head," Dalí pointed out, was the equivalent of an obsession.

Dalí had not wasted his time in Italy idling with James's friends at the Villa Cimbrone; he had spent weeks of dedicated study, particularly of Leonardo da Vinci, with whom he identified as a Renaissance man, equally at home with the arts and with the sciences. The paintings he did during the "James" period, while still Surrealist, do show signs of new developments. This may in part have had to do with Dalí's being cut off from the influence and inspiration of his native landscape by the Civil War, thus propelling him into new and wider subjects.

Dalí always maintained that he was a better writer than painter, and took his writing as seriously as he did his painting. In a letter to Eluard of April 1937 there is an example of his commentary on his own poetry. He told Eluard that he believed that poetry is "the most lyrical expression of thought, from which it follows that the musical expression of thought corresponds to the actual verses. When man is truly inspired, he begins to sing like a nightingale and immediately creates opera. . . ."

Edward James spent some time with the Dalís at Zürs when Dalí was painting his picture and writing his poem. During this stay, Dalí and James had a row for reasons now lost but probably connected with their relationship. However, the disagreement was soon resolved and Dalí requested James to translate the poem into English. Dalí's original was written in French, in what James later described as "a loose metre and also not in rhyme."[10] James's version had a rhyme scheme, and he made the case that he had actually written a new poem based on Dalí's theme and inspiration to convey the "real force and quality of what a poet was feeling in [another] language." The final version was called "An English Variation upon a Poem by Salvador Dalí," and James was at pains in a letter to point out that his poem did follow fairly closely the text of Dalí's original. The postscript to this letter is revealing: "Dalí ends by turning the poem with his last lines into a tribute to his wife; but, graceful though this is, it seems to me out of place in the context and dragged in *'par quatre épingles,'* as they say."[11]

James himself underwrote the cost of printing a book containing both picture and poem, which was published in English by Julien Levy's Surréalistes imprint in New York. As usual, James got little thanks from Dalí, who complained, some months later, that he had not been sent a copy.

The Metamorphosis of Narcissus, when finished, became James's property, as it was completed during the period of their contract. Their collaboration over the poem "Metamorphosis" marked the high note in their relationship, and Dalí consulted James at virtually every stage of the painting's progress, either personally, when James was in Paris, or by letter, when James had, once again, retired to a clinic to be treated for his persistent colitis.

On June 15, for instance, Dalí wrote:

The finished Narcissus has become even more important now with the appearance of the dog which eats notelets (DIONISIUS in the form of a dog changes into a red anemone) this dog . . . is very good in front of this ferocious countryside under an orb which seems to reclaim vegetation. Nothing could grow in this sterile earth, *do you remember? Because it was the land of* underground anemones *which will grow in the next picture—there are no pictures, there is only "one" which you continue all your life on different canvases like frames on real film of the imagination.*[12]

This sentence is central to understanding Dalí's painting. He confirms that what he is doing when he is painting is, in effect, making a film of his subconscious and conscious mind. That his paintings are by no means paranoiac-critical, but much more consciously autobiographical, is beyond doubt.

The landscape of his childhood is a permanent backdrop against which the dramas of his life are played out in paint. And, just as in film, Dalí does not deal in chronology; he moves about freely in time and space. His paintings indicate certain universal and underlying themes from his past (the landscape, the child within it, the father, the voracious woman figure) on which are overlaid subjects from his present. A good example is *Atmospheric Skull Sodomizing a Grand Piano*. This was painted in 1934 and refers to Lorca's attempted seduction nearly ten years earlier; yet it is set in 1934 on the rocky shore of Port Lligat: The ruined houses in the background were destroyed during the Civil War. So in each painting there is an admixture of present preoccupation and eternal theme.

By the end of June, *Narcissus* was finished, and Dalí was writing frantically to James asking him to pay for it to be photographed in color for the planned book, which would cost 3,000 francs. Dalí also asked permission to show the pictures he had just finished (which were bound by contract to James) at his forthcoming exhibition in Paris. "If you're feeling kind," he wrote to James, "bring me the large paranoiac head, and that is all that is needed to complete the exhibition."[13]

The Metamorphosis of Narcissus was shown at the Galerie Renou et Colle in Paris from July 6 to July 30; Dalí also showed—and sold—a great many drawings in the exhibition. This profoundly irritated Ed-

ward James, who believed that Dalí had deliberately finished the drawings in the last four or five days before their contract became active on June 1. When he had visited Dalí in Paris on May 29, James had noted that at least five of the big drawings that turned up in the exhibition had not been started.

He also asserted, in a long letter written at the end of August, that in completing so many drawings just before their contract commenced Dalí was deliberately flooding the market, and that it would be Pierre Colle who would profit from them: "When there had been none for a time . . . he could sell them for your highly inflated prices even though there were many of them, but . . . when I arrive with part two, to introduce as many Dalí drawings again, even if they are as good as the first part, I shall be told, 'Sir, we have already just this minute bought from Renou et Colle and he still has some to sell.' "[14]

In the three years of the duration of the contract between Dalí and James, there were constant arguments about which currency Dalí should be paid in (it changed according to the advantage or otherwise of the pound against the franc). There were also arguments about the frequency of payments, for often James would mysteriously be unavailable when a payment came due. James always paid up in the end, usually when Dalí and Gala, realizing they had pushed him too far, became conciliatory. As James himself put it, "You see we should not stay apart for too long, Gala, you and I; because I am sure that when I see you and Gala again I shall no longer for a moment think of quarrelling or reproaching."[15]

James was clear about the benefits to him of the contract: It safeguarded his own speculative interests in Dalí's future and it guaranteed the purchase of every picture Dalí painted, which would "definitely be the best way to make you do pictures which will hold their importance in the history of painting, through not having been painted in too much haste." In this supposition he was absolutely correct, and the years in which James guaranteed the Dalís an income coincided with a high point in Dalí's work; his paintings were executed in less of a hurry and were far more accomplished technically.

Dalí and Gala wrote to Edward James at the beginning of August from Paris, before setting off on a three-month trip to Italy. Dalí told James

that he had signed a contract with Léonide Massine to work on his ballet *Tristan Fou* and that Schiaparelli would do the costumes. However, he was careful to reassure James that he was naturally to "remain the owner of the models." They had, Dalí told James, been with their "famous and dear" Schiaparelli and ordered on James's account a silk robe with braided colored sequins as they "had the idea that you wanted to give him [Dalí] a present this winter."[16]

Dalí also told James of the relaunch of *Minotaure,* from which James had recently withdrawn his financial backing (he was suing Albert Skira—a case that never came to court and that seemed to have been abandoned by James halfway through). Dalí was not included on the journal's new administrative committee. "I think I was excluded because of my too great friendship with you," he wrote,[17] but he hoped the committee would ask him to collaborate. The first issue was on "Love," with what Dalí described as a sensational Magritte cover.

Dalí and Gala spent the rest of 1937 in Italy, where they once again stayed with James at the Villa Cimbrone and with Lord Berners in Rome. Dalí continued his study of the Italian Renaissance, which, years later, would inform and inspire his postwar religious pictures. These prewar years in Italy provided, in a sense, a grand tour for Dalí; his education in Spain at the Escuela de Bellas Artes had scarcely covered the Italian Renaissance and he was thus repairing a major omission. It is a little-known fact that Dalí was enormously knowledgeable on the history of art, as well as being one of the best-informed of painters on the work of his contemporaries. He took the acquiring of such knowledge very seriously. His expeditions to view little-known frescoes and copies of classical plaster casts were legion.

These visits to Italy also fulfilled the useful function of maintaining the rhythm of Dalí's life, now that Spain was closed to him. This rhythm had become invariable: the winter spent in New York finding new clients, working on his fame; the spring and early summer socializing in Paris, with possibly a small vernissage to wrap up the season; and the late summer and autumn spent painting. Of course, Dalí did work when he was in Paris, but these pieces tended to be either small-scale paintings, some of which, it must be admitted, were rather dashed off, or drawings, studies for work he intended to do in the future.

A great deal of time in Paris was taken up with enlarging his social

circle. While Dalí pretended to scoff at the antics of his aristocratic friends, he would have been mortified to have been banished from their guest lists. He loved the bustle of Paris; now, far from spending every evening with the Surrealists at one or another of Breton's preferred cafés in Montmartre, he figured at glittering parties. Paris, he enthused to Edward James, was "full of musicians, incense and painters—projects everywhere . . ."[18]

Fashion in Paris in the 1930s was inextricably bound up with artistic movements, largely because those who were serious patrons of the arts were the very rich, who tended to dress at the couturiers. And the couturiers themselves, notably Chanel and Schiaparelli, in turn became patrons of the arts; so fashion was one way in which avant-garde trends surfaced and were first communicated. Schiaparelli, a woman of great creativity, launched a dialogue between painting and fashion by employing artists to design accessories, prints, and even dresses for her, much to the envy of Chanel, who then followed suit.

Dalí understood this symbiotic process profoundly and extended his interest in creating fashion to the further step of communicating it. From this time date his collaborations with magazines such as *Vogue, Harper's Bazaar,* and, later, *Flair.* In the autumn of 1937, Dalí began to work with Schiaparelli on a series of fashion and accessory designs descended from the Surrealist ideas he had attempted desperately to sell in the early, poverty-stricken days of 1930.

From this collaboration, almost certainly engineered equally by Bettina Bergery, Dalí's great friend, then Paris editor of American *Vogue,* and by James, came many famous and playful fashion ideas: the shoe hat, for instance, developed from Dalí's predilection for being photographed with one of Gala's shoes on his head during the period when he had been obsessed with such balancing acts.

James commissioned Dalí to produce some special ideas for his friend the actress Ruth Ford. One dress was of French blue crêpe quilted all over in the exact anatomical outline of the bones of the human body. The other was painted with realistic-looking rips and featured a close-fitting cape-cum-hood, designed to be worn over the dress, that was actually torn.

The suit Schiaparelli designed to look like a chest of drawers has obvious links with Dalí's lifelong obsession with drawers as metaphors for those orifices of the human body that had always exercised a per-

verse fascination and terror for him. Its antecedents can be traced back to his early obsession with his boyhood friend Joan Butxaques and the pockets on his suit, together with his later discovery of a seventeenth-century French engraving of a courtier with drawers cut into his coat.

Dalí's obsession with the external skeletons of crustacea surfaced on an evening dress for Schiaparelli for which he designed a lobster print on organza. The lobster has been cooked and is a fresh pink, surrounded by acid-green fronds of parsley. The dress was enormously successful and was bought by many of Schiaparelli's customers, including Wallis Simpson, who purchased it for her trousseau and was photographed in it by Cecil Beaton.

Breton and his cronies saw Dalí's incursion into fashion as a trivialization of the Surrealist movement, but Dalí himself seemed to regard his work with Schiaparelli and his later work designing jewelry as a legitimate extension of his Surrealist activities. Fashion was just another means whereby he could experiment with and communicate the strange landscape of his universe.

In this obsession Dalí was matched by Gala, who was now in the full flower of the ugly yet fascinating maturity that was the beau ideal of avant-garde 1930s fashion. She was Dalí's and Schiaparelli's best model, and Elsa's clothes were frequently given to her. Gone were the days of boys' shorts and bare breasts. Now Gala had acquired a reputation as one of the most ferociously chic women in Paris. This hard, fine-tuned style was her weapon against a world she suspected, and rightly, of undervaluing her.

Dalí had also discovered the theatrical and Surrealist possibilities of window dressing. His first efforts along these lines were for Schiaparelli's little boutique just beside the Ritz in the place Vendôme. Here, a huge stuffed Kodiak bear, which had been given to him the year previously by Edward James, played a part. The bear had been shot by one of James's uncles, and Dalí had caught sight of it on his first visit to West Dean. He fell in love with it, and its hoped-for arrival in Paris was often mentioned in Dalí's letters. "Speed up his journey," Gala wrote to James, "if you do not want Dalí to fall ill from nervous, disturbing, dangerous impatience."[19] When the bear eventually arrived, it had drawers cut into its stomach, was sprayed shocking pink, and, for a time, was hung with Schiaparelli bijoux in the window of her boutique, which it shared with Dalí's lip sofa.

The bear seemed to become a talisman for Dalí. Eventually it arrived in Port Lligat, when Dalí and Gala finally returned there after the war, and loomed over visitors in the tiny hall, holding a visiting-card salver in its paws and draped with whatever found objects, mostly marine, had caught Dalí's fancy. On one occasion, after the war, the former king of Italy was attempting to change into his swimming costume behind the convenient screen of the bear and was disturbed by a friend of Dalí's father who had come to see Dalí with a painting for the artist to authenticate; when told to avert his eyes, the old man refused to believe he had disturbed royalty until the former monarch stepped out from behind the bear.

Another harmless outlet for Surrealist fantasy in the 1930s were the huge fancy-dress balls at which the competition for the most bizarre and amusing costumes kept couturiers and costume designers, both amateur and professional, frantically busy. Marie-Laure de Noailles could be seen attired as a giant tentacular squid, and her host, Comte Etienne de Beaumont, appeared as a luminous starfish at the Bal de la Mer. Chanel was disguised as a tree with her face blacked out at the Bal de la Forêt, given in the forest of Ermenonville by the illustrator André Durst. These bizarre costumes fulfilled a function that went beyond a mere night's enjoyment: They awakened the notion that dress could symbolize its wearer's artistic proclivities rather than just his or her bank balance. Such costumes set fashion free to pursue an intimate relationship with art, rather than simply being a matter of adornment.

This was the era in which some couturiers, notably Chanel and Schiaparelli, abandoned dressmaking in favor of creating fashion that reflected wider and deeper movements of the times. While Dalí's experiments with transferring his personal imagery to clothes cannot be said to have been the inspiration behind this new relationship between art and fashion, his influence certainly pervaded the salons and society gatherings of late-1930s Paris and, eventually, the wider world of ready-to-wear fashion, which adopted many of his ideas in watered-down versions in the years that followed.

Fashion was an amusing divertissement to Dalí. Not everyone approved; Miró, for instance, castigated Dalí as a painter of neckties. But fashion not only stimulated Dalí's dandyish bent; it also provided him with amusing collaborators, which must have been a pleasant change

for a painter used to long hours on his own, or in the company of Gala urging him to work even harder.

From these years date Dalí's first instances of choosing collaborators to work with him in media as different as photography, jewelery, and glass; in the 1960s he would enlist others for "happenings" and "performance art." These collaborators would always be members of that numerous tribe of "porters," that army of willing slaves and acolytes, without whose constant help Dalí could not have lived his life or pursued his art.

Gala's role as a collaborator was subtly changing. Their relationship had settled down into a heightened form of business partnership. Gala still looked after the money and negotiated with patrons and with galleries, and she still saw to all the myriad organizational details of life. But she no longer needed to do much in the way of selling Dalí's work. The Edward James contract guaranteed them security, and she needed only to chase James to whichever house or clinic he was temporarily visiting for a check to materialize.

Distanced now from the Surrealists, Gala spent more time acting as the living embodiment of "the Dalí woman"—the personification of his paintings—indeed, the subject of many of them. But she became bitter that Dalí was now the star and she had to play second fiddle, knowing that their new society friends looked on her as a tiresome adjunct to the glamorous and famous Dalí.

Never a woman to seek female companions, Gala nevertheless formed a friendship with Valentine Hugo; the two women were both interested in clothes and in society, and Valentine also had her own identity as a stage designer. Slowly, then, the neurotic, inward-looking aspect of Dalí's marriage to Gala relaxed, and they began to spend more time apart. Dalí would work alone but would never go out without Gala. She, on the other hand, would see Eluard and, from time to time, her daughter, Cécile. She would go shopping (Gala had a very good eye for furniture; later, she would furnish Port Lligat with well-chosen pieces of Spanish domestic furniture, not popular at the time) or run artistic errands for Dalí.

One of these errands was to find old frames. Dalí was very particular about how his pictures were framed, and many of his paintings' frames are works of art in themselves. Reynolds Morse, who owns the greatest private collection of Dalí's paintings, remembers buying his

first, *Daddy Long Legs, Hope,* in 1943. "I think it cost six hundred dollars," he says, "but it was framed in a very ornate seventeenth-century carved Dutch frame which Dalí and Gala insisted we bought as well, and the frame cost more than double the painting."[20] These elaborate antique frames were rarely purchased; Gala would borrow them for an exhibition and either sell them with the painting or return them. The frames lent—and still lend—an extraordinary effect to Dalí's paintings. Invariably heavy and deep, they lead the eye in to the tiny paintings they frame. The eye expects an Italian primitive or a Dutch painting and is shocked to encounter Dalí's Surrealist world.

Another of Gala's artistic chores for Dalí was to find the best paintbrushes and the best paints, and to research new varnishes and glazes. From the beginning she had insisted that Dalí be more careful of his technique; when she had first met him he was not above sticking small cutout photographs onto a painting and then painting over them.

In January 1938, the International Surrealist Exhibition was put on in the Galerie Beaux Arts by Breton and Eluard, who were joint organizers. By this time Dalí had virtually been expelled from the Surrealist group, or at least from taking part in its inner councils, which he had outgrown anyway. But Breton and his supporters realized that they could not yet afford to ignore Dalí, whose name had, to so many people, become synonymous with Surrealism.

Dalí, too, seemed unwilling to make the final break. He was naturally averse to change, and his timidity when confronted with the unknown mitigated against a sudden abandonment of the group within which he had become known. He also realized that there was no other group then existing in Paris as well-organized as the Surrealists, with as much immediate access to private patrons, to the press, and to the network of international art events that gave the Surrealists valuable showings. Breton, Dalí was well aware, had superb organizational powers. Moreover, Dalí had become famous as a Surrealist painter; his paranoiac-critical theories were central to an explanation of his work at the time, so he could hardly perform a volte-face (though temperamentally, he would always be inclined to do so, just for the sheer mischief of it). There would be no insulting letters, no anti-Surrealist manifestos, from his quarter, for he had too much in-

Self-Portrait, 1923

Voyeur, 1921

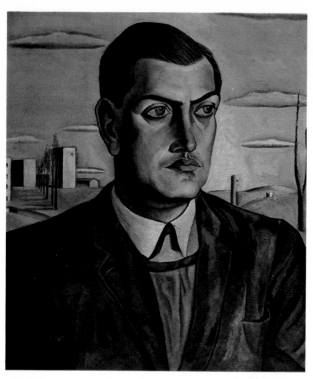

Portrait of Luis Buñuel, 1924

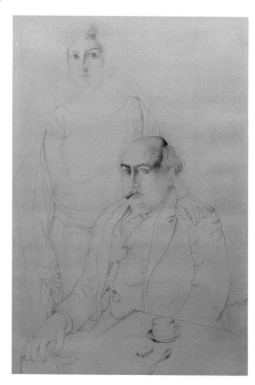

Portrait of the Father and Sister of the Artist, 1925

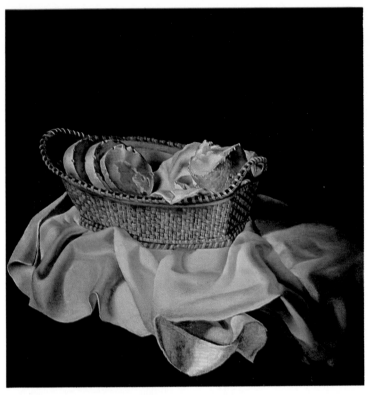

Basket of Bread, 1926

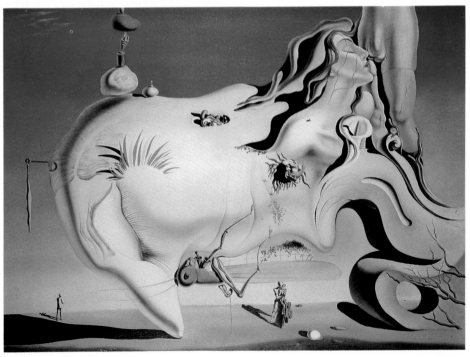

The Great Masturbator, 1929

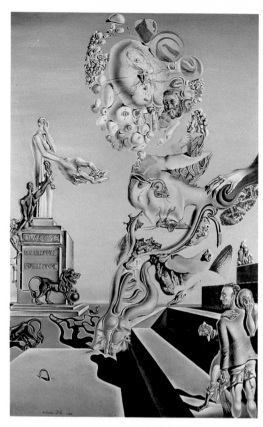

The Lugubrious Game, 1929

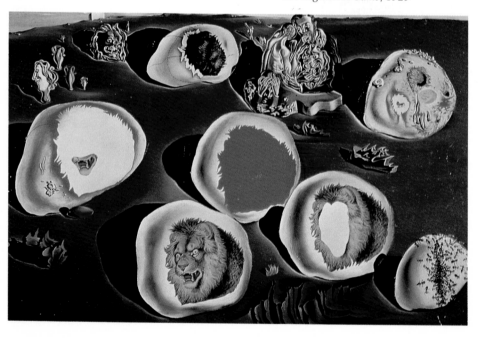

The Accommodations of Desire, 1929

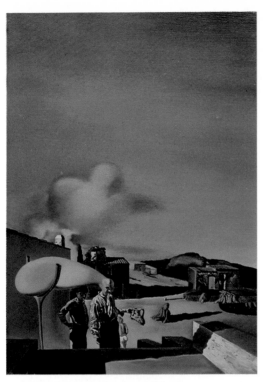

The Average Fine and Invisible Harp, 1932

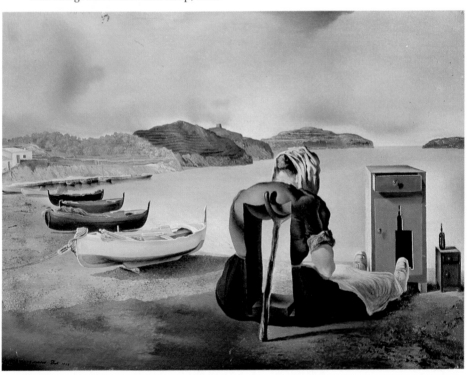

The Weaning of Furniture-Nutrition, 1934

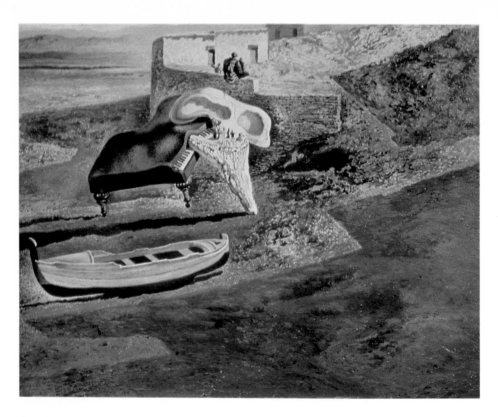

Atmospheric Skull Sodomizing a Grand Piano, 1934

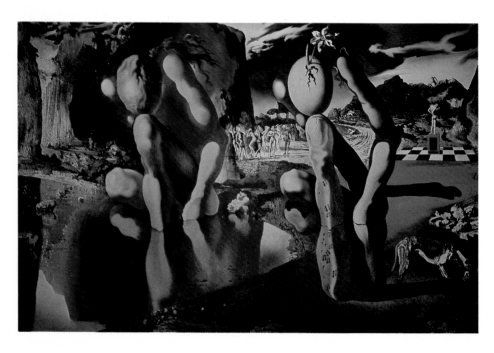

Metamorphosis of Narcissus, 1937

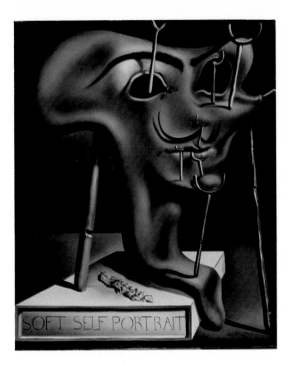

Soft Self-Portrait with Grilled Bacon, 1941

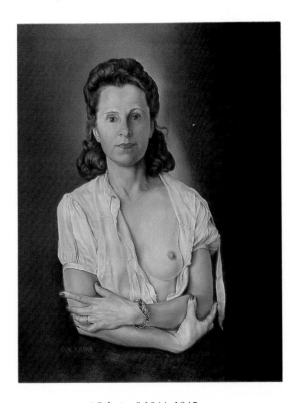

"Galarina," 1944–1945

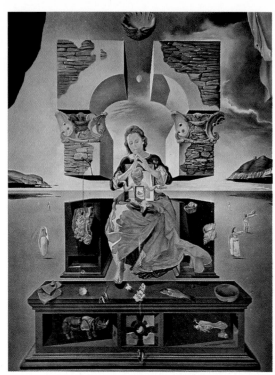

The Madonna of Port Lligat, 1950

The Swallow's Tail, 1983

vested in the theory and practice of Surrealism to be able to strike off on his own. Breton found a solution to the problem of the black sheep within the Surrealist fold by making Dalí special adviser to the exhibition, thus including him in the presentation without allowing him back into the central organization.

There were in the exhibition over three hundred pictures, sculptures, found objects, photographs, and drawings by more than sixty artists from fifteen different countries. To Breton, this demonstrated the continuing vitality of the Surrealist movement. To Dalí, it was a "claptrap collection of jokes and tricks in which the gimmick too often stood in for deficient imagination, the quick hustle was supposed to be as good as a mystery, noise was to take the place of music and Breton's moods were dubbed 'solemn wraiths.' "[21]

In the guise of a catalog, Breton and Eluard published the *Dictionnaire Abrégé du Surréalisme,* in which Dalí was described as the colossally rich principal intellectual of Catalonia. Gala was described (this has been attributed to Dalí, though incorrectly, as the phrase had been in use years before) as a "Violent and Sterile Woman."

Visitors were promised a platform hung with twelve hundred sacks of coal, "revolving" doors, Mazda lamps, echoes, "odors" from Brazil, and other pleasures *"à l'avenant,"* which included a monster pair of cancan underdrawers as big as a whole room. However, when Max Ernst wanted to set up a tableau in which a lion-headed man was shown embracing a woman in deepest mourning, whose uplifted skirt revealed a pair of pink silk panties with a lighted electric bulb inside, there was a scandal. *No fire in the underpants!* came Breton's ukase.

Paris society flocked to the black-tie opening. They were handed torches to negotiate the pitch-black inside-a-coal-mine effect. Breton was sulking and refused to make the opening speech, so Eluard did it for him. The everybody-who-was-anybody audience found mannequins dressed by the Surrealists, including one by Dalí that had a parrot's-head hat, formal gloves, and little spoons stuck all over her. But it was Dalí's *Taxi Pluvieux* that caused the most stir in this evening of happenings. A mannequin sat in the taxi surrounded by greenery on which live snails crawled. From time to time a rainstorm washed over the interior. Dalí subsequently made another version in New York, and a third version, using a different car, is now in the Teatro Museo Gala-

Dalí in Figueres, with, on the hood, a bronze statue of Queen Esther by the Viennese sculptor Ernst Fuchs.

The highlight of the evening was the ballerina Helen Vanel's spectral appearance dancing dressed as a doll (or she might have been a witch out of *Macbeth*). Dalí had arranged her costume and the choreography; and her entrance, holding a live cockerel at arm's length, was no less astonishing than her exit via a pool of water, illuminated by the fitful beams of the torches held by the by now ecstatic audience.

The International Surrealist Exhibition was an immense success, not least for Dalí. Later that spring it moved to the Galerie Robert in Amsterdam where, reorganized in a more conventional manner by Georges Hugnet, it was equally successful. It gave Dalí a taste for "happenings" that he never lost and that he would manifest as very elaborate pieces of performance art in the 1950s and 1960s.

Dalí had met René Magritte in 1929; he saw him once more when he was in Amsterdam for the opening of the exhibition at the Galerie Robert. The *Taxi Pluvieux* had, Magritte told Edward James, inspired him to paint a nude woman of the odalisque kind "on which several snails would be traveling. I will," he wrote, "call it 'In Memory of Salvador Dalí.' "[22]

A brief visit to Florence was followed by a longer visit to London and another weekend at Faringdon with Lord Berners that March. Then it was back to Zürs, where, Dalí told James, he was working with a "rare continuity." Even more exciting was a trip to Vienna to attempt to meet Freud. This was the second of Dalí's three voyages to Vienna, which, he wrote, "were exactly like three drops of water which lacked the reflection to make them glitter. On each of these voyages I did exactly the same thing: in the morning I went to see the Vermeer in the Czernin Collection and in the afternoon I did *not* go to see Freud because I invariably learned that he was out of town for reasons of health."[23]

Dalí had first encountered Freud's theories when he read *The Interpretation of Dreams* at the Residencia. It is reasonable to suppose that he may even have attended a lecture on Freud while there. He found, when he joined the Surrealists, that they had adopted Freud as a sort of patron saint. This was largely due to Breton, who had written, "I

was able to experiment on the sick with the processes of psychoanalyt-
ical investigation, in particular the analysis of dreams and associations
of spontaneous ideas. One could already see that these dreams, these
categories of association, would turn out to constitute, from the begin-
ning, almost all the Surrealist material."[24] Breton and Freud exchanged
letters through the 1920s, but in 1932 this correspondence ceased
abruptly when Breton published *Les Vases Communicants,* in which he
put forward the observation that the sexual motives sought by Freud
in the dreams of others were absent from his interpretations of his own
dreams.

Breton may have become disillusioned about Freud, but Dalí had
not. A year after the termination of the correspondence between
Breton and Freud, which Dalí certainly heard about, Dalí was lunching
with Julien Green, who wrote in his diary the next day that Dalí spoke
of Freud as a devout Christian would speak of the Gospel. Green
asked Dalí whether reading Freud had simplified his life. Dalí said that
Freud, through his writings, had resolved many of his most intimate
problems.[25]

On June 6, Dalí, while eating snails in a village near Sens, noticed
with great excitement a photograph of Freud in a newspaper together
with the information that he had been exiled by the Nazis and was
now living in London. In July, Stefan Zweig, the Austrian writer, also
living in exile from the Nazis, wrote to Freud saying, "Salvador Dalí,
the great painter, who is a fanatical admirer of your work, would very
much like to see you, and I don't know anybody who might be more
interesting to you than he. I like his work tremendously and would be
happy if you would reserve an hour for him."[26] Another letter appears
to have been necessary before Freud would agree to see his young
Surrealist admirer (at the time, Freud was suffering from cancer of the
mouth; he wore an artificial palate and speech was thus immensely
tiring to him). Zweig wrote more fully to Freud on July 18:

*One more word of information. You know how carefully I have always
refrained from introducing people to you. Tomorrow, however, there will
be an important exception. Salvador Dalí, in my opinion (strange as
many of his works may appear), is the only painter of genius of our
epoch, and the only one who will survive, a fanatic in his conviction, and
the most faithful and most grateful disciple of your ideas among the*

artists. For years it has been the desire of this real genius to meet you. He says that he owes to you more in his art than to anybody else. And so we are coming tomorrow to see you, he and his wife. He would like to take this opportunity, during our discussion, to make a short portrait sketch of you, if possible. The real portraits he always does from memory, and from his inner "Gestaltung." As a kind of legitimation, we are going to show you his last picture, in the possession of Mr. Edward James. I think that since the old masters nobody has ever found colors like these, and in the details, however symbolical they may appear, I see a perfection compared with which all paintings of our time seem to pale. The picture is called "Narcissus" and may have been painted under your influence.

This is meant as an excuse, because we are going to form a little caravan. But I think that a man like you should see once an artist who has been influenced by you as nobody else, and whom to know and to estimate, I have always regarded as a privilege.[27]

Dalí, finally granted his audience, and by this time staying with Edward James in the house on Wimpole Street, made great efforts to appear to Freud as "I imagined he imagined me; a Beau Brummel of universal caliber. But I failed. . . . To him I was a case, not a person."[28]

The visit began with a thoroughly auspicious Dalinian coincidence: a trail of snails between him and Freud. Dalí had been eating snails when he learned of Freud's expulsion from Austria; now, when he arrived at Elsworthy Road with his "caravan," he saw a snail on a bicycle set against a wall.

Various versions exist as to what happened that afternoon. Edward James, in a letter to Christopher Sykes, maintained that Freud had talked to him while Dalí sketched Freud hastily but accurately into a drawing book. "Salvador was looking so inspired, his eyes were so blazing with excitement while he sketched the inventor of psychoanalysis, that the old man whispered in German . . . 'That boy looks like a fanatic. Small wonder they have civil war in Spain if they look like that.' "[29]

According to the Dalí authority Professor Carlos Rojas, Dalí vainly tried to convince Freud to read his article "New Considerations on the Mechanism of the Paranoiac Phenomenon from the Point of View of Surrealism." What is certain is that Dalí made several drawings of Freud, the best of which was in india ink on blotting paper and in

which Freud's skull was portrayed in the shape of a snail shell. Dalí had no idea that Freud was dying, but had nonetheless caught death in his drawing, which Professor Rojas maintains is one of the best done in this century.

A day after this visit, Freud wrote to Stefan Zweig with his thoughts:

> *I have to thank you indeed for the introduction of our visitor of yesterday. Until now I was inclined to regard the Surrealists—who seem to have adopted me as their patron saint—as 100 percent fools (or let's rather say, as with alcohol, 95 percent). This young Spaniard, with his ingenuous fanatical eyes and his undoubtedly technically perfect mastership has suggested to me a different estimate.*[30]

Dalí and Gala spent the rest of the summer of 1938 surrounded by Dalí's favorite cypresses in a rented villa near Florence, probably chosen because it reminded him of the Empordà. Hearing from Misia Sert that Chanel, now counted among their closest friends, was suffering from paratyphoid in Venice, they rushed to her bedside. On her night table was a large painted shell, which had been given to her in Capri as a present. Dalí became superstitious about this shell and ordered it to be removed, whereupon, according to him, Chanel's temperature went back to normal. Whatever the truth of this curious interlude, Dalí and Gala accepted an invitation to stay at Chanel's villa, La Pausa, at Roquebrune. Chanel had gone on the offensive against her rival Schiaparelli and was determined to "steal" Dalí away from her. It was the time of the Munich crisis, and the house party, which consisted of Chanel (when she was not in Paris working on her collection) and her former lover and now devoted friend and sometime pensioner, the poet Pierre Reverdy,* was glued, as Dalí put it, to the radio.

Dalí and Gala stayed at La Pausa for four months, during which time Dalí and Reverdy spent a good deal of the time arguing. "His terribly elemental and biological Catholicism made a deep impression on me," Dalí would recall. "Reverdy is the integral poet of the genera-

* Pierre Reverdy published a magazine, *Nord-Sud,* and in the thirteenth issue of the review (March 1918) had issued a series of definitions of "The Image" that were much quoted and discussed by the Surrealists. One of these definitions relates very closely to Dalí: "An image is not strong because it is *brutal* or *fantastic* but because the association of ideas is distant and accurate."

tion of Cubists. He is the soul possessing the most violent and finest set of teeth I have ever known, and has that gift, which is so rare, of spiritual anger and rage. He was 'massive,' anti-intellectual and the opposite of myself in everything, and provided me a magnificent occasion to strengthen my ideas."[31]

They fought, as Dalí put it, dialectically, like two Catholic cocks, and Dalí called these arguments "examining the question."[32] He had not indulged in such stimulating debate since his rows with Buñuel in 1929. For Dalí, exiled from Spain and the lively world of the Catalan intelligentsia, afraid to go back to Paris during the so-called Phony War, the chance that had dealt him such companionship was a happy one, and was reflected in the vigor and strength of his work during this period.

Dalí was preparing for his next exhibition in New York and fulfilling the terms of his contract with Edward James, who was proving elusive, having disappeared on an extended tour of the Balkans with his friend the huge Austrian count Friedrich Ledebur.

He painted one of his most mysterious pictures, *The Endless Enigma,* during his stay in the south of France. There are double, triple, quadruple images in this painting, set in the familiar Empordàn landscape now overcast, gray, and stormy. To explain the picture when it was shown in New York, Dalí drew some celluloid overlays. The first was of the beach at Cap de Creus with a boat and a fisherwoman, shown from the back, mending a sail. The second overlay showed the figure of a philosopher recumbent, reading on the sand. The third was the image of what Dalí described as "the great cyclopean cretin." In the fourth overlay was a greyhound, and the fifth consisted of a conventional still life of a mandolin and a fruit dish containing pears and two figs on a table.

All these images overlap one another in the center of the picture to create a mad, hallucinatory, and very disturbing visual maze. The single images are no less disturbing; to the left of the picture is a stick with the skeleton of a fish balanced on top of it, and to the right, half out of the picture, a portrait of Gala with cruel, staring eyes. Together with the series of "telephone" paintings Dalí did during 1938 (no doubt inspired by his hours spent telephoning his friends for news or listening to current affairs on Chanel's radio), *The Endless Enigma* reflects the fright and confusion of the Munich period. In all these paint-

ings, the eternal landscape of his youth loses its luminescence, and becomes gray and overcast, acting as a background for current events —Chamberlain, Hitler, and the Munich telegram.

The Enigma of Hitler, now in the Teatro Museo Gala-Dalí in Figueres, was, Dalí wrote in *The Secret Life,* a very difficult painting to interpret. Its meaning eluded even Dalí himself. "It constituted a condensed reportage of a series of dreams obviously occasioned by the events of Munich. . . . Chamberlain's umbrella appeared in this painting in a sinister aspect, identified with the bat, and affected me as extremely anguishing at the very time I was painting it."[33]

At the same time Dalí was also making tentative attempts to write his autobiography, which eventually became *The Secret Life.* And having extracted a vague promise from Edward James that he would put on *Tristan Fou* in London, Dalí set to work with Massine and the Ballet Russe de Monte Carlo, subsidized by the generous patron of the arts the Marqués de Cuevas, a Chilean of somewhat dubious lineage who had had the good sense to marry a Rockefeller (the Dalís had met the Cuevases, hosts of some of the most glittering parties of the thirties, in Paris). The title of the ballet was changed to *Venusberg* and subsequently to *Bacchanale.*

Chanel offered her collaboration on the costumes, as she had done in 1920 with the ballet *Le Train Bleu,* and spent two months with Dalí on the designs, neglecting her own collection to do so. She used real ermine and real jewels; Dalí said the gloves for the character of Ludwig II of Bavaria were so heavily embroidered "we felt some anxiety as to whether the dancer would be able to dance with them on."[34] The ballet was eventually staged in New York, since the Ballet Russe de Monte Carlo hastily packed and left Europe for America as soon as war was declared, and before Dalí and Chanel had had a chance to finish the costumes.

In November, Cécile, Gala's daughter, married a young poet named Luc Decaunes. Eluard's correspondence suggests that Gala did not approve of her son-in-law; but since she had neglected Cécile all her life, her opinion would have been irrelevant. Then, in early December, another chapter closed when Eluard's long relationship with Breton and the Surrealist group ended in an argument. The row had started over a poem by Eluard on the Spanish Civil War, *"Les Vainqueurs d'Hier Périront,"* which appeared in *Commune,* a review published by

Breton's "enemy," Louis Aragon. As usual, Breton overreacted by or-
dering "all his good-for-nothings to answer this time without quoting
me."[35] Max Ernst confirmed that each member of the Surrealist group
had to commit himself to sabotaging Eluard's poetry by every means
available. Any refusal would entail expulsion. The row was still rum-
bling in January 1939 as the remaining Surrealists took sides. Support-
ing him, Eluard wrote to Gala, were Man Ray, Magritte, and a few
others "among whom you two above all. Picasso's wavering between
the two."[36]

Dalí's final break with Surrealism would come a year later; already
on the fringes of the group, he sought more and more to distance
himself. In his last letter to Breton (January 2, 1939), Dalí discussed
the manifesto that Breton and Trotsky had written during the former's
visit to Mexico the previous year. "Theoretically," Dalí wrote, "the
document seems to me to be right but you know my skepticism when
it comes to tentative tracts 'of compulsory organization' on the part of
the Surrealists."[37] Breton had always run the Surrealists as a loyalist
cadre, and these comments challenged the authority he had wielded
vigorously for nearly twenty years. Since Dalí also supported Eluard,
Breton looked for a good reason to engineer Dalí's expulsion.

In his text "The Most Recent Tendencies in Surrealist Painting,"
Breton wrote violently:

> Dalí claimed in February 1939, and I have it from himself and took the
> trouble to make sure any element of humor was absent, that all the
> present malaise in the world was racial and that the solution to promote
> is the reduction of all colored people to slavery and the concerted effort to
> accomplish this by all people of the white race. I don't know what doors
> such a declaration could open in Italy or the United States. Doors
> through which he constantly oscillated, but I know which doors it would
> shut.[38]

Dalí's outrageous pronouncement, which gave Breton the excuse to
expel him, has more than a hint of his earlier teasing of the Catalan
intellectuals and was obviously made deliberately. But he was by no
means blind to Breton's influence on his life. Breton, Dalí told André
Parinaud, was the first important person who made him think and
whose contact greatly interested him.

I had ideal means and possibilities of communication but Breton was very quickly shocked by the presence of scatological elements. He wanted no turds and no Madonna. . . . However, setting up taboos is contradictory to the very fundamental of pure automatism. . . . It was censorship, determined by reason, aesthetics, morality, Breton's taste, or by whim. They had in fact created a sort of highly literary neo-romanticism in which I was forever out of favour, and indeed being judged, investigated, subjected to, in a word, inquisitorial procedure.[39]

In distancing himself from the Surrealists, Dalí was also turning away from Europe. He and Gala had obviously discussed the possibility of living in America, since there are references to this in letters from Eluard toward the middle of 1939. His final break with the Surrealists, combined with his exile from his own country and the approach of war, was reason enough to think of making a fresh start in America, a country that had always treated him and Gala extremely well.

They planned to leave for New York on February 15, 1939. Dalí was bursting with ideas for his new exhibition at the Julien Levy Gallery, some of which were less practical than others. "If you have an opportunity to speak with Dalí about his idea of combining his exhibition with a motor and taxicab show, please try to discourage him," Julien Levy wrote somewhat wearily to Edward James on January 26.

At the beginning of February, Dalí held his by now usual vernissage. The invitation was surmounted by a photograph of a splash of milk that formed a coronet (the *couronne de lait);* guests were invited to view *Le Grand Crétin Borgne, Le Siphon Long,* and *Les Violettes Impériales,* among other paintings and objects. M. W. Georges wrote in the February 10 issue of *Beaux Arts:*

One should not imagine that Salvador Dalí lives in a place where snails frolic. On the contrary, it is a 100 percent bourgeois house. If in the apartment it had not been possible to put in a dreary pond, at least the shutters could have been carefully closed and the walls carpeted with black astrakhan, making less mess than sacks of anthracite. But the parquet is waxed, and well waxed; the sculptures on the ceilings are from the seventeenth century.[40]

No sooner had they disembarked in New York than Dalí embroiled himself in a controversy that made headlines, not just in the United

States but all over the world. It had become the fashion, among the smarter department stores, to have "Surrealist" windows. This had been stimulated by fashion magazines, such as *Vogue,* and photographers, such as Horst, influenced by the Surrealists—particularly Dalí. Going to the source of this inspiration (and probably encouraged by Schiaparelli's windows in Paris), Bonwit Teller asked Dalí to execute two windows for them on the subject of "Night" and "Day."

Dalí outdid himself. For "Night" he showed a mannequin lying on a bed of glowing coals under a black satin sheet with holes burned through. A stuffed buffalo head adorned in jewels, which Dalí described as "the decapitated head and the savage hoofs of a great somnambulist buffalo extenuated by a thousand years of sleep," completed the vignette.[41] "Day" contained a bathtub lined in black Persian lamb and filled with water, from which rose three wax arms holding mirrors. In front of the tub stood a wax turn-of-the-century mannequin that he had found in the attics of the store. It was still dusty and swagged in cobwebs. To Dalí, this accumulated dust "gave [it] a patina as superb as that of an old bottle of fine champagne brandy."[42] He clothed the dummy in green feathers, with long, bright red hair. On the walls, upholstered in purple, small mirrors were fixed here and there, and narcissism was further indicated by narcissi floating in the bath. The windows were a development of the themes Dalí had created for the International Surrealist Exhibition the year before. But what had enchanted and amused Paris, long used to Surrealist excess, did not go down well with the chic ladies of Fifth Avenue.

Dalí worked all one night with Bonwit's regular window crew (one wonders what they must have thought of this re-creation of Surrealism in front of their eyes). Finishing at nine-thirty the next morning, in time for the opening of the store, Dalí retired to the St. Regis (where he now habitually stayed) to rest. At five that evening, accompanied by Gala and some friends, he went to have another look at his windows, only to find that the dusty mannequin in the "Day" window had been replaced by a modern version clad in a snappy new suit. Other changes had been made, too; the mannequin under the sheet had been taken out of the "Night" window and replaced by something more conventional.

Incensed, Dalí asked to see the Bonwit executive responsible and demanded that his whole décor be restored, as he had done it, or his

name taken off. His proposal was rejected, whereupon Dalí decided on direct action. A large crowd gathered as he stood for a few moments in the "Day" window. He paused for a moment to savor the act he was about to commit.

> *I took hold of the bathtub with both hands, and tried to lift it so as to turn it over. . . . The bathtub was much heavier than I had calculated and before I could raise one side, it slipped right up against the window so that at the moment when, with a supreme effort, I finally succeeded in turning it over it crashed into the plate glass, shattering it into a thousand pieces.*[43]

Water and glass were all over the pavement as Dalí stepped through the hole his precipitate action had left in the window. He was nearly decapitated by the huge shards of glass that rained down on him.

He was immediately arrested and taken to the nearest police station. Julien Levy, Edward James, and Gala were hastily summoned. James's lawyer told Dalí that he could either stay in custody until his case could be heard in the night court, or he could be released on bail and stand trial much later. Dalí elected to stay in the holding cell, where he met a friendly Puerto Rican who offered him protection from the drunks and tramps among whom he found himself.

Later, in the night court, the judge, Louis B. Brodsky, freed Dalí with a suspended sentence for disorderly conduct and ordered him to pay for the broken pane. He ruled that Dalí's act had been "excessively violent" but made a point of adding emphatically that every artist had a right to defend his work to the limit. "These are some of the privileges that an artist with temperament seems to enjoy,"[44] he said after sentencing Dalí.

The Surrealists, in particular Breton, claimed to be horrified at the subsequent tidal wave of publicity. The incident even prompted Gala's former lover Giorgio de Chirico to an outburst:

> *Dalí . . . is forced (in order to arouse a little interest in his painting, which basically nobody likes) to create scandals in the most clumsy, grotesque and provincial way imaginable, and in this way succeeds more or less in attracting the attention of certain transatlantic imbeciles con-*

sumed with boredom and snobbery; but it looks now as though even these imbeciles have begun to have enough of it.[45]

But by the time his exhibition opened at the Julien Levy Gallery five days later, Dalí had become a popular hero. The catalog alone was a triumph. In a manifesto entitled "Dalí, Dalí!" Dalí rhetorically wrote: "Of a cubist picture one asks: 'What does that represent?' Of a surrealist picture one sees what it represents but one asks: 'What does that mean?' Of a paranoiac picture one asks abundantly: 'What do I see?,' 'What does that represent?,' 'What does that mean?' "[46] He gave his own answer: "The end of so-called modern painting based on laziness, simplicity, and gay decorativism."[47]

In the first five days of the exhibition, sales totaled five drawings ($300–$800 each), among which were the *Portrait of Doctor Freud* and the *Portrait of Harpo Marx,* and fourteen paintings ($400–$3,000 each), the most important of which were *The Endless Enigma* and *The Sublime Moment.* By the end of the exhibition at the beginning of April, over $15,000 worth of work had been sold, as well as several thousand catalogs at thirty-five cents each; but critical reaction was, as always with Dalí, very mixed.

Time magazine referred to the "restless, wasp-waisted artist with his whimsical moustache and eyes of an old crystal-gazer."[48] Dalí told them that the period for Surrealist dreaming was over, the period of paranoiac painting just beginning. He was referring to the double-image paintings such as *The Image Disappears,* a painting that looks at first sight to depict a girl painted in the manner of Vermeer's *Young Girl Reading a Letter* and, when one looks again, is seen to be a portrait of a bearded man.

It was in 1929, Dalí wrote in the accompanying manifesto, that he had first drawn the attention of his Surrealist friends to the importance of the paranoiac phenomenon, and especially to those images of Arcimboldo and Braccelli composed of heteroclite objects, and to the romantic detritus that expands and flowers into those compositions of double configuration almost entirely filled with the death's-head theme.

"Dalí is a bombshell in art," wrote Paul Bird, the critic of *Art Digest.* "He can't be ignored for all the petulent [sic] ostrich-like attitudes of those who intensely dislike his art. . . . The fellow is doing a real

service and this is why it hurts. He is dramatising as it has not been dramatised in years the fact that the art world is a tight little field in the habit of issuing a lot of self-satisfying little dictums and ukases that ought to be upset."[49] In *Art News,* the reviewer pointed out that Dalí had now learned to paint with the same degree of individual genius that he had long since shown in his craftsmanship, and that the result was texture of a much greater depth and far less optical boredom. These, of many reviews, illustrate a problem fundamental to Dalí in his relationship with the art world: The man and his paintings were never separated. His paintings were never considered in isolation; they were considered as part of the Dalí myth.

The Bonwit Teller affair was not the only controversy Dalí managed to create that summer in New York. His pavilion, *The Dream of Venus,* at the World's Fair in Queens, New York, that June, surmounted, in its vision, all previous Dalinian constructions, and its design was accompanied by the usual lunatic maneuverings that encrusted anything Dalí and Edward James undertook together.

The story starts at the beginning of April when James and his lawyer proposed that Dalí design a pavilion at the World's Fair, which was being run by William Morris, the agent and entrepreneur. On April 10, Dalí signed a contract "to create façade and interior designs, costumes, incidental scenery and souvenirs for the exhibition at the World's Fair . . . tentatively named 'Bottoms of the Sea.' "[50] He had a day to prepare the designs for the interiors in rough, and eight days to prepare the designs for the façade. He was to retain the original designs, but the copyright rested with the corporation Edward James had formed for the purpose. Dalí was to receive $2,500 and 20 percent of any dividend declared in excess of the amount of the capital invested.

And then the trouble started. Co-investors in the project included a company in Pittsburgh that was to supply the rubber models necessary for the exhibit. This company in turn was represented, on the day-to-day progress of the project, by the Gardner Display Works in Long Island City. A telegram the Gardner management sent William Morris after they had seen Dalí's design for the façade concluded, "It does not truly represent the show. . . . Our show is 60 percent an underwater

mermaid show and 40 percent a Surrealist show, so why should the front be all surrealist . . . ?"[51]

Next, Edward James concocted a letter, purporting to be from a Gardner employee named Klimo:

> I feel that you should know that this McGeein of Gardiner [sic] Displays is not in favor of the design and is exerting his influence to have it disapproved. . . . I am one of the workmen there and resent this person with his horrible middle-class mind, standing in the way of one who, by comparison, is extraordinary . . .[52]

Row followed upon row, compromise upon compromise, all the way through April and May. Eventually, having been twice postponed due to the sheer muddle created by a combination of Dalí, Edward James, and the Gardner Display Works, the exhibition opened on June 15, heralded by a press release organized by James entitled "Is Dalí Insane?"

In Dalí's pavilion, Venus had been born from the sea and dreamed of her birthplace, whence love arose. He had created underwater the landscape of her prenatal home, as well as a complete room in which appeared the "manic mermaids," playing a soft piano, warming their hands by the fire. The final exhibit, which represented Dalí's impression of the subconscious, featured living mermaids clad in fins, long gloves, and fishnet stockings, floating through the water, carrying out chores such as typing at a rubber typewriter or milking underwater what the press agents termed "a frustrated cow." Dalí called these mermaids "liquid ladies." The pavilion also contained a version of the *Taxi Pluvieux* in which sat Christopher Columbus.

Diana and Duff Cooper were two of the many hundreds of thousands of visitors to encounter Dalí's strange world:

> The entrance is between a lady's legs and when you get in it's dark, except for a dimly lit tank full of organs and rubber corpses of women. Ceaselessly, a beautiful living siren, apparently amphibious, dives slowly around her own bubbles, completely naked to the waist. She fondles the turtles and kisses the rubber corpses' mouths and hands. In the dark I could see Duff's face glowing like a Hallowe'en turnip.[53]

The day before the official press opening, Dalí sailed for Europe on the *Normandie*. This was put down to disgust at his constant battles with "the pig," Gardner, but was in fact because he had to get back to work on his ballet. However, he did not set sail before arranging to have the last word in the form of a manifesto entitled "Declaration of the Independence of the Imagination and the Rights of Man to His Own Madness." This was sparked off by one incident among many in Dalí's increasingly acrimonious dealings with the World's Fair committee, which forbade him to erect, on the exterior of the *Dream of Venus* pavilion, the image of a woman with the head of a fish. Their exact words, quoted by Dalí in his "Declaration," were "A woman with the tail of a fish is possible; a woman with the head of a fish is impossible."[54] Had there been similar committees in ancient Greece, Dalí pointed out, fantasy would have been banned and the Greeks would never have created or been able to hand down to us "their sensational and truculently Surrealist mythology, in which if it is true that there exists no woman with the head of a fish (as far as I know) there figures indisputably a Minotaur bearing the terribly realistic head of a bull."[55]

The next paragraph contains in a nutshell Dalí's attitude to the art establishment:

> *Any authentically original idea, presenting itself without "known anteced-ents," is systematically rejected, toned down, mauled, chewed, rechewed, spewed forth, destroyed, yes, and even worse—reduced to the most mon-strous of mediocrities. The excuse offered is always the vulgarity of the vast majority of the public. I insist that this is absolutely false. The public is infinitely superior to the rubbish that is fed to it daily. The masses have always known where to find true poetry. The misunderstanding has come about entirely through those "middle-men of culture" who, with their lofty airs and superior quackings, come between the creator and the public.*[56]

Judging by his immense popularity with the public during his lifetime and afterward, a popularity that shows no sign of diminishing, Dalí was right.

Edward James substituted for Dalí at the press conference and was disappointed, as he cabled Dalí on June 21, that the press view had been a "slight fiasco." The swimming pool was never emptied and became dirty with dye from the mermaids' gloves, and Julien Levy

"stuck his foot in it" by saying that Dalí had left because of his subconscious. Only the *International Herald Tribune* wrote anything as an immediate result of the press conference, though later in June, *Vogue* came out with a double-page spread of drawings by Dalí, and a brief and fairly noncommittal description. It was a disappointing end to a very trying saga and marked a distinct deterioration in Dalí's relationship with James, who felt that his friend had walked away from trouble, leaving him to pick up the pieces.

Dalí ignored the contents of James's telegram because to him the *Dream of Venus* incident was already closed. When Gala next wrote to James, six weeks later from the Grand Hôtel at Font Romeu in the Pyrenees, she told him Dalí had not replied because he was very excited about the sets and the costumes for his ballet, which was due to be performed on September 14 and 15 at Covent Garden.

Dalí may have moved on to other things, but James had lost a considerable amount of money over the *Dream* affair. Julien Levy said in a letter to him on July 15: "Dalí's 'Dream of Minus' passed finally into the hands of 'old pighead' [by which Levy presumably meant Gardner] and I suppose you were feeling disconsolate and didn't want to communicate with me or anyone."[57] The incident was the beginning of the end of Edward James and Dalí's close relationship; Dalí eventually blamed James for the disaster. However, the friendship was still very close that September: In a draft of a new will, dated the fifth of that month, James left Dalí $25,000, free of tax. Among other bequests to the composer Paul Hindemith, Pavel Tchelitchev, and Henri Sauguet, Dalí's was by far the largest.

Dalí and Gala had been at the Grand Hôtel in Font Romeu for about a month when a general mobilization was announced, and the hotel immediately shut down. They traveled back to Paris to close up their flat, storing as many of their possessions as they could in various warehouses in the city. In this they were helped by Eluard, who would look after the flat and its remaining contents during the war.

Dalí had decided that they should leave Paris because it was going to be too dangerous—by now, far from dreaming erotic dreams about him, he had become terrified of Hitler—and they decided that Arcachon, on the Atlantic coast just southwest of Bordeaux, would be

one of the last places the Germans would reach. It was near the Spanish frontier and the food was excellent. Chanel and Léonor Fini had also fled there.

They rented a large villa at 131, boulevard de la Plage from a Monsieur Calvet. The Villa Flamberge consisted of three buildings, the principal one, in which the Dalís lived, built in colonial style. The villa looked out onto a small tidal basin in which oysters were to be found. Arcachon had been well known to writers in the nineteenth century. Now it was to experience a new influx of artists—among them Marcel Duchamp.

The small circle of refugees met nearly every evening in one or another of Dalí's favorite restaurants—Le Château Trompette or Le Chapon Fin, both discovered by Gala during her daily drives around the area. Dalí was always passionately interested in good food even if, because of a neurotic aversion to chewing, he was only able to pick at it. At this period of his life he was also drinking very heavily, "a great quantity of Bordeaux and anything else he could get his hands on, whiskey, cognac, champagne."[58]

Every morning, according to Monsieur Calvet's son, Gala would visit Dalí's studio and comment on what he had done the previous day, colors that must be changed, and wc.k that was not going well, after which duty she would repair to the beach. Léonor Fini saw a great deal of them both:

> We did not speak of the war; we'd built a sort of untouchable island.
> . . . When Gala used to go to Paris for a day or two, Dalí got very nervous, and despite the fact that our villas were next door to each other, he would insist that I, and I alone, would accompany him to his house.
> . . . They both seemed very interesting to me, but not at all attractive— he at least was a very farfetched personality, but, in spite of his eloquence, he shut up in himself like a sort of "egg" for observing, without any possible connection with others.[59]

Gala made many business trips to Paris. Pictures were stored at Tailleurs et Fils, the framers in the rue du Cherche-Midi, and then at a warehouse on the outskirts of Bordeaux. Many of these pictures belonged, under the old contract, to Edward James. He became worried about them and sent Dalí a "very dry and hardly friendly cable."[60] The

eventual fate of these pictures was to be the cause of much bitterness in later years.

But there were still pictures to be sold, and it was at this time that Peggy Guggenheim bought *The Birth of Liquid Desires.*

Mary [Duchamp] was a great friend of the Dalís, so the first time Gala came to Paris she invited us to dinner together. We got into terrible arguments about my life, of which Gala did not approve. She thought I was mad to sacrifice it to art, and that I should marry one artist and concentrate on him as she did. [Peggy Guggenheim took Gala's advice, marrying Max Ernst, who had been Gala's lover in the early 1920s.] The next day she dragged me all around Paris to find a Dalí painting. We went to a storage house and to their mad apartment which was empty while they lived in Arcachon. I found a good painting, which she thought more appropriate than the first over-sexual one I had chosen quite inno-cently, not noticing what it represented. The one she chose certainly is sexual enough. . . . It is . . . horribly Dalí.[61]

In the middle of October a fresh row erupted over the Ballet Russe, then in New York and planning their autumn season, which was to include *Bacchanale* (as *Tristan Fou* had been retitled). Since Chanel's costumes had not been finished when the ballet company left for New York, new ones would have to be made; there was no possibility of shipping the originals from Paris.

Undeterred by his experience with *The Dream of Venus,* Edward James once again took a hand in Dalí's muddled affairs, cabling him on October 25 to say that Madame Karinska, a White Russian émigrée who was the doyenne of ballet costumiers in New York, could make up his designs from photographs of his drawings. "Mas-sine says if the ballet is not put on in New York next month it will have completely missed the boat. . . . Do you want me to supervise them . . . ?"[62]

A day later, he was urging Dalí to respond to his telegram. The answer, received on the twenty-eighth, cannot have pleased him. "Stop, you poor unfortunate. I beg you not to meddle in this sinister business if you value my friendship. Massine must delay the perfor-mance."

Stung, James shot off another telegram:

Thank you for your pretty rhetoric. Alas, it is you who is going to be the unfortunate, my poor little chap. We are powerless to stop Massine because he has all the rights on his side. If I was going to meddle, it was to protect your work and reputation. So far I have done nothing but introduce Wittenberg [James's lawyer] to Massine and Denham [the general director of the Ballet Russe] to stop proceedings. If you wish I could get my Thomas here from Paris with the Chanel costumes.

The telegrams flew back and forth. James retired from the fray on November 3. On November 9 he sent a telegram to Dalí telling him that his ballet had opened that night.

When the curtain went up on the evening's first ballet—*Bacchanale* was second—Karinska's costumes were still not finished. "People were frantically telephoning, finally jumping into taxis and going over to her workshop," the impresario Sol Hurok remembered, "then a fleet of taxis arrived each carrying costumes and pieces of costumes. . . . Some of the costumes never arrived that night at all, and the girls had to go on stage clad only in their full-length tights, which no one noticed."[63] Here was another Venus, this one with long flaxen hair, stepping out of a Botticelli seashell, with gnomes knitting red wool socks on the stage and a flock of umbrellas springing open at the hero's death.

The more prudish in the audience blushed at the sight of the male ensemble with large red lobsters as sex symbols on their tights. Nini Theilade, portraying Venus, created a sensation because she appeared to be in the nude; in fact she wore a flesh-colored body stocking. Dalí's décor was no less startling than his costumes; it was dominated by a huge swan with a hole in its breast through which dancers emerged. It was all very advanced; yet, wrote the *New York Times* critic John Martin, "to take such a ballet as a serious piece of psychoanalysis or as an important work of art would be a grave mistake."[64]

Dalí wrote to James at the close of the year:

If you would be able to see me for an instant, you would find a change in me that would frighten you—I have dissolved all hints of former frivolity in every area and now am possessed by a flowering and implacable

ferocity. In four months I have worked more than in four years. Do not forget that Picasso invented cubism during the last war. . . .[65]

He wrote the first page in his immaculate copperplate. The second page (probably written later) is in his small writing; and then, ruining the careful attempt at reconciliation, scrawled up the side of the letter is a last message in roughly penciled capitals: "Enough of these ruinous telegrams, write normally, truly and affectionately, as we do."[66]

James misread Dalí in a fundamental manner. Recognizing Dalí's extraordinary ability as an artist, he nevertheless failed to understand that Dalí was even more manipulative when it came to his own interests than he was himself and that, ultimately, no one could come between Dalí and Gala. As with so many other of Dalí's "porters," James eventually became too demanding of Dalí's time and attention, and the result was schism.

For what remained of the year, Dalí and Gala stayed in Arcachon. He began to dig a bomb shelter in the garden, and to talk to Léonor Fini about buying a suit of armor to protect himself against the invading Germans. Friends had already been mobilized (Eluard called himself "the oldest lieutenant in the French army"). It was only a matter of time before they would have to move on. But the small misty provincial world in which they now lived was comfortable and quiet. They had made plans to go to America the following summer for Dalí's next exhibition. In the meantime, even though Europe was collapsing, their own lives seemed secure.

▶
▶
▶
▶
▶

PART THREE

THE RAPE OF SELF-REFLECTION IS COMPLETE 1940–1949

The rape of self-reflection is complete by introspection ravished and confounded through the rapt reveries of self propounded on the archaic mirror's watersheet.

"The Metamorphosis of Narcissus," Salvador Dalí

9

SUBURBS OF A PARANOIAC-CRITICAL TOWN: AFTERNOON ON THE OUTSKIRTS OF EUROPEAN HISTORY 1940–1941

A though of course he did not realize it, the months Dalí spent in Arcachon, furiously painting and eating, were an interlude. It was a time of truce, a time out of time, before his new life began. Paintings such as *Old Age, Adolescence, Infancy (The Three Ages)* contained all the familiar elements. His distant past was represented by the landscape of Cap de Creus: the seated woman with her back turned, mending nets, the tiny figure of Dalí as a child in his sailor suit, the peasant woman with a basket on her head. The immediate past was interpreted by Dalí as a brick wall with shell holes in it that, through the medium of the double image, also represented the heads of old age and infancy.

In another painting, *Two Pieces of Bread Expressing the Sentiment of Love,* the purity of the loaf in a basket in *Cesta de Pan* has become pieces of bread, roughly broken up on a shadowy foreshore; they are moldy. That events outside the little tidal basin at Arcachon also intruded on Dalí's consciousness is apparent from his painting *Visage of War*—an agonized face whose eyes and mouth are filled with skulls whose eyes and mouths, in turn, contain other skulls.

But it is in his unfinished *Portrait of Gala,* and its superb accompanying study made with pencil on paper, that the tension is most ap-

parent. Gala's sideways gaze away from the artist is fixed and glaring, as if she is looking at remembered horrors. This is a masterly drawing, conveying the steel and determination of this extraordinary woman. It also conveys a sort of terror on the part of the onlooker.

Enforced isolation suited Dalí; he was painting hard and well, with a bravura technique, stimulated by the emotion of fear. During his eight months in Arcachon he completed sixteen pictures, destined to be sent directly to America for his next exhibition at the Julien Levy Gallery. There would be no more private views for chic Parisians, now scattered by the eddies and whirlpools of war.

Dalí's mornings were spent, as usual, painting. He occupied his afternoons by laboriously drafting his autobiography, *The Secret Life of Salvador Dalí*, in execrable and unreadable French. The pages show many crossings-out and amendments. Far from being a spontaneous account of his life, and pouring out directly from his subconscious, these drafts show that the work was a literary exercise. He was putting the final touches to a monstrous reinvention of his past.

He also continued to write an extended essay that was to sum up his theories. This he had started two years earlier. Prompted by his memory of the copy of the painting by Millet that he had first seen hung on the wall at his Marist school, Dalí's essay, entitled "The Tragic Myth of Millet's 'Angelus,' " was also inspired by Freud's analysis of Leonardo's *Virgin on the Lap of Saint Anne* and his "Leonardo and a Memory of His Childhood." Dalí's obsession dated back to 1932, when, in his mind's eye—perhaps in a daydream—Millet's *Angelus* had been transformed into a metaphor for predatory sex. He applied the paranoiac-critical method to his analysis of the *Angelus,* which he termed "miserable, silent, insipid, idiotic, insignificant, stereotyped, and full of clichés pushed to the limit."[1] But he pointed out that Van Gogh was also obsessed by the painting, copying it over and over again. And Giacometti had told him of a strange encounter with the *Angelus* on a train in Switzerland that had broken down between two small villages. A print salesman, traveling on a donkey, seized the opportunity to sell his wares, most of which, it seems, were copies of the Millet, to the passengers. The peasants traveling with Giacometti were taken by "some sort of collective frenzy and they hastened to buy all the prints, even though most of them assured Giacometti they had never seen the *Angelus* before."[2]

The painting depicts two peasants, a man and a woman, heads bowed, apparently at prayer in the fields. It is a quiet rural scene and as such has always been popular as an icon of the simpler life. To Dalí the picture was fraught with deeper, more unsettling meaning; buried in this simple scene, he found "the maternal variant of the immense and atrocious myth of Saturn, of Abraham, of the Eternal Father with Jesus Christ and of William Tell himself devouring their own sons." Far from being devout, "the woman with her hands together . . . strikes me as symbolic of the exhibitionistic eroticism of a virgin in waiting, the position before the act of aggression such as that of the praying mantis prior to her cruel coupling with the male that will end with his death."[3] He published the essay with an accompanying close-up photograph of a praying mantis to prove his point.

To Dalí, the man was "riveted to the spot, as if hypnotised by the mother—wiped out." The man stood for a son rather than a father. It may be noted, Dalí later said, that in Freudian vocabulary the man's hat stands for the "sexual arousal being hidden to show his attitude of shame over his virility."[4] The wheelbarrow and the pitchfork are erotic devices, too, Dalí pointed out. There is a dark patch on the ground in the foreground of the painting. Dalí always maintained that Millet had originally painted the peasants' child in a coffin, and that was why their heads were bared. He had no evidence to support this theory, but it was vindicated in 1963 when Madame Urs of the Louvre laboratory had the painting X-rayed at Dalí's request, clearly revealing a child's coffin painted under the basket of potatoes at the feet of the woman. Dalí's explanation for Millet's apparent change of heart was that when he finished the *Angelus,* "sad" paintings were no longer fashionable in Paris.

The *Angelus* formed one of Dalí's basic themes from the early 1930s. In 1933, for instance, he depicted the painting in *Gala and the "Angelus" of Millet Preceding the Imminent Arrival of the Conic Metamorphoses.* In other paintings the figures are transformed into near abstraction in the form of menhirs, or appear in a typically Dalinian landscape as in *Atavistic Dusk,* painted in 1933–1934.

In a preface to a 1934 exhibition catalog for the Galerie des Quatre Chemins, Dalí wrote: "The 'Angelus' is to my knowledge the only painting in the world that permits the immobile presence, the expectant meeting of two beings in a solitary, crepuscular, and mortal land-

scape." Even his first glimpse of New York skyscrapers assumed "the anthropomorphic shapes of multiple gigantic Millet's 'Angeluses' of the tertiary period, motionless and ready to perform the sexual act and to devour one another, like swarms of praying mantises before copulation."[5] Into this popular, academic painting of the nineteenth century he read his own litany of predatory and damaging sex; his obsession with the *Angelus* is, of course, linked to his relationship with his mother and with Gala. Dalí finished the essay while he was in Arcachon but it disappeared, only to resurface and be published twenty-two years later.

While Dalí painted and wrote, Gala developed a curious passion for visiting the wine estates of the region to add to her collection of miniature bottles of Saint-Emilion.

Meanwhile, Dalí and Gala solidified their plans to visit America. In order to solve what might turn out to be a visa problem, Gala wrote to Caresse Crosby in April 1940 asking her to confirm in writing the purpose of their trip to America (which was ostensibly to collaborate on a translation of *The Secret Life*) and that they would be staying with her. This Mrs. Crosby promptly did in a letter dated May 14, four days after Belgium had been overrun by the Germans. The fall of France was now only a matter of time.

Gala made one last, terrifying visit to Paris, alone in a nearly empty train around which bombs fell as it neared the Parisian suburbs. What could have been so pressing to force her into so dangerous a journey? The most likely explanation is that she needed to collect money and a few transportable pictures to finance their life in America, and to arrange for the rest of the pictures, held at the framers in the rue du Cherche-Midi, to be sent down to Bordeaux.

The apartment in the rue de l'Université was just as they had left it, with the exception of the paintings. Gala must have wandered through its rooms remembering the vernissages they had held in those triumphant prewar days. There was no Eluard to comfort her, for he had been drafted. There were no Surrealist meetings at the Café Cyrano, only shuttered shops and empty streets in a city in which she had spent more than half her life. Two weeks after her visit, Paris fell.

Refugees started swarming south. Among them was Jean-Michel

Frank, the architect and decorator, who arrived at the Dalís' at the end of June. He had come to tell them they were fools to stay. He was on his way out of France because he believed, being Jewish (and probably guessing that Gala was, too), that the Germans were going to kill them all. That was enough to bring Dalí's latent panic to the surface.

They left the next day, taking with them only what they could pack into a car. During the journey to Bordeaux Dalí talked nonstop, but Gala, according to their landlord's son, who drove them, sat mute, a terrified expression in her eyes. Perhaps she was remembering her flight from Russia in 1917.

They crossed the bridge at Hendaye at the end of June only just in time, for the Germans closed it permanently two days later. They then had to separate; Dalí, being a Spanish citizen, was not allowed to enter Portugal without a visa, and would have to go to Madrid to get one. His state of mind at the prospect of traveling alone through the country that, having been torn apart by civil war, now terrified him can only be imagined. Gala went to Lisbon to buy tickets for the next boat, and to try to organize friends (certainly Caresse Crosby and probably Edward James) who had money in Europe to cable them the necessary cash, as their own funds were blocked in France.

Dalí went back to Catalonia for the first time since 1936. The Civil War had ended in March 1939, so it was safe for him to return to his beloved Empordà to bid farewell to his family, whom he might never see again. To get to Figueres, he had to cross a landscape of eerie villages whose inhabitants had fled to France. The desolation reminded him of Goya's drawings of similar horrors. He flitted through ruined streets and deserted squares, their colors reduced to black and white in the moonlight, the soundless invisible ghost of the past visiting the future. He knew now the finality of that past. He could never go back to the time of his idylls.

He arrived at his father's house at two o'clock in the morning. At first no one answered his knocks. (It had not been long since a knock on the door in the middle of the night meant arrest and death.) Finally, his father asked who was there. "Me, Salvador, your son." His voice was firm; but his family stared at him, grouped together in the doorway in the dark confronting this intruder, "fanged moustache and

all, appearing like a ghost. They were all looking for a footing in the shifting ground of what attitude to take."[6]

They gave him food, that familiar sacrament of the family—tomatoes, anchovies, and oil. Under the dining-room table were the blackened traces of the fires lit by the anarchists to prepare their meals. His father, surprisingly as big as Dalí had remembered, sat staring at his son. Few words were exchanged. Then it was time to survey the damage; a balcony was missing, having been knocked off by a bomb, and there was a chink in the wall. But in his room, nothing at all had changed. An ivory rabbit sat on the dressing table, and there was the same spot on the curtain. He found old buttons at the bottom of a drawer.

The next day Dalí went to Port Lligat, and found his house deserted and wrecked. The small community of fishermen had been almost wiped out. Ramón de Hermosa, the local beggar who had been Dalí's neighbor, had been removed to an old-people's home in Girona, where he had died. Lidia Nogueres was failing in both mind and body.

Cadaqués, too, had been devastated. Many of the houses were in ruins; even the priest had been killed.

Dalí then went to Madrid to obtain his visa. He stumbled across the sculptor Emilio Aladrén, one of the youngest members of the "Resi" group, and brought news of Lidia to Eugeni d'Ors, who embraced him as if he were never to see him again. A group, depleted but alive, reconvened. It included the philosopher Eugenio Montes and the poet Eduardo Marquina, Dalí's guardian from Residencia days, in whose house Dalí found one of the paintings from his first classical period in Cadaqués. He was introduced to the young lyrical poet Dionisio Ridruejo and the "anti-Góngorist" Raphael Sánchez Moros, both of whom were Falangist intellectuals. This brief resumption of the intellectual life he had known as a student gave Dalí reason to hope that, if the war in Europe ever finished, there might be a place in Franco's Spain for him, if his politics were correct.

From this moment Dalí started to move to the very far right as a matter of expediency. He wrote to Caresse Crosby: "The young group surrounding Falange is surely one of the most intelligent, the most inspired, and the most original of our times, among the desolate medi-

ocrity that shadows the world. I prophesy that the spirit of this world will be saved by Spain, which believes only in realism. . . ."[7]

On July 8, Edward James, then in New Mexico, dispatched telegrams to President Roosevelt, to Sir Samuel Hoare, the British ambassador in Madrid, to Jean-Michel Frank, who was in Lisbon waiting to leave, and to the Duke of Alba, Spain's premier grandee, at that time in London. The content of all these telegrams was the same: *Where is Dalí?* James feared that he was lost in Spain, that he might be shot, like Lorca. News of Dalí's disappearance reached Buñuel, now in New York. (Buñuel had nearly had to go to work washing dishes in a hotel kitchen to support his wife and his two small children, but he had, luckily, found a position working on anti-Nazi propaganda films for Nelson Rockefeller's Office of Inter-American Affairs at the Museum of Modern Art.) Buñuel contacted James, saying that he might be able to help through his family in Spain. "I think his case may be serious," wrote Buñuel, "but above all we must talk. . . . If I want to speak to you, it's more because I am seeking a sort of moral reassurance before undertaking anything and I know you are his friend."[8]

Meanwhile, James had tracked down Gala in Lisbon. On July 20, Dalí himself telegraphed James: After a marvelous visit to Spain, he too was now in Lisbon and urgently needed $500 immediately to be sent to the Hotel Metropole.

Lisbon was sufficiently full of aristocratic and royal refugees to satisfy even Dalí's insatiable thirst for blue blood and celebrity. He was always turning around and saying, "Doesn't that look like Schiaparelli?" only to find that it *was* Schiaparelli. José María Sert got on a tram by the zoo just as the Duke of Windsor crossed the street in the direction of Paderewski, who was sitting on a bench. "At the far end of the square," he wrote, "the one you see from behind, wearing a brown suit, looks like Salvador Dalí. . . ."[9]

While Dalí was expounding his newfound right-wing philosophy, Gala was having difficulty getting an exit visa from the Portuguese because her Spanish passport had vanished. The prospect of Dalí escaping to America while Gala, a Jew, was stuck in Europe must have been terrifying.

Finally, however, her visa came through and they both left on the

Excambion on August 8. Arriving in New York, they spent ten days at the St. Regis organizing money, which was still proving difficult. "Anyway," Gala wrote to Caresse Crosby, "we are doing what we can." On the twenty-ninth they traveled to Caresse's country estate, Hampton Manor, near Bowling Green, Virginia, where they found a house full of artists. This was not entirely to their taste, for they both preferred that Dalí be the only artist in residence. Henry Miller was adding pages to the second part of *Tropic of Capricorn,* according to Anaïs Nin, who was staying there with him. A young artist, John Dudley, and his wife, Flo, were also present.

Anaïs Nin, never a woman who liked being upstaged, was not impressed by her first view of Dalí and Gala: "Both were unremarkable in appearance, she all in moderate tones, a little faded, and he drawn with charcoal like a child's drawing of a Spaniard, any Spaniard, except for the incredible length of his moustache."[10]

It was not long before trouble started in Caresse's little commune. It was one thing to keep artists happy over a weekend, mingling with Parisian society, drinking a great deal of champagne, and making Surrealist films. It was quite another story when they were frightened, far from home, short of money, with nowhere else to go, and trying to work in completely strange surroundings.

Caresse's house had been built by Thomas Jefferson, and its first owner, John Hampton de Jarnette, used to shoot arrows at visitors as they approached. It was isolated. The tiny local hamlet, named De Jarnett, boasted one general store with chairs set round a potbellied stove, which Dalí invariably visited at the end of his morning's painting. It must have seemed a long way from Europe and the spoiled existence of grand hotels and luxurious house parties to which he had become accustomed.

But Gala was made of steel when it came to protecting her investment; it was not long before the household revolved around Dalí. The library was declared out of bounds because she had annexed it for his studio. John Dudley was bullied into driving into Richmond to find bits and pieces Dalí needed for his painting. Anaïs Nin was dragooned into translating an article for him, and Caresse was asked to invite *Life* magazine to come and visit. "Mrs. Dalí never raised her voice, never seduced or charmed. Quietly she assumed we were all there to serve Dalí, the great, indisputable genius."[11]

Gala conducted conversations in French (she could by now speak English perfectly well), which humiliated John Dudley, who had been allotted by her the status of not very bright errand boy (possibly because he found his own young wife more attractive than he did the Surrealist muse). Dudley, suffering from an inability to work, was irritated, too, by Dalí's cheerful industriousness, and by the singing and whistling that could be heard from the library while he painted.

For his part, Henry Miller was annoyed when Gala and Dalí cuddled in public (public demonstrations of affection were nothing new; the Dalís had incurred Marie-Laure de Noailles's wrath by their amorous conduct on a sofa at her house in the south of France). Miller resorted to his favorite weapons, contrariness and contradiction. Matters were not improved by his verdict on Dalí's work: "The River Styx, the river of neurosis that does not flow."[12]

Anaïs Nin, however, liked to hear Dalí talk and could speak to him in Catalan. Gala loathed this new intimacy, especially when Dalí showed Nin his work. Always on her guard against potential rivals for Dalí's affections, though these were not usually women, Gala must have been frightened by Nin's obvious achievements and talents, and her independence from Miller.

Due, more than likely, to Gala's maneuverings, none of the other guests was featured in the *Life* magazine piece. The whole article hinged around Dalí and his efforts to turn Hampton Manor into a Surrealist happening. A picture taken in the library showed Dalí, Gala, and Caresse working round a prize Hereford bull sitting rather sulkily on the carpet. *Life* told its readers that "Dalí had invited [it] in for after-dinner coffee."[13] Dalí was also shown on the snow-covered lawn in the midst of a composition entitled *Effet de Sept Nègres, un Piano Noir et Deux Cochons Noirs sur la Neige,* which was, essentially, a piece of performance art. A grand piano was slung from a tree, pigs were placed in position, and a septet of local blacks and, of course, Gala posed for the camera in front of Hampton Manor's neo-classical façade. Other photographs showed Dalí and Gala around the potbellied stove in the general store in De Jarnett, while Caresse did the shopping in a leopard-skin coat. The piece appeared in *Life* a week before Dalí's exhibition opened at the Julien Levy Gallery in April 1941.

In spite of the increasingly tense atmosphere, the alarums and the

excursions, work went on. Dalí painted five pictures between August 1940 and April 1941 at Hampton Manor, and he also spent a great deal of time on his autobiography.

At first the plan was that Caresse would translate it, but this proved beyond her, as the many drafts and redrafts she worked on indicate, and eventually Haakon Chevalier was entrusted with the arduous task of trying to decipher Dalí's appalling handwriting and almost impenetrable spelling ("book" became "buc," "Freud" became "Froid"). It was also intended that Caresse would set up her own printing press in one of the cottages on her estate, but this proved impractical.

The Secret Life is the culmination of the continuous process of self-mythologizing that Dalí had begun at the Residencia (or even before). All his heavily embroidered obsessions are gone into in minute and occasionally very funny detail. We meet Gradiva, "she who advances," and Dullita, the little Russian girl first glimpsed in Señor Trayter's stereopticon. Dalí introduces us to Joan Butxaques, the "pocket" boy, and to Lidia Nogueres.

Dalí liked crustaceans because they wore armor to conceal their soft flesh beneath, and his autobiography is written, whether consciously or not, to conceal almost every truth about his life and about himself as a human being. Soaring flights of fancy and metaphor deliberately obscure the central facts: his relationship with his mother and his father, his closeness to his sister, his father's relationship with his aunt. He goes to immense pains to obscure the fact that he lived his life through anything other than the paranoiac-critical method. In effect, he was treating his whole life as a paranoiac-critical work of art, just as he regarded his paintings as frames in the film of his life.

But he was perfectly capable of writing highly intelligently on a variety of subjects and in a "normal" manner. His series of letters to J. V. Foix, to Sebastià Gasch, to Lorca, are the letters of a nervous but clever man, very much in touch with reality, who takes his painting and his writing very seriously. So, in spite of his deliberate obfuscations, in spite of himself, from time to time reality breaks through the clouds of invention in *The Secret Life,* especially when he is describing his youth in Cadaqués. This was so central to his own idea of his

being, to the formation of his personality, that even he could not distort it enough to conceal it.

The manuscript was written on bits of letterhead paper taken from hotels. In the first part, "Anecdotic Self-Portrait," Dalí firmly tells us of his intent: "My fixed idea in this book is to kill as many . . . secrets as possible, and to kill them with my own hands."[14] With this ominous Dalinian intent, the book was published in 1942 to shocked reviews.

A visit to Hampton by Caresse Crosby's drunken American husband, Selbert Young, whom she had married after the death of Harry Crosby and whom she was in the process of divorcing in Reno, put a temporary end to the commune in mid-September 1940. Hearing his wife had filled her house with artists, Young arrived one night with a woman friend expecting an orgy, turned on all the lights, and found Dalí and Gala asleep in one room, Henry Miller alone in another room, and John and Flo Dudley in a third. Ordering everyone to leave immediately, he was ignored; he then rushed down the stairs, shouting that he would destroy all Dalí's paintings. At this, Dalí and Gala took fright, dressed, packed up all the paintings, and left for Washington, from which they telegraphed Caresse in Reno: "Monsieur Young is staying with his girlfriend at Hampton Manor, we left and are at the Hotel Shoreham, we await your advice."[15]

At first, they decided to seek out Edward James in Taos, New Mexico. James had been living in a cottage belonging to the wealthy Mabel Dodge Luhan, a great friend of Gertrude Stein and Alice B. Toklas, and, famously, the hostess to D. H. Lawrence during his American sojourn. James had taken another cottage and studio for Dalí, paying two months' rent as a present. Dalí and Gala were of course delighted to accept this offer and telegraphed James that they were on their way. But then Mrs. Luhan changed her mind, telling James: "I heard that Dalí is someone who breaks windows of big shops and I am sure I should not like him, your friend; also I do not want my windows broken."[16] So Dalí and Gala went on to California, where Dalí had been given a commission to paint a portrait of the wife of Jack Warner, the head of Warner Bros. She was reported to have said that she wanted Gainsborough to paint her, but settled for Dalí.

James, meanwhile, had become very friendly with D. H. Lawrence's widow, Frieda, during his stay in Taos and determined that the Dalís would like to meet her when they arrived in California. It did not go well:

> *Mrs. Gala Dalí was so offensively inhospitable toward the bright-eyed old lady. . . . Frieda Lawrence was not dressed in a Chanel or a Schiaparelli, that obviously was the reason why they considered civility would be wasted on her.* "Pauvre Edouard," *was what Gala remarked the next day,* "qu'est-ce que tu es devenu! Ta vie ces jours-ci avec des restes."[17]

Gala also took the opportunity of attacking Taos, announcing that she had found it a miserable, cheap, godforsaken hole, and that she had been impressed by nothing but its dirt and a discarded orange peel she'd noticed.

While in Hollywood, Dalí was trying to persuade Bette Davis to make a film with him. He asked another guest at the Beverly Hills Hotel, Baron Alexis de Rédé, a friend of Dalí's Paris acquaintance Arturo López-Wilshaw, to help. "They asked me whether I would translate the scenario into English, but nothing came of it," the Baron de Rédé recalled. "Bette Davis turned down the project and they immediately went back east."[18]

In 1941, the Dalís returned to Hampton Manor for three months (the turbulent Selbert Young had been evicted). Here Dalí began to design *Le Jardin de Caresse,* an elaborate Baroque plan for a garden that was so expensive it was never carried out. He also embarked upon a new career as a jewelry designer in conjunction with Chanel's great friend and erstwhile collaborator the Sicilian Duke of Verdura, whom he had known in Paris before the war. The Duke visited Hampton Manor to discuss the project. His arrival turned out to have Surrealist overtones.

Collecting the hapless Duke off the train, Gala and Caresse made several detours to hardware and grocery stores while Gala explained that the house was without electricity. The car turned off the road into a small forest of pines and drove down what was apparently little more than a deserted bridle path. In an account of his visit published in *Harper's Bazaar* and somewhat revoltingly titled "Massa Dalí in Ole

Virginny," the Duke described a beautiful house surrounded by de-
cayed trees. One of the galleries was falling in, he noted, and most of
the windows had no glass. The Duke also noticed that there was no
carpet and that the furniture consisted solely of a few broken-down
settees. Trailing across a deserted sitting room they came to double
doors, which led to Dalí's studio. The doors swung open to reveal Dalí
lit by the reflections of a fire, but by little else. With his left hand he
was rocking a cradle filled with ashes. A cheerful conversation with
Dalí informed the Duke that supper would be taken *en fête* in the local
cemetery. The Duke decided to get drunk. It was not until he noticed
a radio with an electric cord and asked how it worked in a house
without electricity that the three turned to one another and burst out
laughing. Dalí had spent days furnishing a ruined and empty house.
On finally reaching the real Hampton Manor, the Duke was reassured
to find his bags unpacked and everything "to a king's taste."

Surrealist joke this may have been, but it procured Dalí a long
mention in *Harper's Bazaar* to coincide with his exhibition. Once again
he had cleverly manipulated events to his own advantage. But this
manipulative quality, which had become more apparent after his en-
forced departure from Europe and his residence in America, with its
attendant fears of poverty and unfamiliarity, had now come to affect
even his closest friends. Early in 1941, Edward James drafted a long,
plaintive letter to Dalí, couched in the third person:

> *Nowadays I sometimes wish that [he] were not quite so sane, not quite so*
> *coldly calculating. He was certainly more disarming when his craziness*
> *was nearer to being genuine. For there are two Dalís: the one of his world*
> *of vivid, genial and absorbing paranoia, in which he lives more than half*
> *his life—the other the shrewd business Dalí, which his wife Gala has*
> *created and keeps trained and caparisoned in a shell of impenetrable*
> *conceit—this last is the Dalí* qui n'hésite pas de profiter le maximum
> de tout . . . ses amis non exceptés.[19]

James had attempted to raise the question of the *Bacchanale* debacle,
but Dalí refused to discuss it. "I had no desire for a wasteful scene,"
James wrote—which of course is just what he did want—a scene to
prove that Dalí still cared for him as more than just a source of money
or introductions.

Writing that April to Yvonne de Casa Fuerte (who, it should be remembered, was not a favorite of Dalí's, nor he of hers), James noted that he had found Dalí very changed by the influence of his friend Chanel's worldview and the victories of Fascism. "When he speaks of politics," James wrote, "one can't help but realise that he has become pro-Franco; it's so he can return to his own country one day, without problems, it's understandable, but all the same it's antipathetic when you think how left-wing he was when the radical Republic and the ideas of the Left were in the ascendancy."[20]

The days when Dalí stayed overnight with James at the Ritz were long over. Though he saw Dalí frequently during his years in America, and still remained a patron and a potential source of money, James as a lover had now been relegated to the past.

That spring, Julien Levy told Edward James that the new pictures were very serious and very good. Having just viewed a newsreel of Dalí, Levy had been worried that Dalí was beginning "to go off the deep end of nonseriousness"[21] but, considering his paintings, Levy admitted, "the dialectic remains even."[22]

James received an invitation to the forthcoming exhibition at the beginning of April. It read, "Salvador Dalí requests the pleasure of your company at his last scandal, the beginning of his classical painting," to which engraved message Dalí had added, "Will the little Edward come or not? Love from your Dalís."

On April 15, James wrote to Dalí and Gala to tell them that not only would he not be able to come to their exhibition, but that he could not afford to buy even one picture. If only the fifteen or sixteen pictures that had been lost en route from Paris had arrived, he told them, he could exchange a new Dalí for an old one, or for two or three old ones. There were, he said, some very good pictures in that group. Clearly, the matter of the missing pictures, last seen at the framers Tailleurs et Fils in Paris, and now seemingly vanished somewhere in occupied France, was not going to be forgotten.

Dalí's exhibition opened at the Julien Levy Gallery on April 22, 1941, to almost universal acclaim, moved to the Arts Club in Chicago on May 23, and ended its tour at the Dalzell Hatfield Gallery in Los Angeles, running there from September 10 to October 5.

Dalí took a *New Yorker* writer on a tour of his latest paintings, telling the critic that the exhibition marked his return to classical influences, showing the effects of Ribera and Leonardo. "More design, balance, and precise technique," he said, pointing to a canvas called *Family of Marsupial Centaurs.*

The catalog cover featured a classical victory arch, which framed Dalí's *Soft Self-Portrait with Grilled Bacon.* The arch was flanked by figures inspired by Il Bronzino, and the artist's name was drawn out in beautiful copperplate in the traditional golden sections. This was followed by a text entitled "The Last Scandal of Salvador Dalí," written by "Felipe Jacinto" (Dalí himself), which ended with a definition of "Form," the definition being a list of expressions and words from "Shape" to "Serpentine." Of the nineteen paintings, several, in spite of Dalí's vaunted return to classicism, still used the double-image device, notably No. 11, the *Bust of Voltaire,* in which the bust becomes dancing maidens, and No. 14, *Slave Market,* which treated the same subject.

There were two finished portraits in the exhibition: that of Mrs. Harold McCormick, whom Dalí had painted in Hollywood, and Lady Louis Mountbatten, whom Dalí had painted in his best Surrealist manner with green snakes coming out of her hair. There was also a sketch for a portrait of the Spanish ambassador and some drawings. The six pieces of jewelry were the result of the collaboration between the Duke of Verdura and Dalí. And finally, as if Dalí needed to prove yet again his versatility, there was a crystal cup, executed by Steuben Glass, called *The Sleep of Nautilus.*

The last page of the catalog contained a fragment of the manuscript of *The Secret Life,* due to be published that autumn by the Dial Press but eventually delayed until July 1942. The page is a series of drawings, pieces of writing, captions, more writing over the first in a different script, more drawings. If the whole manuscript looked like this, it is a wonder the book was ever published at all.

The New York critics were by now inured to Dalí and gave him good if not ecstatic notices. Most commented on his technique and took his publicity in their stride—the East Coast had seen it all before, and besides, the high tide of the Surrealist shock wave had long since receded; external events had, as it were, overtaken subconscious scandals. It was during this period that the sales of Dalí's paintings started to fall off. *Daddy Long Legs, Hope,* for instance, was still in Julien Levy's

stock two years later when Reynolds Morse bought it. As Morse recalled, "You had quite a big choice, because there were a lot of them around in various galleries by that time, and they just were not selling."[23] The audience Dalí had created for his work before the war—that is, the smarter set in America and Europe—were either not able or not in the mood to buy paintings. Patrons like Edward James and Arturo López-Wilshaw, who had managed to get to America, were, if not poor, certainly not as well off as they had been, since most of their money was frozen in English and European bank accounts.

There were, as yet, no new patrons in America to replace the upper crust of Paris. Even though they had made several trips to the United States in the 1930s, Dalí and Gala had mainly mixed with the transatlantic café society—just those people who were most affected by the war. It would take the Dalís some time to find new enthusiasts for his work. But there was one patron willing to spend money on Dalí, and that was the Marqués de Cuevas, who had funded *Bacchanale,* Dalí's collaboration with the Ballet Russe de Monte Carlo. With his wife's Rockefeller millions, the Marqués had shipped the company to America at the outbreak of hostilities, and they were now based in New York. *Bacchanale* had been a surprising commercial success on its 1940 tour of America, and now the Marqués undertook to fund a new ballet to be called *Labyrinth,* for which Dalí would write the libretto and design the scenery and costumes; the choreography was to be created by Massine. Dalí spent 1941 preparing this, traveling at the start of summer to stay with the Cuevases at Franconia, New Hampshire, where they had an estate, to discuss it. The libretto, based on the myth of Theseus and the Minotaur, was set to Schubert's Seventh Symphony, and was very successfully premiered at the Metropolitan Opera House in New York on October 8, 1941, subsequently going on tour.

One problem remained. Where was Dalí going to work? Hampton Manor had been a temporary expedient. Gala and Dalí knew they needed to be in New York, just as they used to be in Paris, in the winter and spring, to organize shows and encourage clients and patrons; but they had to find somewhere quiet to live in the summer, where Dalí could paint.

They found it, who knows how, in the unlikely location of the Del

Monte Lodge Hotel at Pebble Beach, in California. Pebble Beach is an exclusive enclave in Monterey County, where the rugged coastline looks something like the Costa Brava, although the light is very different, being veiled rather than clear. From the summer of 1941, and for the remaining seven years Dalí and Gala spent in America, they would migrate there every June, to return east in late September or October.

This sojourn on the West Coast had the effect of distancing Dalí from other members of the Surrealist group, most of whom had regrouped, insofar as they were able to, in the old Surrealist configurations. André Breton, Max Ernst, Marcel Duchamp, the Swiss Kurt Seligmann, even Yves Tanguy, all lived in New York. Breton was, moreover, in another magnificent sulk at having to leave Paris and had refused to learn English, thus isolating himself from the artistic life of Manhattan. Dalí, on the other hand, had established his beachhead in America years before and was regarded by the American art establishment as the very spirit of Surrealism—they were not interested in Breton and his dicta issued in a foreign language. This added fuel to the fire that was already blazing between Breton and Dalí. The anagram "Avida Dollars," invented by Breton, dates from this time, as do such comments as "All Dalí can hear is the squeak of his patent-leather shoes." The two did not meet again for years.

The Del Monte Lodge Hotel was a clever choice by Dalí (or probably Gala), for it was used to dealing with celebrities; many people from the film world stayed there. As soon as he saw Dalí and Gala, Herb Caen, who did publicity for the hotel, thought they would ask for a special celebrity rate. He was not wrong. "Hotels are always happy to have us," Gala told Caen. "Dalí makes publicity for a hotel. We do not ask for rates—they are given to us." Dalí and Gala were given a double room at a special rate, and an adjoining studio for free.

The Dalís became friendly with Caen and his wife, and often shared a barbecue with them. It was during one of these dinners that Dalí broached an idea he had had: He and Gala were fortunate, he told the Caens, to have left France when they did, but other artists were not so lucky, and those who came later were in financial need; they, therefore, would raise funds for them by giving a benefit party. Dalí told Caen that Gala had already spoken to Alfred Barr at the Museum of Modern Art, who thought the idea of a benefit a good one. This led Herb Caen to suppose that the party would be given in New York. Not

at all, said Dalí, they would give it at the Del Monte Lodge Hotel, and it would attract publicity from all over America.

Thus began the affair of the Night in a Surrealist Forest ball, held on September 2, 1941. Dalí and Gala needed the exposure such a party would no doubt give them (and they probably cast their minds back to the Bal Oneirique and the avalanche of publicity that it had produced seven years previously). They may also have thought that the party would attract important producers from Hollywood, potential patrons for the films Dalí longed to make there.

Dalí had already prepared a list of things he would need to stage this event, which included two thousand pine trees, four thousand gunnysacks, two tons of old newspapers, twenty-four animal heads, twenty-four store-window mannequins, the largest bed in Hollywood, and two truckloads of squash, pumpkins, dried corn, melons, and other fruit. Even this list, said Dalí, was not complete, and should also include a wrecked automobile and some wild animals, one of which should be a baby tiger: For a night in the forest, he explained, one must have animals. Dalí then drew a sketch indicating how he saw all these elements fitting together. The trees were to create the atmosphere of a forest, the gunnysacks, filled with crumpled newspaper, would be suspended from the ceiling to create a grotto effect. One end of the room would be dominated by the bed, on which Gala would be lying. From the bed a long table would extend out into the room. Along this table, between every four chairs, there would be a mannequin with an animal head, and by the trees there would be some wild animals peering out. Dalí left till last the tiger cub: It would be lying with Gala on the bed.

> "And the wrecked automobile, where does that fit in?" asked the bewildered but game Herb Caen. "Ce n'est pas difficile," replied Dalí. "In America people are always in automobile accidents. . . . We will have a wrecked automobile that is overturned. In it we will have a nude model who lies there dead. From the automobile there will emerge two dancers —their bodies bandaged—and they will perform a dance of death."[24]

After Herb Caen had looked at the sketch, Gala took it from him and tore it, as was her habit, into a multitude of small pieces. No one was going to get a Dalí drawing for nothing.

First, Caen had to work through the list. The largest bed in Hollywood was easy; he found the one Mae Murray had used in *The Merry Widow*. Ten people could sleep in it. The animal heads came from the famous Max Reinhardt film production of *A Midsummer Night's Dream*. There were plenty of wrecked cars in a wreckers' yard at Monterey, and a Chevrolet was bought for $50. I. Magnin provided the nude store mannequins. And then there were the wild animals. The Fleishhacker Zoo in San Francisco was the nearest place to get some, and as it turned out, Mr. Fleishhacker was an acquaintance of Caen's. Dalí gave the hapless Caen a list of twenty animals, including the tiger cub and a giraffe. It then fell to Caen to telephone his friend with his somewhat unusual request. "The giraffe is out but the rest of the animals can come, provided you have four guards and transportation,"[25] he was told. Holding off breaking the news to Dalí about the nonappearance of the giraffe, Caen encountered further requests, among which were twelve hundred shoes in which Dalí wished to serve the first course of the banquet.

News of this extraordinary party spread all over America. Over a thousand people applied, although there was room in Dalí's enchanted forest for only four hundred. The rest of the guests were allowed to wander in and out of the forest, but had to sit at tables strung along the hallways of the hotel. Every socialite worth a column inch was flying in specially for the party. The Vanderbilts, the Hitchcocks, the Sanfords, and the Winston Guests flew in from New York; from Hollywood came Bob Hope, Bing Crosby, Ginger Rogers, and Clark Gable. The party was obviously going to be another Dalí triumph—even the wild animals arrived at the prearranged time.

Dalí's costume caused a sensation. It consisted of a Victorian anatomical chart of the rib cage in which various sections could be lifted up to reveal the heart, the lungs, and the kidneys. This had been a particularly happy *trouvaille* by Dalí in a junk shop in San Francisco.

The party came, was a great success, and went, leaving Herb Caen with an arm broken in three places, and with expenses far outrunning the receipts. Several letters from Alfred Barr asked where the money for the struggling European artists was. But no funds were ever forthcoming. The party had been of value only to Dalí.

* * *

Dalí was now distanced even further from the Surrealists in exile, but it is to be supposed that he did not much care. He moved in social circles in New York when he was in residence at the St. Regis, and, though affable with the locals in Monterey (to the extent of once judging a high-school painting exhibition), he spent most of his time there working. The distance he put between himself and his fellow artists during these years in America would never again be bridged. By 1948 he had dispensed even with the services of dealers, and simply hired a gallery once every two years to hold a new exhibition. This withdrawal from the company of fellow painters and from the art scene, with its complicated web of interrelationships among dealers, critics, and artists, goes a long way to explain why, for many many years, Dalí was not taken seriously by the majority of critics and curators.

He found his own patrons and his own collectors, many of whom were his alone—that is to say, he "created" them as collectors for his work only. He hung his own shows and masterminded his own publicity in consumer rather than art magazines, with Gala looking after the finances. In effect, for nearly three decades, Gala acted as both his dealer and his business manager. In the beginning, it was simple, but later it grew far too complicated for her to deal with, and this created a vacuum into which stepped those who realized how to exploit the situation to their own—certainly not to Dalí's—advantage.

His politics also distanced him from his contemporaries, and it was not until the pop artists such as Andy Warhol discovered him in the 1960s that he resumed relations with the art world. But his relations with the general public never wavered. Dalí and his public had a great mutual love affair: He exerted a personal fascination; he had a genius for publicity; and the public, who felt excluded from abstract expressionism, turned in relief to him, because they could (at least almost) understand his paintings because of their literary and figurative content. More than any other painter of this century, Dalí played the role of the artist as madman and magician; and the public—understanding that this was how a real artist should behave—willingly bought the myth so carefully constructed by Dalí.

In 1941, Dalí was offered his first retrospective at the Museum of Modern Art. James Thrall Soby, the curator, and Alfred Barr, the museum's director, worked extremely hard on the installation, and it

attracted a great deal of critical comment and many visitors when it opened in November. However, the exhibition was not without such problems as Dalí habitually created. Soby wrote to Barr to say that he had told Dalí that he could not have a decorated Frigidaire in the show. "As he described it to me, the Frigidaire definitely sounded like Mr. Clark's tombstone. I thought it better to object at once."[26]

El Sueño, a soft, melting portrait of Buñuel, was seen for the first time in this retrospective, as well as a new version of *La Miel es Más Dulce que la Sangre.* "Dalí steals the show," wrote the *Art Digest* critic. "He is 20,000 volts of uninhibited imagery. . . . The value of the Dalí paintings is largely subjective. . . . A Dalí painting is never boring; a Dalí painting is never empty of thought."[27]

But the art critic Peyton Boswell differed from this point of view:

> *Dalí's is a voice of his time. When times change and humans return to sanity the vogue for his exquisitely painted and temptingly titled nightmares will change with them. While we wait, there can be little harm in escaping for a while from the strain of worldwide hysteria by shedding our worries in the presence of Dalí's incongruous juxtapositions of familiar objects.[28]*

Though he may not have consciously known it, Dalí was already beginning to lay the foundations for his next great phase in painting; but it would take him the eight years he spent in America, sundered now from both his Spanish roots and his Surrealist colleagues, to crystallize and develop it.

10

AT THE HOUR OF
THE CRACKLED VISAGE
1942–1944

The retrospective exhibition at the Museum of Modern Art marked the end of Dalí's Surrealist phase. True, he continued to paint "Surrealist" pictures throughout the 1940s, particularly in his commissioned portraits of society women, for which he applied his "Surrealist code." But, with one or two exceptions, the paintings he did in the seven remaining years he was in America represent a transition from his Surrealist manner to something new—something that was to take years to gestate before it was philosophically coherent enough for Dalí to use it in his paintings. He had to experience and codify new emotions, new terrors, new joys, before he could paint them. The old codes of crutches, skulls, ants, and milk, dating from the illogical fears of his childhood and developed over the Surrealist years, would now no longer suffice.

His 1941 show at the Julien Levy Gallery hinted at this new code. A few of the critics managed to spot it. "Recently he threw out the smooth Renaissance-via-Böcklin surface and went back to the Mannerists for attenuated forms and thick impastos through which he proclaimed he had become 'Classic,'" wrote the critic in *The New Yorker*.[1] James Thrall Soby had indicated in his catalog analysis that Dalí would henceforth be paying more attention to the conscious than to the subconscious mind. "If he does," the *New Yorker* critic pointed out, "he is fully equipped to become the twentieth century's leading academician."[2]

Dalí was not, however, planning to become a twentieth-century version of a pompier painter. For he was experiencing a crisis of displacement, a crisis of age. Even he must have realized after America went to war that it would be many years before he would be able to go back to his mineral landscape, which had, in a sense, become his religion. The shores of the Monterey peninsula only served to remind him of what he had lost and, for all he knew, lost forever. He was a Catalan without a homeland, married to a Russian, living in a country he despised—in his novel *Hidden Faces* he wrote of America: "Its fruit has no flavor, its women have no shame and its men are without honor!"[3] Dalí was homesick, and in being homesick he began to return to the certainties of his childhood, among which was the simple Catholicism of his mother. Thirty years later, he told Max Aub:

> I am sure the Catholic religion is almost the best of all and that the soul is immortal and all that sort of thing. I know it theoretically, but I lack faith or, maybe basically, doubt. I'm almost sure that afterward there'll be nothing—and this comes from my atheist upbringing by my parents and from my anarchist culture and so on. . . . In spite of that, when the time comes I'll do what has to be done as if it were true.[4]

Some sort of internal subsidence was imperceptibly changing Dalí's personality; spiritual fissures were beginning to exaggerate his ever-present cruelty, his ironic streak. He became self-indulgent, if not indolent. He was now entering his middle years, a time when mortality is no longer an abstraction but a distant reality, and he began to be frightened of his own death.

> Maybe if I now believed . . . I'd begin to tremble like a leaf and get terribly frightened. I'm always sure that at the end it will be sorted out, or faith will come and everything will be arranged, or they'll prolong life for fifty years, or hibernation. . . . I cannot admit the total disappearance of my person.[5]

Being a man of incredible energy when it came to mining his own introspections, his own fears, Dalí started to explore his new direction

in paint; *Resurrection of the Flesh,* started in 1940, was not finished until 1945. "Here we see Toledo," Dalí told Robert Descharnes, with whom in the latter part of his life he spent many hours analyzing his paintings.

> *The Church of the Capuchins on the day of the Resurrection of the Flesh. All the people buried here come to life again. On the left side in the foreground one sees a Spanish prince, the other figures are beggars, monks and guards condemned by the Holy Inquisition. It is a kind of Doomsday in which gold, power, thought, love and death are all brought up for judgment before life.*[6]

Dalí returned to this picture time and time again; it became for him a diary of his attitude toward the war. The Germans were parading through Paris when Dalí started the picture, and leaving the city, defeated, when he signed it, "after having registered in it as in a seismograph all of the fever of those terrible years."[7]

Painted in monochrome, this painting reveals much about Dalí's state of mind. Toledo is an obvious reference to the days he spent in that city with Buñuel, Lorca, and his other friends of the Residencia as a member of Buñuel's Noble Order of Toledo. It is obvious that this painting is a bridge between his Surrealist period and the later religious phase. That Dalí worked on it, on and off, for five years suggests that it was a private piece, exploratory rather than commercial, and that he worked on it in the short intervals Gala allowed him between executing the many commissions that came his way.

These years in America saw a widening of the gulf in Dalí's work between the commercial and the exploratory, a time when he could still trot out his Surrealist lexicon and simultaneously establish the basis for his future philosophies. Dalí being Dalí, he found outlets for his creative energies in addition to painting commercial portraits; it is almost as if he were trying to avoid having to do "serious" painting, which might have led to unhappy introspection, by taking on a bewildering and sometimes incomprehensible series of other projects.

The first of these was to write his autobiography *The Secret Life.* When the Dalís were in residence at Hampton Manor, Caresse Crosby went to Reno to study animal husbandry at the University of Nevada

and secure her divorce from Selbert Young. She left Henry Miller refining *Tropic of Cancer* on one side of the house and Dalí painting in the library. On her return from her eight-week course, sometime at the beginning of 1941, she found Dalí in a sea of closely scrawled yellow sheets in the library, and Henry Miller surrounded by rather dainty watercolors and busily at work on another on an easel, specially borrowed for the purpose, in his bedroom.

Henry Miller's watercolors have not survived, but *The Secret Life of Salvador Dalí* has. When it was published in 1942, it immediately attracted severe criticism. Malcolm Cowley, writing in *The New Republic* in January 1943, said that in a hundred years it would be "evidence of the collapse of Western Europe" and not merely a "military disaster." To Clifton Fadiman of *The New Yorker* it was a "grinning nightmare of a book," and Dalí was "a bad boy, and if you think bad boys should not be permitted to write their memoirs, you had better not poke your nose into *The Secret Life.*"[8] No man in our time, not even Hitler, had exploited his paranoia with greater efficiency, Fadiman concluded.

But it was George Orwell, in his essay "Benefit of Clergy: Some Notes on Salvador Dalí," who criticized *The Secret Life,* and Dalí himself, in terms so strong that "Benefit of Clergy" was held to be obscene and defamatory. Originally meant to be published in the *Saturday Book* of 1944, it was cut out of the edition before distribution and did not appear in print until 1946. Orwell must be taken seriously. Having spent many months in Catalonia fighting with the leftist POUM at the beginning of the Civil War, he knew and understood Catalonia and the Catalans, their exuberant irony, and their love for hyperbolic and energetic bad taste. On the other hand, his left-wing stance and his puritan outlook colored his view of Dalí:

> *Autobiography is only to be trusted when it reveals something disgraceful. A man who gives a good account of himself is probably lying since any life when viewed from the inside is simply a series of defeats. . . . Not merely the humiliation but the persistent ordinariness of everyday life has been cut out. . . . His autobiography is simply a strip-tease act conducted in pink limelight. But as a record of fantasy, of the perversion of instinct that has been made possible by the machine age, it has great value.*[9]

He then analyzes certain episodes in Dalí's book as clues, and concludes that "he seems to have as good an outfit of perversions as anyone could wish for."

> If it were possible for a book to give a physical stink off its pages, this one would. . . . But against this has to be set the fact that Dalí is a draughtsman of very exceptional gifts. . . . He is an exhibitionist and a careerist, but he is not a fraud.[10]

Orwell sees in *The Secret Life* a direct and unmistakable assault on sanity and decency, even on life itself. He tells us that Dalí is "as antisocial as a flea. Clearly, such people are undesirable, and a society in which they can flourish has something wrong with it."[11]

Orwell concludes that every new talent is either crushed or exempt from the moral laws that are binding on ordinary people and that, as yet, there is no middle way between these two extremes. "Just pronounce the magic word 'Art' and everything is OK. So long as you paint well enough to pass the test, all shall be forgiven you."[12]

What Dalí clearly needed, according to Orwell, was diagnosis.

> The question is not so much what he is as why he is like that. . . . He is a symptom of the world's illness. . . . Neither ought one to pretend, in the name of "detachment," that such pictures as "Mannequin Rotting in a Taxicab" are morally neutral. They are diseased and disgusting and any investigation ought to start out from that fact.[13]

The Secret Life is not an autobiography; it is the culmination of twenty years' work by Dalí reinventing the events and relationships of his childhood and adolescence in order to exorcise the truth, with which he would never be able to deal, and thereby refining his own myth to the point where it became a permanent mask, a permanent work of performance art.

As Oscar Wilde wrote in "The Decay of Lying," "This unfortunate aphorism about Art holding the mirror up to nature is deliberately said by Hamlet in order to convince the bystanders of his absolute insanity in all art matters." If, in other words, art is the mirror, then we look into that mirror and see a mask. "Life is the mirror and art the reality," Wilde concluded.

Dalí, too, understood this. He would quote the line from Descartes —*"Larvatus prodeo"* ("I advance masked")—on the title page of *Hidden Faces*, in the body of which is included the following poem by Calderón de la Barca:

En este mundo traidor	*In this treacherous world*
Nada es verdad ni mentira	*Nothing is the truth, nor a lie*
Todo es según el color	*Everything depends on the color*
Del cristal con que se mira.	*Of the crystal in which one perceives it.*

In *The Secret Life* and *Hidden Faces*, Dalí chooses the color of the crystal. We can see his life only as he chooses to let us see it. Eventually, he forbade any other version. He refused to cooperate with any other biographer.

Yeats told Oscar Wilde that he envied those men who become mythological while still living, to which Wilde replied, "I think a man should invent his own myth,"[14] which is exactly what Dalí did. Consciously, he set down in words the version of his life he wanted known. He even tried to stop publication of his diary. In it he came across as a normal adolescent in a small Catalan town surrounded by a loving and equally normal family. In *The Secret Life,* he deliberately re-creates his life as a work of art. He looks in the mirror and he describes the mask, not the face.

Reality does, however, obtrude, but so enmeshed is it with surreality that only by very careful textual analysis can Dalí's lapses into truth become apparent. All through the book, the descriptions of Cadaqués and its inhabitants, for example, ring true. His first visit to Paris, however, described in the book as a triumph, was in fact a period of terror and misery—and his homesickness breaks through the obscuring prose. There are great set pieces, particularly his first meeting with Gala, which as an account of a curious courtship is perhaps unrivaled in contemporary literature. The anointing of himself with goats' dung, the pearl necklace, the inverted dandyism, are extremely funny as well as ludicrous. Dalí could not admit to ordinary emotion or an ordinary reaction to what was, after all, the far from unusual pursuit of a male innocent by an experienced and cunning woman.

The book gave James Thurber some richly humorous possibilities,

which he was not slow to take advantage of in a piece in *The New Yorker* of February 27, 1943, entitled "The Secret Life of James Thurber." He wrote that he had to be the first to admit that the naked truth about himself

> *is to the naked truth about Salvador Dalí as an old ukulele in the attic is to a piano in a tree and I mean a piano with breasts.*
>
> *Señor Dalí has the jump on me from the beginning. He remembers and describes in detail what it was like in the womb. My own earliest memory is of accompanying my father to a polling booth in Columbus, Ohio, where he voted for William McKinley. . . . What Salvie had that the rest of us kids didn't was the perfect scenery, characters and costumes for his desperate little rebellion against the clean, the conventional, and the comfortable. He put perfume on his hair (which would have cost him his life in, say, Bayonne, N. J., or Youngstown, Ohio) . . .[15]*

Meanwhile, André Breton's anagram for Salvador Dalí—"Avida Dollars"—caused the painter much amusement. In the first issue of *Arson*, the magazine he had founded in New York, Breton wrote:

> *The rustle of paper money, illuminated by the light of the moon and the setting sun, has led the squeaking patent-leather shoes along the corridors of Palladio into that soft-lit territory of Neo-Romanticism and the Waldorf Astoria. There in the expensive atmosphere of* Town and Country, *that megalomania, so long passed off as a* paranoiac *intellect, can puff up and hunt its sensational publicity in the blackness of the headlines and the stupidity of the cocktail lounges.[16]*

In *The Secret Life,* Dalí described Luis Buñuel as an atheist, "an accusation that at the time was worse than being called a communist," Buñuel would comment in his autobiography.[17] Although Buñuel did not know it at the time, a man named Prendergast, a member of the Catholic lobby in Washington, subsequently began using his influence to try and get Buñuel fired from his job at the Museum of Modern Art. Buñuel carried on, unaware, until the publication of a hostile article about him in the *Motion Picture Herald*. Alfred Barr advised him not to give in, but he decided to resign from the museum anyway and found himself virtually unemployable at the age of forty-three.

After his resignation, Buñuel made an appointment to meet Dalí in

the bar of the Sherry Netherland Hotel. They ordered champagne, and Buñuel began to berate Dalí. "He was a bastard, I told him, a *salaud*, his book had ruined my career."[18] Dalí's answer was typical: "The book has nothing to do with you, I wrote it to make *myself* a star." Soothed by liberal helpings of champagne, they parted without coming to blows, but the rupture was final—Buñuel was to see Dalí only once more, and he and many of their mutual friends from the Residencia and the remnants of the Surrealist group now living in America never forgave Dalí.

If *The Secret Life* is a work of fiction interspersed with small bouts of reality, *Hidden Faces* (which Dalí wrote two years after *The Secret Life* appeared) is a novel containing a great deal of autobiography.

The Dalinian reality is easier to spot in the novel, which owes a debt to Dalí's admiration for the decadents—Huysmans, Lautréamont, Wilde, De Sade, and Villiers de l'Isle-Adam—but is also a further example of how he turned his life into art—whether it be a painting, a novel, or, ultimately, a work of performance art. *Hidden Faces* tells the story of Paris high society and of a group of lovers in the interwar period, and describes the effect that the war has on their lives, their relationships, their loves, and their morality. Dalí's translator, Haakon Chevalier, maintained that the novel deals with the Tristan and Isolde myth, but this is difficult to locate amid the numerous mistaken identities, pairings-off, and unhappy love affairs.

To Dalí, *Hidden Faces* was "an anagram sealed in the fire of his personality and in the blood of his wife," and he admitted that those who read attentively both his autobiography and his novel would discover beneath their structure the familiar presence of the essential myths of his own life.[19]

We first meet the group of decadent French aristocrats and American millionairesses in Paris, "in society," in about 1936. The book, therefore, is set in the time when Dalí was in limbo; he could not go back to Spain, missed it desperately, and turned his attention more and more toward America, where the latter half of the novel is set, mainly in the Palm Springs home of the Marqués de Cuevas. Paris—the modernity and avant-gardism it represented—and Parisian society, once so needed, once so necessary, once so courted, were, by 1936, as

familiar and despised by Dalí as a love affair that has ended out of boredom:

> *The fog of Paris disgusts me even more than that of London. . . . Here people talk too much and too well about everything. You become monstrously intelligent, everything gets mixed up—the ugly seems beautiful, criminals are saints or sick people, the sick are geniuses! . . . In the pitiless light of Spain it's different . . . there is no more Paris, no more Surrealism, no more anguish. . . . All your fears, all your remorse, all your theories and laziness, all the contradictions of your thought and all the dissatisfactions accumulated by your doubts disappear. . . .*[20]

The aristocrats who had supported him in the early 1930s are now depicted as unfeeling poseurs with too much money and rancidly unsatisfactory sex lives. These leaders of society are obsessed by one another's clothes, by interior decoration, and by whether they have been invited to smart society balls. Real people, such as Christian Bérard, the disheveled, bearded painter and fashion illustrator, are interspersed with fictionalized characters:

> *Bérard waved a sheet of white paper . . . the list. "But, my dear," [says the Comte de Grandsailles,] "you know perfectly well that it isn't the guests that count on such occasions. . . . One gives balls for those one doesn't invite." . . .*[21]
> *. . . The group [of pederasts and smart women] were in the middle of debating the following question. "What do women prefer, men 'to go out with' or 'men to go home with'?" One woman said: "Why, to go out with, of course!" Another broke in, amid acclamations from the pederasts: "I like a man to go out with and a woman to go home with." Another one said: "With me it's just the opposite, I like a woman to go out with and two men to go home with."*
> *"Why not all six, like the Greek courtesans?"*
> *"Ah, that's the temperamental kind," sighed Cécile Goudreau. . . . "We in Auvergne in the country achieve the same result with two hard boiled eggs and a guitar string."*[22]

Just such a conversation might have taken place after dinner during a house party at the Serts' Mas Juny or at Chanel's La Pausa or at the Noailles' villa at Hyères.

Almost every sexual deviation is a matter of normality in *Hidden Faces*. There are lesbian seduction scenes, there is some—but not much—heterosexual sex, which never seems to satisfy, and at the center of the book there is "Cledalism," the art of the voyeuristic orgasm. Dalí explained Cledalism in the foreword to the novel:

Since the eighteenth century the passional trilogy inaugurated by the divine Marquis de Sade had remained incomplete: Sadism, Masochism . . . It was necessary to invent the third term of the problem, that of synthesis and sublimation: Cledalism derived from the name of the protagonist of my novel, Solange de Cléda. Sadism may be defined as pleasure experienced through pain inflicted on the object, masochism as pleasure experienced through pain submitted to by the object. Cledalism is pleasure and pain sublimated in an all-transcending identification with the object.[23]

The hero is the Comte de Grandsailles, loosely modeled on Comte Etienne de Beaumont with touches of the Vicomte de Noailles and Arturo López-Wilshaw. Grandsailles also has touches of Des Esseintes in Huysman's *A Rebours* and of Henry Wotton in Wilde's *The Picture of Dorian Gray*, for good measure. The heroine, the ill-starred Solange de Cléda, is a combination of Bettina Bergery, Caresse Crosby, and Marie-Laure de Noailles. "With her sun-tanned complexion, so sculptural and adorned with diamond necklaces and cascades of satin, she so completely personified Parisian actuality that it was as if one of the fountains of the Place de la Concorde has just broken into the room."[24]

The opium-smoking Cécile Goudreau is a thinly disguised portrait of Coco Chanel—he gives the game away when he has her mention the Auvergne, Chanel's birthplace. Dalí describes her irresistibly:

She had the face of a bird that looked like a cat, and the body of a cat that looked like a bird. . . . What was catlike about her was the fixed green gaze and the masculine cynicism of her pointed teeth . . . a kind of Balzacian character, intelligent, déclassée, having become a real Parisian institution by dint of intrigues.[25]

The time-wasting *ennuyée* Barbara Stevens, an American millionairess whose idea of a strenuous morning is to walk from the Ritz, where

she lives, to Schiaparelli next door in the place Vendôme and back again, is Daisy Fellowes, heiress to the Singer sewing-machine fortune and a part-time fashion editor at *Vogue*. Dalí is particularly amusing about the stratagems such idle women employ to fill their days: a complicated cat's cradle of canceled appointments, lateness, cocktail parties.

> *Like many weak creatures chained to their absolute caprice, she felt free and at ease only when she could arbitrarily abolish the cares and obstacles with which she had purposely strewn her way the day before.*[26]

Too often had Dalí been the victim of such games, too often had Gala been kept waiting while she was trying to sell pictures or ideas. Now Dalí exacted his revenge for those slights of the early 1930s, which neither he nor Gala would ever forget or forgive.

It is when we come to Veronica, Barbara Stevens's daughter, and the Polish refugee Betka, who becomes her pensioner and then her lover, that we approach the nearest we will ever come to the truth about the relationship between Dalí and Gala.

> *Veronica bewitched her friend by the unbridled galloping of the thousand-and-one nights of her fantasy with which she would eventually enchain her friend's wonder-starved spirit. It was a kind of delirious fairy-tale with just two fairies: the two of them.*[27]

Veronica is Dalí himself, and he put into her mouth many things that were deeply and painfully relevant to his own life: His relationship with his mother, about which he is idealistic in *The Secret Life*, here assumes a very much more sinister note as he describes how Barbara Stevens takes her daughter to bed with her when she cannot sleep or is unhappy.

Dalí's subconscious breaks the surface and emerges into print time and time again, most noticeably when he discusses Veronica's relationship with Dr. Alcan, the psychiatrist. The anagram (Jacques Lacan was the young psychiatrist Dalí had known in Paris in the early thirties) is obvious; what follows is revealing in the extreme:

She wanted two things of him [Alcan]. Help in recovering her moral equilibrium and connections through whom she might gain admission to a hospital. . . . Veronica herself knew too much about psychoanalysis to be the dupe of her natural and inevitable tendency to "transference" and was able to limit her need to see him constantly, sometimes twice a day, to a simple faithful friendship, a friendship, however, to which she knew she would be obliged to give a good deal of herself, perhaps even too much, as soon as the doctor should require it.

Everything that she had been dying to tell, but had never been able to tell Betka, whom she adored and whom she was almost ready to hate because of this, she could and even had to tell now to Alcan.[28]

Dalí's father makes an appearance as the Comte de Grandsailles's faithful notary. "We notaries should really keep away during these pleasurable moments," Dalí has him say—perhaps Dalí's father really did say it—"and appear only at the historic hour, at ten o'clock in the morning, to announce either ruin or fortune."

Picasso, Dalí's other father figure, from whom he had become estranged as a result of their diametrically opposed reactions to the Civil War, is also an irresistible target:

Barbara dragged herself aimlessly about the room, enjoyed its silence which a while ago made her nerves feel raw, and was even prepared to feel indulgent about the large Cubist painting of Harlequin by Picasso which she had had to buy so much against her will. "You know," she said, "what reminded me of my dinner? You'll never guess—the Picasso! Exactly the same colour as Mrs. Reynolds's hat, the one she was wearing the day she invited me as we crossed downstairs in the lobby; that same blue, and that same flame-red."[29]

Dalí portrays himself also as he must have been when he first came to Paris—as Soler the Catalonian, "in a state of constant agitation, spilling his Martini, burning himself on his cigarette, dragging the armchairs about and being of service to everyone; what a 'specimen' he was—he did ultra-sophisticated fashion photographs, claimed to have invented a new religion and made leather helmets for automobile drivers by hand!"[30]

In the introduction to *Hidden Faces*, Dalí poses the understandable question: "Why did I write this novel?" To which he answers:

First because I have time to do everything I want to do, and I wanted to write it.

Second, because contemporary history offers a unique framework for a novel dealing with the development and the conflicts of great human passions and because the story of the war and more particularly of the poignant post-war period [he meant post–World War I] had to be written.[31]

Naturally, this novel attracted a great deal of highly critical attention when it appeared in May 1944, notably from Edmund Wilson, writing in *The New Yorker*, who said that it was one of the most old-fashioned novels anyone had written in years, consisting as it did "of a potpourri of the properties, the figures and the attitudes of the later and gamier phases of French romantic writing."[32] Wilson also said that the descriptions of the balls and banquets would take the English reader back to Disraeli, Bulwer-Lytton, and Ouida, so it was surprising to suddenly hear about Hitler. At the end of his very long review, Wilson concluded that Dalí's

literary models have been bad ones, and, from the moment he abandoned his real métier, they have swept him into a retrogression that affords one of the most curious examples of the contemporary stoppages and lapse of the arts in collision with the political crisis.[33]

Orwell, too, in his review of *The Secret Life*, notes the "Edwardianisms" in the drawings in the book.

Take away the skulls, ants, lobsters, telephones and other paraphernalia and every now and again you are back in the world of Barrie, Rackham, Dunsany and Where the Rainbow Ends. . . . *Perhaps Dalí can't help drawing that kind of thing, because it is to that period and that style of drawing that he really belongs.*[34]

Dalí had, of course, still been painting during his years in America, but in the main he had worked to commission, and painted portraits of society women such as Mona Harrison Williams, Dorothy Spreckels, and anyone else who would pay his very high prices. There was a good reason for this; his big pictures were not selling, and, as he

admitted to Edward James, he did not want to paint a big picture unless the sale of it was already guaranteed. The portraits were all guaranteed.

In April 1943, at the Knoedler Gallery he showed an exhibition of these portraits under the title "American Personalities." It included his masterly portrait of Princess Artchil Gourielli, better known as Helena Rubinstein. Helena Rubinstein had been painted as a witch by Pavel Tchelitchev, as a flowery *jolie laide* by Raoul Dufy, as an Indian maharani by Marie Laurencin. Bérard had depicted her in a white smock clutching her son Horace to her ample bosom. She liked having her portrait painted, but it was also very good for her image as the world's leading beauty queen.

She was a worthy subject for Dalí, as forthright in her way as Marie-Laure de Noailles had been in hers, and as singular in her looks. Dalí's response to this forcefulness was to paint her as a latter-day Prometheus, chained to Cap de Creus by her ropes of unpolished emeralds. "He felt I was bound by my possessions, which is very far from the truth,"[35] said Madame Rubinstein.

Of all the society portraits painted by Dalí at the time, the Rubinstein is the most penetrating, harking back as it does to his earlier, purer, Surrealist work. Dalí himself believed that he was recognized as a portrait painter in America only after he painted this portrait—or so he told Madame Rubinstein. He was obviously making sure that his enormously rich subject, who prided herself on her patronage, would commission other works, as indeed she did.

The reason for the success of the portrait is that Dalí was interested by this complex woman. He had known her for years before he painted her; they had probably met in Paris in the early 1930s. She certainly knew everyone he knew in prewar Paris. There were even closer connections; when Madame Rubinstein had first started to make a great deal of money before World War I, she had been taken up by the ubiquitous Misia Sert, then Madame Thadée Nathanson, wife of the publisher of the prestigious magazine *La Revue Blanche*.

Misia had taken up this "Madame" who wanted to be "different," not just another beautician who had the money to become a patron of the arts. Misia had introduced her to Mallarmé, Renoir, Vuillard, Dufy, and Proust, who once interrogated Madame Rubinstein about how she thought a duchess would apply makeup.

Later, Misia had taken up Coco Chanel and put her through the same rigorous cultural course. "In 1919 I woke up famous," Chanel once told Dalí, "and with a new friend who was to give its full meaning to my success."[36] Dalí too knew and admired Misia Sert's taste without ever becoming close to her (Gala would not have allowed it), and in Madame Rubinstein he met yet another product of Sert's "finishing school."

In New York, Madame Rubinstein received Dalí in her bedroom, lolling on her famous Perspex bed, and wiped her nose on her silk satin sheets. Dalí loved her and sat quietly as she told him of her life. Modigliani was "nice but not clean," Matisse "a rug pedlar" because he bargained too sharply. Hemingway was "a big mouth with filed teeth," Joyce "nearsighted and smelling bad." D. H. Lawrence was "timid and dominated by women." She summed up Proust as "a little Jew in a fur coat smelling of mothballs."[37]

Madame Rubinstein had bought a thirty-six-room triplex apartment on Park Avenue, and she and Dalí met frequently at the end of 1942 to discuss three panels that she had commissioned him to paint for her dining room. History does not relate what she felt about Dalí. But he was certainly very amused by her, paying her the highest accolade: She was "Dalinian," but she needed the paranoiac-critical method to round her out. She became Dalí's replacement for Chanel—the two women were, after all, similar characters with similar aims; and they both liked to indulge in endless reminiscences.

The three panels depicted "Morning," "Noon," and "Night," and were painted in Dalí's Surrealist manner. On the evening the panels were first shown, one of Helena Rubinstein's guests asked Dalí whether they had any hidden meaning. "The whole thing is an allegory of life," Dalí explained. "It is for the viewer to decipher. If no meaning is found, then there is none."[38] There is almost a trompe l'oeil effect about the carved window cases in two of the murals, through which the spectator can see a simplified version of the Empordàn landscape.

When the murals were finished, Dalí turned his attention toward the card room, suggesting that it be turned into a music room. "I will design a fountain spouting from a grand piano. It will hang from the ceiling and never be played, that is the essence of Surrealism."[39] Madame Rubinstein declined his offer.

* * *

Dalí's life had now settled into a routine that echoed his life in prewar Europe. The spring and autumn would be spent in New York, and the winter and summer in the Del Monte Lodge Hotel, painting. Dalí had acquired a studio, part of a neighboring estate built in the Spanish missionary style, and here he worked on his commissions, and inter-mittently on *Resurrection of the Flesh*.

Dalí and Gala led a self-contained, lonely life in Monterey. He had no one with whom to discuss painting except Gala, whose conversa-tion about his work always tended to be critical rather than discursive. Worse still, he was virtually cut off from any intellectual conversation that might have stimulated him into developing new ideas. He and Gala were living in limbo. They did not know that Gala's mother and surviving siblings were under siege in Leningrad. Neither did they know that, in Paris, Eluard was eking out a miserable and dangerous existence under the occupation, trying to keep what remained in Dalí and Gala's flat intact from marauding Germans. Nor had they heard that Cécile's husband, Luc Decaunes, had been imprisoned by the Germans and that she was living in the Dalís' flat surrounded by paintings that Gala had not managed to ship south, some of which Cécile sold for food—the cause of her later complete estrangement from her mother.

Gala was bored and disgruntled, and spent a great deal of her time driving up and down the coast in a huge Cadillac or plotting how to make more money out of Dalí, whom she kept a virtual prisoner during these months of work.

One friend from the interwar years did, however, manage to keep in touch. Edward James had settled in California in about 1941 and spent most of the war in Los Angeles, where he had become involved with the Vedanta movement, led by Gerald Heard. Dalí and Gala were dismissive and contemptuous, and caused James much heart search-ing. Several telegrams passed between them in 1942 as James at-tempted to see them, or asked when, for instance, the Rubinstein panels were to be put up, so that he might be there. They continually put him off. Finally, he wrote them a curt letter, after which he was

grudgingly invited to spend a week at the Del Monte with them in the spring of 1943.

This must have been a successful reunion, at least as far as business was concerned, for in a letter James wrote that July to his lawyer in New York, it becomes apparent that Dalí and he had struck a new deal, whereby Dalí would exchange six pictures, five of which he was to paint, the sixth being the *Cesta de Pan,* for James's house on Culross Street, in Mayfair. In this letter, James questions how much these paintings might be worth, as the value of the house had increased, he asserts, and he could sell it any day for cash, "which Dalí admits he cannot do with his big pictures."

The exchange never went through, and Dalí did not get his house in London. By November 1943, matters had again deteriorated to the point where James wrote a very long letter to the New York office of his accountants, Peat, Marwick, Mitchell, on the subject of his prewar contract with Dalí and the pictures that were, as far as he knew, still in the framers on the rue du Cherche-Midi. He believed he had "a case of negligence against Mr. Dalí for having failed to fulfil the terms of the contract. . . ."[40]

What did happen to the pictures? They were shipped from occupied Paris to Bordeaux and were awaiting dispatch in a hangar at the Bordeaux airport when the Germans, under Einsatzstab Rosenberg, had them sequestered in December 1940; with typical German thoroughness Rosenberg had, on December 3, issued a receipt for "two packing cases" to the French customs and shipped them off to Germany. After the war, sustained efforts were made to recover the pictures, only two of which have been found. The fate of the others would, in any case, have been difficult to determine because there was no catalog or manifest of them. Only by piecing together the whereabouts of all the pictures painted during the time Dalí was under contract to James can the loss of a large number of pictures from this period be estimated.

The continuing grievance represented by these pictures distanced Dalí and James even more during the latter part of the war. But the rift was due to more than the loss of the pictures; their relationship had been so dislocated by its removal from Paris to California that they really had very little in common anymore. The Vedanta movement and, subsequently, the idea of establishing a foundation at West Dean

occupied much of James's energies, and these preoccupations, coupled with James's enormous difficulty getting any money at all out of England, precluded him from supporting Dalí or buying any more paintings from him. There was also the lingering (and correct) suspicion that Gala had sold pictures on the side in defiance of the contract.

Dalí's pictures were not selling during this early part of the war; no modern art was. The war and the war economy put a temporary end to business in the art world, and had it not been for his portraits and commissions, Dalí and Gala would have been very hard up.

However, a patron who would be of inestimable importance in the years ahead suddenly appeared, as if from nowhere.

Far from being a member of the European aristocracy on the lookout for a perverse or fashionable Surrealistic thrill, Reynolds Morse, a Coloradan by birth, an inventor and a shrewd businessman, was by nature a born collector, by inclination a patron. He and his wife, Eleanor, had become collectors in the mid-1930s. They did not confine their collecting to Surrealism. "We had a huge collection of the Western painter Charles Patridge Adams—we liked his realism and technique," Morse recalls.[41] This has now been given to the Denver Public Library. In the course of forty-five years, Reynolds Morse has formed the largest collection of Dalí's work in the world, together with an extraordinary reference library, all housed in a specially built museum in Florida.

Reynolds Morse already owned a de Chirico, a Tanguy, and a Magritte in 1943, and knew of Dalí because a friend owned two (which Morse subsequently bought). "We discovered that it wasn't difficult to find really good Dalís at the time. There were a great many of them that had not sold—some pictures sat in New York for four or five years. . . . I saw the picture of *Daddy Long Legs of the Evening—Hope!* in *The Secret Life,* and found out where it was and went to New York to see it. It was a sublime moment."[42]

The purchase of *Daddy Long Legs* was made in the spring of 1943. That winter, when they returned to New York for their annual round of gallery visiting, the Morses made an appointment to meet Dalí and Gala for a drink in the King Cole Room in the St. Regis, then and for the rest of his life Dalí's preferred meeting place. The meeting went well. "Dalí talked excitedly about his painting and drew a skull on a

napkin while he talked," Reynolds Morse remembers. "When we left, Eleanor said, 'Where is that little thing he did?' The drawing had disappeared, Gala had taken it."[43]

Dalí liked the Morses, probably because he felt they were buying his pictures not as an investment or because they were impressed by his fame but because they really liked and understood them. Their support and encouragement came at the right time for Dalí, now that interest in his Surrealist pictures had waned and new ideas were necessary.

The Morses were impressed by Dalí and subsequently purchased the painting *Average Atmospherocephalic Bureaucrat in the Act of Milking a Cranial Harp,* which they bought directly from Gala. "We paid eight hundred fifty dollars, which is what she wanted for it. The title will go down in history, the picture is worth the price for the title alone," says Morse.[44] From the Knoedler show in April 1943 they bought a watercolor entitled *The Madonna of the Birds.* They began to grow closer to Dalí, if not to Gala, and eventually they were accorded the status of privileged patrons.

Every season they would journey to New York to help the Dalís hang their new show, and this special vernissage was always followed by dinner, during which Gala would discuss which picture from the show she felt they should acquire. Sometimes the Morses agreed with her, sometimes they did not. It took five years, and a great deal of coercion on Gala's part, to persuade the Morses to buy *The Ram.*

The Morses continued to buy the work of other painters—"three or four Magrittes, de Chiricos, a Tanguy, a Miró; by the mid-1940s we had maybe five to ten pictures by these other Surrealists which cost us about five hundred dollars up." These other purchases always irritated Gala, who did not like anybody else selling to the Morses. "She had to be tough, but Dalí always used to say to us when he had heard we had bought from someone else: 'Don't make us too poor. The little stuff is OK, but not too much.' "[45]

In 1944, the Morses bought from Dalí's first exhibition at George Keller's Bignou Gallery. Dalí had had to change dealers because Julien Levy had closed his gallery due to diminishing interest in avant-garde art. Keller was to be the last dealer the Dalís would ever work with. When Keller retired in 1948, Gala decided they would henceforth deal directly with museums and important collectors, such as the Morses

and Chester Dale. It was a fateful decision, leaving Gala on her own in financial matters, which, as she grew older, became more and more muddled; Dalí was left open to the dealings of unscrupulous middlemen.

Morse was a careful collector and a staunch ally, especially during the years after the war, when Dalí's paintings fell out of favor with the American art establishment. But the Morses remained faithful and bought one or two pictures a year from the Dalís. Once Dalí had reestablished himself in Spain in the early 1950s, the Morses followed him to his native land, largely in order to understand the influences that had shaped his work.

In the lean American years, Dalí turned to another patron who was only too willing to give him an outlet for his creativity: the Marqués de Cuevas. The Marqués had plenty of money in America, which he was keen to spend on adventurous ballets for his new company, Ballet International.

Dalí was to design the sets for Antony Tudor's proposed production of *Romeo and Juliet,* but familiar rows over interpretation intervened.

> *Nothing seems to me less "pastoral" than Shakespeare, and* Romeo and Juliet *in particular strikes me as not at all pastoral. . . . Apart from the scene of the balcony . . . nearly all the rest of the play is filled with violence, street fights, the violent hatred of the rival families, death and necrophillic [sic] sentiments far from veiled; I don't see any sheep or shepherds anywhere. . . . You also say that nothing I do for this ballet must be such that it could be interpreted . . . as possibly Surrealistic. . . . I am no longer interested in the Surrealist movement, nor mere Surrealism; but fortunately everything I do is 100 percent Dalí.*[46]

In 1944, Dalí did, however, design the costumes and scenery for three ballets; and in October that year *Sentimental Colloquy* was produced in New York. The Marqués de Cuevas approached Paul Bowles, then known as a composer rather than as a writer, to do the music, and Dalí to design the sets.

Bowles had met Dalí and Gala at a dinner the year before and had not been impressed:

It was very formal and so dark in the candlelighted room that when the butler set the salad bowl down near Dalí before tossing the salad, Dalí gazed over the twilit surface of the top lettuce leaves and said that he was reminded of Switzerland. Then he told a story about a small girl lost in a blizzard in the Alps. When she was more dead than alive, a fine St. Bernard arrived with a keg of brandy around his neck. The dog then attacked her and ate her. "C'est beau," [Dalí] added, looking at the salad bowl as though the story were still glowing there in the air above it.

Gala had adopted fantasy for the evening. No matter what the general conversation was about, she brilliantly brought it back to the idée fixe she had chosen, which was that I must buy a large aviary and shut her into it and then come and scatter food to her and whistle at her. "Je veux être votre perroquet," she told me, fixing me with her startlingly shrewd eyes.[47]

Sentimental Colloquy was based on Verlaine's poem of the same name, which begins *"Dans le vieux parc, solitaire et glacé . . ."* The choreography was by André Eglevsky. Bowles had composed the music without seeing Dalí's designs and had not attended dance rehearsals, so the dress rehearsal came as a revelation to him, and not a pleasant one:

My heart sank as I saw the stage and what was happening on it. Eglevsky and Marie-Jeanne came on sporting underarm hair, great hanks of it that reached to the floor. There were men with yard-long beards riding bicycles at random across the stage, and there was a large mechanical tortoise encrusted with coloured lights. . . . The Marqués had assured me repeatedly that this ballet would have none of the usual Dalí capers; it was to be the essence of Verlaine, nothing more. I had been royally duped. . . . He [Dalí] was sitting directly in front of me with Gala watching the rehearsal. All at once he swung around and said: "Vous auriez dû être ici hier soir. Merde, c'était beau! J'ai pleuré." I wanted to reply, "Ce soir c'est mon tour." Instead, I smiled vacuously and said, "Vraiment."[48]

According to Bowles, the hisses began as soon as the curtain rose on opening night.

Undaunted, the Marqués staged Dalí's *Tristan Fou* on December 15, 1944, set to Wagner's music and with choreography by Massine. This

was accorded a better reception, partly because the sets were in Dalí's new classicizing approach to his painting.

Another outlet for Dalí's abundant creative energies and his need for money manifested itself in the mid-1940s; he was asked to devise the dream sequences for Alfred Hitchcock's film *Spellbound*. Taken from a book by Francis Beeding entitled *The House of Dr. Edwardes*, the film, starring Gregory Peck and Ingrid Bergman, told the story of a man without a name, an amnesiac victim who is convinced that he is a murderer. Ingrid Bergman played a psychiatrist, Dr. Constance Peterson, who falls in love with the amnesiac while she is treating him. Sure of his innocence, she sets out to restore his memory by psychoanalysis, meanwhile helping him avoid the police. Dalí's designs were to provide the visual illustration of an amnesiac's dreams in which were clues to his identity, as well as clues to the murder he may or may not have committed.

The ins and outs of Dalí's involvement with this project started with a telephone call from his movie agent Fe Fe (Felix Ferry), who, as Dalí later said, "ordered a nightmare from me by telephone. . . . The director, Hitchcock, told me the story of the film with an impressive passion, after which I accepted. Hitchcock is one of the rare personages I have met lately who has some mystery."[49]

Hitchcock described his motives during a BBC documentary on Dalí:

> I requested Dalí. [David] Selznick, the producer, had the impression I wanted Dalí for the publicity value; that wasn't it at all. What I was after was . . . the vividness of dreams. As you know, all Dalí's work is very solid and very sharp with long perspectives and black shadows. . . . Actually, I wanted the dream sequences to be shot on the back lot and not in the studio at all. I wanted them shot in the bright sunshine, so the cameraman would be forced to stop down and get a very hard image. This was again the avoidance of the cliché. . . . Dalí was the best man for me to do the dreams because that's what dreams should be. So that was the reason I had Dalí.[50]

The expense of hiring Dalí worried Selznick, prompting a telegram from Ferry on July 18, 1944:

Dear David: Please make up your mind and let's sign the Dalí contract. His name, his personality and his talent will be an asset to The House of Dr. Edwardes. *I know you won't have the heart to refuse my first deal.*[51]

Dalí insisted on remaining the owner of his dream-sequence sketches, amounting to about ten in all, which he wanted to exhibit the next autumn in London. This prompted a barrage of letters and telegrams from Selznick and his advisers. Eventually a contract was signed, in which the ownership was split down the middle. Dalí was to receive $4,000 on the satisfactory completion of the paintings to be used in the film.

Dalí arrived at the studio on August 30 for his first day shooting the dream sequence. Trouble blew up immediately:

I went to the Selznick studios to film the scene with the pianos and I was stupefied at seeing neither the pianos nor the cut silhouettes which must represent the dancers. But right then someone pointed out to me some tiny pianos in miniature hanging from the ceiling and about forty live dwarfs who, according to the experts, would give perfectly the effect of perspective that I desired. I thought I was dreaming.[52]

This scene was eventually eliminated, as neither Dalí nor Hitchcock liked the final effect.

The other sequences went off without much trouble, and Dalí was paid his $4,000. However, Selznick ordered reshoots, and the final version of *Spellbound,* while still featuring Dalí's sequences, differed from what had been planned in that the paintings were repainted for tonal values, and sections of them were made into three-dimensional constructions for the trick photography that was eventually used. Dalí summed up his experience in one notably Dalinian sentence: "Le best parts in Hitchcock que I likie he should keep, that much was cut."[53]

Meanwhile, Dalí's work on *Resurrection of the Flesh* proceeded quietly, without publicity, without pronouncements, as did his other great masterpiece of the time, his classical portrait of Gala, *"Galarina,"* which he started in 1944, from sketches and finished drawings he had made while staying at Hampton Manor. It took him over a year and

540 hours to paint. While painting it, Dalí later told Robert Descharnes, he thought of Raphael painting *La Fornarina*. Gala's bared breast represented to Dalí bread, a theme to which he was to return time and time again, but never with the absolute perfection, the classical purity, of this painting. It was preceded by an equally fine drawing, executed in 1943, in which Gala wears, in addition to the snake bracelet given to her by Edward James so long ago after the row in Modena, a baroque pendant. In the final painting this has been eliminated, but all else is the same. Gala's penetrating eyes could still, apparently, look through walls, and there is no mitigation of the harshness or self-possession of her expression. This is the best portrait Dalí ever did of Gala and possibly the most revealing of all the portraits he painted of her; it is both illusionistic and classical. She stares out of the canvas, cold, challenging, baring her breast not as an indication of sexuality but as a formal challenge to the onlooker—Dalí.

Their relationship was changing. Gala was now neither Egeria nor partner in whatever sexual games Dalí wished to play, but mother and jailer. Unable to deal with this situation, Dalí responded by elevating Gala to the status of a Madonna, so that it was unthinkable to touch her or even to think of her sexually.

Gala was, in the mid-1940s, becoming more overt in her pursuit of a separate sex life. Voyeurism had palled and she began to strike off on her own, leaving Dalí at work in his studio. She began with determination to pursue young men. In her mid-fifties, she was still good-looking, as supple as a young girl. But when she turned and showed her leathery, now face-lifted expression, she looked her age.

Jimmy Ernst, Max Ernst's son, tells the story of how he met Gala in New York sometime in the 1940s. He knew that she had split up his parents' marriage, but pressed into joining the Dalís on a shopping trip, he did not demur—after all, that had been twenty years before, when he was very small. But on the day proposed, Gala turned up alone, telling him that Dalí was indisposed. They spent the day going here and there in New York, aimlessly and without buying anything. Finally, they went to the Russian Tea Room, where Gala moved in for the kill:

> It was a constant encounter of knees, thighs and shins. Finally, Gala
> suggested that he come back to the hotel with her, whereupon Jimmy

Ernst stood up and left. When he next saw Gala, she walked up to him and shouted, "Tu es de la merde . . . monstre!"[54]

Gala was becoming more violent and greedier. She actually hit people who did not do what she wanted. She spat at them, she scored their faces with her rings. She had turned into a terrifying maenad.

In his early forties, Dalí was no longer the slim, beautiful, young Spaniard who could be so "adorable," so "funny and gay." He was already middle-aged; he had become plumper, less spiritual in his looks. In pictures taken of him at the time, his mustache has grown bigger and he is wearing suave pin-striped suits. He had matured. Gala liked only young men of about Paul Eluard's age when they met in Switzerland, or the age Dalí looked when she met him in Cadaqués. Dalí had become too old for her.

In his paintings Dalí dealt with this new phase in his relationship with Gala by desexing her and putting her beyond the reach of mere mortals. He would be able to turn a blind eye—even to encourage— her pursuit of ever-younger men. He would be loyal in the face of Gala's betrayal and eventual desertion, and he would come to terms with his loneliness. But he would be deeply and irreparably wounded by her. Henceforth their life together had a different balance. Dalí was there to work, to earn money, so that Gala could pursue her violent appetite for sex and her desire to preserve her youth. There was less affection, less reverence, less sympathy between them now. For Gala, there was an increasing, never to be satisfied demand for wealth, luxury, and independence. For Dalí, there was the prospect of spending the rest of his life in the prison he had always said he would make for himself.

11

MELANCHOLY, ATOMIC URANIC IDYLL
1945–1949

D alí and Gala had become accustomed to life in America. They substituted the Del Monte Lodge Hotel for Port Lligat, Hampton Manor for the Moulin du Soleil, the Marqués de Cuevas for Edward James. They were profoundly selfish and did not allow the war in Europe to disturb them too much, though Dalí designed a calendar in 1942 that was sold for the benefit of free France. He was not, however, immune to the philosophical opportunities the war offered him as a painter in terms of inspiration, as is plain from a short article he wrote for *Esquire* magazine, in which he described his double images as being similar to camouflage.

On March 18, 1945, Gala received the first news of Eluard in five years. Gala's apartment on the rue de l'Université had been saved but was due to be requisitioned. Eluard was reassuring: "We'll put anything fragile or valuable in the drawing room which we'll lock as well as the study, which is still tidy."[1] Fuel was nonexistent, he reported, and a recent snow had stayed on the ground for three weeks. This was hardly encouraging. Gala decided not to go back to Europe until things improved. She persuaded Dalí to stay put in America for the next three years. Even the news that Cécile was going to be married again, which came in a letter of November 1945, and the subsequent information early in 1946 that she was pregnant, failed to affect Dalí and Gala in their comfortable isolation in America.

And comfortable it was. They had now settled on the St. Regis as their permanent home in New York, to the point where Dalí had, in a gesture of solidarity with his lost world of the Empordà, placed a piece

of rock from Cap de Creus in one of the globes that lit the King Cole Room.[2] It stayed there for twenty years.

They made occasional forays to Hollywood, for Dalí had never abandoned the idea of making films, and he liked meeting the stars, on one occasion fulfilling a long-held ambition when he was introduced to Greta Garbo.

Dalí and Gala seemed to have few friends in these days. The people they saw were either patrons, and cultivated as such—under which heading would come the Marqués de Cuevas, Arturo López-Wilshaw, Helena Rubinstein, Reynolds and Eleanor Morse, Caresse Crosby—or an audience that waited for Dalí's next extravagance. Always solitary, preoccupied with his work and with developing his new philosophy of painting, Dalí obviously did not mind the vacuum in which he now found himself. He had the peace and quiet he needed to work.

A lengthy profile of Dalí by Winthrop Sargeant, published in *Script* magazine, gives an idea of the shape of Dalí's life in Monterey at the time. He and Gala rose early in their cottage at the Del Monte Lodge Hotel, which Sargeant described as being equipped with a nondescript supply of conventional furniture, and resembling nothing so much as a rather luxurious tourist cabin. After breakfast they would go for a walk on the beach; then Gala would drive Dalí the short distance to his studio, where a vine had crept in through a hole in the wall and was growing down inside. Here he would work all day on his paintings, or his ballets, or on his writing. It was a quiet, productive life. Dalí saved his histrionics for his winter visits to New York.

In the peace and quiet of Monterey in 1945, Dalí solved the problem of where next to take his painting: He reinvented Surrealism in the classic tradition. He returned once more to a familiar theme and painted *Basket of Bread*. This second version, now in the Teatro Museo Gala-Dalí, was painted early in 1945 and used as propaganda for the Marshall Plan. He later described this painting to Luis Romero as "the most esoteric and most Surrealist of anything I have painted to date."

William I. Nichols, who at that time edited *This Week* magazine (which had, at its height, a circulation of 15 million), broke with tradition and put *Basket of Bread* on the cover. The Dalís immediately enrolled the Nicholses in their roster of patrons to be cultivated. The Nicholses were not particularly impressed by the double act. They told Meryle Secrest that they admired Dalí's work, but felt he was very

opportunistic and a snob, and that his relationship with Gala resembled that between the Duke of Windsor and his formidable, dominating Duchess. (Dalí's cousin Montserrat Dalí y Bas would have agreed. In the 1950s she saw Gala and the Duchess talking together, and thought to herself: "It's amazing that two such ugly and determined women should have attracted two of the most famous men in the world."[3])

Three Apparitions of the Visage of Gala was painted at the time Dalí and Gala met the Nicholses, and depicts three rocks in the familiar Empordàn landscape, on which appears Gala's face. In these portraits Dalí depicts Gala as a classical muse with an unaccustomed softness to her expression. A portrait of Gala with her back turned, *My Wife Nude, Contemplating Her Own Flesh Becoming Stairs, Three Vertebrae of a Column, Sky and Architecture,* was still demonstrably Surrealist, but to the left of Gala is a stone wall in which is set a classical head. Gala is looking at a building that is also her own skeleton. Dalí later explained to Robert Descharnes that:

> When I was five years old I saw an insect that had been eaten by ants and of which nothing remained except the shell. Through the holes in its anatomy one could see the sky. Every time I wish to attain purity I look at the sky through the flesh.[4]

The atom-bomb attack on Hiroshima on August 6, 1945, was both a great shock to Dalí and a development in which he took an enormous interest. He began a series of paintings based on nuclear fission, on which he worked in parallel to his religious pictures. The first of these, *Melancholy, Atomic Uranic Idyll,* harked back, in the sense of some of the forms he used, to his Surrealist years, especially the head in the foreground, which is reminiscent of the form of the earlier *A Couple with Their Head in the Clouds,* but which here contains a bomber rather than clouds and sky. There is a soft watch in the painting that turns into a vulva form, eaten by ants; there are other hints of Dalí's past in the figure of a little boy and another soft watch draped on the head.

Dalí used the double-image device again in *The Three Sphinxes of Bikini,* in which the atomic explosion becomes three heads, one of which in turn becomes two trees; all are set in the Empordàn landscape. In *Apotheosis of Homer (Diurnal Dream of Gala),* he sought to

combine both his rediscovered classicism and his new "nuclear paint-ing," as he termed his interest in the floating atoms that are the basis of nuclear fission. But still he could not get away from the landscape of Cap de Creus, which forms a background to the many curious events depicted in the painting.

However much Dalí insisted that Surrealism was a spent force and that classicism was the future of painting, Surrealism, or his particular brand of it, still crept into most of his paintings during 1945, mainly in his backgrounds. In *Portrait of Mrs. Isabel Styler-Tas,* for instance, he represents her in two images: One is a perfectly straightforward por-trait; in the other, Dalí turns her into a Surrealist landscape. In *Napo-leon's Nose Transformed into a Pregnant Woman, Strolling His Shadow with Melancholia Among Original Ruins,* there is a return to the familiar land-scape of the Empordà. In November 1945, Dalí showed eleven of these recent paintings at the Bignou Gallery in New York, together with illustrations for forthcoming editions of *Don Quixote* and *The Autobiography of Benvenuto Cellini,* and drawings he had done a year previously to illustrate Maurice Sandoz's *The Maze.*

Dalí chose to accompany this show with the first edition of his own newspaper, *Dalí News,* "Monarch of the Dailies," the main headline of which was "Dalí Triumphs in Apotheose [*sic*] of Homerus," followed by a subheading reporting the death of Richard Wagner (who'd been dead a good sixty years already) and a box proclaiming Dalí's latest exhibition at the Bignou Gallery under the heading "Dalí Launches His Winter Offensive." He worked on this unusual tabloid with his school-friend from Figueres, Jaume Miravitlles, who had made a career in publishing in South America and was now a refugee in New York. The publication owes much to the Surrealist feuilletons to which Dalí had contributed in the 1930s, and its antecedents go even further back, to *Studium,* the little magazine he worked on while at the Municipal School of Drawing in Figueres. Quite what Dalí hoped to achieve by creating his own press cuttings, as opposed to relying on journalists to keep him supplied with a never-ending stream of clippings, is not clear. In the foreword to the Bignou show catalog he wrote, "I feel I am more capricious than ever," so perhaps capriciousness explains this strange little venture into newspaper publishing.

Dalí and Gala would spend hours looking at press clippings care-fully stuck into scrapbooks. "The trouble was, they really did not

understand English well enough to realize that many of the clippings were making fun of Dalí. All they cared about was how much space Dalí got," Reynolds Morse says.[5]

The show at the Bignou Gallery received generally lukewarm reviews, but in a letter to Reynolds Morse of February 2, 1946, James Thrall Soby wrote that he thought the show "much better . . . and far more serious than the portrait show of a few years ago. Unfortunately, his *Dalí News* . . . seems to have put people off a good deal, though personally I rather admire his refusal to appear repentant and his insistence on the megalomania to which he is and for so long has been committed."[6] Soby also told Morse that the show sold extremely well and at high prices, which must have been reassuring to Dalí.

Dalí's ballet designs had come to naught, but another project was to offer itself early in 1946. This would absorb him for months, but would also end in frustration. It was Walt Disney's plan to work with Dalí on an animated film based on "Destino," a song about a simple love affair. The film, as Disney originally saw it, was to be a combination of animation, live action, and special effects, and the end product, which was to last about six minutes, was to have been one segment of a film consisting of several short episodes. Such anthologies, for instance Disney's own *Make Mine Music,* had been very popular in the mid-1940s.

The contract duly signed, the project was turned over to a Disney artist, John Hench, to supervise Dalí's work. Now senior vice president of Disney Imagineering, Hench remembered Dalí as a renaissance man who, unlike his public image, was perfectly sane. Dalí told him:

> *The difference between me and a crazy person is a crazy person dwells in a kind of fantasy—he's in another room from reality. When I walk in that room, I know where I am; I leave the door open. A real crazy person can't get out—the door is locked.*[7]

According to Hench, Dalí was allowed complete freedom at Disney:

> *Walt came in and looked at the work from time to time; he saw the storyboard in progress and decided to let Dalí go ahead and see what*

would happen. Walt was kind of entranced by the whole thing. They had a rapport from the beginning that was unusual. They got along remarkably, without much conversation—there was a sympathy there.[8]

Every morning, Dalí came to the Disney studio with new ideas for Hench to incorporate into the scenario. The two men would often go and see some "really mediocre" western at a little cinema in Monterey:

Dalí would be absolutely entranced and then afterward he'd tell me what the picture meant; he'd redo the story. The inevitable stampede of the bulls would be somebody's libido, this short little man would be the alter ego of the protagonist. . . . He built fabulous stories out of these really banal pictures.[9]

Dalí and Gala were guests of Jack Warner, who had acted as an intermediary on the Disney contract and had commissioned a portrait of himself that Dalí began at the same time he was working on "Destino." It took him five years to finish, and it depicted Warner and his schnauzer, Dragon. When he saw the finished portrait for the first time, Warner wanted a few alterations; his hand, the wall. Dalí reminded him that it was all right for him to edit films, but not Dalí's paintings.[10]

Hench and Dalí had decided at one point to make a fifteen-second color film to show Disney. This was to be the only part of the project that went beyond storyboard stage. The sequence showed two distorted faces set into the backs of turtles that moved toward each other in one of Dalí's bleak Empordàn landscapes. As they came together, Dalí employed the double-image device in making the space between the profiles take on the shape of a ballerina whose head was a baseball on the horizon.

After three months' work, Disney changed his mind about the future success of anthology films and canceled the project. He later described the "Destino" experience as "most unusual. Ordinarily good story ideas don't come easily and have to be thought for, but with Dalí it was exactly the reverse. He constantly bubbled with new ideas, not only for the picture, but in fact they spilled over into all directions, such as machines, furniture, jewellery. . . ."[11] Disney and Dalí remained friends.

* * *

With the end of World War II, friends from Europe started to come to New York. Gala was less than welcoming when she encountered Prince Jean-Louis Faucigny-Lucinge. The Prince would recall: "I kissed her and said, 'I'm very moved at seeing you again,' because I hadn't seen Gala for eight years—my wife had died. . . . She said, 'Are you? Me, not at all.' I thought it such an answer, like a knife. . . . It was such an extraordinary, ice-cold answer."[12]

The Prince was equally startled by the change he observed in Dalí, whom he remembered as an amusing and adorable companion, and a wonderful painter:

> *I rang up Dalí, and with another friend of mine we decided to dine. At that time Gala did not go out much with Dalí at night, I don't know why. So Dalí asked me what I would like to do, and at that moment in New York there were those wonderful new jazz orchestras. So I said I'd like to go to a jam session. We decided to meet at the St. Regis and go on from there.*
>
> *When he came down to meet us—I hadn't seen him since 1940, of course—he had this enormous mustache, and a cane with a false diamond in the top of it. I turned to my friend and said, "Really, it's embarrassing to have to go out with him, we are going to be stared at all over the place." I couldn't have been more wrong. We went to about twelve places to hear jazz, and everywhere we went a photographer popped up, and people came to the table saying, "Mr. Dalí, Mr. Dalí, please sign my program," and things like that, and I realized I was with an accepted eccentric personality, and I was not embarrassed walking around with him, far from. He'd become a type, and once you've become a type it's all right, because you are accepted by everybody.[13]*

News reached Dalí and Gala from Paul Eluard at the end of 1945 that Breton and his cronies, now mostly back in Europe, had been spreading rumors that Dalí had painted the portrait of Franco's ambassador to the United States. "There are a number of bastards whose traps I'd like to shut," wrote Eluard.[14] In March 1946, Eluard wrote to Gala again:

> *As concerns your return, I think you have everything to lose by it. The political situation is not stable yet. And you can hardly count on many sales of your paintings. The market is bad at the moment. People are holding on to their money. Furthermore, you must realize that life is*

difficult, very difficult. You need a lot of money. And, above all, every-
thing is tiring. I can't see you forever in the Métro and walking, and your
apartment is difficult to heat. Mine is tiny, but Nusch never lets up for a
minute. In my opinion, you should first make an investigative and set-
ting-to-rights trip, if you really care to leave America, where Dalí enjoys
a popularity and benefits that you'll have a hard time recreating here.[15]

This sounds as if Eluard were manufacturing reasons—good reasons—
why Dalí and Gala should not come back to Paris, while avoiding the
central reason: Dalí's politics were extremely suspect. In the nervous
atmosphere in Paris in the postwar years, when collaborators were
shot, Dalí might get into trouble. Eluard might also have been trying to
protect Cécile from the certain wrath of her mother on the subject of
the paintings and furniture Cécile had sold to keep herself going dur-
ing the war.

Gala decided to take Eluard's advice and to stay in America. Eluard
relet the Dalís' apartment to Georges Hugnet in June 1947. Hugnet
had long been an admirer of Dalí's and had not gone over to Breton's
point of view. He guaranteed that he would move out immediately
when the Dalís wanted the apartment back. But they never did reclaim
it, and sold it in the early 1950s. Paris was no longer to be home to
them. They visited it twice a year, but New York was their base. "They
were Americans by this time," says Michael Stout, their New York
lawyer for many years. "They had lived there for nearly ten years; by
the time I met them in the mid-1960s, they were certainly not Spanish
anymore."[16]

In their last year of American exile, life for Gala and Dalí went on
much as it had done since 1940. Prompted by Reynolds Morse, the
Cleveland Museum of Art held a retrospective show of Dalí's work in
October 1947. Most of the paintings were from Cleveland collections,
notably Morse's own and that of his friend Dr. Rosoman. This exhibi-
tion was accompanied by a talk given on the local radio station by
Morse, who reported, among other things, that Dalí's *The Sublime Mo-
ment* had been painted as a challenge to the photographer's art. Dalí
had labeled it, Morse said, "handmade color photography." "When
you see the picture," Morse told his listeners, "you will perhaps under-
stand why the art of the future can no longer be concerned with those
subjects on which the camera can focus, but must turn inward to the

rich untapped sources of human imagination."[17] Morse also raised the question of Dalí's position among contemporary painters. What he said on the subject nearly half a century ago is still valid today:

> *To date, the average student of Dalí has been distracted from his serious work by [Dalí's] flair for publicity. As a result, few people ever have good reason to regard Dalí as the great modern master that he is. Instead, they think of him as an actor. . . . But for all his other activities, it will still be for his profound studies of contemporary psychology seen in his imaginary paintings that he will be remembered longest. Chief among his reasons for being misunderstood is our almost conditioned adverse reaction to the work of any bold pioneer.*[18]

Morse concluded his talk with a quote from his foreword to the catalog of the Cleveland retrospective, in which he said of Dalí that he "prophetically reveals the dreams, fears, hopes, and frustrations of modern man, and has succeeded more than any other artist in expressing the nostalgia, the terror, the poetry, and the confusion of our times."

Perhaps Dalí, too, felt that as a painter he had begun to be ignored, for as an accompaniment to his exhibition at the Bignou Gallery, held from November 1947 until January 1948, he produced a new book, entitled *Fifty Secrets of Magic Craftsmanship,* which is in effect a manifesto about the actual business of being a painter. Contained in the book, along with the secret of why the sea urchin slumbers and why a great draftsman should draw while absolutely naked (Dalí never did), are some indications of how seriously Dalí took his technique. He starts with the secret of the five different movements of five different brushes. He mentions the secret of the sympathies and antipathies of the painter's retina, and says that artificially pigmented cowrie shells are extremely useful for refining the painter's retina. He also reveals the secret of knowing how to paint before learning how to draw—a direct reference to his earliest years, before Joan Núñez taught him academic draftsmanship at the Municipal School of Drawing. He lists the colors he uses, including the "wasp" medium, in which wasp venom is used to thin color. He also lists ten rules for anyone who wishes to be a painter, among which are "Begin to paint by learning to draw and paint like the old masters. After that, you can do as you like; everyone

will respect you. . . . No lazy masterpieces. . . . Painter, paint.
. . . If painting doesn't love you, all your love for her will be unavail-
ing."[19]

Among the paintings in this new show was one that hints at Dalí's
insecurity at the time, which may well have been engendered by the
canards Breton was spreading about his politics in Paris. This is *Por-
trait of Picasso,* which could be described as a classical portrait also
partly inspired by Arcimboldo. It shows Picasso with a Carthaginian
coiffure surrounded by despised folkloric objects (mandolins, carna-
tions, jasmine). Just as Dalí had castigated Lorca for his folkloric and
sentimental tendencies, now he attempted to comment on the work of
Picasso, who he believed had destroyed twentieth-century art by his
constant attacks on technique.

Picasso occupies a unique place in Dalí's pantheon. Dalí must have
heard a great deal about Picasso from Ramón Pitxot, and when Dalí
went on his first brief visit to Paris, Picasso was the only painter of the
bande Catalane he wished to meet. While living in Paris he saw Picasso
frequently, and was taken by him to meet Gertrude Stein, who was not
impressed:

> Well I said and Picasso said well you did see Dalí, sure I said but you did
> not come no said Pablo you see I knew you would tell him what you
> thought of my poetry and you would not tell me. Sure I did I said and
> that was easy why said he, why I said because you see one discusses
> things with dull people but not with sensible ones, you know that very
> well I said getting a little angry, one never discusses anything with any-
> body who can understand one discusses things with people who cannot
> understand and that is the reason I discussed with Dalí and I do not
> discuss with you. What he said Dalí cannot understand anything, of
> course he can't I said, you know that as well as I do. . . .[20]

By the mid-1930s, after Dalí's first trip to America—which was, of
course, financed by Picasso—their friendship soured as Dalí became
more successful and Picasso moved away from the Surrealist group.
After the Civil War, when Dalí's politics moved further and further to
the right, the rift widened. It widened even more after Picasso had
painted *Guernica* and Dalí had refused to contribute to the Spanish
Republic's pavilion at the 1937 Paris World's Fair.

Dalí still admired Picasso, but in 1951 he announced that they had come to an official parting of the ways:

I am fusing Surrealism with the mystical. Dalí stands for fusion, Picasso for confusion. We're both geniuses. Spain is a land of contrasts—sun and shadow. Picasso at seventy-one stays in the cold shadow of outmoded art; Dalí, much younger, at forty-six, has come up into the wholesome sun.[21]

Later, he had this to say:

Towards the genius, Picasso, I am nothing but grateful; for his Cubism— vital for my aestheticism, for having loaned me money for my first journey to America—vital for my fortune, for his anarchism, for my monarchism.[22]

Picasso refused to rise to Dalí's barbs. Dalí wrote to him from time to time; he never answered. As far as Picasso was concerned, Dalí had ceased to exist. Finally, in "Cuckolds of Modern Art," published in 1956, Dalí said of Picasso: "Picasso destroys. I am a builder. We are the two poles of Spanish anarchy."

Dalí published a second edition of *Dalí News* at the time of the Bignou exhibition in 1947. He listed his prophecies for the postwar world: "After the First World War it was Psychology. After the Second World War it will be Physics."[23] Instinct would be replaced by intelligence, watercress salad by romaine lettuce, parachutes by helicopters, new-ness by antiquity. He then descended to some quasi-Nostradamian predictions, of which the most interesting is that Belgium would show glory in legislation and finance—a prophetic reference to the EEC, perhaps?

This was fun, and showed that Dalí had returned refreshed to many of his youthful jeux d'esprit, but it did not serve to change the critics' minds. They still regarded him as a species of post-Surrealist mounte-bank and jack-of-all-creative-trades, however hard he tried to alter this view. Manifestos had been a major part of prewar Surrealist promo-tional activity; *Dalí News* carried much less weight in the postwar world.

Dalí's isolation told against him, too; he had not belonged to any "group" since his rift with the Surrealists. Individuality also meant being out of fashion. Still, Dalí's preoccupation with floating atoms led him into an interesting and important collaboration with the Hungarian photographer Philippe Halsman. They had met during a 1944 *Life* assignment that had reawakened Dalí's fascination with the opportunities presented by photography. The date of their first collaboration is unknown, but it must have taken place sometime in the mid-1940s. In 1948, Dalí and Halsman became more ambitious:

> *Dalí likes to be photographed by me because he is interested in photographs that don't merely record reality. In photographs too he wants to be shown above reality, that is, Surrealistically. . . . Whenever I need a striking or famous protagonist for one of my wild ideas, Dalí graciously obliges. Whenever Dalí thinks of a photograph so strange that it seems impossible to produce, I try to find the solution.*[24]

A famous image arose out of this collaboration. It is called *Dalí Atomicus,* and in it Dalí, the easel, and the subject he is painting, which is already pictured on the canvas, are in suspension. Dalí was very excited at the original idea since it seemed to reflect the atom in suspension, and Halsman went to the St. Regis to discuss it. "I know what the picture should be," Dalí told Halsman. "We take a duck and put some dynamite in its derrière. When the duck explodes, I jump and you take the picture."

"Don't forget that we are in America," Halsman replied. "We will be put in prison if we start exploding ducks."

"You're right," Dalí told him. "Let's take some cats and splash them with water."[25]

The resultant sitting took five hours, twenty-six throws of cats, chairs, water, and twenty-six catchings of very wet cats. The photograph was published by *Life* and picked up all over the world. Eventually, it was included in an exhibit of "Fifty Great Photographs of the First Half of the Century." Dalí and Halsman went on to collaborate on a series of photo-constructs over the years, culminating in an amusing book, *Dalí's Moustache,* which was an extension into photography of the original games about mustaches played at the Residencia. Dalí's

mustache had become his mask, as he explained in the preface to the book:

> On the day I disembarked in New York my photograph appeared on the cover of Time magazine. It showed me wearing the smallest moustache in the world. Since then the world has shrunk considerably while my moustache, like the power of my imagination, continued to grow. . . . Some day perhaps one will discover a truth almost as strange as this moustache —namely, that Salvador Dalí was probably also a painter.[26]

One photo was revealing: It showed Dalí with his mustache waxed so that the points extended vertically past his eyes to his eyebrows. Dalí had written the caption: "Like two erect sentries, my moustache defends the entrance to my real self."[27]

Dalí and Gala sailed for Le Havre on July 21, 1948. From there, they went to Paris, where they had been asked to stay with Arturo López-Wilshaw and his wife in their house in Neuilly. During the few days they were there they met up with many old friends, including Comte Etienne de Beaumont. One encounter at the López-Wilshaw house was to bear rather strange fruit; this was with Peter Brook, who reached an agreement with Dalí during a "wild night" that the artist should design the sets and work with him generally on a production of Richard Strauss's *Salome* for the 1949 season at Covent Garden.

In Paris, they sorted out the lease of their flat, and saw Eluard, Cécile, and Gala's two-year-old granddaughter. Then, wishing to avoid any confrontation with Breton, they headed straight for Spain and Figueres where, after his welcome by his family in 1940, Dalí was assured of a loving reunion. Gala was far less confident of her reception and hovered in a doorway down the street before being beckoned into the house.

Dalí's father was now a very old man. Tieta had died of cancer during the war; Ana Maria kept house for him. She was an embittered spinster living on her memories of those magical summers in the 1920s before Gala had come on the scene and, according to Ana Maria, spoiled everything. Dalí's father, a confirmed atheist all his life, had turned back to the Church during the war, and now believed his

son was living in mortal sin because, in the eyes of the Church, he was not married.

In Figueres, nothing had changed. But Dalí and Gala had changed, and the familiar objects and furniture that had so reassured Dalí on his fleeting and frightening visit before leaving Europe in 1940 must have looked very diminished on his return eight years later. Moreover, Ana Maria resented Gala bitterly. The "whore" had got everything; Ana Maria had nothing except an elderly father to look after. It must have been a difficult homecoming. Dalí and Gala went on to Port Lligat.

One of Dalí's friends, José María Prim, an artist he admired greatly, had been living in the house during the war and looking after it; Dalí now bought another *barraca* to add to those he already possessed. Though little of their furniture or possessions were left after the depredations of the vigilantes, their old friend and benefactress Lidia Nogueres was still alive, and so were those fishermen who had escaped the firing squads of the Civil War. Here, at last, they could feel that they had come home.

Ignacio Agustí, a journalist who worked for *Destino,* a local weekly photo magazine, encountered them just after their return. Dalí was meeting cameramen of the *No Do* cinema newssheet, and had arranged a spectacle for them: Two people were dressed in sheets as ghosts, holding a large, torn canvas through which stepped Dalí and Gala. The music of a double bass and pipes enlivened the scene; the whole event was a precursor of many such happenings in the house over the next twenty years.

The photographs were shown in the August 15 edition of *Destino,* which had on its cover a portrait of Dalí, holding *Fifty Secrets of Magic Craftsmanship,* together with his father, who looked glum and elderly.

Many things had changed in the Empordà. Doors that had been shut to Dalí and Gala before the war because the locals hated her and because Dalí's father had turned him out were now open to them because they were rich and famous. For all that, Gala despised the Catalans, never learned to speak Spanish or Catalan, and treated most of Dalí's local friends with utter contempt. Now she had returned, triumphant, in a mink coat, and obviously rich.

They were forty-four and fifty-five years old. Dalí was in excellent health, although he had developed a slight middle-aged paunch. His face was strong, handsome, and self-confident. He had lost the fre-

netic, nervous look of his prewar years, when his suits were too tight, too "tango dancer," and he had slicked his hair down like Rudolph Valentino. Now he dressed in pin-striped suits when he was "on show" and, cane apart, began to look like the son of the bourgeoisie that, beneath all, he basically was.

Gala was still compelling. Her hair was long, puffed up in the fashionable pompadour manner, and invariably tied with a black Chanel bow, of which she appeared to have an inexhaustible supply. When not in Port Lligat she dressed in smart if aging Chanel suits with a great deal of real jewelry; when in Port Lligat, however, they both wore casual clothes. Dalí had a predilection for two-toned western jackets he had bought in America, and Gala liked to dress in short, tight trousers and a sweater or shirt.

Their relationship had lasted so long and had been so continually celebrated in Dalí's paintings that they were readily accepted by the new society that was springing up in postwar Europe. Dalí had overcome his youthful shyness and was actually very good company and now *he* was the attraction, rather than Gala. She began to resent bitterly her secondary role. This resentment turned a woman who had always been cold into a personality of such relentless self-will, such monumental self-regard, such icy disregard for the feelings of anyone except herself, that she sent shivers down the spine of almost everyone she met. Dalí was now to pay, and pay extravagantly, for the years Gala had spent being his "porter" and for the insults she felt she now endured as his shadow. For Peter Brook, the Dalís were "a unique case in art history—Macbeth in a beautiful hygienic Frigidaire of a house."[28]

Dalí and Gala spent a month at Port Lligat, making improvements on the house with Emilio Puignau, the builder. Now began the gradual transformation of a series of interconnected fishing huts into a combination of workshop, home, castle, watchtower, garden, laboratory— and theater. The olive groves behind the original *barracas* were acquired bit by bit, and the original olive terraces planted with edgings of lavender and rosemary. A wall was built from the house to the cliff, at the end of which a little summerhouse was constructed, inside which Dalí stuck found objects, such as twisted pieces of driftwood,

and whitewashed them. There were steps to a little beach. For the next thirty years, the house grew, became more of a fortress; and every summer, when Dalí and Gala returned to it, they would find something new to divert them.

In the summer of 1948, Dalí worked on his designs for Luchino Visconti's production of *As You Like It,* which was to be produced in Rome that autumn, and on preliminary sketches for Brook's *Salome.* When Brook arrived at Port Lligat, he found Dalí conducting a hunt for the women with the biggest goose pimples and brooding about Velázquez. After that introduction, the collaboration went well. Later, though, as Brook was about to leave, with Dalí's drawings packed away in his case and an old taxi waiting to take him over the mountain on the first leg of his journey back, what he called an "odious thing" suddenly happened. Dalí demanded a receipt for the drawings and refused to let him leave until he got it—in case, Dalí said, Brook was killed on the way home.

Dalí might well have been prescient: Driving down the Costa Brava to Barcelona with four friends, including Edgar Neville, Count Balenge, Brook was held up by a group of anti-Franco partisans. One of their number had been wounded in a skirmish, and they needed the big "capitalist Cadillac" to take their comrade to a safe hospital. Brook's friends were tied to trees to wait until the partisans had been to Barcelona and back. Brook was terrified that the partisans would destroy Dalí's drawings if they found them and saw his signature— Dalí's reputation as a Franco-royalist would see to that. Hours later, one of the men in Brook's party managed to wriggle loose from his ropes and free the others, and they then walked to the nearest village. It was not until Edgar Neville persuaded the local police to allow him to call the mayor of Barcelona that help finally came in the form of 100 soldiers, who marched Brook and his party to the scene of the crime, where all the luggage was recovered. (When *Salome* was staged in November 1949, Brook advertised in a newspaper in Toulouse, whence he had been told the partisans had come, inviting them to London to see the opera from front-row seats. There was no response, and he found out later that they had all been killed.)

Dramas of a more purely theatrical type beset *Salome.* The first hint of trouble came in a telegram of October 10, 1949, to David (later Sir

David) Webster, assistant producer of Covent Garden, from Karl Rankl, the musical director, in which Rankl said:

> *Saw* Salome *sets 1st time today absolutely impossible for requirements of music and singers. . . . No sound would be heard from singers as placed too far backstage. . . . Rankl*[29]

When applied to for help by Brook, Dalí said he was going to Rome, which in fact he did, for an audience with Pope Pius XII. Just before the opening, Dalí sent a demand from Rome for a gloomy rhinoceros to throw a "cloud of death" over the finale. The request was ignored. The costumes were only partly realized, and Ljuba Welitsch, the star, ordered two sets made, her own version and Dalí's. As Peter Brook told Fleur Cowles later, that kind of collaboration simply was not good enough:

> *Dalí should have carried through. Yet even when he does, he sometimes feels his thumb-print isn't as big as he wants it—and then he decides to do something dreadful to enlarge it. He's too difficult. . . . And now it's too late, he's too old hat.*[30]

So controversial did the production become that there was no public dress rehearsal and the sets were kept top secret. The opening night, on November 11, 1949, was a mixed success: Some cheered, others booed. There were fourteen curtain calls—none taken by a put-out Rankl. The *Manchester Guardian* said that although many of the costumes were rather silly, they did not stand much in the way of the work. The *Daily Mail* called the staging a "shocker," while Eric Blom in the *Observer* said, "If the production had to be odd, it may be that it was not odd enough."

In the *Observer*, Peter Brook replied to criticism with the answer that Dalí was the only artist in the world whose natural style has

> *both what one might call the erotic degeneracy of Shaw and the imagery of Wilde. Dalí and I studied the score, and set out to make a true music drama in the style of the great religious painters. . . . But they [the critics] decided that Dalí and I were out only to annoy them. There at*

least I might claim that they underestimated us; if that had been our intention I think that between us we could have done far worse.[31]

The production did not last; except for Dalí's wigwam-like Nazarene costumes, it was completely redesigned in January 1951 by Christopher West.

And as for Dalí, he was wrestling with the problem of how not to appear "old hat" to a new generation of painters to whom Surrealism was history and abstract expressionism the future. How he tried to solve this problem is the story of the next thirty years of his working life.

▶
▶
▶
▶
▶

PART FOUR

──────────

AT THE VERGE OF NIGHT, RED CUTLERY GLITTERS 1950–1979

"Oh heavy body mine!" the manflower cries. "Right to the dull mouths of the night you slip while at the verge of night, red cutlery glitters, and dawn's torn veins on the blood's jetty drip."

"The Metamorphosis of Narcissus," Salvador Dalí

12

THE MADONNA OF PORT LLIGAT
1950–1962

A na Maria had never become reconciled to Gala's presence and influence on her brother's life, and believed (incorrectly) that it was Gala who had betrayed her during the Civil War. In 1949 the tenuous truce that had been established was permanently shattered when Ana Maria brought out her own version of her brother's early life, aided by a Catalan writer from Figueres named Miguel Brunet. Her account tells her version of events up to the moment of Dalí's estrangement with his family, which she still blamed on the Surrealist movement.

Salvador Dalí Visto por su Hermana gave a very different version from that which Dalí had been at such pains to construct in *The Secret Life*. Ana Maria presented her readers with a view of a perfect family paradise into which snakes—the Surrealists—entered. She portrayed her brother as normal and likable, given to outbursts of juvenile high spirits from time to time, living in amity with his family. Here were no early and incomprehensible signs of genius, nor dark undercurrents, but an average middle-class life, both pleasant and productive. Lorca, far from being in love with her brother, is portrayed by Ana Maria as a genial poet and her potential suitor. There are endless summer days of picnics and outings, festivals and parlor games, and prayers at twilight in a cozily "correct" world. It is only when the Surrealists and the drug-taking Gala come on the scene, according to Ana Maria, that this paradise is invaded and spoiled forever.

Dalí, always jealously protective of the authorship of his own myth, was of course furious. "She was jealous," he told Louis Allen in an

interview in 1951. "This is not the first time that an aggrieved sister has written with malice or misunderstanding about a famous brother; it happened in the case of Nietzsche too."[1] Ana Maria had cause for jealousy of Gala and her brother. Their life, after all, was rich and successful. They, after all, had not suffered through the Civil War or World War II, which they had spent in safety and luxury in America. No longer did the little house at Es Llaner echo to the sounds of Lorca reading love poetry Ana Maria thought was meant for her; no longer did her brother paint her—he painted only Gala. Exciting visitors never came to pay attention to the sister; they anchored in the bay at Port Lligat, and Ana Maria never met them. She was now thirty-eight and unlikely to marry, due both to her sexual proclivities—now obviously lesbian—and to the ties of convention binding her to an aging and difficult father.

Ana Maria's book also reflected the general attitude among the more conventional Figuerans. Gala had made it perfectly clear that she thought the *tertulias* in the Café Sport Figuerense were provincial and dull in the extreme. Dalí, however, did care very much what his fellow Figuerans thought of him; he cared more about the opinions expressed in the cafés of the *rambla* than of what international art critics said. Despite his years with Gala and the long sojourn in America, he was still the son of the notary, and life in the Empordà was still the only reality.

Dalí was distraught when the book came out. When he went back to New York that winter, he called Reynolds Morse and said, "There's terrible trouble, come down to New York to see me immediately."

"We went to New York," Reynolds Morse remembers, "and saw Dalí who was wound up and said, 'My sister has destroyed my image, I have worked all these years to prove what a monster I was and she has ruined my legend, she has proved I am just a nice little boy.' " Dalí walked up and down the room in rage and despair as Morse looked on.[2]

Dalí had engraved a special card that he distributed to all his friends —and sometimes to people he had just met—telling them not to read the book because it did not tell the truth about him. To Dalí's father, however, the picture his daughter had painted was a great deal more palatable than the truth, as is apparent in his foreword, which, in the first edition, was printed in a facsimile of his own handwriting:

I would have avoided many disappointments had I had the presentiment that I would be reading this book in my old age, since it reflects the history of our home with absolute fidelity. I sometimes wonder whether it is the hand of my wife that guided that of our daughter through these pages. It must be so, since they give me much comfort.[3]

By 1951 Dalí had become, outwardly at any rate, somewhat more philosophical about the book. But the rupture it caused between him and his family was total. Dalí never spoke to his father again.

This time Dalí would not be driven away by parental disapproval. He intended to spend half the year in Spain, whether his family wanted to see him or not. His father, by now in his late seventies and virtually retired, was not nearly as influential as he had been before the war; and Dalí himself was very rich. It was not long before many of those town worthies who had cut him in deference to his father's wishes before the war began to find their way to Port Lligat.

In the last months of his life, Dalí's father was reduced to sitting in a café at the edge of the *rambla,* drinking cup after cup of coffee in the hope of seeing his famous son parading up and down with his cane.

In 1959, Dalí and Gala finally returned properly to Port Lligat. Their house had been vacated by José María Prim, the painter who had rented it during the war, and restored and made habitable by Emilio Puignau. Dalí and Gala returned to Spain for an entire summer for the first time in eleven years.

From now on, Dalí's life was a regimen written in stone; always a man who preferred "prisons of his own making,"[4] he could function only within an unchanging routine. In April or May he would return to Port Lligat from New York. In October, as the autumn came, he would set forth for Paris, which involved a complete packing-up of the work that had been done that summer, such "found objects" as Dalí wished to take with him, and all the paraphernalia of a painter. This routine was invariable and, in its rigorous sameness, somewhat like a royal progress; in October, the Dalís and whoever was in their entourage that year would have a farewell lunch at the Hotel Durán in Figueres, at which he lunched every Tuesday while he was at Cadaqués, and Dalí would pay the bill for the whole summer. Emil Pomés,

the taxi driver from Cadaqués who was friendly with the Dalís (his sister was Ana Maria's housekeeper until her death), says that the Dalís would always insist that the taxi drivers taking their luggage away from Cadaqués should eat at the Hotel Durán on their return from Perpignan, and that this meal would be the first to be put on the bill for the next year.

The Dalís always went by train from Perpignan, "the center of the universe."[5] In a television interview he gave to the Ecole des Beaux Arts in the 1970s, Dalí described his feelings as the train drew away from the station toward Paris: "As the train moves off I become irresponsible, I look forward to eating ortolans, I have done my work for the year. Now Dalí can play."[6] During the 1950s, the Dalís formed the habit of staying with the López-Wilshaws in Neuilly (and annoying them by arriving with trunks full of dirty laundry). They would then return to New York at Thanksgiving by boat from Le Havre. (Dalí, afraid of any sort of travel, had conquered his fear of boats but did not make his first airplane trip until 1975.)

After the Dalís had returned to Spain, the Morses, every year from 1954 on, would make a visit to Cadaqués to discuss work in progress, at which point Gala would start to sell them a picture, or seek to involve them in whatever project Dalí had going at the time. They were a permanent fixture in the Dalí's lives, but they always felt that they were patrons, and that they were never treated as friends. One reason for this, perhaps, is that Morse had once parried a pass made by Gala: "She asked me to her room when Dalí wasn't around and showed me some of his erotic drawings, saying something like 'There are more where that came from,' and then she propositioned me." Morse demurred politely, but Gala apparently never forgave him.[7]

The Spain—or, rather, Catalonia—to which Dalí returned after the war was very different from the country he had left. The Catalans had been squashed by Franco and their language outlawed because, as Franco once infamously remarked, it reminded him of the barking of a dog. All official business was conducted in Castilian, and so was all teaching. Separatist movements were brutally and violently suppressed and their ringleaders hanged.

Dalí was in a very difficult position. He had now allied himself with

Franco and the forces of the right, yet he was a Catalan and proud of it, and had every intention of living in Catalonia. Of course, not all those who lived in Figueres or in Port Lligat were active separatists. Most were occupied in rebuilding the shattered economy of the area, which had not recovered from the Civil War (the first waves of tourism had yet to enrich the Costa Brava). It was a bleak period of agonizingly slow reconstruction. "Almost all the houses in Cadaqués were in ruins in the late 1940s," Montserrat Dalí y Bas remembers. "Roofless, without walls, about half the houses in the village were deserted and had been for fifteen years, since the worst days of the Civil War."[8] As an avowed Francoist, Dalí might have been in an adversarial position with regard to the separatists; but since he had shown his solidarity, if rather late, by returning to Catalonia and putting his house in order, the separatists gave him a wide berth. Moreover, a certain indulgence had always been accorded extrovert eccentricity in Catalonia, especially when linked to artistic achievement (witness the case of Gaudi). In these potentially tricky postwar political waters, Dalí benefited from this tradition.

On September 21, 1950, Dalí's father died, still estranged from his son. Dalí was in Paris at the time and was too late to bid Don Salvador farewell, but he saw his father's body before it was buried and kissed "his cold hard mouth with my ardently living lips."[9] Dalí had called his father a giant of strength, violence, authority, and imperious love; to Dalí, his father was Moses plus Jupiter.[10] But his father had also been the architect of the destruction of any hope of a normal life for Dalí.

One would have expected that on the death of his father Dalí would have been set free from the specters of his childhood and youth; but the ghosts would not be exorcised, for habit was too strong and too engrained. Even in death his father hovered in Dalí's consciousness and over much of what he achieved—especially in the 1950s, when his memories of his father were still fresh.

Don Salvador's inflexibility and his grief for the elder brother whom Dalí never knew fueled Dalí's genius and stoked his creative fires until, in the end, their relationship ignited and burned. But even at the end of his life Don Salvador had attempted to look after this wayward son. In a will he made early in 1950, after his final rupture with his son,

Dalí's father left him 22,000 pesetas and some but not all of the paintings done by Dalí that hung in the two family houses. These were early works, most dating from the period when Dalí, having been expelled from the art school in Madrid, was living at home, painting desperately in order to have a corpus of work to take with him to Paris. But were the paintings in fact Don Salvador's to bequeath? Weren't they all Dalí's property anyway, and merely lent to his father? Ana Maria claimed the share left to her in her father's will, and thus began the next stage of the quarrel between the siblings.

Two years after Dalí's father's death, in September 1952, Don Evaristo Valles y Llopart, a notary from Cadaqués, tried to serve a summons on Dalí at his house in Port Lligat to sort out the difficulties Dalí had created in the probate of the will. Dalí refused to have anything to do with this probate, claiming that he had always owned all the paintings. Llopart was admitted by Dalí's maid, who told him her master would not see him. The notary waited in the hall hoping to get Dalí's signature to the deed, one way or another. He was not pleased when Dalí appeared

> in a violent manner and seized the original, tearing it into pieces and throwing it onto the floor. And when I tried to collect it, he prevented me in a gross and haughty way, giving me a kick. When warned that it was a public document, he said it was all the same to him, since in his house he gave the orders. Continuing in his violent way with insults and shoves and giving me kicks, he threw my son-in-law Alonso and me out of the house.[11]

Dalí's version was that the notary had burst into his studio and disturbed a valuable book of drawings he was studying at the time. Whatever the truth, the incident served to make Dalí even more unpopular with the conservative elements in Figueres and Cadaqués.

Opinions about Dalí were further polarized by a lecture he gave on October 12, 1951, entitled *"Picasso y Yo."* Long before the lecture began in the Teatro María Guerrero in Madrid, the theater was jammed with people. Dalí spoke briefly to journalists in the anteroom, saying that the attitude of Picasso was sincere but circumstantial. In art, Dalí

said, inspiration came before craft; but without the latter it was impossible to paint. In cubism there was nothing that was not explicable and comprehensible, Dalí sniffed, adding that many of his contemporaries neither could nor would draw.

Then he went into the auditorium to give his speech, an apologia for his own attitude toward Spain and politics that also contained a condemnation of Picasso for his espousal of the Communist cause and his continued absence from Spain. As always, Dalí began, Spain belongs to the world of maximum contrast:

> . . . in this instance in the persons of the two most antagonistic painters of contemporary painting: Picasso and I, your servant. Picasso is Spanish; I am too. Picasso is a genius; I am too. Picasso will be seventy-two; and I about forty-eight [he was actually forty-seven]. Picasso is known in every country of the world; so am I. Picasso is a Communist; I am not.[12]

Why did Picasso turn Communist? asked Dalí.

> I am going to explain my theory or opinion. I believe there are two factors involved: one determining and decisive, and the other to create ambience. What prepared the ambience is the fact that Picasso has always had a sort of taste (almost pathological) for misery and poor people. . . .
> At the time of the Civil War, and this is what I consider the sentimental determinant that explains Picasso . . . a group of Red intellectuals, sitting on the terrace of a Madrid café, had the idea of sending a telegram to Picasso naming him as director of the Prado. This cable went straight to Picasso's heart. For the first time arose a feeling of solidarity among certain intellectuals in Spain who had never agreed before.[13]

Dalí flung down the gauntlet with this speech, which was met with bursts of supportive laughter and loud applause. In parts it was a diatribe against his sister and the rest of his family, and against those gossips of the Figueres *rambla* who had never believed his estimate of his own worth. It was also an apology addressed to those on the Catalan and Spanish left who had branded him a renegade, a turncoat, and a coward. But more important, it was a summary of all Dalí had come to believe in the past and a prediction of all that he was to set about doing as a painter and as an intellectual in the future.

* * *

The more frivolous social side of Dalí was well to the fore in September 1951, when he attended the *fête des fêtes* given by an old friend from prewar Paris society, the Mexican millionaire Carlos de Bestegui, at his newly acquired Palazzo Labia in Venice. The palazzo's central hall contained a superb fresco by Tiepolo entitled *The Banquet of Antony and Cleopatra*—a fitting background for a fancy-dress ball virtually worthy of the heyday of Versailles. People still talk about it over forty years later. The theme was the Venice of Longhi and Casanova, which gave considerable license to the partygoers. The López-Wilshaws came as a Chinese ambassador and ambassadress, complete with retinue, arriving in a Chinese junk; Lady Diana Cooper came as Tiepolo's Cleopatra in a dress by Schiaparelli; Mrs. Reginald Fellowes represented eighteenth-century America; Barbara Hutton and her escort, Colonel Anthony Porson, came identically dressed (by Balenciaga) as masked and sequined eighteenth-century gallants; and the couturier Jacques Fath was the Sun King in a costume so heavily embroidered he was unable to sit down. The Dalís' arrival at the ball was a spectacle engineered by Christian Dior. They came as giant phantoms of Venice in eight-foot-high white costumes with black pompoms. Masked and tricorned, they were accompanied by a midget. Whether they were able to dance on the stilts they assumed for this spectacular entrance, history does not relate.

Dalí was painting fewer pictures now, for his new ideas demanded a painstakingly realistic technique and absolute concentration. He could paint only in Port Lligat; the silence, the isolation, the light refracting off the rocks in the little bay, were as much a part of his paintings as his impeccable draftsmanship. When the Dalís were in New York, one room in the St. Regis was always set aside as a studio, but Dalí would only draw there, rarely if ever paint.

Time, too, was against the production of a great many pictures. Seven months of the year were spent in Paris and in New York, where Dalí occupied himself with either cultivating old and new clients or collaborating with others on ideas that, while stimulating his overactive brain and giving him material that he eventually fed into his paintings, took him away from his brush. One such project in 1950

took him back to films: He designed the dream sequence for Vincente Minnelli's hit *Father of the Bride*.

His painting now showed two separate strands of thought. The first concerned those classical-religious themes that had been maturing in his mind since his painstaking studies in the mid-1930s of the Italian Renaissance masters. "It is certain that Dalí finds himself at a major turning point in his work," wrote the art critic Michel Tapie at the time, "but it is also certain that he approaches religious art thoroughly at home with psychic problems, very near to mysticism . . . in the tradition, however, of this Baroque art at which Mediterranean peoples have always excelled and which has given us, from Bernini to Pedro de Mena, so many masterpieces."[14] Dalí had regressed to becoming a Spanish Catholic painter; his paranoiac period was no more. This infuriated a great many of the remaining Surrealists and, also, Edward James, who wrote Dalí a very long letter:

Your pretence at Catholicism is in the eyes of everybody a mere mockery. Nobody believes, nobody could believe that there is a grain of religious sincerity in the overtures which you are now making to the Roman Catholic Church. You have told me time and time again that this would be your next step since you felt that the Papacy would be the eventual winner in Europe and the Vatican would come out on top after the various world conflicts of Communism and Fascism and Democracy had worn themselves out. . . . That the rock of Saint Peter . . . should be treated by you as if it were a bandwagon is not going to make you accepted by any serious or dignified representative of that great church. . . . Your big Madonna, though technically accomplished and laboriously executed, is so redolent of the cynicism, bogus religious posturing and hypocrisy which is behind its conception, that it positively stinks of superficiality and uninspired fabrication from yards away as one approaches it. For all its ingenuity of detail it remains principally fit to take its place where it will eventually belong among those discarded English Academy or French "salon" canvases which rot in old warehouses or are kept by the impoverished descendants of the artist who, in the end, unable to afford the space for them in their limited lodgings, are forced to cut up the canvases and sell them by the square foot to those who like to paint over an already painted surface. This is about as far from the spirit of Raphael as Walt Disney is from Hieronymus Bosch.[15]

The Madonna of Port Lligat, the "big Madonna" referred to by James, was the first fully developed painting of Dalí's religious period; there were two versions, one fairly simple one painted in 1949, and one far more complicated and elaborate version finished in 1951. But it was Dalí's 1951 *Christ of Saint John of the Cross,* first shown at his one-man show at the Lefevre Gallery in London in December of that year, that became as much of a twentieth-century icon as has *The Persistence of Memory.*

The writer Daniel Farson, then working for the newsweekly *Picture Post,* visited Dalí in the summer of 1951 while he was painting the *Christ;* unusually, Dalí allowed him into his studio to see the work in progress. Farson was the first outsider to see the painting:

> We entered the cloistered silence of the studio and he drew the curtains to avoid reflections, for the canvas was still wet. Christ was caught by the same light we had left outside. His foreshortened body—a startling feat of perspective—floated over the same early evening sky above the familiar formation of the rocks.[16]

The painting, which Dalí had started on July 23, was finished just in time for the exhibition in December, where it was seen by Dr. Honeyman, then the director of the Glasgow Art Gallery, who took home with him a photograph of the painting and another of the study for the figure of Christ, which was also in the exhibition. The drawing was priced at £250 and the painting at £12,000, but Honeyman believed that if a public art gallery was interested, Dalí would accept a lesser sum. Deliberations then ensued between the president of the town council, J. D. Kelly, and his colleagues, who ultimately agreed that Glasgow had "done nothing courageous in the matter of buying a picture since it had purchased the portrait of Thomas Carlyle by Whistler."[17] The picture was traveling to Spain and then Switzerland on exhibition, and could be viewed by the purchasing committee in Glasgow for only twenty-four hours. A special meeting of the committee was held in the Satinwood Salon of the city chambers. "The unframed painting, set into an upright packing case, stood on the floor," it was later reported. "It was immediately evident that the painting had the effect of stirring hitherto unknown depths in the emotions of many who viewed it."[18] A cross section of the public, assembled

hurriedly in the city chambers, reacted extremely strongly, both for and against, but the purchase went ahead for £8,200, including the copyright. Dalí's *Christ of Saint John of the Cross* is still the best-selling postcard the museum produces, thirty years after they bought the original.

Not by any means all the critics were on Dalí's side. That archetypal dandy Osbert Lancaster was not impressed, writing an essay the day after the exhibition opened at Lefevre entitled "Is Salvador Dalí Still Painting to the Gallery?":

> . . . With all the technical equipment of a promising student at the Academy Schools in the days of Lord Leighton, this Spanish exhibitionist revived the old method of presentation, changed the subject-matter and was hailed by a forgetful public as a new genius. Cleverly combining the classical and the homely, he painted nude goddesses and meaty still-lives with all the fiddling realism of a Victorian ARA [Associate of the Royal Academy]. The only difference was that where the ARA used two canvases he used one. Removing the goddess's face he replaced it with the Sunday joint and put a chest of drawers in her stomach for good measure. Where the ARA drew his inspiration from the Bible or Tanglewood Tales, Dalí relied on the gospel according to Freud. In both cases the result smelt of literature. Now we are told all that is over. Reconciled to the Church a new, regenerate Dalí presents a series of canvases dedicated to the highest themes open to an artist. It is as though a tout who normally offered "artistic nudes" had suddenly changed his stock-in-trade to illuminated Mass-cards. But all produced by the same firm. The same arbitrary composition, the same inevitable low horizon, the same linoleum finish. And just about as much religious feeling as "Through the night of doubt and sorrow" played on a Wurlitzer in the interval of a leg show.[19]

Lancaster rounded off his review by concluding that Dalí had emerged in the 1950s as the "Lord Leighton of Sunset Boulevard."

Such bile often has reasons other than those declared: Lancaster himself had been a leading figure in the Victorian Revival movement of the 1930s. At that time Lancaster shared with Dalí a love of Victorian pictures, but Lancaster had by the early 1950s moved on and, while not exactly a prophet of modernism, had certainly eschewed his previous interest in narrative academic painting.

Dalí's reaction, in typically fractured French, to his friend Fleur Cowles, was magnanimous:

CI L'INTELLIGENT VOUS CONBAT C'EST SALUTAIRE, LE DESASTRE CET QU'AND UN IMBECILE T'AICHE DE VOUS DE FENDRE.*[20]

The second strand in Dalí's painting concerned itself with the nuclear issue, depicted most notably in *Disintegration of the Persistence of Memory,* which he painted on and off from 1952 to 1954. Here, according to the painting's owner, Reynolds Morse, who obtained the description from the artist himself, the rectangular blocks represent the atomic power source. The form of the head of the soft self-portrait of Dalí is depicted in a fluid manner. The representation of the rocks on the Bay of Cullero and the forlorn olive tree link the scene back to his paintings of Cap de Creus; the painting depicts those nuclear discoveries that have disturbed the serenity of Port Lligat and the entire world.

Dalí had, of course, always been interested in natural science (his father had once thought of agronomy as a viable career for him). As he grew older this interest became stronger and developed into a deeper understanding of the philosophical questions posed by developments in quantum and nuclear physics. Dalí kept up with scientific developments through *Scientific American,* which had become one of his favorite magazines when he finally learned to read English in the early 1940s. His lawyer, Michael Stout, remembers Dalí's excitement when a new issue of the magazine would arrive, and that Dalí was able to read it cover to cover in no time at all and then discuss its contents knowledgeably.

It was as if his study of physics added a fourth dimension to the world he painted, another twist—not Surrealist but metaphysical—to the inner landscape he portrayed. This is particularly manifest in another painting exhibited at the Lefevre Gallery at the same time as the *Christ,* entitled in the catalog *Dalí à Six Ans Soulevant avec Précaution la Peau de l'Eau pour Observer un Chien Dormir à l'Ombre de la Mer.* The painting contains the familiar themes of the granite cliffs reflected in a

* If the intelligent man combats you, it is salutary; the disaster is when an imbecile tries to defend you.

mirrorlike sea, but now the sea is turned back by the child-Dalí figure, revealing a dog below its surface. It is as if Dalí has painted the sea as the heavy water of an atomic reactor. Physics and Surrealism fuse in this painting, but there is a hint, too, of something else: The painting contains some elements of Piero di Cosimo's *A Satyr Mourning Over a Nymph* (which is in the National Gallery in London and was almost certainly seen by Dalí in the 1930s). The nymph in Cosimo's painting is lying in a landscape that looks as if the sea has been turned back, and she is being regarded by a very grave dog, the same dog that made his appearance in *The Metamorphosis of Narcissus*. Dalí would paint a further version of this work, entitled *Dalí Nude, in Contemplation Before the Five Regular Bodies Metamorphosized into Corpuscles, in Which Suddenly Appears the Leda of Leonardo Chromosomatized by the Visage of Gala*. In another painting in the exhibition, *Exploding Raphael Head*, Dalí combines the classical in the form of the interior of the Pantheon with Raphael's head of a Madonna, thus forming another in the series of his double images; now, however, nuclear physics intervene, and the head is splitting into its component atoms.

The 1950s were a time of vivid intellectual and artistic activity for Dalí, who was seeking his own way out of what he saw as the dead end of modernism toward something that would better reflect the Atomic Age without leaving tradition behind. It was classical tradition on which he then erected his metaphysical structures. This new preoccupation with what he termed his "Nuclear Mysticism" had led him to write his "Mystic Manifesto," which formed the theme of an exhibition at the Berggruen Gallery in Paris in June 1951. His view of the painters of the then emerging abstract expressionist movement was typically succinct: "They might as well be painting with shit, their material comes so directly from the tube of their biology without mixing in it even a bit of their heart or soul."[21]

After his show in London, Dalí went on to New York. He began to experiment not just with the application of metaphysics to his painting but with new and perhaps easier ways of making money. The means by which Dalí could make even more out of exploiting his cornucopia of talents was not long in presenting itself.

In February 1952, Dalí went on a lecture tour of America dis-

coursing on "this new cosmogony which integrates metaphysics with the general principles of progress unheard of in the exact sciences of our times."[22] What the students at the University of Northern Iowa in Cedar Falls, or the burghers of Kansas City, Dallas, and Winter Park, Florida, made of this lecture is hard to imagine. One is tempted to draw a parallel with Oscar Wilde's American lecture tour in the 1880s, when he spoke on the aesthetic movement. The audiences in both cases came to see the dandy in performance rather than to listen to the lecture. In Dalí's case, as in Wilde's, the tour was a great success.

Back in Port Lligat in May, Dalí began to write what he had intended to be a second volume of his autobiography, originally entitled *Re-Secret Life* but eventually published as *Diary of a Genius*. The book ostensibly covers eleven years of Dalí's life, from 1952 to 1963. Neither an autobiography nor a diary, it is a series of *pensées* loosely linked by an intermittent diary format. In it, Dalí develops certain themes: nuclear mysticism, farts, and the mystical implications of the rhinoceros horn as central to his painting; as Dalí put it in the diary, "Leonardo had his eggs, Cézanne cubes and cylinders, Ingres preferred spheres. I have my rhinoceros horn."[23]

That summer Dalí painted his third important nuclear-mystic painting, which he called *Assumpta Corpuscularia Lapizlazulana* and of which he said that it represented the culminating point of Nietzsche's feminine will to power, the superwoman who ascends to heaven by the virile strength of her own antiprotons. Dalí termed these protons "Nicoids." The model for this canvas's Christ on the Cross, above which Gala is seen ascending into heaven, was a ten-year-old boy named Juan, the son of one of the fishermen from Port Lligat, whom Dalí and Gala had virtually adopted. The boy slept in their room with them, and Gala played with him, dressing up their cat to amuse the child. "Juan is a true mixture of Murillo and Raphael," wrote Dalí.[24] There is no further mention of this shadowy member of the Dalí ménage; perhaps when he grew up he was of little further use to them as a son-substitute.

The diary refers only to the time Dalí spent in Port Lligat; it makes no mention of the part of his life spent in Paris and New York. It is as if his real life were led in the Empordà and the rest was but a dream, irrelevant, not to be counted. The "diary," therefore, ends in November, at the time when Dalí left for his winter capitals.

By June 1953 Dalí was into his epistolary stride as he discussed a film he wished to make about a paranoid woman in love with a wheelbarrow, to be called *The Flesh Wheelbarrow*. Dalí was particularly pleased with the scene in which Nietzsche, Freud, Ludwig II of Bavaria, and Karl Marx were to sing their doctrines with "incomparable virtuosity," answering one another antiphonally to music by Bizet. He returned to one of his recurrent themes—the old lady with an omelet on her head. "Each time the omelette slides off and falls into the water, a Portuguese will replace it for her with a fresh one."[25]

On August 7, 1953, Arturo López-Wilshaw pulled into Dalí's small bay on his yacht, *Gaviota*, with the Baron de Rédé and other friends on board. Fun and games ensued:

> *Today we were photographed in super-disguise. Arturo had on a Persian costume and a necklace of large diamonds with the emblem of his yacht. I, the ultra-revisionist, wore turquoise Turkish trousers and carried an archbishop's mitre.[26]*

Dalí was pleased to be given the Turkish trousers and a chair that was a copy of a Louis XIV sledge, the back made out of tortoiseshell surmounted by a gold crescent.

But in spite of the high-society games, hints of deep doubt creep into Dalí's diary entries—as if he has constantly to reassure himself that he is doing what he wants and living the life he wants:

> *Sunday's path of perfection. Everything must be better! This summer we shall see the Lópezes twice. My "Christ" is the most beautiful thing. I feel less tired. My moustache is sublime. Gala and I love each other more and more. Everything must be better! Every quarter of an hour I become even more lucid, and I feel more perfection between my clenched teeth! I shall be Dalí, I shall be Dalí! Now my dreams must be filled with ever smoother and more beautiful images so as to feed my thoughts during the day.[27]*

Dalí was now forty-nine and may have been suffering from a form of the male menopause. Gala was in her early sixties, and much to the

horror of the inhabitants of Cadaqués she had developed a passion for almost daily expeditions with the young fishermen of the port, during which they would take her bright yellow boat and sally forth to the hidden coves of Cap de Creus, have a picnic, and make love. Dalí had always condoned Gala's nymphomania, but her continued absences on these sexual fishing parties left him to his own devices when painting. Having been used to Gala's almost continual presence in his studio, where she read to him while he worked, his increasingly solitary existence at a difficult time in his life must have saddened him. On August 11 he records an unusual event: Gala asks him to go with her on a trip to Cap de Creus and they spend an afternoon "worthy of the gods"; but then, he adds, when they return they feel "exactly as if [they] had lived through a dead afternoon."[28]

The almost psychic closeness he had shared with Gala for the past twenty-five years was gradually but surely coming to an end; yet Dalí refused to believe it and constantly reassured himself as to Gala's loyalty and devotion. In his *Dalí Nude* painting there is an air of supplication in the way he depicts himself as he looks at Gala's face, an air almost of bewilderment. Not even the visits of the Lópezes or other friends, such as Eugeni d'Ors, making his first trip to Cadaqués in nearly fifty years to write his book *Lidia de Cadaqués,* could allay Dalí's growing sense of isolation.

Dalí did have company that summer and for some years to come in the shape of Tim Philips, a young Canadian with ambitions to paint who was the heir to the Massey-Ferguson fortune. Dalí wrote that an angel had sent Philips to him, adding that he had set up a studio for Philips in a shed. But, still, Dalí needed to reassure himself. On August 24 he writes that it is like a honeymoon with Gala: "Our relations are more idyllic than ever."[29]

Meanwhile, in spite of his obvious unhappiness and loneliness, Dalí was working as hard as ever on a new painting in his religious series, the *Corpus Hypercubicus.* Robert Descharnes tells us:

> All of Dalí's painting is based on research which reveals his need to control his imagination and his technique by strict rules. . . . Dalí discovered in Ramon Llull's New Geometry the perfect square of the "Figura Magistralis."[30]

It was this theory of Llull's that inspired Juan de Herrera, the Spanish architect who built the Escorial, to write his *Discourse on the Cubic Form,* which in turn inspired Dalí to paint *Corpus Hypercubicus.*

By September 1953 the Dalís were on their way again to Paris and New York.

Before they departed, Dalí made sure that his beloved Port Lligat would never be destroyed through overdevelopment by persuading Franco (who knows how) to sign a decree officially declaring Port Lligat a "national beauty spot." The document stated that the "secluded spot of Port Lligat is every day more and more in danger" and that Franco's action in putting it under government protection was to save it from undergoing what the document laid out as "lamentable denaturalizations that, without doubt, would militate against the specific quality of austerity that it is expedient to defend."[31] Dalí had made sure that the mineral magic of his landscape would not be ruined by the increasing invasion of tourism along the Costa Brava, and that the world he had made his own would remain inviolate as long as he lived.

Now a new period in Dalí's life began, stimulated by the growing distance between him and Gala. Gala was always present when it came to business dealings or entertaining important clients, but tended more and more to spend time with young men. Even when it came to the smart parties she used to love going to with Dalí, she now needed coaxing to accompany him and would leave after he had been absorbed into the crowd, going off for a rendezvous with some young lover. Old friends noticed the change. Max Ernst called Gala a "parody of a woman," and Léonor Fini observed that she had become a living impersonation of herself, and that "she wore this like an armour, very closed up inside herself."[32]

The most important addition to Dalí's circle of personal friends was a woman very different from Gala. Nanita Kalachnikoff is a beautiful and intelligent Spaniard, the daughter of the writer José María Carretero, who is known as *"El Caballero Audaz"*; she was married to a

Russian and lived for most of the year in New York. Dalí called her "Louis XIV," for her face, particularly its commanding nose, always reminded him of the Sun King. They met by chance at a charity ball in New York in 1953, and formed the closest and happiest friendship of Dalí's later years, a friendship that would last until the end of his life. At first they saw each other in New York during the winter and sometimes in Spain in the summer, but during the next twenty years she spent more and more time with Dalí, traveling with him, always a slightly mysterious figure in the background of Dalí's so-called Court of Miracles but always very close to him. Dalí treated her as a combination best friend, accomplice, talisman, and adviser.

In the last years of the 1950s, Kalachnikoff and Dalí became so close that she was the only person, aside from Gala, he would permit to touch him. It was she, for instance, who used to wash his hair and put it into rollers before he made one of his appearances. There is some evidence that Gala eventually took fright at the growing importance of this relationship, and it is said by friends of Dalí's that one of the main reasons Dalí and Gala married in the Catholic Church was because of Gala's apprehension. Gala may have taken steps to protect her "investment" as early as 1955, for it was in that year that Dalí organized an audience with Pope Pius XII, ostensibly to show him his painting *The Madonna of Port Lligat* but in reality to obtain an authorization to marry Gala in church (made possible by the death of Paul Eluard three years previously).

On his way to the audience, Dalí ran into René Clair, the film director, whom he had met through Buñuel in Paris in the late 1920s. Clair asked him where he was going "with all those strings" (Dalí had not given up the habit of attaching himself bodily to his paintings when in transit). When Dalí told him he was taking a painting to show the Pope, René Clair did not believe him and teased Dalí by asking him to give the Pontiff his respectful regards. By the time Dalí came back, Clair had read of the audience in the *Osservatore Romano.*

The religious marriage between Dalí and Gala took place three years later, in 1958. Unlike almost everything that Dalí ever did, the marriage was kept very quiet. The ceremony was held in the anonymity of Girona rather than in Figueres or Cadaqués.

Gala, while never becoming very close to Nanita Kalachnikoff, certainly tolerated and latterly encouraged her place in Dalí's life. She was

useful. Dalí could safely be left in her company, for instance, when Gala wished to spend time with one of her young lovers.

Kalachnikoff continued to be a somewhat enigmatic fixture. It was possibly she who was instrumental in inadvertently introducing Dalí to Captain Peter Moore, an Irishman who at the time was working for Alexander Korda, the filmmaker. One story has it that Captain Moore met Dalí in 1951 when Moore was setting up an internal television circuit in the Vatican, and that he was instrumental in arranging for Dalí's audience with the Pope; another version is that Moore was sitting in the Palm Court of the Plaza Hotel, taking tea one day, when Dalí and Kalachnikoff walked in. Dalí made a fuss about the music and tried to get the violinists to play zarzuela music or, failing that, some tangos, and in so doing attracted attention, including the eye of Captain Moore. He came over to their table and introduced himself. In any event, Moore made it his business to stay in touch with Dalí, occasionally helping him by running errands. In 1955, for instance, he obtained for Dalí the important commission of a portrait of Laurence Olivier as Richard III, which was to be used as a film poster. But it was not until 1962 that Moore actually went to work for Dalí.

In 1951, Robert Descharnes, a young French photographer and writer on the avant-garde whose work had been published in *Horizon, Réalités, Art News,* and other magazines, met Dalí in Paris because Dalí wanted him to photograph the face of a young woman for the sketches of a painting on which he was working. The next year, Descharnes went to see Dalí and Gala for the first time in Port Lligat, and so was drawn into the expanding circle of Dalí's regular collaborators. Beginning by taking photographs of Dalí, Descharnes, who had already made one experimental film based on Dalí's friend Georges Mathieu's first major tachist work, *The Battle of Bouvines,* found himself working in 1954 with Dalí on his film *The Prodigious Adventure of the Lacemaker and the Rhinoceros.*

Dalí was ceaselessly active during the 1950s. There were books to be illustrated and to be written, jewelry to be designed, fashion and even a perfume to be marketed. Dalí's collaborators included Descharnes and the Figueres photographer Meli (Meliton Casals Casas), Philippe Halsman, and Mrs. Mafalda Davis. Mrs. Davis first

came to the attention of the jet set through her status as unofficial lady-in-waiting to King Farouk's first wife, Queen Fawzia. An Egyptian by birth, she sprang suddenly to prominence in that portion of international society that had re-formed after the war. Some of the cast of characters were the same, such as the López-Wilshaws and Carlos de Bestegui; some were newcomers. Mrs. Davis was one of the first to realize that Dalí's inexhaustible geyser of ideas and creativity could be put to solid commercial use for his financial benefit. Her first exercise was to sign the painter up to produce a perfume called Rock and Roll.

Whatever Dalí touched turned to gold, but Dalí was always in a terrible muddle. Contracts were signed, advances paid and then forgotten. The company that had given him the contract to create a perfume held a press conference to launch the idea they thought Dalí had been working on. He, of course, had done nothing. Arriving at the press conference, he seized a photographic flashbulb and named the scent Flash.

The one entry in Dalí's diary for 1955 concerns a lecture he gave at the Sorbonne on December 17 entitled "The Phenomenological Aspects of the Paranoiac-Critical Method." He arrived in a white Rolls-Royce entirely filled with cauliflower. The lecture concerned his ongoing obsession with the twin themes of Vermeer's *The Lacemaker,* which he had first observed hanging on the wall of his father's study, and rhinoceros horns. Dalí took his audience deep into his mind, leading them from connection to connection, from the logarithmic spirals of *The Lacemaker* to the copy of the painting he had made—and then replicated fifty times—to the photographs he had taken of these replicas installed in the garden at Port Lligat, surely an early example of art installation owing much to the games he had played before the war. He showed the audience slides of the Vincennes Zoo, where he had confronted a rhinoceros with the painting (the rhinoceros promptly slashed it). Dalí demonstrated not only art installations but an early piece of performance art.

He then drew connections between the morphology of the horn and of sunflowers—"a sort of galaxy of logarithmic curves in the shape of a sunflower"—and then proceeded to cauliflower, the morphological problem of which was, to Dalí, identical to the sunflower, insofar as it, too, is composed of logarithmic spirals. The audience applauded as each connection was made; Dalí concluded his lecture by saying, "Af-

ter my remarks this evening, I think that in order to be able to proceed from the *Lacemaker* to the sunflower, from the sunflower to the rhinoceros, and from the rhinoceros to the cauliflower, one must really have something inside one's skull."[33]

In 1956, Dalí picked up his diary again; the entries are less introspective and more confident. On May 10, for instance, he wrote that he was "in a state of permanent intellectual erection, and all my desires are granted."[34] Joseph Forêt, the art publisher, had made the laborious trip to Port Lligat weighted down with heavy lithographic stones to persuade Dalí to illustrate *Don Quixote* for him. At the time (but not later), Dalí was "against the art of lithography for aesthetic, moral and philosophical reasons," considering the process was "without strength, without monarchy, without inquisition."[35] In other words, the project either bored Dalí, or Forêt was not prepared to pay enough for it. Forêt, however, was persistent to the point that Dalí suggested he might execute these lithographs by the expedient of shooting bullets filled with ink at the stones by means of a specially constructed harquebus. Forêt agreed. (As with so many of Dalí's ideas, this one had its roots buried deep in his past; according to him, he had won a bet when at the Residencia in Madrid that he would win the Grand Prix for painting without touching his canvas with a brush. The results of Dalí's flicking paint at the blank canvas did, indeed, win the prize.) Georges Mathieu provided a fifteenth-century harquebus, and in Paris that winter, aboard a barge on the Seine, Dalí fired his first salvo. He called this novel way of creating an image "Bulletism." It was his answer to abstract expressionism.

The lithographs sold for large sums of money, which gave Dalí pause. However much he played jokes or "cretinized" the public, they would still pay, and pay handsomely, for anything at all signed "Dalí." The germ of this idea lay dormant in Dalí's mind for some years, but when it flowered in the mid-1960s, it would lead Dalí into some extremely questionable activities.

The latter years of the 1950s were very productive ones for Dalí as a painter. In 1955 came *The Last Supper,* another controversial religious picture, which was bought by the American collector Chester Dale and subsequently given by him to the National Gallery of Art in Washington, D.C., where it still hangs in spite of the efforts of various directors of the museum over the years to have it relegated to a basement. In

1958–1959, Dalí began the first of the huge narrative works depicting historical events and Spanish myths that were so much a feature of his art in the 1960s. *The Discovery of America by Christopher Columbus,* a vast painting over twelve feet high, was bought by Huntington Hartford, then, subsequently, by Reynolds Morse.

In his first diary entry for 1958, Dalí admits that it was difficult to hold the world's interest for more than half an hour at a time:

> I myself had done so successfully every day for twenty years. My motto has been: "Let them speak of Dalí, even if they speak well of him." I have been successful for twenty years to the extent that the papers publish the most incomprehensible news items of our time sent by teletype.[36]

Dalí's attitude had always been that quantity was better than quality when it came to publicity, and in the mid- to late 1950s, he deliberately courted publicity with a series of carefully contrived happenings that fed the public's appetite for anything about him. One such included Dalí being

> reborn; in the torchlit gardens of the Princess Pallavicini in Rome, rising out of a cubic egg covered with magic inscriptions by Ramon Llull, after which he delivered an oration in Latin. In Paris, Dalí resuscitated his pre-war bread theme and walked through the city carrying a loaf of bread fifteen yards long which was left on the stage of the Théâtre Etoile, where he delivered a lecture on Heisenberg's "cosmic glue." In Barcelona, Dalí and Luis Dominguín, the great matador, announced their plans to hold a Surrealist bullfight at the end of which a helicopter, dressed as an Infanta in a dress by Balenciaga, would carry the sacrificed bull into the sky and then set it down in the sacred mountains of Montserrat. In New York, Dalí called a press conference at which he was dressed in a golden space-suit inside an "ovocipede"—a transparent sphere indicating his intrauterine memories.[37]

But it was television that really brought Dalí home, as it were, to millions who were not interested in his painting but were fascinated by this eccentric who always made sure he gave a "good show." He told Mike Wallace as much in a lengthy television interview in 1958: "You see in Dalí is one marvelous painter, in living time is one marvelous clown . . . is thousand times much more interesting to everybody."

"You want to be a marvelous clown as well as a marvelous painter?" asked Wallace.

Dalí replied, "If it is possible, live two together is very good, you know. Charlie Chaplin is one genuine clown but never painted like Dalí. . . . Most important in my life, modern clown, modern painting, modern draftsmanship, is my personality. . . . My personality is more important than any of those little facets of my activities. . . . The painting, the clowning, the showmanship, the technique—everything is only one manner for express the personality of Dalí."[38]

Dalí understood the power of television. Indeed, he consciously treated his appearances as happenings that had to be carefully thought out and choreographed. When, for instance, he appeared on CBS in 1956, his list of demands for his appearance included an assortment of electronic stunts, the head of a rhinoceros, twelve cauliflowers, a film clip of an atomic explosion, a reproduction of *The Lacemaker,* and a photograph of a rhinoceros horn superimposed onto the head of the lacemaker.

Alan E. Brandt was the publicity man for the CBS morning show at the time, and it fell to him to deal with Dalí, who had decided to take his position as "director" in the control room. Four cameras were used to shoot in a strict sequence dictated by Dalí, who was also filmed "directing" the segment. In the course of his direction he caused the camera to sweep across the studio to give pictures of the entire crew, including the propmen, at work with their cauliflowers.[39] Dalí was using television to make experimental films descended from those ideas he had developed with Buñuel in the late 1920s. Twenty years later, when he was being interviewed by Russell Harty for the BBC film *Hello Dalí,* he managed to manipulate the cameras, director, and technicians in such a way as to create a personal and Surrealist narrative that took place within and in spite of the fairly conventional interview Harty was attempting to conduct.

It was not just the international press that was interested in Dalí's personality; so were an increasing number of psychiatrists who saw in him, as Freud had done twenty years before, an articulate example of abnormal psychology always available for close observation. Jacques Lacan, who had analyzed Dalí in the early 1930s, subsequently wrote papers on him. After the war, Dalí attracted others, such as Dr. Pierre Roumeguère of the Paris Faculty of Medicine, the author

of a treatise entitled "The Dalinian Mystique in the Context of Religious History."

Jean Bobon, who was the chief psychiatrist at the psychiatric clinic at the University of Liège, observed in an essay he wrote in 1957:

> *Dalí was a man particularly wrapped in paradox and contradictions. His work is so vast and rich as to seem at first glance to be confused, and full of fantasy, sometimes obvious, apart from all consideration of technique. It is nothing of the kind. In fact it expresses a remarkable continuity. . . . Dalí is known as a "perverse polymorph"—sexuality, genitalism, masturbation, and exhibitionism underlie his "secret life." All this, which is only part of a superficial explanation, is shown in the burgeoning erectile head where the sexual instincts appear cerebralized and sublimated by art. . . . Everything corresponds and is symbolic in the Surrealist work of Dalí, whose richness of expression is often the more profound the less it might seem so.[40]*

By the end of the 1950s, Dalí was certainly, together with Picasso, the best known painter in the world. But he still managed to play his lifelong game with the public according to his own rules; he managed to keep the "secret within his secret." Television can be revealing, however, and sometimes, though not very often, Dalí would drop the mask and reveal himself to be a man of extraordinary intelligence and concentration, one very different from the clown he had created for a public voracious not for orations about logarithmic spirals but for yet more instances of his eccentricity.

The love affair between Dalí and the media was one of manipulation on both sides; everyone got what they wanted. Dalí got the fame he had craved ever since he needed to prove himself to his father, and the media had found a subject who would always oblige with some eccentric happening. In the 1950s, Dalí was still in control of this second, clowning personality he had created. In the ensuing two decades, however, as Dalí grew older, he and his simulacra would swing monstrously out of control as the lines between clowning and the truth began, inevitably, to blur, and his Surrealist antics became, in the end, his real life.

13

THE HALLUCINOGENIC TOREADOR
1963–1969

In 1960, twenty years after he wrote the epilogue to *The Secret Life*, in which he described how he saw himself naked in a mirror and came to the conclusion that his "body exactly resembles that of my adolescence, except for my stomach which has grown bigger,"[1] Dalí congratulated himself in *Diary of a Genius* that his hair was still black, his feet had not yet known the "degrading stigma of a single corn,"[2] and that the incipient obesity of his belly had corrected itself after an appendicitis operation the year before. The last of the great dandies was, at fifty-six, at the top of his bent as a shamanistic conjuror of magic, fame, and money. As Georges Mathieu wrote at the time:

> Endowed with the most prodigious imagination, with a taste for splendour, for theatre, for the grandiose, but also for games and for the sacred, Dalí disconcerts shallow minds because he hides truths by light, and because he uses the dialectic of analogy rather than identity. For those who take the trouble to discover the esoteric meaning of his movements, he appears as the most modest and the most fascinating magician, who carries lucidity to the point of knowing that he is more important as a cosmic genius than as a painter.[3]

Dalí himself always maintained, whether he truly believed this or not, that painting was his least important aspect.

> The thing that really counts is the almost imperialist structure of my genius. Painting is only an infinitesimal part of that genius. I express

*myself, as you know, with jewellery, flowerbeds, eroticism, mysticism.
. . . Painting is only one of the means of expression of my total genius,
which exists when I write, when I live, when in some way or other I
manifest my* magic. *. . . . A painting is such a minor thing compared to
the magic I radiate.*[4]

But a painter he was; he sought out and informed himself of new
ideas, principles, physical laws, laws of the natural world, scientific
discoveries, all to inspire and to feed his painting, just as his fertile
subconscious had informed his early Surrealist work. As he himself
put it:

It is from some ideas stemming from Perpignan station that:

*While looking for the "quantum of action"
The painting itself, the painting it self, the
paint ing it self is there.
While looking for the "quantum of action"
How many experiments will he paint there
The painting itself, the painting it self, the
paint ing itself is there.*

*I had to find in paint this "quantum of action" which nowadays rules the
microphysical structures of matter, and it could be found only through my
capacity to provoke—supreme provocateur that I am—all the kinds of
accidents that might escape the aesthetic and even animist scrutiny, in
order to be able to communicate with the cosmos. . . . The painting
itself, the painting it self, the paint ing itself is there.*[5]

Dalí kept himself well-informed about scientific developments. James
Thrall Soby wrote in the 1946 Museum of Modern Art exhibition
catalog that "Dalí is a carnivorous fish . . . swimming between the
cold water of art and the warm water of science."[6]

Dalí himself admitted that he was not only an *agent provocateur* but
also an *agent simulateur.*

*I never know when I start simulating, and when I'm telling the truth. This
is characteristic of my deep essence. It often happens that I say some-
thing, fully convinced of its importance and seriousness; a year later I
realize how childish the thing is and how uninteresting, to the point of*

being lamentable. On the other hand, I may say something with a laugh, just to appear smart or to astound someone, but as time passes I become convinced that I've come out with something very fine and very important. These alterations ultimately confuse me, but I always manage to extricate myself. But whatever happens, my audience mustn't know whether I'm spoofing or being serious; and likewise, I mustn't know either. I'm in a constant interrogation; where does the deep and philosophical Dalí begin, and where does the loony and preposterous Dalí end?[7]

Slowly, imperceptibly, his world was changing. The friends he had made before the war were now old, dying, certainly not willing to provide him with the audience and approbation he constantly craved. The remnants of the old smart Paris society had virtually vanished, but a new and very different generation was growing up to replace those lost by time.

The discovery of Dalí by the postwar generation had its genesis not only in the constant publicity that attended his every pronouncement or happening but also in a Surrealist exhibition put on at the Galerie Charpentier in 1964, not by Breton but by Patrick Waldberg, an art critic who had parted ways with Breton and the survivors of the Surrealist movement in 1951. Breton was furious. Dalí's *Le Jeu Lugubre*, a version of *The Persistence of Memory*, several drawings, and a Surrealist object, *Homage to Kant*, formed part of this exhibition, and a new audience discovered for itself what Dalí had actually achieved at the height of his powers and while working in the center of the Surrealist movement.

Dalí had become very popular with young Parisian intellectuals at the beginning of the decade. They saw in him a vibrant survivor of what they were coming to regard as the golden age of dissent, the 1920s. Having turned their backs on existentialism at the end of the 1950s, the students of Saint-Germain had become interested in Surrealism, seeing, in the rebelliousness and generally iconoclastic attitude of the Surrealists' activities in the 1920s, a matrix from which they could organize their own dissent. The lecture Dalí gave at the prestigious Ecole Polytechnique, for which five hundred students assembled in evening dress to hear him talk about Castor and Pollux, the divine twins, became a statement of how Dalí saw himself in the modern world.

Dalí maintained cordial relations with Parisian students throughout the decade, culminating in his distributing at the Sorbonne on May 18, 1968, in the middle of the *événements* of the time, a tract entitled "My Cultural Revolution: Quantified Institutions."

Add a quantum of libido to the anti-pleasure organizations, as, for example, UNESCO. Make UNESCO a Department of Public Cretinization, so as not to deprive ourselves of what has already been done. Include here praiseworthy, folkloric prostitution, but add to this a very strong libidinous and spiritual energy. Thus to metamorphose the threshold of superboredom in a true erogenous zone, under the auspices of Saint Louis, the first legislator of venal love. Note: There where a cultural revolution has occurred the fantastic will grow.[8]

However, when the barricades went up, Dalí and Gala took fright and set off precipitously in the latest in their series of big black Cadillacs for Spain. They did not even pause for their accustomed gourmet halts at Dijon and Lyon.

Dalí was about to be taken up by a generation that was less interested in his painting or in his political views than in the phenomenon of his personality, in his fame, and in the means whereby he fed this monstrous mistress. Dalí's insouciant attitude toward his sexual problems also struck a chord with this younger public, who equated his struggles to fulfill his curious sexual destiny with their own desire for sexual liberation.

The first postwar baby boomers had grown up into an era of unequaled prosperity. Those who came of age in the mid- to late 1960s were the largest generation on earth, and they had enormous spending power. They traveled constantly, as only the rich had been able to do before World War II. They were adventurous people who thought nothing of taking a bus to Katmandu dressed in flowery rags; who explored Eastern mysticism; who took drugs; and who turned their backs on conventional society. Many of them found their way to Dalí at Port Lligat, and gradually these flower children adopted him as a mascot of liberation and eccentricity.

Dalí was an obvious father figure for the liberated 1960s; after all,

he had been leading a very public, liberated, and hedonistic life for the previous three decades. "Those kids worship me. . . . They know that I am more or less responsible for their exaggerations and their paroxysms," Dalí told Alain Bosquet, who had said that they were not part of Dalí's generation. But, asked Bosquet, did they really know him? "We meet unknowingly in mysticism," Dalí replied.[9] "Of course," wrote one critic, obviously not an admirer of the Dalí myth, "his inspirational short cuts to knowledge could hardly fail with the semi-literate young."[10]

What made Dalí different from the hippies slouching toward magic and Nirvana, however, was that Dalí worked enormously hard and led a disciplined life. Unlike his new acolytes, Dalí did not take drugs—he knew he did not need to expand his mind by this means. (Gala, on the other hand, may well have done.) Indeed, he now never even drank, not since he had passed out after drinking sherry about fifteen years previously, an occurrence that had frightened him, for Dalí was immensely protective of his intelligence, in a very superstitious way, and feared losing control of it.

His audience of flower children with long, lank, Pre-Raphaelite hair and vacant eyes thrilled Dalí because he liked the way they dressed. More important, they provided him with a wonderfully appreciative new public for his happenings. Because they practiced free love, the hippies also provided him with a constant supply of fresh young boys and girls seemingly without any inhibitions at all, prime candidates for his sexual cabarets. In the 1960s, these carefully staged erotic pantomimes provided more complicated and decadent equations than even the most advanced Surrealists had dreamed of.

Dalí's personality and fame were also a magnet to leading figures in the subculture of the period, among whom was Ultra Violet, who became a star in Andy Warhol's early films and was one of the icons of the early 1960s; she floated into Dalí's orbit under her original name: Comtesse Isabelle de Bavière. It was not long before Dalí asked Ultra Violet whether he could make a drawing of her in the nude: "I recline on a gondola draped with Venetian draperies. A large lobster shell, dipped in a bath of gold, rests on the arm of a Madonna, ready to be incorporated into the portrait *Venus Awaiting a Phone Call*."[11] True to form, Dalí was reworking a theme he had embarked on many years before, in this case the Venus motif he had used at the World's Fair in

1939 and, at the beginning of his career, in *Venus and a Sailor (Homage to Salvat-Papasseit)*. Having done a lightning drawing, Dalí then aroused Ultra Violet with erotic passes of the lobster, but he never touched her, saying, *"Jouons à nous toucher les langues."* Seizing the golden lobster, he caressed Ultra Violet's thigh with it, trailing its tail through her pubic hair. She reached to embrace him, but he screamed, "Not yet, my little Catholic girl"; then the telephone rang and Dalí used the lobster as a receiver (a repetition of another familiar theme). Then he threw it out of a window.

Dalí's Court of Miracles consisted of a fluctuating cast of dwarf hermaphrodites, cross-eyed models, twins, nymphets, and transvestites (who to Dalí were the personification of his double image). Dalí also surrounded himself with more conventional friends and advisers, among whom were Albert Field, a sixty-year-old schoolteacher from Astoria, New York, who had been appointed Dalí's official cataloger and archivist; the elegant Nanita Kalachnikoff; and Captain Peter Moore, who, in these early years of the 1960s, was putting together more and more deals for Dalí. The Court met in Paris, it met in New York, and it found its way to Cadaqués in the summer, becoming more and more extravagant, drawing into its circle not only members of high society but also hippies Dalí had picked up on the beach below his house. That these pickups were casual is to understate the manner in which Dalí found his acolytes. Julian Hope, the opera director, remembers a visit to Cadaqués in 1969: "Roger—a friend of mine— and I were in the hotel just above the house, just looking down on it, and the great man suddenly appeared, so we said, 'Bonjour, maître,' and we were absolutely thrilled when he asked us to drinks that evening at six o'clock."[12] During drinks, Dalí told Hope's friend Roger that he had a rather Pre-Raphaelite look and was a perfect Saint Sebastian. Thereupon Hope was firmly shown the door by the butler, leaving Roger with Dalí. Roger appeared the next morning looking very white and never talked about what had happened. "Obviously it was rather a routine in a sense, staging these things," Hope concluded.[13]

But Dalí had not diminished entirely into a voyeur with a paintbrush; he continued to cultivate the company of more serious people in the interests of his scientific researches. The contrast made of his life

a uniquely Dalinian mixture of the silly and the serious. He wanted to experience everything.

Among the serious people were Francis Crick and James Dewey Watson, the discoverers of the DNA double helix. The two scientists had lunch with Dalí in New York in 1962, together with Ultra Violet. Crick and Watson were puzzled by Dalí's deliberately mangled English. The menu was in French, and Dalí ordered puree of string beans for them, claiming it would nourish their own deoxyribonucleic acid. The lunch went from eccentric to absurd as Dalí pulled out of his pocket a lobster painted gold. He explained that he was fascinated with scientific literature and had recently read that the urine of geniuses contained a large amount of nitrogen. Ultra Violet told the two Nobel Prize winners that she had once drunk Dalí's urine to raise her genius level, but all it had done was to give her pimples. Crick and Watson suddenly remembered they had a plane to catch.

Eccentrically though he may have expressed it, Dalí was genuinely interested; he incorporated the double helix into his repertoire of images and syntactical references in his paintings. DNA became part of his work in progress.

Dalí began the 1960s by exhibiting in New York the first of a series of huge mythological paintings, of which he would produce one a year for the decade. Dalí explained that *The Discovery of America by Christopher Columbus,* also known as *The Dream of Christopher Columbus,* depicted in its foreground an effigy of the New World in the form of a giant sea urchin surrounded by the orbit of an artifical satellite. "This is the form of the new earth, prophesied two years before the flight of a satellite confirmed the so-called caricatural pear shape on which so many beings live without the slightest curiosity as to this form."[14]

The Ecumenical Council, painted and exhibited in 1960, celebrated the coronation of Pope John XXIII, and represented a return to Dalí's nuclear-mystic mood, being a further development on the theme of Gala as a classical Madonna, combined with nuclear-mystical atomic tracks, symbolic of the times.

In 1961, Dalí turned his attention to the ballet again, and wrote the story for and designed *Ballet de Gala,* choreographed by Maurice Béjart, which had its premiere at the Teatro Fenice in Venice. The

collaboration between Dalí and Béjart was not without problems—beginning with their second meeting to discuss the ballet, for which Béjart arrived at Port Lligat slightly early. He knocked on the front door, which was eventually opened by Dalí, who, pointing a finger at Béjart as if he had never seen him before, said, "You have come to assassinate me," trembling visibly the while. It took some time to reassure Dalí that he had, indeed, met Béjart in Barcelona a few days before.

When Dalí arrived in Venice in August 1961, Béjart encountered another problem: Gala had locked Dalí in his hotel bedroom to finish two paintings promised to rich Americans and would neither let him out nor let Béjart in to work with him. Dalí told him:

"Come to the hotel tomorrow morning and we'll walk round Venice together." But when I knocked at the door, Gala locked Dalí in the bathroom, or perhaps he was merely taking a bath and did not realize what was happening in the room outside. Meanwhile, Gala told me that Dalí had no wish to see me, but that evening at the theater, Dalí asked me why I had not come to the hotel to seek him out that morning.[15]

This was typical of Gala: She was never happy unless Dalí was working at some lucrative project. She did not mind whom she offended; she virtually kept Dalí a prisoner while he worked. "She was," says a friend of Dalí's, "very, very greedy indeed, but at the same time she was not very good with the money Dalí earned; she would keep checks in her handbag for years without cashing them, store cash in suitcases and forget it, and start bank accounts and forget them too."[16]

Dalí himself was completely oblivious to the mechanics of money and never had a signature on the many bank accounts Gala opened for them. She would hand out meager amounts of pocket money to him, knowing that if he did have any cash on him he would immediately spend it, either on some object that had caught his fancy (and of which Gala was sure to disapprove) or on taking a huge group of friends and hangers-on to a meal in an expensive restaurant. Accustomed to being treated as a child by his father, Dalí saw nothing abnormal in his wife's behavior.

Time magazine headed its review of this latest theatrical venture "Dalí vs. Scarlatti." On a balcony above the conductor Antal Dorati

and seventeen musicians wearing eighteenth-century breeches, peri-wigs, and white silk hose sat Dalí, attired in a gondolier's outfit and his familiar *barretina,* the red Catalan cap. He began splashing brown and gold paint onto a canvas with such vehemence that he splattered the astonished first-night audience below. He then ripped the canvas apart, and out flew a dozen frightened homing pigeons, flapping about wildly. The curtain then rose on Scarlatti's *The Spanish Lady and the Roman Cavalier,* a new title for his long-forgotten opera *Scipio in Spain,* composed in 1714. What they got, said *Time,* was Scarlatti heavily laced with Dalí.

The rising curtain revealed a ghostly painted image of Dalí, and as the gauze tableau faded out the heroine came on, her two-yard-long tresses supported by a red crutch. She then extracted what *Time* called a pie-size watch from her bosom and bestowed it on her suitor. There were other Dalinian touches: a colored tableau showing a large violin walking on spindly legs and stretching an arm toward a piano gushing milk, a blind man sitting before a television, and a procession of eight actors who dropped armfuls of china as an accompaniment to the music.

The Spanish Lady was followed by the Surrealist *Ballet de Gala,* set to music by Scarlatti. Onto a darkened stage walked a figure pushing a wheelchair, in which sat a cripple holding a flashlight. Soon the stage was filled with other cripples, who discarded their crutches, began plunging wire frames into seven barrels (filled with a liquid specially prepared by the French perfume house Guerlain) to produce weird geometric bubbles. In the ballet's climax, Ludmilla Tcherina emerged as the Supreme Mother in a black-and-white gown with flesh-colored breasts. Her nourishing power was symbolized by a cascade of "milk" (liquid carbon dioxide) from beneath the rafters (echoes of the *couronne de lait* Dalí had used before the war as a monarchical and Surrealist symbol). Such tried devices apart, Dalí was up to several other old tricks; those who had been in America during the war and had seen *Bacchanale* would have recognized many of *Ballet de Gala*'s props, but the predominantly European audience had never seen any-thing like it.

Reactions on the whole were bad. But *Ballet de Gala* was restaged in Paris later in the 1960s and found favor with a much younger audi-ence to whom Dalí's strange symbolism did not come as a shock.

* * *

In 1962, Dalí returned in his painting to yet another recurrent theme, that of the work of Mariano Fortuny, whom he had admired since the early 1930s. As a homage to the Catalan painter, Dalí exhibited *The Battle of Tetuan* at the Palau Tinell in Barcelona, telling Robert Descharnes that "this is how the Dalinian pictorial war has just begun."[17]

Dalí's huge canvases of the 1960s commanded enormous prices from a new generation of millionaire collectors in America. Steel magnates, bank presidents, and oil barons liked these big narrative pictures because they could understand them, unlike the work of the abstract expressionist painters. Dalí's big, handsome canvases appealed to patrons like Huntington Hartford and Chester Dale, who bought such paintings as *The Battle of Tetuan* and *The Last Supper* with a view to their eventual bequest to important museums.

It is interesting to compare these vast canvases of the late period of Dalí's work with the tiny pictures he painted at the height of his Surrealist period in the early to mid-1930s. The diminutive Surrealist landscapes with symbols from Dalí's subconscious scattered on their foreshores have a neurotic and precise intensity that the later, larger canvases lack. Dalí's inner obsessions had been mined out, and in their stead came these huge mythological scenes that relied for their effect on an external "story" combined with a far less exacting technique, resulting in a slackening of the tension that is typical of the earlier work. Dalí had, it would seem, finally lost touch with the wellsprings of his subconscious and, as far as painting was concerned, drew his ideas and inspiration from a much more superficial level of thought.

Occasionally during the early 1960s, however, Dalí would go back to the era of minute and sublimated erotic obsession in his painting. References to *Honey Is Sweeter than Blood* (1928) may be found in *Hyperxiological Sky*, in which a beach is depicted at severe angles, intersecting one another. In this painting, Dalí replaced the curious arrow forms that punctuated the flat surface of the beach in the original with inlaid gold nails and a tooth. These inlays were also somewhat reminiscent of the technique Dalí used in the painting *Anthropomorphic Beach* (1925), which had been banned from the Galeries Dalmau exhibition that year.

"I want to dedicate this painting to García Lorca with an inscription," Dalí told Robert Descharnes at the time, "for he had asked me to do so for another similar one: *Honey Is Sweeter than Blood.* 'Put my name in the painting so that my name may serve some purpose in the world.' I have finally decided to write the name of García Lorca combined with that of Gala, which forms the name 'Galcia Larca.' "[18]

In the sixties, painting was all about scale, and Dalí's work at the time was no exception. In 1963, the "big" painting, *Galacidalacideoxyribonucleicacid (Homage to Crick and Watson)*, depicting Gala in a nuclear landscape above which hover classical figures, was bought for $150,000 by the New England Merchants, National Bank of Boston, for one of those corporate collections whose support played a big part in Dalí's success during this period. *Homage to Crick and Watson* measured over 11′ × 10′ and looked imposing hung in a bank headquarters.

The catalog note for the exhibition at Knoedler read:

At a time when the titles of pictures are rather short (i.e. "Picture No. I" or "White on White") I call my Hommage [sic] to Crick and Watson Galacidalacideoxyribonucleicacid. It is my longest title in one word. But the theme is even longer: long as the genetical persistance [sic] of human memory. As announced by the prophet Isaiah—the Saviour contained in God's head from which one sees for the first time in the iconographic history his arms repeating the molecular structures of Crick and Watson and lifting Christ's dead body so as to resuscitate him in heaven.[19]

In explaining the painting at the time it was exhibited at Knoedler to Carlton Lake, the writer and art critic, Dalí said it had been painted with only three colors.

Mars brown, a golden yellow, ultramarine blue and that's all. It is in the spirit—oh, it is different of course, but it has that same dreamlike quality —of Watteau's painting "The Embarkation for Cytherea." Not the one in the Louvre; the one in Berlin. There is the same feeling in the crowd of figures that spiral upward toward the top of the canvas.[20]

Sometime late in 1962, Peter Moore became a full member of the Dalí circle, obtaining a commission on every contract he could bring

in—but not for Dalí's paintings, which he never sold. This very important activity was Gala's exclusive domain. Moore was infinitely better at negotiating graphic and other applied-art contracts for Dalí than Gala was at selling his paintings; she was no good as an art dealer. It was the right time for Moore to link his future with Dalí, who now referred to him as his "military attaché," for international interest in Dalí's work seemed to strengthen in inverse proportion to the growing disenchantment of the art establishment. The captain was able to capitalize in the form of contracts for Dalí to make prints, jewelry, limited-edition sculpture, even to design a fashion collection for a manufacturer named Jack Winter. But even though Gala had entrusted Moore with contractual negotiations, her secretive habits of a lifetime were still strong and he was not privy to what the Dalís did with their money; it was apparently years before he even knew the name of their bank.

"The beginning years, when [Moore] worked for him, were very happy ones for Dalí and Gala," says Nanita Kalachnikoff. "They had more and more money for which Dalí really didn't have to work so hard, and he was always coming up with new ideas to make money."

In 1963, Dalí finally published "The Tragic Myth of Millet's 'Angelus,'" on which he had been working in Arcachon before the fall of France. The manuscript had been lost for twenty-five years. Unlike his earlier Surrealist treatises, it did not attract a great deal of critical attention. However, another publishing venture in this year, *Dalí de Gala*—published in English as *The World of Salvador Dalí*—was favorably received. It was the fruit of a ten-year collaboration between Dalí and Robert Descharnes, containing candid photographs of the painter and his house, together with a commentary from Dalí on certain of his paintings and a portfolio of paintings from 1918 to 1962, obviously chosen and arranged by Dalí. For once the Dalinian prose was clear and explanatory rather than deliberately gnomic. The photographic portraits by Descharnes are unusual, too, in that many of them show the "deep and philosophical Dalí" rather than the "loony and preposterous" version he typically presented to the world.

Ever since Descharnes had met Dalí in 1951 he had been taking photographs of the painter, his wife, his work, and the minutiae of his

daily life. *Dalí de Gala* posed the question as to what the source of Dalí's inspiration was and attempted to answer it in a combination of photographs, paintings, and Dalí's comments on the paintings and on his life generally. Descharnes wrote in the introduction:

> *Whether one likes it or not, Salvador Dalí is one of the greatest painters of our century. The fact that both his work and his personality are in dispute changes nothing. While many of his contemporaries are today installed in sound and peaceful success, each of Dalí's paintings, and each of his actions, stirs up polemic. Yet controversy proves how fully alive his work is, and we are compelled to recognise that a prodigiously gifted artist lies behind the eccentricity. Tenaciously, Dalí continues to communicate his message, to make visible the invisible, to show the other face of both ourselves and our universe.[21]*

There is a slightly defensive note to this introduction; clearly, Descharnes was aware of the indifference shown to Dalí by the art critics of the time, who lauded abstract expressionism and dismissed Dalí as an aging mountebank. However, echoes of past preoccupations are to be found throughout the book, not only in the paintings but in the happenings Dalí staged for Descharnes's camera: for instance, a photograph of Dalí draped in a white sheet, a direct reference to the photographs taken in the early 1930s in the garden at Port Lligat of Dalí and René Crevel dressed in white sheets and pretending to be ghosts.

In the book, Dalí often added footnotes to his paintings. *The Great Paranoiac* (1936), he pointed out, was a face composed of the people of the Empordàn country, who are the greatest paranoiacs produced by the Mediterranean. Dalí explained that he had painted this picture after a discussion on Arcimboldo with José María Sert.

Descharnes took many photographs of Dalí's house at Port Lligat, concentrating on the found and the altered objects, such as the plain wooden kitchen chairs to which Dalí was wont to attach pieces of driftwood he picked up at random on the beaches of Cap de Creus, together with petrified starfish and shells; or the Surrealist elephant, a sculpture made of a nautilus shell, amber, moonstones, a lobster carapace, and the spine and feet of tiny birds.

The house, as photographed by Descharnes at intervals between the

mid-1950s and the mid-1960s, has a curiously impersonal atmosphere: Found objects are arranged tidily on shelves and tables; there are flowers, but they seem to have been placed there for photographic effect rather than because Gala or Dalí loved them. The only part of the house that looks real is Dalí's studio, where Gala's strict notions of tidiness and arrangement obviously did not hold sway. Here, a plaster cast of a sculpture from the Parthenon has rhinoceros horns stuck all over it. In another corner, a nineteenth-century medical plaster cast of a section of the inner ear and the eustachian tubes has tiny little dolls nestling in it. There are curiously shaped fossils from the beaches, pictures of Gala as a young girl in Russia, golden cockleshells. On the left-hand side of the studio, a staircase leads up to "a raised platform where piles of strange objects were stacked—window dummies, a model of a molecular structure, more stuffed animals and a quantity of Venetian masks. There was a full-size replica of Praxiteles' 'Hermes' rigged out with a fencer's mask and a Davy Crockett hat, and in the place of honour was The Canvas."[22] In its diversity and curious contents, Dalí had reassembled in his studio an approximation of his teacher Señor Trayter's cabinet of curiosities, which had so frightened him as a small boy.

Descharnes also commented on Dalí's predilection—opposed on the whole successfully by Gala—to fill the house with objects of transcendent bad taste that had caught his fancy. "Of course," wrote Descharnes, "this attraction for such objects is not limited to Dalí alone; hideous objects are everywhere in Catalonia. But as they do for his fellow Catalonians, Gaudí, Fortuny and Miró, these provide a powerful and unfailing source of inspiration."[23]

That Dalí's eccentric love of bad taste was far from being an expression of his uniqueness and individuality, but was, rather, a commonplace in Catalonia, was perceptively pointed out by Donald Sutherland, writing in *Arts Magazine:*

> As a Catalonian he has a disengagement or secessiveness enough to be able to play at being a Spaniard, to overdo it and parody Spain itself. And he has other local advantages, foremost of which is that he can raise the cursi, a Spanish but still more a Catalonian form of bad taste, including too emphatic a good taste, into a virtue and a way of life. He can do this with a good conscience, even in a fervour of provincial patrio-

tism, whereas a more central Spaniard would be restrained from such showiness, if not from the whole question of taste, by his compulsion to sombre dignity and his tragic sense.

. . . Fantasy seems to be a major vein of expression in Catalonia but in Spain proper it is minor or even exotic. As it occurs in Don Quixote or the greguerías of Ramón Gómez de la Serna or in the caprichios and disparates of Goya or of Solana it stays closely related to the hardest realities and rarely wanders away on its own. A sheer de luxe fantasy in Madrid would be a Flemish or Moorish or Italian import. Yet again, Catalonia is an industrial region, and Dalí is free to be endlessly industrious, to put an appalling number of man hours into the act of painting. This may compel the deference of Catalonia and America, but would surely be dismissed in Madrid with an aristocratic shrug as an attempt to pass off manual labour, no matter how skilled, as a serious value, offsetting his cheapnesses. So his position is ambiguous but not really confusing.[24]

Dalí's relations with the townspeople of Figueres had not much improved since his return to Spain in the 1950s. They thought of him as an eccentric, half mad, who did not take things seriously and couldn't bequeath anything to the town, owing to the meanness of Gala, who had often said in public that she did not like Figueres. The town's little museum, the Museo del Empordàn, did not own a Dalí painting or even a drawing. Ramón Guardiola Rovira, the mayor of Figueres, tried to rectify this situation. (Guardiola had met Dalí in 1956 over a lawsuit concerning the destruction of olive trees on Dalí's Port Lligat property by a frost. Dalí had studied the stricken trees very closely and noticed that the appearance of certain insects led to the recovery of some of the trees. Guardiola had been impressed by Dalí's good sense and scientific knowledge.) When Dalí came to Port Lligat at the beginning of May that year, Guardiola petitioned him for a donation.

The Figueres photographer Meli, an intimate of Dalí's, acted as a go-between and told Guardiola that Dalí would not be satisfied with a room; he wanted a whole museum. Dalí himself told Guardiola he wanted to create a museum in the town's ruined theater.

Restoring the theater, which had, together with the neighboring hospital and other buildings on the plaza del Ayuntamiento, been in ruins since the Civil War, was of prime importance to Guardiola, irre-

spective of its ultimate role after restoration. The old hospital had already been turned into a plaza, but it would have been uneconomical to return the theater to its former use; it was a roofless ruin covered by vegetation and infested by rats, and an impromptu fish market had established itself in the northeast wing. Various schemes had been suggested by the town council, including pulling the whole thing down and driving a road through the space thus obtained.

But the theater was worth restoring; it had been built in 1849 in neo-classical style by the Catalan architect Josep Roca Bros and painted by Félix Cagé, who had also decorated the Paris Opéra and the Barcelona Liceu, but it had virtually been destroyed in the Civil War by Moorish troops who lit a fire in it.

Dalí confided to his friend the writer Baltasar Porcel his reasons for wanting to create a museum devoted to his work in the ruined theater:

> . . . I'm an eminently theatrical painter; also . . . it is in front of the church where I was baptized and, you know, I'm Catholic, Apostolic and Roman, and it was in the vestibule that my first pictures were shown.[25]

(Dalí had, in fact, had the idea fifteen years earlier, when his pictures were shown in the Royal Palace in Milan, which had also been bombarded.)

Guardiola was enthusiastic about the museum idea, and suggested that a corrida be organized to raise the initial funds; accordingly, Mario Gelart, the impresario who owned the bullring, was involved. On August 3, 1961, the plenum of the Ayuntamiento approved Guardiola's proposal to award Dalí the Silver Fig Leaf, the city's highest award, which was subscribed to with ten-peseta donations, presumably as an encouragement to Dalí and Gala to donate paintings and money to the museum project. But it was not long before the fundraising committee became worried. There wasn't enough public support, and Dalí's extreme ideas involved using a helicopter to remove the dead bull as a homage to "Spanish verticality." He also wanted dozens of pitchforks sunk into the sand (another homage, this one to his mustache); he wanted a play to be acted in front of the first bull; he wanted fireworks at the end. Each idea caused more concern to the eminently conservative committee. Guardiola was less worried, as he knew that only 50 percent of Dalí's ideas ever came to fruition.

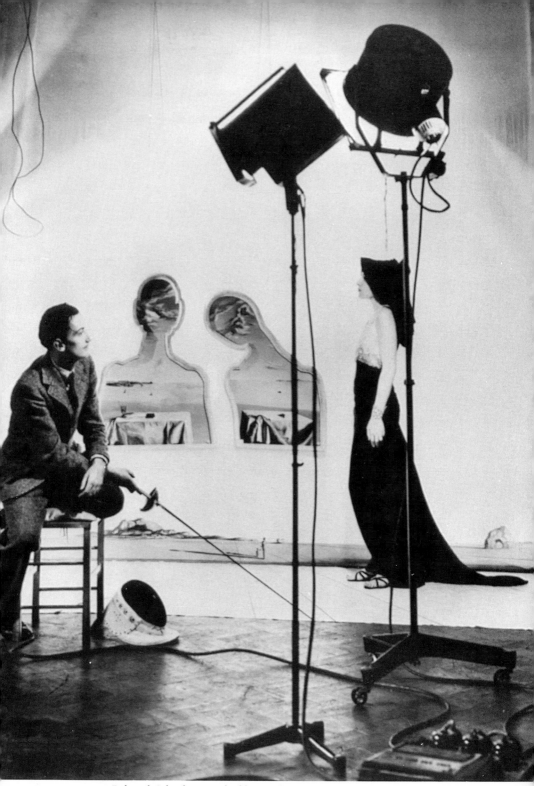

Dalí and Gala photographed by Cecil Beaton in 1938, in front of
A Couple with Their Head in the Clouds.

Dalí painting *The Enigma of Hitler* at Coco Chanel's house, La Pausar, on the French Riviera, in 1939.

Dalí and Edward James discussing the *Dream of Venus* installation at the World's Fair in Queens, New York, in 1939.

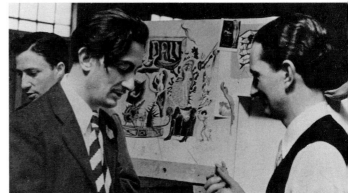

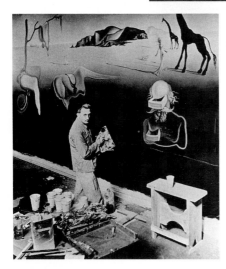

Dalí painting a backdrop.

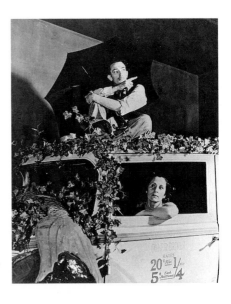

Dalí and Gala in the American version of the *Taxi Pluvieux*. The first version was made for an exhibition in Paris in 1938, and a third now sits in the Teatro Museo Gala-Dalí in Figueres.

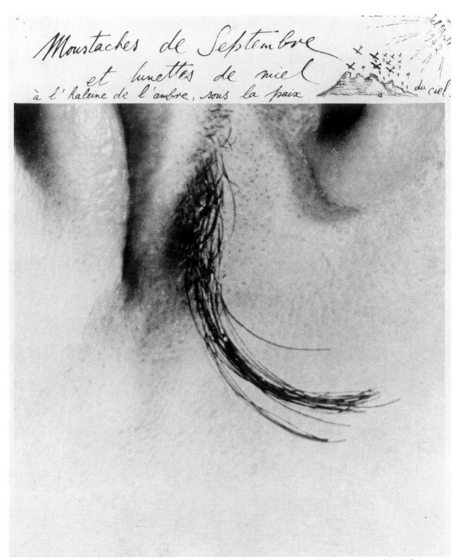

Moustaches de Septembre, possibly by Man Ray. The poem and drawing are by Dalí:

Moustaches de Septembre
et lunettes de miel
a l'haleine de l'ambre
sous la paix du ciel.

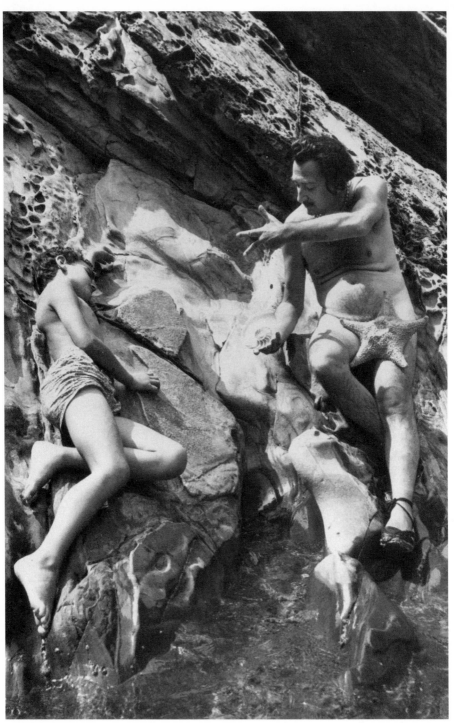
Dalí on the rocks at Cap de Creus in 1955 with Juan, the fisherman's son from Cadaqués.

Dalí's performance piece at the Paris zoo in 1955 involved a rhinoceros, a loaf of bread, and a copy of Vermeer's *The Lacemaker*.

Watched by Juan, Dalí and Gala are served sea urchins at Port Lligat in 1955.

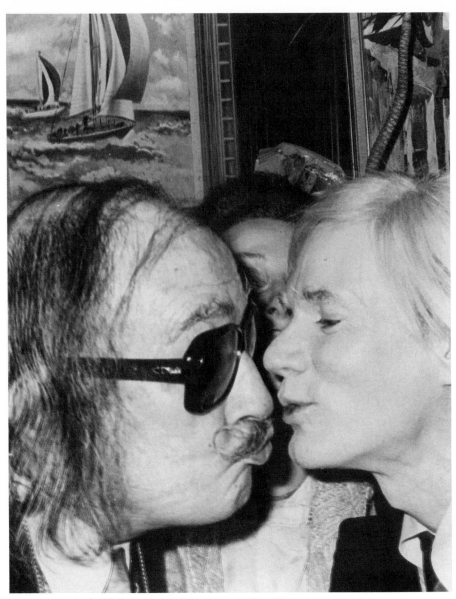

Andy Warhol greets Dalí at a party in New York in the mid-1970s.

The façade of the Teatro Museo Gala-Dalí in Figueres.

At his installation as a member of the Beaux Arts in Paris in 1979, Dalí wielded the ceremonial sword given him by Paul Louis Weiller.

Dalí on his last visit to Paris in 1981.

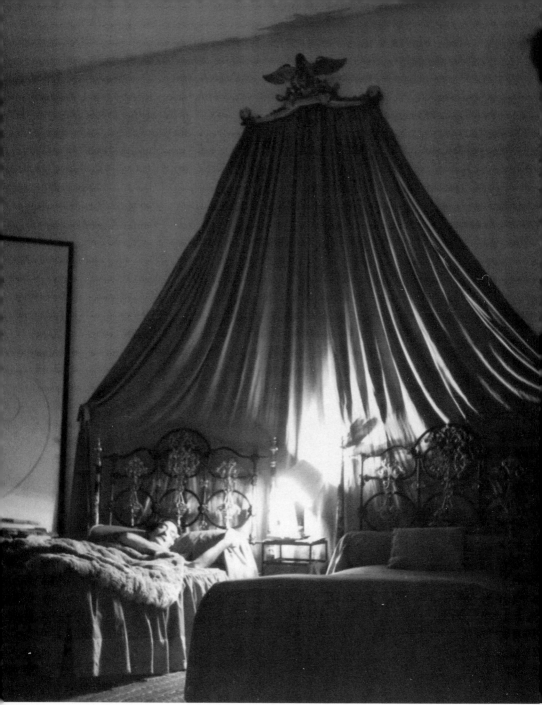

Dalí in the bedroom at the house at Port Lligat, toward the end of his life.

Dalí drew the design of the program, which featured a submarine (a reference to its inventor, Monturiol) and helicopter, together with a photograph taken by Meli of Dalí in the bullring in a tar barrel. The program and the dinner cost 300 pesetas a person and included the arrival at the plaza de Toros of "Big-Heads and Giants"—the Christian Dior costumes in which Dalí and Gala had made their entrance at the Bestegui ball nearly ten years before. Dalí and Gala, however, entered the bullring in their Cadillac and sat in a special box.

After this spectacular entrance there was an extraordinary bullfight, during which the Molero brothers, three noted matadors, killed six bulls from Valladolid; Gala became so overexcited that she threw a gold bracelet at one of the matadors. Next, a plaster bull, made by Niki de Saint-Phalle and Jean Tinguely, containing a dove, fireworks, and rockets in the head, tail, and horns, was piqued and duly exploded. Bits of it hit Dalí, on the cheek, and two members of the Guardia Civil in the audience. The bull disintegrated in a cloud of smoke.[26]

These Dalinian high jinks irritated many of the Figuerans, especially the Guardia Civil. But, as Dalí told Guardiola later, it was important that there should be some anti-Dalinian feeling. A local newspaper, *El Noticial Universal,* pointed out that "although a considerable respectable part of the city disagreed with it, the 'homage' was a success."

Unfortunately, the helicopter could not be used, for the Tramontana was blowing very strongly that day, and a takeoff was out of the question. After the corrida, the members of the committee and Dalí went to his birthplace and unveiled a plaque, during which someone in the huge crowd, not impressed, shouted "Imbecile" at Dalí, who said, "Keep him, there aren't many like him left."

After this, the Silver Fig Leaf was presented, and Dalí, accepting it, quoted Montaigne to the effect that reaching the universal is through the ultra-local. "I promise you all I'll continue to be your ambassador throughout the world," he told the huge crowd.[27] At 8:30 P.M. the theater was officially declared open as the Teatro Museo. Dalí explained his plans for it, and planted a fig tree in what had been the auditorium. There followed a folkloric festival, featuring a group from Pallarols with horses and mules; then there were fireworks, spelling out "Dalí and Gala" and "Viva Figueres," followed by a civic dinner provided by Señor Durán, the local hotelier, ending at three in the morning.

Dalí considered his museum open, but the townspeople of Figueres, who had been entertained by the fiesta, did not show their enthusiasm for the project (probably because they felt Dalí was so rich he could pay for it himself), and now no money was forthcoming either from the public subscription or from the Ayuntamiento. "I am a precision madman, a painter who works seriously and who plays the clown as a hobby. . . . They won't forgive me for it," Dalí once told Guardiola,[28] who believed passionately that Figueres needed an attraction such as the Dalí museum was likely to provide. The town was neither prosperous nor well known; Dalí, Guardiola believed, "universalized" it.

Dalí immediately fired off a number of ideas: He would put a Cadillac in the theater's old patio as a showcase and fill it with mannequins showing off jewels. There would be rain in the car, along with ferns, climbing plants, frogs, leeches, and snails. The exhibition would take place the following spring and be open for seven days. (Dalí told off someone who said they would come only for the car.) This re-creation of the *Taxi Pluvieux* worried Guardiola, who thought it would place too much emphasis on Dalí's "funny" side. His response was not alleviated by Dalí's next suggestion, no doubt prompted by Gala, which was that the museum would be filled entirely with reproductions that would be better than originals.

> There will be no original work. I shall install in the large, ruined window frames enormous photographs of all my pictures—photographs treated with plastic to resist rain and bad weather. I desire that there shall be a perfect diplomatic compromise between the damage to the walls and the pictures, which are to be superimposed on the damage.[29]

Gala was averse to giving the town any paintings, but Guardiola and his plenum knew that the museum would not come to fruition without her help, so they made sure they involved her in all their deliberations. Gala had the odd tantrum, once telling Guardiola, "Let others buy works and give them to the museum, that's how things are done nowadays."[30] She playfully added that unless the works were acquired and the museum built, she would send six anarchists to blow the place up.

But Guardiola was convinced, against the evidence, that Dalí would take the museum seriously, so he attempted to secure financial sup-

port from the management of the Fundación de Bellas Artes, Ministerio de Educación, Madrid. Writing at the end of the year to Guardiola from New York, Dalí came up with the idea of erecting a geodesic dome over the theater's stage. He enclosed a clipping from *Time* magazine to show what he meant. Matters rumbled to and fro, literally for years.

Dalí's life in Cadaqués in the latter half of the 1960s grew more and more frenetic as the flood tide of hippies and flower children swept through Europe and onto the little beach at Port Lligat. The simple life of the Costa Brava fishing villages had succumbed to the tourist boom, and the old, hard, moral life of the inhabitants was beginning to disintegrate.

In the Court of Miracles, Dalí's acolytes had their own language. A penis was called a "limousine," and instead of making love they talked of "the sewing machine"—in view, as Dalí once explained, of its motion.

In 1965, Dalí was spending some days in Barcelona on business when Sue Guinness, who knew him from her childhood and often went about with him, visited a louche nightclub in the Barri Gòtic and spotted a wonderful-looking blond singer appearing under the sobriquet "Peeki d'Oslo." The next morning, Mrs. Guinness mentioned this discovery to Dalí, who insisted they visit the nightclub that night so that he could see for himself. This was how he met Amanda Lear, who would eventually fill the space left vacant at his side by Ultra Violet's defection to Andy Warhol.

Most of Dalí's followers saw him as a prophet, a visionary, rather in the way that Indian gurus were regarded by rock stars. This sat well with Dalí's own conviction of his shamanistic abilities. In exchange for meals and entertainment, his acolytes posed in the nude for him, sometimes sitting on transparent plastic cushions so that he could see their private parts in intimate detail. Quite often, during these sessions, Dalí would not draw at all but quietly masturbate behind his blank canvas.

Dalí was an energetic inventor of erotic games to stimulate his jaded senses; on one occasion in the Hôtel Meurice in Paris, for instance, he made one of the female members of the Court crawl, time and time

again, through a long red velvet tube he had had made, which went from one side of the room to the other and was stretched over very small hoops. Dalí explained that he wanted to reverse the usual process; instead of man coming out of the sex of a woman, he wanted to see woman emerging from the sex of a man.[31] He wanted to take the tube back to Cadaqués for the summer, but Gala put her foot down.

Dalí's erotic Masses, rather like his paintings, began to take place on larger and larger canvases: Entire palaces were hired for the night, and peopled with dwarfs and transvestites. Dalí would tour his parties, one room after another containing various tableaux of permutations of sexual congress. Gala was never at these orgies; she took her young men elsewhere. (In 1963 the constant parade of young men came to a temporary halt when Gala fell in love with the twentyish William Rotlein, who bore a passing resemblance to Dalí as a young man. Gala threw herself into this affair with the same energy she had employed when she first met Dalí in 1929, dragging Rotlein around Italy, where they swore fidelity to each other at Romeo and Juliet's tomb. Rotlein went the way of all Gala's infatuations, eventually, and she returned to her habit of choosing a young man from Dalí's entourage and seducing him with the idea that her encouragement and attentions could make him as famous as Dalí.)

Gala, now approaching her seventies, was tired of looking after Dalí and wanted to lead a separate life. He had always promised her a *castello* in Tuscany to which she could go when she wished, but had never fulfilled this promise. Eventually, though, in 1969 he bought her a reasonable substitute for her Tuscan *castello,* sited between Figueres and Barcelona. He had it restored for her, and in it he painted frescoes and even trompe l'oeil radiator covers and doorways. Gala spent much time in her castle with her young lovers while catering to Dalí's masochism by allowing him to visit her only if he first wrote a supplicatory letter. Gala and Dalí were drifting further and further apart, but his endearing loyalty had not become submerged in the sticky morass of sexual excess that marked these years. He still eulogized Gala and trusted her to do all his business dealings for him.

Gala found other ways to spend Dalí's money in the 1960s and early 1970s; cheap to the point of obsession about spending money on

clothes, on servants, or on entertaining, she nevertheless became a fierce gambler and would lose thousands at the roulette wheel. (Enrico Sabater, the secretary who succeeded Peter Moore, once said that Gala preferred to take her share of the Dalí wealth in cash because it allowed her "complete liberty of action in her private life."[32] She further enmeshed Dalí in work that, if not uncongenial to him, left him very little time to paint pictures he wanted to paint; she signed many contracts for Dalí's services to get back the money she had lost at roulette, and Dalí worked against an ever-ticking clock to fulfill those contracts.

Dalí had always maintained that the most productive time of his life as a painter had been those months he had spent in the barracks in Figueres, during which he had painted *Cenicitas,* and that to function properly he needed a "prison." Gala, through her avarice, provided him not with a prison but with a treadmill.

Most of the enormous amounts of money that passed through Gala's hands during the 1960s and 1970s came in from the sale of prints, lithographs, and postcards and went out through injudicious commercial ventures. The couple's increasingly decadent lives needed a great deal of money, and, just as they were decadent in private, so now they became truly decadent in matters pertaining to Dalí's art. When Gala came to realize that literally anything Dalí signed was worth money to someone, she set in motion the events that led to what has been called the "Dalí scandal":

During the 1960s, Dalí virtually lost control of the process by which his prints were reproduced. He knowingly signed blank sheets of paper that could then be used for "limited" editions of lithographs. The result was that the quality of a Dalí image or the number of prints that were made were matters left to those who possessed the blank sheets of paper. And, because Dalí and Gala were so obsessed with money, they entered into contracts to produce work that Dali did not have a hope of fulfilling within the specified time.

In one particular case, that of a contract to design tarot cards, the original, badly drawn contract was assigned (or, according to rumor, gambled away at a card game) from its original owner to a restaurateur who then sold it to a New York publisher. Even Dalí was horrified that a contract for his work could be treated so, and virtually stopped work on the tarot images, whereupon the publisher sued him. In the process

of this lawsuit, money was frozen in some of Dalí's bank accounts. Dalí and Gala panicked, and settled out of court. As a condition of the settlement, Dalí was made to sign all the paper required for completion of the entire contract, even before the images were printed on it. Thus there were 17,500 blank sheets of paper with Dalí's signature on them. Dalí sought to find a way of controlling the rights to the ensuing prints and turned to Enrico Sabater, a young, poor, and ambitious Catalan of Dalí's acquaintance who aspired to become a dealer in the artist's work. Dalí asked him whether he would like to buy the paper and the rights.

Enrico Sabater had worked as a football correspondent for the local Girona newspaper, and as a chauffeur and an estate agent; when Dalí first met him in the 1960s, he was trying to earn his living as a photographer. But as a potential secretary, Sabater had virtues that Peter Moore did not; he was a local and spoke Catalan, and this, to Dalí, was very important. Sabater's opportunity to move in on what must have appeared to be the cash equivalent of an oil well came in the early 1970s, when Dalí's profitable and easy relationship with Peter Moore was beginning to break up.

This breakup occurred because Moore had opened his own Dalí museum in Cadaqués, in the Hotel Miramar, which the Surrealists had stayed in during the summer of 1929 and which Gala had latterly used as a rendezvous. This had touched a raw nerve of Dalí's, for he felt that Moore's museum was in direct competition to his still-unfinished museum in Figueres. Conflict between Dalí and Moore escalated when the then Prince Juan Carlos and his family paid two informal visits to Dalí's uncompleted museum in Figueres, but declined to visit Moore's. On the second occasion, Moore was furious and tried to remonstrate with Juan Carlos. That was too much for Dalí and Gala, who since receiving the Cross of Isabella the Catholic in 1964 had become more monarchical than ever and had assiduously cultivated the recognition of the future King of Spain and his family. By 1973, Dalí had severed his connections with Moore entirely and had begun to involve Sabater in his projects.

As the 1960s wore on, Dalí produced very few paintings; those he did complete were huge canvases that took several summers to complete.

Pêche au Thon, sold to the millionaire Paul Ricard, took him three years' work in the Port Lligat studio with the help of an assistant, Isidor Bea. Bea's role in Dalí's work has never been satisfactorily explained, but it is generally believed that he sized the canvases, squared them up, and possibly painted some images that did not interest Dalí personally.

The Hallucinogenic Toreador, completed in 1970, was conceived by Dalí in an art-supply store, where he saw a box of Venus pencils. This suggested to him a double image of the Venus de Milo, a recurring image in his syntax, and the features of the torero. The legendary flies of Saint Narciso (said to emerge from the tomb of Saint Narciso whenever a foreign power tries to invade Spain) depicted by Dalí in this painting symbolized the "modern tourist invasion of Cap de Creus which even the flies of Saint Narciso have been unable to halt!"[33] Dalí once remarked that he was not too worried by the profanation of his beloved Cap de Creus because its rocks would "eventually vanquish the French tourist, and time would destroy the litter they leave everywhere."[34]

Time, if not tourism, was also beginning to destroy Dalí and Gala, as it was destroying the remote world of Cap de Creus and the Empordà. Gala's endemic bad temper had begun to turn into savage viciousness that was genuinely frightening. Her hoarse, Russian-inflected voice would say the most appalling things to those people (and they were becoming more numerous) who she felt did not appreciate her enough. "One thing about her, she didn't care who she spat at or hit," an intimate said. "They could be an aristocrat, a millionaire, or just the maid, she would treat them all abominably." She had begun to lash out physically at Dalí, too. The big rings she wore, designed for her by Dalí, inflicted considerable damage on him. Meanwhile, Dalí was becoming a more exaggerated version of the dandy figure he had been virtually all his life. But the velvets and gold-embroidered waistcoats, the canes and the mustache, the long straggly hair, were now not so much the habiliments of a dandy but the sad, tawdry indications of a life gone awry. Dalí was still a hero to the hippies, who floated about him in Port Lligat, Paris, and New York, but to others he was an increasingly tragic and solitary figure.

On December 11, 1969, the poet Mathieu Galey wrote in his journal of a meeting with the Dalís:

Chez Florence: the Dalís—he more and more like Barbey d'Aurevilly with his dyed mane, his frilled shirts, his green velvet jacket with bouffant sleeves, to say nothing of his folding lorgnette and his stick he keeps with him even at table. But Gala was the real surprise for me: a death's-head rigged out like a wardrobe dealer; one wouldn't think her worth two sous with that shapeless piece of tow on her head and the Prisunic false teeth; only her gray-blue eyes now grown pale remain—the woman who, with Elsa [Elsa Triolet, Louis Aragon's wife], inspired two great poets—wretched![35]

Wretched Dalí and Gala indeed were; tied to each other not by the comfortable bonds of a life shared or work accomplished but by self-indulgence, by secrets, by greed, by loyalty outworn and outdone. Their very lives, fifty years of constant companionship, diverged even more during the last days of the 1960s; Gala wanted to live, *la princesse lointaine,* in her grand castle, surrounded by young men. Dalí wanted to live as the central and inspirational figure in the middle of a cacophonous court of misfits, sexual adventurers, and exhibitionists, in the full glare of flashbulbs, interspersed with serious work carried out, as he had always done it, quietly, on his own, in Port Lligat.

He clung, however, desperately to Gala, even though she ignored him except as a means of making money. His paintings of her done toward the end of the 1960s, such as *Portrait of Gala* (1967), reflect this neglect; they have a distant, wistful quality about them. It is as if Dalí is painting Gala from memory rather than from life. Gone, in these portraits, are the eyes with their fierce expression that could see through walls; gone are the harsh features, the challenging expression, even the sexual invitation. Dalí painted Gala now as a sad, frail, late-middle-aged woman with a ridiculously young hairstyle who looks lost, as indeed she was to him.

The rest of their life together was a gradually descending spiral of loss and recrimination as Gala became even more rapacious in her pursuit of money, of young men, and of her irrecoverable youth, which she tried in vain to bring back with the aid of plastic surgery. Dalí became more and more the clown, a role he had created for himself and refined but that was now beginning to subsume him entirely. For he needed the attention that Gala no longer gave him, except when she was trying to force him to finish profitable commis-

sions. He needed the attention, too, of television cameras and journalists. He was always surrounded by people, but they wanted to know only Dalí the clown, or to profit from his acquaintance in one way or another. Few now were the friends with whom he could be himself, or with whom he could be natural. For he himself began to forget where the philosophical Dalí ended and the preposterous Dalí began.

▶
▶
▶
▶
▶

14

PUZZLE OF AUTUMN
1970–1979

The ferocious painting schedule imposed upon Dalí by Gala started to slow down in the early 1970s: From working up to twelve hours a day when he was in Port Lligat, he was now able to spend only four to five hours in his studio. This infuriated Gala. She would ever more frequently lock him in until he had finished work on a contract. These contracts were negotiated with little reference to Dalí's own wishes, and, as a consequence, he fell further and further behind in fulfilling them, often giving them the most casual attention and thus devaluing his later canon and his reputation.

He was caught in a prison of his own making: To keep the approbation of Gala and maintain the hugely extravagant lives to which they had both become accustomed, Dalí was stretching his resources, day after day, often on work to which he was completely indifferent. He was tired and sad. He had collaborated with Gala in the rape of his own art, and he was paying the price. He fell back on themes he had already worked and reworked; sometimes these themes came from the very distant past, as in the 1976 painting *Monstruo Blando Adormecido (Soft Monster Sleeping)*, which showed the amorphous monster he had depicted in *The Great Masturbator*, now petrified, lying on a broken paving stone with part of its snout broken off, against a background of a gray beach and a gray sky.

Dalí's painting slowed down also, as the art critic Luis Romero saw, because of the "constant solicitations deriving from his fame," and because of the intrigues that surrounded the museum.[1]

* * *

The museum project had not advanced at all by 1968, in spite of a formal audience Dalí had had with Franco that year in Madrid, during which Franco expressed his interest in the museum, telling Dalí, "You will convert it into the mecca of Western art."[2] Dalí's decision to add a geodesic dome to the original plans, which had, in principle, been agreed to by the Fundación de Bellas Artes and the Housing Ministry, had added an extra sum to the budget, necessitating further applications for money. (The original budget had been approved at the end of December 1969: 11,589,154 pesetas to be paid in three installments—3 million in 1970, 3 million in 1971, and the rest in 1972.)

The year 1970 was a decisive one for the museum. On April 1, Dalí gave a press conference. Even though he was weary, he managed to put on a performance. He appeared at the top of a gilt spiral staircase, clad in a green velvet suit with a brocade waistcoat, and delivered three blows with his cane (reputed to have belonged to Sarah Bernhardt) to get attention. There then appeared a girl wearing transparent veils and carrying an enormous tray on which reposed a reproduction —in chocolate—of Dalí's head, in which the eyes and the whiskers moved. He accepted the gift and told the assembled journalists that although it was April Fools' Day he was going to be serious, as he always did the opposite of everyone else. He revealed that his fee for a minute of publicity was $10,000. "I have been one of the first great artists who have worked for publicity," he said. "Einstein gave me the idea. He asked someone who invited him to a party, 'How much will you pay me if I go?' I find," Dalí added, "this reaction to be perfectly logical."[3]

The museum, he revealed, would also be for young artists. There would be space for the avant-garde Living Theatre and for fashion designer Paco Rabanne's models, and the museum would be the richest in the world. But he was not to be drawn into a clarification of what he himself would be donating. Years later, he told his friend Baltasar Porcel, "Between Paris and New York, Gala and I have a hundred works of great quality to give to the museum. What is happening is that we hand them over one by one, for if they are given all at once,

no one enjoys it, but if we give them slowly, then they will appreciate it."[4]

On Dalí's return to Barcelona from Figueres toward the middle of April 1970, he gave an interview to *La Prensa* in which he said that he was working very hard for the museum and that it was his greatest preoccupation: "I'm painting a cupola with all the mythology of the Empordà, creating an apotheosis of the Tramontana." He added, revealingly, that he would equal Picasso's gifts to Barcelona.[5] "Another point. In the Teatro, there are eighty niches, which were the old boxes. Well, they'll all be filled with my sculptures or by Surrealist objects."[6] He also made what was, in hindsight, an important statement when he told *La Prensa*, "When I die, if it should come to that and because I don't have any children, I shall give all I possess to the National Patrimony."[7] Little attention was paid to this pronouncement at the time.

Further impetus was given to the museum by the rich local land-owner Miguel Mateu Pla, who had known Dalí since his childhood and was a close and influential friend and supporter of Franco. In June 1970, Franco paid a private visit to Mateu at his castle of Perelada, situated between Figueres and Cadaqués; it was correctly rumored locally that they wanted a tête-à-tête about Catalonia. Five days later the museum plans had been approved by Franco. Dalí told the press that there would be an honorary committee composed of representatives from Versailles and the Metropolitan Museum in New York, and "my great collector, Morse." Going back on his statement that his works would be left to the National Patrimony, he now promised to leave everything to the museum. It was a promise he and Gala had no intention of keeping.

When in Spain, Dalí began to spend several days a week away from Port Lligat in Figueres. There were two reasons: First, he was personally involved in the construction of the museum, which he took very seriously, studying details with the young architect, Emilio Pérez Pinero, and, clad in a hard hat, overseeing the workmen. Second, he was lonely: Gala was now spending most of her time in amorous assignations at Pubol, the *castello* he had bought her, leaving Dalí to the dubious attentions of the "Ginestas" (his word for blonds, after a

yellow flower that grew locally) and a few loyal friends, such as Emilio Puignau.

These frequent excursions to Figueres—he had usually visited it only on Tuesdays—also reduced the time Dalí spent in his studio painting. The lack of Gala's strict discipline was beginning to have its effect, although when there was an interview to be done or an important visitor to Port Lligat to be entertained, she would return, and the myth of Dalí and Gala's relationship remained unbroken. Dalí never admitted that he missed Gala; in an interview he gave to *L'Express* in 1971, when asked how he coped with solitude, he answered bravely, "I am never alone. I am used to being with Salvador Dalí always, and that for me is a permanent party."[8]

He could often be seen, in these early days of the 1970s, alone in Figueres, reading in the Canet library or drinking coffee in the Café l'Exprès or, later, in the Cafetería Astoria. He had resumed the pattern of his early life. Rather than isolating himself in the house in Port Lligat to paint on his own, he preferred to spend time in Figueres among his oldest friends. His compatriots took him for granted—after all, he had always lived there—but the increasing number of tourists drawn to the area began to ask him for autographs, at which Dalí would pull grotesque faces. They were trespassing on the all-important "private" Dalí.

The Hallucinogenic Toreador was completed in the summer of 1970, together with some drawings. Dalí had also found a new area of research that captivated him: He had begun to be fascinated by three-dimensional art. (Actually, he had been aware of stereoscopic possibilities for many years, for he possessed a pair of glasses that had been made in 1900 for viewing the stereoscopic postcards he had collected as a young man.) He was studying the work of Gerard Dou, a contemporary of Vermeer, in whose canvases he thought he had discovered stereoscopic images. He had seen some work by Dou in a book he had found in Paris; he then discovered that Dou often painted two slightly different versions of the same picture. This led Dalí to the conclusion that these "double" pictures were meant to be looked at stereoscopically, so that each eye sees a different image (it is the superimposition of the two images on the brain that gives this impression of

an added dimension). He began a series of experiments using a Fresnel lens in order to create such images for himself.

Although he was beginning to slow down, this was a period in which he received much acclaim. In 1971, Reynolds and Eleanor Morse opened a museum devoted to their Dalí collection, over fifty of his most important paintings. The museum was first housed in their home; then, when it grew too big, in a specially constructed wing of their office in Cleveland. In November 1970 the Museum Boymans–Van Beuningen in Rotterdam had organized the first of what would be several major Dalí retrospectives held in Europe and America during the 1970s. This show included paintings lent by Edward James, many of which were eventually bought by the museum. The exhibition was a resounding success, crowned by Dalí's and Gala's unannounced appearance at the opening.

These retrospectives performed the invaluable service of introducing the postwar generation to Dalí's early Surrealist work, and served to remind his contemporaries of his very real and consistent achievements as a painter, as opposed to a publicity-hungry clown, over nearly half a century. Attendance records were broken at the Boymans–Van Beuningen retrospective, as, later in the decade, they would be broken at other exhibitions of Dalí's work, proving that he still had the power to appeal to a large public, if not to art critics.

But even Dalí's long war with art critics was coming to an end. Most of them were repulsed by his right-wing politics; but younger commentators were beginning to reevaluate his achievement and separate the art from the personality. John McEwen wrote in the London *Sunday Times:*

> *His late work can be faulted on grounds of repetition and gush, but more often it continues to fulfil his exploratory intentions and it never betrays his impeccable standard of technical skill, a skill equally evident in large and small paintings.*
>
> *It shows that Dalí, for all his self-assertion, was the opposite of egocentric in his earnest endeavours to find a way forward for painting in a world of increasing scientific domination. . . . He continued to preach the superiority of complexity to simplicity, hierarchies to equalities, metaphysics to politics, maturity to youth.*[9]

Dalí's intellect had not slowed down. His visual research extended into an investigation of holograms, stimulated in 1971 by the award of the Nobel Prize to Dennis Gabor for his work on lasers. Dalí met Gabor, who advised him on the preparation of three holographic compositions, and in 1972 the Knoedler Gallery in New York exhibited the three works, which drew from Robert Hughes, the art critic for *Time* magazine, the comment that "Dalí has simply used a new medium to transmit his old mannerisms."[10] Dalí's interest in holograms, however, was not that of a man preparing to jump onto a new bandwagon, but that of a man of sincere and ardent curiosity engaged in a lifelong series of painterly experiments linked to science.

In this period, Dalí also became the first in what would become a series of guest editors for the Christmas issues of French *Vogue*. Jocelyn Kargère, then artistic director of the magazine, stayed with Dalí for three months during the preparation of his issue and grew close enough to him to be allowed to watch him at work in his studio:

He did one thing that, at that time, I had never seen before. He had a little model theater, no bigger than a foot long, in which he videoed— direct video on television. He had a camera set up in front of it and he moved the sets and the little figures about and then filmed them; he made up a little theater piece this way. Then, one day, I saw him sitting in the garden on a bench with pen and paper; he was sitting there without drawing. I had the impertinence to come up, and he told me to sit down beside him, and he did a gesture to me not to talk. I waited, at least half an hour, before the first drop of rain came, and he said, "Now I will show you something." And all of a sudden, a drop fell on the paper. He took his pen and drew a line through the raindrop, and when the ink went into the raindrop it spread. More raindrops came, and he drew more, and all of a sudden there was the most beautifully drawn tree with branches, and Dalí said, "This is a happening." What was extraordinary was that his pen had to go through a place where the drop fell, which he couldn't calculate, but he knew what would happen when he did it; it was like Japanese calligraphy. I'm sure it had been in the back of his mind for years, and here it had come to fruition.[11]

In the original agreement to produce the Christmas *Vogue*, written by Dalí on a piece of brown paper, he charged no fee but retained rights to all the material he produced. His drawings had to be sent to

Paris to be reproduced—and Gala objected to this violently. Kargère recalls:

> She hated me because I was taking away what was due to her. The drawings he gave me had to be done in secrecy in the bathroom. I was locked up with Dalí in the bathroom while he was drawing, and he said, "Hide these away." Every time he did something, Gala took it, either to sell it or exchange it. There was a secret place in Dalí that one just could not reach, and there was something between him and Gala that was very difficult to unravel. To me she was evil . . . the way she had of ignoring me and looking at me. I could tell there was a force there that was the dark force behind Dalí. She was a vampire, but he couldn't live without her, either. I think she was an outlet for the darkness that one didn't see in him; but one saw it in Gala. He was careful, he walked on tiptoes when it came to Gala. Often he used the phrase "Gala wouldn't like it" or "Be careful of Gala."[12]

Kargère claims that Dalí was the most knowledgeable art historian he had ever met:

> He not only kept up, he changed his paintings or his subject matter to keep up. Even when old, he had the vitality and the virility to be in touch. One evening when I was at Port Lligat, there was a remarkable discussion between Albert Skira and Dalí on the subject of when English art had begun. Skira contended that it started with Van Dyck, but Dalí said no, it started with Hogarth, because he was purely English.[13]

Dalí took Kargère on expeditions. One evening there was to be a concert in the church at Cadaqués, and he told him, "You will see something I saw as a child, which is the most Surrealist thing you will ever see. . . . Surrealism didn't invent anything, it comes from the primitive depths of man."[14] The service was to honor the patron saint of the fishermen, and the men had worked all the previous night to gather as many lobsters as they could. They then laced the live lobsters to the golden columns of the high altar, and in the light of the candles the crustaceans' pincers moved very slowly in time to the music.

Dalí took his work as guest editor for French *Vogue* very seriously, just as seriously as he had taken *Minotaure* forty years earlier. He still believed, as did the Surrealists, that magazines were a legitimate vehi-

cle through which one could broadcast thoughts. He understood the proselytizing power of publications such as *Vogue*. When the Christmas issue finally came out, with a cover and masthead designed by Dalí, it rapidly became a collector's item and a benchmark for other magazines. He had taken enormous trouble over it. The cover showed a photograph of Marilyn Monroe doctored to look like Chairman Mao. The first page held a reproduction of the painting *Les Enervés de Jumièges,* by the pompier painter E. V. Luminais, over a poem written by Dalí:

Les énervés	*The fatigued*
de la Mediterranée	*of the Mediterranean*
aimer	*loving*
flotter	*floating*
énervés	*fatigued*
moyen âges	*middle-aged*
les vogues de l'eau rossignolée	*the fashions of the nightingaled*
voile ce qui va se porter	*water*
cet été	*veil what's going to go on*
	this summer

In the ensuing pages, Dalí quoted Proust and Ronald Firbank, and rendered homage to Gala, who was pictured at Pubol. There was a poem by Chairman Mao, together with a picture of the Chinese princess Tu Wan, who had been discovered in her tomb in a jade-and-gold costume. There was a picture of the Dalinians at play around the Port Lligat swimming pool (designed by Dalí and inspired by the shape of a plastic packing case for a transistor radio), together with huge photographs of Proust, the Surrealist novelist Raymond Roussel, and Mao. The issue was rounded out with many pages of Dalí's suggestions for Christmas presents, in which he had taken commercial jewelry and other objects and turned them, by means of collage, into Surrealist found objects.

The photographs in this issue of French *Vogue* give a good idea of the cast of characters likely to be found at Port Lligat at the time: Amanda Lear; the Miles twins, two English hippies; and Carlos Lozano.

Lozano, a Colombian brought up in San Francisco, had been spotted by Dalí in performance with the Living Theatre in Paris. He had very long hair and the obsidian good looks of his Indian forebears, and had been swept up in Dalí's train. "The first afternoon I spent with Dalí in Paris, we went to the Musée Grévin. Dalí had it opened especially, so we could see it in peace, and I posed for him there." Lozano was exceptional in his ability to get on with both Gala and Dalí, and thus his friendship with Dalí lasted until Dalí died.

Dalí and Gala had always been interested in celebrities. During the 1970s they became particularly fascinated by the emerging phenomenon of rock superstars, latter-day dandies who were famous in the same populist way that Dalí was famous. Dalí loved them, and they admired him. He cultivated them assiduously; he made a hologram of Alice Cooper's brain that formed part of the exhibition at the Knoedler Gallery in 1972, and John Lennon commissioned him to create a birthday present for Ringo Starr. But the world of rock and roll, while intriguing him with its excess and its power of worldwide communication, also produced the greatest threat to his happiness in the unlikely figure of an unknown singer from Ohio called Jeff Fenholt.

Peter Brown had worked for the Beatles for many years when he went to Port Lligat to discuss John Lennon's present. He became friendly with Dalí and Gala and subsequently took them to see the Paris production of Andrew Lloyd Webber and Tim Rice's *Jesus Christ Superstar*. "They were fascinated by the idea of having a rock opera about Jesus Christ," he says, "and I think that led them on to becoming interested in the whole development of rock and roll at the time."[15]

Later, Peter Brown put on *Superstar* in New York and cast Jeff Fenholt in the leading role, having spotted him at an open call:

> *He had never done anything except play in this unknown band somewhere in the Midwest. . . . He had a skinny, Christlike body and he couldn't act, but it didn't matter . . . there was a lot of street-smart about him, using people, but he was nice enough so that one didn't mind it.*[16]

Quite how Gala met Jeff Fenholt is unclear; she and Dalí may have seen his photograph (they were in the habit of inviting actors they liked the look of to visit them, and then asking them to strip naked so

that they could be painted by Dalí). By the end of 1973, Fenholt had become Gala's companion. He was also a regular visitor to Dalí's Sunday afternoon "Paupers' Teas," as he liked to call them, sweeping in on Gala's arm and being introduced as "Jesus Christ."

Gala started to give Fenholt large sums of money. He began to believe that he was a messiah and told an interviewer from *Women's Wear Daily* that he was the "source of God." Gala would often fly him to Pubol and lock herself up with him there for weeks at a stretch, leaving Dalí to his own devices at Port Lligat.

For Dalí, Jeff Fenholt was as unimportant as all Gala's other affairs had been; he believed that her sexual activities did not affect his relationship with her. But in the end, this particular attachment became too obsessive for him to ignore. He had been loyal to Gala all their time together, but when he discovered how much money she was giving Fenholt, and that she had also broken the habit of a lifetime and given him some of Dalí's precious paintings, he became deeply resentful. Gala had finally overstretched the tolerance of his masochistic temperament.

Gala abandoned all caution, believing that with her encouragement Fenholt would become a musical superstar, just as her encouragement had made Dalí a star fifty years earlier, and she spent an enormous amount of Dalí's money on installing musical equipment for Fenholt at Pubol.

Gala's almost mystical involvement in Dalí's work had turned now to surly indifference. "I never saw them out together in New York," Peter Brown remembers of that period in the early 1970s. "Dalí went with me to the John and Yoko drawing exhibition that caused all the fuss, and came to several parties at my house, but always without Gala. I really don't think they saw much of each other." She was even ruder to old friends than she'd been in the past. The Baron de Rédé remembers taking offense at a lunch in New York in the mid-1970s, when Gala came up to him and asked, "Do you still see all those stupid people?"

When they were in New York or Paris, Gala would make an entrance at Dalí's gatherings in the King Cole Room or in his suite at the Meurice, and then leave to see Fenholt. It was a pattern they had established long before, but the fundamental difference now was that Gala was no longer prepared to look after Dalí. He was bereft.

Still, there were new friends among the courtiers Dalí had gathered around him in New York; Andy Warhol, to whom Dalí had been introduced in the 1960s by Ultra Violet, was a regular. Warhol had patterned his own passage to fame closely on Dalí's and regarded Dalí both as a model and as competition:

> I'm never sure whether Dalí copied transvestites from me or I copied transvestites from Dalí. Gala is always the last one to arrive at dinner. She makes a dramatic entrance on the arm of a teenage boy with long blond hair who played the lead in Jesus Christ Superstar somewhere, once. Gala is not too tall, but she walks erectly. . . . She's the only person I know besides Ethel Merman who absolutely refuses to let me take her picture, let alone tape-record her. When Gala enters the room, Dalí stands up, snaps his fingers, calls for silence and announces "Gala! Y Jesucristu Superstar." Everybody claps. It's like being with royalty or circus people. That's why I like being with Dalí—because it's not like being with an artist, he wouldn't be caught dead in a loft.[17]

Warhol was never able to persuade Gala to be photographed, even though he tried for years. Dalí once explained to him that "the strength of Gala it is in her privacy. Gala *never* is pho-to-graphed."[18]

Dalí still insisted that Gala was his sole inspiration and, toward the end of 1973, began a new painting of her that was intended to be both a confirmation of their long relationship and an exercise in stereoscopy. *Dalí from the Back Painting Gala from the Back Externalized by Six Virtual Corneas, Provisionally Reflected by Six Mirrors* shows Dalí at his easel painting Gala, whom we see together with Dalí reflected in a mirror framed with one of the elaborate Dutch frames he loved. There are also depicted two canvases, neither of which is finished. What we can see is Gala's implacable gaze and, behind her, Dalí, visibly aged, gazing at her as if in horror at what he sees.

Peter Moore's long connection with the Dalís finally ended in 1973. "She exchanged me for someone younger," he subsequently said. This left Dalí relying upon Enrico Sabater, who was producing projects for Dalí.

Moore had built himself a house in Port Lligat opposite Dalí's. Dalí

could scarcely avoid gazing upon it every day; Moore's museum in Cadaqués rubbed salt in the wound. Dalí had lost both his wife and his "military attaché," and was now reliant on whatever Sabater could bring in.

His health was beginning to falter. In 1974 he suffered from a hernia and a troublesome prostate. He became thinner and began to look fragile; his face had started to sag and was covered with large, brown blotches that made him think he might have skin cancer. His hair, which had always been thick and lustrous, began to fall out, and he grew it very long, letting it hang over his collar, to compensate. Age, so long kept at bay by the sheer force of his personality, was now catching up and almost overtaking him.

In spite of the untimely death of the architect Pinero, the museum in Figueres was opened on September 23, 1974, in Dalí's seventieth year. But even at this moment of triumph, Dalí and Gala made their separate ways to the museum. Dalí, escorting Amanda Lear, headed a cavalcade from Port Lligat; Gala arrived from Pubol with Fenholt. After speeches by the mayor and by Dalí in front of the town hall, during which Dalí was presented with the Gold Medal of Figueres, the crowd invaded the museum.

Gala left early for Pubol, incensed because Fenholt had got left behind in the stampede. It was a cold, wet day for the opening, but the whole of Figueres turned out to see the ceremonial procession.

Dalí had finally opened his museum after over a decade of effort, and the curiosities it contained reflected the vision he managed to impart to his whole life. The museum has never failed to fascinate visitors. It is a labyrinth of Dalí's memories, combined with the ultimate expression of the Surrealist theory of the found object. It contains references to all the many ideas and images that preoccupied Dalí throughout his long life and, as such, is a three-dimensional autobiography.

The approach to the museum across a small plaza is marked by a statue that pays homage both to the Catalan philosopher Francesc Pujols and to the mystic poet Ramon Llull. The sculpture is formed of a twisted olive tree out of which the heads of the two men protrude. The neo-Palladian façade of the museum contains in its center a hel-

meted diver—a reminder of Dalí's deep dives into the subconscious and his spectacular appearance at the 1936 International Surrealist Exhibition in London. The diver is amplified by female figures on the balconies whose torsos and bellies are pierced with ameba-shaped holes, just as the nurse's body in *Weaning of Furniture-Nutrition* was pierced. These female figures bear long loaves of bread on their heads and are leaning on crutches, both being essential and enduring symbols in Dalí's world—the bread representing Communion, the crutches symbolizing death and resurrection. Above the diver and the female figures is a series of suits of armor, alluding to Dalí's notion of carapaces as a protection against the world; above these suits of armor are figures waving a greeting to the visitor.

The former auditorium of the theater is open to the skies, the walls stripped down to the bare brick. It is overlooked by arches, which formerly led into the boxes, through which visitors can look down from the encircling corridors onto the patio. Dalí made this central space into a garden, at the center of which is parked one of his most successful Surrealist objects, the *Taxi Pluvieux*. This third and last version employs one of Dalí's black Cadillacs, possibly the one originally owned by Al Capone, inside which sits a mannequin bowered in plastic greenery. On the Cadillac's hood reposes a sculpture by Ernst Fuchs of Queen Esther. Behind the car, and raised to a great height, is Gala's bright yellow fishing boat, the one in which she would set out with young fishermen for her long afternoons of love in the little beaches and caves of Cap de Creus. Looking down on this patio garden is a frieze of washbasins, symbolizing purification.

The stage is surmounted by the great geodesic dome and is thus always flooded with light. Dalí painted a permanent backdrop for it, representing the bust of a man. In his breast there is a heavy open door through which can be glimpsed a verdant island with the familiar cliffs and lines of cypresses. There are bullrings—the bull, having been sacrificed, is carried off on another of Dalí's familiar symbols, the grand piano, and is followed by a trail of prelates, echoing the mood of *Resurrection of the Flesh*. On the altar, Dalí painted a "soft" Christ, crucified.

There is a room, adjoining the stage, known as "the treasure" because of the important paintings it contains, including *Cesta de Pan* and the commanding *"Galarina,"* together with Dalí's earlier study for

the portrait. On the first floor is a drawing room (probably the room in which Dalí first exhibited his pictures at the age of fifteen), on the ceiling of which is a sky painted by Dalí with some of his recurrent themes: Dalí and Gala are holding up the sky, and next to them there is a bust of the "Logical Demon," along with wheels of triumphal chariots and Danaëan showers of gold.

Not only did Dalí show his own work in the museum, but he also donated things that had special meaning to him, such as Jean-Louis-Ernest Meissonier's easel, some Gaudi furniture, a Guimard Métro entrance, and an Art Nouveau bed Dalí had painted. He also gave paintings by other artists he admired, including Fortuny, Bouguereau, and Modesto Urgell, and the head of an apostle by El Greco, juxtaposed in the exhibit with a rhinoceros head. There are prints by Piranesi and designs for the Bestegui ball all mixed up together by Dalí using a logic to which only he had the key. One of his most important paintings, *The Persistence of Memory,* lost to the Museum of Modern Art in New York, is represented here by a tapestry copy, and in the room with it is also a great Napoleon III bed in the form of an enormous shell supported by four dolphins.

As the visitor winds his way through the museum, along corridors hung with Dalí's drawings and constructions, past vignettes he created especially for the museum, such as the Mae West tableau, he is chasing an invisible logic; there is obviously a pattern to this jumble of symbols, objects, paintings, and drawings, but there is also a feeling of caprice, as if Dalí put into the museum anything that caught his fancy, rather as a jackdaw might bring glittering objects to its nest.

The infrastructure of the museum is obviously a retrospective of Dalí's life and work, but it is overlaid with found objects to the point that, by the end of the tour, the visitor is bewildered and disoriented. There is a hallucinatory buildup that has a curious effect; for the museum does what Dalí intended it to do, which is to open the door to the curious world of his imagination. It is indeed, as Dalí described it, a "kinetic Sainte-Chapelle." Nothing is ever still in this museum, everything moves, from the visitor winding his way around the corridors to the dynamics of the edifice itself.

The Teatro Museo Gala-Dalí was, in its way, the last true work of the Surrealist movement. André Breton could have been describing it when he wrote in the second Surrealist manifesto in 1930:

The terror of death, the cafés chantants *of the other world, the shipwreck of sound reason in sleep, the crushing curtain of the future, towers of Babel, mirrors of inconsistency . . . these all-too-gripping images of the human catastrophe are perhaps nothing but images. Everything leads one to believe that there exists a certain point in the spiritual domain where life and death, the real and the imagined, past and future, the communicable and the incommunicable, the high and the low, cease to be seen as contradictions.*[19]

Many Figuerans thought this museum was Dalí's final Surrealist joke. The best joke is that today it attracts more visitors than does the Prado.

The opening of the museum in 1974 stimulated Dalí to paint more than he had done for the previous three or four years, and *Ruggiero Freeing Angelica, Transformation Anchorite Figure from Behind, Explosion of Faith in a Cathedral, Angels Contemplating the Ordination of a Saint,* and *Battle of Clouds* were all completed during that summer. Between 1973 and 1977, he also worked on a series of "transformations" of the eighty *"caprichos"* of Goya. None of this interesting, later work found favor with Gala, for she knew there was little money in it for her.

Fifty Secrets of Magic Craftsmanship, which had first been published in America in 1948, was brought out in a larger and revised edition in 1974. Here Dalí was at his intriguing best, passing on the knowledge he had so seduously gained over fifty years in a typically Dalinian style where jokes conceal the serious message beneath. The book purports to be an instruction manual for the aspiring painter; there is, for instance, a page devoted to the diverse kinds of brushes, which Dalí classifies as "Parsimonious," "Alert," "Passionate," "Fiery," and "Monotonous," together with his renditions of each of the brushes. Dalí tells his audience that the "true painter must be able, before an empty desert, to fill his canvas with extraordinary scenes," and proves his point by depicting the painter seated in a delicately Japanese-looking desert before huge canvas filled to the edges with Madonnas, Venuses with drawers, women with crutches, and so on. Dalí also says that "the true painter must be able, from a shepherd, a ram, a bird and an ear of wheat, to create a unique monster," and he proceeds to do just that in front of our eyes.[20]

Later in the book, Dalí draws very specific diagrams of his palette and gives us the secrets of the colorist; then he compares, also by means of diagrams, the plasticity of the media, and provides a list of stable colors in which the painter might place his confidence (Venetian red, for instance, is described by Dalí as possessing the secret of all that is biological—"It is the Adam and Eve of colors"—whereas silver white is the "Jupiter of colors, possessing the secret of earthly and terrestrial opacities"). Dalí also gives a list of colors that do not lend themselves to painting, including English sky blue. He goes into considerable technical detail about colors and their use, the fruit of many years of research on Gala's part. "Extra Secret," for instance, is his recommendation that zinc white should be employed very lightly, like a glaze over the solid silver white, "for it is by this means that you will obtain the most absolute whites in your picture."[21] There are comments about the effects of liquid amber used by the old masters, which Dalí tried to reproduce after a formula by Taubes, with a saturation of linseed and copal oil. Dalí also demonstrates in a complicated drawing the aphorism "The true painter must be able patiently to copy a pear while surrounded by rapine and upheaval."[22]

The endnotes to this manual are no less revealing of Dalí's breadth of knowledge than the text, including as they do works like *The Theoretical Shape of Large Bubbles and Drops* (1913), *The Spiders of Great Britain* (1913), and *A Study of Splashes* (1908). Dalí concludes his book with a list of stable colors taken from Jacques Blockx's *A Compendium of Painting,* to which he appends his own technical comments.

The largest entry is devoted to Naples yellow. "There are those who believe that Naples yellow is extracted from the lava of Vesuvius," he tells the reader. "Others confirm that this color was first made in Naples, but having affirmed that the color was imported to Italy from France and Germany, I felt it useless to continue my researches."[23]

Fifty Secrets of Magic Craftsmanship is a serious manual and sums up a lifetime of technical research. Dalí ends a later edition of this book by giving away yet one more secret, a fifty-first, concerning stereoscopic painting, the latest development in his continuing research into his art.

By 1975, Enrico Sabater had been put completely in charge of Dalí and Gala's business affairs, and was busy making an enormous amount

of money for Dalí from his dealings in graphics, jewelry, and repro-
ductions. Michael Stout, a New York attorney specializing in the laws
of intellectual inheritance, began working for Dalí in 1975. Stout was
to prove an important stabilizing influence:

> I met them at a small cocktail party at the St. Regis at the end of 1974 or
> the beginning of 1975. I was taken to it by a Latin American art dealer
> who knew Dalí. I was not very interested by fame but I wanted to meet
> him, and Dalí turned out to need a lawyer. Dalí asked me how I charged,
> and I replied, "By the quarter hour." "Just like a taxi," Gala said approv-
> ingly. They invited me to dinner with the secretary to talk to him further,
> and that is how it all began.[24]

A year after Stout had become Dalí's lawyer he set up a company for
Dalí jointly with Sabater in Girona called Dasa Ediciones to produce
posters, postcards, and a museum newsletter, and shortly after that
two more companies involving Sabater were set up in the Dutch Antil-
les. One was called Demart Pro Arte NV and the other Dasa NV. "In
1976 they were given notice of an income-tax audit by the Internal
Revenue Service," Stout recalled:

> Apparently Gala had been running their business in a very irregular way,
> taking cash to and fro between Spain and America and Switzerland,
> unhampered by customs officials, who were apparently too terrified of her
> to search her baggage. They had to reveal everything they could possibly
> reveal to me to help me fight this tax case. They had made a big mess of
> their tax affairs, but I managed to fight it by proving that they had no
> intention of ever living in America. They did not even get a discount from
> the St. Regis for a long stay, but paid the ordinary daily rate. The IRS
> accepted this, otherwise they could have gone to jail; they subsequently
> got $200,000 in refunds for the years 1972, 1973, and 1974.[25]

In September 1975, Franco ordered the execution of five of a group of
eleven Basque terrorists. Dalí sent a telegram of congratulations, news
of which reached the press. When interviewed on French radio, he
was injudicious enough to say that Franco ought to have executed all
eleven. (In 1971, when Franco had condemned some other terrorists
to death, Dalí had said in an interview in *L'Express* "Personally, I am

against the necessity of execution. I believe that a man has no right to take life, even that of the biggest criminal . . . but twenty death sentences is more economic than the millions of deaths in a civil war."[26] The interviewer professed shock, but Dalí confirmed: "All that I am saying is monstrous, but the Civil War was monstrous too.")[27] This time, the protests against Dalí's typically cruel and flippant remarks were serious. His comments stirred up old fears that were never far below the surface in Catalonia, even forty years after the Civil War.

There were many threatening telephone calls, and graffiti was scrawled over the house at Port Lligat. The chair Dalí was wont to sit in by the window at the Via Veneto restaurant in Barcelona was blown up. Dalí and Gala panicked at this violent reaction; Dalí had always secretly believed he would be assassinated, and so strong was his fear now that he took an airplane to New York, arriving there in a pitiable condition of terror in mid-October.

Dalí could never resist giving an interviewer a good quote, and in his constant desire to "cretinize" journalists and, through them, the public, he would push shock and provocation to the limits. But this time he had gone too far. Catalan nationalism, for so long held in abeyance by Franco, was experiencing one of its periodic upswings. Why did Dalí not subscribe to this movement? Because he had a horror of what he perceived to be the parochialism of Catalonia. He did not believe in separatism, he believed in Spain.

When Franco died a month later, on November 20, the blow to Dalí was shattering, for he had come to depend on him as an authoritarian father figure, the only man who could keep Spain from the abyss of another civil war. But gradually, Dalí transferred his allegiance to King Juan Carlos, Franco's designated successor, perceiving him to be another strong man. Still, Franco's death shocked and frightened Dalí to the point where he began to show serious signs of ill health. Dalí began to have problems with his shoulder and also, according to Robert Descharnes, with his left leg. He began to tremble uncontrollably, leading to suspicions that he had Parkinson's disease, which had killed his father. Curiously, Dalí could, at least for a while, control this trembling when he painted or drew, so it may have been psychosomatic in origin rather than physiological. Reynolds Morse believes that

Dalí was suffering from the onset of a nervous breakdown, brought about by the incessant demands of Gala. He would have bursts of violent rage, and fall to the floor kicking and screaming, shouting that he was a snail. It was more and more apparent that his mental processes, always precarious, were beginning to fall apart.

Dalí referred himself to the psychoanalyst Dr. Pierre Roumeguère, whom he had known since the 1950s. When interviewed in the 1970s, Roumeguère had this to say:

> The truth is that Dalí no longer has any wish to live. He is seventy-six. He recently told Amanda Lear, his muse, "I'm letting myself die." That he has Parkinson's disease is certain, but what's happening here is an autosuicide—quite simply because Gala is no longer concerned with him. She is eighty-six and only has two or three hours of lucidity every day, and she uses these up thinking about Jeff, the young hero of Jesus Christ Superstar, whom she also calls Salvador and whom she went back to find in the USA by Concorde whenever she was able. Now she is too exhausted, and when she is not "wandering" she brutalizes, bullies, and insults Dalí as much as possible. Well, it's his whole world falling apart. You must have heard about those babies who have been separated from their mothers because of war or serious illness who let themselves die from despair. It's the same with Dalí.[28]

In 1978, Dalí was operated on for prostate trouble by Dr. Antonio Puigvert of Barcelona. The operation was a success, and for a while Dalí was himself again, inscribing a souvenir photograph to the doctor "Al meu Angel del Pipi, Doctor Puigvert." However, his recuperation was marred by Gala, who in the hospital anteroom boasted loudly about her love life and her gigolos to anyone who had the patience to listen to what must have seemed the ravings of a very old woman. Dalí began to worry about her health as well as his own; her many face-lifts had staved off old age, as had her frequent visits to Dr. Niehans's clinic, where she received live-cell injections that had the effect of boosting her sexuality, but now even she was beginning to fail.

Not all of Dalí's life was led in despair; there were occasions during which he seemed to be able to recapture his old form. One of these

was his election in 1978 and installation in May 1979 as a Foreign Associate Member of the Beaux Arts in Paris. Dalí had been quite pleased to have been accorded this honor, and for the ceremony, at which Gala made a by now rare appearance at his side, he looked healthy and alert, clad in a heavily embroidered tailcoat with green borders, carrying a larger than usual sword given to him in the Hotel Meurice by an old friend, the financier Paul Louis Weiller. The sword had been made in Toledo, which must have pleased Dalí. The handle depicted Leda's swan, as well as a nose, a mouth, and a chin, and had been designed by Dalí and subscribed to by his friends, whose names were to be engraved on the blade (this was never actually done). He was received under the cupola by the acting president of the Beaux Arts, the composer Tony Aubin, who introduced him by saying that Dalí was a genius, that he knew it, and the audience knew it and that there was no doubt of it, for if it were otherwise, then Dalí would not have been with them today, nor would he be himself.[29]

Dalí, in his acceptance speech, spoke on "Gala, Velázquez, and the Golden Fleece," as well as digressing to make several jokes that drew laughter from some academicians and shocked silence from the rest. His speech included thoughts on Montaigne, Leibniz, and René Thom, the mathematician who devised the theory of catastrophe that was beginning to preoccupy Dalí.

This is the most beautiful aesthetic theory in the world. . . . I myself very much wanted to talk to him about the railway station at Perpignan, but I also was afraid that he was mocking me. Therefore, I waited diplomatically for the propitious moment as I was accompanying him to the elevator and I said to him, "Dear sir, you have read what I say, that if there had not been the space that exists between Salses and Narbonne— that is, Perpignan—there would not have been the initial drama of the continental drift," and he said, "Not only that, I can assure you that Spain pivoted precisely—not in the area of—but exactly where the railway station stands today."

Then I took him and had him come back to my parlor, where there were fifty witnesses, and I said, "Mr. René Thom, will you repeat that," and he said exactly the same thing. . . . Well, that gave me a great deal more pleasure than when someone says to me that a picture is pretty because of its color or I don't know what; there are still other scholars who have found . . . Now all that I say is going to be proven; there is

enough for forty years before people can digest all that, because naturally these are rather arduous things, and that is why I myself, I always end by saying, "Long live the railway station at Perpignan, and long live Gala."[30]

Dalí and Gala spent that summer in Port Lligat and Cadaqués, respectively, with Enrico Sabater in attendance acting now as a combination of business manager and nursemaid.

Six months after his admission to the Beaux Arts, the French honored Dalí even further with a huge retrospective of his work from 1920 to 1980 at the Centre Georges Pompidou in Paris. Dalí had wanted all his works hung one above the other in a single hall "as in the salons of the last century in order to see all Dalí in a single glance."[31] Instead, the presentation was chaotic. The catalog was printed in two volumes with a cloth cover of Dalí's ripped-fabric design for Schiaparelli.

On December 17, Dalí, Gala, and Enrico Sabater arrived at the Centre Georges Pompidou to have a preview, but they were not allowed into the museum because the employees had gone on strike; some said this strike was called as a protest at Dalí's having advised Franco to shoot more terrorists. Dalí was booed in the street and hurriedly left with Gala. They did not linger for the opening but fled to New York by plane.

Dalí would never see his retrospective. For now began his long, sad journey toward death.

► ► ► ► ►

PART FIVE

THIS APPROACHING METAMORPHOSIS
1980–1989

Man's parched grey substance of your brain is drained
of quick and liquid, and the parchment hiss
of the dropped grain is in the ground ingrained
by this approaching metamorphosis.

"The Metamorphosis of Narcissus," Salvador Dalí

15

THE HORSEMAN OF DEATH
1980–1982

W hen Dalí and Gala arrived in New York in December 1979, he
made it known that this would be the last time he would visit
the city. All his old friends were dying or had disappeared. Gala
was furious on hearing this, since she was obsessively concerned with
spending as much time with Jeff Fenholt as possible, and Fenholt was
in New York.

Michael Stout was pressed into service as a porter:

> I worked as a footman, chauffeur, and maid for them that final winter in
> New York. They became very sick, and I remember Gala would not eat
> the food in the St. Regis, so we had to bring it in from Laurent, one of
> their favorite restaurants. I had to serve them, too, because union rules
> forbade the waiters to serve food that had been brought in from outside
> the hotel; I looked after them every single day until they went back to
> Spain in mid-April.[1]

Though Dalí and Gala had had flu shots on their arrival in the United
States, both fell ill in February and were forced to stay in New York far
longer than they usually did. Nanita Kalachnikoff remembers that Dalí
implored her not to abandon him. Time went on, but neither Dalí nor
Gala showed any improvement. At the end of March, Stout went off
for a much-needed holiday, leaving the Dalís in the care of
Kalachnikoff, but two days after his departure he was called back.
Dalí's health had deteriorated. "He never had a healthy day after that,"
Stout says.

In April, they went back to Spain. They were so terrified of paparazzi that they flew into Paris and then transferred to a chartered Mystère jet that took them to Perpignan, whence they went to Port Lligat. Enrico Sabater then took them to the Incasol clinic in Marbella to convalesce. Dalí had insisted on the Incasol to be near Kalachnikoff, whose house was in the hills nearby. It was a disastrous choice, for the Incasol is a very expensive health spa more used to dealing with millionaires' weight problems than with real illness. Dalí became confused and incoherent, and Gala obstructed the medical staff, on one occasion refusing to let the nurses give Dalí medication. Only she should prescribe for him, as she had always done. The results of her quackery were catastrophic.

They returned to Port Lligat in May, Dalí somewhat better, to find the servants unpaid and the house unheated. Kalachnikoff saw Dalí again at the end of June:

> It was tragic. In two months he had completely degenerated, and when I went into his room he tried to crawl under the sofa like a dog, because he didn't want me to see him in such an awful condition.[2]

Reynolds Morse and Michael Stout, hearing of the desperate situation Dalí was now in, made an emergency trip to Cadaqués at the end of May, together with Robert Descharnes, and found that Gala had dismissed their doctor and was feeding Dalí with tranquilizers (and with stimulants when she wanted him to work) from her own traveling pharmacopoeia. Gala herself appeared to be suffering from intermittent senile dementia and would not at first listen to Morse and Stout, refusing to admit that there was anything wrong with Dalí that her pills could not cure.

It took them nearly ten days to persuade Dalí to consult Dr. Puigvert, who had operated on him for his prostate problems three years before. Puigvert diagnosed side effects of too many American antibiotics, which had caused toxemia and the onset of arteriosclerosis. Dalí complained of trembling and of difficulty in walking and swallowing. Puigvert said, "Dalí has always laughed at life; now life is laughing at him."[3] Other experts were consulted. Dr. Manuel Subirana prescribed antidepressants. Professor Juan Obiols diagnosed acute paranoia.

On the evening of July 17, while writing out a prescription, Obiols suffered a massive coronary and died in front of Gala. Later, it was said that Gala, incensed at the amount Obiols was charging, screamed at him so ferociously that he had a heart attack. The servants summoned Dalí's friend Antoní Pitxot, and the body of the psychiatrist was dragged out of the house without Dalí knowing what had happened— he was subsequently told by Puigvert that Obiols had gone to South America. When Obiols's family arrived the next day, Gala, who knew them well, did not bother to show up and offer them condolences. Disaster followed upon disaster; Dr. Ramón Vidal y Teixidor, the psychiatrist who subsequently assumed Obiols's role, broke his leg in the house.

Gala now began to keep everyone away from Dalí. She would always answer the telephone, and told friends to ring back. She barred Robert Descharnes (whom she had always hated, possibly because he was well-meaning and straightforward) from all contact with Dalí, and when Jordi Pujol, president of the Generalitat of Catalonia, came to Cadaqués at the end of August to ascertain for himself how ill Dalí was, he was told that Dalí was not in a fit state to see him, or even to speak to him on the telephone. Some paparazzi in Cadaqués did, however, manage to breach Gala's defenses and took photographs of the shrunken Dalí held up by his majordomo, Arturo Caminada, and a nurse. At this point, Ana Maria had to ask the press for clarification about her brother's health.

Morse and Stout announced the creation of a group called "Friends to Save Dalí." "We proved pretty well that under Gala's untender care Dalí has been reduced to a shell of his former self," Morse said, citing as well her failure to straighten out the artist's cloudy Spanish tax situation.[4] In reference to this problem, Morse pinpointed one of Dalí's major worries: Dalí had been advised that he would be better off from a tax point of view if he became a resident of Monaco, and an apartment was accordingly bought in the principality. In the event, Dalí never used it and Gala visited it infrequently. However, Dalí's abandonment of Spanish residency created a situation in which it was perfectly possible that he might have to leave Spain, or pay punitive taxes if he remained there, as he wished, for six months of the year.

Ironically, the success of the Georges Pompidou retrospective had been more than repeated when the exhibition moved to the Tate Gal-

lery in June 1980 and became the best-attended exhibition (with the exception of a Constable show in 1976) that the Tate ever mounted, prompting plaudits from art critics such as John McEwen, who, writing in *The Spectator,* took the opportunity to reassess Dalí's achievement:

> *It is the spirit, the heroic scale and supreme attention to the detail of Dalí's pictorial defence—that is cowing. The fact that he has also found time to create a vast audience for painting (other people's as well as his own, no doubt) through his own remorseless exhibitionism—rather in the way Muhammad Ali has done for boxing, once also an activity in need of an audience—only increases one's sense of awe at his fanatical energy and dedication. . . . Nor, as is also commonly assumed, has he lacked influence. He is revealed as a father of such latterday movements as Pop and Photo-Realism. . . . Nevertheless he leaves a legacy of affirmation and hope in the continued relevance of painting as a means of communication in the modern world, and will surely one day be vindicated.*[5]

Slowly, Dalí began to recover his equilibrium, and by the autumn of 1980 he had started to paint again and was working for four or five hours a day. "But Gala still fed him tranquilizers, which were the worst thing for him," Reynolds Morse says.[6]

On October 25, 1980, Dalí appeared in public for the first time since April. He shambled into the Teatro Museo Gala-Dalí, to the accompaniment of music from *Tristan und Isolde,* with Gala, who threw flower petals at a throng of photographers. They were accompanied by Enrico Sabater.

> *Dalí's right hand, his painting hand, shook uncontrollably, his white mustache drooped. "You see how my hand is trembling?" he asked the assembled journalists defiantly. "Well, look now," and then he held the shaking hand still. Although his limbs were clearly invaded by disease, the old Dalí wit was still there. Asked about his Spanish tax problems he retorted, "I love to pay taxes, but I don't know anything about this because Gala takes care of it and she's not going to say anything because this is my press conference." Turning slowly, Dalí unveiled a horrible painting he had completed during his isolation in Port Lligat, a grotesque, lurid, purple beast recumbent. Its title: The Happy Horse. "It is a little*

*rotten," Dalí told the assembled press. "I don't know if you can see that it
is a horse or a donkey, but you can see that it is rotten."[7]*

To add to the Dalís' troubles, the Generalitat of Catalonia, worried at
the physical and financial state of their most famous son, began an
investigation into the conduct of his financial affairs, which upset Dalí
profoundly. This inquiry may have prompted Dalí and Gala to sum-
mon a new porter to their aid.

Jean-Claude du Barry was a Frenchman from Gascony who owned
model agencies in Paris. Dalí had met him in 1968 at the Ritz in
Barcelona, and Du Barry had, since about 1975, been providing Dalí
and Gala with male and female models for Dalí to paint and as candi-
dates for their erotic Masses. "I was to Dalí what Petronius was to
Nero, his superintendent in amorous questions and in creative ones
too. I found the models for his pictures, especially the *Saint Sebastians.*
. . . . I was his 'officer of arses,'" Du Barry used to tell people, with
satisfaction.[8]

On August 18, 1980, Du Barry (whose original claim to Dalí's atten-
tion was that he was the nephew of a music-hall performer called Le
Pétomane whose act, in which he farted to music, had been immortal-
ized in *Pétomania,* one of Dalí's favorite books) was summoned to Port
Lligat by Gala. "I started to call Dalí's old clients," he told *The New York
Times.* "I told them, 'If you want to do business with Dalí, call me.'"
Du Barry arranged for $1.3 million in contracts. Eleven of these con-
tracts, drawn up by Du Barry, gave a Paris graphics dealer, Gilbert
Hamon, worldwide rights to turn out Dalí lithographs or engravings
that were in reality reproductions from color slides that had little in
common with true lithographs. Some of these were to be stamped with
a print of Dalí's thumb.

Alarmed by this development, Robert Descharnes moved to get Dalí
to join SPADEM (Société de la Propriété Artistique des Dessins et
Modèles), an enterprise based in Paris formed to protect worldwide
copyright. The affair came to a head in March 1981 in Paris when Dalí
gave the news agency Agence France-Presse a brief statement in which
he said: "I declare that for several years and above all since my sick-
ness, my confidence has been abused in many ways and my will was
not respected. That is why I am doing everything to clarify this situa-
tion, and Gala and I are once again resuming our freedom."[9]

Although he had not named Enrico Sabater in this communiqué, Dalí's secretary demanded that the artist issue another statement saying that Sabater was not the target of this accusation. Dalí stood firm, and Sabater departed. Du Barry's brief reign in dealing on behalf of Dalí was brought to an end by the emergence of Robert Descharnes, who, with the support of Reynolds Morse and Michael Stout, became Dalí's new business manager. Descharnes was the best candidate because, as Morse later put it, he was prepared to spend an enormous amount of time looking after Dalí and Gala, and could be trusted to safeguard Dalí's best interests while circumnavigating Gala.

Other aspects of Dalí's life were also now falling into place; his Madrid lawyer, Miguel Domènech, reported that the artist's irregular tax situation permitted him to live in Spain, and that the proper treatment for Dalí's Parkinson's disease meant that he could, once again, hold a paintbrush.

But Dalí's private life was still in turmoil. By 1981, his Parkinson's had advanced to the point where he was consulting Dr. François Lermitte, head of the neuropsychiatric unit of La Pitie–Salpetrière hospital in Paris. Gala, who was terrified of illness in general, and in particular when it might affect Dalí's earning power, panicked and told anyone who would listen, including the waiters at the Hotel Meurice, that Dalí was finished as an artist and a man, and that she was thinking of getting a divorce. It was hardly surprising that news of this rift in the "perfect" relationship made the international press.

Matters between them reached a nadir late one evening in February at the Meurice. Enrico Sabater was woken by Dalí, who was hammering at his door and shouting "Help!" Sabater rushed to the Dalís' suite and found Gala lying on the floor next to her bed. A hastily summoned doctor diagnosed two broken ribs, and lesions along her legs and arm. She was taken to the American Hospital in Neuilly for emergency treatment. Sabater asked Dalí (who had a black eye) what had happened, and when he had composed himself, Dalí told him that he had finally had too much of Gala's taunts and her insistence that they must go back to New York so that she could see Fenholt. He had struck her again and again with his cane, and she had punched him back.

Subsequently, Sabater gave an interview to Gala's biographer, Tim McGirk:

Gala needed enormous quantities of money. Dalí was too sick to produce anything—he had been for a while. Gala had literally forced Dalí to put his fingerprint on a document that, as Dalí found out, signed away some reproduction rights Dalí didn't even own. Dalí had also received news that Jeff Fenholt had sent the paintings given him by Gala to be auctioned at Christie's in New York, which had enraged him, for while he knew Gala had been giving Fenholt money from time to time, he had not realized the extent of these gifts. From this point, until the time of her death eighteen months later, Gala and Dalí would be locked in a bitter and sometimes very public battle which often ended in blows.[10]

When King Juan Carlos paid a visit to Dalí and Gala in Port Lligat in August 1981, Gala tried to persuade Dalí not to wear his red cap. "How can I not wear it?" replied Dalí. "Am I supposed to show the King the wound that you've opened in my skull with your shoe?"

That autumn, back in Port Lligat, Dalí was excited by the addition of the Torre Gorgot, bought by the Generalitat to add to the exhibition space of the Teatro Museo Gala-Dalí. Adjoining the original building, the Torre Gorgot (which Dalí renamed the Torre Galatea) formed part of the original city walls of Figueres and gave valuable space for the enlargement of the museum. The only dissenting voice to this plan had been Gala's; she described the Torre Gorgot as "a ruined house that had belonged to Catalan bourgeois and that would cost too much to restore."[11]

All the members of the museum's board were invited to the opening ceremony, including Prince Jean-Louis Faucigny-Lucinge, Dalí's old friend from Paris, who would recall:

There was a tremendous banquet and speeches. All the authorities were there, the president of Catalonia, everybody. It was a big event. And then, in the afternoon, Dalí left because he was too unwell, and it was decided that we should go and see him at Púbol, where he was expecting us. When we arrived we were led into the courtyard, from which a stone staircase went up to a platform. A few of us were asked to mount to the platform because we were told that a window would open nearby and Dalí would show himself. We waited, and the crowd was shouting, "Dalí! Dalí!" and after about an hour a shutter was pushed aside and we saw

Dalí pushed in a chair, wearing a white dressing gown and a turban, with his big cane. Quicker than I am telling this story he pushed his chair back and disappeared again. I suppose he couldn't face the crowd, or didn't even see us. It was very sad.[12]

At the time of the inauguration of the Torre Galatea, the Generalitat of Catalonia awarded Dalí its highest honor, the Gold Medal, and in Madrid the Ministry of Culture expressed an interest in staging a major retrospective Dalí exhibition. But it was all too late. As one of his doctors said, "He is ill but of nothing specific."

Dalí and Gala were almost permanently separated by now. A month would go by without even a telephone conversation, and when they did talk, all Gala would say was that New York was the only place they should live because she wanted to be near Fenholt. But there were to be no more trips to New York or even to Paris for either of them.

On February 24, 1982, during a rare visit to Port Lligat, Gala slipped while climbing out of the bath and chipped her femur. Because she also had serious skin lesions, she was taken to a clinic in Figueres to consult Raymond Vilain, a French dermatologist.

By February 28 her condition had become so grave that she was rushed to the Platon clinic in Barcelona, where, on March 2, she was operated on. The operation was successful, but her arteries were too fragile to take transfusion needles and the decay of her skin had accelerated. It had been weakened not just by age but by the face-lifts and tucks, which now erupted in hideous sores. It was as if her tremendous willpower, which had kept her young for so long, had now vanished, as had her conscious self, except for a few lucid moments.

When Gala was in the Barcelona clinic, Dalí visited her once, and then refused to return or to listen to news of her. She had become one of his *putrefactos,* the nightmare of decaying flesh that had haunted him all his life. Her tiny but indomitable body was decaying in front of his eyes. Dalí, who had always thought he would die before Gala, was now in the process of losing her to the earth that had claimed his brother, his namesake. She who had always been able to banish his terrors had now become the embodiment of the worst of his fears.

At the end of March, she was brought back to Port Lligat to die in

the room she had shared with Dalí for decades. Her bed, beside his, was turned so that she could see Cap de Creus out of the window.

On May 26, a spokesman for Dalí issued a press release stating that Gala was "fine and at this very moment up out of bed." But two weeks later, Joaquim Goy, the priest from La Pera, was summoned to give Gala extreme unction, and, at the same time, Benjamin Artigas, the mayor of the little village of Pubol, was telephoned and asked to prepare a tomb for Gala in the castle. "Be discreet, the press must know nothing," he was told.[13]

Gala was clad in a blouse of white silk brocade for the last rites, which were attended by Dalí, but she would not, as the priest predicted, die yet. "This one will take her time," the priest told Artigas.

Dalí wandered about the house asking Miguel Domènech, his lawyer, Gonzalo Serraclara, his cousin, Antoní Pitxot, and Robert Descharnes whether she would die. He had a screen put between his bed and hers, because, as he said, she would not let him sleep.

In these last days of Gala's life, Cécile made a visit to say good-bye to the mother who had been lost to her so many years before. She was told that Gala refused to see her.

Gala died alone in the bedroom on June 10. She was probably eighty-nine, though her passport gave her age as eighty-four. Her eyes, which once could pierce walls, were open and staring at the little bay and the cliffs beyond. Those present in the adjoining antechamber, waiting with Dalí, heard an extraordinary guttural sound come from Dalí's mouth as she breathed her last. Later, Arturo Caminada told journalists, "When Madame died, el Señor had the same reaction as always. He said she wasn't dead, that the madam would never die."[14]

Now began a sequence of events of true Surrealist horror: Gala's body had to be moved to Pubol immediately and secretly if she was to be interred there. Spanish law is strict about burials and forbids a corpse to be moved until a judge has seen it. In addition, permission for private burials outside cemetery walls is rarely given. So her tiny body was wrapped in a blanket and laid on the backseat of Dalí's blue Cadillac to be driven one last time by Arturo Caminada the eighty kilometers to Pubol over twisting and turning mountain roads. Caminada later said it was the only time she had ever traveled in the back of the car. A nurse went with the body so that if the car were stopped it would appear that Gala had died on her way to the hospital.

When her body arrived at Pubol, a death certificate was issued, giving the cause of her death as cardiac arrest with the underlying cause being senile arteriosclerosis. She was embalmed and dressed in one of her favorite red velvet Chanel suits, the black Chanel bow in her hair, the rings Dalí had designed for her on her fingers. She was made up and placed in a glass-topped coffin. She was buried at six in the evening on June 11.

Dalí was not there, but he went to visit the tomb some hours later, accompanied by Antoni Pitxot, Arturo Caminada, Gonzalo Serraclara, Robert Descharnes, and Miguel Domènech. Dalí cried. A few days later, he returned to the crypt at night, completely alone. The nurses, alerted by the noise, saw Dalí, his hands lifted to the screen that concealed the mausoleum, weeping disconsolately. His face was covered with tears.

In the two years that he lived at Pubol, he never went to the crypt again.

Dalí without Gala seemed an impossibility. They had preserved their "secret within a secret" for over fifty years and had built an elaborate myth of their undying love for each other, which they then proceeded to destroy.

Gala will always remain an enigma, in spite of the portraits Dalí painted of her. Was she a grasping and salacious refugee who had found in Dalí a passport to the luxury she craved? Or was she a mystic, a Rasputin-like figure, who held the key to the deepest levels of Dalí's subconscious?

Dalí himself was frank about her initial attractions:

> . . . most of all I was truly, snobbily taken by Gala's cosmopolitan charm. Here I had, within reach of my hand, of my mouth, a Parisienne, the wife of a famous Surrealist poet, an elegant, divine woman, coming to me from the far corners of Europe—Eluard and Gala were back from Switzerland, where they had visited René Crevel, who was there for his health—with her wardrobe valise lush with laces and labels of great couturiers. A woman I had heard so much about, who was the stuff on which I much had dreamed. And this woman was talking to me about me, asking me about my secret self, and I was able to spread myself before

her, evoke her deeper curiosity and passionate interest. Gala was of my
own size. I had just found the sister soul. . . . She knew I was not the
flighty Argentine dancer I seemed to be, nor one of those blasé characters
around her, but an abysm of terror and fright, a child of genius lost in the
world, the horrible world teeming with stupidity as well as monsters with
mandibles, claws, and talons, imbued with hatred for all that was beyond
them.[15]

It must not be forgotten that in their early years Gala worked pun-
ishingly hard both to support and to establish Dalí, not only by unrav-
eling his tortuous complexes, thus enabling him to lead a relatively
normal life, but also by making him into a better painter technically—
a painter who was less interested in the physical act of painting than in
the act of communication. She achieved this by insisting that he nei-
ther skimp nor take shortcuts and that he study technique. She also
researched the forgotten formulations of color by the old masters.

Did Gala corrupt Dalí? No. Ever since his student days in Madrid he
had had ambitions to be mondain and a natural tendency toward the
life of a dandy. He preferred an expensive dry martini in the Ritz bar
to a glass of beer in a café; Gala encouraged this, because her one
ambition was to lead the secure, protected life of the rich, to whom
money, being so plentiful, finally became irrelevant. She did not cor-
rupt Dalí, but she encouraged him in his dandyish tendencies and in
his voyeurism to further her own ends, and at her door must be laid
much of the blame for the bleakly perverse life the couple lived lat-
terly.

Gala was not so much Dalí's muse as his impresario, the mother he
had lost, the sister he had desired, and the only possible wife for a
man of his nature and his tendencies. The "Russian whore" had out-
lived every opprobrium. Dalí had accepted her every action—save that
of abandoning him, her life's work, in favor of a stupid and venal
gigolo. She had been as faithful to Dalí as her nymphomania and
avarice would allow, and had kept Dalí's secrets as closely as she kept
her own.

A woman of deep and strong passions, she was both Dalí's salvation
and his doom. Jocelyn Kargère commented:

I think she was an outlet for his darkness, which he never externalized
except through Gala. The man worked, he was always working, doing

something visually, doing what he wanted to do, and I think Gala was the person who kept out extraneous material, the people, the small talk, but she regarded everything he did as hers to do with as she wished, to help satisfy her—and she could never be satisfied, so she hounded Dalí until he could take no more.[16]

Dalí must have the last word:

Gala had already achieved a degree of maturity and despair that made her sensitive to the full reality of my tragedy, allowed her to communicate immediately with my most secret self and offer me the gift of her radiant energy, almost mediumistically. Through her I was in communion with the cry of life.[17]

16

THE IMAGE DISAPPEARS
1983–1989

"After Gala's death," recalls the art dealer Carlos Lozano, "Dalí's life became gray; he was surrounded by men in gray suits; all the color, the madness, and the Surrealist fun had gone from his life forever. It was all gray."[1]

Dalí forgot the last terrible years of her disloyalty and neglect, and wandered around the echoing white rooms of Pubol uttering disjointed sentences about the happiness he had known with Gala and how beautiful she had been. He painted nothing and sat for hours in the dining room with all the shutters closed. "It is very difficult to die," he said to a friend.

Antoní Pitxot, on one of the last of their rare sorties, pointed out an orange tree whose fruit was shining in the sun: " 'Don't show me things I have loved so much,' Dalí said, shaking his head. 'It is bad for me to see them, for I know I will be leaving them soon.' "[2]

Nothing could move Dalí from his despair. Carlos Ballus, one of the psychiatrists treating him at Pubol, analyzed his state of mind as follows:

The death of Gala marked the end of an epoch and initiated a state of renunciation. . . . The process of inversion, reclusion, and renunciation is already manifesting itself. For Dalí, the loss of Gala is an immense sadness.[3]

But outside the walls of the castle, much was afoot. Since the death of Picasso in 1983, Dalí was by common consent the best-known

living Spanish painter. The central Spanish government and the Generalitat of Catalonia had begun to concern themselves about the fate of his vast inheritance of pictures, and to form the intention that Dalí's scattered holdings be brought back to Spain before his death so that the Spanish state would, as he had indicated, be able to inherit the collection with a minimum of red tape.

After Gala's death the way was now clear to do this, and government officials lost no time. Gala had always violently resisted anything being moved or, worse, given away, and her intransigent attitude had in the past stopped the sensible disposition of the pictures, drawings, memorabilia, and objects she had annexed and stored. So secretive had she been that no one knew exactly what was stored—or where. The Georges Pompidou retrospective had prompted Gala to bring several major works out of warehouses, but there was obviously much more to be discovered.

Before mounting the complex international operation to find Gala's caches and move them back to Spain, Dalí's legal and fiscal status in Spain (made uncertain because of his fervent pro-Franco leanings and by his adoption of Monegasque citizenship) had to be reaffirmed. The King and Queen of Spain had made the first and most important move in this direction by visiting Dalí at Port Lligat in the summer of 1981, anchoring their yacht *La Fortuna* in the bay, and permitting their photographs to be taken with Dalí and Gala. In March 1982 Dalí's award of the Gold Medal of Catalonia was a further recognition of his restored reputation.

Next followed a contract, signed by Dalí, significantly enough, just eight days after Gala's death, for a retrospective exhibition of his works under the auspices of the Ministry of Culture. The retrospective would first be shown in Madrid and subsequently in Barcelona "as a testimonial to the transcendental contribution of Spanish artists to the art of the twentieth century."[4]

On July 20, 1982, just over a month after Gala's death, King Juan Carlos awarded Dalí the Grand Cross of Charles III and a marquessate. Dalí would now be known, at his own request, as the Marqués de Dalí de Púbol. This title ensured that his family name was ennobled as well as himself. Eleven days after this royal decree had been made public, the Kingdom of Spain bought *Cenicitas* and *Arlequín* from Dalí for 100 million pesetas. These two paintings represented Dalí's early and pure

Surrealist period and his postcubist work respectively. Simultaneously, Dalí gave Spain a third picture, *The Three Glorious Enigmas of Gala*, which was the last large-scale picture he had painted of her.

Meanwhile, laborious efforts were being made to bring back from New York Dalí's effects, which had been in storage for years. Gala had told Miguel Domènech, in one of her brief periods of lucidity, that there was "nothing in New York." There were in fact 1,211 paintings, drawings, and engravings, as well as statues, magazines and newspapers, clothes, personal objects, and documents.

On September 29, 1982, after extraordinarily complex legal matters about the disposition of this inheritance had finally been sorted out, the whole collection was flown to Barcelona on an Iberia Airlines DC-10 felicitously named *Goya*. When it had cleared customs, the many packing cases were taken to Pubol. Among the items of particular interest were the scrapbooks Gala had kept during the American years and the manuscript of a very early Dalí essay, *"L'Amour et la Mémoire,"* dedicated to his sister, which he had written in 1930. This erotic poem confirmed the rumors about Dalí's relationship with his sister, commencing as it did with the following lines:

L'image de ma soeur	The image of my sister
avec l'anus rouge	with the red anus
et plein de merde	full of shit
l'image de ma soeur	the image of my sister
avec le sexe ouvert	with her open sex

The anonymous resident of Cadaqués who had spread the story that he had seen Dalí and Ana Maria embracing naked on the beach in the late 1920s might not have been making it up, and this would explain much in Ana Maria's subsequent attitude toward Gala.

While his reputation and his oeuvre were being restored to Spain, Dalí's life in Pubol continued at its slow and sad pace. The lavish dinners of ortolans and sea-urchin soup were now things of the past. In fact, Dalí refused to eat, saying that he could not swallow. He demanded constant attention and he would scream hoarsely or weep for hours. He indulged in incomprehensible conversations, repeating

that he wanted to die. The small child who had deliberately spilled his milk and coffee down his shirt eighty years before, or had screaming fits when he was not allowed to wear his golden crown, now surfaced from Dalí's deepest subconscious, and his sense of loss and terror first engendered by the specter of his dead brother rotting in the grave marked "Salvador Dalí" returned in full force.

By the beginning of 1983 his spirits appeared to lift somewhat; he began to paint again and could sometimes be persuaded to take short walks in the gardens accompanied by a nurse. The staff at Pubol now included four nurses, two of whom were always on duty; the faithful Arturo Caminada; a married couple who cooked and cleaned; and, as befitted a man who was rapidly being transmogrified into a living piece of the national heritage, he was also guarded by two members of the Guardia Civil, who spent most of their time in the kitchen of the castle watching soccer on television.

Dalí painted on small canvases never measuring more than 36 inches by 28 inches. He sat in the dining room on a stool and always painted by artificial light. The dining room contained a huge table, and on the walls were various trophies, including a lion's head garlanded in dried flowers. While Dalí painted he would often be accompanied by one of the nurses, Carme Fábregas, who had first nursed him at Antonio Puigvert's clinic. Señorita Fábregas would read to him, as Gala had always done in the past. Dalí's preferred choice was René Thom's writings.

Every Saturday, Dalí's assistant, Isidor Bea, would come to the castle to prepare Dalí's canvases for him. As the months wore on, empty canvases accumulated. Often, Dalí would attempt to paint something in the morning; then, in a frenzy of rage, he would throw his brushes to the floor and, in the afternoon after his siesta, destroy what he had done. In January 1983 he destroyed eleven canvases in such a manner. But what was he painting? All these last pictures related to the theory of catastrophe and were flat, graphic works, two of which, *Cutlet and Match—The Chinese Crab* and his last painting, *The Swallow's Tail,* which he finished, according to Robert Descharnes, in May 1983, contained references to violins—the violins of Ingres, perhaps?

By the end of February 1983 it was obvious that Dalí's brief interlude of sanity was coming to an end; by May 1983 he finally stopped painting forever because, as Carlos Ballus maintained, "he could no

longer put in motion those intellectual processes that were the basis of his work as a painter."[5]

Dalí now passed the major part of his time in bed in the dark, crying and waiting for the death that refused to come. But even in such straits, his extraordinary will persisted. "Dalí still needs to be dominant," Carme Fábregas said. This will manifested itself in insults to his nurses (he often called them whores) and his refusal to eat the food prepared for him. A friend, the hotelier and restaurateur Jaime Subires, would come to Pubol with food to tempt his appetite. All Dalí would eat was mint sorbet, which Subires brought in industrial-size containers.

Eventually it became necessary to feed him by force, for he was slowly and deliberately starving himself to death, or perhaps he believed that he was hibernating. He would often be subject to nightmares and hallucinations. But from time to time his terrors would recede and he would have a good day with his mind clear. He could then talk of new projects with something of his old enthusiasm. At the time of his eightieth birthday in May 1984, he showed positive signs of a sustained improvement.

The retrospective in Madrid had been a great success; naturally, Dalí could not attend, so the young Prince Felipe of Asturias was deputized to represent him, and the King and Queen attended the opening ceremony.

In June 1984, on the anniversary of Gala's death, the retrospective opened in Barcelona. Dalí expressed his desire to be there, but at the last minute, frightened by the journey and of being exposed to the public gaze as old and feeble, he excused himself. But the idea of the retrospective seemed to put new heart into him, and he surprised his attendants on the day of the opening by thanking them for their patience and telling them he thought he might recover. That evening, he got out of bed to study some photographs of the Torre Galatea. He had begun to eat again, requesting omelets and even asking for a glass of wine. His improvement, though slow, was more and more apparent, and in June he was well enough to make a trip to the museum in

Figueres, accompanied by Arturo Caminada, Antoní Pitxot, and a nurse, and he walked, with help, through the museum for almost two hours to see his work and the progress of certain alterations.

But his desire to dominate his little court at Pubol led to disaster. He would ring his bell constantly at night to bring one of his attendants to his side, for he hated to be left alone in his huge four-poster bed. On his better days, he rang the bell over twenty-five times. The constant ringing resounded throughout the castle, and the nurses, exasperated by the noise, changed the bell for a light that went on when Dalí pressed a button. This frustrated Dalí enormously, and on August 30, 1984, he pressed the button continuously in the middle of the night, thus creating a short circuit that set his bed on fire.

When Robert Descharnes, who was staying in the castle (as he frequently did to attend to Dalí's affairs), was awakened by the nurses, he went into Dalí's room and found the painter crawling toward the door underneath the smoke. The huge bed was in flames. At first it appeared that Dalí was so little harmed that, the next day, he was driven to the museum, dressed in a smoking jacket and wearing a white turban. There he inaugurated a memorial to Gala. But two hours later he was admitted, as a precautionary measure, to the clinic of Nuestra Señora de Pilar in Barcelona. It turned out that his burns were more serious than had at first been supposed, covering 18 percent of his body. He had been burned on his buttocks, groin, and upper legs. Four days later he had to have skin grafts—a difficult procedure for someone suffering from malnutrition and weighing less than 100 pounds.

The delay in treating his burns, and his undernourished state, led to intense speculation, first in the Spanish press and, subsequently, internationally. All the old stories about friends and family being refused admission to the castle were now aired again, and even Ana Maria joined in the worried chorus, going so far as to visit Dalí in the clinic with one of their cousins. Dalí had not seen his sister for thirty years. Her version was that he looked at her without speaking but with tears in his eyes. Another version has it that he tried to hit her and shouted, "Push off, you old lesbian." The latter is the more convincing.

Gradually, against all odds, the eighty-year-old Dalí recovered. The skin grafts healed and, now being fed by a tube in his nose, he began

to put on weight. The fire had saved his life. It was the type of irony Dalí appreciated.

He never went back to Pubol, but in October 1984 he was removed from the clinic and established in a bare, cool room in the Torre Galatea. He had come to spend his last days in the Escorial he had constructed so carefully.

By February 1985 Dalí was well enough to grant an interview lasting an hour and a half to Spain's premier newspaper, *El País*. He approached the interviewer with great enthusiasm, demanding more and more questions. He discussed his visits to Franco and the strange death of the composer Vincenzo Bellini, aired some thoughts on monotheism, and observed that artists were like truffles: "They have their place when they are creating and another when they are not."[6]

Dalí also discussed modern art in a lucid manner:

Modern art is a catastrophe. As Picasso said of his work, "Here I do nothing more than create checks without limits." I am very interested in Umberto Boccioni, De Kooning, and the American hyperrealists, who are good precisely because they are not Americans, but Dutch in origin and have Dutch blood. De Kooning is a giant, like the Colossus of Rhodes with one foot in Amsterdam and the other in the United States. With some figures [Dalí was referring to the series "Women," painted between 1947 and 1952] it is difficult to tell whether they are women or landscapes. In reality they are geological cataclysms.[7]

Dalí appeared to be on his old mettle, despite the tube running up through his nose; in his diminished but now stable physical state he had started to draw again, though his hand trembled badly. Early in 1986 he produced twenty drawings as gifts for King Juan Carlos, the mayor of Madrid, and the representatives of all the nations who attended the ceremony on the occasion of Spain's entry into the Common Market. Though the outlines of the drawings are feeble, there is still the faint echo in them of the energy and strength Dalí had once had, and of what he once had been.

Far from being reclusive, Dalí now actively encouraged visitors to his tower. In 1986, *Vanity Fair* published photographs of him taken by Helmut Newton. Dalí was wearing a satin robe he had specially designed for the sitting, over which he had put the Grand Cross of

Isabella the Catholic (the Grand Cross of Charles III and the Gold Medal of Catalonia had been lost in the fire at Pubol). "I was told that he didn't want the tube in his nose camouflaged in the photo," Helmut Newton wrote in *Vanity Fair*. Dalí ended his interview with Robert Wernick with a familiar clarion cry from the past: "I am against Cézanne," he said, "I am for Meissonier."

Gradually, imperceptibly, in 1987 Dalí began to fail. No more visitors from the outside world came to see him, and he seemed to be in a state between dreaming and waking. By the end, the faithful Arturo Caminada and Antoni Pitxot, with whom Dalí could still communicate, were the only two people he wanted to see. He slept a great deal of the time, but allowed the light into his room during the day. Over the next two years, his amazing spirit began to fade and his indomitable body to wind down.

He would lie for hours in his tower in the museum, listening to an old record he had of music played at Maxim's. The chatter of the diners, the violins, the clink of glasses, took him back to his happiest days, when he was one of the most celebrated painters in the world, and dined every night at the plush red Paris restaurant. He was Dalí, surrounded by his chattering Court of Miracles, arranging erotic Masses, admired and imitated by the same society that had originally rejected him. The violins were playing in the background and there were ortolans for dinner.

He was Dalí, and he had painted "the picture," the "one," which he continued all his life on different canvases, like frames on the film of his imagination. He had painted his father in his black suit walking in the plain of Empordà. He had painted his sister leaning out of a window in Cadaqués and Lorca on the beach of memory. He had painted the strange, bleached beaches and basalt cliffs of Cap de Creus, all the while watching the lions turning into eagles, observing that time is soft and melting. He had painted the creatures that populated his subconscious and were always ready to attack him: the grasshopper, the snail, the rhinoceros, the spindly elephants, and, from early memory, the dying whale he had transformed into his self-portrait.

He was Dalí, and he had hidden behind the twin antennae of his mustache, advancing masked into a world he was determined to con-

quer by willpower, by manipulation, and by working fifteen hours a day.

He was Dalí, and he had loved and painted Gala for fifty years—as a rapacious sexual monster, as a Renaissance beauty, as a Madonna, and as Jesus at the Last Supper. He had painted the film of his life and had experienced the secret of all secrets, the union of time and space that is, as he always believed, the secret of God.

In November 1988, Dalí was taken to the Quirón clinic in Barcelona suffering from heart failure. He immediately requested that a television be placed in his room so that he could watch the reports of his impending death. At his bedside were Arturo Caminada, Antoní Pitxot, and Maria Lorca, the mayor of Figueres, who maintained that during one of his visits Dalí had indicated that rather than being buried beside Gala at Pubol, he wished to be interred under the geodesic dome in his museum.

"He was a very calculating man, even in his last years," the mayor later said, "and I believe that to be interred in the midst of his work is something he thought about a great deal."[8] Pitxot also remembered a conversation he had had with Dalí at Port Lligat at the beginning of the 1980s, before the death of Gala, during which Dalí had said that he did not want to be buried in the small cemetery at the top of the hill behind the house (which might have been the obvious choice) but in Figueres. Pitxot believed that this was because his father was buried there.

On December 5, Dalí was visited by King Juan Carlos, who confirmed that he had always felt a special and intense devotion to Dalí. Dalí, aroused from his final reverie, promised the King he would recover in order to take up his painting again.

Dalí went back to Figueres for the last time on December 14, and died on January 23, 1989, in the clinic where he had been taken as his heart failed. His favorite old scratched record of *Tristan und Isolde* was playing, making the sound, as he had once said, of sardines frying in oil.

His body was embalmed as he had requested and was laid out in

state for a week at the museum in Figueres. Then the coffin was carried by four museum guards, wearing uniforms Dalí had designed, to the little church of Sant Pere for a brief funeral service. Dalí's life had come full circle, for here he had been baptized and had taken his first Communion. As his coffin passed from the church into the museum, the people lining the streets burst into applause in a spontaneous show of appreciation for the artist who had made their town famous. Thousands lined up to see him in death, as they had lined up during his life; they wished to obtain a final glimpse of the painter whose work and whose eccentricities had been so much part of the fabric of the twentieth century.

They saw Dalí lying in a coffin dressed in a white tunic embroidered with a golden crown and a large D. His face was peaceful; death had smoothed out the marks of pain, and Dalí's bone structure could be seen in all its angular beauty. The famous mustache, which for so long had drooped sadly, had been waxed into sharp points for the last time.

Dalí was buried as he had lived, at the center of the stage of the little provincial opera house he had, by his own magic, turned into his Theater of Memory. He lies there now, the ultimate exhibit in his Surrealist wonderland, under an unmarked slab beneath his geodesic dome. There is a final jest about his resting place, which he would have thoroughly appreciated: His mortal remains lie just above the ladies' lavatories.

Under the stage, in an empty room that in the old days of the theater was probably used to store props, is a simple plaque set into the wall, recording his title and his birth and death. But his real memorial is all about him. It is the *Taxi Pluvieux* and the paintings, Gala's bright yellow fishing boat and the loaves of bread on the walls. It is *"Galarina,"* the portrait of his muse and his destroyer. It is also the hundreds of thousands of people who every year file through the corridors of his museum, the last and greatest Surrealist object, in search of the remains of a man who had eternally captured their imagination.

He was Dalí, and, as he once said, every brushstroke he made was the equivalent of a tragedy experienced.

EPILOGUE

ime has not stopped for Dalí on his bleached beaches, nor on the plain of Empordà, in the years since his death. His personality haunts the people who knew him and the places he made his own. He haunts the village of Cadaqués to the point where one feels one might, even now, see him turning a corner by his father's house on his way to Cap de Creus.

His house at Port Lligat, strangely enough, contains no hint of his presence. It is shuttered and abandoned. The garden has reverted to a rocky hillside; only Gala's withered rosemary and lavender bushes mark the old pathways. Broken columns lie on their sides among the thistles and the olive trees, and a wrecked and burned-out car has been abandoned in the fishing boat that Dalí used to form the ribs of his Christ installation.

His true memorial is his work as a painter, as a writer, as a publicist, and as a performance artist. And this is the problem; he was so protean during his life that only now can a sufficient perspective begin to be employed to evaluate his work and his place in the canon of twentieth-century painting. A man of rare intelligence, but also a man trapped by the fragility of his own psyche, Dalí is still an enigma, a variation on the well-worn theme of the artist as shaman, as a creator of magical images.

In the years since his death there has been a growing wish among art historians to separate Dalí's personality from his art. This is particularly difficult to do in Dalí's case, as he made of his life a work of art that both informed his work and nourished it. Dalí's portrayal of himself as a dandy-eccentric has hindered a proper appreciation of his

very real achievements. But art historians will, it is to be hoped, persevere, for beneath Dalí's posturing public figure is an artist who never ceased to explore his inner and outer worlds and their possibilities, a painter who never ceased in his endeavors to find a way that painting might advance and inspire in a century increasingly dominated by the abstract marvels of scientific discovery.

It may be that critics will also begin to reevaluate the later periods of Dalí's art, instead of dismissing all the work he did after his great Surrealist period ended in the early 1940s. He may, in future, be regarded not simply as a Surrealist painter who, when he had finished mining the post-Freudian mother lode, turned, exhausted, to religious and narrative pictures, but as a painter who struggled to relate his art to the discoveries of his time.

Hindering a proper appreciation of his oeuvre is the fact that Dalí deliberately distanced himself from the art establishment. He enjoyed society, wealth, and maturity at a time when the dominant view in the art world was Marxist and when youth was worshiped. He was not named "Avida Dollars" for nothing. But this anagram did not disturb Dalí; rather, it amused him and confirmed him in his opposition. For he had, from a very early age, a profound appreciation of the creative results that could be obtained from the tensions that arose from confrontation and opposition. "I want people to speak of Dalí badly if possible, well if there's nothing else for it," he once told Max Aub. At the least, his deliberate confrontations with authority resulted in some extremely interesting pieces of performance art, while the vast and continuous publicity surrounding him brought his work, in the name of art, constantly to the attention of a huge international audience of people who had become alienated from modern art because they could not understand it.

So where does Dalí belong in twentieth-century art? He is a creator, not a destroyer, a force to be reckoned with because his paintings strike resonant chords in those who are, paradoxically, not interested in painting. Dalí was the consummate communicator in his painting, in his writing, and through the public performance he put on for nearly sixty years. He reaches out to us; we feel that we know him. We are interested in everything he does because he has a quality of enthusiasm and daring, of pushing down barriers.

"He is the archetype of the modern artist," Alain Jouffroy wrote,

"where one can find all the nostalgias, all the rebellions that agitated a Picasso, a Braque, a Max Ernst—in that dizzy space-time where imaginary museums and the most opposed sensibilities are jamming like traffic in the evening rush hour."[1]

There will be many reassessments of Dalí's work. But his daring and courage, his will to conquer his fears, and the paintings that brought those fears into the light will speak beyond his life, beyond the cycles of critical fashion, will speak across time and beyond the century that this curious, paradoxical, tormented man made so thoroughly his own.

BIBLIOGRAPHY

1. DALÍ'S MAIN BOOKS

The Secret Life of Salvador Dalí. New York: Dial Press, 1942.

Hidden Faces. New York: Dial Press, 1944.

Fifty Secrets of Magic Craftsmanship. New York: Dial Press, 1948.

Manifeste Mystique. Paris: Robert J. Godet, 1951.

Dalí's Moustache: A Photographic Interview (with Philippe Halsman). New York: Simon & Schuster, 1954.

Dalí on Modern Art: The Cuckolds of Antiquated Modern Art. New York: Dial Press, 1957.

Diary of a Genius. New York: Doubleday, 1965.

Dalí by Dalí. New York: Harry N. Abrams, 1970.

Dalí, Oui: Méthode Paranoïaque-Critique et Autres Textes. Paris: Denoël, 1971, 1979.

2. SELECTED POEMS, ESSAYS, TRACTS, AND PAMPHLETS BY DALÍ

"Cuan els Sorolls S'Adormen." *Studium* No. 6, Figueres, 1919.

"Tardes de Estiu." unpublished, 1919–1920.

"Sant Sebastià." *L'Amic de les Arts* No. 16, Sitges, 1927.

"Reflexions." *L'Amic de les Arts* No. 17, Sitges, 1927.

"Film-Arte, Fil Antiartístico." *Gaceta Literaria* No. 24, Madrid, 1927.

"Manifest Groc" (with Lluís Montanyà and Sebastià Gasch). Barcelona: F. Sabader, 1928.

"Poema de les cosetes." *L'Amic de les Arts* No. 27, Sitges, 1928.

"Le Chien Andalou." *Mirador* No. 39, Barcelona, 1929.

"L'Ane Pourri à Gala Eluard." *Le Surréalisme au Service de la Révolution* No. 1, Paris, 1930.

"La Femme Visible." Paris: Editions Surréalistes, 1930.

"L'Amour et la Mémoire." Paris: Editions Surréalistes, 1931.

"Objets Surréalistes." *Le Surréalisme au Service de la Révolution* No. 3, Paris, 1931.

"New York Salutes Me" (tract). New York, 1934.

"The Conquest of the Irrational." New York: Julien Levy Gallery, 1935.

"Surrealism in Hollywood." *Harper's Bazaar,* New York, June 1937.

"Metamorphosis of Narcissus." New York: Julien Levy Gallery, 1937.

Dictionnaire Abrégé du Surréalisme (with André Breton and Paul Eluard). Paris: Galerie des Beaux-Arts, 1938.

"Dalí, Dalí!" (exhibition catalog). New York: Julien Levy Gallery, 1939.

"Declaration of the Independence of the Imagination and the Rights of Man to His Own Madness." New York: privately printed, 1939.

Dalí News, "Monarch of the Dailies," Vol. 1, No. 1, New York, 1945; Vol. 1, No. 2, New York, 1947.

"Aspects Phénoménologiques de la Méthode Paranoïaque-Critique." La Vie Médicale (special number: *"Art et Psychopathologie"*), Paris, 1956.

Le Mythe Tragique de "L'Angelus" de Millet, Interprétation Paranoïaque-Critique. Paris: Société Nouvelle des Editions Pauvert, 1963 and 1978.

Ma Révolution Culturelle (tract). Paris, 1968.

"Gala, Velázquez, et la Toison d'Or." lecture at the Académie des Beaux Arts, Paris, May 9, 1979.

3. OTHER WORKS

Acton, Harold. *More Memoirs of an Aesthete.* London: Hamish Hamilton, 1970.

Ades, Dawn. *Dada and Surrealism Reviewed* (with an introduction by David Sylvester and a supplementary essay by Elizabeth Cowling). London: Arts Council of Great Britain, 1978.

———. *Dalí.* New York: Thames and Hudson, 1990.

Agar, Eileen. *A Look at My Life* (in collaboration with Andrew Lambirth). London: Methuen, 1988.

Alexandrian, Sarane. *Surrealist Art.* London: Thames and Hudson, 1970.

Anderson, Jack. *The One and Only: The Ballet Russe de Monte Carlo.* New York: Dance Horizons, 1981.

Andrews, Wayne. *The Surrealist Parade.* New York: New Directions, 1988.

Aranda, Francisco. *Luis Buñuel: A Critical Biography.* Edited by David Robinson. London: Secker and Warburg, 1975.

Art Magazine. February 1963, 69–3

———. January 1959, 52.

———. February 1968, 66.

Art News. February 1959, 12–19.

———. "Dalí and the Bathtub on the Ceiling," by Vivien Raynor (n.d.).

———. "Is Dalí Disgusting?" by G. R. Swenson, December 1965.

Aub, Max. *Conversaciones con Buñuel.* Barcelona: Aguilar, 1985.

Bailey, Martin. "When Is a Fake Not a Fake?" *Observer,* August 11, 1985.

Balakian, Anne. *Literary Origins of Surrealism.* New York: Kings Crown Press, 1947.

Baldwin, Neil. *Man Ray: American Artist.* New York: Clarkson N. Potter, 1988.

Ballet Russe. *Bacchanale* souvenir program. New York: 1939–1940.

Barthes, Roland. *Eléments de Sémiologie. Le Degré Zéro de l'Ecriture.* Paris: Denoël-Gonthier, 1953.

Bataille, Georges. *"Le Jeu Lugubre." Documents* No. 7, Paris, December 1929.

Behar, Henri. *André Breton: Le Grand Indésisable.* Paris: Calman Levy, 1954.

Béjart, Maurice. *Un Instant dans la Vie.* Paris: Flammarion, 1979.

Bobon, Jean. *"Contribution à la Psychopathologie de l'Expression Plastique, Mimique et Picturale." Acta Neurologica et Psychiatrica Belgica,* Brussels, December 1957.

Bonnet, Marguerite. *André Breton: Naissance de l'Aventure Surréaliste.* Paris: Librairie José Corti, 1975.

Bosquet, Alain. *Conversations with Dalí.* New York: E. P. Dutton, 1969.

Bowles, Paul. *Without Stopping.* Hopewell, N.J.: Ecco Press, 1985.

Boyer, Marie-France. *"Dalí Se Laisse Mourir d'Amour"* (interview with Dr. Pierre Roumeguère). *Le Point,* Paris, 1979.

Brassaï. *The Artists of My Life.* New York: Viking, 1982.

Braudel, Fernand. *La Méditerranée: L'Espace et l'Histoire.* Paris: Flammarion, 1985.

Brenan, Gerald. *The Spanish Labyrinth.* New York: Cambridge University Press, 1985.

Breton, André. *La Beauté Convulsive.* Paris: Centre Georges Pompidou, 1991.

———. *Claire de Terre.* Paris, 1923.

———. *Introduction au Discours sur le Peu de Réalité.* Paris, 1924.

———. *Légitime Défense.* Paris: Editions Surréalistes, 1926.

———. *Manifesto du Surréalisme.* Paris, 1924.

———. *Point du Jour.* Paris: Gallimard, 1970.

Breton, André, and Paul Eluard. *L'Immacule Conception.* Paris: Seghers, 1961.

Breton, Françoise, and Loren Barrutti. *Coneixer Catalunya, la Familia i el Psarentin.* Barcelona: Dopesa, 1978.

Brotchie, Alastair. *Surrealist Games.* London: Redstone Press, 1991.

Brook, Peter. *The Shifting Point.* London: Methuen, 1988.

Buckle, Richard. *George Balanchine: Ballet Master.* New York: Random House, 1988.

Buñuel, Luis. *My Last Sigh.* New York: Alfred A. Knopf, 1983.

Buot, François. *René Crevel.* Paris: Grasset, 1991.

Calas, Nicholas. *The Peggy Guggenheim Collection of Modern Art.* Turin: Fratelli Pozzi, 1967.

Canaday, John. *Mainstreams of Modern Art.* New York: Holt, Rinehart, and Winston, 1966.

Carol, Marius. *El Final Oculto de Un Exhibicionista.* Madrid: Plaza y Janés, 1990.

Casson, Hugh. *Diary.* London: Macmillan, 1981.

Caws, Mary Ann. *Surrealism and the Literary Imagination: A Study of Breton and Bachelard.* London: Mouton, 1966.

Cerwin, Herbert. *In Search of Something: Memoirs of a Public Relations Man.* San Francisco: privately published, 1966.

Chadwick, Whitney. *Myth in Surrealist Painting 1929–1939.* London: Thames and Hudson, 1955.

———. *Women Artists and the Surrealist Movement.* London: Thames and Hudson, 1991.

Channon, Sir Henry "Chips." *The Diaries of Sir Henry Channon.* Edited by Robert Rhodes James. London: Weidenfeld and Nicolson, 1967.

Charbonnie, Georges. *Le Monologue du Peintre.* Paris: Julliard, 1960.

Cheatham, Owen (Foundation). *Dalí: Art-in-Jewels,* New York: Graphic Society, n.d.

Cocteau, Jean. *La Comtesse de Noailles: Oui et Non.* Paris: Librairie Académique Perrin, 1963.

————. *Past Tense: Diaries* (Vol. 1). New York: Harcourt Brace Jovanovich, 1983.

Colacello, Robert. *Holy Terror: Andy Warhol Close-Up.* New York: HarperCollins, 1990.

Commune di Ferrara. *Sculture Illustrazioni Multipli.* Assessorato Istituzioni Culturali, 1989.

Connolly, Cyril (writing as "Palinurus"). *The Unquiet Grave.* London: Horizon, 1944.

Conover, Anne. *Caresse Crosby: From Black Sun to Roccasinibalda.* Santa Barbara: Capra Press, 1989.

Cooper, Diana. *Trumpets from the Steep.* London: Rupert Hart-Davis, 1960.

Cowles, Fleur. *The Case of Salvador Dalí.* London: Heinemann, 1959.

————. *Friends and Memories.* London: Jonathan Cape, 1975.

Crevel, René. *Dalí, ou l'Antioscurantisme.* Rome: Pequeña Biblioteca Calanus Scriptorius, 1978.

————. *Difficult Death* (foreword by Salvador Dalí). San Francisco: North Point Press, 1986.

Crosby, Caresse. *The Passionate Years.* Hopewell, N.J.: Ecco Press, 1979.

Dalí, Ana Maria. *Salvador Dalí Visto por Su Hermana.* Barcelona: Ediciones Juventud, 1953.

————. *Tot l'Any a Cadaqués.* Barcelona: Editorial Joventut, 1951.

Danilova, Alexandra. *Choura: The Memoirs of Alexandra Danilova.* New York: Alfred A. Knopf, 1986.

de Chirico, Giorgio. *The Memoirs of Giorgio de Chirico.* Translated by Margaret Crosland. London: Peter Owen, 1971.

De Guell, Comte. *Journal d'un Expatrie Catalan.* Monaco: Editions du Rocher, 1946.

Del Arco, Manuel. *Dalí in the Nude.* St. Petersburg, Fla.: Salvador Dalí Museum, 1984.

Descharnes, Robert. *Dalí de Gala.* Lausanne: Denoël, 1962.

————. *Salvador Dalí.* London: Thames and Hudson, 1985.

————. *Salvador Dalí: The Work, the Man.* New York: Harry N. Abrams, 1984.

————. *The World of Salvador Dalí.* London: Macmillan, 1972.

Dopagne, Jacques. *Dalí.* Paris: Léon Amiel, 1974.

Draeger. *Dalí.* New York: Harry N. Abrams, 1970.

Editorial Mediterrania. *Salvador Dalí Dedicatories.* Barcelona, 1989.

Ellmann, Richard. *Oscar Wilde.* New York: Alfred A. Knopf, 1988.

Eluard, Paul. *Au Rendez-Vous Allemand.* Paris: Editions de Minuit, 1945.

————. *Letters to Gala: 1928–1948.* New York: Paragon House, 1989.

Ernst, Jimmy. *A Not-So-Still-Life.* New York: St. Martin's/Merek, 1984.

Ernst, Max. *Ecritures.* Paris: Nouvelle Révue Française, 1970.

Faucigny-Lucinge, Prince Jean-Louis. *Fêtes Mémorables des Costumes 1922–1972.* Paris: Herscher, 1986.

Farson, Daniel. *Sacred Monsters.* London: Bloomsbury, 1988.

Flanner, Janet. *Darlinghissima: Letters to a Friend.* New York: Pandora Press, 1988.

Ford, Hugh. *Published in Paris.* New York: Pushcart Press, 1975.

Foucault, Michel. *Les Mots et Les Choses.* Paris: Gallimard, 1966.

Freud, Sigmund. *The Interpretation of Dreams*. London: G. Allan, 1913.

Galey, Mathieu. *Journal: 1953–1973* (Vol. I). Paris: Grasset, 1986.

Gallego, Julian. *Vision et Symboles dans la Peinture Espagnole du Siècle d'Or*. Holland: Klincksieck, 1968.

García de Valdeovellano, Luis. *Un Educador Humanista: Alberto Jiménez Fraud y la Residencia de Estudiantes*. Barcelona: Ariel, 1972.

García Lorca, Federico. *Obras Completas* (3 vols.). Madrid: Aguilar, 1986.

———. *Selected Letters*. Edited and translated by David Gershator. New York: Marion Boyars, 1984.

Garland, Madge. *The Indecisive Decade: The World of Fashion and Entertainment in the Thirties*. London: Macdonald, 1968.

Gascoyne, David. *A Short Survey of Surrealism*. London: Cobden Sanderson, 1936.

Gershman, Herbert S. *The Surrealist Revolution in France*. Ann Arbor: University of Michigan Press, 1969.

Gibson, Ian. *Federico García Lorca: A Life*. London: Faber and Faber, 1989.

Goëmans, Camille. *Goëmans, Oeuvre*. Brussels, 1970.

Gold, Arthur, and Robert Fizdale. *Misia*. New York: Alfred A. Knopf, 1980.

Gómez de la Serna, Ramón. *Dalí*. London: Macdonald, 1984.

Gómez de Liano, Ignacio. *Dalí*. Barcelona: Ediciones Polígrafa, 1984.

Green, Julien. *Diary: 1928–1957*. Edited by Kurt Wolff, translated by Anne Green. London: Collins Harvill, 1975.

———. *Journal (1926–1934): Les Années Faciles*. Paris: Plon, 1970.

———. *Oeuvres Complètes*. Paris: Gallimard, 1975.

———. *Personal Record: 1928–1939*. London: Hamish Hamilton, 1940.

Guggenheim, Peggy (Marguerite). *Confessions of an Art Addict*. London: André Deutsch, 1980.

———. *Out of This Century*. London: André Deutsch, 1979.

Guardiola Rovira, Ramón. *Dalí y Su Museu*. Girona: Editoria Empordanesa, 1984.

Halsman, Philippe, and Yvonne Halsman. *Halsman at Work*. New York: Harry N. Abrams, 1971.

Haslam, Malcolm. *The Real World of the Surrealists*. Milan: Rizzoli, 1978.

Hayward Gallery. *Homage to Barcelona: The City and Its Art*. London: Arts Council, 1985.

Horton, Philip. *Hart Crane: The Life of an American Poet*. New York: Holt, Rinehart, and Winston, 1962.

Hugnet, Georges. *Pleins et Délies*. Paris: Authier, 1972.

Hurok, Sol (in collaboration with Ruth Goode). *Impresario: A Memoir*. London: Macdonald, 1947.

Ilie, Paul, ed. *Documents of the Spanish Vanguard*. University of North Carolina, 1969.

———. *The Surrealist in Spanish Literature*. Ann Arbor: University of Michigan Press, 1968.

James, Edward. *The Heart and the Word: A Selection of Poems*. London: Weidenfeld and Nicolson, 1987.

———. *Swans Reflecting Elephants: My Early Years*. Edited by George Melly. London: Weidenfeld and Nicolson, 1982.

Jean, Marcel. *Histoire de la Peinture Surréaliste*. London: Weidenfeld and Nicolson, 1960.

———, ed. *The Autobiography of Surrealism*. New York: Viking, 1980.

Jean, Raymond. *Eluard*. Paris: Le Seuil, 1968.

Josephson, Matthew. *Life Among the Surrealists*. New York: Holt, Rinehart, and Winston, 1962.

Krauss, Rosalind, and Jane Livingston. *L'Amour Fou: Photography and Surrealism*. New York: Abbeville Press, 1985.

Lacan, Jacques. *De la Psychose Paranoïaque dans Ses Rapports avec la Personnalité*. 1932. Reprint. Paris: Le Seuil, 1975.

———. *D'une Question Préliminaire de Tout Traitement Possible de la Psychose*. Paris: Le Seuil, 1955.

———. *Le Problème du Style et la Conception Psychiatrique des Formes de l'Expérience*. Minotaure No. 1, Paris, May 1933.

Lake, Carlton. *In Quest of Dalí*. New York: Putnam, 1969.

Leiris, Michel. *Mots Sans Mémoire*. Paris: Gallimard, 1969.

Lear, Amanda. *My Life with Dalí*. London: Virgin Books, 1985.

Leroi-Gourhan, André. *Les Réligions de la Préhistoire*. Paris: Presses Universitaires de France, 1971.

Levy, Julien. *Memoirs of an Art Gallery*. New York: Putnam, 1977.

———. *Surrealism*. New York: Black Sun Press, 1936.

Lifar, Serge. *Ma Vie*. London: Hutchinson, 1965.

Lubar, Robert S., and A. Reynolds Morse. *The Salvador Dalí Museum Collection*. New York: Little, Brown, 1991.

Lynes, Russell. *Good Old Modern: An Intimate Portrait of the Museum of Modern Art*. New York: Atheneum, 1973.

McAlmon, Robert. *Being Geniuses Together*. Revised, with supplementary chapters by Kay Boyle. New York: Doubleday, 1968.

McGirk, Tim. *Wicked Lady: Salvador Dalí's Muse*. London: Hutchinson, 1989.

McLeave, Hugh. *Rogues in the Gallery: The Modern Plague of Art Thefts*. Boston: David R. Godine, 1981.

MacNiven, Ian, ed. *The Durrell-Miller Letters 1935–80*. London: Faber and Faber, 1988.

Martin, Richard. *Fashion and Surrealism*. London: Thames and Hudson, 1988.

Meli. *Dalí Vist per Meli*. Figueres: Organitza i Patrocina Fundació Gala-Dalí, 1985.

Melly, George. *Paris and the Surrealists*. London: Thames and Hudson, 1991.

Miravitlles, Jaume. *Gent que he Conegut*. Barcelona: Destino, 1980.

Morris, C. B. *Surrealism and Spain, 1920–1936*. Cambridge: Cambridge University Press, 1972.

Morse, A. Reynolds. *The Dalí Adventure: 1943–1973*. Cleveland, 1973.

———. *A Dalí Primer*. St. Petersburg, Fla.: Salvador Dalí Museum, 1970.

———. *A New Introduction to Salvador Dalí*. Cleveland: Stratford Press Company, 1960.

———. *Salvador Dalí: A Panorama of His Art*. Cleveland, 1974 (privately published).

Musée Nationale d'Art Moderne. Centre Georges Pompidou Salvador Dalí Retrospective 1920–1980 catalog. Paris, 1979.

Nin, Anaïs. *The Diary of Anaïs Nin: 1939–44* (Vol. III). New York: Harcourt Brace Jovanovich, 1969.

Olano, Antonio D. *Adios Dalí.* Madrid: Maeva Ediciones 1989.

Oppenheimer, Helen. *Lorca: The Drawings.* London: Herbert Press, 1986.

Orwell, George. "Benefit of Clergy: Some Notes on Salvador Dalí (1944)," in *Collected Essays.* London: Secker and Warburg, 1944.

———. *Homage to Catalonia.* London: Secker and Warburg, 1938.

Ors, Eugenio d'. *Lidia de Cadaqués: La Locura de Amora de la Famosa Pescadora, por el Joven Xenius.* Barcelona: Planeta, 1982.

El País. El Ultimo Dalí. Madrid, 1985.

El País and Louis Parrot. *Hommage Rea Dû à une Amitié Exemplaire par l'Académie des Lettres et des Arts de Périgord.* Périgueux: L'Atelier de Pierre Fanlac, 1981.

Parinaud, André. *The Unspeakable Confessions of Salvador Dalí.* London: Quartet Books, 1977.

Pauwels, Louis. *Les Passions selon Dalí.* Paris: Denoël, 1968.

Penrose, Anthony. *The Lives of Lee Miller.* New York: Holt, Rinehart, and Winston, 1985.

Penrose, Roland. *Man Ray.* London: Thames and Hudson, 1975.

———. *Scrapbook: 1900–1981.* London: Thames and Hudson, 1981.

Pla, Josep. *Cadaqués.* Barcelona: Editorial Juventud, 1964.

———. *Cosas Mar y de la Costa Brava.* Barcelona: Editorial Juventud, 1957.

———. *Salvador Dalí: Obres de Museu.* Barcelona: DASA Ediciones, 1981.

Puget, Henry. *Dalí: L'Oeil de la Folie.* Paris: Editions Jean Boully, 1989.

Puigvert, Dr. Antonio. *Mi Vida y Otras Más.* Madrid: Planeta, 1981.

Purser, Philip. *The Extraordinary World of Edward James.* London: Quartet Books, 1978.

Ray, Man. *Self-Portrait.* New York: McGraw-Hill, 1963.

Reed, Jan. *The Catalans.* London: Faber and Faber, 1978.

Rey, Henri-François. *Les Noces Catalanes Barcelone-Paris 1870–1970.* Paris: Artcurial, 1985.

Rodrigo, Antonia. *Lorca-Dalí: Una Amistad Traicionada.* Madrid: Planeta, 1981.

Rogerson, Mark. *The Dalí Scandal.* London: Gollancz, 1987.

Rojas, Carlos. *El Mundo Mítico y Mágico de Salvador Dalí.* Madrid: Plaza y Janés, 1985.

Romero, Luis. *Dalí (Todo Dalí en un Rostro).* Barcelona: Ediciones Polígrafa, 1975.

———. *Dedalico Dalí.* Madrid: Primer Plano, 1989.

———. *The Hallucinogenic Toreador.* Barcelona: Editorial Mediterrania, n.d.

Rose, Sir Francis. *Saying Life: The Memoirs of Sir Francis Rose.* London: Cassell, 1965.

Rothschild, Guy de. *The Whims of Fortune.* London: Granada, 1985.

Sánchez Vidal, Agustín. *Buñuel, Lorca, Dalí: El Enigma sin Fin.* Barcelona: Ediciones Planeta, 1988.

Santos Torroella, Rafael. *La Miel es Más Dulce que la Sangre.* Barcelona: Seix Barral, 1981.

————, ed. *Salvador Dalí, Corresponsal de J. V. Foix, 1932–1936*. Barcelona: Editorial Mediterrania, 1986.

————, ed. *Salvador Dalí: Lettere a Federico*. Milan: Rosellina Archinto, 1987.

Secrest, Meryle. *Between Me and Life: A Biography of Romaine Brooks*. New York: Doubleday, 1974.

————. *Salvador Dalí*. New York: Dutton, 1986.

Senent-Josa, Joan. *Arte Ciencia Dalí*. Barcelona: Ajoblanco, 1991.

Sempronio. *Los Barceloneses*. Barcelona: Editorial Barna, 1959.

Shanes, Eric. *Dalí: The Masterworks*. New York: Portland House, 1990.

Shattuck, Roger. *The Banquet Years*. New York: Random House, 1968.

Soby, James Thrall. *Salvador Dalí*. New York: Museum of Modern Art, 1946.

Soler Serrano, J. *Conversa con Dalí* (undated tapes).

Sorlier, Charles. *Mémoires d'un Homme de Couleurs*. Paris: Le Pré aux Clercs, 1985.

Steegmuller, Francis. *Apollinaire: Poet among the Painters*. London: Rupert Hart-Davis, 1964.

Stein, Gertrude. *Everybody's Autobiography*. New York: Random House, 1937.

Stitch, Sidra. *Anxious Visions, Surrealist Art*. Containing essays by James Clifford, Tyler Stovall, and Steven Kovacs. New York: Abbeville Press, 1991.

Studium. *La Revista del Jove Dalí*. Figueres: Edicions Federals 1989.

Tapie, Michel. *Dalí*. Paris: Editions du Chêne, 1957.

Truffaut, François. *Le Cinéma selon Hitchcock*. Paris, 1966.

Tual, Denise. *Au Coeur du Temps*. Paris: Carrère, 1987.

————. *Le Temps Dévore*. Paris: Fayard, 1980.

Ultra Violet. *Famous for 15 Minutes*. New York: Avon, 1990.

Utrillo, Miguel. *Salvador Dalí y Sus Enemigos*. Sitges-Barcelona: Ediciones Maspe, 1952.

Valette, Robert D. *Eluard: Livre d'Identité*. Paris: Henri Veyrier, Tchon, 1967.

Van de Pas, Annemieke. *Salvador Dalí: L'Obra Literaria*. Barcelona: Editorial Mediterrania, 1984.

Vieuille, Chantal. *Gala*. Lausanne: Editions Favre, 1988.

Waldberg, Patrick. *Surrealism*. New York: Oxford University Press, 1978.

Warhol, Andy, with Robert Colacello. *Andy Warhol's Exposures*. New York: Grosset and Dunlap, 1979.

Weld, Jacqueline Bograd. *Peggy: The Wayward Guggenheim*. London: Bodley Head, 1986.

Wolff, Geoffrey. *Black Sun: The Brief Transit and Violent Eclipse of Harry Crosby*. New York: Random House, 1985.

NOTES

PROLOGUE

1. Robert Hughes, *Barcelona* (New York: Alfred A. Knopf, 1992), ix.
2. Russell Harty, *Hello Dalí* (Aquarius series, BBC), 1972.
3. Salvador Dalí, *The Secret Life of Salvador Dalí* (New York: Dial Press, 1942), 34.
4. Ibid.
5. Salvador Dalí, *"L'Ane Pourri à Gala Eluard,"* *Le Surréalisme au Service de la Révolution* No. 3, Paris, 1931.
6. Salvador Dalí, "To Spain Guided by Dalí," *Vogue,* New York, May 15, 1950.

CHAPTER 1

1. Lluis Permanyer, "Dalí," *Playboy,* Barcelona, January 1979.
2. Alain Bosquet, *Conversations with Dalí* (New York: E. P. Dutton, 1969), 121.
3. André Parinaud, *The Unspeakable Confessions of Salvador Dalí* (London: Quartet Books, 1977), 16.
4. Dalí, *The Secret Life of Salvador Dalí,* 16.
5. Parinaud, *Unspeakable Confessions,* 23.
6. Josep Pla, *Salvador Dalí: Obres de Museu* (Barcelona: DASA Ediciones, 1981), 60, 61.
7. John Richardson, *A Life of Picasso,* Vol. 1 (New York: Random House, 1991), 139.
8. Dalí, *Secret Life,* 77.
9. Josep Pla, *Il Hominem* (Barcelona: Editorial Juventud, 1964), 43.
10. Pla, *Obres de Museu,* 24.
11. Parinaud, *Unspeakable Confessions,* 12.
12. Fleur Cowles, *The Case of Salvador Dalí* (London: Heinemann, 1959), 32.
13. Salvador Dalí, *Hidden Faces* (New York: Dial Press, 1944), 70.
14. Josep Pla, *Cadaqués* (Barcelona: Editorial Juventud, 1964), 43.
15. Dalí, *Secret Life,* 65.
16. Ibid., 5.
17. Salvador Dalí, "False Memories of Childhood" (manuscript), (Caresse Crosby Collection, Special Collections/Morris Library, Southern Illinois University at Carbondale, Illinois), 1.
18. Ibid.
19. Dalí, *Secret Life,* 41.
20. Salvador Dalí, privately printed catalog, Cleveland, 1954.
21. Mrs. Jonathan Guinness, conversation (October 1989).

22. Parinaud, *Unspeakable Confessions,* 64.
23. Pla, *Obres de Museu,* 63.
24. Dalí, *Secret Life,* 65.
25. Cowles, *Case of Salvador Dalí,* 161.
26. Dalí, *Secret Life,* 70.
27. Ibid., 71.
28. Mrs. Jonathan Guinness, conversation (October 1989).
29. Dalí, *Secret Life,* 81.
30. Ibid.
31. Edward James, unpublished fragments.
32. Ibid.
33. Parinaud, *Unspeakable Confessions,* 136.
34. Dalí, *Secret Life,* 115.
35. Ibid., 116.
36. Parinaud, *Unspeakable Confessions,* 46.
37. Dalí, *Secret Life,* 144.
38. Ibid., 150.
39. Salvador Dalí, *"Tardes de Estiu"* (unpublished, circa 1919–1920).
40. "Puvis," review of Dalí's first exhibition, *Ampordà Federal,* January 11, 1919.
41. Salvador Dalí, *"Cuan els Sorrols S'Adormen," Studium* No. 6, Figueres, June 1920.
42. Salvador Dalí, *Continuation of Book Number 6 of My Impressions and Private Memoirs* (privately printed for the Morse Foundation) (Cleveland, Ohio: 1962), 26.
43. Ibid., 27.
44. Ibid., 41.
45. Parinaud, *Unspeakable Confessions,* 46.

CHAPTER 2

1. Salvador Dalí y Cusi, *Logbook* (quoted in Dalí, *The Secret Life of Salvador Dalí,* 204).
2. Dalí, *Secret Life,* 156.
3. Ibid., 159.
4. Pedro Fernandez Cocero, *"Natalia Cossío Evokes the Students' Residence,"* Triunfa, Madrid, December 18, 1976. (The Residencia de Estudiantes was reestablished in 1990, after having been closed for nearly sixty years.)
5. Ibid.
6. Ibid.
7. *"Revista Residencia"* No. 1, Madrid, 1926, 80.
8. Federico García Lorca was the son of a rich landowner in Granada. He had already published *Impresiones y Paisajes,* a prose work, by the time he enrolled in the Residencia in 1919. In this early work he described a trip he had taken with his sociology professor and fellow students from Andalusia.
9. *"Revista Residencia,"* 80.
10. José Bello de Larrasa, known as "Pepín," was born in Huesca, Aragon, and

studied medicine, but never completed his studies. His outstanding characteristic was his delight in announcing bad tidings. Anti-Franco, he spent much of the Civil War in hiding.

11. Eugenio Montes was a poet, critic, and literary editor. He later contributed to *La Gaceta Literaria* and published the scenario of *Un Chien Andalou* on its front page on June 15, 1929.

12. Emilio Filippo Tommaso Marinetti, the leader of the Italian Futurist movement, was the author of the *Futurist Manifesto,* whose modernist cadences would become a stylistic influence on Dalí's writings toward the end of the 1920s.

13. Ana Maria Dalí, *Salvador Dalí Visto por Su Hermana* (Barcelona: Ediciones Juventud, 1953), 82.

14. The Spanish poet Luis de Góngora y Argote (1561–1627). His baroque style was characterized by a Latinate vocabulary and syntax, intricately wrought metaphors, hyperbole, richly colored images, mythological allusions, and a general strangeness of diction. In his later years, Dalí admired Góngora immensely, as had Lorca, and he used Góngora's poetry as a model for his own writing.

15. Ana Maria Dalí, *Salvador Dalí Visto por Su Hermana,* 89.

16. Antonia Rodrigo, *Lorca-Dalí: Una Amistad Traicionada* (Barcelona: Editorial Planeta, 1981), 49.

17. Dalí, *Secret Life,* 161.

18. Ibid.

19. Ibid., 162.

20. Ingres, *Maxims.*

21. Rodrigo, *Lorca-Dalí,* 31 (a letter from Dalí to his parents).

22. Dalí, *Secret Life,* 161.

23. Ibid., 162.

24. Rodrigo, *Lorca-Dalí,* 80.

25. Ibid.

26. Dalí, *Secret Life,* 174.

27. André Breton was born in Tinchebray (Orne) in 1896. The son of a gendarme, Breton studied medicine in Paris, was mobilized in 1915, and served in several neuropsychiatric centers. In the years 1919–1925 he participated in the Dada movement, and in 1922 he took over the editorship of *Littérature,* subsequently assuming the leadership of the Surrealist movement.

28. Philippe Soupault was a poet and a member of the Dadaist and, subsequently, Surrealist movements.

29. André Breton, editorial, *Littérature,* Paris, 1920.

30. The poet Rafael Alberti was a close friend of Lorca's. Decorated by Stalin during a trip to Moscow in the mid-1930s, he lived in Argentina and Italy during the Franco years, subsequently returning to Spain.

31. Agustín Sánchez Vidal, *Buñuel, Lorca, Dalí: El Enigma sin Fin* (Barcelona: Ediciones Planeta, 1988), 59.

32. Dalí, *Secret Life,* 175.

33. Rafael Alberti, *La Arboleda Perdida* (quoted in Sanchez Vidal, *Buñuel, Lorca, Dalí,* 40).

34. Dalí, *Secret Life,* 176.
35. Ibid., 177.
36. Luis Buñuel, *My Last Sigh* (New York: Alfred A. Knopf, 1983), 61.
37. Ibid.
38. Ibid., 62.
39. Ibid.
40. Ibid.
41. Dalí, *Secret Life,* 176.
42. Ibid.
43. Luis Romero, *Dalí (Todo Dalí en un Rostro)* (Madrid: Ediciones Polígrafa, 1975), 323–24 (letter from Dalí to Sebastià Gasch).
44. Dalí, *Secret Life,* 203.
45. Rafael Alberti, *"Helix,"* Vilafranca del Penedes No. 4, 7.
46. Rodrigo, *Lorca-Dalí,* 29.
47. Dalí, *Secret Life,* 234.
48. Antoní Pitxot, conversation (June 1991).
49. Rodrigo, *Lorca-Dalí,* 32 (letter from Dalí to Josep Rigol Fornaguera).
50. Fernando Diaz-Plaja, *"Cosas del Dictador 1931"* (quoted in *El País,* June 25, 1976).
51. Federico García Lorca, *Obras Completas* Vol. II, 22d ed. (Madrid: Aguilar, 1986), 937.
52. José Moreno Villa, a talented painter and writer, was fifteen years older than Buñuel when they both lived at the Residencia. When the Republic was declared in 1931, Villa was made director of the Royal Library. During the Spanish Civil War he lived in Valencia, but he was later exiled and died in Mexico in the mid-1950s.
53. Montserrat Dalí y Bas, conversation (June 1990).
54. Federico García Lorca, *"Oda a Salvador Dalí,"* in *Obras Completas,* 775.
55. Ana Maria Dalí, *Salvador Dalí Visto por Su Hermana,* 59.
56. Ibid.
57. Federico García Lorca, *Epistolari,* ed. Christopher Maurer (Madrid: Alianza, 1983), 133.
58. Ibid.
59. Ian Gibson, *Federico García Lorca: A Life* (London: Faber and Faber, 1989), 159.
60. Anonymous reviewer, *La Gaseta de les Arts,* Barcelona, 1925. (The anonymous reviewer may very well have been Sebastià Gasch.)
61. Parinaud, *The Unspeakable Confessions of Salvador Dalí,* 34.
62. Dalí, *Secret Life,* 206.
63. Ibid.
64. Ibid., 203.
65. Ibid.
66. Parinaud, *Unspeakable Confessions,* 58.

CHAPTER 3

1. Dalí, *The Secret Life of Salvador Dalí,* 205.
2. Sebastià Gasch, "Salvador Dalí," *L'Amic de les Arts,* Sitges, January 1927.
3. Sebastià Gasch, "Salvador Dalí," *Ciutat* No. 10, Barcelona, February 1927.
4. Ibid.
5. J. V. Foix, "*Presentations Salvador Dalí,*" *L'Amic de les Arts,* Sitges, January 1927.
6. Dalí, *Secret Life,* 207.
7. Ibid.
8. Rafael Santos Torroella, *La Miel Es Más Dulce que la Sangre* (Barcelona: Seix Barral, 1984), 236.
9. Ibid.
10. Ibid.
11. Gino Severini was Giorgio de Chirico's brother and the author of *I Valori Plastici,* which Dali read during his time at the Residencia.
12. Santos Torroella, *La Miel,* 236.
13. Ibid.
14. Rafael Santos Torroella, ed., *Salvador Dalí: Lettere a Federico* (Milan: Rosellina Archinto, 1986), 38.
15. Ibid., 40.
16. Ibid., 49.
17. Ibid.
18. Ibid.
19. Ibid.
20. Parinaud, *The Unspeakable Confessions of Salvador Dalí,* 75.
21. Salvador Dalí, "*Sant Sebastià,*" *L'Amic de les Arts,* Sitges, July 1927.
22. Ibid.
23. Bosquet, *Conversations with Dalí,* 52.
24. Buñuel, *My Last Sigh,* 103.
25. Agustín Sánchez Vidal, *Buñuel, Lorca, Dalí: El Enigma sin Fin,* 158.
26. Ibid., 160.
27. Buñuel, *My Last Sigh,* 102.
28. Max Aub, *Conversaciones con Buñuel* (Barcelona: Aguilar, 1985), 54.
29. Antoní Pixtot, conversation (June 1991).
30. Dawn Ades, *Salvador Dalí* (London: Thames and Hudson, 1982), 40.
31. Bosquet, *Conversations with Dalí,* 37.
32. Sanchez Vidal, *Buñuel, Lorca, Dalí,* 37.
33. Ibid.
34. Ibid.
35. Santos Torroella, *Lettere a Federico,* 72.
36. Bosquet, *Conversations with Dalí,* 35.
37. An unpublished, undated paper, prepared for acceptance into the Barcelona Academia de Bellas Artes by Rafael Santos Torroella, concerned itself with this incident and with the exhibition of other controversial pictures.

38. Sánchez Vidal, *Buñuel, Lorca, Dalí,* 189.
39. Ibid.
40. Charles Caboud, *"Buñuel," Nuevo Cine* No. 50, Mexico City, 1966.
41. Roger Vailland, *Le Surréalisme Contre la Révolution* No. 2, 1930.
42. André Breton, editorial, *Littérature,* Paris, 1929.
43. James Thrall Soby, undated papers, Museum of Modern Art Archive, New York.
44. Edward James, undated letter to Dalí in which Georges Ribemont-Dessaignes is quoted.
45. Prince Jean-Louis Faucigny-Lucinge, conversation (December 1989).
46. Dalí, *Secret Life,* 208.
47. Ibid.
48. Ibid., 209.
49. Ibid., 213.
50. Ibid.
51. Luis Buñuel, interview in *Art in Cinema,* San Francisco Museum of Modern Art, 1947.
52. Comte Etienne de Beaumont was a leader of Paris society between the wars, and was much given to organizing fancy-dress balls at which he invariably appeared *en travesti.*
53. Dalí, *Secret Life,* 215.

CHAPTER 4

1. Dalí, *The Secret Life of Salvador Dalí,* 224.
2. Edward James, undated autobiographical fragment, circa 1980.
3. Tim McGirk, *Wicked Lady, Salvador Dalí's Muse* (London: Hutchinson, 1989), 22.
4. Ibid., 23.
5. Jimmy Ernst, *A Not-So-Still-Life* (New York: St. Martin's/Merek, 1984), 28.
6. Ibid., 84.
7. Ibid.
8. André Thirion, *Revolutionaries Without Revolution* (London: Cassell, 1972), 82.
9. Ana Maria Dalí, *Salvador Dalí Visto por Su Hermana,* 82.
10. Buñuel, *My Last Sigh,* 96.
11. Dalí, *Secret Life,* 226.
12. Ibid., 231.
13. Ibid.
14. Ibid., 233.
15. Ibid., 241.
16. Paul Eluard, *Letters to Gala, 1928–1948* (New York: Paragon House, 1989), 61.
17. Dalí, *Secret Life,* 248.
18. Thirion, *Revolutionaries Without Revolution,* 181.
19. Cyril Connolly (writing under the pseudonym "Palinurus"), *The Unquiet Grave* (London: Horizon, 1944), 118.

20. Dalí, *Secret Life*, 250.
21. Georges Bataille, "*Le Jeu Lugubre*," *Documents* No. 7, Paris, 1929.
22. Dalí *Secret Life*, 250.
23. Buñuel, *My Last Sigh*, 115.
24. Dalí *Secret Life*, 252.
25. Agustín Sánchez Vidal, *Buñuel, Lorca, Dalí: El Enigma sin Fin*, 247.
26. Ibid., 229.
27. Dalí, *Secret Life*, 253.

CHAPTER 5

1. Dalí, *The Secret Life of Salvador Dalí*, 60.
2. Dalí admired Raymond Roussel's Surrealist work *Voyage in Africa* immensely, and fifty years later was still recommending it as one of the most important novels of the Surrealist movement.
3. Dalí, *Secret Life*, 257.
4. François Buot, *René Crevel* (Paris: Grasset, 1991), 285.
5. Dalí, *Secret Life*, 260.
6. Ibid., 262.
7. Eluard, *Letters to Gala*, 285.
8. Dalí, *Secret Life*, 264.
9. Ibid.
10. Lecture given by Dalí at the Barcelona Ateneo, March 22, 1930.
11. Ibid.
12. Ibid.
13. Ibid.
14. Ibid.
15. Dalí, *Secret Life*, 268.
16. Emilio Puignau, conversation (June 1990).
17. José Luis Cano, interview with Dalí, *Destino*, Girona, June 1948.
18. Dalí, *Secret Life*, 277.
19. Prince Jean-Louis Faucigny-Lucinge, conversation (December 1989).
20. Dalí, *Secret Life*, 282.
21. Brassaï, *The Artists of My Life* (New York: Viking, 1982), 28.
22. Prince Jean-Louis Faucigny-Lucinge, conversation (December 1989).
23. Parinaud, *The Unspeakable Confessions of Salvador Dalí*, 166.
24. Meryle Secrest, *Salvador Dalí* (New York: E. P. Dutton, 1986), 141.
25. Prince Jean-Louis Faucigny-Lucinge, conversation (December 1989).
26. Anonymous, *L'Affaire de "L'Age d'or"* (privately printed, Paris, 1931).
27. Julien Levy, *Memoirs of an Art Gallery* (New York: Putnam, 1977), 133.
28. Robert Caby, editorial, *L'Humanité*, Paris, December 13, 1931.
29. Salvador Dalí, *La Femme Visible* (Paris: Editions Surréalistes, 1930), 152.
30. Ibid., 152.
31. McGirk, *Wicked Lady, Salvador Dalí's Muse*, 72.
32. Dalí, *Secret Life*, 293.
33. Ibid., 297.

34. Ibid., 302.
35. Levy, *Memoirs of an Art Gallery*, 72.
36. Parinaud, *Unspeakable Confessions*, 175.
37. Editorial, *Hartford Times*, Hartford, Connecticut, November 1931.
38. Parinaud, *Unspeakable Confessions*, 169.
39. Dalí, *Secret Life*, 311.
40. Interview, *Newsweek*, January 15, 1945.
41. Caresse Crosby, *The Passionate Years* (Hopewell, N.J.: Ecco Press, 1979), 328.
42. Dalí, *Secret Life*, 318.
43. Eluard, *Letters to Gala*, 122.
44. Salvador Dalí Retrospective catalog (Paris: Centre Georges Pompidou, 1979), 134.
45. Eluard, *Letters to Gala*, 127.
46. The questionnaire focused on the nature of desire, both secret and public, and was the idea of Marco Ristitch, a Yugoslavian Surrealist, who published the answers in *Nadrealism danas i ovde* No. 6, June 1932.
47. Rafael Santos Torroella, ed., *Salvador Dalí, Corresponsal de J. V. Foix, 1932–1936* (Barcelona, Editorial Mediterrania, 1986), 63.
48. Ibid., 67.
49. Salvador Dalí Retrospective catalog, 134.
50. Santos Torroella, *Salvador Dalí, Corresponsal de J. V. Foix*, 83.
51. Brassaï, *The Artists of My Life*, 34.
52. Louis Aragon, "Le Modern Style ou Je Suis," prologue to Roger Guerrant, "L'Art Nouveau en Europe," Paris, 1965.
53. Prince Jean-Louis Faucigny-Lucinge, conversation (December 1989).
54. Ibid.
55. Julien Green, *Diary: 1928–1957*, ed. Kurt Wolff, trans. Anne Green (London: Collins Harvill, 1975), 35.
56. Julien Green, preface to the Salvador Dalí Retrospective catalog, 56.
57. Santos Torroella, *Salvador Dalí, Corresponsal de J. V. Foix*, 66.
58. Ibid.
59. Ibid.
60. Ibid., 66.
61. Ibid., 67.
62. Lewis Mumford, "Notices," *New Yorker*, November 20, 1933.
63. Anonymous, "Salvador Dalí," *Art News*, New York, December 5, 1933.

CHAPTER 6

1. Dalí to André Breton, Scottish National Gallery of Modern Art Collection, Edinburgh.
2. Parinaud, *The Unspeakable Confessions of Salvador Dalí*, 194.
3. Peggy Guggenheim, *Out of This Century* (London: André Deutsch, 1979), 86.
4. Salvador Dalí Retrospective catalog, 197.
5. Ibid.
6. Bosquet, *Conversations with Dalí*, 43.

7. Georges Hugnet, *Pleins et Délies* (Paris: Authier, 1972), 110.

8. Eluard, *Letters to Gala,* 185.

9. Parinaud, *Unspeakable Confessions,* 112.

10. Ibid.

11. Josef Pierre, "Breton and Dalí," in the Salvador Dalí Retrospective catalog, 136.

12. Ibid.

13. Ibid.

14. Santos Torroella, *Salvador Dalí, Corresponsal de J. V. Foix, 1932–1936,* 135.

15. Santos Torroella, *Salvador Dalí: Lettere a Federico,* 96.

16. McGirk, *Wicked Lady, Salvador Dalí's Muse,* 75.

17. Ibid.

18. Santos Torroella, *Salvador Dalí, Corresponsal de J. V. Foix,* 137.

19. Ibid., 137.

20. Jacques Lacan, *D'une Question Préliminaire de Tout Traitement Possible de la Psychose* (1955; reprint, Paris: Le Seuil, 1966), 536.

21. Dalí, *The Secret Life of Salvador Dalí,* 18.

22. Jacques Lacan, *D'une Question Préliminaire,* 536.

23. Edward James, unpublished letter to Truman Brewster, September 19, 1963.

24. Herbert Read, "Bosch and Dalí," *The Listener,* November 14, 1934.

25. Edward James, unpublished, undated mss.

26. Georges Michel, *From Renoir to Picasso* (London: Gollancz, 1952), 124.

27. Denise Tual, conversation (May 1990).

28. Santos Torroella, *Salvador Dalí, Corresponsal de J. V. Foix,* 147.

29. Secrest, *Salvador Dalí,* 147.

30. Parinaud, *Unspeakable Confessions,* 137.

31. Ibid., 138.

32. Ibid.

33. Crosby, *The Passionate Years,* 138.

34. Ibid.

35. Dalí, *Secret Life,* 250.

36. "Mrs. Joella Levy Baylor" catalog entry, Christie's sale of Dada and Surrelist art, November 29, 1989.

37. Julien Levy, "Euphonic Surrealist Manifesto," introduction to catalog of Dalí's first one-man show at the Julien Levy Gallery, New York, 1934.

38. Anonymous, *Art Digest,* New York, February 1, 1935.

39. Anonymous, "If You Were in New York," *Arts and Decoration,* New York, 1934.

40. Conway Wilson-Young, conversation (January 1965).

41. Levy, *Memoirs of an Art Gallery,* 123.

42. Crosby, *The Passionate Years,* 332.

43. Manuel del Arco, *Dalí in the Nude* (St. Petersburg, Fla.: Salvador Dalí Museum, 1984), 33.

44. Buñuel, *My Last Sigh,* 123.

45. Dalí, *Secret Life,* 338.

46. Parinaud, *Unspeakable Confessions,* 380.

47. Dalí, unpublished letter to Edward James, May 1935.

48. Crosby, *The Passionate Years,* 380.
49. Dalí, unpublished letter to Edward James, May 1935.
50. Santos Torroella, *Salvador Dalí, Corresponsal de J. V. Foix,* 155.
51. Ibid.
52. Ibid.
53. Secrest, *Salvador Dalí,* 155.
54. Parinaud, *Unspeakable Confessions,* 124.
55. Buot, *René Crevel,* (Paris: Bernard Grasset, 1991), 422.
56. Aub, *Conversaciones con Buñuel,* 561.
57. René Crevel, *Difficult Death,* trans. David Rattray, foreword by Salvador Dalí (San Francisco: North Point Press, 1990), 10.
58. Edward James, unpublished letter to Diana, Lady Abdy, October 20, 1935.
59. Ibid.
60. Gibson, *Federico García Lorca: A Life,* 412–15.
61. Ibid.
62. Santos Torroella, *Salvador Dalí, Corresponsal de J. V. Foix,* 153.
63. Edward James, undated draft of letter to Yvonne, the Marquesa de Casa Fuerte.
64. Edward James to Edith Sitwell, October 22, 1935.
65. Dalí to Edward James, February 20, 1936.

CHAPTER 7

1. Marie-Laure de Noailles to Edward James, January 25, 1936.
2. Dalí to Edward James, February 20, 1936.
3. Santos Torroella, *Salvador Dalí: Lettere a Federico,* 81.
4. Dalí to Edward James, February 20, 1936.
5. Edward James, undated autobiographical fragment, possibly written in the late 1940s.
6. Dalí to Edward James, May 9, 1936.
7. Dalí to Edward James, late May 1936.
8. Ibid.
9. Dalí (in Cadaqués) telegram to Edward James (in London), May 8, 1936.
10. Edward James to Dalí, June 3, 1936.
11. Dalí to Edward James, May 20, 1936.
12. Ibid.
13. Ibid.
14. Levy, *Memoirs of an Art Gallery,* 176.
15. Ibid., 177.
16. Roland Penrose, *Scrapbook: 1900–1981* (London: Thames and Hudson, 1981), 60.
17. Eileen Agar, with Andrew Lambirth, *A Look at My Life* (London: Methuen, 1988), 67.
18. Santos Torroella, *Salvador Dalí, Corresponsal de J. V. Foix, 1932–1936,* 155.
19. Editorial, *Daily Mail,* July 2, 1936.
20. Anonymous editorial, *Studio* No. 112, September, 1936.

21. Dalí, *The Secret Life of Salvador Dalí*, 271.
22. Edward James to Dalí, undated, probably written at the end of 1939.
23. Ibid.
24. Parinaud, *The Unspeakable Confessions of Salvador Dalí*, 198.
25. Ibid.
26. Dalí, *Secret Life*, 261.
27. Ibid.
28. Dalí to Edward James, undated.
29. John G. Frey, "From Dada to Surrealism," *Parnassus* VIII, December 1936.

CHAPTER 8

1. Edward James, undated note.
2. Ibid.
3. Ibid.
4. Ibid.
5. Dalí to Edward James, February 19, 1937.
6. Dalí to Harpo Marx, end of February 1937.
7. Salvador Dalí, "Surrealism in Hollywood," *Harper's Bazaar,* May 1937.
8. Dalí to Harpo Marx, end of February 1937.
9. Dalí, *Secret Life*, 332.
10. Edward James to Ralph Kornfeld, October 12, 1938.
11. Ibid.
12. Dalí to Edward James, June 15, 1937.
13. Dalí to Edward James, end of June 1937.
14. Edward James to Dalí, 31 August 1937.
15. Ibid.
16. Dalí to Edward James, August 1937.
17. Ibid.
18. Dalí to Edward James, August 1937.
19. Dalí to Edward James, undated, probably written at the beginning of September 1936.
20. Reynolds Morse, conversation (April 1991).
21. Dalí, *Secret Life*, 157.
22. René Magritte to Edward James, February 1938.
23. Dalí, *Secret Life*, 23.
24. André Breton, *Entretiens* (Paris: Centre Georges Pompidou, 1979), 36–37.
25. Julien Green, *Journal (1926–1934): Les Années Faciles* (Paris: Plon, 1980), 267.
26. Cowles, *The Case of Salvador Dalí*, 291.
27. Stefan Zweig to Sigmund Freud, July 18, 1936, *The Letters of Sigmund Freud, 1873–1939*, edited by Ernst L. Freud (London: The Hogarth Press, 1961).
28. Dalí, *Secret Life*, 24.
29. Edward James to Christopher Sykes, July 20, 1939.
30. Cowles, *The Case of Salvador Dalí*, 292.
31. Dalí, *Secret Life*, 371.
32. Ibid.

33. Ibid.
34. Ibid.
35. Ibid., 379.
36. Eluard, *Letters to Gala*, 239.
37. Salvador Dalí to André Breton, January 2, 1939, quoted by José Pierre in *Salvador Dalí* (Paris: Centre Georges Pompidou, 1979), 137.
38. André Breton, *Des Tendances les plus récentes de la peinture surréaliste*, quoted in *André Breton, La Beauté convulsive* (Paris: Centre Georges Pompidou, 1991), 246.
39. Parinaud, *The Unspeakable Confessions of Salvador Dalí*, 127.
40. M. W. Georges, *"Chez Salvador Dalí," Beaux Arts*, Paris, February 10, 1939.
41. Anonymous editorial, *Time*, March 27, 1939.
42. Parinaud, *Unspeakable Confessions*, 186.
43. Dalí, *Secret Life*, 374.
44. Quoted in all the New York daily newspapers that morning.
45. Giorgio de Chirico. *The Memoirs of Giorgio de Chirico*, trans. Margaret Crosland (London: Peter Owen, 1971), 129.
46. Introduction to Julien Levy Gallery catalog of Dalí exhibition, New York, 1939.
47. Ibid.
48. Anonymous editorial, *Time*, April 2, 1939.
49. Paul Bird, "The Fortnight in New York," *Art Digest*, April 1, 1939.
50. Contract among DWF, Inc., Edward James, and Dalí, April 10, 1939.
51. W. M. Gardner to William Morris, April 1939.
52. Edward James (purporting to be a workman on the *Dream of Venus* set) to William Morris, April or May 1939.
53. Diana Cooper, *Trumpets from the Steep* (London: Rupert Hart-Davis, 1960), 242.
54. Dalí, "Declaration of the Independence of the Imagination and the Rights of Man to His Own Madness," June 1939.
55. Ibid.
56. Ibid.
57. Julien Levy to Edward James, July 15, 1939.
58. Secrest, *Salvador Dalí*, 175.
59. Chantal Vieuille, *Gala* (Lausanne: Editions Favre, 1988), 126.
60. Edward James to Dalí, September 3, 1939.
61. Guggenheim, *Out of This Century*, 130.
62. Edward James to Dalí, October 25, 1939.
63. Sol Hurok, with Ruth Goode, *Impresario: A Memoir* (London: Macdonald, 1947), 209.
64. John Martin, "The Dance: Surrealism and Americana," *New York Times*, November 19, 1939.
65. Dalí to Edward James, late 1939.
66. Ibid.

CHAPTER 9

1. Salvador Dalí, *Le Mythe Tragique de "L'Angelus" de Millet, Intepretation Paranoïaque-Critique* (1963; reprint, Paris: Société Nouvelle des Editions Pauvert, 1978), 4. (Dalí wrote this extended essay in early 1940 but left the manuscript behind when he fled Arcachon. It came to light again twenty-two years later.)
2. Carlos Rojas, "Salvador Dalí, or the Art of Spitting on Your Mother's Portrait," lecture given at the Spanish Institute, London, November 1989.
3. Parinaud, *The Unspeakable Confessions of Salvador Dalí,* 154.
4. Ibid.
5. Dalí, *Secret Life,* 334.
6. Parinaud, *Unspeakable Confessions,* 198.
7. Dalí to Caresse Crosby, end of July 1940.
8. Luis Buñuel to Edward James, July 19, 1940.
9. Dalí, *Secret Life,* 391.
10. Anaïs Nin, *The Diary of Anaïs Nin, 1939–1944* (Vol. III) (New York: Harcourt Brace Jovanovich, 1969), 40.
11. Ibid.
12. Ibid., 41.
13. Anonymous, "*Life* Calls on Salvador Dalí," *Life,* April 1, 1941.
14. Dalí, *Secret Life,* 11.
15. Dalí, telegram to Caresse Crosby, September 10, 1940.
16. Edward James, *Long Postscript to My Youth* (unpublished manuscript).
17. Edward James to Yvonne, the Marquesa de Casa Fuerte, April 11, 1941.
18. Baron Alexis de Rédé, conversation (May 10, 1990).
19. Draft of unmailed letter from Edward James to Dalí, March 1941.
20. Edward James to Yvonne, the Marquesa de Casa Fuerte, undated.
21. Julien Levy to Edward James, early spring 1941.
22. Ibid.
23. Reynolds Morse, conversation (April 1991).
24. Herbert Cerwin, *In Search of Something: Memoirs of a Public Relations Man* (privately published, San Francisco, 1966), 12.
25. Ibid., 17.
26. James Thrall Soby to Alfred Barr, October 21, 1941.
27. Paul Bird, *Art Digest,* December 1941.
28. Peyton Boswell, "Peyton Boswell Comments," *Art Digest,* December 1941.

CHAPTER 10

1. Anonymous, "Ants in Brentano's," *New Yorker,* May 8, 1943.
2. Ibid.
3. Salvador Dalí, *Hidden Faces* (New York: Dial Press, 1944), 334.
4. Aub, *Conversaciones con Buñuel,* 348.
5. Ibid.

6. Robert Descharnes, *Salvador Dalí: The Work, the Man* (New York: Harry N. Abrams, 1984), 201.
7. Ibid.
8. Clifton Fadiman, *New Yorker*, January 2, 1948.
9. George Orwell, "Benefit of Clergy: Some Notes on Salvador Dalí (1944)," in *Collected Essays* (London: Secker and Warburg, 1944), 209–19.
10. Ibid.
11. Ibid.
12. Ibid.
13. Ibid.
14. Richard Ellmann, *Oscar Wilde* (New York: Alfred A. Knopf, 1987), 284.
15. James Thurber, "The Secret Life of James Thurber," *New Yorker*, February 27, 1943.
16. André Breton, "Avida Dollars," *Arson* No. 1, 1942.
17. Buñuel, *My Last Sigh*, 182–83.
18. Ibid., 183.
19. Dalí, *Hidden Faces*, 212.
20. Ibid., 39.
21. Ibid., 43.
22. Ibid., xii.
23. Ibid.
24. Ibid., 82.
25. Ibid., 57.
26. Ibid., 72.
27. Ibid., 183.
28. Ibid., 62.
29. Ibid., 84.
30. Ibid., 81.
31. Ibid., xii.
32. Edmund Wilson, "Salvador Dalí as Novelist," *New Yorker*, July 1, 1944.
33. Ibid.
34. Orwell, "Benefit of Clergy," in *Collected Essays,* 127.
35. Helena Rubinstein, *My Life for Beauty* (New York: Simon & Schuster, 1964), 93.
36. Parinaud, *The Unspeakable Confessions of Salvador Dalí*, 95.
37. Rubinstein, *My Life for Beauty*, 93.
38. Parinaud, *Unspeakable Confessions*, 210.
39. Ibid.
40. Edward James to Peat, Marwick, Mitchell, November 29, 1943.
41. Reynolds Morse, conversation (April 1991).
42. Ibid.
43. Ibid.
44. Ibid.
45. Ibid.
46. Dalí to Antony Tudor, undated.
47. Paul Bowles, *Without Stopping* (Hopewell, N.J.: Ecco Press, 1985), 252.
48. Ibid., 255.

49. James Bigwood, "A Nightmare Ordered by Telephone" (unpublished manuscript).
50. *Arena,* BBC 2, 1986.
51. Bigwood, "A Nightmare Ordered by Telephone," 3.
52. Ibid., 8.
53. Ibid., 23.
54. Ernst, *A Not-So-Still-Life,* 132.

CHAPTER 11

1. Eluard, *Letters to Gala,* 251.
2. Mrs. Jonathan Guinness, conversation (May 1989).
3. Montserrat Dalí y Bas, conversation (June 1990).
4. Descharnes, *Salvador Dalí: The Work, the Man,* 297.
5. Reynolds Morse, conversation (April 1991).
6. James Thrall Soby to Reynolds Morse, February 2, 1946.
7. Jordan R. Young, "Dalí and Disney," *Los Angeles Times,* May 1989.
8. Ibid.
9. Ibid.
10. Cowles, *The Case of Salvador Dalí,* 251.
11. Ibid., 207.
12. Prince Jean-Louis Faucigny-Lucinge, conversation (December 1989).
13. Ibid.
14. Eluard, *Letters to Gala,* 254.
15. Ibid., 258.
16. Michael Stout, conversation (December 1991).
17. Reynolds Morse, WTAM, Cleveland, October 19, 1947.
18. Ibid.
19. Salvador Dalí, *Fifty Secrets of Magic Craftsmanship* (New York: Dial Press, 1948), 23.
20. Gertrude Stein, *Everybody's Autobiography* (New York: Random House, 1937), 25.
21. Cowles, *The Case of Salvador Dalí,* 263.
22. Ibid.
23. Salvador Dalí, *Dalí News* Vol. 1, No. 2.
24. Philippe Halsman and Yvonne Halsman, *Halsman at Work* (New York: Harry N. Abrams, 1971), 85.
25. Ibid., 93.
26. Salvador Dalí and Philippe Halsman, *Dalí's Moustache: A Photographic Interview* (New York: Simon & Schuster, 1954), 118.
27. Ibid.
28. Cowles, *The Case of Salvador Dalí,* 199.
29. Karl Rankl to David Webster, October 10, 1949.
30. Cowles, *The Case of Salvador Dalí,* 202.
31. Peter Brook, "Salome," *Observer,* December 1, 1949.

CHAPTER 12

1. Louis Allen, "Salvador Dalí," *The Month,* November 1951.
2. Reynolds Morse, conversation (April 1991).
3. Ana Maria Dalí, *Salvador Dalí Visto por Su Hermana,* 5.
4. Parinaud, *The Unspeakable Confessions of Salvador Dalí,* 161.
5. Dalí, *The Secret Life of Salvador Dalí,* 243.
6. José Sangla, interview with Dalí, ORTF, 1972.
7. Reynolds Morse, conversation (April 1991).
8. Montserrat Dalí y Bas, conversation (June 1990).
9. Parinaud, *Unspeakable Confessions,* 13.
10. Ibid., 23.
11. Legal document issued and signed in Figueres on September 5, 1952, by Don Evaristo Valles y Llopart, notary.
12. Dalí, *"Picasso y Yo,"* speech given under the auspices of the Institute of Iberian Culture, Teatro María Guerrero, Madrid, October 12, 1951.
13. Ibid.
14. Michel Tapie, *Dalí* (Paris: Editions du Chêne, 1957), 48.
15. Edward James to Dalí, undated, probably 1952.
16. Daniel Farson, *Sacred Monsters* (London: Bloomsbury, 1988), 48.
17. *Scottish Art Review* Vol. IV, No. 2, 1952 (special issue devoted to Dalí).
18. Ibid.
19. Osbert Lancaster, "Is Salvador Dalí Still Painting to the Gallery?" *Daily Express,* December 5, 1951.
20. Cowles, *The Case of Salvador Dalí,* 274.
21. Dalí, *Fifty Secrets of Magic Craftsmanship,* 21.
22. Robert Descharnes, *Salvador Dalí* (London: Thames and Hudson, 1985), 323.
23. Salvador Dalí, *Diary of a Genius* (New York: Doubleday, 1965), 12.
24. Ibid., 86.
25. Ibid., 94.
26. Ibid., 96.
27. Ibid., 97.
28. Ibid., 98.
29. Ibid., 104.
30. Robert Descharnes, *The World of Salvador Dalí* (London: Macmillan, 1972), 208.
31. *Boletín Oficial del Estado,* November 28, 1953.
32. McGirk, *Wicked Lady, Salvador Dalí's Muse,* 130.
33. Salvador Dalí, lecture at the Sorbonne, Paris, December 17, 1955.
34. Dalí, *Diary of a Genius,* 139.
35. Ibid., 171.
36. Ibid., 172.
37. Ibid.
38. Mike Wallace, *The Mike Wallace Interview* (ABC), April 19, 1958.
39. Cowles, *The Case of Salvador Dalí,* 155.

40. Jean Bobon, "Contribution à la Psychopathologie de l'Expression Plastique, Mimique et Picturale," *Acta Neurologica et Psychiatrica Belgica* (special issue), Brussels, December 1957.

CHAPTER 13

1. Dalí, *The Secret Life of Salvador Dalí,* 399.
2. Dalí, *Diary of a Genius,* 191.
3. Ibid., 193.
4. Bosquet, *Conversations with Dalí,* 20–1.
5. Ibid., 195.
6. James Thrall Soby, catalog to Dalí exhibition, Museum of Modern Art, New York, 1946.
7. Bosquet, *Conversations with Dalí,* 88.
8. Dalí, "My Cultural Revolution: Quantified Institutions" (tract distributed at the Sorbonne, Paris, May 18, 1968).
9. Bosquet, *Conversations with Dalí,* 88.
10. Anonymous, "Dalí and the Bathtub on the Ceiling," *Art News,* September 1964.
11. Ultra Violet, *Famous for 15 Minutes* (New York: Avon, 1990), 68.
12. Julian Hope, conversation (May 1990).
13. Ibid.
14. Descharnes, *The World of Salvador Dalí,* 70.
15. Maurice Béjart, *Un Instant dans la Vie* (Paris: Flammarion, 1979), 166.
16. Conversation (anonymous).
17. Descharnes, *The World of Salvador Dalí,* 201.
18. Ibid., 73.
19. Carlton Lake, *In Quest of Dalí* (New York: Putnam, 1969), 16.
20. Ibid., 22.
21. Descharnes, *The World of Salvador Dalí,* 11.
22. Amanda Lear, *My Life with Dalí* (London: Virgin Books, 1985), 46.
23. Descharnes, *The World of Salvador Dalí,* 70.
24. Donald Sutherland, "The Ecumenical Playboy," *Arts Magazine,* February 1963.
25. Quoted in Ramón Guardiola Rovira, *Dalí y Su Museu* (Girona: Editoria Empordanesa, 1984), 41.
26. Mrs. Jonathan Guinness, conversation (November 1989).
27. Guardiola Rovira, *Dalí y Su Museu,* 70.
28. Ibid., 21.
29. Ibid., 72.
30. Ibid.
31. Ibid., 46.
32. McGirk, *Wicked Lady, Salvador Dalí's Muse,* 133.
33. Eric Shanes, *Dalí: The Masterworks* (New York: Portland House, 1990), 203.
34. Ibid.
35. Mathieu Galey, *Journal 1953–1973* (Vol. I) (Paris: Grasset, 1986), 46.

CHAPTER 14

1. Luis Romero, *Dedalico Dalí* (Barcelona: Primer Plano, 1989), 246–47.
2. Guardiola Rovira, *Dalí y Su Museu*, 131.
3. Ibid., 151.
4. Ibid., 153.
5. Ibid., 154.
6. Ibid.
7. Ibid.
8. Anonymous, *"Salvador Dalí Va Plus Loin avec L'Express,"* L'Express, May 1971.
9. John McEwen, "Salvador Dalí," *Sunday Times* (London), January 1989.
10. Robert Hughes, "Salvador Dalí," *Time*, May 1972.
11. Jocelyn Kargère, conversation (May–June 1971).
12. Ibid.
13. Ibid.
14. Ibid.
15. Peter Brown, conversation (December 1991).
16. Ibid.
17. Andy Warhol (with Robert Colacello), *Andy Warhol's Exposures* (New York: Grosset and Dunlap, 1979), 197.
18. Robert Colacello, *Holy Terror: Andy Warhol Close-Up* (New York, HarperCollins, 1990), 197.
19. André Breton, "Second Surrealist Manifesto," Paris, 1930.
20. Dalí, *Fifty Secrets of Magic Craftsmanship,* (New York: Dial Press, 1948), 54.
21. Ibid., 122.
22. Ibid., 130.
23. Ibid., 109.
24. Michael Ward Stout, conversation (December 1991).
25. Ibid.
26. Dalí interview with *L'Express*, May 1971.
27. Ibid.
28. Marie-France Boyer, *"Dalí Se Laisse Mourir d'Amour"* (interview with Dr. Pierre Roumeguère), *Le Point*, June 1979.
29. Speech given by Tony Aubin, acting president of the Académie des Beaux Arts, France, on the occasion of Dalí's admission into the Académie on May 9, 1979.
30. Dalí acceptance speech on being admitted into the Académie des Beaux Arts, France, on May 9, 1979.
31. Julien Green, introduction to the Salvador Dalí Retrospective catalog, 8.

CHAPTER 15

1. Michael Ward Stout, conversation (December 1991).
2. Nanita Kalachnikoff, conversation (January 1991).
3. *El País, El Ultimo Dalí* (Barcelona, Ediciones El País, 1985), 12.

4. James Makham, "Salvador Dalí," *New York Times,* December 13, 1991.
5. John McEwen, "Salvador Dalí," *The Spectator,* July 5, 1980.
6. Reynolds Morse, conversation, (April 1991).
7. *El País, El Ultimo Dalí,* 107.
8. McGirk, *Wicked Lady, Salvador Dalí's Muse,* 109.
9. Dalí, communiqué to Agence France-Presse, March 18, 1981.
10. McGirk, *Wicked Lady,* 150.
11. *El País, El Ultimo Dalí,* 80.
12. Prince Jean-Louis Faucigny-Lucinge, conversation (December 1989).
13. *El País, El Ultimo Dalí,* 81.
14. McGirk, *Wicked Lady,* 159.
15. Parinaud, *The Unspeakable Confessions of Salvador Dalí,* 90.
16. Jocelyn Kargère, conversation (January 1990).
17. Parinaud, *Unspeakable Confessions,* 91.

CHAPTER 16

1. Carlos Lozano, conversation (March 1992).
2. *Paris Match,* March 9, 1984.
3. *El País, El Ultimo Dalí,* 189.
4. Contract between Dalí and the Ministry of Culture, June 18, 1982.
5. *El País, El Ultimo Dalí,* 192.
6. *El País,* February 24, 1985.
7. Ibid.
8. *El País,* January 21, 1990.

EPILOGUE

1. Alain Jouffroy, "An Appreciation of Dalí," *Arts,* Paris, 1958.

INDEX

NOTE: *Artistic works by Dalí appear directly under their titles; his written works under his name. All other works appear under names of the authors or artists, at the end of their entries.*

About the Author

MEREDITH ETHERINGTON-SMITH is the author of *Jean Patou* and *The "It" Girls*, a biography of Elinor Glen and her sister Lady Duff-Gordon. A Fellow of the Royal Society of Arts, she has written for numerous British newspapers including the *Daily Telegraph, The Times,* and the *Independent,* has been an editor of *Go, US,* the London editor of Paris *Vogue,* and deputy editor of *Harpers and Queen.* She lives in London and is now editor of *Christie's International Magazine.*

Other DA CAPO titles of interest

JACKSON POLLOCK
Energy Made Visible
B. H. Friedman
New foreword by the author
350 pp., 64 illus.
80664-9 $14.95

SURREALISM
Julien Levy
New introd. by Mark Polizzotti
202 pp., 68 illus.
80663-0 $17.95

JOSEPH SOLMAN
A Monograph
Introd. by Theodore F. Wolff
208 pp., 200 illus.,
nearly 175 in color
79665-1 hardcover $50.00
80639-8 paperback $29.50

ANDY WARHOL
Films and Paintings:
The Factory Years
Peter Gidal
159 pp., 120 illus.
80456-5 $14.95

**DIALOGUES WITH
MARCEL DUCHAMP**
Pierre Cabanne
152 pp., 20 illus.
80303-8 $9.95

**EARLY AMERICAN
MODERNIST PAINTING
1910-1935**
Abraham A. Davidson
342 pp., 178 illus., 8 in full color
80595-2 $19.95

EVA HESSE
Lucy Lippard
251 pp., 264 illus.
80484-0 $18.95

JOAN MIRÓ
Selected Writings and Interviews
Edited by Margit Rowell
364 pp., 33 illus.
80485-9 $14.95

LUIS BUÑUEL
A Critical Biography
Francisco Aranda
327 pp., 101 photos and sketches
80028-4 $11.95

A JOSEPH CORNELL ALBUM
Dore Ashton
256 pp., 107 illus.
80372-0 $22.95

KANDINSKY
Complete Writings on Art
Edited by Kenneth C. Lindsay and
Peter Vergo
960 pp., over 250 illus.
80570-7 $24.95

MAN RAY
American Artist
Neil Baldwin
449 pp., 64 illus.
80423-9 $16.95

**THE MEMOIRS OF
GIORGIO DE CHIRICO**
278 pp., 24 illus.
80568-5 $13.95